Polish Jewish Culture beyond the Capital

Polish Jewish Culture beyond the Capital

Centering the Periphery

Edited by Halina Goldberg
and Nancy Sinkoff

with Natalia Aleksiun

RUTGERS UNIVERSITY PRESS
NEW BRUNSWICK, CAMDEN, AND NEWARK, NEW JERSEY
LONDON AND OXFORD

Rutgers University Press is a department of Rutgers, The State University of New Jersey, one of the leading public research universities in the nation. By publishing worldwide, it furthers the University's mission of dedication to excellence in teaching, scholarship, research, and clinical care.

Library of Congress Cataloging-in-Publication Data

Names: Goldberg, Halina, 1961– editor, writer of introduction. | Sinkoff, Nancy, 1959– editor, writer of introduction. | Aleksiun, Natalia, 1971– editor.
Title: Polish Jewish culture beyond the capital : centering the periphery / edited by Halina Goldberg and Nancy Sinkoff, with Natalia Aleksiun.
Description: New Brunswick, New Jersey : Rutgers University Press, [2023] | Includes bibliographical references and index.
Identifiers: LCCN 2022054247 | ISBN 9781978836037 (paperback) | ISBN 9781978836044 (hardcover) | ISBN 9781978836051 (epub) | ISBN 9781978836068 (pdf)
Subjects: LCSH: Jews—Poland—Intellectual life—19th century. | Jews—Poland—Intellectual life—20th century. | Jews—Poland—Social life and customs—19th century. | Jews—Poland—Social life and customs—20th century. | Jews—Poland—Identity. | Jewish arts—Poland.
Classification: LCC DS134.55 .P657 2023 | DDC 943.8/004924—dc23/eng/20221109
LC record available at https://lccn.loc.gov/2022054247

A British Cataloging-in-Publication record for this book is available from the British Library.

This collection copyright © 2023 by Rutgers, The State University of New Jersey
Individual chapters copyright © 2023 in the names of their authors
All rights reserved
No part of this book may be reproduced or utilized in any form or by any means, electronic or mechanical, or by any information storage and retrieval system, without written permission from the publisher. Please contact Rutgers University Press, 106 Somerset Street, New Brunswick, NJ 08901. The only exception to this prohibition is "fair use" as defined by U.S. copyright law.

References to internet websites (URLs) were accurate at the time of writing. Neither the author nor Rutgers University Press is responsible for URLs that may have expired or changed since the manuscript was prepared.

∞ The paper used in this publication meets the requirements of the American National Standard for Information Sciences—Permanence of Paper for Printed Library Materials, ANSI Z39.48-1992.

rutgersuniversitypress.org

To the Jewish artists, writers and poets, musicians, theater and cabaret performers, architects, filmmakers and moviegoers, patrons of the arts, teachers and journalists, and communal and youth movement activists of Polish lands: We stand on your shoulders.

Contents

Note on Place Names,
Personal Names, and Transliterations ix

Introduction 1
Halina Goldberg and Nancy Sinkoff

PART I
Tradition and Rebellion

1 "The Holiday That Applies to Everyone":
 Ararat *Kleynkunst* Theater and the
 Challenge of Populist Modernism 15
 Zehavit Stern

2 Elkhonen Vogler, Forgotten Poet
 of Yung-Vilne, in Vilna and
 the Litvak Borderlands 37
 Justin Cammy

3 Scandalous Glass House:
 On Modernist Transparency
 in Architecture and Life 56
 Bożena Shallcross

4 Jewish Expressionism between
 Discourses of Revival and Degeneration:
 The Yung-Yidish Group 75
 Małgorzata Stolarska-Fronia

PART II
Performers and Audiences

5 The Theatrics of Bais Yaakov 97
 Naomi Seidman

6 A Spectacle of Differences:
 Bracha Zefira's Tour of Poland in 1929 113
 Magdalena Kozłowska

7 Music of "the Foreign Nations" or
 "Native Culture": Concert Programming
 in Interwar Lwów as a Discourse about
 Jewish Musical Identities 127
 Sylwia Jakubczyk-Ślęczka

8 From *Lodzermensz* to *Szmonces* and Back:
 On the Multidirectional Flow of Culture 152
 Marcos Silber

PART III
Maps and Spaces

9 The Layered Meanings of an Unbuilt
 Monument: Kraków Jews Commemorate
 the Polish King Casimir the Great 171
 Alicja Maślak-Maciejewska

10 Mapping Modern Jewish Kraków:
 Women—Cultural Production—Space 188
 Eugenia Prokop-Janiec

11 Movie Theaters and the Development of
 Jewish Public Space in Interwar Poland 212
 Ela Bauer

12 The Politics of Jewish Youth Movement
 Culture in Interwar Poland's Eastern Borderlands 228
 Daniel Kupfert Heller

Acknowledgments 249

Appendix: Soundscapes of Modernity Program 253

Selected Bibliography 267

Notes on Contributors 287

Index 291

Note on Place Names, Personal Names, and Transliterations

Poland's political boundaries changed constantly from the late eighteenth until the mid-twentieth century. So, too, did the names of its urban centers and peripheries. Polish Kraków was known as Kroke to Yiddish-speaking Jews, Polish Wilno as Vilna to Jews and as Vilnius to Lithuanians. Germans and Austrians called Polish Lwów Lemberg, while Jews called the same city Lemberik and Ukrainians considered it Lviv.

In this volume, we use Polish geographic names, with the Yiddish designation in parentheses at its first mention in a chapter when relevant. The capital city is referenced with the English Warsaw rather than the Polish Warszawa. In some instances, when the Yiddish designation is central to the argument of the chapter, we prioritize that version. Thus, in the chapter on Yiddish poetry's connection to the local landscape, the geographic names reflect the Yiddish use. When the local concept of Lodzermensz is presented as crossing linguistic boundaries between Polish and Yiddish, the Polish term is used rather than the YIVO transliteration of Yiddish (while the city's name continues to be referenced with the Polish name Łódź). Primary sources using alternative geographic spellings are rendered according to the source; bibliographic references to publication places have been revised throughout for consistency (e.g., "Warszawa" to "Warsaw").

In the case of personal names, the situation is even more complicated, as individuals used different variants of their names in different cultural contexts, and local transliterations of names from Yiddish and Russian are maddeningly inconsistent. To further confuse matters, those who emigrated from Poland (most frequently to Palestine/Israel, Anglo countries, the Soviet Union, or Latin America) sometimes adopted names and spellings reflecting the languages of their new homes. Thus, inconsistencies abound. For example, when English texts refer to Shimen Dzigan (Pol. Szymon Dżigan; 1905–1980) and Yisroel Shumacher (Pol. Izrael Szumacher; 1908–1961), the famous comedic duo from Łódź, Dzigan's last name retains the Polish spelling (without the diacritical on the *z*), while Shumacher's

name is typically anglicized. Throughout this book, we use the Polish spellings of individuals' names, except where the spellings of some, such as Sholem Aleichem, are already standardized in English. We retain the original spellings of authors' bylines in the text and the primary sources' original languages.

Transliterations of Yiddish follow YIVO guidelines, of Hebrew those of the *Encyclopedia Judaica*, with the modification that the *ḥet* is rendered as *ḥ*. An apostrophe separates two vowels with distinct vocalization, as in *kolno'a* (movie theater). No hyphens separate prefixes, such as *hey* or *vav*. For Russian and Ukrainian, we use the Library of Congress system.

Polish Jewish Culture beyond the Capital

Introduction

Halina Goldberg and Nancy Sinkoff

Poland has never been a fixed geographic entity; its legendary white birch forests are arguably the most consistent component of its landscape. Reaching its largest expanse in the seventeenth century as the Rzeczpospolita Obojga Narodów (Polish-Lithuanian Commonwealth), the country was dismembered and occupied in the late eighteenth century by three empires (Russia, Prussia, and Austria), with its "sovereignty" maintained in the semiautonomous Congress Kingdom established in 1815 and Polish cultural hegemony granted by the Habsburgs to the province of Galicia in 1867. The state's full independence was only regained in the aftermath of World War I. In 1919, Poland's national boundaries circumscribed but a slice of the vast outline of its early modern "golden age," but those hard-won borders—and Poland's political autonomy—were short lived. A mere twenty years after the founding of the Second Republic, Poland was once again dismembered and occupied by two new imperial forces (Nazi Germany and the Soviet Union), gaining a dependent sovereignty under the Soviets that lasted from 1945 until 1989. Again, the state's national boundaries shifted, this time westward, where they remain today—the new borders of modern Poland.

As Poland's political boundaries changed, so too did its urban centers and peripheries. Kraków (Yid. Kroke) was a significant center in the Commonwealth, the symbolic seat of the Polish monarchy, while the cities of the eastern borderlands, such as Wilno (Yid. Vilna; Lith. Vilnius), Lwów (Yid. Lemberik; Ger. Lemberg; Ukr. Lviv), and Tarnopol (Ukr. Ternopil), gained in importance under the rule of the Polish magnate class. With the partitions, Warsaw's stature grew, overshadowing Kraków, although the latter continued to represent the spiritual, cultural center of a dispossessed nation (the Polish émigrés in Paris and London also claimed their importance in preserving the Polish "center" abroad). During the interwar years, Warsaw became the republic's official capital, but the peripheral centers did not relinquish their identities, including their cultures, languages, and denizens' sense of space, both symbolic and physical, and feelings of belonging.

1

The region's vast Jewish population, whose density increased the farther east they settled, always had its own sense of "center" and "periphery," an identification that oscillated depending on the political and cultural value system of the particular segment of the Jewish population.[1] For rabbinic-oriented Jews, Vilna always reigned supreme; yet in the late nineteenth century, Jewish secularists and Yiddishists also claimed the city as *their* center.[2] In 1802, Kazimierz (Yid. Kuzmir), once a separate city with a large Jewish population, became incorporated into Kraków, which itself remained a separate city-state until 1846, when it became part of Galicia, the Habsburg province. Since the sixteenth century, the hundreds of *shtetlakh* (Yid. market towns) throughout the region were home to multitudes of Jews, who may or may not have related to Poland's urban centers. Hasidim, the new pietists of the eighteenth century, increasingly fashioned their sense of center and periphery based on the locales of their rebbes' courts; for them, Góra Kalwaria (Yid. Ger) and Lyady were more important than Warsaw or Vilna.[3] Small-town youth who never traveled to Warsaw and Kraków may have felt that their *rynek* (Pol. market square) was the center of their lives.

The return to state sovereignty in 1919 posed extraordinary challenges of political, cultural, linguistic, and bureaucratic integration among the geographic sections of partitioned Poland.[4] This integration was greeted differently by its new citizens, including the Jews, Germans, and Ukrainians—the republic's large national minorities—who could claim, at least theoretically, full rights to define themselves as Poles. Not all these groups, particularly the Ukrainians, were enthusiastic about independent Polish rule.[5] Most Jews, however, welcomed the reestablishment of the state with fervor. Eager to become Jewish Poles in the fullest sense in the Second Republic, the various Jewish communities in Poland brought their religious difference, their distinctive ethnicity, their linguistic choices (German, Polish, Yiddish, Russian, and Hebrew), and their complex history in the former partitioned areas of Poland to the process of national belonging.[6]

In the spring of 1937, the Galician-born historian and YIVO activist Filip Friedman (1901–1960) wrote a two-part series on "regionalism" in the Yiddish section of the bilingual journal of the Jewish Society for Knowing the Land (Yid. Yidisher gezelshaft far landkentenish; Pol. Żydowskie Towarzystwo Krajoznawcze).[7] The organization Polish Society for Knowing the Land (Pol. Polskie Towarzystwo Krajoznawcze) cultivated an independent, modern Polish identity among the citizens of the new republic by reacquainting them with the areas of partitioned Poland through local historical investigations, nature excursions, sports, "engaged" didactic tourism, and adult education, among other activities. Many Jewish Poles were eager participants in this effort but also felt an urgency—which increased after marshal Józef Piłsudski's death—to create a specific Jewish society devoted to an engagement with distinct Jewish sites in Polish lands. These sites included cemeteries and synagogues, Jewish arts and crafts, and the collection of and investigation into regional Jewish folklore, including songs and folktales, which were left out of Polish tours and guidebooks of the period. Friedman was an active proponent of *landkentenish* (Yid. knowing the land), which dovetailed perfectly with his

commitment to YIVO's collection (Yid. *zamlung*) efforts; his engagement with local, communal history; his Yiddishism; and his desire to provide evidence for the long history of Jewish attachment to Polish soil.[8]

In his columns, Friedman urged his Jewish readers to embrace "regionalism" as a counterweight to the superficiality of consumerism, materialism, and homogenization that was plaguing the new republic.[9] Emphasizing Jewish embeddedness in regional spaces in Poland—Friedman's and others' explicit commitment to *doikayt* (Yid. "hereness" or at-homeness)—threatened Zionist activists' rejection of the Diaspora. The regionalists' nonpartisan political stance was also opposed by the fractious, ardent leftists who sought to galvanize the Jewish under- and working classes to challenge the harsh social class oppression within Jewish society. For Friedman, though, regionalism reinforced the integrity of Polish Jewish identity for both Jews and their Christian fellow citizens. The regional differences among Polish Jewry, he argued, should be seen as a source of strength and creativity and not one of disunity or national separateness. Uncovering the eight-hundred-year history of Jews *throughout* Polish lands—not only in its major cities—would provide incontrovertible evidence of Polish Jewish belonging.[10] Done correctly by resisting the centralizing pull of the metropole, the work of *zamlers*, historians, ethnographers, and linguists could highlight the dynamism of interwar Polish Jewish culture and make abundantly clear the rootedness of Jews in Polish soil while at the same time underscoring their regional diversity.[11]

This, too, is the goal of our volume.

In most discussions of Jewish life and creativity before World War II, the oft invoked "long shadow of the Holocaust" looms in the background.[12] This is hardly surprising, given that the destruction of Poland's Jewish community stands as a catastrophic caesura in the thousand-year history of Jews in Poland. It shapes and colors our perception of every facet of Polish-Jewish history. But we tend to forget that while there was much to fill Poland's Jews with fear and hopelessness during the 1930s, they could not have had the full foresight of the *khurbn* (Yid. catastrophe).[13] They lived and created in the "here" and "now" of the only home they knew and to which most were deeply attached.

For those of us who study Poland's cultural heritage, the subsequent erasure of the multifaceted Jewish engagement with that tradition makes it imperative to present our readership with this lost history. Today's Poland is replete with palimpsests whose earlier layers reveal the riches of Jewish life in Poland before World War II and of the contributions of Polish Jews to Polish culture. Yet these historical layers often remain invisible, even to the most perceptive of us. Halina Goldberg relates,

> I grew up in the old section of Łódź with Yiddish-speaking Holocaust-survivor parents whose families' connection with the city went back to the mid–nineteenth century. Our strolls through the city often became history lessons. Still, I had no awareness that not one but two Yiddish-language theaters—the Scala, whose repertory ranged from Goldfaden to Shakespeare and George du Maurier, and the famed *kleynkunst* Ararat—once thrived just around the corner from our building.

Nor did I know that the composer Aleksander Tansman and the aptly named pioneer of aerospace science Ary Szternfeld (Yid. starfield), both Jews, spent their youth in buildings on either side of mine. I read and reread a thousand times my beloved childhood book, Janusz Korczak's *Król Maciuś Pierwszy* [*King Matt the First*], without any inkling of his extraordinary contributions to children's welfare before the war, nor his tragic sacrifice in the Warsaw ghetto. As a teen, I shrieked at the top of my lungs the witty lyrics and catchy tune of "Sex Appeal" not knowing that the song, first popularized in 1937, was created by Jews—the remarkable composer of tangos and foxtrots, Henryk Wars from Warsaw, and the ingenious lyricist from Lwów, Emanuel Schlechter. The list goes on: I didn't know that the hospital where my parents' cardiological ailments were treated was founded in the late nineteenth century and was operated until 1939 by the Jewish community and that the name it bore after the war was that of Dr. Seweryn Sterling, a Jewish activist who led largely successful efforts to rein in tuberculosis among the working people of Łódź; nor did I realize that the little hill across the street from our building, which in the winter was so perfect for sled rides, was in fact the rubble of the Ezras Izrael (the "Litvak") Synagogue, destroyed by the Nazis in 1939....

If I, with my parents offering daily local history lessons, did not know any of this, if this history, lying in plain sight, was so deeply hidden from our view, what was the extent of this ignorance among my contemporaries, and what are its continuing repercussions?

Since the 1990s, there has been considerable momentum to study Jewish life in prewar Poland, yet so much of that history remains to be rediscovered and integrated into European history, Jewish history, and Polish Jewish studies. Shelves of books have been written on market towns by both academics and nonacademics.[14] But when it comes to urban centers, Polish Jewry has been conceptualized through studies of the metropole: Warsaw and its assimilating circles, its Jewish press, Jewish politics, and more.[15] Likewise, the history of Jews in Poland in the modern period has also often been framed solely as a political narrative.[16]

This collection of essays resists these still dominant modes of discourse by choosing a different geographic, chronological, and topical angle. It highlights the diversity and vitality of Polish Jewish urban culture beyond Warsaw before World War II. It also addresses the production and consumption of culture—including literature, film, cabaret, theater, architecture, the fine arts, and music—from the late nineteenth century until the outbreak of the Second World War, emphasizing cities other than Warsaw in the resurrected Second Republic (1918–1939). By focusing on culture, this book allows us to highlight the rich and multifaceted cultural production of Jewish artists that is largely unknown but also to draw attention to the engagement of Jewish audiences with various art forms, both high and low. We also explore the cultural collaborations and tensions between Jews and Christians that opened an unprecedented space for intellectual and artistic creativity and reinvention. Ultimately, the cultural lens

allows a richer, more layered understanding of Polish-Jewish, Polish, and East European history.

Approaches in this volume also complicate the prevailing discourse about Jewish cultural production that has long focused on listing famous Jews and their contributions to Polish culture. This model of studying prewar Jewish culture, characteristic of the discovery of the Polish Jewish past in the early 1990s, tends to emphasize Jewish creativity in the Polish language and has been geared toward general Polish audiences. The writings of Janusz Korczak (1878–1942), the songs by Marian Hemar (1901–1972), and the poems by Jan Brzechwa (1898–1966) have been accepted as part of Polish culture. In 2017, grassroots cultural activists in Poland lobbied for designating the year as devoted to the memory of the symbolist poet Bolesław Leśmian (1877–1937). More recently, similar initiatives considered the life and work of the poet and children's author Julian Tuwim (1894–1953) and of the Polish writer of science fiction Stanisław Lem (1921–2006). All too often listing these names served the goal of showcasing pre–World War II Poland's multiethnicity. For countless Polish children, the discovery that many authors listed on the curriculum were Polish Jews remains a transformative moment. But what happens if we discuss Jewish culture in Poland without relating it—and thereby reducing it—to its (non-Jewish) Polishness? Or if we redefine "Polishness" in the Second Republic to include all its national minorities and their cultural production? This integrated history of arts and humanities has been long overdue.

The title of our book, *Polish Jewish Culture beyond the Capital: Centering the Periphery*, challenges the scholarly focus on Warsaw by shifting it to other locales and by emphasizing the dialogues and counterpoints among a variety of centers and their peripheries. The center/periphery pairs are construed in various ways—the capital city of Warsaw versus other large cities, provincial urban hubs versus surrounding provinces, the conceptual framework of West versus East, or specific cities in Western Europe versus their Polish counterparts. We demonstrate that the cultural exchanges within these pairs were not unidirectional. Ideas did not simply flow from centers to other locations but also emanated from "peripheries" and shaped "centers." Women's history, often pushed to the margins of scholarship, is also explored in this volume. Essays pay close attention to the role of gender in terms of both cultural production and its consumption. With a more evenhanded presentation of women's roles as producers, intermediaries, and consumers, male-centered historical narratives are challenged.

Geographically, this volume focuses on the cities with large Jewish populations in the lands that lay within the borders of the independent Second Polish Republic. By examining cultural landscapes beyond Warsaw and relationships with other sites of cultural production, the geographical networks of centers and peripheries—local, national, and international—are illuminated. What emerges is a complex geographic and conceptual matrix of Jewish urban spaces onto which the cultural activities of Jewish artists and audiences can be mapped. In the process, we encounter multidirectional cultural interchanges that often crossed religious, ethnic, and state lines in the most unexpected ways.

While *Polish Jewish Culture beyond the Capital* focuses on cultural relations and cultural activism among Polish Jews, it offers a variety of urban encounters in which the relations between majority and minority did not necessarily mean that the majority culture dominated; rather, the relationships were more complex and their directionality could be reversed, with, as in American jazz, the minority culture shaping the whole. Individual chapters engage with cultural scenes in large urban centers—Łódź, Lwów, Kraków, and Wilno—as well as smaller cities (e.g., Lublin) and cities in the eastern borderlands, such as Grodno, Równe, and Pińsk. By studying a large range of urban centers and taking into consideration the particular circumstances of the aforementioned cities, this volume provides a more nuanced understanding of Polish Jewish culture at once diverse, interwoven, full of contradictions, and distinct.

Chronologically, this book encompasses the particularly rich period in Polish Jewish culture from the late nineteenth century until the outbreak of the Second World War. This period was defined by momentous political events, including the emancipation of the Jews in Habsburg Galicia, the assassination of Czar Alexander II, the 1905 revolution, the First World War, and the reconstitution of the Polish state. In Galicia, emancipation saw the expansion of suffrage and the struggle for political rights, which were accompanied by the growth of the Jewish middle class. The Polonization of the education system there created opportunities for Polish Jews to become intimately familiar with Polish history and literature when attending Polish schools and universities.[17] During the same period, Russian Poland industrialized, giving rise to a large Jewish working class and the seeds of a Jewish bourgeoisie and intelligentsia—a process studied by Filip Friedman in his monograph on Łódź.[18] The period also witnessed the birth of powerful new ideologies and movements, especially socialism, Zionism, and "assimilation," which called for acculturation to Polish culture while retaining Jewish self-definition. These movements played an enormously important role on the Jewish street on the eve of the First World War and throughout the new state. All these factors created fecund circumstances for nurturing a particular brand of artistic modernity, defined by the diffusion of languages and styles that ranged from folkism, to functionalism, to expressionism, and to abstraction, all seeking to meet the needs of the new mass Jewish and general audiences with an insatiable appetite for both popular and refined entertainment.

This book was inspired by an international conference, "Centering the Periphery: Polish Jewish Cultural Production beyond the Capital," which included a concert, "Soundscapes of Modernity: Jews and Music in Polish Cities." Both events were part of the Fifth Annual Polish Jewish Studies Workshop held at Rutgers University in March 2018, organized by Natalia Aleksiun, Halina Goldberg, and Nancy Sinkoff. Several of the chapters in this volume emerged from the conference; others were solicited to round out the geographic and thematic scope of the book. The concert, too, was a novum, presenting orchestral, choral, and chamber music, written and produced by Jews in both secular and religious contexts, most of which was little known and some of which was never performed.[19]

Our book is divided into three parts. The chapters in each section are consciously multidisciplinary to illustrate that the cultural conversations in Polish lands were not circumscribed by one kind of cultural form. It is, therefore, possible that a particular chapter could easily fit into a different section, and several of the chapters are in direct conversation with one another—which we indicate within the text or notes of each chapter. Readers are invited to read the chapters as stand-alone pieces or to add a metaphor, as solo instruments, and yet to read the volume as a whole, which will allow the symphonic points and counterpoints among the chapters to be heard.

Part 1, "Tradition and Rebellion," introduces readers to modern artistic expressions in visual arts, theater, poetry, and architecture that challenged the traditional Jewish world. Chapter 1, Zehavit Stern's "'The Holiday That Applies to Everyone': Ararat *Kleynkunst* Theater and the Challenge of Populist Modernism," focuses on Łódź, which was home to a theater aimed at the Jewish working class of this industrial city. Ararat, Stern argues, was molded by tensions: nationalism versus universalism, center versus periphery, and populism versus elitism. Although committed to the impoverished, "uncivilized" Jewish masses of industrial Łódź, Ararat was equally devoted to the lofty ideals of art and beauty and to a modernist ethos. It constantly strived to find the middle way between high-brow modernism and the comforts of *shund* (Yid. trashy culture) and to offer "the holiday that applies to everyone"[20]—that is, art that conformed to high aesthetic standards yet remained accessible to all.

In chapter 2, "Elkhonen Vogler, Forgotten Poet of Yung-Vilne, in Vilna and the Litvak Borderlands," Justin Cammy marks the first introduction for English-language readers to the interwar Yiddish poetry of Elkhonen Vogler (1907–1969), a leading member of the Yiddish literary group Yung-Vilne (Young Vilna). Cammy's chapter adds a new dimension to our volume's engagement with peripheries by analyzing Vogler's pastoral and rural landscapes, which stand in contrast to the much-discussed relationship of Jews to urban space. He argues that Vogler combined modernist experimentation with a fabulist's imagination to produce book-length poems that claimed Lithuanian landscapes as an organic, distinguishing feature of Litvak Jewish identity. The chapter explores how Vogler offered readers a highly individualized poetics of *landkentenish* that sought out intimate relationships with the Polish-Lithuanian borderlands.

Bożena Shallcross's "Scandalous Glass House: On Modernist Transparency in Architecture and Life," the third chapter, looks at the built environment by focusing on the work of Maksymilian Goldberg (1895–1942), a member of a new generation of Polish-Jewish architects who entered the scene after World War I. Known for his predilection for the modernist architectural style known as "functionalism," Goldberg was commissioned by Irena Krzywicka (née Goldberg; 1899–1924), a Polish-Jewish writer and intellectual, to build a home on a wooded lot in Podkowa Leśna. The result, the Glass House, was perceived by her neighbors and the entire community as outrageous and offensive to their taste, as it destabilized the architectural paradigm of the Polish manor, which prevailed in this

posh neighborhood. Not only did the form of the Glass House cause outrage, but so did the building's social functions. Krzywicka, who espoused in her activism a strong feminist agenda, rejoiced in creating scandals and sensations at the house, augmenting its startling form with its instantiation as a vital cultural and social site.

Chapter 4, Małgorzata Stolarska-Fronia's "Jewish Expressionism between Discourses of Revival and Degeneration: The Yung-Yidish Group," discusses the members of Yung-yidish, one of the earliest formal groups of Jewish avant-garde expressionist artists. Her chapter revises the common view that modern artistic thought permeated the East from the West. Instead, she shows that the rapidly urbanizing and industrial city of Łódź produced a special cultural setting for the emergence of Yung-yidish's radical aesthetic experiments in visual art. Yung-yidish's Jewish expressionism illustrated a predilection for spirituality, including engagement with the grotesque, mysticism, Hassidic piety, and apocalyptic and messianic themes.

Part 2, "Performers and Audiences," treats the interplay between new artistic forms—high-, middle-, and lowbrow—and their consumers. This section includes chapters that direct scholarly attention toward middle- or lowbrow culture and help reconfigure another conceptual center/periphery template. Not only has scholarship historically privileged explorations of high culture, but also, more significantly, it has segregated inquiries into high art and popular "entertainment" genres into discrete scholarly fields.

In chapter 5, "The Theatrics of Bais Yaakov," Naomi Seidman explores the little-known avant-garde theater activities of Sarah Schenirer (1883–1935), the founder of the Bais Yaakov movement, which was devoted to modernizing traditional Jewish education for girls: itself a modernist project. Schenirer mentions attending avant-garde plays in a number of entries in her Polish-language diary, which were censored in Yiddish and Hebrew translation, illustrating that her founding of an orthodox girls' school system meant not the abandonment of her interest in the theater but rather its transposition to a different stage. On this stage, the performative aspects of Bais Yaakov as a whole, particularly its reshaping of girls' gender roles, could be given full play—for the girls themselves and for the audiences who watched them perform.

Magdalena Kozłowska's chapter, the volume's sixth, "A Spectacle of Differences: Bracha Zefira's Tour of Poland in 1929," decenters the dominant Ashkenazic cultural milieu of interwar Poland by focusing on a Jewish-Yemenite singer from Mandatory Palestine, Bracha Zefira (1911–1988). Zefira visited not only the major cities of the time, such as Warsaw, Kraków, Łódź, Lublin, and Białystok, but also smaller places such as Grodno, Tomaszów Mazowiecki, Chełm, and Brześć. Her performances introduced both the Jewish and non-Jewish middle classes to the existence of "Oriental" Jewry through a direct encounter, which led to ambivalent readings of her "Otherness" on the part of many strata within Polish Jewry who, themselves, struggled with their own difference amid a dominant Christian culture.

Sylwia Jakubczyk-Ślęczka explores musical life in interwar Lwów in chapter 7, "Music of 'the Foreign Nations' or 'Native Culture': Concert Programming in

Interwar Lwów as a Discourse about Jewish Musical Identities." She focuses on the transformation of the idea of "Jewish music" and presents the Jewish elite's views on art and folkloristic musical genres, both Jewish (written by Jews or on Jewish topics) and non-Jewish. Her research illuminates the aesthetic and political shifts, which resulted in three different yet interwoven directions of cultural politics: "assimilation," a populist turn to "the people," and the creation of Jewish art music. Her study also highlights Lwów's role as the regional musical center of eastern Galicia and the changing orientations toward other political and conceptual centers—Vienna, Warsaw, St. Petersburg, and in the last period, Palestine.

The literary culture of Łódź, known as the workers' city, is the focus of chapter 8, Marcos Silber's "From *Lodzermensz* to *Szmonces* and Back: On the Multidirectional Flow of Culture." Silber focuses on a group of cabaret artists in the city, whose artistry complicates the reductionist binary of "Polish" and "Jewish" culture. His chapter explores the complex process of cultural transference that involved language, ethno-national discourses, and class stereotypes. The flow of cultural exchange was not unidirectional; there was a constant ebb and flow from Łódź to Warsaw and back again and then forward, in both Polish and Yiddish. In this process, there was no one center and one periphery; rather, cultural production was always a multidirectional flow of culture.

Part 3, "Maps and Spaces," foregrounds the spatial component of Polish Jewish cultural production. If many chapters in this volume introduce readers to little-known performances, literary works, and buildings, chapter 9, Alicja Maślak-Maciejewska's "The Layered Meanings of an Unbuilt Monument: Kraków Jews Commemorate the Polish King Casimir the Great," unpeels the layers of the Polish Jewish past to study a cultural artifact that never came into existence. Yet by focusing on the efforts of late nineteenth-century Cracovian Jews to raise the money for and erect a full-figure statue of Casimir the Great, the fourteenth-century Polish king who was perceived as the great benefactor of the Jews, Maślak-Maciejewska shows how Jews sought to initiate and participate in the Polish commemorative practices of fin de siècle Galicia. In so doing, they asserted their sense of belonging within a highly Polonized environment, one increasingly defined by ethno-national exclusion.

In "Mapping Modern Jewish Kraków: Women—Cultural Production—Space" (chapter 10), Eugenia Prokop-Janiec literally sleuths out the city's gendered geography between 1890 and 1939. She examines the modern institutional spaces in which Jewish women in Kraków carried out cultural activities. Female Jewish students, teachers, doctors, journalists, translators, social activists, writers, artists, and scholars inhabited a wide range of spaces, such as the Jagiellonian University, the Academy of Fine Arts, educational societies, reading rooms for Jewish women, libraries, editorial offices, social organizations, the theater, and artistic salons, which both mirrored and differed from the spaces frequented by Christian Polish women. Mapping Kraków with attention to changing gendered spaces of female cultural expression shows that there were key locations in which Jewish and Christian Poles blurred the denominational divisions within the city.

"Moving pictures," that startling new art form of the early twentieth century, became an extremely creative vehicle for modernizing Polish Jews. While many scholars have focused on Jewish filmmakers, chapter 11, Ela Bauer's "Movie Theaters and the Development of Jewish Public Space in Interwar Poland," shows how being a movie consumer was a means by which Jewish society—in both big cities and smaller market towns—encountered the secular world and its values.[21] During the 1920s and 1930s, movie theaters functioned as Jewish public spaces where lectures, political meetings, and other cultural activities took place. The chapter illustrates that "Jewish space" needs to be conceived beyond the boundaries of tradition, religion, and family.

Activities organized by political clubs were also a form of leisure for Polish Jewish youth in the interwar period. Daniel Kupfert Heller's "The Politics of Jewish Youth Movement Culture in Interwar Poland's Eastern Borderlands" (chapter 12) compares the political culture of Jewish youth movements in the *shtetlakh* of Poland's eastern borderlands, the provinces of Wołyń and Polesie, to that in the country's urban centers. He investigates the complex relationship between the urban leadership of "official" youth movement culture and the Jewish youth in Poland whom they tried to mold. Drawing on the autobiographies collected in the 1930s by the YIVO (the Jewish Scientific Institute) in Vilna, on the correspondence of the period, and on *yizker bikher* (Yid. memorial books), Heller focuses on two of the largest Zionist youth movements in interwar Poland, Hashomer hatsa'ir and Betar. His chapter illustrates the distinctiveness of political culture in the region's market towns and in the cities, a distinctiveness shaped by diverse commitments to religion, gender, and the role of government officials in the youth movements' activities and cultural life.

In 1938, students in schools belonging to the Central Yiddish School Organization (CYSHO; Yid. Di tsentrale yidishe shul-organizatsye) throughout Poland had worked for a year on an exhibit that depicted the history and accomplishments of the Polish Jewry. Set to open in Warsaw on April 2, 1939, the exhibition was shut down by government inspectors without any explanation, a cruel ploy to erase the representation of one thousand years of Polish Jewry's rootedness. The young American-born Lucy Schildkret (later the historian Lucy S. Dawidowicz), completing her year as an *aspirant* (Yid. research fellow) at the YIVO in Vilna, traveled to Warsaw to see the cordoned-off exhibit. She bitterly remarks upon the purpose of the injunction in her memoir, penned fifty years later: "You didn't need any legal or legalistic explanations to understand why the Polish authorities had closed the exhibit. At just that time, the government and the antisemitic parties at its helm were clamoring to drive the Jews out of Poland, charging that they were alien to the country. This CYSHO exhibition graphically documented just the opposite. It showed the deep roots that Jews had struck in Poland and how abundantly they had contributed to Poland's industrial development and cultural endeavors."[22] The CYSHO exhibit resulted from the efforts of Jewish children throughout the territories of the new republic, in both peripheral locales and urban centers, who rather than engaging with the political ambitions of national autonomy, stated

simply, "We are Polish Jews. We are at home." So, too, this volume reasserts the cultural *doikayt* of Polish Jewry. By exploring Polish Jewish culture in new locales and by including the periods of both Poland's partitions and Polish independence, this volume showcases the multivalent texture of Polish Jewish cultural production as it was in its time.

For the concert program of "Soundscapes of Modernity: Jews and Music in Polish Cities," see this volume's appendix. For sound recordings, visit https://polish jewishmusic.iu.edu.

NOTES

1. Gershon Hundert, "Some Basic Characteristics of Jewish Life in Poland," in *Poles and Jews: Renewing the Dialogue*, vol. 1 of *Polin: Studies in Polish Jewry*, ed. Antony Polonsky (Oxford: Basil Blackwell for the Institute for Polish-Jewish Studies, 1986), 28–34.

2. Jerold C. Frakes, *Jerusalem of Lithuania: A Reader in Yiddish Culture History* (Columbus: Ohio State University Press, 2011); Cecile E. Kuznitz, "On the Jewish Street: Yiddish Culture and the Urban Landscape in Interwar Vilna," in *Yiddish Language and Culture: Then and Now*, ed. Leonard Jay Greenspoon (Omaha: Creighton University Press, 1998), 55–92.

3. For an essential new geography of Hasidism, see Marcin Wodziński, *Historical Atlas of Hasidism*, cartography by Waldemar Spallek (Princeton, N.J.: Princeton University Press, 2018).

4. Joseph Rothschild, *East Central Europe between the Two World Wars* (Seattle: University of Washington Press, 1974); Brian Porter-Szűcs, *Poland in the Modern World: Beyond Martyrdom* (West Sussex: Wiley Blackwell, 2014).

5. Israel Bartal and Antony Polonsky, eds., *Focusing on Galicia: Jews, Poles, and Ukrainians, 1772–1918*, vol. 12 of *Polin: Studies in Polish Jewry* (London: Littman Library of Jewish Civilization, 1999); Bohdan Budorowycz, "Poland and the Ukrainian Problem, 1921–1939," *Canadian Slavonic Papers* 25, no. 4 (December 1983): 473–500.

6. David Engel, "Citizenship in the Conceptual World of Polish Zionists," *Journal of Israeli History* 27, no. 2 (2008): 191–199.

7. Filip Friedman, "Regionalizm," *Yoyvl Numer Landkentenish*, April 1937, 3–7; Filip Friedman, "Regionalizm," *Landkentenish* 2, no. 24 (June 1937): 1–3. The journal *Landkentenish: Tsaytshrift far fragn fun landkentenish un turistik, geshikhte fun yidishe yishuvim, folklor un etnografiye* (Knowing the land: Journal for questions of knowing the land and tourism, the history of Jewish settlements, folklore, and ethnography) was published from 1935 to 1939. On Friedman's historiography, see Salo W. Baron, "Eulogy: Philip Friedman," *Proceedings of the American Academy of Jewish Research* 29 (1960): 1–7. On regionalism in the Second Polish Republic, see Kathryn Ciancia, *On Civilization's Edge: A Polish Borderland in the Interwar World* (Oxford: Oxford University Press, 2020): 180.

8. On YIVO's *zamlung* efforts, see Jeffrey Veidlinger, ed., *Going to the People: Jews and the Ethnographic Impulse* (Bloomington: Indiana University Press, 2016). See particularly Sarah Ellen Zarrow, "'Sacred Collection Work': The Relationship between YIVO and Its Zamlers," in Veidlinger, *Going to the People*, 159–175.

9. Samuel Kassow, "Travel and Local History as a National Mission," in *Jewish Topographies: Visions of Space, Traditions of Place*, ed. Julia Brauch, Anna Lipphardt, and Alexandra Nocke (Burlington, Vt.: Ashgate, 2008), 243.

10. Friedman's articles note eight hundred years of Jewish settlement in Poland. It is more commonplace now to refer to one thousand years of settlement.

11. Friedman wrote, "The growing metropole has sucked out the absolute best, most talented, creative forces from the province: where there is still a gifted scholar or artist,

he is pulled to the metropole. . . . So, in this way, centralization took everything from the province: the people, the older cultural values and the possibilities to create new cultural values. The province became sterile and uniform." Filip Friedman, "Regionalizm," *Yoyvl Numer Landkentenish*, April 1937, 5.

12. Celia S. Heller, *On the Edge of Destruction: Jews of Poland between the Two World Wars* (New York: Columbia University Press, 1977).

13. For a new book emphasizing interwar Polish Jewry's vulnerability, see Kenneth B. Moss, *An Unchosen People: Jewish Political Reckoning in Interwar Poland* (Cambridge, Mass.: Harvard University Press, 2021).

14. Some outstanding examples are Eva Hoffman, *Shtetl: The Life and Death of a Small Town and the World of Polish Jews* (Boston: Houghton Mifflin, 1997); Glenn Dynner, *Yankel's Tavern: Jews, Liquor, and Life in the Kingdom of Poland* (Oxford: Oxford University Press, 2014); Yohanan Petrovsky-Shtern, *The Golden Age Shtetl: A New History of Jewish Life in Eastern Europe* (Princeton, N.J.: Princeton University Press, 2014); and Jeffrey Shandler, *Shtetl: A Vernacular Intellectual History* (New Brunswick, N.J.: Rutgers University Press, 2014).

15. See Helena Datner, *Ta i tamta strona żydowska inteligencja Warszawy drugiej połowy XIX wieku* (Warsaw: Żydowski Instytut Historyczny, 2007); Agnieszka Jagodzińska, *Pomiędzy: Akulturacja Żydów Warszawy drugiej połowy XIX wieku* (Wrocław: Wydawnictwo Uniwersytetu Wrocławskiego, 2008); Glenn Dynner, François Guesnet, and Scott Ury, eds., *Warsaw: The Jewish Metropolis; Essays in Honor of the 75th Birthday of Professor Antony Polonsky* (Leiden: Brill, 2015); Scott Ury, *Barricades and Banners: The Revolution of 1905 and the Transformation of Warsaw Jewry* (Stanford, Calif.: Stanford University Press, 2012); and Joanna Nalewajko-Kulikov, *Mówić we własnym imieniu: Prasa jidyszowa a tworzenie żydowskiej tożsamości narodowej (do 1918 roku)* (Warsaw: Neriton, 2016).

16. See, for example, Gershon Bacon, *The Politics of Tradition: Agudat Yisrael in Poland, 1916–1939* (Jerusalem: Magnes, 1996); Ezra Mendelsohn, *On Modern Jewish Politics* (Oxford: Oxford University Press, 1993); Marcin Wodziński, *Hasidism and Politics: The Kingdom of Poland, 1815–1864* (Oxford: Littman Library of Jewish Civilization, 2013); and Joshua Zimmerman, *Poles, Jews, and the Politics of Nationality: The Bund and the Polish Socialist Party in Late Tsarist Russia, 1892–1914* (Madison: University of Wisconsin Press, 2004). It should be noted that Mendelsohn's important synthetic volume incorporated both visual and literary sources.

17. Natalia Aleksiun, *Conscious History: Polish Jewish Historians before the Holocaust* (Oxford: Littman Library of Jewish Civilization in association with Liverpool University Press, 2021).

18. Filip Friedman, *Dzieje Żydów w Łodzi, od początków osadnictwa Żydów do r. 1863 stosunki ludnościowe, życie gospodarcze, stosunki społeczne* (Łódź: Nakładem Łódzkiego Oddziału Żydowskiego Towarzystwa Krajoznawczego w Polsce, 1935).

19. See the program "Soundscapes of Modernity: Jews and Music in Polish Cities" in this volume's appendix.

20. See Moyshe Broderzon, "Der veg fun unzer teater," quoted in Moyshe Pulaver, *Ararat un lodzher tipen* (Tel Aviv: Y. L. Peretz, 1972), 14.

21. The standard reference work is J. Hoberman's encyclopedic *The Bridge of Light: Yiddish Film between Two Worlds*, updated and expanded ed. (Hanover, N.H.: Dartmouth College in association with the National Center for Jewish Film, 2010). See, too, Marcos Silber, "Cinematic Motifs as a Seismograph: Kazimierz, the Vistula and Yiddish Filmmakers in Interwar Poland," *Gal-Ed: On the History and Culture of Polish Jewry* 23 (2012): 37–57; and Joshua Walden, "Leaving Kazimierz: Comedy and Realism in the Yiddish Film Musical *Yidl Mitn Fidl*," *Journal of Music, Sound, and the Moving Image* 3, no. 2 (Autumn 2009): 159–193.

22. Lucy S. Dawidowicz, *From That Place and Time* (New York: W. W. Norton, 1989), 163.

PART I

Tradition and Rebellion

CHAPTER 1

"The Holiday That Applies to Everyone"

ARARAT *KLEYNKUNST* THEATER AND THE CHALLENGE OF POPULIST MODERNISM

Zehavit Stern

An industrial and commercial hub, interwar Łódź (Yid. Lodzh) was hardly associated with fine art and culture. The Yiddish literary scene of this town, located merely seventy miles from the capital, was regarded as no more than "a literary-journalistic hallway leading into the Warsaw grand hall," to use the words of the Łódź-born Hebrew and Yiddish writer Avraham Levinson (1891–1955).[1] Other realms of Łódź's Jewish or Polish culture, such as visual arts, theater, and performance, were perceived no better. "For artists from other parts of the country," explains art historian Marek Bartelik, "moving to Łódź was at best an exploration of a *terra incognita* and an aesthetic vacuum, and at worst, a trip to an economic and cultural Siberia."[2]

Occasionally, however, new stars appeared in Łódź's dusty gray sky, arousing curiosity even among savvy Varsovians. Such was the Ararat art cabaret—an acronym for Artistic Revue Theater (Yid. *Artistish Revi Teater*), later reinterpreted also as Artistic Romantic Theater or Artistic Revolutionary Theater—which held its first public performance in October 1927. Fourteen months later, the humble Łódź ensemble received a favorable report in the Warsaw-based *Literarishe bleter* (Literary pages), the most prestigious Yiddish art journal of the interwar era.[3] Accompanied by four formidable photos, reproduced in figure 1.1, the brief review crowns the theater "a great success" and concludes, "The time has come for the joyous Łódź Ararat to descend from its Łódź heights to Warsaw."[4]

While complimenting the peripheral ensemble, the anonymous writer ridicules its pretentious name, Ararat, which alludes to the elevated landing place of Noah's ark and evokes notions of rebirth and redemption. Only in the Polish cultural

15

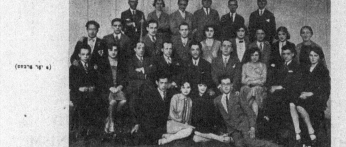
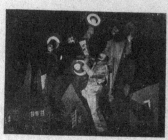
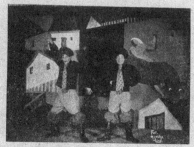
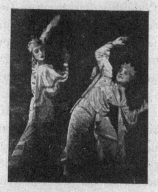

Figure 1.1. A visual summary of Ararat's first year of performance (1927–1928), published by *Literarishe bleter* (Literary pages), the leading Yiddish art periodical in interwar Poland. "Der lodzher revi-teater Ararat," *Literarishe bleter* 5, no. 49 (December 7, 1928): 949. Courtesy of the Historical Jewish Press Project, founded by the National Library of Israel and Tel Aviv University.

capital, he implies, would the dramatic ensemble be truly appreciated and able to evolve into a professional theater.[5] The center, to judge by this review, finds it hard to treat favorably a peripheral art institution that defines itself as an aesthetic acme.[6]

True, the expectation that a successful theater ensemble would move from "the periphery" to Warsaw—or at least arrive there for a tour—was rooted not only in prejudice or elitist bias but also in historical reality. The Vilner trupe (Vilna troupe), which moved from Wilno to Warsaw in 1917, only seventeen months after its premiere, is a famous example demonstrating such "centripetal" forces; the *kleynkunst* ensemble Sambatyon (1926–1929) is another one. Ararat too would ultimately relocate to Warsaw, where it would enjoy a constant flow of viewers, crucial for its sustainability. This transition, however, occurred only in 1934, following successful tours in Warsaw in 1931 and 1932, a series of economic crises, and a significant shift in style that involved moving away from the radical experimentalism of its early days in proletarian Łódź.[7] Was there perhaps also a benefit (albeit not in the commercial sense) of Ararat's peripheral position? Could the margins generate new possibilities unavailable at the center?

Indeed, the short-lived Ararat operated within a threefold marginal realm: Łódź vis-à-vis Warsaw, Yiddish vis-à-vis Polish, and art cabaret vis-à-vis traditional theater. Despite this trifold minor position—but also thanks to it, I argue—Ararat managed to open up a space of creative freedom and innovation. The ensemble's soirees, composed of music and dance numbers alongside satirical skits and one-act plays, brought together highbrow and popular culture, global concerns and local legends, and folklore and modernist sensibilities. This unique amalgam was part of Ararat's aesthetic quest, which lies at the center of this chapter.

Questions arise: In what sense was Ararat shaped by its trifold marginal position? How did the art cabaret reflect and respond to Łódź as a rapidly growing town, home to a large, impoverished proletariat living alongside wealthy bankers and industrial magnates? Did the pioneer ensemble fulfill the high aspirations evoked by its suggestive name? Did it indeed manage to become an "Artistic Revue Theater" or an "Artistic Revolutionary Theater" and imbue the popular cabaret with aesthetic sensibilities and political commitment? This chapter investigates these and other queries, situating them within concentric circles of historical context: interwar Jewish Łódź; Yiddish culture's war on *shund* (Yid. trashy fiction, theater, or film) and its embrace of folklore; the European cabaret craze of the 1920s and especially its more refined branch, the art cabaret; European and especially Russian modernism and its (in)famous elitist bent; and the interwar proletarian arts movement.

The greatest challenge to anyone inquiring into the history of Ararat is the scarcity of sources. Not only do we lack any sound or image recordings of the performances, but also the majority of the texts are unavailable to us today; this is due to the ephemeral nature of the genre, as well as to the calamitous life story of Moyshe Broderzon (1890–1956), the ensemble's founder, manager, and main playwright, who fled Łódź when it was occupied by the Nazis in September 1939. Having survived the war, he was arrested by the Soviet state in 1950 and sent to

a labor camp, where he spent the last years of his life. What we know about Ararat thus draws on a handful of memoirs written by former Ararat members, such as Shimen Dzigan, Sheyne-Miryam Broderzon (Moyshe Broderzon's wife), and Moyshe Pulaver; several artifacts (photos, theater bills, a leaflet celebrating Ararat's fourth anniversary) saved in their personal archives; and a few newspaper reviews and ads. While Broderzon's essays provide a good sense of Ararat's theatrical and sociopolitical credo, it is more challenging to reconstruct the actual performances. This chapter will nevertheless strive to do both: define the ensemble's goals and evaluate the means taken to fulfill them. As befitting its immediate cultural environment of proletarian Łódź, Ararat's aesthetic vision was pronouncedly democratic and inclusive, seeking, in the words of Broderzon, to fulfill the ideal of theater as "the holiday that applies to everyone" (der yontev vos iz khal af dem klal).[8] Translating Jewish traditional vocabulary into the language of art, Broderzon's simple and yet imaginative coinage sums up well Ararat's aesthetic vision, a vision that may be defined as populist modernism, a fascinating and underexplored branch of European modernism, far from its common view as elitist, inaccessible, and detached from history, society, and politics.

Populist Modernism

A quintessential product of its time, Ararat should be understood as part of the modern struggle to create a secular Jewish culture in the larger context of European modernism. The ensemble's unique mixture of irony, dark pessimism, and relentless optimism, as expressed in its public statements and performances, clearly echoes the revolutionary spirits of the European interwar era. It also attests to the specific moment in Polish-Jewish history in which it came into being, shortly after Piłsudski's May 1926 coup d'état, a blow to the highly antisemitic Endecja (National Democracy) party, and before the horizons of interwar Poland—and Europe in general—further darkened with virulent nationalism, racism, and antisemitism. The turmoil of the Great War and the Russian Revolution, the high hopes evoked by the newly founded Polish republic, and the modernist demand for a radical break with the past, constant experimentation, and declaring one's aesthetic and political goals—all these factors shaped Ararat's vision and repertoire.

Established at the time when Bertolt Brecht and Kurt Weil started developing their satirical operas *The Rise and Fall of the City of Mahagonny* (*Aufstieg und Fall der Stadt Mahagonny*) and *Threepenny Opera* (*Die Dreigroschenoper*), Ararat too sought to combine low and high elements; however, it took the opposite path. Whereas Brecht and Weil introduced popular elements—such as jazz, German dance music, or sensational urban crime stories—into the opera, considered in Weimar Germany to be an aristocratic form of art, Broderzon's ensemble took on a task that seemed even harder: to bring art, beauty, lofty poetry, and drama into the cabaret, a popular form of entertainment, while not losing touch with their intended working-class audiences. Ararat was by no means the first ensemble to introduce highbrow elements into the popular cabaret. Alongside flashy,

erotic, and sensational cabarets à la Moulin Rouge or the Folies Bergère, which bloomed throughout the Roaring Twenties from New York to London and from Barcelona to Berlin, numerous art and literary cabarets appeared in Europe in the first decades of the twentieth century, including, for example, the short-lived Zürich-based Cabaret Voltaire (February–August 1916), where the Dada movement famously came into the world, and the more stable St. Petersburg's Krivoe zerkalo (Broken/false mirror; 1908–1931).[9] Poland too had a very active scene of literary cabarets, including the sophisticated prewar Zielony Balonik (The little green balloon), based in Kraków, or Qui Pro Quo, Morskie Oko (Sea eye), Perskie Oko (Persian eye), and Banda (The band)—all based in Warsaw.[10] The Łódź-based literary cabaret Bi-Ba-Bo (1913–1915), discussed in chapter 8, took a less elitist approach than other art cabarets, and Ararat no doubt looked up to it as a model.[11]

Interestingly, however, Ararat's most direct mentor was based not in Poland but rather in Germany. Der blaue Vogel (The blue bird, known also in Russian as the Siniaia Ptitsa; 1921–1931), arguably the most impressive cabaret in interwar Berlin, was founded in 1921 by Russian émigrés and combined Russian folk songs, modernist theater, and satirical sketches in its performances.[12] (One such performance is captured in the photo reproduced in figure 1.2.)

In 1924 and 1926, Der blaue Vogel toured Łódź, and during their second visit, one of the ensemble's directors gave a workshop at Broderzon's acting studio, which a year later evolved into the Ararat art theater. Der blaue Vogel performed a translation of Russian literature and folklore into German culture, relying not only on the universal power of dance and music but also on the common language of interwar European modernism. Although it took place within the limited borders of Jewish Łódź, Ararat's quest for a common language was perhaps even more challenging than that of the German-Russian cabaret, as it strived to translate the idiom of European avant-garde for the people of Łódź, from the wealthy merchants and industrialists of Piotrkowska Street to the slums of Bałuty.[13]

Figure 1.2. Der blaue Vogel in Berlin, ca. 1920. Source unknown. Reproduced by permission of Alamy Ltd.

Inspired by these various models, Ararat developed its own vision of what might be called populist modernism. As befitting the industrial city of Łódź, where the majority of the Jewish population were impoverished sweatshop workers, Ararat strived to create an art theater yet also to make its performances accessible to all. Unlike other institutions of the so-called proletarian art—such as the New York Yiddish Artef theater or the Soviet Proletkult theater, which were representatives of a dramatic theatrical network for political agitation—Ararat's main goal was not to educate or mobilize the masses to action.[14] Rather, it sought to express and relieve, albeit momentarily, the socioeconomic plight of its economically disadvantaged audiences. The ensemble's strong commitment to the working classes shaped the group's repertoire, manifestos, public statements, and anthem, which I will examine more closely in what follows.

Ararat: The Summit and the Deluge

Sung in every performance, the Ararat anthem portrayed an image radically different from that of an elevated sacred summit, or the haven of a well-designed ark, inhabited by the chosen few. Rather, the anthem, which may be read as the group's poetic manifesto, depicts Mount Ararat as the desirable yet faraway, perhaps unattainable, goal of a group of young swimmers struggling bravely in the dark in the aftermath of a disastrous deluge:

> A world dies out in black shimmer,
> The Flood prevails no more—
> Paddling away, young swimmers
> Are looking for a shore!
>
> The sky is still so cloudy,
> No sign of peace and calm . . .
> Without an ark toward Ararat
> We swim, we swim along![15]

The courageous optimism in the face of a harsh reality expresses well the worldview of Broderzon, Ararat's art director and arguably the most prominent cultural activist in interwar Łódź. Within months of his return to Łódź from Moscow, where he spent the turbulent years of World War I and the Bolshevik Revolution, Broderzon founded the *Yung-yidish* art journal (1919), which served as a realm of creative cooperation between writers and visual artists (Broderzon's relationship with Lodzian expressionist artists is addressed in chapter 4).[16] A series of other ephemeral initiatives followed: a publishing house (1920–1921), a puppet theater (Khad-gadye; 1922), and an opera (*Dovid un Bas-Sheve*; 1924, with music by Henekh Kon, who was Broderzon's collaborator on many other projects).[17] In addition to founding and directing these various art projects, Broderzon also published seven lyrical and dramatic works and gave numerous poetry recitations in various cafés and literary circles during the 1920s.

Committed to Yiddish culture and no less to a modernist ethos, Broderzon was always in search of new ways of aesthetic expression with a specifically Jewish character and, as we shall see, a local flavor. Notwithstanding the many obstacles he encountered, Broderzon, dubbed "the Prince of Jewish Manchester," kept working, infecting others with his obstinate optimism.[18] No professional actors in Łódź? Broderzon opened a studio to train young actors, which later evolved into the Ararat ensemble.[19] No funding for the art theater? Broderzon raised money among local philanthropists and cut costs by renting an inexpensive hall, well located at the town center yet alas often unavailable over the weekend. No less importantly, he persuaded not only the actors but also the technicians and even the theater director (who happened to be Broderzon's brother-in-law) to share the collective's meager profits—in fact, to work for scarcely any money. Low turnout, as was often the case in the cabaret's first few months? When the close circles of family and friends were exhausted, the group continued to perform in front of a nearly empty hall, constantly producing new programs and waiting to be discovered by the townsfolk.[20] The ensemble, which according to Dzigan followed from early on the principle of "not taking the box office into account," struggled to draw Łódź audiences to their "avant-garde" shows, which didn't fit Yiddish theater's bill (mostly comedies or tear-jerking melodramas). Constantly on the verge of a financial catastrophe, Ararat nevertheless refused to betray its aesthetic creed. Rather, it was always in search of creative solutions, such as going on tour around the Polish provinces, in Warsaw, and even in Western Europe (sadly, the latter ended up winning the group critical acclaim but no financial gains).[21] Whatever the challenges, Broderzon and his avid young followers—or "Hasidim," as they were humorously called—kept struggling, "swimming" toward their "Ararat," an aesthetic, moral, and social vision that I will now strive to define and contextualize.

The Jewish Mayakovsky? Broderzon as a Mild Revolutionary

In order to better understand Broderzon's aesthetic vision, one must go back to his formative years—namely, his Moscow period. As a Russian citizen, he was forced to leave Łódź during the 1914 German occupation and spent the next four years in Moscow, absorbing the revolutionary spirits of the First World War and the Bolshevik Revolution. These years had a crucial effect on his aesthetic visions, marking his rebirth as a modernist artist. It is in Moscow that he became involved in the radical aesthetic transformations taking place in Russia at the time. Under the influence of the Russian avant-garde, he came to see theater as a prestigious arena of cutting-edge experimentation for artists of various media and simultaneously as a powerful social and political tool. He also took an active part in the quest for specifically Jewish modernist art, cooperating with visual artists such as El Lissitzky, Yisakhar Ber Ryback, and Iosif Chaïkov and becoming involved in initiatives such as the 1917 Circle for Jewish National Aesthetic and the 1918 Moscow Circle of Yiddish Writers and Artists.[22] Finally, the Moscow period also shaped Broderzon's bohemian persona, which upon his return to Łódź became

all the more notable. Yekhiel Yeshaya Trunk depicts Broderzon's return to Łódź as the grand entrance of an actor, for whom Łódź's literary scene and public sphere served as a stage:

> Moyshe Broderzon returned to Łódź from Moscow with all the prerequisites of a great, maybe the greatest Yiddish poet.... Moyshe Broderzon's physiognomy itself was enough to make him appear in Łódź like the darling of the Muses. Like a poetic lion he displayed a head full of black hair as well as black sideburns à la Pushkin. From the Russian revolution, he brought with him a Russian worker's black shirt, which garishly cried forth from Broderzon in the streets of Łódź like a destructive threat. On this black proletarian shirt, he wore all kinds of necklaces made of amber and coral.... On his long out-stretched finger ... he wore framed and faceted gemstones and amulets. One could clearly see that as soon as these fingers held a pen, they could really perform magic. Łódź immediately bowed its head.[23]

While Broderzon—pictured in figure 1.3, a drawing by his friend and collaborator Artur Szyk—may have cultivated at the time "sideburns à la Pushkin," his more immediate source of inspiration, in terms of looks and beyond, was the Russian futurist artist Vladimir Mayakovsky (1893–1930). A contemporary of Broderzon, Mayakovsky too was a multifaceted artist: a poet and master of poetry recitation, playwright, theater director, and illustrator. Tall, dark, charismatic, and handsome, not unlike Mayakovsky, Broderzon adopted some of the salient traits of the Russian poet's bohemian appearance, including colorful bow ties, eccentric shirts, peculiar hats, a mane of thick black hair (which Mayakovsky occasionally shaved), and a dangling cigarette. No wonder, then, that upon returning to Łódź, he became known as "the Jewish Mayakovsky."[24]

However, while sharing a mane of black hair and a penchant for eccentric shirts, Broderzon and Mayakovsky greatly differed in temperament and aesthetic stance. The optimistic and hospitable Broderzon was clearly at odds with the tormented "bad boy of Russian poetry," who offered his lover a "rainbow of shudders" and in another poem provocatively declared, "I love to watch children dying."[25] While the two modernist poets shared an image of a chaotic world in need of a radical change ("a stormy tohubohu" [a shturmisher toyu-vovoyu], in the words of the *Yung-yidish* manifesto), Broderzon's vision was far from the futurist orientation toward a brave new world of urbanism and technology.[26] Rather, it was utterly humanistic, declaring itself as the God-blessed guardian of "eternity, beauty, and truth."[27] This remained Broderzon's ethos throughout the 1920s and 1930s, notable in the various art forms with which he engaged. Over a decade after the launch of *Yung-yidish*, Broderzon's programmatic essay "The way of our theater" ("Der veg fun unzer teater"), published on the occasion of Ararat's fourth anniversary, similarly proclaimed the ensemble as "striving for truth and earnestness."[28] Ararat's emblem—seen in figure 1.4, in the form of an embraced couple, seemingly a clown and an actress, framed by a heart—was another expression of Broderzon's humane attitude, far from the futurist's cult of the machine.

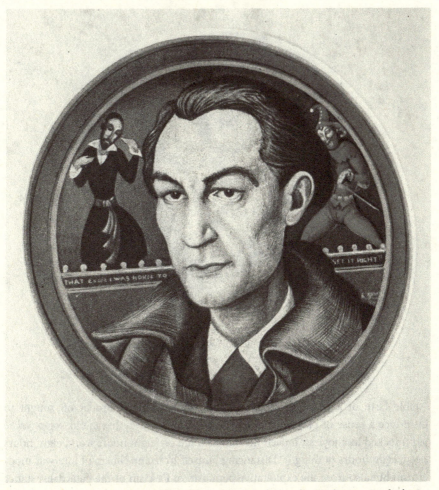

Figure 1.3. Artur Szyk, *Portrait of Moyshe Broderzon*, n.d. Moyshe Broderzon, *Forshtelungen* (Łódź: Nayer Folksblat, 1936/1937), 3.

Whereas the futurists rejected literary canons ("Damn Homer and Ovid / for not having made characters like us / pocked and sooty," exclaims Mayakovsky in "A Cloud in Trousers"[29]), *Yung-yidish*'s manifesto celebrated "the eternal language of the prophets,"[30] and Ararat's repertoire included short "numbers" based on the work of renowned Yiddish writers such as Y. L. Peretz or H. Leyvik. Moreover, while the futurists were known for the scandalous literary evenings they organized, in which they read poetry and manifestos, "performed concerts of 'noises,' and exchanged verbal and even physical abuse with the audience," Broderzon was motivated by what he described as a "comedian's mission" (Yid. komedyantishe shlikhes): bringing joy to "the hearts of thousands of sorrowful people."[31] The difference between these two aesthetic and social visions was rooted not only in Broderzon's amiable temper and humane worldview but also in his intended audiences. While futurism (like other branches of modernism) aimed its attack at the bourgeoisie's

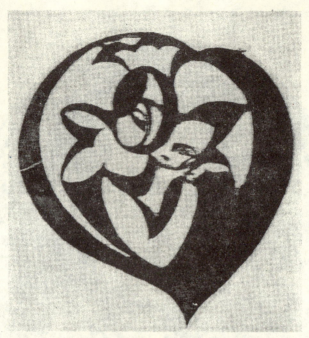

Figure 1.4. Ararat's emblem. Moyshe Pulaver, *Ararat un lodzher tipen* (Tel Aviv: Y. L. Peretz, 1972), 6.

"stable taste of a peaceful, serene, and secure existence," Broderzon sought to introduce a sense of play, dream, and holiday to everyday Jews (Yid. *tog-teglekhe yidn*) locked in a joyless, indeed meaningless life of "eight hours work, eight hours sleep, eight hours nothing."[32] Distancing himself from the elitism of interwar modernism but also from the exploitative populism of Fascism or the paternalist stance of the Soviet state, Broderzon took on himself the seemingly humbler and in fact more complicated task of shaping the aesthetic sensibilities of the working class.

Compared with his Russian contemporaries (both the "cubo-futurists" and the "ego-futurists"), Broderzon was thus a mild, almost "conservative" revolutionary. He also seemed moderate in comparison with Yiddish expressionist poets such as Uri Tsvi Grinberg and Perets Markish, who promulgated a more radical social vision and aesthetic language. While other modernist poets promoted free verse, Broderzon remained loyal to conventional rhyming schemes. A virtuoso rhymester and a regular winner of public rhyming competitions, Broderzon employed his rhymes in various genres: poetry, lyrical dramas, or humorous songs and sketches written for Ararat. His proclivity for rhyming was often scorned by other modernist poets. Markish, for example, refused to publish Broderzon's poetry in *Khalyastre* (The gang; 1922–1924), the expressionist periodical he edited.[33] Melekh Ravitsh, a close friend of Markish and of Grinberg and a member of their art group Khalyastre, criticized Broderzon in his lexicon of Yiddish writers for having "too much form," by which he meant Broderzon's adherence to meter and rhyme.

"The content," he continued, "often hangs loose on Broderzon like a child in his father's clothes."[34]

In line with his "mild revolutionary" spirit, Broderzon presented Ararat's approach as the golden mean. Avoiding the dichotomous rhetoric so common among radical thinkers and activists (good versus evil, high versus low, etc.), he constructed trilateral structures in which Ararat featured as mediating between extremes. In his essay "The way of our theater," he portrayed the young generation as facing two opposing choices: apathetic and joyless existence ("thin-blooded," in his figurative language), on the one hand, and the destructive stance of those who do not know where they are going and rebel out of spite, on the other. Broderzon described the latter as *hefkerdik*, an adjective derived from the Yiddish and Hebrew term *hefker*, of which Yiddish poets of his generation were very fond. Originally a derogative term meaning "ownerless property" or "licentious behavior," modernist poets used it to imply a wild and undisciplined existence. Yet while other Yiddish modernist poets, such as Moyshe Kulbak and Perets Markish, celebrated the radical *hefker* position, Broderzon associated it with young people who were ignorant, cast adrift, or sheeplike. The "golden mean" he offered between these two alternatives consisted of more basic elements: "need, will, and excitement."[35]

Beyond the *Kunst/Shund* Dichotomy: Bonding with the Public

There is, however, one dichotomy that Broderzon could not do without: that of *kunst* (art) versus *shund* (trash). As Dan Miron has shown in *A Traveler Disguised*, the *kunst/shund* binary goes back to the 1880s, when Sholem Aleichem created—"almost single-handedly," as Miron argues—the idea of a Yiddish cultural tradition, crowning Abramovich as the "grandfather" of Yiddish literature and Yitskhok Yoyel Linetski and Abraham Goldfaden as the two founding "giants."[36] Upon constructing this paternal lineage, Sholem Aleichem made sure to contrive a counterforce, or a villain, a role he assigned to the popular writer Shomer (pseudonym of Nokhem Meyer Shaykevitch; [1849?]–1905), who became a living metonymy to the very concept of *shund*.[37] In the realm of Yiddish theater, where the struggle for respectability was felt sharply, the *kunst/shund* dichotomy played an even more crucial role. As Michael Steinlauf writes, *shund* constituted most of the plays performed, and critics, eager to see *kunst* on the Jewish stage, constantly rained brimstone and fire on *shund* productions and on the masses who flocked to see them.[38]

The well-established *kunst/shund* binary is clearly echoed in the writing of Broderzon, who, in his introduction to the Ararat program *Meshiekh kumt* (Messiah comes; 1928–1929), quoted Max Erik: "*Kleynkunst* is a technical expression. Ultimately, there is no small (*kleyn*) or large art, there is either Art or *shund*, worthless writing."[39] Similarly, in "The way of our theater," Broderzon defined Ararat as opposed to other forms of popular culture. Ararat, he argued, was "not revue, cabaret, variety shows, not only shallow entertainment. Our theater of small forms is a theater of great ambitions ... striving for truth and earnestness."[40]

While reiterating the common *kunst/shund* binary, Broderzon nevertheless developed his own unique interpretation of it. Whereas many Yiddish writers and activists directed their arrows at the avid *shund* consumers, Broderzon found no fault with the audiences, only with *shund* itself and with those who created it for the sake of profit only. Moreover, while criticizing *shund*, Broderzon attacked no less vehemently the idea of art for art's sake, as expressed, for example, in the cubo-futurist ideal of "the word as such," in the proposition to "treat the poetic word as an object in itself devoid of any referent," or in the *za-um* (trans-reason) poetry to which this credo gave birth.[41] In stark contrast to these elitist experimentations, typical of early modernism in prerevolutionary Russia, Broderzon strived to create, in his words, "the holiday that applies to everyone."[42] This aspiration, he testified, was the reason he decided to dedicate his art, indeed his life, to theater rather than to poetry and closet drama, in which he was heavily invested during his early days. In an interview published in *Literarishe bleter* in May 1926, sixteen months before Ararat's premiere, he declared,

> My future work will not consist of writing dramas, heroic dramas; not literary but rather theatrical, not for the book market but rather for the stage. I wish to dedicate myself to Yiddish theater. In my view, after Goldfaden we have had no Yiddish. . . . You may ask: how will Yiddish theater be resurrected? The question regarding Yiddish theater is strongly related to the one concerning the crisis in art in general. As long as art will not be needed by all, as long as art will not be genuine daily bread for everybody, it will remain in crisis. . . . The key thing is definitely the contact with the public. And the public is not at all so banal.[43]

In opposition to elitist modernists, who, Broderzon seemed to believe, were turning their backs on the people, his ideal was communicative and inclusive. His dream was to create an art theater that would nevertheless be approachable, popular, and even commercially successful. In hope, so it seems, of finding a generous investor among the journal readers, Broderzon elucidated his vision at some length. He did not abstain from criticizing some of the greatest names in Yiddish theater, as well as his own *Yung-yidish* journal, for forsaking the masses:

> I practically imagine that the answer to the question of Yiddish theater will come in a mechanical and commercial way: there will be a Jew who will understand that a theater is a good business, that the Jewish masses love theater, and will set up a theater, in which he'll make a bond with the Jewish masses. I don't mean, understandably, that this will happen through prostitute-dramas and prostitute-duets. The bond will be, surprisingly enough, through aesthetic means. And when there'll be such a bond, the question of Yiddish theater will be solved. Partial means won't help here. This is why the experiments of Turkow and Lipman did not succeed. . . . I say now that since *Yung-yidish* did not form a true and complete bond with the public, it was worthless.[44]

Synthetic Theater

Broderzon's optimistic vision of an art theater that would also be popular and profitable was not quite realistic. Despite Broderzon's skills at cutting expenses and his sincere efforts to connect with the masses, Ararat constantly faced financial crises. The ensemble's location in Łódź, where the Jewish population consisted of a large, impoverished proletariat and only a small number of rich merchants who were often estranged from Yiddish and/or Jewish culture, made the challenge even greater. Despite Broderzon's efforts to recruit investors, Ararat, like other art theaters, had to rely on philanthropy rather than on profit-oriented ventures.

Notwithstanding its lack of commercial success, Ararat gained its share of public attention and, for a few short periods of time, was well received among audiences in Łódź and beyond. Yet did the group also manage to become an art cabaret? Did it fulfill Broderzon's vision of a theater that was both accessible and aesthetically valuable? What set the ensemble apart from popular forms of entertainment to which Broderzon scornfully referred as *divertissement*? A master of essays and grand declarations, who used to write, as Dzigan relates, in "a festive tone ... with many foreign words, and a tangled style," Broderzon tended to address such questions in general terms rather than to provide specific answers. Dzigan continued to claim that even people from the intelligentsia could not understand Broderzon's introductions.[45] In a 1928 letter to the Łódź Artist Society (*Artistn-farayn*), Broderzon wrote, "The methods of our work? They are the methods of seeking and experimenting, to show Yiddish theater the best and most beautiful achievements in the realm of theater art."[46] In "The way of our theater," written four years later, he still defined his vision first and foremost in terms of intent, portraying Ararat as a theater of great ambitions, intentions, and will. While such grandiose assertions may sound frustratingly vague, they nevertheless define Ararat's essence: an enterprise driven by immense optimism and marked by a sincere and ongoing aesthetic search, with no pre-given answers.

On a more concrete level, Broderzon did enumerate a few salient features of Ararat: the use of the local dialect rather than Volhynian Yiddish, which was standard in Yiddish theater; a repertoire that not only sought suitable content or literary form but rather also took "into consideration theatrical temperament and pathos";[47] and improvisation, which Broderzon defined as "something that was inherited from and sanctioned by the commedia dell'arte."[48] Last but not least, Broderzon defined Ararat as a "synthetic theater," a notion he drew from Aleksandr Tairov's Moscow Kamernii theater (literally "chamber theater," though in its heyday, it consisted of 1,210 seats), which established itself as a key realm of experimentation exactly in the years that Broderzon spent in Moscow (1914–1918).[49] In a reaction against Konstantin Stanislavski's realism, which dominated the Moscow Art Theater, Tairov envisioned a theater that incorporated different aesthetic languages, including music, mime, dance, and drama, merging them into one synthetic whole. At the same time, he also sought to differentiate himself from Vsevolod Meyerhold's symbolist theater by giving more freedom to the actors and

opening up a space for creativity, flexibility, and improvisation—a key concept, as we have seen, also in Broderzon's aesthetic vision. The ideal of "synthetic theater" is mostly apparent in Ararat's longer "numbers," which were often the last show on the program (or concluded the first part) and involved the whole ensemble. Such a "synthetic" number was, for example, the show entitled *Garbage* (*Opfal*, from Ararat's first program), which presented a gallery of twenty characters from Łódź, mostly lowly ones (e.g., a prostitute, a lamplighter, a drunkard, a janitor, a water carrier, a newspaper boy, and workers) alongside a few members of the higher classes (e.g., a bookkeeper, a merchant, and an industrialist; see figure 1.5).[50]

It was in such performances that Broderzon sought to achieve a certain sense of synthesis, or wholeness, as well as a sense of the ensemble's teamwork. To judge from the reviews, these numbers were not necessarily the best part of the show, nor were they the most popular ones. To trust the Yiddish humorist Der Tunkeler (pen name for Yoysef Tunkel), the impression was that of a chaotic mishmash rather than a synthesis or a Gesamtkunstwerk. In a brilliant parody of Broderzon's declarative essays, he wrote, "We have no time and no patience to go to an opera, drama . . . night venues, bars, comedy, circus, cinema, chanson, a philharmonic concert, ballet, museum. . . . We want to have all together, a vinaigrette of all ten muses."[51] And indeed, in 1930, when the ensemble, troubled from the failure to attract the local audiences, introduced certain changes to its dramaturgy, it got rid of the multiplayer scenes, originally crucial to Broderzon's vision of recreating Łódź's "masses" on the stage and creating a "synthetic" experience.

Folksy (*Folkstimlekh*) Theater

Last, another term that sheds light on Ararat's attempt to mediate between art and popular culture may be found in the concluding paragraphs of Broderzon's "The way of our theater": "We are going to bind ourselves with the Golden Thread (*goldenem fodem*) of Goldfaden's brilliant folksy (*folkstimlekher*) theatricality that got unravelled and entangled in the skein of *shund* horrors. Jewish consciousness . . . help us, encourage us to reach the Golden Thread—and the lost feather of the Golden Peacock!"[52] In this nostalgia-ridden paragraph, ending in a prayerlike tone (addressed to "Jewish consciousness" rather than to God), Goldfaden's nineteenth-century theater is presented as the authentic folk Yiddish theater. Broderzon longs here for a lost "folk" quality that, he believes, blinked for a short moment in those early days, before *shund* came to dominate Yiddish theater. A master of pun, Ararat's director interprets the very name of Goldfaden, considered the founding father of Yiddish theater, as implying a "golden thread" (*goldener fodem*)—indeed, the "golden chain" (*goldene keyt*) of Jewish cultural continuity.[53] Broderzon did not seek to identify concrete folkloristic materials (e.g., tales, songs, proverbs, rituals, etc.) in the work of Goldfaden, who was actually a *maskil* (a member of the Jewish enlightenment movement), but rather used the term *folkstimlekh* to signify that which is cherished by "the folk": indeed, what one might simply call "popular." In fact, notions such as *folkstimlekh*, the golden peacock (a traditional Yiddish

symbol), and Goldfaden are utilized in this paragraph to elevate popular theater, so often associated with *shund*, and endow it with the romantic aura of "authenticity" and national pride.

Terms such as *folk* and *folkstimlekh* were salient not only in Broderzon's essayistic writing but also in Ararat's first programs, which included numbers described as *folkstimlekh-primitiv*, or a "folk dance," and engaged with figures such as klezmer musicians or a *maggid* (traditional itinerant preacher). Broderzon and the cultural circle around him—including graphic artists such as Yankl Adler, Marek Szwarc, and Wincenty Brauner (Yitskhok Broyner) and musicians such as Henekh Kon—were no doubt inspired by the folklore revolution of Y. L. Peretz, who collected folk songs and tales among the people, aiming to make the modern reworkings of these findings into the basis of secular Jewish culture. Yet *folk* and *folkstimlekh* were used in Ararat's programs, as in Broderzon's writing, rather freely and often simply meant anything that could boast a *heymish* flair, something familiar and Jewish. Such terms seem to have been useful in attracting different kinds of audiences: both the ones looking for the warmth of nostalgia or fabricated "authenticity" and the more sophisticated ones, who subscribed to Peretz's nationalist agenda. Whatever the case, *folkstimlekh* numbers, such as a pseudo-Hasidic dance (performed, quite untraditionally, as a solo by a female dancer), were clearly Ararat's most popular numbers and helped negotiate the inherent tension between popular performance and art theater, romantic nationalism, and international modernism. (See figure 1.6.)

One should, however, keep in mind that not only Peretz and Sh. An-sky (the renowned Jewish ethnographer and playwright of *The Dybbuk*) were behind Ararat's extensive use of "folkloristic" elements. The art cabaret Der blaue Vogel, mentioned previously, was another significant source of inspiration. The Russian émigré ensemble employed dance and music in order to overcome language barriers and attract German audiences. At the same time, it also benefited from the exotic flair that Russian folk songs had for many German theatergoers. For the Russian expatriates, on the other hand—a weighty part of the group's patrons—folk dance and music meant something completely different. For them, the performance of Russian folklore served other goals, such as expressing nostalgia or promoting an identity quest, which must have been quite agonizing for many in the decade following the Soviet Revolution. While the social and cultural contexts are very different, the Russian émigré audiences of Der blaue Vogel had something in common with many among Ararat's varied audiences, wealthy or impoverished, intellectuals or handworkers, who were also moving away from their traditional culture and taken-for-granted backgrounds and regarded folklore as a possible anchor to their cultural—or national—identity. In its use of folklore, as in its "synthetic" performances of Łódź's realia, Ararat's populist modernism was never an escape from the concrete sociopolitical reality. Rather, it engaged with it in new, experimental ways.

Eventually, neither the vision of "synthetic theater" nor the "folksy" numbers allowed Ararat to survive and flourish; rather, its success was due to the talent and

ערשטער פּראָגראַם פֿון "אַראַרט" (פּויליש)

I.

1) TABAKIERKA — p-g A. Goldfadena
 Szejne Mirjam, Iza Harary i Sz. Dzigan.
2) KRAWCZYKI — prymityw ludowy
 M. Puławer i L. Zylberman.
3) KOZKA — taniec ludowy Iza Harary.
4) SWACI — parodja
 Sz. Ha er, M. Nelken, M. Puławer i B. Szumacher.
5) NA STRAZY — I. L. Perec — obraz chóralno-plastyczny.

II.

6) HULTAJ — M. Kulbak
 Szejne Mirjam, L. Zylberman, M. Puławer i Sz. Dzigan
7) DJALOG — J. Oberzanek • S. Hauer i L. Zylberman.
8) GLAT KOSZER — Muzyka R. Rozental
 plastyczna scena taneczna: Szejne Mirjam, Sz. Dzigan,
 M. Puławer i J. Rajnglas.
9) CZY OPŁACA SIĘ ŻENIĆ — J. Tunkiel
 Sz. Dzigan i J. Rajnglas.
10) DZWONY — H. Lejwik
 Szejne Mirjam, B. Szumacher, Sz. Dzigan, M. Puławer,
 J. Rajnglas i M. Nelken.

III.

11) M. Broderson ZAUŁKI ŁODZI

OSOBY:			
Ulicznica	— L. Zylberman	I śpiewak	— Sz. Goldsztajn
Latarnik	— J. Rajnglas	Gazeciarz	— S. Hauer
Pijany	— M. Nelken	Buchalter	— D. Kazanower
Stróż nocny	— M. Kon	Przemysłowiec	— M. Nelken
Policjant	— B. Szumacher	Tragarz	— Sz. Goldsztajn
I Robotnik	— D. Kazanower	I uczeń	— M. Puławer
II Robotnik	— J. Rajnglas	I uczeń	— Sz. Dzigan
Handlarz	— M. Puławer	Chaplin	— J. Rajnglas
Biuralistka	— Szejne Mirjam	Dozorca	— M. Kon
Złoty młodz.	— Sz. Dzigan	II śpiewak	— Sz. Goldsztajn

Conferencier: D. KAZANOWER.
Muzyka aranżowana przez HENRYKA JABŁONA
Dekoracje i kostjumy wedł g projektu art. malarza R. ROZENTALA
wykonane we własnej pracowni.

Figure 1.5. Ararat's first program in Yiddish and Polish. Pulaver, *Ararat un lodzher tipen*, 26–27.

ערשטער פּראָגראַם פֿון „אַרט"

I.

1) פּושקע־טאַנץ — לוּט א. גאָלדפֿאַדען
שײנע מרים, אירא האַראַרי און ש. דושיגאַן

2) שנײדערלעך — פֿאָלקס פּרימיטיוו מ. פּולאַווער מיט'ן אַנסאַמבל

3) דאָס קאָזעלע — פֿאָלקס טאַנץ אירא האַראַרי

4) שדכנים — פּאַראָדיע
ש. הױזער, ק. נעלקען, פּולאַװער און ש. שומאַכער

5) דער װעכטער — י. ל. פּרץ כּיתּראל־פּלאַסטיש בילד: דער נאַנצער אַנסאַמבל

II.

6) הולטײ — מ. קולבאַק
שײנע מרים, ל. זילבערמאַן, מ. פּולצװער און ש. דושיגאַן

7) דאָס טעפּעל — י. אַבערזשאַנעק — דיאַלאָג: ש. הױזער און ל. זילבערמאַן

8) גלאַט בשׂר (פּלאַסטישע טאַנץ סצענע) — מוזיק ר. ראָזענטאַל
שײנע מרים, ש. דושיגאַן, מ. פּולאַװער און י. רײנגלאַס

9) חתונה האָבען — אַג'עצה — י. סונקל ש. דושיגאַן און י. רײנגלאַס

10) די גלאָקן — ה. לײװיק
שײנע מרים, שומאַכער, ש. דושיגאַן, מ. פּולאַװער י. רײנגלאַס און מ. נעלקי

III.

11) מ. בראָדערזאָן אַפּפֿאַל

פּערזאָנען:

גאַסטנערוי — ל. זילבערמאַן	זינגער	— ש. גאָרדנבערג	
לאַמפּוטלעכטער — י. רײנגלאַס	גרסטונג'ס־יונגל	— ש. הױזער	
סכיר — מ. נעלי קן	בוכהאַלטער	— ד. קאָזאַנדער	
נאַכטוואַכטער — ב. קאַץ	אינדוסטריעלער	— מ. נעלקין	
תלמידאַנט — ש. ג. שמאַכער	פּרצנער	— ש. גאָרדשטיין	
אַרבעטער — ד. קאָזאַנדער	שילקר	— מ. פּולאַװער	
II אַרבעטער — י. רײנגלאַס	II ס לער	— ש. דושיגאַן	
סאַטע — ב. פּולאַדער	טעפאָלין	— י. רײנגלאַס	
בערעסי'סקע — שײנע מרים	סטרוז	— ב. קאַץ	
גאָלדענער יוננגערמאַן — ש. דושיגאַן	זי גער	— ק. גאָלדשטײן	

קאָנסט. א'סיג.: ד. קואַנאָװער
מוזיק אינגעזירט דורך הענריק יאַבלאַן
ז בקאַראָצעס און קאָסטיומען פּרױעקטירט פֿון ר. ראָזענטאַל
און אױסגעפֿערטיגט אין אײגענעם האַרטסטאַט.

Figure 1.5. *(continued)*

Figure 1.6. Ararat in Y. L. Peretz's "Di Shverd" (The sword). Pulaver, *Ararat un lodzher tipen*, unnumbered page between 24 and 25.

ambition of two young actors: Shimen Dzigan and Yisroel Shumacher. Ararat's ultimate migration to Warsaw in 1934 brought fame and financial gains yet also aesthetic shifts, as it evolved from a cabaret combining modernist set design with popular songs, Yiddish classics with pseudo-Hasidic dances, to a troupe performing satirical skits, which eventually became the Dzigan and Shumacher's Theater. Did this radical shift signify abandoning Ararat's initial lofty ideals? Not necessarily. In the harsh reality of Łódź (and Warsaw) of the 1930s, when Jews faced disappointment with the promise of the new Polish republic going unfulfilled, escalating anti-Jewish hostility, and a global economic crisis, it was apparently political and social satire that could best fulfill Broderzon's vision of "the holiday that applies to everyone."

Notes

1. See Avraham Levinson's short memoir "Łódź, My Hometown" [in Hebrew], in *Kitve Avraham Levinson* (Tel Aviv: Davar, 1956), 1:256. This memoir is also available online: Avraham Levinson, "Łódź, My Hometown" [in Hebrew], Project Ben-Yehuda, accessed February 7, 2023, https://benyehuda.org/read/2244.

2. Marek Bartelik, *Early Polish Modern Art: Unity in Multiplicity* (Manchester: Manchester University Press, 2005), 28.

3. See Moyshe Broderzon, "Der veg fun unzer teater," quoted in Moyshe Pulaver, *Ararat un lodzher tipen* (Tel Aviv: Y. L. Peretz, 1972), 12.

4. "Der lodzher revi-teater Ararat," *Literarishe bleter*, December 7, 1928, 949. Translations from Yiddish throughout the chapter are by the author.

5. See Broderzon, "Der veg fun unzer teater," 12.

6. On Yiddish *kleynkunst* (miniature theater, art cabaret), see *The YIVO Encyclopedia of Jews in Eastern Europe Online*, s.v. "Kleynkunst," by Mirosława M. Bułat, accessed August 1, 2022, http://yivoencyclopedia.org/article.aspx/Kleynkunst. Renowned groups included the popular Azazel (Warsaw, 1924-1928) and Sambatyon (Wilno-Warsaw, 1926-1929). On the Azazel *kleynkunst* Teater, see Diego Rotman, *Habamah kevayit ara'i: Hate'atron shel dzigan veshumakher (1927-1980)* (Jerusalem: Magnes, 2017), 13-14; and Jane Peppler, "Ola Lillith's Edgy, Avant-Garde Yiddish Cabaret," Digital Yiddish Theatre Project, accessed August 1, 2022, https://web.uwm.edu/yiddish-stage/ola-lilliths-edgy-avant-garde-yiddish-cabaret.

7. As Rotman writes, in the early 1930s, Ararat became less invested in theatrical experimentation and in collective work and more in the individual talents of specific actors, especially Shimen Dzigan and Yisroel Shumacher, who in 1932 became the ensemble's directors. Ultimately, the ensemble disassembled and transformed into the comical duo known as the Dzigan and Shumacher's Theater. See Rotman, *Habamah kevayit ara'i*, 50, 273.

8. See Broderzon, "Der veg fun unzer teater," 14.

9. On the vibrant cabaret and light opera scene in Weimar Berlin, see Anton Kaes, Martin Jay, and Edward Dimendberg, eds., *The Weimar Source Book* (Berkeley: University of California Press, 1994), 551-593. On Russian art cabaret, see Barbara Henry, "Theatricality, Anti-theatricality and Cabaret in Russian Modernism," in *Russian Literature, Modernism and the Visual Arts*, ed. Catriona Kelly and Steven Lovell (Cambridge: Cambridge University Press, 2000), 149-171. On the Warsaw art cabaret, see Beth Holmgren, "Acting Out: *Qui Pro Quo* in the Context of Interwar Warsaw," *East European Politics and Societies and Cultures* 27, no. 2 (2013): 205-223.

10. As Knut Andreas Grimstad and Marcos Silber have shown, Jews and Jewish culture played prominent roles in these cabarets. See Marcos Silber's "From *Lodzermensz* to *Szmonces* and Back: On the Multidirectional Flow of Culture" (chapter 8 in this volume). See also Knut Andreas Grimstad, "Shmontses," in *Enzyklopädie jüdischer Geschichte und Kultur*, ed. Dan Diner (Stuttgart: Verlag Metzler, 2014), 5:468-472. On the Jewish presence in Weimar cabaret, see *Encyclopedia of Jewish History and Culture Online* [original German edition: *Enzyklopädie jüdischer Geschichte und Kultur*], s.v. "Cabaret," by Peter Jelavich, accessed August 10, 2022, https://referenceworks.brillonline.com/entries/encyclopedia-of-jewish-history-and-culture/*-COM_0385.

11. Silber argues that while there is no direct evidence that Moyshe Broderzon, composer Henekh Kon, and other members of his milieu attended the performances, we do know they were in touch with members of the Bi-Ba-Bo. See Silber's "From *Lodzermensz*." There was also a short-lived but influential cabaret in St. Petersburg named Bi-Ba-Bo (1917-1918).

12. Der blaue Vogel was highly praised by the German press and elsewhere throughout Europe, where it toured in big cities, such as Paris and London. See Kaes, Jay, and Dimendberg, *Weimar Source Book*, 557-558.

13. The busy Piotrkowska Street, in the very heart of the city, was home to some of Łódź's most wealthy people but was also the site of the Astoria Café, the watering hole of Jewish artists and intellectuals, including Ararat members.

14. On the Artef, see Edna Nahshon, *Yiddish Proletarian Theatre: The Art and Politics of the Artef, 1925-1940* (Westport, Conn.: Greenwood, 1998). On the Proletkult, see Lynn Mally, *Revolutionary Acts: Amateur Theater and the Soviet State, 1917-1938* (Ithaca, N.Y.: Cornell University Press, 2000).

15. See Rotman, *Habamah kevayit ara'i*, 35. Interestingly, when Dzigan and Shumacher were arrested as Red Army defectors in 1941, they used the Ararat's anthem to communicate with each other, humming it across the walls of their cells. See Shimen Dzigan, *Der koyekh fun yidishn humor* (Tel Aviv: Gezelshaftlikher komitet, 1974), 214-219. Dzigan is cited in

Rotman, *Habamah kevayit ara'i*, 106. The source for the anthem is Shimen Dzigan, *Dzigan albom in vort un bild* (Tel Aviv: Strod Press, 1964), 5.

16. On Broderzon and the Yung-yidish movement, see also Gilles Rozier, *Moyshe Broderzon: Un écrivain yiddish d'avant-garde* (Saint-Denis: Presses universitaires de Vincennes, 1999); Jerzy Malinowski, "The 'Yung Yiddish' (Young Yiddish) Group and Jewish Modern Art in Poland, 1918–1923," in *Jews in Lodz, 1820–1939*, vol. 6 of *Polin: Studies in Polish Jewry*, ed. Antony Polonsky (Oxford: Basil Blackwell for the Institute for Polish-Jewish Studies, 1991), 223–230; and Zehavit Stern, "From Jester to Gesture: East-European Jewish Culture and the Re-imagination of Folk Performance" (PhD diss., University of California, Berkeley, 2011). All three issues of *Yung-yidish* were recently digitized by Stanford University and are now available online: Stanford University's Special Collections, Rare Books Collection, PJ5120 .A399 FF, accessed February 7, 2023, https://searchworks.stanford.edu/view/5682397.

17. On a recent orchestration of the Yiddish opera *Bas-Sheve* (performed in Germany and Poland in August 2019), see Jake Marmer and John Schott, "Interview with Joshua Horowitz on the Orchestration of *Bas-Sheve*," Digital Yiddish Theatre Project, February 13, 2020, https://web.uwm.edu/yiddish-stage/interview-with-joshua-horowitz-on-the-orchestration-of-bas-sheve.

18. The title "the Prince of Jewish Manchester" can be found, for example, in Dzigan, *Der koyekh*, 72.

19. Founded in 1925, the short-lived studio, which faced both personal and economic hardships, was transformed into Ararat. See Rotman, *Habamah kevayit ara'i*, 32; and Pulaver, *Ararat un lodzher tipen*, 55–61.

20. See Dzigan, *Der koyekh*, 65–68.

21. See Dzigan, 61, 82.

22. For Broderzon, who was born in Moscow and spent his childhood in Belarus, Russian was a mother tongue (alongside Yiddish). Thus, although Broderzon resided in Polish Łódź since the age of ten and for most of his adult life, he was better connected to Russian than to Polish culture and in a sense felt at home in his World War I Moscow exile. On modernist Jewish art in early twentieth-century Moscow, see Seth Wolitz, "The Jewish National Art Renaissance in Russia," in *Yiddish Modernism: Studies in Twentieth-Century Eastern European Jewish Culture*, ed. Brian Horowitz and Haim Gottschalk (Bloomington, Ind.: Slavica, 2014).

23. Yekhiel Yeshaya Trunk, *Poyln: Zikhroynes un bilder* (New York: Farlag "Unzer tsayt," 1951), 6:105–106.

24. See, for example, Dzigan, *Der koyekh*, 72. One should bear in mind that Jewish writers and journalists were (and still are) all too eager to find European equivalents to Jewish artists, artworks, and genres. Sholem Aleichem was thus dubbed "the Jewish Mark Twain" (and also "the Jewish Gogol"), S. Y. Abramovich's *Travels of Benjamin the Third* was labeled "the Jewish *Don Quixote*," Jacob Gordin's play *Mirele Efros* became "the Jewish Queen Lear," the Purimshpil was declared the Jewish commedia dell'arte, etc.

25. These are the opening words of Mayakovsky's poem "A Few Words about Myself," which concludes the short cycle of poems "I" (1913).

26. On futurism, see Anna Lawton, ed., *Russian Futurism through Its Manifestoes, 1912–1928* (Ithaca, N.Y.: Cornell University Press, 1988). On Russian futurism, see Vladimir Markov, *Russian Futurism: A History* (Washington, D.C.: New Academia, 2006).

27. *Yung-yidish* 1, February 1919, 1. (The so-called *Yung-yidish* manifesto appears on the first page of the periodical's first issue. No author or title is provided.) For online access to the *Yung-yidish* journal, see note 16.

28. Broderzon, "Der veg fun unzer teater," 17.

29. Mayakovsky also writes, "I know / a nail in my boot / is worse than Goethe's fantasies!" Vladimir Mayakovsky, "A Cloud in Trousers," in *Russian Poetry: The Modern Period*, ed. John Glad and Daniel Weissbort (Iowa City: University of Iowa Press, 1978), 17.

30. *Yung-yidish* 1, February 1919, 1.

31. Broderzon, "Der veg fun unzer teater," 9. On the futurist events, see Lawton, *Russian Futurism*, 10.

32. See Lawton, *Russian Futurism*, 206. On Ararat, see Broderzon, "Der veg fun unzer teater," 13.

33. Interestingly, however, Markish nevertheless used lines from Broderzon's poem "To the stars" ("Tsu di shtern") as the motto of his art journal *Khalyastre* (The gang). See Melekh Ravitsh, "Moyshe Broderzon," in *Mayn leksikon* (Montreal: Komitet, 1945), 1:49–51.

34. Ravitsh, "Moyshe Broderzon," 50.

35. In Yiddish: "noytvendikayt, viln, bagaysterung." See Broderzon, "Der veg fun unzer teater," 11.

36. Dan Miron, *A Traveler Disguised: The Rise of Modern Yiddish Diction in the Nineteenth Century* (New York: Schocken Books, 1973; Syracuse, N.Y.: Syracuse University Press, 1996), 27–28.

37. Sholem Aleichem famously dedicated to Shomer his long tirade *Mishpet shomer*. See Sholem Aleichem, *Shomers mishpet* (Berdichev: Sheftl, 1888). See also Justin Cammy, "Judging the Judgment of Shomer: Jewish Literature versus Jewish Reading," in *Arguing the Modern Jewish Canon: Essays on Literature and Culture*, ed. Justin Cammy et al. (Cambridge, Mass.: Harvard University Press, 2009), 85–127.

38. Michael Steinlauf, "Fear of Purim: Y. L. Peretz and the Canonization of Yiddish Theater," *Jewish Social Studies*, n.s., 1, no. 3 (Spring 1995): 45–65.

39. Cited in Rotman, *Habamah kevayit ara'i*, 22.

40. Broderzon, "Der veg fun unzer teater," 17.

41. Lawton, *Russian Futurism*, 13. The 1915 Italian futurists' essay "The Synthetic Futurist Theatre" constitutes a good example of modernist elitism. While the futurists' declared goal was "to excite its audience, that is make it forget the monotony of daily life," they also stated that "it's stupid to pander to the primitivism of the crowd." See Filippo Tommaso Marinetti, Emilio Settimelli, and Bruno Corra, "The Synthetic Futurist Theatre: A Manifesto" (Milan, 1915), trans. Suzanne Cowan, *Drama Review* 15, no. 1 (Autumn 1970): 142–146.

42. Broderzon, "Der veg fun unzer teater," 14.

43. Cited in A. Alperin, "Moyshe Broderzon," *Literarishe bleter*, May 7, 1926, 299.

44. Cited in Alperin, 299.

45. Dzigan, *Der koyekh*, 107. Cited in Rotman, *Habamah kevayit ara'i*, 45. In my view, what is special in Broderzon's introduction is not his use of "fashionable" foreign words but rather his effort to rely on a religious Jewish vocabulary while reinterpreting traditional terms in a secular modern spirit, as in his use of the "holiday/everyday" (*yontev/khol* or *vokhedik*) dichotomy or in his choice to end his essay in a "prayer" addressed to Jewish consciousness and society.

46. Quoted in Rotman, *Habamah kevayit ara'i*, 48.

47. In its constant search for "theatricality," Ararat was probably inspired by Yevgeny Vakhtangov, whose production of *The Dybbuk* (for the Habima Theater) came to Łódź in 1926 and left an immense impression on the students of Broderzon's theater studio. Brecht defined the main features of Vakhtangov's theater as "Theater is theater" and "The how, not the what." See Rotman, *Habamah kevayit ara'i*, 31.

48. See Pulaver, *Ararat un lodzher tipen*, 14–15. For an analysis of Broderzon's fascination with commedia dell'arte and his refashioning of the Purimshpil as the Jewish equivalent of this Italian genre of popular entertainment, see Stern, "From Jester to Gesture."

49. Broderzon may have been also inspired by "The Synthetic Futurist Theatre" mentioned previously.
50. See Pulaver, *Ararat un lodzher tipen*, 26–27.
51. See Der Tunkeler, "Kleynkunst bine: Teater-lektsye," in *Sefer hahumoreskot vehaparodi'ot hasifrutiyot beyidish: Mivḥar ketavim humoristiyim al yehude mizraḥ eropah vetarbutam beFolin ben shete milḥamot ha'olam*, ed. Yekhiel Shayntukh (Jerusalem: Magnes, 1990), 159.
52. Broderzon, "Der veg fun unzer teater," 17.
53. *Di goldene keyt* (The golden chain) is of course also the title of Y. L. Peretz's famous modernist play, first published in Yiddish in 1907. For myth and reality regarding Goldfaden's "authentic" Yiddish theater, see Alyssa Quint, "Avrom Goldfaden's *Sheygets* Theater," in *Leket: Yidishe shtudyes haynt / Jiddistik heute / Yiddish Studies Today*, ed. Marion Aptroot et al. (Düsseldorf: Düsseldorf University Press, 2012), 233–252.

CHAPTER 2

Elkhonen Vogler, Forgotten Poet of Yung-Vilne, in Vilna and the Litvak Borderlands[1]

Justin Cammy

Elkhonen Vogler (1907–1969) was among the most important poets of the literary and artistic group Yung-Vilne (Young Vilna), the last of the major Yiddish modernist groups in interwar Poland.[2] He drew inspiration from Yung-Vilne's pride in its hometown through a poetics of *landkentenish*, engagement with local human, cultural, and physical geographies.[3] His two book-length narrative poems of the 1930s, set in the countryside where he grew up, staked a romantic claim to nature as a defining part of Litvak identity. Vogler took Yiddish poetry out of the city at a time when Jewish urban life was oversaturated with internal political divisions, challenging economic conditions, and anxiety about the rising influence of right-wing nationalists in Poland. Though the demands on the Yiddish poet to promote an ideological cause were intense, especially with the Soviet Union across the border, Vogler preferred writing about the flora and fauna of the Polish–Lithuanian–White Russian borderlands to provide local audiences and a transnational Yiddish readership with a concrete geography through which to embolden their sense of *doikayt* (hereness), a principle of diasporism in which Jewish life was informed by local languages, local folkways, and its embeddedness in a specific landscape. In so doing, Vogler steeled readers against the logic of Zionism and territorialism that argued that the future of Polish Jewry lay elsewhere and imaginatively resisted the domestic nativism in the 1930s that sought to deny Jews their place in Poland. If the social landscape of the eastern European city and the mythopoetic world of the shtetl were already well-established settings for modern Yiddish literature, Vogler sought to secure Litvak Jewry's organic roots in the region by reading its fate in and through a visceral connection with pastoral environments that lay just beyond city limits. His focus drew that which was of peripheral concern to many other interwar Yiddish writers to the heart of his aesthetic project.

37

What were the psychological and social conditions that led Vilna-born Elkhonen Rozhanski, who would later adopt the pen name Vogler, into the Lithuanian countryside and to emerge as the neofolk romantic of his generation of local writers? As a child, Khonen (as he was known by his family), or Khonke (as he was called by his friends), was sickly and awkward looking. He was teased with the nickname "snub nose," a painful slight that, at a young age, taught him about the cruelty of human interactions and piqued his interest in alternative sources of fellowship. Tragedy struck the Rozhanski household in 1914 when his father died suddenly. Khonen became an orphan, and his family fell into a poverty that was even deeper than Vilna Jewry's already acute wartime conditions. His older sister, Sore, recalls that they were so poor that their mother could not afford to buy them shoes, forcing the children to walk around during the summer with sores on their feet. Khonen's mother and her four children moved to a village near Wiłkomierz (Yid. Vilkomir), northwest of Vilna. While their mother wandered the neighboring villages bartering her late husband's clothes for food, the children found themselves on their own to explore the region's forests, lakes, and rivers. It was Khonen's first extended exposure to pastoral life and to a world where Lithuanian, Polish, and Belorussian peasants; local tribes of Roma; and Jews interacted. The young boy insisted on watching the sunset whenever possible and collecting his own fruit to eat from the trees. Though the move from a three-room flat in Vilna to a single room in the countryside was not easy for his mother and siblings, young Khonen experienced nature as a generative source.[4]

The stress of supporting a family of four as a single mother eventually took its toll on Khonen's mother. When winter arrived and the children could no longer bathe in the river, she begged their landlord to allow them to use his bath once a week. On the eve of Passover 1916, Khonen's mother collapsed, a victim of malnutrition or typhus, as she prepared to go to the butcher to beg for food to prepare the festival meal. The Rozhanski children were now on their own. Nine-year-old Khonen was placed in a hospital and then in an old-age home until a place could be found for him in an orphanage, where he lived until he was sixteen. He increasingly withdrew into himself, keeping his poetic scribblings a private matter. Khonen's orphanage was close to a river, and he often would take a book with him and walk along its shore until he reached the forest, where he was free to read and write undisturbed. He carried with him into adulthood the imprint of nature's abundance, which became a convenient contrast to his own poverty and sense of abandonment.

When Khonen completed the course of study at the orphanage, he was sent to a vocational school run by the relief organization Help Through Work to learn a trade to support himself. His artistic talents earned him certification as a commercial painter. Like Mani Leib, the immigrant Yiddish poet in New York who offered thanks that "I'm not a cobbler who writes, but a poet who makes shoes," Vogler would observe the following about himself: "By day he paints signs, but at night by the walls, / he composes poems and speaks to himself. / The dangling cigarette between his lips is his sadness, burning / until his tears

extinguish it."⁵ Work was sparse, and though he never asked for a handout, his siblings often helped him get through the week by providing him with a meal or some pocket money.

By the late 1920s, the ambitious teenage writer could no longer keep his poetic aspirations under wraps. He sent several pieces to the Yiddish press for consideration and was surprised to find one of his poems published in Warsaw's *Shprotsungen* (Fresh growths) in 1925. It was at that moment that he assumed the literary pseudonym Vogler, or "wanderer." Since all pseudonyms are meant to project some aspect of a writer's self-image, Vogler's called attention to his fate as an orphan, to his sense of apartness from the social demands of urban life, and to the symbolic, associative quality of his literary style.

It is around this time that a new literary coterie emerged in Vilna, designed to foster the creativity of young Yiddish writers and artists. Khonen was among the most devoted early members of what would later come to be known as Yung-Vilne, a group of poets, writers, journalists, activists, and artists who were united by pride in their hometown, a commitment to new experiments in Yiddish creativity, and a shared generational experience (all were born on the cusp of World War I and marked by war, displacement, the spirit of revolution, the struggle for Polish and Lithuanian independence, and the assertion of Vilna as a major center and exporter of secular Jewish culture). Yung-Vilne would gather on Sabbath afternoons to engage in their own form of spiritual fellowship. While the gang grew increasingly animated the more they imbibed, Khonen often retreated into himself, sometimes not saying a word for hours at a time: "He kept everything inside.... He needed devoted friends to help him get by, whom we referred to as 'Khonke's nannies.'"⁶

Vogler's poetry was a reflection of his reserved personality. When the group was first introduced together in print in the pages of the daily *Vilner tog* in 1929, he self-consciously presented himself as inhabiting "a palace of [his] own silence" where he sat alone on a throne.⁷ His friends in Yung-Vilne kept a close eye on their sensitive colleague. Henekh Soloveytshik, who worked summers alongside local peasants in the country, invited Vogler to join him there to provide him with some relief from a summer in the city. When in Vilna, Vogler spent most of his spare time between the reading room of the Strashun library, the city's most prestigious Jewish library, and Velfke's tavern, a favorite haunt of the Yung-Vilne writers, local intellectuals, and draymen. He was so poor that often, after nights of debate and drink, he could not afford to pay the watchman the measly tip required to permit him back into the courtyard of his apartment on Stefańska Street. He would wait by the gate shivering until someone else came home or fall asleep on the street until someone left for work at dawn so as to piggyback in on another's contribution.

Vogler transformed his loneliness and poverty into the very subject of his writing. He increasingly lost himself in a highly stylized symbolic poetics, as when he offers an interpretation of his craft in the second issue of the *Yung-Vilne* magazine:

The world is—a book by a crazy poet
The days and nights watch over him—they stand on guard;
The villages—are its fallen pages
And the cities—are its hard covers. . . .

. . . Every letter—is a peasant, every word—is a family
The diacritics—the dots and the dashes—are the animals,
Dogs and wolves—who bark, howl and moo, and then fall silent.
But people weep—and their tears are the commas.[8]

Vogler manufactures an entire imaginative universe through his focus on components of language and textuality and their comparison to the local peoples, animals, and places with which he is most intimate. The hard covers of his books that feel to him as heartless as the modern city, the fallen sheets of the poet's notebook that are like forsaken provincial villages, and the anthropomorphizing of grammar as a peasant family situate his poetic project in a specific cultural space. In order to be moved by such verse, readers must learn to read associatively, to accustom themselves to unusual syntax, and to come to terms with Vogler as a folk modernist whose metaphoric landscape invites them to relate to sociocultural and natural features of the region in new ways.

It is important here to acknowledge the influence of earlier writers who cleared creative ground in developing a distinct environmental poetics informed by the local borderlands. With Warsaw as the largest Jewish city in Europe (and the center of Yiddish publishing) and Łódź as its industrial powerhouse, Vilna was a provincial city that sought to make up for what it lacked in demographic or economic influence by building on its reputation as a center of both traditional and secular Jewish cultural innovation. Accordingly, local writers grew interested in localism and regionalism as a way to claim their place on the Yiddish cultural map and to resist the neocolonial dangers of a Yiddish Republic of Letters dominated by Warsaw.[9] It was not uncommon for Litvak poets, especially once they found themselves elsewhere, to write affectionately about Lite (Lithuania) as their homeland. Dovid Eynhorn, born in Wołkowysk (Yid. Volkovysk; now in Belarus) in 1886, opens an early edition of his collected works with the words "My soul belongs / my soul belongs / to my town, located / on the soil of Lithuania."[10] His early poems explore the same birch trees, streams, and meadows that would animate Vogler several decades later, as when Eynhorn confesses in his poem "Lite" (1906), "The land hypnotized me."[11]

If Eynhorn planted the seeds of inspiration, Moyshe Kulbak realized their full potential. Born in 1896 in Smorgon, a town east of Vilna in present-day Belarus, Kulbak was the most important and charismatic Yiddish poet in Europe during Vogler's youth. His influence left an indelible mark on students coming of age in Vilna in the 1920s, when he taught at its Yiddish-speaking gymnasium. By then, Kulbak had already penned one of the most beloved Yiddish revolutionary poems, "Di shtot" (The city; 1919). But it was his 1922 epic *Raysn* (the Jewish term for White Russia) that established the model for celebrating the human diversity

and natural wonders of this corner of eastern Europe, as when he stages cross-cultural desire through an erotic encounter between a Poseidon-like Lithuanian rising from the waters of the Niemen River greeted by the supple waves and modest beauty of the Viliye (Pol. Wilia), situating his writing amid the major rivers than run through the region and cross its political borders. In *Raysn*, Kulbak explores the simple folkways of a rustic family of Jewish raftsmen and their relations with local peasants to celebrate the ethnic hybridity of the borderlands. He followed it several years later with the ode "Vilne" (1926), in which he invites the city to be read (and thus interpreted) as a kind of sacred text ("You are psalm spelled in clay and iron"; "You are a dark amulet set in Lithuania"; "You are a psalm written on the fields")[12]. The poem revels in (rather than evades) the tension between tradition and modernity, establishing Yiddish as an integrative force and imagining an urban built landscape and atmosphere that is sated with Jewishness.[13] Kulbak's Vilna was not just a literary subject but an entire sensory experience, a humanist evocation of Yiddish sacred space. Vogler later acknowledged just how profound an influence Kulbak was in legitimating Vilna and the broader region in which it was located as a literary subject: "Kulbak's shadow is intertwined with my own. The two cannot be separated.... I recall waiting for him by the door of the Real Gymnasium on a wintry day just to be able to look at him in the face and hear his voice.... He was summer in Yiddish literature.... In Kulbak, Jews and White Russians lived in peace. The bounty of the land united them. Kulbak's writing was rooted in the soil of Lithuania, in its old oaks trees from which he drew his inspiration.... He was instantly recognizable due to his sunny perspective and his earthy scent."[14]

Yung-Vilne's early membership actively encouraged the exploration of the region's diverse human, urban, and natural geographies. For instance, the heroes of Henekh Soloveytshik's prose stories were Lithuanian and Polish peasants and non-Jewish villagers. At one of the group's public readings in Vilna in the early 1930s, Soloveytshik appeared in tall boots and a short pelt, having just returned from the provinces. He tossed a heavy potato sack onto the stage and began to recite by heart his most recent story about a peasant who murders the nobleman who attempted to seduce his daughter. When he reached the point in the narrative where the peasant's axe is about to come crashing down on the lecherous nobleman, a dark stream of blood began to trickle from his sack onto the stage and down into the audience. People jumped out of their seats in fear, perhaps thinking that Soloveytshik had brought the nobleman's head with him. In fact, the sack contained several frozen calf heads he had brought home that had begun to thaw during his reading. Such was the performative nature of Soloveytshik, who actively cultivated a persona drawing from the folkways of rural life.[15]

For his part, the poet Shimshn Kahan enjoyed parading around town in fancy Russian shirts done up at the neck with a red scarf and tall, shiny black boots. In 1925, after his education in Vilna's Yiddish secular schools, he elected to move to the picturesque village of Troki, where he had spent summer vacations as a child, to work as a farmer and tutor.[16] Troki was one of the region's most beautiful places,

nestled amid dozens of lakes and featuring a medieval castle. It was a community where Jews, Russians, Poles, Lithuanians, Karaites, Tatars, and Roma lived side by side. These cross-cultural encounters left an indelible mark on Kahan's imagination. A romance developed with a local Roma (Gypsy) girl. The two ran away together, but her father, the local chief, sent a messenger after them warning that unless she returned (with or without Kahan), she would suffer permanent banishment from the clan. Heartbroken, she returned to her family and Kahan to Vilna, where he translated folk songs from Russian, Ukrainian, White Russian, and the local Roma language into Yiddish. Many of his translations were put to music and sung by the city's Yiddish choir. Life with the Roma prompted some of Kahan's most original work, injecting the cultural diversity of the local countryside into Yung-Vilne's thematic repertoire. He recited one such poem, "Litvishe tsigayner" (Lithuanian Gypsies), at the group's third annual public reading in March 1932. Kahan invited Yiddish audiences to recognize that they shared more in common with their Roma neighbors than they might imagine. Both were minority groups who were often scapegoated by nationalists as alien implants, both relied on strong group bonds to sustain their culture, and both shared a diasporic consciousness. Kahan's Yiddish translations of their folk songs contributed to a vision of culture where Jews and other peoples were intertwined in mutual respect.[17] The urge to capture a distinct regional flavor was also pursued by the group's leading visual artist Bentsye Mikhtom, whose drawings featured local landmarks and Jewish and Polish folk motifs.

Vogler's first significant contribution to this genealogy of a regional environmental Yiddish poetics promoted by such writers as Eynhorn and Kulbak appeared in 1935, when he was the first member of Yung-Vilne to publish an independent volume, *A bletl in vint* (A page in the wind). Its book cover, illustrated in a folk style by fellow Yung-Vilne artist Rokhl Sutzkever (figure 2.1), features imagery of local trees, birds, and animals and a tiny sketch of Vogler himself.[18] It also introduces the volume as a *poeme* (a long, narrative poem), signaling his frustration with the limitations of the modernist short lyric and a groping toward the monumental. At the same time, Vogler's introduction to the volume hints at his own creative anxieties, including the paradox of being a member of a literary group in one of the global centers of modern Yiddish culture who nonetheless cultivated the persona of a homeless wanderer and who felt no more respected than a "discarded page [carried off] in the wind."[19] The poem's prose preface defends the work's unusual romance between his first-person (human) speaker and a plum orchard:

> With trembling fingers, I tear out the last pages of my notebook, written in 1935, and consign it to the wind. Perhaps it will accidentally carry them off somewhere and bring solace to this discouraged author, giving him some courage in his free time (from his job as a sign painter) to record afresh earlier poems that were erased from his old notebook.
>
> That is why I wrote on the cover "A Page in the Wind," although the poem really should have been titled "My Marriage to the Plum Orchard." But I feared

Figure 2.1. Cover art by Rokhl Sutzkever for Elkhonen Vogler, *A bletl in vint* [A page in the wind] (Vilna: Yung-Vilne, 1935).

that had I given it that title a critical reader would have strung me up (and perhaps he still will after reading this poem . . .) on the neck of the alder tree, the heroine of this poem, who has been a loyal friend from my orphaned childhood until now (or more precisely: until midnight, when these lines are being penned).[20]

Vogler sought to inoculate himself against those who looked to young Yiddish writers to address the most pressing social and political challenges of the day, and he recognized that his poem's pastoral setting and romantic theme would leave it open to accusations of artistic self-absorption. With all the challenges facing the Jews of Poland in 1935, who would be interested in a folktale about his love for a country orchard? I argue that readers miss the point if they assume that Vogler's wanderings amid the warmth and friendship of the trees and fields, the rivers and soil, and the animals and the birds of the Lithuanian countryside eschew political work. To the contrary, by giving his native natural landscape a Yiddish voice, he provides a distinctly regional texture to Yiddish poetry's broader project of imagining Yiddishland, including an insistence on the preservation of rural Yiddish dialect: "The alders and birches who are the heroes of this poem speak a Yiddish that is somewhat old-fashioned and Russified. The trees of my Lithuanian fields and towns imitate the people in the poor huts that still speak that way."[21]

A bletl in vint is divided into three sections, each subdivided into various chapters. The first two sections—"A khasene" (A wedding) and "A roman" (A romance)—tell the story of the speaker's courtship and marriage to a plum orchard from spring through late summer. As with Kulbak's *Raysn*, the ambition was to bring rural sunshine to urban Yiddish literature in order to free it from the social tensions of urban and shtetl life and to draw from the simpler folkways of village life.

Vogler's modernist *poeme* borrows from folktales by anthropomorphizing the entire natural world. Its Yiddish is earthy and provincial, heavily accented with Slavic elements and with local Jewish idiom. Terms such as *pasiekes* (chopped-down forests used for pasture), *lupes* (lips), *krasaviets* (handsome young man), *reynikeytn* (Torah scrolls), *lyubovnitses* (young lovers), and *odlige* (a moist frost) are among the more than fifty included in a glossary of "Vilna localisms" at the end of the volume, a further indication of the degree to which language was deployed to mark the rootedness and the distinctiveness of the region's Jews.[22] By endowing the flora and fauna of his Litvak countryscapes with human qualities of emotion and intelligence, he takes full possession of the province's natural features. Elsewhere, he brings in the region's diverse populations by seeing in a stalk of wheat a full-breasted peasant woman. As the poem unfolds, it does the work of naming specific spaces, animals, trees, and fruits, showing a depth of intimacy with the regional landscape that performs a much deeper Yiddish linguistic repertoire than readers abroad were familiar with. In differentiating among a *shliakh*, a *gostinets*, a *trakt*, and a *stezshkele* (all variations of roads), the poem shows off the hybridity of Yiddish culture through its linguistic openness and provides a way to map the project of *landkentenish*, the movement of Jewish home tourism that promoted

knowledge of local landscapes. Moreover, by anthropomorphizing the natural world, Vogler lures readers into engaging with the environment as more than just something one passes through on the way between destinations. Rather, it is sentient and alive. For instance, in Vogler's imaginative universe, the main river that runs through Vilna is not just a river but a lonely maiden awaiting the return of her fiancé; the birch tree is not just a tree but an *agune* (an abandoned wife) worried that her husband, a rainbow, has left her to pursue an affair with the sun; and the highway by the orchard is not just a road but an old bachelor who moans beneath the burden of the heavy wagons that drive over him. Vogler's personifications (and frequent Judaizations) of the natural world invited readers to take possession of the minutiae of Vilna's pastoral surroundings by seeing their own lives and humiliations reflected in them. Consider the following short episode of the country rose:

> She has a rendezvous today
> With the young butterfly.
> But the bug, that ugly scoundrel,
> Won't give her a moment's peace.
>
> She has so many suitors—
> Summer birds and bees.
> She toys with all the men
> With her aristocratic manners.[23]

Vogler's talents as a nature fabulist come alive in this brief scene that overflows with erotic sensuality. However, flirtatious desire gradually transforms into predatory violation. First, the butterfly kisses the "red breasts" of the rose while she is passed out drunk, unable to provide her consent. Then, a jealous swarm of bees challenges the butterfly suitor for control over the sleeping rose. After they vanquish him, they sting the rose's lips and tear off her clothes—Vogler's poetic interpretation of their thirst for pollen amid her petals and filaments.[24]

If this episode offers readers a way of taking notice of something as simple as a wildflower in a field by translating nature's dance into human terms, it also reveals how betrayals lurk where they are least expected, as when innocent flirtations fall victim to gang rape as the rose is violated by a swarm of bees. The terrifying episode allowed Vogler to offer his own gloss on contemporary Jewish life, capturing both the romance of home and those sudden moments in which mass violence threatened to destroy it.[25] If we think of the rose, the butterfly, and the bees as codependent but different species inhabiting the same space—each organically rooted in and belonging to the land—Vogler's scene would have been read as an interpretation of his multinational borderland community of Jews, Poles, Lithuanians, and others.

Vogler's most important accomplishment in *A bletl in vint* is the national claim it asserts on a particular corner of Europe. He reads Jewishness into the Litvak borderlands by endowing them, as Kulbak had in his own writing, with an aura of sacredness that could appeal to readers whose Jewishness was defined more by

their sense of national self-consciousness than religious commitments. In Vogler's poetic world, both here and thereafter, the wind rushing through the trees recites *tilim* (psalms); a canary's chirp is akin to the sanctification of a marriage through the recitation of the *kidesh* (blessing over wine); woodpeckers peck out moral advice on the trees, suggesting that "*tsedoke* [acts of righteousness] will save you from death"; wolves howl the *yisgadal* (the traditional prayer recited by mourners); and the sparrows *shokl* (sway) back and forth on the branches, just as Jews do in prayer.[26] Vogler's native Litvak landscapes are not an imagined homeland but a fully realized, intimate, organic, and substantive Jewish cultural space.

Though Kulbak's influence on Vogler's generation of emerging local writers is undeniable, it is important to note that they functioned within different political moments. The revolutionary-era springtime of possibilities that Kulbak expresses in *Raysn* was entirely different from the world in which Vogler wrote a decade later, a mood reflected in his volume's final section, "Na-venad" (Homeless). Here, the fantasy union between a Yiddish-speaking Jew and a natural environment of raw beauty comes to a tragic end when his beloved, the plum orchard, dies in late autumn, leaving behind her brokenhearted lover and a bushel of fruit, which represents their orphaned children. Humans cannibalize the young plums when they cut into them with their sharp teeth; the red juice they excrete as they are consumed is likened to human blood. The poem's portrayal of a pastoral idyll cut short was a way for Vogler to write himself both into the landscape and then out of it, staking a Jewish bond with it while also anticipating its passing. Here, we see a profound uncertainty about the future, a catastrophist streak that was a feature of the Yung-Vilne generation who resisted sentimentalizing their world, preferring instead to expose its fissures and anxieties. If the speaker's love for the orchard symbolizes the deep bond that developed over centuries between the region's Jews and their environment and if its fruit signifies the cultural richness that was produced over time on its soil, then the orchard's death and the fate of her orphaned children suggest a profound crisis of faith in the viability of Jewish life in situ. Vogler's verse functions simultaneously as an intimate textual expression of home and an elegy on the inevitability of leave-taking.

More than eight hundred people attended a Sabbath event in September 1935 at the Vilna Conservatory organized by Yung-Vilne in celebration of the volume's publication. The room was packed with representatives of the city's Yiddish intelligentsia and local youth. Eliyohu Shulman, a writer visiting from New York, was given the honor of introducing the evening by putting Vogler's book into a comparative framework. He spoke about the influence of Southern writers in the United States, casting Vogler as an important model for regionalism in Yiddish literature and inviting readers to celebrate the distinct environmental and cultural geographies of Yiddish-speaking Jews living over a vast territory. When it came time for the poet to speak, his shyness overtook him, and he could barely whisper a few words of embarrassed appreciation.[27] He had good reason to fear the opinions of critics, several of whom considered his writing overly self-involved.[28] Vogler's sensitivities were stung by such criticism. When he wrote in early 1936 to A. Liessin,

the respected editor of New York's Yiddish art journal *Di tsukunft*, to ask him to consider publishing a fragment of a newer poem, his words could not have inspired much confidence: "The truth is, I don't believe in myself. Perhaps my poems have little worth."[29] He needn't have worried. Vogler's achievement outweighed his self-doubt. He was the first member of Yung-Vilne to publish an independent volume, and *A bletl in vint* put the group on the Yiddish literary map and carried within its pages the promise of their name to bring both an honest generational perspective and a specifically *vilnerish* (of the Vilna region) flavor to readers at home and abroad. Vogler tried to live up to expectations in a metapoetic lyric in which he co-opted the language of tradition to promote his secular humanist understanding of the role of the Yiddish poet as one who "flings his sorrow into the *shkhine*—the brilliant dawn light / and brings it as a sacrifice to God—beauty and justice."[30]

With these commitments in mind, between 1935 and 1938, Vogler got to work on an even longer verse narrative set in the period around World War I, when Vilna went from being a czarist city under German occupation to one of the central sites of contention between the newly established Polish and Lithuanian states. Rather than engaging directly with the political drama of the historical moment, the poem seeks refuge from "the storm" by retreating to "the North Lands, Eden" that correspond to Vogler's pastoral borderland worlds where life is simpler among the tall (Jewish!) birch trees by the highway and between its quiet rivers, which he calls its "Christines." Vogler's ability to simultaneously inscribe Jewishness upon the landscape while also engaging with it as Slavic (and Christian) space allows him to celebrate the interethnic and interreligious hybridity of the borderlands. For instance, in the section "The Cross's Ancestry," Vogler contributes to a broad interwar corpus of Yiddish texts interested in the Jewish Jesus as part of their modernist sensibilities:[31]

> The highway is a well-trod wandering Jew,
> his son-in-law, the Cross, is blond....
> The Cross's great-grandfather is a fir
> a pope with long gray hair,
> and his great-grandmother
> is an alder, a tall pious Gentile woman.
> His grandfather is an oak tree
> And the willow is his hunchbacked Jewish grandmother.[32]

The poet's song celebrates an ecosystem that embraces the mixing and coexistence of different species as a countermodel to life in Vilna, which was increasingly divided by nationality and religion. Vogler's poem gradually defamiliarizes the cross as a symbol of Christian power and difference, domesticating it as a member of the family and an organic part of Jewish lore and life.

The finished volume, *Tsvey beriozes baym trakt* (Two birch trees by the highway), appeared in 1939, published by the Jewish Literary Union and PEN Club in Vilna. Its cover art by Rokhl Sutzkever once again communicates a fondness for rustic simplicity (figure 2.2). But Vogler was anxious about whether his newest

Figure 2.2. Cover art by Rokhl Sutzkever for Elkhonen Vogler, *Tsvey beriozes baym trakt* [Two birch trees by the highway] (Vilna: Yidisher literatn-fareyn un PEN-klub in Vilne, 1939).

book-length fable would make sense to readers. Several months before its publication, he organized a private reading for his friends Arn Mark (who helped edit his first book) and Shloyme Belis. The entire evening was cloaked in a veil of secrecy. When the two guests arrived, they found Vogler's kitchen table set for a feast, but not before he read aloud all 159 handwritten pages. Aware of Vogler's insecurities, Mark offered nothing but praise. But Belis was frustrated: "The Russians have an expression: getting lost between two pine trees. But you, Khonke, you get lost between two birch trees!"[33] Belis's central complaint went to the heart of Vogler's

aesthetic, which involves his technique of piling one metaphor on top of the other to create an associative poetic universe that leaves readers scrambling for interpretive footing. Vogler responded to their critique by providing one of the most unusual prose forewords to a poetic volume in all Yiddish literature. "A Footpath to the Highway" serves as both a reader's "guide" to his brand of neofolk modernist experimentation and a preemptive self-defense:

> The contours of this poem were sketched in the fields. Not once did the peasants find me behind a willow tree and ask:
> —Are you alone?
> —Oh, grey joy of mine! I am not alone. The dawn is always by my side. . . .
> I am not lonely. I am intimate with the blooming orchards. . . . I have so many silent friends among the plants and animals. They sparkle in my eyes by day, and at night I kiss them in my blue dreams. I am neither alone nor poor because—poverty is my fortune. As long as there is sun and music in the world, I am rich. . . . The White-Russian mint fields and the wild strawberries are mine. The young forest of walnut trees and the cool balsams—all mine. And this poem that I chant is also almost entirely mine. I did not overhear it from anyone else, aside from the sad rustle of the grey Lithuanian rivers and from the region's orphaned swallows. Yes, birds were a great inspiration. I learned the *nign* [the melody] directly from them, but the words are mine alone. Everything the pious nightingale and sick canary sang for me I have tried to translate into lucid, trilling Yiddish. . . .
> . . . And now, I beg my modest, maternal Yiddish to forgive me the many Slavicisms I breathed into my crippled, broad stanzas. I appreciate that localisms can be obstacles in the middle of a poem's path. . . . Don't blame me: the poem was reared in the hot arms of old-blue Vilna, clinging to the stray White Russian towns that surrounded it. Because of the special dusk-color of our gray landscape I bear the simple grey garland of Slavicisms—the heart and soul of my soil, the only part of my poem not exchanged for more refined, polished words. . . . When it came to the names of Lithuanian towns, their streams, or to back streets and alleys in Vilna—the only available translation could come from stammering Grandmother Lite and her grandchild—quiet teacher Vilna—themselves.[34]

Vogler reads human qualities into the birds with which he communes that are akin to the socioreligious realities he encountered in Vilna, whether it be its thick layers of tradition or sickness born of acute poverty. His earthy variety of Litvak Yiddish, sated with localisms and Slavicisms, is as organic as the naturescapes that inspire it, underscoring the importance of regional dialect in laying claim to and conjuring home.

Elsewhere in the foreword, the poet rejects the kind of ideological co-option that might have lent his verse a more self-confident spirit, a clear critique of fellow Yiddish writers who had allowed their verse to serve the cause of politics rather than art. Instead, Vogler seeks to evoke a truth that is closer to the lived experience of the moment:

I know that my poem is not joyous. . . . It may be that it flows against the hot streams of our times. I can't escape from the land of my birth, from its black sadness. I don't circle around the moist depths of my sorrow and I don't always come to readers with a well-trodden highway of complicated thoughts and ideas. But over the abyss of blue feeling and red sorrow, I try to toss the reader a bridge—a metaphor.

But bridges of metaphor are slippery, they have no handrails, so it's possible I've stumbled in places. Nonetheless, perhaps the reader will detect in my poem his own suffering and joys, and also his experiences. . . .

. . . In this poem I tell the story of the highway and his two sisters, birch trees, who got engaged to the cross—the spirit of the world. I know that the trees and country roads are alive. And perhaps they are even better than we mortals because their sorrow is green, and their longing blue. . . .

A confession about my fable: Sir Doubt confided to me long ago that I am not cut out to address real-world problems, especially the challenge of the Cross. And this cross—the conscience of the earth, the hero of this poem—I bring along like a close relative from the forest, and also a symbol of affliction, righteousness, and orphanhood. And so, because the highway is Jewish, I also had his son-in-law convert to Judaism.

. . . Not for nothing do I include here a section called "The Old Wind and the Young Wind" (yes, dear friends, there are two winds). The winds play entirely different roles. For instance, the old brown wind is gluttonous and married. He is an angry teacher. He buried our poor mother and taught us the Jewish alphabet from her tombstone. But the young, mild wind (the highway's lackey), our dream and our hope, the one who ought to have protected us from our current realities, the one who ought to have sipped the tears of our apples and brought us the scent of youth, freedom, and possibility—that wind is deceitful and tricked us. He led the birch trees to shame and betrayal. He led our springtime to death, and our author to regret and pessimism.[35]

Far from clarifying matters, Vogler's introduction provides scant hermeneutic direction. The reader gains psychological insight into not only Vogler but also a moment in time when the Jews of eastern Europe themselves feel on the precipice, pushed to read their own fate under the shadow of the cross. Accordingly, the warning that his writing "flows against the hot streams of our time" is somewhat misleading. While it is true that the poem shuns any overt call to political action, it is far from apolitical. Everything from its use of localisms (accompanied by a glossary of terms at the end) to its effort to claim Jewish space does political work. By having the poem shift its setting between the local countryside and Vilna itself, Vogler also exposes the degree to which local identity is deeply rooted in relationships between urban and pastoral, modern ideas and traditional folkways, and Jewish and non-Jewish cultures. Vogler could not have provided a more substantive model for poetic *doikayt*.

At the same time, Vogler exposes his political exhaustion through the fable of the Young Wind, "our dream and our hope who shields us from reality."[36] The

wind here serves as a symbol for a youthful idealism that is initially refreshing but gradually reveals the storminess of internecine partisanship. Though, at first, the Young Wind is attractive and charming (like any new political ideology or movement), he is gradually shown to be a charlatan because he is more interested in satisfying his own primal desire for power. He moves from wasting his nights away with a gorgeous "maiden—the red rose—on her green divan" to besmirching the reputation of another suitor, a nut tree, who has been promised as a fiancé to a virginal birch tree.[37] The Young Wind uses the power of his rhetoric to capture the birch tree's heart, only to dump her once she allows him to fondle her leaves. The work is a devastating critique of the false messianism of a contemporary politics (Jewish and internationalist) that overwhelmed daily life through its ideological arguments, promises, and politicized social affiliations.

Vogler writes himself into this expressionistic reading of the natural environment in the figure of the poet, who appears as the hero of a folktale told by a provincial highway to a nut tree about a "wanderer" (Yid. Vogler) named Elkone.[38] This mysterious figure (who is compared to one of the *lamedvovnikim* of Jewish folklore upon whom the world's existence allegedly depends) approaches various animals during his journey to inquire about whether they have ever experienced such phenomena as justice, truth, freedom, and love. When they all answer in the negative, he despairs of ever finding true goodness in the world. He decides to drown himself in the Viliye River after she promises to relieve him of his suffering by embracing him in the gentle caress of her arms. Elkone's immersion into her waters is an act of ritual purification from the civilization's contaminants. Poetically, it invites the reader's retreat from reality into his alternative universe of poetic fantasy. Only once the "gray truth" of the times is polished clean by the "diamond dream" that is the local river does "the poet" provide "a new path for those who are lost."[39] The volume's final stanzas proclaim the redemptive possibility of Vogler's brand of Yiddish folk modernism, which is deemed authentic by virtue of its primal bond to a natural world that has not yet been corrupted by politics. If the prevailing sentiment among Elkhonen Vogler's literary contemporaries was that art ought to serve as a means of raising social consciousness, by 1939 he concluded that Yiddish poetry could best serve readers by providing them with an escape from it.

During the brief window of Lithuanian rule over Vilna in 1940, when the city's Jews and thousands of refugees enjoyed relative safety, the poets of Yung-Vilne continued their work unabated, persuaded that one form of resistance to the tyranny that threatened to consume them was through a regional environmental poetics that would allow them to, literally, stand their ground on this corner of Yiddishland. Though much of Polish Jewry was already under German occupation, Vogler's Yung-Vilne colleague Avrom Sutzkever published *Valdiks* (Of the forest), a collection of ecstatic Yiddish hymns set in the local forests that approximated pantheistic celebration. Vogler, too, rooted himself even deeper in his native soil during these years. In "Postne Lite" (Modest Lithuania), published in the first joint miscellany between Yung-Vilne and Yiddish writers in Kaunas

since the incorporation of Vilna as Vilnius into the Lithuanian republic, he hints that what his region lacks in economic or political power, it makes up for in the richness of the affective bonds it inspires in its inhabitants. His speaker imagines himself sovereign over an "enchanted land" that transcends artificial political borders, a place where he "consume[s] the ripe juices of [his] dream."[40] Within a few short years, Jewish Vilna was completely destroyed. Such lyrics could no longer serve the immediate needs of a Yiddish readership whose entire world had been shattered.

Vogler was fortunate to escape Nazi occupation by fleeing to the Soviet interior and spending the war years as a refugee in Kazakhstan. Perhaps it was fate that a writer who adopted the pen name Vogler then wandered from Moscow to Łódź before finally settling in Paris in 1949, where he continued to work as a Yiddish journalist until his death in 1969. It fell on Vilna's surviving writers and poets to sustain a site-specific mythopoetics of Jewish space as part of a broader landscape of memory and collective mourning. For Vogler, the intuitive response to loss (many of his Yung-Vilne colleagues were murdered, and the rest were dispersed to such far-flung cities as New York, Tel Aviv, Buenos Aires, and Montreal) was to reinscribe the region's Jewishness as primordial, as in the opening lyric to his only postwar volume, *Friling afn trakt* (Springtime on the country highway):

> I was born in the Land of Lite;
> Her highways, weaved with blue steps,
> and her sour cherries in bloom
> are the gateways to my spirit.[41]

Despite Yiddish literature's frequent association with the modern city and the shtetl, Vogler's artistry exemplifies the claim that it also possesses an important tradition of exploring specific rural landscapes, their folkways, and their natural features to provide a more organic conceptualization of home. Though Yiddish writers arrived belatedly to the Romantics' admonition "Let Nature be your teacher,"[42] its classic writers often dispatched their characters into nature as part of their critique of the disconnection between religious culture and the world beyond it, since nature was seen as diverting attention away from tradition. Yiddish modernist writers were especially keen to expand the borders of Yiddish to spaces that were not traditionally considered Jewish. In some cases, wandering through nature provided them with a new vocabulary for spiritual sublimation, while in other cases (such as Vogler's creative engagement with the Lithuanian borderlands), the claiming of rural space through Yiddish was part of a broader cultural project designed to provide readers with a vocabulary of homeland and an experience of their rootedness in it. Vogler's center was the Polish-Lithuanian pastoral, as much a Jewish space as the large multinational cities we have come to associate with the blossoming of Yiddish culture in the interwar period.

Notes

1. In this essay, references to Litvak or Lithuanian Jews and landscapes refer not to the borders or inhabitants of the independent Lithuanian republic during the interwar period but rather to a much larger geography encompassing Lithuania, northeast Poland, northern and western Belarus, and parts of the Baltics. The area was known as Lite in Yiddish (Heb. Lita) and its inhabitants as Litvakes. Litvak Jews constituted one of the large subgroups of Yiddish-speaking eastern European Jewry (the others being Galician and Polish Jews), who were distinguished not only by region but also by differing folkways, dominant forms of religious expression, and Yiddish dialect.

2. For more on Yung-Vilne, see Abraham Novershtern, "Yung-Vilne: The Political Dimension of Literature," in *The Jews of Poland between Two World Wars*, ed. Yisrael Gutman et al. (Hanover, N.H.: University Press of New England; Waltham, Mass.: Brandeis University Press, 1989), 383–398; and Justin Cammy, "Tsevorfene bleter: The Emergence of Yung-Vilne," in *Focusing on Jews in the Polish Borderlands*, vol. 14 of *Polin: Studies in Polish Jewry*, ed. Antony Polonsky (London: Littman Library of Jewish Civilization, 2001), 170–191.

3. For more on *landkentenish*, see Samuel Kassow, "Travel and Local History as a National Mission: Polish Jews and the Landkentenish Movement in the 1920s and 1930s," in *Jewish Topographies: Visions of Space, Traditions of Place*, ed. Julia Brauch, Anna Lipphardt, and Alexandra Nock (Burlington, Vt.: Ashgate, 2008), 241–263.

4. For biographical information on Vogler, see Eliyohu Shulman, *Yung-Vilne 1929–1939* (New York: Getseltn, 1946); Elkhonen Vogler, "Di mishpokhe Yung-Vilne," *Di goldene keyt* 23 (1955): 174–181; and Shloyme Belis, "Bay di onheybn fun Yung-Vilne," *Di goldene keyt* 101 (1980): 22–29.

5. Elkhonen Vogler, *A bletl in vint* (Vilna: Yung-Vilne, 1935), 22. The reference to Mani Leib is from John Hollander's translation of "Ikh bin" (I am) in *The Penguin Book of Modern Yiddish Verse*, ed. Irving Howe, Ruth Wisse, and Chone Shmeruk (New York: Penguin, 1987), 128–131.

6. Belis, "Bay di onheybn," 25.

7. Elkhonen Volger, "In palats fun mayn shvaygn," *Vilner tog*, October 11, 1929.

8. Elkhonen Vogler, "Tsevorfene bleter," *Yung-Vilne* 2 (1935): 33–34.

9. Warsaw, the largest Yiddish-speaking city in Europe, was also the center of the Yiddish press and publishing industry. By the interwar period, Tłomackie 13, the headquarters of the Association of Jewish Writers and Journalists, was considered the main address for Yiddish literature in Poland. Vilna and the broader culture of the Litvakes for whom it functioned as a center sought to compensate for what they lacked in demographic strength by cultivating the qualitative strength of Vilna's traditions of scholarly excellence and creative dynamism through such institutions as YIVO (the Jewish Scientific Institute).

10. Dovid Eynhorn, "Mayn heym," in *Gezamlte lider 1904–1924* (Berlin: Farlag yidishe arbeter-bukhhandlung, 1924), 9.

11. Dovid Eynhorn, "Lite," in *Gezamlte lider*, 17–18.

12. Moyshe Kulbak, "Vilne," trans. Nathan Halper, in Howe, Wisse, and Shmeruk, *Modern Yiddish Verse*, 407–411.

13. If earlier critics read Kulbak's "Vilne" as an expressionist work, concluding with a rousing fusion between speaker and subject ("I am the city!"), Jordan Finkin argues that Kulbak's ode is part of a larger performative, ethnopoetic trend in modern Yiddish literature that conjures traditional folkways while providing an elegy on their loss. See Jordan Finkin, "Yiddish Ethnographic Poetics and Kulbak's Vilna," in *Writing Jewish Culture: Paradoxes in Ethnography*, ed. Andreas Kilcher and Gabriella Safran (Bloomington: Indiana University Press, 2016), 94–115.

14. Elkhonen Vogler, "Moyshe Kulbak: Der dikhter fun royer erd," *Di goldene keyt* 43 (1962): 103–105.

15. See Leyzer Ran, "Der umbakanter Yung-Vilner dertseyler Henekh Soloveytshik," *Di goldene keyt* 101 (1980): 96–101.

16. Daniel Tsharni, "Ver zaynen di Yung-Vilianer?," *Literarishe bleter*, February 26, 1937, 135.

17. By the late 1930s, Kahan had enough material to assemble the volume *Gildene podkoves* (Golden horseshoes), a collection of Yiddish poems and translations about local Roma life. The manuscript was lost during the chaos of the Second World War and never published.

18. Rokhl Sutzkever was one of only two women to join the ranks of Yung-Vilne. She trained in the art faculty of Vilna's Stefan Batory University. In November–December 1938, the Jewish Art Society of Vilna and Yung-Vilne cosponsored an exhibition of more than sixty of her works. It catapulted her to local fame. Catalog titles of her work suggest that she shared with Vogler a thematic interest in Vilna's natural and built landscapes. See Shloyme Belis, "Vegn fir molers fun Yung-Vilne," *Di goldene keyt* 109 (1982): 36–41.

19. Vogler, *A bletl*, 7–8.

20. Vogler, 7–8.

21. Vogler, 7–8.

22. Vogler, 61–63. Vogler was not the only member of Yung-Vilne to include a glossary of terms for his writing. The Yiddish of Moyshe Levin's short stories was so unabashedly local that his first collection included a lexicon for the benefit of readers elsewhere. See Moyshe Levin, *Friling in kelershtub: Noveln un humoreskes* (Vilna: B. Kletskin, 1937).

23. Vogler, *A bletl*, 29.

24. Vogler, 30–31.

25. Acts of anti-Jewish hooliganism were increasingly frequent in Vilna and across Poland. For instance, Dr. Max Weinreich, the director of the city's Jewish Scientific Institute, lost his eye in one such attack in 1931. Vogler's Yung-Vilne colleague Moyshe Levin published a story about a local Jewish glazier who struggled to balance the short-term economic benefits of being called upon to fix the shattered windowpanes of Jewish-owned stores against his dignity and personal security as a Jew. See Justin Cammy, "The Prose of Everyday Life: Moyshe Levin's Vilna Peoplescapes," *Colloquia* 48 (2021): 239–258; and Moyshe Levin, "Tsalel the Glazier after the Pogrom: A Tale of the November Days in Vilna, 1936," trans. Justin Cammy, *Colloquia* 48 (2021): 267–275.

26. Vogler, *A bletl*, 11, 49, 52; Elkhonen Vogler, *Tsvey beriozes baym trakt* (Vilna: Yidisher literatn-fareyn un PEN-klub in Vilne, 1939), 119.

27. A brief report on the event was included in "Fun unzere shraybtishn," *Yung-Vilne* 3 (1936): 94–95. The report noted that in an interview published in *Belgishe bleter*, the Yiddish poet Moyshe Broderzon named Vogler's volume as one of the four best books published in Poland in 1935.

28. Y. Rapoport saw in Vogler a poet of gifted potential whose overemployment of metaphor overwhelmed his writing with *kunst-shtik* (creative horseplay): "Several of its individual poems are very beautiful, but only as discrete units. In the context of a longer poem, his style seems much too artificial. It becomes nothing more than artistic acrobatics.... Imagery cannot go on interminably." See Y. Rapoport, "Der blondzshendiger Vogler," *Di tsukunft*, November 1936, 759–760.

29. Elkhonen Vogler to A. Liessin, Abraham Liessin Archive, YIVO Institute for Jewish Research, RG 201, folder 383.

30. Elkhonen Vogler, "Der dikhter," in *Vilner almanakh*, ed. A. Y. Grodzenski (Vilna: Ovnt kurier, 1939), 127. In Jewish mysticism, the *shkhine* is the feminine manifestation of the divine.

31. See Neta Stahl, *Other and Brother: Jesus in the 20th-Century Jewish Literary Landscape* (Oxford: Oxford University Press, 2012); and Matthew Hoffman, *From Rebel to Rabbi: Reclaiming Jesus and the Making of Modern Jewish Culture* (Stanford, Calif.: Stanford University Press, 2007).

32. Vogler, *Tsvey beriozes baym trakt*, 47–50.

33. Belis, "Bay di onheybn," 28.

34. Vogler, *Tsvey beriozes*, 3, 8. As with his previous volume, Vogler here also included a glossary of almost three dozen "localisms," which provided his Yiddish with a specific folk register and regional flavor.

35. Vogler, 4–6.

36. Vogler, 6.

37. Vogler, 29.

38. Vogler, 100.

39. Vogler, 41.

40. Elkhonen Vogler, "Postne Lite," in *Bleter 1940: Zamlbukh far literatur un kunst* (Kaunas: Union of Yiddish Writers and Artists in Lithuania, 1940), 137. Reprinted in Elkhonen Vogler, *Friling afn trakt: Lider un poemen* (Paris: Farband fun di Vilner in Frankraykh, 1954), 22–23. The urge to chronicle Vilna as a center of Jewish Lite had a distinguished history in rabbinic, maskilic, and modern literature, especially at times of significant political or cultural transition. The year 1939 alone saw the appearance of Grodzenski, *Vilner almanakh* (Vilna almanac), and Zalmen Szyk, *Toyznt yor Vilne* [A thousand years of Vilna] (Vilna: Gezelshaft far landshaftkayt in Poyln-Vilner opteyl, 1939), each of which featured contributions by the writers of Yung-Vilne. Szyk's volume was an ambitious attempt to map a multicultural spatial consciousness by devoting significant room to Polish, Lithuanian, and Belorussian sites alongside Jewish ones. Vogler's "Postne Lite" was thus part of a broader moment of spatial and cultural self-assertion.

41. Elkhonen Vogler, "Di toyern fun mayn gemit," in *Friling afn trakt*, 15. The opening section of this volume returns to many of the poet's prewar themes, from imagining filial ties to country locales ("My brother is the Vilna Highway") to celebrating the region's diversity ("The Shepherd Mikite and His Flute").

42. William Wordsworth, "The Tables Turned," in William Wordsworth and Samuel Taylor Coleridge, *Lyrical Ballads 1798 and 1802* (Oxford: Oxford University Press, 2018), 81.

CHAPTER 3

Scandalous Glass House

ON MODERNIST TRANSPARENCY
IN ARCHITECTURE AND LIFE

Bożena Shallcross

Conceptually, a periphery is, by its logic, excentric, as it usually exists outside the frame of cultural significance. As a culturally coded spatial category, due to its insufficient or total lack of significance, it incorporates the unrepresented or underrepresented, the overlooked and seemingly uninspiring. In this chapter, the well-trodden modernist binarism of the center and the periphery is renegotiated anew, without the full hierarchical reversal of their status and functions that is so frequent in contemporaneous discourse. Here, the periphery does not quite become the center, nor does the center expand outward to subsume its periphery; rather, the periphery, still contingent on the center, gains enough creative autonomy to produce a new value dialectically. To observe the complexities of this process, I focus on two *excentric* entities: a small modernist villa known as the Glass House—designed and built by functionalist architects Maksymilian Goldberg and Hipolit Rutkowski between 1928 and 1932—and the villa's owner, Irena Krzywicka, a writer and activist who commissioned its construction on a wooded plot of land. Krzywicka and her country retreat in Podkowa Leśna (Horseshoe Grove), a town on the outskirts of Warsaw, were imports from Warsaw, and thus they were excentric. They were also defined by an overarching modernist idea of transparency, albeit not in a particularly radical manner. Usually, architectural transparency is constructed through the openness of walls, glass insertions, unobstructed views, an opening of material surfaces to otherwise hidden and unobservable spatial depths, and so on, while human transparency allows one to gain information about others or observe the performance of certain actions in a practically unlimited range of behaviors, sources, and situations. Practicing transparency in daily life tends to be circumscribed and controlled by long-established societal, cultural, and ethical norms. It was the modernist movements of the 1920s and 1930s that revolutionized this quality and foregrounded it as an important and novel artistic concept. On the

one hand, Krzywicka's house conveyed this quality through an interplay between a novel employment of huge glass windows and its solid, white walls. On the other, ignoring moral and social conventions of the time, she shaped a gendered, *excentric* selfhood, forging a transparent and emancipated womanhood. Krzywicka's openness about her erotic life and her Glass House were two facets of the same phenomenon illustrating this illusive idea of transparency. What follows is my critical intervention into this reflexive relationship and its contexts.

The Poverty and the Allure of Glass

In order to analyze the concept of transparency, it is necessary to linger for a moment on the spectacular career of glass in modernism. Architectural modernism created a successful new aesthetic of transparency that explored the potential of glass, concrete, and steel as its main materials.[1] In this triad, glass played a critical role. Walter Benjamin, in his 1929 essay about surrealism, commented thus on the innovative employment of glass: "To live in a glasshouse is a revolutionary virtue par excellence. It is also an intoxication, a moral exhibitionism, that we badly need. Discretion concerning one's own existence, once an aristocratic virtue, has become more and more an affair of petit-bourgeois parvenus."[2] The transitional class of the petite bourgeoisie, which Karl Marx located between the aristocracy and the proletariat, had no taste for glass as the transitional material par excellence. Benjamin aligned glass with class and targeted only the petite bourgeoisie for its aspirational pursuit of discretion. Glass afforded transparency and, thus, spoke to people with modern aesthetic sensibilities—which the petite bourgeoisie eschewed and even feared.

Benjamin returned to his interest in a class/glass revolution four years later with the following comments: "It is no coincidence that glass is such a hard, smooth material to which nothing can be fixed. A cold and sober material into the bargain. Objects made of glass have no 'aura.' Glass is, in general, the enemy of secrets. It is also the enemy of possession."[3] Benjamin participated in creating the modernist myth of transparency by seeing glass as transparency's best medium, one that defied the secretive and hypocritical petite bourgeois set of values and lifestyle demarcated by interiors laden with decorative elements and possessions. The creation of so-called phenomenal and literal transparencies implied, among others, a divestment of homes of paraphernalia and, in effect, a removal of their inhabitants' traces.

At that time, such a truly transparent glass house, with all four walls made of glass, was still a matter of architectural fantasy. It materialized much later, in the postwar years of 1947–1949, as the masterful work of the modernist American architect Philip Johnson in New Canaan, Connecticut. Johnson's design of his own house was remarkable for entirely obliterating the concept of exteriority, with no opaque front facade or even back walls.[4] The transparency of the glass allowed the outside to merge with the building's uncluttered and clean-lined interior. Johnson's transparent structure erased the notion of the house as a holder of secrecy and

reduced objects to a bare minimum; in doing so, it realized and epitomized high modernism's delayed, liberating tendencies.

One could, probably with varying results, discard each of Benjamin's claims. Today we reject each of his assertions: it is possible to permanently affix other materials to glass and to imbue it with a visually alluring texture. Moreover, glass can protect secrets, although usually glass implies clarity. Glassmakers can praise glass for its extreme flexibility; homeowners for letting natural sunlight into their homes. Finally, it could be argued that stained glass windows have been historically bestowed with exuding an aura that, in my opinion, has few, if any, equals.[5]

As a modernist cultural trope conditioned by the enormous potential of transparency, a glass building was accepted not only because it allowed light through. Functional, sunny, and uncluttered interiors were also considered beneficial for both physical and mental health. Advances in technology (e.g., steel frames, reinforced concrete) allowed the further development of supertall buildings with glass walls. Behind Benjamin's embrace of modernist glass lurk two additional and quite different utopias: one that promised supertall skyscrapers and another that envisioned the idea of simple elegance in glass villas for the affluent. The predominance of the idea of supertall skyscrapers began to fade away after the September 11 attacks; following some highly controversial efforts, certain countries prohibited them. Likewise, living in transparent houses turned out to be impractical precisely because their transparency facilitated voyeurism. Both utopian ideas became a demythologized reality.

The modernist dream of a glass house also had an impact in Polish architecture. The name Szklany Dom was quite popular at the time, and there were several glass houses built in interwar Poland, to mention only Juliusz Żórawski's design from 1938 on Adam Mickiewicz Street in Warsaw as one example of the fashion. The trope, likewise, affected literature. Let me note two East European writers who were seduced by its allure or disenchanted by its promise. In the Soviet Union, Evgeniy Zamyatin wrote the dystopian novel *We* (1920–1921), in which an infrastructure of glass buildings serves as a perfect conduit for the regime's principle of total surveillance. In the Polish literary context, in turn, Stefan Żeromski's novel *Przedwiośnie* (*The Coming Spring*; 1924) tells the story of a young Pole from Baku who, after leaving Russia for Poland because of the Bolshevik Revolution, realizes that his father's vision of the country, of its beauty and economic wellness (epitomized in his phrase "glass houses"), was a pure phantasm meant to lure him there. In reality, no such clean and elegant glass houses were there, only poverty. Żeromski's phrase is laden with an ironic friction between the ideal of glass houses and the reality of poverty; however, there is a notable disparity between the writer's allegiance to modernity, exemplified in this catchphrase, and his post-Romantic, often lyrical rhetoric. Emblematic of the exilic dream of Poland as a country where poverty is eradicated and prosperity is embodied in glass buildings, the phantasm is marked by the underlying dystopic intimation.[6] The same unfulfilled allure marks the ultimately dystopian fate of the garden city Podkowa Leśna.

The Birth of the Garden City Movement: From Howard to Lilpop

If we consider the Crystal Palace of 1851 as the onset of the "era of transparency," then sustainable urban planning was another crucial part of the utopian vision of a future world characteristic of modernism, especially as shaped by the garden city movement inspired by the British urban planner Ebenezer Howard (1850–1928). His book, *To-Morrow: A Peaceful Path to Real Freedom* (1898), initiated the interest in designing affordable, lower-income communities located on the outskirts of big cities. Howard envisioned garden cities as green, affordable, self-contained, and egalitarian communities created in response to congested, polluted, and dirty urban centers such as London. His work initiated a global movement that influenced, among others, the wealthy Polish industrialist Stanisław Lilpop, who founded the town of Podkowa Leśna (Horseshoe Grove), near the Młochowskie Forests, to the west of Warsaw.

Lilpop owned a large plot of land outside Warsaw, in Brwinów, and considered developing a garden city there even prior to World War I. In 1925, he created the joint-stock company that sold the grounds as smaller plots. Even at the onset of the project, Lilpop's Podkowa Leśna did not have the radical edge of Howard's vision.[7] One detail of the Podkowa Leśna initiative demonstrates that Lilpop did not have in mind an egalitarian, progressive, and self-reliant town: the town's commemorative cornerstone was marked with a statue of the Virgin Mary, its pedestal inscribed with a list of participating companies. With the exception of greenery, this combined celebration of Catholicism and capital, with Podkowa Leśna as its end result, was a stark departure from Howard's vision.

Indeed, in contrast to the garden city movement's main tenet, Podkowa Leśna was, from its inception, a space for a select population, since Lilpop intended to develop this alternative, green space for the Varsovian bureaucracy and middle class. It turned out, however, to be more than this, for it eventually became one of the wealthiest neighborhoods in Poland. The town's conceptual origin is reflected in its name and plan, since Podkowa Leśna has a half-circular, horseshoe-like layout somewhat similar to Howard's circular garden city plan. We should remember, however, that this was a coincidence, since the circular form was not how Howard intended to shape garden cities. Podkowa Leśna has retained its exclusive character such that it is today populated by Poland's most affluent citizens; no agricultural activity takes place there, even if there is horticulture for aesthetic purposes. It seems that in Podkowa Leśna, only the element of ample green space, both public and private, natural and cultivated, has remained untouched from Howard's original idea, with three nature preserves located there as well.

The Goldberg and Rutkowski Firm

When the cannons of the Great War fell silent, European cities were in a ruined state, their physical structures destroyed by the conflict and neglect. The new reality

of the interwar period was a time of unprecedented development of all essential spheres of life, especially in recently independent and reunified countries such as Poland. The myriad pressing demands resulting from the wartime destruction of the built environment, such as a lack of family housing, schools, and all kinds of municipal architecture, presented architects with both enormous challenges and opportunities. One of the most urgent needs of the newly independent nation was creating a representative and impressive capital city: Warsaw was to be a modern metropolis. Leading architects answered society's needs and aspirations in a way that left a legacy in Polish architecture, even though many of their built projects were destroyed during World War II. Those that survived, however, demonstrate the enticing purity and simplicity of the functionalist style, as it was called then in Poland. The creator of the style, the American architect Louis H. Sullivan, first introduced the famous phrase "form follows function" in his article "The Tall Office Building Artistically Considered." For him, this concept was also expressed in "the pervading law of things organic and inorganic."[8] By this, he meant that a building should be based on the principle of function and purpose, while form (beauty, ornament, etc.) was of secondary importance; in practice, Sullivan did not refrain from ornamentation. Ultimately, functionalism merged with another architectural movement known as the international style of the 1920s and 1930s only to be absorbed by the huge tributary that was modernism, which included numerous other schools, styles, and media in the visual arts, literature, dance, music, theology, and philosophy.

In the context of the architectural giants of high modernism—such as Walter Gropius, Le Corbusier, and Ludwig Mies van der Rohe, whose novel designs reverberated throughout the world—neither Krzywicka's house nor its designers are known outside Poland. The only exceptions, arguably, are the architectural and cultural historians interested in the phenomenal interwar growth of the Polish school of architecture and its participation in the International Congresses of Modern Architecture (CIAM).[9] Krzywicka's Glass House was built in the functionalist style, which some architectural critics associate with the universalism of the international style. According to Henry-Russell Hitchcock and Philip Johnson, the idea and purpose of an international style, an aesthetic of universal appeal that abjures any element identified with a particular national style, was to create simple, economically prudent, and functional building designs based on geometric forms, straight lines, and flat roofs.[10] Krzywicka's building fulfilled all these criteria. Her Glass House, erected in the culturally obscure wooded corner of eastern Europe (read, periphery), destabilized the continuity of the historical and eclectic paradigms prevailing in Podkowa Leśna's traditional and upper-class neighborhoods. More importantly, Goldberg created it *against* the main canon of Polish national architecture, disrupting and refreshing the stalled imagination and legacy of a manor house to embrace the principle of pure and unadorned function.

Both Goldberg and Rutkowski were renowned, prolific, and respected architects in Poland. Goldberg (1895–1942), an assimilated Polish Jew, received an excellent education, graduating from the Polytechnic in Lwów in 1914 and from

the Monumental Architecture Department of the Polytechnic in Warsaw in 1922. He was associated with the periodical *Architektura i Budownictwo* (Architecture and construction), where he was both a contributor and a member of the Editorial Committee.[11] His projects received international awards on several occasions: a bronze medal at the Paris Exhibition in 1925, honorary diplomas in Budapest in 1929 and 1932, and finally a gold medal in Paris in 1937. He was one of the founders of the Association of Architects of the Polish Republic (Stowarzyszenie Architektów Rzeczypospolitej Polskiej). As a member of a generation of Polish-Jewish architects educated after World War I, who largely embraced functionalism, Goldberg consistently worked in the modernist architectural idiom.[12]

His partner Hipolit Rutkowski (1896–1961) took a different path toward his education, as he first practiced architectural design in 1913 at Teofil Wiśniowski's firm and, next, took several courses at the Architects' Association in Warsaw. Rutkowski started to cooperate with Goldberg in 1923, and in 1927, together they opened an independent architectural studio; because of this cooperation, it is sometimes difficult to ascertain the exact authorship of some projects. With Goldberg, he designed Dom Prasy (The Press House), one of the most interesting functionalist industrial buildings in Warsaw, according to the architectural historian Jarosław Zieliński.[13] Rutkowski's design style was functionalist, although he also opted for eclecticism and included in his numerous works various elements of diverse historical styles.

Together, Goldberg and Rutkowski designed many examples of banks, schools, offices, and manufacturing facilities. The unprecedented architectural boom in interwar Poland also included residential housing. In the luxurious Saska Kępa neighborhood of Warsaw, the firm designed functionalist single-family houses that added a modernist touch to the area's distinctive character.[14] They participated in the concerted effort to shape anew the depleted urban spaces across the country. The assertion that Goldberg was stylistically influenced by de Stijl[15] has been modified by the recent approach in the history of interwar architecture that assesses the modernist movements in various European countries not in terms of originality but as an interrelated network of friends, couples, and collaborators who shared and exchanged their ideas across borders.[16] Goldberg enacted and participated in this kind of network in several ways: beginning from his collaboration with Rutkowski, through his editorial activity at *Architektura i Budownictwo*, and on the highest international level in CIAM.

The simple house Goldberg designed for Krzywicka was slightly outside his ambitious lexicon, yet aesthetically it was not inferior to his more challenging architectural designs. A special issue of *Architektura i Budownictwo*, prepared for CIAM in 1935, included among photographs of four complete projects by Goldberg and Rutkowski, one of Krzywicka's Glass House, which brought international attention to the firm and its designs.[17] By Krzywicka's admission, the design was well matched to her initial modest financial means and expectations.[18] Strangely, for she was fond of name-dropping, she did not mention the architect's name and pushed him into anonymity by referring to him only as a *znajomy architekt* (an architect acquaintance) who asked for *skromne pieniądze* (modest money).[19]

Her gesture of negation posits whether it is at all possible to analyze her relationship with Goldberg that is at the very bottom of the creative process that yielded the Glass House. It is my contention that the relationship defies analysis while inviting speculation. The only existing historical "document," the vestige that bespeaks their connection, is her Glass House. The design was special, and Krzywicka was aware of its insularity and striking presence.[20] Yet she did not give any credit to its designer and the movement he represented, even deleting his name from her memoir; in doing so, she sentenced him to oblivion in the eyes of her readers. Within the seemingly transparent microcosm of her memoir, she created an obstacle that obfuscated Goldberg, who was both an extraordinary artist and human being. Bohdan Lachert, one of the leading twentieth-century Polish architects, described Goldberg—his friend and competitor—thus: "One of the most outstanding architects. Phenomenal memory. Subtle and sharp intelligence. Wonderful orator and satirist."[21] Lachert described an exceptional artist and man, a depiction at odds with Krzywicka's reluctance to give him richly deserved credit, even after his death. The anonymized architect's role seems to have been limited to his drafting the plan and function as a legally mandated fixture. In a way, Krzywicka obliterated the house's genealogy to present herself as its real creator, not just the cocreator.[22] Here lies the aporia in analyzing her and her house as separate entities.

Initially a small summer cottage, the Glass House's unique aura is still preserved today in its full splendor, afforded and enhanced by its wooded environs. Yet for all its merits, it could not withstand comparison to the other designs by Goldberg and Rutkowski, especially the much larger, elegant, and polished buildings of very affluent Varsovian families. Among them was the impressive Herman and Regina Klein villa that the firm designed in a functionalist style or one of their later projects, such as the Wolfram House, in which the architects embraced a "softened" version of functionalism by introducing rounded corner walls and deep loggias, which gave the structure a less sharp shape.[23]

The white walls and sharp cube shape of the Glass House bespeak the purity of Goldberg's adherence to geometric modernism, including possible associations with Kazimierz Malewicz's geometric abstraction.[24] The main entrance to the flat-roofed white stucco house is not in a street-facing facade, itself characterized by the bold visual contrast of a single small, dark window in a white wall. The structure seems to illustrate the divide between nature and architecture inherent in modernist designs of the 1930s. As if in anticipation of such criticism, the architect introduced some subtle accents to the house, in particular two wooden trellises on the wall underneath the wood-shaded window for climbing plants. The building's clean lines and sharp contours are also softened by the warmth of wooden planks horizontally covering a large bay section in the street-facing facade. The blinded bay window seems to be oddly disregarding its function of letting in light, an issue addressed by the two tall, narrow windows on the sides of the projecting bay section.[25] Nonetheless, it was one of Goldberg's favorite features that the Klein villa shares with Krzywicka's house. (See figure 3.1.)

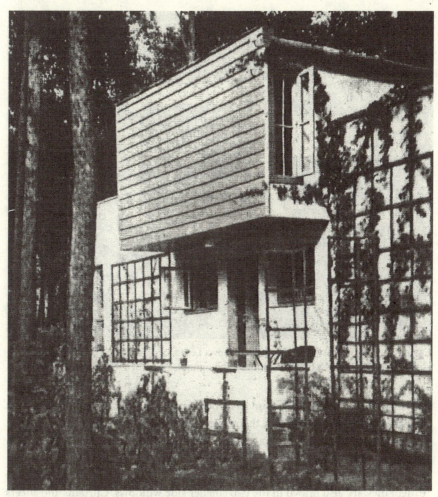

Figure 3.1. Krzywicka's Glass House in Podkowa Leśna, designed by Maksymilian Goldberg and Hipolit Rutkowski. *Architektura i Budownictwo* 6, 7, and 8 (1935): 75.

The wall of the garden-facing side was designed symmetrically, with the large middle window flanked by smaller ones on either side, all of which allow light into the living room. The proportion of this wall given over to the windows prompted naming the villa the Glass House.[26] (See figure 3.2.)

The transparency of the large bay window opening the interior of the living room to the woods gave rise to another effect modifying the modernist separation of nature and architecture. The perspective from the living room places its internal built environment in a dialectical relationship with the external natural surroundings. These interventions harmonize the building and its green environment and serve to attenuate the effect of stark geometrization. This monumental window in the rear of the Glass House, which is not visible to passersby, informs us of Krzywicka's limitations on the transparency of her house.[27] Clearly, Goldberg's client

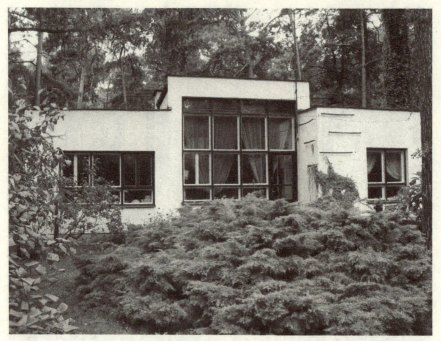

Figure 3.2. Krzywicka's Glass House in Podkowa Leśna, back, designed by Maksymilian Goldberg and Hipolit Rutkowski. Modern photograph. Photo by Piotr Borowiec, 2008.

had some desire for privacy, and the Podkowa Leśna house illustrates her less radical embrace of transparency than expected from the self-professed scandalist.

This need to control visual access to her private life is further evidenced in Goldberg's drawing of the house's rear side. The drawing is too delicate to reproduce here, but it shows curtains (or sheers) in the monumental window facing the garden; they are also drawn in the two smaller side windows. Curtains and sheers enhance privacy by obstructing the potential for outsiders to see in. Such screens were not necessary in this very private part of the house, which was inaccessible from the street. The consequences of the draftsman's cautious gesture of drawing a veil over the interior cannot be dismissed. They would curtail the transparency of the house and add a more bourgeois sensitivity to Krzywicka's otherwise épater le bourgeois conduct, also signaling Goldberg's rejection of the modernist principle of exposure to the eye. In the context of Benjamin's exultations over the transparency of glass, Goldberg's sketch demonstrates that he did not slavishly follow any aesthetic dogma or imperative.

Enter Krzywicka

Krzywicka was fond of wearing many hats: she was a progressive critic, writer, translator, promotor of sexual education, feminist-activist, and attractive, elegant socialite who belonged to the elitist artistic milieu of interbellum Warsaw (figure 3.3). In addition to her leftist and intellectual credentials, she was also a

Figure 3.3. Portrait of Irena Krzywicka in Beaulieu-sur-Mer, 1925. Photo courtesy of Polona, a digital library administered by the National Library of Poland. F.33147/I.

devoted mother of two boys. Born Irena Goldberg in 1899 in the Siberian city of Eniseĭsk (Yeniseysk) in Krasnoĭarskiĭ kraĭ, Russia, to assimilated Polish-Jewish parents exiled there for socialist activism, she moved with them to Warsaw as a child. There her father, Stanisław (a physician by education), died three years later of tuberculosis contracted during exile. Her mother, Felicja, married Jekutiel Portnoj (1872–1941), one of the Bund's founding fathers and prominent leaders.[28] Irena thus grew up in the sophisticated milieu of the Polish-Jewish intelligentsia where Polish literary masterpieces by Adam Mickiewicz were read along with Karl Marx's writings, both of whom were forbidden authors for her parents' generation.[29]

In Warsaw, she attended Aniela Warecka's private school for girls, which enjoyed a positive reputation, for it accepted both Jewish and Polish pupils;[30] nonetheless, Krzywicka remembered some discriminatory situations that occurred in the school.[31] Later, she enrolled at Warsaw University and attempted to write a dissertation in the field of Polish literature, which she did not complete due to a disagreement with her supervisor. She married Jerzy Krzywicki, a lawyer and son of renowned Marxist sociologist Ludwik Krzywicki (1859–1941). Shortly after their wedding, Krzywicka went to Corsica with a new lover, the famous German poet Walter Hasenclever;[32] her flight from Krzywicki caused the perception of their relationship as an open *małżeństwo koleżeńskie* (companionate marriage). Indeed, Krzywicka mentions in her memoir that prior to the marriage, she and Krzywicki envisioned their union to be open to the enrichment that other partners would bring to their lives.[33] Krzywicka rationalized her approach to the question of marriage by insisting, for example, that women's financial independence was crucial. Her understanding of this model of marriage was better crystallized thanks to the American lawyer Benjamin Barr Lindsey's book *Małżeństwo koleżeńskie* (*The Companionate Marriage*), which she reviewed in 1932.[34]

A period of further travels, flirtations, and transgressive encounters with famous men of letters followed. Krzywicka rejoiced in scandals and thrived on sensationalism but above all was actively engaged in the cultural life of Warsaw as a theater critic, a novelist, and a journalist. She moved among its artistic and intellectual elite, in the very center of the ferment that characterized the capital city of that time.[35]

In 1927, when Krzywicka had already published numerous works of journalism, she interviewed interbellum Poland luminary Tadeusz Boy-Żeleński—a talented and prolific satirical writer, critic, and translator as well as a physician—while she was herself in the third trimester of pregnancy with her first son, Piotr. Initiated on the basis of mutual interests and political proclivities, their friendship eventually turned into a deeply involved love affair and intellectual partnership. It suffices to quote one confession from her memoir to illustrate her insistence on transparency in communication: "I could not resist Boy, whenever there was an opportunity."[36] This feeling did not prevent her from defending her marriage's integrity. True to her ideas of conscious motherhood, she made the rational and strategic decision to distance herself for a while from Boy-Żeleński in order to have her second child,

Andrzej (born in 1937), with her legal husband, only to revive her relationship with her much older "boyfriend" afterward. It lasted till 1939; at the beginning of the war, Boy-Żeleński left for Lwów.[37]

It would be difficult to ascertain who radicalized whom politically, as both Krzywicka and Boy-Żeleński had clearly defined political agendas prior to their relationship. I believe that they inspired each other, although Boy-Żeleński gave her more visibility and, to refer to Magdalena Środa's view of Krzywicka as an influential and powerful feminist, more power.[38] With Boy-Żeleński, she passionately fought for women's abortion rights and opened the Council for Motherhood Awareness, a free, private clinic for disadvantaged women.[39] In order to popularize their program, they published *Życie Świadome* (The conscious life) as a supplement to the leading liberal weekly *Wiadomości Literackie* (Literary news; 1924–1939). *Życie Świadome* also aptly defines Krzywicka's feminist agenda, which was devoid of psychoanalysis; many of her emancipatory objectives, such as securing equal rights for women, were articulated and argued in a purely rationalist fashion.[40] Both Krzywicka and Boy-Żeleński paid a price for their activism and journalism in becoming targets of attacks by the ultraconservative press. Krzywicka, who undoubtedly enjoyed her role as both a bohemian and an intellectual, according to her cousin and philosophy professor Jan Garewicz, cultivated sensationalism as her deliberate strategy: "Irena liked to provoke. . . . She was doing this deliberately, so everybody talked about her. She liked to be a public persona who is spoken about. In one word—Irena Krzywicka—the nation's scandalist."[41]

The question is, To what extent was this scandalous but in fact rational, public persona that she constructed over the years related to her and Goldberg's modernist project in the peripheries of Warsaw? The idea behind the construction was driven by a double ideal of a built glass house and of unconstructed nature: the house's transparency and functional design were combined with the surrounding, uncorrupted wood preserves. Even the name of the street, Sosnowa (Pine) Street, reflected the overall framework of a garden city. On the surface, her pastoral summer house was tactlessly new and offensive to her neighbors' aesthetics but had little to do with her her modernist desire to push further the envelope of morals;[42] for this, she retreated to *Życie Świadome* and other similar outlets.

Krzywicka possessed a strong desire for a quiet, peaceful place of her own outside the city: "I was granted a great happiness of which I dreamed since childhood: I had my own garden, [an] orchard that bore delicious fruits, and trees on the remainder of the plot."[43] In reality, the house satisfied more than one of Krzywicka's pleasure drives; there she cultivated both her garden and her romantic liaison with Boy-Żeleński, who would occasionally join her in gardening. Once built and inhabited, the Glass House became a vital cultural and social site, where the unconventional Krzywicka wrote, raised her children, and enjoyed gardening.[44] She often spent her weekdays there with Boy-Żeleński, with her husband visiting on the weekends. The house also turned out to be a great place for the escapades of Ziemiańska Café patrons, a sort of cultural center temporarily transplanted from Warsaw.[45]

Her lifestyle and her house's design, however, had an impact on the immediate neighborhood and illustrated how she pushed for cultural and aesthetic transformations beyond those of women's rights and sexual freedom. From Krzywicka's point of view as the building's owner, it was not only *her* proverbial dream home; she also praised its novel architectural qualities. Her concern for functionality led her to choose a flat rather than sloped roof for the building. This seemingly practical decision triggered an adverse reaction among her traditional neighbors: "The design, for that period, was unusually modern and caused a great sensation in the area. Because of its flat roof, for which the Formists and Szczuka have struggled so much, and which at that time was inconceivable in our climate. It turned out, however, that it was durable, practical, and much cheaper than a sloped one. Beside this, the little house stood with its back turned against the street, from which one could see only a blind wall overgrown with roses."[46] She valued the house's purposeful functionality that determined its interior design: "So, it was a one-level house with a tripartite cross-section. Two similar bedrooms constituted one-third; the living-room and a small vestibule another; and one-third consisted of a small bedroom, bathroom, a corridor to the kitchen, as well as a kitchen with an alcove and staircases to the cellar and to the attic. The house thus was functional not only from its exterior. The actual front of the house faced the garden, which produced the impression of depth."[47]

The house's culturally excentric position within Podkowa Leśna was due not only to its designer's adherence to modernism, for she owned a house in a traditional neighborhood defined by its population's political conservatism. Krzywicka's seemingly modest and unobjectionable building was also at odds with other buildings in the area. As she points out, this misalliance was quickly politicized beyond the aesthetic discordance existing between her glass abode and her neighbors' columned manors: "Since they came prevailingly from the Endecja milieu, *the aversion* was even stronger. Absurd, but true."[48] Krzywicka's Glass House destabilized the continuity of the historical and Zakopane styles as dominant architectural paradigms in Podkowa Leśna.[49] The traditional architecture of the Polish manor that prevailed in this quiet and elegant neighborhood reflected the nationalist and conservative political leanings of its residents: bourgeois generals, lawyers, and scientists.[50] This community found Krzywicka's house and lifestyle disgusting and offensive, effects that "the nation's scandalist" did not mind. The Glass House remains intriguing for its awkward placement on the cultural map as a site for the Polish and Polish-Jewish elitist cultural milieu of the 1930s.[51] This disturbance of the historical paradigm was part and parcel of Krzywicka's deliberate, provocative modernist taste that resulted in centering the peripheral status and character of the enclave her Glass House represented in Podkowa Leśna.

The problematic assimilation of Krzywicka/Goldberg's Glass House into the neighborhood anticipates the controversial postwar introduction of modernist glass houses in America. The architect and historian of architecture William D. Earle writes about the unfavorable perception of the new architectural paradigm in the traditional, small town of New Canaan, Connecticut, where white picket

fences were preferred over the "white matchboxes," as the new building type was called.[52] In America, houses in the new style—initially perceived as "scandalous and shocking" despite having been designed by leading architects according to changes brought about by the war—caused a negative reaction similar to that in Podkowa Leśna years earlier.

There the building's modernist sharpness was tempered particularly in terms of its transparency. Although it was much less radical than the idea of life on display, as articulated by Benjamin, it proved to be a rational interchange between a purposeful architectural concept and the owner's and her family's lifestyles. To put it differently, Krzywicka's Glass House became an extension of her, a stage and a substitute for her persona and aspirations. The transparency theme of the house is exemplified by its huge back window. In Krzywicka's description, this opening onto the garden and nature activates an interplay between the inside and the outside. As she puts it, "The living room had one entirely glassed wall. One entered a smallish and rather low vestibule through a narrow patio, with the door there leading to the living area. Immediately, a huge perspective onto the great room and the garden, which nearly entered the place, was revealed."[53] As an architectural feature, transparency can thus be understood literally as a medium for admitting light and metaphorically for enhancing mental clarity, which indicates its rationalist roots in the Enlightenment. Judging from her writing, her behavior, and the opinions of her contemporaries, transparency—as her psychological disposition—manifested itself not only in Krzywicka's life and the decisions she made. She was neither prone to the exhibitionism à la surrealists nor inclined to a fully confessional mode, despite her memoir's title and her reputation. By today's standards, the promise in the title of *Wyznania gorszycielki* (Confessions of a scandalist) to reveal the whole scandalous truth is unfulfilled, having mostly been restricted to a sphere of unrealized potential controlled by her conscious and rational self. Nonetheless, Krzywicka's personality possessed an open aspect, a perception of her in her milieu to which Agata Tuszyńska's 2009 biography of Krzywicka testifies. The philosopher Leszek Kołakowski was in fact very fond of her transparent conduct: "I truly liked her, actually, I loved her. She was so 'on the surface.'"[54] She embraced a kind of semitransparency, more suggestive than detailed, a teasing strategy of potentiality more than a "lifting of the veil" covering the sphere of her intimate life and private space.[55]

Krzywicka's Glass House likewise offers this type of transparency, in sync with her modernist taste fused with her emancipated personality and foregrounded by her social aspirations and leftist politics. These traits evince Krzywicka's efforts at revising social and moral boundaries, as well as the way she (and Goldberg) destabilized the architectural boundaries of interbellum Poland. Aside from these emancipatory strategies, other parallel practices are discernible in her inhabitation process, such as her excentric transfer of the established centers of Ziemiańska Café and *Wiadomości Literackie* to a very different, quiet, and less exposed context in Podkowa Leśna. Her house's design, her library made public, and her presence there along with the transfer of the elitist milieu's personalities were rejected

without any direct emancipatory impact on the neighborhood. Subsequently, the Glass House defies the sharp binary opposition of center-periphery and supports a more nuanced understanding of their interplay. While its avant-garde architectural design belongs to the center of modernist architecture and urban planning movements, which in Poland of that period usually meant Warsaw, Gdynia, and Kraków, the Glass House was not located in these cities or any other urban center, and therefore it generated an enhanced architectural newness. Thus, the house was deterritorialized as an enclave where a liberated Polish-Jewish woman lived a seemingly happy life with her two men and two sons, surrounded by the woods and the conservative, oft hostile political atmosphere of the 1930s.

The Glass House never ceased being an intriguing artistic design. It countered discourses dominating Polish culture at that time by embracing modernist values, by its deterritorialization and political subversion, otherwise crucial for construing the Jewish identity and agency of its owner and of its designer. It also had a different energy, created by the will of three exceptional individuals: Lilpop's vision of a garden city, Goldberg's artistic plan, and Krzywicka's progressive politics and mores. Finally, it was also the material agency of glass, its misguiding transparency morphed into an obstacle in the form of the house's rear wall facing the neighbors to have protection from their voyeuristic gazes and judgmental attitudes.

This case does not illustrate a simple reversal of values and positions that dominate the postmodernist discourse, according to which a center moves to the periphery and bestows on it its revolutionary energy. This kind of flip did not happen, and the center did not absorb the peripheric space of Podkowa Leśna. Neither did Krzywicka emancipate herself entirely from the established order of the center's supremacy over the periphery, although through practices of social action and empowerment of lower-class women, through a daring architectural experiment and her sexual proclivities mixed with utopian hopes, she created a modern site on the cultural topography of Warsaw's outskirts. By understanding the rules of the center while construing a new, more balanced meaning for the peripheral enclave, she endowed the latter with a novel cultural significance. Reframing the periphery was a dialectical effort that Krzywicka, steeped in Karl Marx's writings, knew intimately.

Notes

1. These explorations also coincided with inquiries into the psychoanalytical concept of the concealed subconscious and the mechanics of revealing a hidden truth on the psychoanalyst's couch. See, for example, Carol Pinel, Julio Guillen, and Dominique Reniers, "Transparency and Truth: Towards a Cult of Confession," *Recherches en psychanalyse* 11 (2011): 29–37.

2. Walter Benjamin, "Surrealism: The Last Snapshot of the European Intelligentsia," trans. Edmond Jephcott, in *Selected Writings*, vol. 2, *1927-1934*, ed. Michael Jennings, Howard Eiland, and Gary Smith (Cambridge, Mass.: Harvard University Press, 2001), 209.

3. Walter Benjamin, "Experience and Poverty," trans. Rodney Livingstone, in Jennings, Eiland, and Smith, *Selected Writings*, 2:733–734.

4. The architect used solid internal walls for his bathroom.

5. See Detlef Mertins, "The Enticing and Threatening Face of Prehistory: Walter Benjamin and the Utopia of Glass," *Assemblage* 29, no. 1 (April 1996): 6–23.

6. Martin Kohlrausch analyzed and contextualized Żeromski's phrase at length in his book *Brokers of Modernity: East Central Europe and the Rise of Modernist Architects, 1910–1950* (Leuven: Leuven University Press, 2019), esp. 15–19.

7. Lilpop built a classic manor house called Stawisko for himself on a remaining piece of land (1926–1928; architect Stanisław Gądzikiewicz). The Polish manor was a typical one-story homestead of the gentry that usually had a large, accentuated roof and a portico in the front facade. Stawisko was later occupied by Lilpop's daughter Anna and her husband, Jarosław Iwaszkiewicz, who was a talented and renowned poet and writer as well as a member of the poetic group Skamander. When the couple moved into the Stawisko manor, it became a frequent meeting site for Warsaw's artistic elite.

8. Louis H. Sullivan, "The Tall Office Building Artistically Considered," *Lippincott's Monthly Magazine*, March 1896, 56, 403–409.

9. CIAM (Congrès Internationaux d'Architecture Moderne) was an influential organization founded in 1928 and dissolved in 1959; its main goal was to disseminate principles of modernism in urban planning and architecture.

10. Henry-Russell Hitchcock and Philip Johnson, *The International Style: Architecture since 1922* (New York: W. W. Norton, 1932).

11. *Architektura i Budownictwo* also functioned as a forum for avant-garde architects. A group of highly respected Polish architects of Jewish origin was affiliated with the periodical, including Julian Sadłowski (né Julian Puterman), Edward Seydenbeutel, Jerzy Gelbard, Lucjan Korngold, Henryk Blum, and Grzegorz Sigalin, among many others.

12. In a notable departure from his style, Goldberg submitted a neoclassical design to the competition for the National Museum in Warsaw. His project did not win the competition, and a modernist design was selected instead.

13. Jarosław Zieliński, *Atlas dawnej architektury ulic i placów Warszawy*, vol. 10, *Mackiewicza-Mazowiecka* (Warsaw: Wydawnictwo Towarzystwa Opieki nad Zabytkami, 2004), 180–181.

14. To mention only the houses on 22 Jan Styka Street, 34/36 Walecznych Street, 2 Bajońska Street, and 3 Paryska Street, as well as the two-family houses on 3/5 Bajońska Street; 27, 29, 29A Alfred Nobel Street; and 10 Genewska Street.

15. As argued by Michał Wenderski, *Cultural Mobility in the Interwar Avantgarde Art Network: Poland, Belgium and the Netherlands* (New York: Routledge, 2019).

16. Katarzyna Uchowicz and Aleksandra Kędziorek discuss this aspect of architectural modernism in "Sieciotwórcza rola maszyny do pisania: Z Katarzyną Uchowicz, badaczką architektury modernizmu, rozmawia Aleksandra Kędziorek," *Autoportret: Pismo o dobrej przestrzeni* 3, no. 62 (2018): 104–123, https://autoportret.pl/artykuly/sieciotworcza-rola-maszyny-do-pisania/.

17. Although Krzywicka considered *only* Goldberg to be involved in the project.

18. Irena Krzywicka, *Wyznania gorszycielki* (Warsaw: Czytelnik, 1992), 223. Her view, while it cannot be dismissed, sounds rather odd in the light of the fact that at that time she bought not just one but three parcels of land in Podkowa Leśna.

19. Krzywicka, 223. Her gesture of erasing Goldberg's name is counterbalanced by some acts of commemorating him. For example, there is a plaque bearing his name mounted on a majestic oak tree growing on 22 Jan Styka Street in Warsaw. Proclaimed as *the* natural monument, the tree gained its own name: Dąb Maksymiliana Goldberga (Maksymilian Goldberg's Oak).

20. Quite ironically, such a design turned out to be a harbinger of a new normal, an early and unknowing prototype of the miserable *pudełka* (boxes) that mushroomed during the

Polish People's Republic, especially in the 1960s, and were a degraded form of pure and unadorned modernist form.

21. See Olga Szymańska, "Lachert, the Law Courts on Leszno and Saska Kępa," Jewish Historical Institute, accessed November 2019, https://www.jhi.pl/en/articles/lachert-the-law-courts-on-leszno-and-saska-kepa,331. This was an initiative of the Jewish Historical Institute to conduct a series of interviews with a group of architects entitled "Wywiady o zmarłych architektach Żydach" (Interviews concerning the deceased Jewish architects). Anna (Chana) Kubiak, an employee of the Jewish Historical Institute, conducted the interviews in the 1950s. It should be noted that Goldberg went to the Warsaw ghetto despite his friends' willingness to protect him, for such protection of a Jew equaled death. If not indicated otherwise, all translations are mine (B. S.).

22. In her memoir, she even writes about being engaged in some heavy physical labor at the construction site.

23. Alas, unlike Krzywicka's house, this villa was expanded after the war at a cost to its original aesthetics.

24. The anonymous authors of the Facebook page dedicated to Goldberg and Rutkowski indicate a possible impact of Kazimierz Malewicz's suprematist paintings on several aspects of the Glass House's design, in particular on its elongated white cubes and the huge, dark rectangle of the garden window. Goldberg & Rutkowski, "Willa Ireny Krzywickiej (ok.1930), Podkowa Leśna projekt Goldberg & Rutkowski," Facebook, December 11, 2013, https://www.facebook.com/Goldberg-Rutkowski-430161493751825/photos/432421530192488.

25. The light blocked by the wooden planks did not matter much when the room served as a tiny attic space. The postwar owners replaced the planks with glass.

26. Marta Leśniakowska, "Pokój z widokiem. Barbara Brukalska & Nina Jankowska, sp. z o.o.," in *Szklane domy: Wizje i praktyki modernizacji społecznych po roku 1918*, ed. Joanna Kordjak (Warsaw: Zachęta, 2018), 104–123.

27. Opening the building's back onto a quiet and light backyard makes sense in city center projects, where noise and traffic are often unbearable. On Sosnowa Street, it had a surprising effect that expressed a desire for more privacy.

28. The Bund was a secular, socialist Jewish labor union and political party that was opposed to Zionism and was founded in 1897 in Vilna, Poland. It supported the Yiddish language and culture as well as a commitment to a Jewish future in eastern Europe. The Bund's activities are discussed in chapter 11.

29. Indicative of the milieu's tight-knit character and small size is the fact that Irena's mother, Felicja Goldberg (née Barbanel), was a school friend of Rosa (Róża) Luxemburg.

30. Little is known about Aniela Warecka, who owned "8-klasowa Wyższa Realna Szkoła Żeńska" (the eighth-grade higher technical school for girls) between 1900 and 1906. The school was later incorporated into Stowarzyszenie Szkoły Handlowej (Association of School of Commerce).

31. Indeed, Krzywicka did not recall the school fondly. See her essay "Bez łezki" [Without a Little Tear], in *Kredą na tablicy: Wspomnienia z lat szkolnych*, ed. Jan Baranowicz et al. (Warsaw: Czytelnik, 1958), 281–294.

32. Walter Hasenclever (1890–1940) was a German expressionist poet and playwright whose works were banned (and burned) by the Nazis.

33. A marriage should be "wzbogaceniem, nie zubożeniem życia" (an enrichment, not an impoverishment of life). Krzywicka, "Bez łezki," 171.

34. Lindsey's writings were popular in interbellum Poland; besides *The Companionate Marriage* (with Wainwright Evans, 1927), his *Bunt młodzieży* (*The Revolt of Modern Youth*; with Wainwright Evans, 1925) was also important in the emancipatory discourse of the time.

35. The metaphor of Warsaw's life as a ferment speaks to both its interwar dynamism and the fact that the center of the city's cultural topography was never fixed but rather always moving. No wonder that Krzywicka dreamed about a quiet retreat—a little house with a huge, wooded lot—at which to relax from the busy life in the capital.

36. Krzywicka, *Wyznania gorszycielki*, 211.

37. Today's Lviv is in Ukraine. Boy-Żeleński was killed there by the Nazis in 1941, while Krzywicka's husband was murdered by the Soviets in 1940 in Katyń.

38. Magdalena Środa, *Kobiety i władza* (Warsaw: Wydawnictwo W. A. B., 2009).

39. The clinic was unpopular and frequently attacked by the Catholic Church; the pastoral letters from the bishops opposed seeking medical assistance there. See Krzywicka, *Wyznania gorszycielki*, esp. 241–242.

40. Some contemporary critics consider her rationalism as the weakest aspect of her intellectual agenda. See, for example, Anna Nasiłowska, "Życie Świadome i nieświadome," *Teksty Drugie* 2011, no. 4 (2011): 120–125. See, too, Agata Zawiszewska, *Życie Świadome: O nowoczesnej prozie intelektualnej Ireny Krzywickiej* (Szczecin: Wydawnictwo Naukowe Uniwersytetu Szczecińskiego, 2010).

41. Cited in Agata Tuszyńska, *Krzywicka: Długie życie gorszycielki* (Kraków: Wydawnictwo Literackie, 2009), 43–44.

42. Cited in Tuszyńska, "And, again, there was something that offended the tastes of that period in this aspect." Tuszyńska, 224.

43. Krzywicka, *Wyznania gorszycielki*, 224.

44. Moreover, keen on educational practicalities, she opened a small private library for the locals—villagers' children—in the Glass House, where her mother fulfilled the role of a librarian.

45. Ziemiańska Café, located on Mazowiecka Street, was a favorite daily meeting place of Warsaw's cultural elite. Its popularity grew when the poetic group Skamander chose it for its rendezvous.

46. Krzywicka, *Wyznania gorszycielki*, 223. Flat roofs became a staple of modernist architecture, although they have always been used in warmer climates. The Formists was a Polish avant-garde artistic group organized in 1917 that, as the name signals, celebrated form. Mieczysław Szczuka (1898–1927), Krzywicka's friend, was a Polish avant-garde artist close to Russian constructivism, a mountaineer, and a member of the Blok group. He produced numerous utopian designs of workers' colonies that reflected his practical constructivist approach to design and reality.

47. Krzywicka, 224.

48. Krzywicka, 224. The term *Endecja* refers to the National Democracy party and was a popular synonym for the national conservatives of the time. Emphasis mine (B. S.).

49. Zakopane style, popular at the turn of the previous century, was inspired by the vernacular wooden architecture of the highland region called Podhale.

50. The house dominated by another major architectural grammar could be interpreted as a sample of minor architecture in a sense articulated by Gilles Deleuze and Félix Guattari, *Kafka: Toward a Minor Literature*, trans. Marie Maclean (Minneapolis: University of Minnesota Press, 1986). Jill Stoner theorized minor architecture in political terms as a phenomenon emerging from the bottom of the power structure of the time. This genealogy cannot be aligned with the Glass House, if only for the fact that this modernist villa does not have a proletarian lineage. See Jill Stoner, *Toward a Minor Architecture* (Cambridge, Mass.: MIT Press, 2012).

51. After the last war, its sophisticated and lively mix of bohemians and intellectuals was gone, and its fame gradually faded away. The building survived unscathed, however,

and remains largely unchanged, with some small exceptions such as the bay window modification.

52. William D. Earle, *The Harvard Five in New Canaan: Midcentury Modern Houses by Marcel Breuer, Landis Gores, John Johansen, Philip Johnson, Eliot Noyes, and Others* (New York: W. W. Norton, 2006).
53. Krzywicka, *Wyznania gorszycielki*, 224.
54. Cited in Tuszyńska, *Krzywicka*, 312.
55. Pinel, Guillen, and Reniers, "Transparency and Truth," 31.

CHAPTER 4

Jewish Expressionism between Discourses of Revival and Degeneration

THE YUNG-YIDISH GROUP

Małgorzata Stolarska-Fronia

"Just as Goethe had his spiritual city of Weimar, I have mine: Łódź!"[1] With these words, Moyshe Broderzon (1890–1956) ended his defense of Łódź (Yid. Lodzh) in a polemic with Yitskhok Lichtensztajn (Isaac Lichtenstein; 1888–1981) published in 1933 in the leading Yiddish journal of the day, *Literarishe bleter*. Lichtensztajn had provoked him by his statement that the Lodzermensz (Yid. Lodzhermensh; Ger. Lodzermensch; a quintessential inhabitant of Łódź) has died, has emigrated, or is no longer in Łódź, living now "in Paris, London, in various Americas or other Eretz Israels, but not in Łódź."[2] This rather deliberately dramatized conversation between two Jewish artists of Łódź revolves around one of the strongest myths of this city: that a unique type of citizen was a creation of the young city and developed in specific social, cultural, and political conditions. Whether factory owners, lumpenproletariat, vagabonds, or artists, they were all Lodzermenszen: people of Łódź. The tension between a "peripheral" locality with a distinct sense of pride as well as its self-conscious fashioning of images and representations marked by prejudices and the so-called centers—be it Warsaw, Berlin, or Paris—is one of the main features that triggered the Jewish Łódź artists to fashion their own artistic projects and creative directions.[3] Even though many of them had attended various schools in the metropoles of Moscow, Düsseldorf, and Berlin, they decided that Łódź was the best place to start anew.[4] This chapter analyzes this tension between Łódź and the West, in turn illuminating how Łódź became a city of the avant-garde.

Born in Moscow, Moyshe Broderzon, a poet, playwright, and director, became a Lodzermensz in 1918 and then one of the leading figures in local cultural life.[5]

75

Although his fame stretched far beyond the city limits, he became a strong advocate for those who remained committed to the city and did not emigrate: "We are Lodzians, if not by birth, then at least [because we were] created by certain special circumstances."[6] He added a new meaning to the name Lodzermensz through his role in the creation of the Yung-yidish group, which became one of the most important avant-garde groups of interwar Poland, in turn redefining modern Jewish art.[7] The identity of the Lodzermensz was important for Jewish artists; it gave them freedom to experiment with various cultural projects in the fields of poetry, visual arts, and theater and, more importantly, allowed them to remain outside the hierarchical categorization that privileged the center (in their case, the closest reference point was Warsaw, followed by Berlin, Düsseldorf, and Paris) over the periphery. Yung-yidish strove to create a new Jewish style—Jewish expressionism—based on the forms and languages of expressionism, cubism, and futurism yet infused with Jewish spirituality.

This chapter examines the creative work of the Yung-yidish group from Łódź as an exemplar of Jewish expressionism, a concept that is also inscribed in the very term the *Jewish avant-garde*.[8] It will also analyze the relationship between the artistic and intellectual milieus of Łódź and Berlin. The intersection of the creativity of Yung-yidish, expressionism, and the Jewish avant-garde highlights the necessity to reorient the periphery as the center. The methodological approach draws on Piotr Piotrowski's concept of horizontal art history, which decenters the "center" and invites so-called peripheral cultural spaces to discussions of originality and creativity.[9] I argue that we need to shift our focus from Berlin eastward, to Kiev, Warsaw, and Łódź, urban locales that developed various offshoots of the idea of a new Jewish art articulated through expressionistic language after World War I. Rather than being inspired by Western ideas, these "peripheries" were, in fact, centers in their own right of both theoretical and practical experimentation.[10] Indeed, the *Metzler Lexikon: Avantgarde* places the focal point of the Jewish avant-garde in Poland, Ukraine, and Lithuania circa 1920 and only later in Germany and France.[11] And even before World War I, the local avant-garde in Germany and France consisted of artists from the Russian Empire, many of whom, like Yisakhar Ber Ryback (1897–1935) and Abraham Manievich (1881–1942), were pogrom refugees from the former Pale of Settlement.

Łódź is an excellent locale for a case study. In 1919, the Yung-yidish group emerged, functioning outside the linear system of the center and the periphery and creating art that was a fusion of the local context (Łódź), Jewish mystical thought, and the spirit of the European avant-garde. Operating within the dialectics of the Jewish revival, the members used the language of expressionistic forms, with explicit references to futurism and cubism, to express the spiritual condition of their generation. They longed for an authentic religious experience that they projected onto the Hasidic idea of *hitlahavut* (Heb. ecstatic prayer) and for a spirit of collectivism. In their revival efforts, the artists of Yung-yidish exhibited a constant tension between the center and the periphery as they created an independent art form.

The Łódź Artistic Scene

Łódź, a city whose origins lay in its being a farming village, rose to the rank of "Poland's cotton capital" in the mid–nineteenth century.[12] The rapid development of Łódź was due first to immigrants, especially German-speaking weavers—with many Yiddish- and Polish-speaking artisans arriving in the city too—followed by factory owners, who filled this once provincial town with industrial buildings and impressive architecture that rivaled Warsaw's aesthetic allure. After Poland regained independence in 1918, the city's multicultural character became even more manifest. Although not free of conflict, the national, ethnic, and religious minorities living in Łódź, including a Jewish population constituting 30 percent of the city, were able to pursue their own cultural endeavors.[13] They set up their own institutions, associations, and political parties whose voices rang autonomously in the cultural polyphony of Łódź. Jews also had representatives in the municipality.[14]

In this context, Yung-yidish was born, the second formal artists' collective—after Kiev's Kultur-Lige—that set itself the goal of creating a new type of Jewish art. Yung-yidish aspired to create a recognized style equal to those already well established within the general art historical canon. As a model example of Jewish expressionism, Yung-yidish sought a new language of iconography under the influence of apocalyptic and messianic thought. Many of these ideas may have been derived from Germanophone philosophical writings by Ernst Bloch (1885–1977), the German Marxist philosopher, and Franz Rosenzweig (1886–1929), the German Jewish philosopher and Bible scholar, which the young Yankl Adler (1895–1949)—an active member in the German avant-garde milieu since 1914—brought with him to Łódź to build the foundations for a local Jewish artists' group. However, equally significant was the traditional upbringing of the group's members that combined with the Łódź genius loci. Yankl Adler was born in the shtetl Tuszyn, near Łódź; his first language was Yiddish; and his first education was in a *kheyder*. As a member of Yung-yidish, he combined his Jewish heritage with his artistic persona, dressing in a gaberdine (Pol. *chałat*)—a traditional long Jewish coat—thus acquiring the role of the *tsadik* of his new art collective. He eagerly spoke and wrote in Yiddish. The Jewish language formed a distinct cultural space not only in terms of the spoken language but also as a language of art and poetry. Yung-yidish fought for its inclusion among other avant-garde languages in interwar Europe.

Moyshe Broderzon, on the other hand, brought a spirit of artistic experiment to Łódź, which originated not from the West but in the Russian cubo-futurist art of Vladimir Mayakovsky.[15] Additionally, Yung-yidish was strongly inspired by the ideas of the Polish modernist poet Stanisław Przybyszewski (1868–1927), an important figure in the movement Młoda Polska (Young Poland), who was also the first one to introduce the art of Edvard Munch to the German milieu.[16] Young Jewish artists undeniably knew Przybyszewski's ideas not only thanks to their contacts with the Poznań-based BUNT, an artistic group of graphic artists and poets affiliated with the magazine *Zdrój*, but also because of the themes in his writing. In his work, Przybyszewski expressed his fascination with Jewish mysticism and

Kabbalah. Jewish avant-gardists were drawn to the countercultural imperative he promoted in his philosophy. The young artists experienced a sense of the apocalypse, and in their creation of a counterculture, they departed from social norms, abolished the hierarchical relationship between the center and the periphery, and thus recognized the voice of the margins. This was already signaled in 1899 by Przybyszewski in his "Confiteor," where he wrote, "Art . . . is the recreation of the soul's life in all its manifestations, regardless of whether they are good or bad, ugly or beautiful. The imperative of the soul stands above the imperative of classical beauty."[17]

The advocates of Jewish expressionism proclaimed it as equal to other artistic movements and sought to remove a variety of hierarchies resulting from the tensions that the new term could evoke. First, they asserted the value of Jewish culture with its own literature, art, and music, which, often seen as the opposite of European high culture, was frequently marginalized. Second, they demonstrated that the accepted discourse and theory about artistic influence emanating from centers toward peripheries (specifically from western to eastern Europe) was more complicated; in many respects, they reversed this pathway. The hierarchical structure in which the Jewish artists from Łódź were entangled had yet another trajectory: their relationship as artists and as Ostjuden to the Jewish artists from Western Europe, mainly in Germany and France.

The Berlin-based Die Pathetiker group (1912) is considered the first expressionist formation to bring together Jewish and non-Jewish artists.[18] The group's program made no express mention of the desire to create modern Jewish art. However, its ideas, visual language, and iconography all clearly reflect the Jewish thought of the time, especially Martin Buber's ideas of the Jewish Renaissance and his philosophy of dialogue and conceptualization of Hasidim; Franz Rosenzweig's ideas on revelation, messianism, and apocalypse developed after World War I; and the writings on the Kabbalah and Jewish mysticism by Ernst Bloch, Walter Benjamin (1892–1940), and Gershom Scholem (1897–1982). The works of Ludwig Meidner (1884–1966) and Jakob Steinhardt (1887–1968), the chief members of the group, contain key motifs of expressionist art: revelation, apocalypse, and messianism. What is characteristic of their work, however, is that these artists often identified their chosen aesthetic with Jewish content. In so doing, they reinvigorated the expressionist milieu in Berlin.

At the same time, the Jewish avant-garde milieu established in East European cities like Kiev, Łódź, and Warsaw toward the end of World War I was actively involved in searching for a new form of Jewish art. They sought to deny the primacy of specific subject matter (as previously conceived in the so-called ghetto art) over form. In their manifestos, these artists announced and analyzed the need to create a new, radical expressionist art that would reflect the worldview of their younger generation. They drew inspiration from Jewish mysticism, Hasidic culture, and Yiddish literature and, unlike their Western colleagues, courageously formulated the tenets of a new Jewish art operating within the avant-garde paradigm of novelty, experiment, and revolutionary proclamations. Indeed, the visits of East European artists

to Berlin brought a refreshing breath of cultural air to the western capital. Soon, they began to be seen as transmitters of authentic Jewish culture.[19] For the Jewish artists from Germany, this was a source of fascination and perhaps even envy.

The emergence of avant-garde ideas within this community has often been attributed to the influence of the other "centers," including Poznań due to the connections between the Poznań group BUNT and Yung-yidish, Düsseldorf due to connections with Die Junge Rheinland via Yankl Adler (and from which Yung-yidish supposedly derived its name), or Paris, where Marek Szwarc (1892–1958) had been part of the Makhmadim, which foreshadowed his later involvement in Łódź.[20] Yet the ideas highlighted by Yung-yidish epitomized hybridity; they were products of a network of crisscrossing trajectories, running from east (Kiev) to west (Berlin, Düsseldorf) through the territory of independent Poland (Poznań).[21] Symbolic of this attitude is an expressionist woodcut by Yankl Adler showing the poet Broderzon on the title page of the latter's poem *Shvarts-shabes* (Black Sabbath) from 1921 (figure 4.1).

Perhaps in reference to Broderzon's theatrical activity, his face looks like a mask, and the large, slanted eyes, with their piercing pupils, lend it an animal expression. Circling around the artist's bust, with its distinctive face and a hand holding a book, animating the background, is a scattered collection of attributes. These seemingly haphazard items, which are all part of the visual narrative, are reminiscent of the individualistic, fragmented language of Broderzon's poetry.[22] They constitute a semantic rebus that, once read, forms a coherent artistic manifesto echoing the ideas that this Jewish expressionist articulated in his writings that were inseparably connected to the unique Łódź spirit. Broderzon was a legend of the Łódź avant-garde, reinforced by his apartment's being the site of Yung-yidish's establishment.[23] His experimental poetry in Yiddish referencing Jewish mysticism, as well as stage works, strongly inspired the visual imagination of young artists from Łódź.

To the left of the poet's likeness are a clock and a lantern, symbols of the industrial city of Łódź, where life buzzed to the rhythm of factory clocks. To the right, in the background, is a building with two chimneys and rectangular, deformed shapes of buildings. These are yet more semantic clues pointing to Łódź, representing a frenzied and dynamic organism, just like the young Jewish artists in Yung-yidish. The natural interpretation of this picture as a graphic poem is confirmed by the Hebrew/Yiddish letter ש woven into the image and, above it, the Roman letter *M* painted at a ninety-degree angle on the factory tower with the two chimneys. These two letters are a code reflecting Broderzon's complex personality. The letter ש may refer to the first consonant of his poem's two title words, שװאַרץ (*Shvarts*) and שבת (*shabes*). It is also the first letter of שטעטל (shtetl; Yid. market town), where the poetic narrative unfolds. The large, modern-style *M* could stand for "metropolis," *miasto* (Pol. city), or even "Manchester," Łódź's nickname. It is also, significantly, the first Roman letter of the artist's name, Moyshe.

We are thus faced with a complicated set of symbols and visual semantic figures that show the poet's appearance as one that is organically part of the very fabric of the developing young city. At the same time, the Hebrew/Yiddish letter ש signals

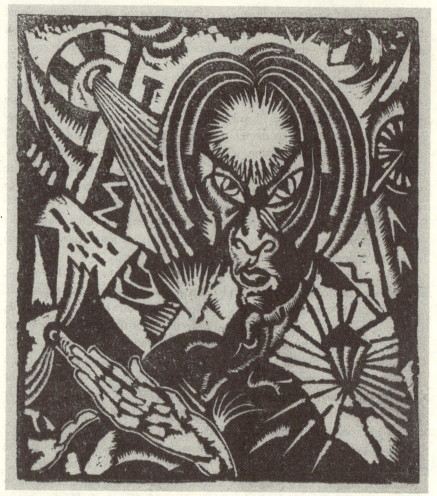

Figure 4.1. Yankl Adler, *Portrait of Moyshe Broderzon*, 1921. Moyshe Broderzon, *Shvartsshabes* (Łódź: Farlag Yung-yidish, 1921), 681. Reproduced by permission of the National Library of Poland.

his connection to the movement to revitalize Yiddish literature and culture and the traditions of the shtetl, a recurrent motif both in Broderzon's work and in the work of other members of the Yung-yidish group. This is additionally expressed by his open left hand, which is stretched toward an open book. Multiple sources of light—the lantern, the small explosive sign next to the letter *v*, a stream of light from the image's right upper corner (referencing a waterfall), and the illuminated forehead of the poet—all refer to light as a symbol of the revolutionary idea of Jewish cultural revival. It is a common iconographical motif stemming from socialist and Zionist iconography and earlier from the Haskalah, the Jewish Enlightenment. Iosif Chaĭkov (1888–1986) elaborated this theme visually on the cover of *Shveln* (Threshold) by Perets Markish (1895–1952), the cofounder of the Warsaw group

Di Khalyastre and a radical expressionist poet, which was published in 1919 by the Kultur-Lige in Kiev.[24] Broderzon's image represents the expressionists' embrace of a new model of portraiture, with a figure or face surrounded by several objects that signify their relationship to modernity as exemplified by symbols of urban development (e.g., the lantern, clock, and industrial tower), and his simultaneous embeddedness in Yiddish culture and language.

In Search of a New Jewish Style

One of the key notions used in the discourse about new Jewish art by the expressionists and the Jewish avant-garde was "Jewish spirituality" or, more often, "Jewish soul." These terms found their way into reviews and artistic manifestos, exerting a substantial influence on the notion of Jewish national art. This bond between Jewish spirituality and expressionism stemmed almost directly from the perception of Judaism as a dynamic, developing culture, full of symbolism and mysticism—the so-called expressive Judentum of Henokh Fuchs (1878–1949), a German rabbi and Jewish historian.[25] Fuchs contrasted the expressionist nature of Jewish culture with superficial secular culture or to Western culture in general, which he associated with impressionism. Yisakhar Ber Ryback and Boris Aronson (1898–1980), members of the Kiev Kultur-Lige, asserted in 1919, "Impressionism is alien to the Jewish perception of form,"[26] and "[Impressionism] is focused on optical impression rather than on philosophy or symbolism."[27] According to Ryback's and Aronson's logic, the impressionist aesthetic, which they viewed as alien to Jewish culture, could not procure the rank of a national style, as it did not contain "distinguishing national traits." They concluded that only abstract art based on folk motifs could convey national ideas and referenced Marc Chagall, one of the first modernist visual artists to try to give his work a national character. This testified to the fact that expressionist artworks could also be abstract. They spoke of the "ecstatic force of Chagall" and of the "*national* pathos of his representations."[28]

The myth of Chagall as the first modern artist had a long life. Henryk (Henokh) Berlewi (1894–1967), who in addition to being an artist was also an art critic, shared this view of Chagall's art. In his essay "The Meandering Ways of Jewish Art," he wrote, "[Chagall] represented our generation's spiritual quest for a Jewish art, [his paintings] are an expression of longing, mysticism, satire, naivety, the grotesque— all the traits which are so deeply rooted in the Jewish soul."[29] This view of Chagall helps explain why he became a model for the artists of Yung-yidish. In fact, as late as 1925, when the members of Yung-yidish had long since parted ways, Berlewi still wrote of Chagall in the same vein. In his article "Jewish Artists in Contemporary Russian Art," he claimed that through a mixture of Western European influences and elements of exotic folk art, he turned the artistic experiment into a canon.[30] Consequently, he mentioned Chagall as "the only artist who has succeeded in the most perfect way because he had a 'specific spiritual structure.'"[31]

This view of Chagall continued to hold among Jewish artists and art critics through the decades. In the pages of *Nasz Przegląd*, an influential Polish-Jewish

daily published in Warsaw, Chagall was called by his Polonized name, Marek Szagał. Jewish art historian and art critic Leopold Strakun wrote about Chagall's art, "Szagał finally puts an end to the barren period in our painting, where Jewishness was stuck in naive subject matter."[32] He also indicated that Chagall's work was an expression of his Jewish mind. Michał Weinzieher developed this thought by reflecting on the essence and source of the "extravagance," as he called it, of Chagall's art. He claimed that the key to understanding it is the artist's origin: "I see a lot of complications and contradictions in the Jewish *psyche*. Szagał is a strange child of this often-strange nation."[33]

While considering Chagall an important inspiration for the art of the Jewish expressionists from Łódź, Berlewi pointed out that the activity of the Yung-yidish group was also part of the Jewish Renaissance: "Indeed, we, Jewish artists from Poland, have strived—in full exaltation—for a national art."[34] He thus confirmed the sentiment of Yankl Adler, who saw expressionist art as the artistic manifesto of the young generation of Jewish artists. Berlewi was shortly to become an advocate of the neutral form of mechano-facture (*mechano-faktura*) and to discard the ambition of taking part in the creation of a Jewish national style. However, his declaration is vital for understanding why expressionism seemed most fitting to convey the experiences of the generation shaped by the Great War. In a 1926 interview conducted by the Yiddish writer Isaac Bashevis Singer, Berlewi reflected on his own determination and his own "national turn": "I don't know to what extent it could be sensed, all I know is that it's what I was aiming for. At the time I was overcome by a psychosis of searching, I wanted to find the way to a specific Jewish style, Jewish primitivism."[35] This expression also pinpoints the very specific form of the Jewish Renaissance as created by Jewish artists from Poland and earlier from Russia and Ukraine (Kiev); it was seen as a combination of modern art language and forms derived from folk aesthetics. Chagall's representation of "Jewish" towns (*shtetlakh*) and the Jews in them was seen as an expression of the "Jewish soul," which Berlewi sometimes referred to as *dos pintele yid*.[36] He and others understood it to mean a specific sensitivity that influenced the overformal and overthematic nature of Jewish national art; it was often cited in reviews of both Yung-yidish and Kultur-Lige exhibitions.

ŁÓDŹ AND THE JEWISH AVANT-GARDE:
TABULA RASA IN SPACE AND FORM

The question of how to define the Jewish national style in the discourse of avant-garde art and the issue of whether the subject matter should have primacy over form persisted. Berlewi noted that the two notions were frequently confused when it came to Jewish art: "In my opinion, Jewish art should be expressed through a specific form inspired by the Jewish spirit."[37] Jewish artists tried to discard the hegemony of subject matter so characteristic of the art of Jewish realists and of so-called ghetto artists who Depicted genre scenes with Jews through their holidays or everyday actions. The tragedy of World War I, which required recovering from

the trauma of wartime experiences for Jewish artists in Germany and creating art in an independent country for Jewish artists in Poland, made it necessary and possible to develop a new style. A Jewish artist, according to Berlewi, is free of the "burden" of artistic tradition, schools, and programs. He commences his journey as a tabula rasa, a void, his task being to develop a new artistic language to fill this void. Such assumptions resonate with the symbolic image of Łódź itself: a city with no history, nascent, with no clear national culture and program, poised to fill the void. The experience of Łódź for a generation of Yung-yidish artists perfectly harmonized with their artistic goals, and Broderzon's poetry and his art theories (he authored manifestos in the first and second issues of the journal *Yung-yidish*) were probably the first and strongest sources of inspiration for young Łódź artists. Broderzon's literary works were lavishly illustrated by his fellow artists, among them members of Yung-yidish. They created a form of optic poetry, which would complement the written word. In 1920, *Tkhiyes hameysim* (Resurrection), with pictures by Yitskhok (Wincenty) Brauner (also spelled Broyner), was published. The Yung-yidish publishing house also issued *Perln oyfn bruk* (Pearls on the cobblestones; 1920), with subtle decorations by Józef Hecht.

Contemporary scholarly attempts to determine what should be considered typical features of Jewish expressionism have not led to a univocal conclusion or clear-cut definition. There is, however, some consensus that Jewish expressionism included a predilection for the grotesque, the deployment of mystical themes, a special bond with Hasidic spirituality, and the appropriation of apocalyptic and messianic threads expressed in ecstatic form.[38]

Jewish Messianism and Its Visual Discourse

The apocalyptic experience of World War I strengthened the messianic paradigm in Jewish thought, art, and literature. Although the broad concept of messianism has been extensively researched in modern Jewish thought, philosophy, and literature, little attention has been devoted to its representations in the visual arts.[39] These representations had enormous visual potential and nurtured the imagination of many Jewish avant-garde artists. Jewish artists created visual art in the post–World War I world that drew on conceptions of messianism derived from philosophy, poetry, and literature. Die Pathetiker in Berlin have earlier developed the concept of messianism in their works.[40] But the idea of messianism in expressionist Jewish art attained its most complex form in interwar Poland, where Jewish artists drew on the Romantic tradition of Polish messianism.[41] The Polish bard Adam Mickiewicz (1798–1855), the progenitor of the messianic vision of the Polish people, whom he called "the Christ of nations," praised Jews for the high spiritual mission they were destined to fulfill in Poland.[42] He emphasized the strong spiritual, religious activism of Jews, which he saw as their distinguishing feature. Mickiewicz believed that the Jewish and Polish nations were united by a "mystical union recognizing common, messianic mystery of souls."[43] All young Poles, Christian and Jewish alike, were well steeped in Mickiewicz's apocalyptic

image of Poland's destiny to redeem the world, which was continued by representatives of the Młoda Polska movement, such as Stanisław Wyspiański. And young Polish Jewish artists were especially inspired by Mickiewicz's "philosemitism," which was noted in the contemporary press.[44] For example, Maks Bienestock, a reviewer and admirer of Broderzon's art, analyzed the content of Broderzon's *Shvarts-shabes*, which depicts the fall of the world without God and a world controlled by Satan, and found its visual equivalent in two graphics by Yitskhok Brauner: *The Dancing Devil* and *Tekiye gedola* (The great shofar blast). The first was printed in the second issue of *Yung-yidish*, complementing Broderzon's manifesto and leading to Bienestock's description of the poem as follows:[45] "All of life is one big dance ... of evil and malicious spirits; all mankind is evil, unmerciful, surrounded by only blood and sin, therefore the desperate Jew, aristocrat, suffers, modern Christ returns to his cross, unable to bear the sight of the rogue crowd. The plague of hatred is sweeping the whole world, humanity is deaf to the call of the shofar of liberation (the golden horn of Wyspiański)."[46]

Likewise, the writings of Stanisław Przybyszewski of Młoda Polska, which highlighted the specific mystical properties of Jewish culture, were absorbed by the Jewish expressionists active in the Second Polish Republic. Acutely interested in Kabbalah and Jewish mystical movements, Przybyszewski perceived the Jews as a community endowed with a distinct spirituality that resulted from their history of persecution and exile. He referred to the Jews as the "yeast of progress."[47] Broderzon's poetry was often associated with the poetry of Młoda Polska. The image of the world dominated by evil and destruction presented in Broderzon's works, from whose chaos a new reality was to be born, echoes the Romantic idea of messianism and includes the paradigm of Jewish revival. Both Christian and Jewish Poles drew from the well of apocalyptic and messianic aspirations in the interwar period.

The artists from Łódź and Warsaw in Yung-yidish and in Di Khalyastre developed the visual aspect of the apocalypse and of the messianic ideal, centering it on the idea of creating a new Yiddish culture. Avant-garde Yiddish literary and poetic circles elaborated programs and manifestos that heralded the dawn of a new, postapocalyptic reality. Their authors included Perets Markish ("The aesthetics of struggle in modern poetry"), Uri Tsvi Grinberg ("Proclamation" and "Manifesto to the opponents of new poetry"), and members of the Yung-yidish group, including the aforementioned Moyshe Broderzon and Henryk Berlewi.[48] In his 1922 manifesto "Struggle for a New Form," Berlewi called for the creation of a new postapocalyptic artistic language: "Our Times are devoid of style; it is a period of anarchy in art. We lack ground under our feet; tradition has disappeared. We are left as if after an earthquake or a violent storm, and we are forced to take up building anew, a new which so far has not existed. Is it our bad or good luck? To have no defined purposes, no limitations of tradition, no yoke of a prevalent school, to have no style, even such as would reflect our times!"[49] But while Berlewi postulated creation without the "limitations of tradition," other expressionists felt the need to restore the sacred, like Yankl Adler in his 1921 manifesto "Expressionism": "We are weighted down with the burden of a great, great longing for God

and eternity, for the power that made Creation happen.... The art of the twentieth century, Expressionist art, was born from this longing and it is a seventh day and the commonplace week is over."[50]

The Yung-yidish artists' visual representations of the messianic idea lack explicit personification.[51] They did not use the repertoire of traditional religiously laden art,[52] such as showing the Messiah on a donkey riding toward the gates of Jerusalem, but instead opted for symbolic representations that constitute the repertoire of illuminated manuscripts or synagogue decorations (i.e., a peacock or other references to mystical writings, such as those represented in El Lissitzky's illustrations for Moyshe Broderzon's poem *Sikhes khulin*).[53] Unlike their Berlin predecessors, Die Pathetiker, they did not refer directly to biblical or prophetic narratives.[54] Instead, their manifestos and art related to the revolutionary, activist aspect of the messianic idea to suggest a syncretistic triad: redemption through revelation and liberation. The Jewish expressionists saw their main task as turning the profane into the sacred. They represented this transformation by using the dichotomy between darkness—perceived as a postapocalyptic emptiness in which demons prowl—and light, which had salvific power.

Jewish expressionist visual artists also used the shtetl as a symbol of the locus that had descended into decadence and where old customs and habits struggled against impure forces. Their artistry was informed by the literary oeuvre of the renowned Yiddish author Y. L. Peretz, whose *shtetlakh* were the sites of mystical experiences but also the homes of ordinary people and of their quotidian grievances and tragedies. In his *At Night at the Old Market* (1907), the shtetl night is suffused with apocalyptic images rooted in symbolic thought and folk beliefs. Darkness is associated with impure forces and with destruction. Light, the first of God's creative products in the book of Genesis, is the opposite. In the sacredness of the shtetl, in the cover of darkness, demons prowl and impure instincts are roused.

Two works by Yitskhok Brauner, *The Dancing Devil* (figure 4.2) and *Tekiye gedola* (figure 4.3), reveal a similar cosmic vision of a world trapped between good and evil, and this vision foreshadows the transformation from an apocalyptic reality into a messianic future. They represent the comprehensive program of an avant-garde group of artists who chose the apocalyptic shtetl heralding the messianic message as the backdrop for the revival of Jewish art and culture. Even if the artists must join forces with evil, they are the ones to bring back holiness.[55] We see here another aspect of the centrality of the Jewish "periphery" in the works of the artists of Łódź: the locus of their main narration of the transformation of Jewish culture occurs not in the metropolis, the center, but in the shtetl. The fulfillment of messianic prophecy can only take place in the peripheral shtetl.

For the East European Jewish expressionists, their peripheries were the motors of redemption. Łódź was not a shtetl, but its rapid development from a rural to an urban space in the nineteenth century illustrates that the boundaries between what is considered central and that which is on the margins can be very fluid. Additionally, at least half of the Yung-yidish members had shtetl roots that they

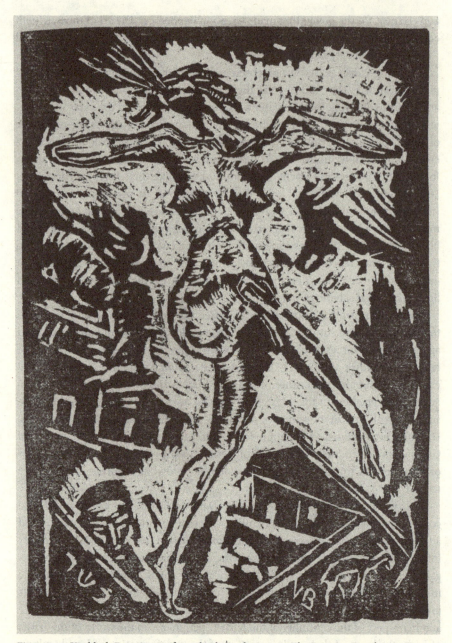

Figure 4.2. Yitskhok Brauner, no formal title but known as *The Dancing Devil*, 1919. *Yung-yidish*, nos. 2–3 (1919). Image courtesy of the Department of Special Collections, Stanford University Libraries.

Figure 4.3. Yitskhok Brauner, no formal title but known as *Tekiye gedola* (The great shofar blast), 1919. *Yung-yidish*, nos. 4–6 (1919), 13. Image courtesy of the Department of Special Collections, Stanford University Libraries.

transformed into an important part of their self-definition as modern avant-garde Jewish artists. We have noted previously that Yankl Adler "performed" his eastern European background by dressing in a long coat, making "the Ostrower rabbi out of himself," in the words of Yekhezkl Moyshe Nayman.[56]

While the messianic idea was developed by Jewish expressionists from the avant-garde metropolis of Berlin, Łódź's creative artists proved more revolutionary in their activism.[57] First, the intense figurative motif of prophets used by Jakob Steinhardt and Ludwig Meidner, both of whom saw *themselves* as prophets of modern Jewish art, was much less likely to appear in the iconography of the Yung-yidish group, who expressed their ideas more experimentally on the border between abstract art and figurism. Second, the Berlin expressionists developed the prophetic theme and other biblical topoi based on the ideology of cultural Zionism and nineteenth-century Jewish art. Steinhardt's main source of knowledge regarding the culture, folk imagination, and mystical ideas of East European Jewry was the prose of Y. L. Peretz and of S. Y. Agnon, which he read in German translation.[58] Agnon's work, in particular, became a conduit for a positive vision of the religiosity of the Ostjuden. Like other German Jews who looked to the spirituality of their East European brethren as a symbol of the possibility of the redemption of modern Jewish culture and a solution to the crisis in German-Jewish identity, Steinhardt interpreted the world of the Ostjuden as a realm of the sacred and of "the original religious experience." His visual art confirmed the ideological shift in the perception of the eastern European Jew; the gaunt, melancholy Jew no longer carried negative connotations but was a symbol of Jewish asceticism and profound spirituality.

The Polish-Jewish artists perceived this approach as conservative, apologetic, and backward: a precise inversion of the long-standing German-Jewish view of the Ostjuden. This distinction illustrates that in terms of the cultural web between artists from the east and west, the traditional relation between center and periphery needs to be challenged and the direction of artistic influence reversed. In Łódź, Jewish expressionists considered revolutionary artistic approaches and attitudes central to the fulfillment of a messianic mission. They combined the universal aspect of the birth of the new man in the postapocalyptic reality with formal issues, announcing the dawn of a new utopian world and of a new type of art. At the same time, they did not shun the syncretic approach to the messianic myth and included elements of Christianity in their worldview.

Conclusion

Trying to define its phenomenon, energy, and ethos, local Jewish artists called Łódź the city of newcomers (*kumen-shtot*) or the Jerusalem of Poland.[59] The interview with Broderzon cited at the beginning of this chapter was conducted at the time when both the Jewish avant-garde and the general avant-garde had almost ceased to exist. It was Broderzon's last attempt to keep alive the unique moniker "Lodzermensz," which eluded clear divisions into either center or periphery but

connoted someone with a vital, separate identity. Yung-yidish artists also eluded these categories. In the memoirs of the Yung-yidish artists, they refer to their efforts to create a new environment in the city and hopes to reach Jews from other cities and countries as a "melankholishes tsvishn-shpil" (Yid. a melancholy inbetweenness).[60] They succeeded in creating a new Jewish culture and art by constructing its very definitions, yet their paths began to diverge outside the context of Łódź as early as 1922.

Several Polish Jewish artists emigrated when they experienced weak popular reception of their work. Yet they were often thwarted in their ability to continue their innovative conceptions in their new homes abroad. Despite undeniable similarities, mutual inspirations, and contacts, there were fundamental differences between Jewish expressionists based in Germany, where many of the émigrés settled, and those in Poland. Berlin's artistic activists were not interested in developing revolutionary Jewish art and were not particularly keen on using the ideas of their East European Jewish colleagues. Although Jakob Steinhardt opened his home to many Jewish émigrés, including Henryk (Henokh) Barczyński (1896–1941), El Lissitzky (1890–1941), Yisakhar Ber Ryback, and Josef Budko (1888–1940), their discussions did not focus on developing a new Jewish avant-garde art. Rather, the impetus for the meetings was the host's need to be in contact with the "authentic" culture of East European Jews that he believed had been lost by his acculturated parents' generation. For German Jewish artists, Jewish art did not extend beyond the stereotypical traditional themes of Sabbath evenings in the shtetl or of East European Jews submerged in melancholy or ecstatic prayer. Henryk Berlewi characterized this attitude of the Berliners already in 1925: "[It] is not at all a question to [delve into] some deeper insight into the world of the Jewish ghetto, the secrets of its mysticism and grotesqueness, and to unveil them in a specifically Jewish form, as Szagał, Ryback and others did."[61] Rather, as Adler exclaimed, the Jewish avant-garde had to look forward, even toward, an apocalyptic end: "We are Lodzians, we are trained in spirituality! . . . We are eternally excited about the new. Only death is certain . . . and maybe we are doubting even in death."[62] This illustrates the special position that the Łódź artistic milieu occupied within the web of the European avant-garde, a position that resulted from the city's genius loci, history, social structure, and local culture. Łódź's cultural space defined its artists, their ideas, and their fate and gave them the energy not only to challenge the hegemonic urban centers but also to face the eternal principles of life.

Notes

1. Yitskhok Lichtensztajn, "Moyshe Broderzon—der Lodzher," *Literarishe bleter*, December 22, 1933, 831.

2. Lichtensztajn's original expression is this: "Der Lodzhermensh ist, shaynt mir, geshtorben." Lichtensztajn, 831.

3. Marcos Silber's chapter in this volume analyzes the two latter features as represented in popular culture.

4. The artists from Łódź who created Yung-yidish had studied abroad: Moyshe Broderzon in Moscow, Henokh (Henryk) Berlewi in Antwerp and Paris, Yankl Adler in Düsseldorf, Marek Szwarc in Paris, and Yitskhok (Wincenty) Brauner in Berlin. Their very biographies point to centrifugal influences on their art, challenging the hegemony of the center.

5. For insight into Broderzon's Moscow years as formative for his further activities in Łódź, see Zehavit Stern's chapter in this book. The journalist Maks Bienestock considered him the first Jewish expressionist par excellence. Maks Bienenstock, "Nowe prądy w literaturze młodożydowskiej: Mojżesz Broderson," *Nowe Życie* 6 (1924): 349–367. Reprinted in Polish translation by Zbigniew Targielski in Jerzy Malinowski, *Grupa "Jung Idysz" i żydowskie środowisko "Nowej Sztuki" w Polsce: 1918–1923* (Warsaw: Polska Akademia Nauk. Instytut Sztuki, 1987), 191–209.

6. Lichtensztajn, "Moyshe Broderzon," 831.

7. For more on the Yung-yidish group, see Malinowski, *Grupa "Jung Idysz,"* and Jerzy Malinowski, *Painting and Sculpture by Polish Jews in the 19th and 20th Centuries (to 1939)*, trans. Krzysztof Z. Cieszkowski (Warsaw: Polish Institute of World Art Studies, 2017), 195–297.

8. Expressionism was known for its stylistic eclecticism in which artistic inspiration derived from cubism, futurism, and Dadaism. Jewish expressionism was a cultural current and not merely as an artistic style; it was nurtured in the soil of the German-Jewish philosopher Martin Buber's idea of a Jewish Renaissance yet gained its mature form in the art of Polish-Jewish artistic milieus in Łódź (Yung-yidish) and Warsaw (Di Khalyastre).

9. See Piotr Piotrowski, "Toward a Horizontal History of the European Avant-Garde," in *Europa! Europa? The Avant-Garde, Modernism and the Fate of Continent*, ed. Sasha Bru, Jan Baetens, and Benedikt Hjartson (Berlin: De Gruyter, 2009), 49–58.

10. This applies to a whole number of centers of avant-garde aesthetic thought and artistic practice in Poland, Romania, Russia, Ukraine, and Hungary. See Mark H. Gelber and Sami Sjöberg, eds., *Jewish Aspects in the Avant-Garde: Between Rebellion and Revelation* (Berlin: De Gruyter, 2017).

11. See Lidia Głuchowska and Hubert van der Berg, "Jüdische Avantgarde," in *Metzler Lexikon: Avantgarde*, ed. Hubert van der Berg and Walter Fähnders (Stuttgart: J. B. Metzler, 2009), 163–165.

12. Zygmunt Lorentz, *Narodziny Łodzi nowoczesnej* (Łódź: Nakładem Prezydjum Rady Miejskiej, 1926), 26.

13. In 1914, 170,000 of the city's 500,000 inhabitants were Jews. See *The YIVO Encyclopedia of Jews in Eastern Europe Online*, s.v. "Łódź," by Robert Moses Shapiro, accessed August 4, 2022, http://yivoencyclopedia.org/article.aspx/%C5%81odz.

14. See Jacek Walicki, "Żydzi i Niemcy w samorządzie Łodzi lat 1917–1939," in *Polacy-Niemcy-Żydzi w Łodzi w XIX I XX w. Sąsiedzi dalecy i bliscy*, ed. Paweł Samuś (Łódź: Uniwersytet Łódzki, 1997), 359–376.

15. For details, see Zehavit Stern's chapter in this volume.

16. Julius Hart, "Aus Przybyszewskis Sturm- und Drangjahren," *Pologne Litteraire*, no. 20 (May 15, 1928), quoted in Gabriela Matuszek, *"Der geniale Pole?" Stanisław Przybyszewski in Deutschland (1892–1992)*, trans. Dietrich Scholze (Hamburg: Verlag Literatur & Wissenschaft, 2015), 106.

17. Stanisław Przybyszewski, "Confiteor," *Życie* 3, no. 1 (1899): 1–4.

18. In 1921, the poet Yvan Goll published the essay "Der Expressionismus stirbt," in which he criticized the tendency to multiply the manifestos and programs. He also criticized what he regarded as less-than-novel inclinations towards pathos; a year later, Henryk Berlewi announced the "agony of the expressionist movement." See Henryk Berlewi, "Międzynarodowa wystawa w Düsseldorfie," *Nasz Kurjer* 209 (August 7, 1922): 2.

19. See Małgorzata Stolarska-Fronia, "Mistyczny Wschód i apokaliptyczny Zachód: Związki pomiędzy ekspresjonistami żydowskim z Polski i z Niemiec na podstawie księgi gości Jakoba Steinhardta," in *Materiały LXV Ogólnopolskiej Sesji Naukowej Stowarzyszenia Historyków Sztuki, Warszawa, 24-25 listopada 2016*, ed. Anna Sylwia Czyż and Katarzyna Chrudzimska-Uhera (Warsaw: Zarząd Główny SHS, Oddział Warszawski SHS, 2017), 230-248; Verena Dohrn and Gertrud Pickhan, eds., *Osteuropäisch-jüdische Migranten in Berlin 1918-1939* (Göttingen: Wallstein Verlag, 2010); and Anne-Christin Sass, *Berliner Luftmenschen: Osteuropäisch-jüdische Migranten in der Weimarer Republik* (Göttingen: Wallstein Verlag, 2012).

20. The relations between the Yung-yidish and milieus of Poznań, Düsseldorf, and Paris have been emphasized in most studies devoted to the group. See Malinowski, *Painting and Sculpture*; and Lidia Głuchowska, "Artyści polscy w orbicie 'Der Sturm': Historia i historyzacje," *Quart* 29 (2013): 3-15.

21. See Piotrowski, "Toward a Horizontal History," 55. *Maḥmadim* (The precious ones) was the first modern Jewish art journal founded in Paris, in 1912, by Marek Szwarc, Iosif Chaïkov, and Yitskhok Lichtensztajn.

22. A more detailed study of both of these texts can be found in Gilles Rozier, *Mojżesz Broderson: Od Jung Idysz do Araratu* (Łódź: Hamal, 1999), 12.

23. A. Alperin, "Intervyu mit Moyshe Broderzon," *Literarishe bleter*, May 7, 1926, 298.

24. Di Khalyastre was a Jewish avant-garde literary and artistic movement, operating between 1919 and 1924 in Warsaw. It combined a radical spirit of futurism and expressionism with Yiddish culture. Among the artists involved in Di Khalyastre were also some members of the Yung-yidish group, such as Marek Szwarc, Yankl Adler, and Yitskhok Brauner. See *The YIVO Encyclopedia of Jews in Eastern Europe Online*, s.v. "Khalyastre," by Seth L. Wolitz, accessed February 23, 2023, https://yivoencyclopedia.org/article.aspx/Khalyastre.

25. Henokh Fuchs, "Expressionistisches Judentum," *Jüdisch-liberale Zeitung* 4, no. 4 (1924): 1-2, https://sammlungen.ub.uni-frankfurt.de/cm/periodical/pageview/2617988?query=Fuchs.

26. The original article was published in Yiddish; I have used the German translation. See Yisakhar Ber Ryback and Boris Aronson, "Wege der jüdischen Malerei (Gedanken eines Künstlers)," in *Zwischen Stadt und Steppe: Künstlerische Texte der ukranischen Moderne aus den 1910er bis 1930er Jahren*, ed. Marina Dmitrieva (Berlin: Lukas Verlag, 2012), 132.

27. Ryback and Aronson, 132.

28. Ryback and Aronson, 132. Emphasis mine.

29. I have used the Polish translation of Yiddish text. See Henryk Berlewi, "Kręte drogi sztuki żydowskiej," in *Polak, Żyd, artysta: Tożsamość a awangarda*, ed. Jarosław Suchan and Karolina Szymaniak (Łódź: Muzeum Sztuki w Łodzi, 2010), 374. Originally published in Yiddish as Henrik Berlevi, "Der zig-zag fun der yidisher kunst," *Almanakh: Aroysgegebn durkhn fareyn fun yidishe shrayber un zhurnalistn in Frankraykh* 1 (1955): 97-108.

30. Henryk Berlewi, "Jewish Artists in Contemporary Russian Art," trans. Rachel Field, *In geveb: A Journal of Yiddish Studies*, February 5, 2018, https://ingeveb.org/texts-and-translations/jewish-artists-in-contemporary-russian-art.

31. Henryk Berlewi, "Żydowscy artyści we współczesnej sztuce rosyjskiej," *Nasz Przegląd*, August 16, 1925, 7.

32. Leopold Strakun, "Marek Szagał," *Nasz Przegląd*, May 17, 1924, 4.

33. Michał Weinzieher, *Nasz Przegląd*, February 2, 1925, 3.

34. Berlewi, "Kręte drogi sztuki żydowskiej," 371.

35. Icchok Baszewis Singer, *Felietony, eseje, wywiady* (Warsaw: Sagittarius, 1993), 195. The interview with Berlewi was published in Jud-Beyt, "Bej Henrik Berlewi," *Literarishe bleter*, November 5, 1926, 194. In the same interview, the artist confesses that after he went to Berlin in 1922, he devoted all his attention to abstract forms, and he abandoned literary expression

as well as strictly Jewish subjects. According to Piotr Piotrowski, Berlewi supposedly made the decision to break with the expressionist tradition at the International Congress of Progressive Artists in Düsseldorf in 1922, which he attended while still a member of Yung-yidish. Piotrowski, "Toward a Horizontal History," 175.

36. Berlewi, "Kręte drogi sztuki żydowskiej," 370.

37. Berlewi, 376.

38. See quotations by Berlewi.

39. Anson Rabinbach, "Between Enlightenment and Apocalypse: Benjamin, Bloch and Modern German Jewish Messianism," *New German Critique* 34 (Winter 1985): 78–124.

40. Die Pathetiker artists, such as Ludwig Meidner and Jakob Steinhardt, deployed messianic themes, which can be seen in Steinhardt's etching *Messianic Times* and in Meidner's apocalyptic landscapes.

41. Polish Romantic messianism was mainly a literary phenomenon born after the 1830 November Uprising. In Mickiewicz's version it had deep roots in religious thought and the so-called spirituality of the Polish nation. He perceived Poles as a collective destined for playing a messianic role in all peoples' freedom and spiritual renewal.

42. Maria Janion, *Bohater, spisek, śmierć: Wykłady żydowskie* (Warsaw: Wydawnictwo W. A. B., 2009), 233. In defense of Judaism, Mickiewicz argued with the Polish poet Zygmunt Krasiński's antisemitic descriptions of Jews. See Adam Mickiewicz, *Dzieła*, ed. Julian Maślanka, trans. Leon Płoszewski (Warsaw: Czytelnik, 1998), 10:138 and 11:170.

43. Janion, *Bohater, spisek, śmierć*, 236.

44. See, for example, M. Braun, "Syjonizm Adama Mickiewicza," *Nasz Przegląd*, January 14, 1939, 7.

45. *Yung-yidish*, nos. 2–3 (1919), but the image is not titled. Scholarship refers to it as *The Dancing Devil*; *Tekiye gedola* (The great shofar blast) is mentioned on the journal's last page. The journal has been digitized by Stanford University's Special Collections, Rare Books Collection, PJ5120 .A399 FF, https://searchworks.stanford.edu/view/5682397.

46. Bienenstock, "Nowe prądy w literaturze młodożydowskiej," 349–367. Reprinted in Malinowski, *Grupa "Jung Idysz,"* 195. The "golden horn of Wyspiański" refers to the famous quotation from the Polish poet's monumental work *The Wedding* (1901). In the poem, the horn symbolizes a call to fight for Polish freedom, while the end of the sentence suggests that this call is in vain and one should give up all hope.

47. "Drożdże postępu," in Stanisław Przybyszewski, *Moi współcześni: Wśród obcych* (Warsaw: Instytut Wydawniczy Biblioteka Polska, 1926), 191.

48. "The aesthetics of struggle in modern poetry" appeared in the Yiddish journal *Ringen*, no. 10 (1922): 35–41. For a Polish translation, see Karolina Szymaniak, ed., *Warszawska awangarda jidysz: Antologia tekstów* (Gdańsk: Słowo/obraz terytoria, 2005), 47–69. "Proclamation" and "Manifesto to the opponents of new poetry" were published in *Albatros*, no. 1 (1922): 3–4, 4–5. Both can be found in Polish translation in Szymaniak, *Warszawska awangarda jidysz*, 47–69, 73–79.

49. Henryk Berlewi, "The Struggle for a New Form," in *Between Worlds: A Sourcebook of Central European Avant-Gardes, 1910–1930*, ed. Timothy O. Benson and Eva Forgács, trans. Wanda Kemp-Welch (Cambridge, Mass.: MIT Press, 2002), 182. Originally published as "In kamf far der nayer forem," *Ringen*, nos. 1–6 (1921): 31–33.

50. Jankl Adler, "Expressionism [lecture fragments]," in Benson and Forgács, *Between Worlds*, 182. Originally published as "Ekspresjonizm [fragmenty z prelekcji]," *Nasz Kurjer*, no. 292 (1920): 4.

51. I consider the crucifixion motifs frequently encountered in the works of the Yung-yidish artists or even Nativity scenes not part of their messianic iconography but rather part of a Christological one.

52. In medieval Haggadot, the Messiah on a donkey often appears as an illustration for Shabbat HaGadol (the Sabbath before Passover)—that is, the Washington Haggadah from Italy (1478), the Tegernsee Haggadah (before 1489), and the Venice Haggadah (1609).

53. Moyshe Broderzon, *Sikhes khulin* (Moscow: Nashe Iskusstvo, Shamir, 1917).

54. A prophet weeping over the destruction of the Temple was a frequent motif employed by Jakob Steinhardt, and Ludwig Meidner created a series of self-portraits as a prophet.

55. This is close to the Hasidic concept of *nefilat hatsadik*, "the descent of the zaddik," which, according to Gershom Scholem, acquired its importance especially in Sabbatean doctrine. See Gershom Scholem, "*Devekut*, or Communion with God," in *Essential Papers on Hasidim: Origins to Present*, ed. Gershon Hundert (New York: New York University Press, 1991), 293.

56. Yekhezkl Moyshe Nayman, "Yankl Adler," *Literarishe bleter*, February 22, 1935, 114.

57. However, it is important to emphasize that the same attitude was represented by the Kiev milieu of artists involved in the Kultur-Lige group.

58. Yitzkhok Leyb Peretz, *Gleichnisse*, trans. Alexander Eliasberg, with lithographs by Jakob Steinhardt (Berlin: Verlag für Jüdische Kunst und Kultur Fritz Gurlitt, 1920); Yitzkhok Leyb Peretz, *Musikalische Novellen: Mit fünf Original-Lithographien von Jakob Steinhardt*, trans. Alexander Eliasberg (Berlin: Verlag für Jüdische Kunst und Kultur Fritz Gurlitt, 1920); Samuel Agnon, *Das Buch von den polnischen Juden*, ed. Samuel Agnon and Aharon Eliasberg (Berlin: Jüdischer Verlag, 1916); Samuel Agnon, *Die Erzählung vom Toraschreiber*, trans. Max Strauß (Berlin: Verlag Marx, 1923).

59. A. Alperin, "Intervyu mit Moyshe Broderzon," *Literarishe bleter*, May 7, 1926, 298.

60. Nayman, "Yankl Adler," 111.

61. Henryk Berlewi, "Przegląd artystyczny," *Nasz Kurjer*, no. 172 (June 24, 1925): 4.

62. Nayman, "Yankl Adler," 114.

PART II

Performers and Audiences

CHAPTER 5

The Theatrics of Bais Yaakov

Naomi Seidman

In January 1930, a column in the Warsaw daily *Haynt* that reported on curious or noteworthy events in the small towns of Poland described the sensation caused by plays put on that season by Bais Yaakov, the all-girls Orthodox school movement, a sensation that the reporter claimed was in fact an entirely predictable annual phenomenon:

> I knew in my heart that when the beloved holiday of Hanukkah came to an end, the "Provincial Mirror" [column] would be inundated with stories and anecdotes regarding Bais Yaakov. What kind of stories? Bais Yaakov schools have a well-established protocol that repeats itself every year, everywhere from Hoduciszki to Lututów. The formula is that Bais Yaakov girls put on a play—but only for women. The not-so-fair sex must not make an appearance in the hall. Many fights break out over this issue. This is exactly what just happened in Chmielnik. The Chmielnik Bais Yaakov was determined to show the sinners and freethinkers that one could be a pious Jewish girl and still take an interest in the arts. The schoolgirls thus put on a play—*Judith*—on the Saturday night that fell within Hanukkah. The young people of Chmielnik are theater-crazy, and they were very excited. "It's true that it's Orthodox theatre, but at least it's a play!" They awaited this evening as, pardon the comparison, one awaits the Messiah. The posters finally went up, with a small postscript stating expressly, "Entrance only for women!"[1]

The postscript seems to have attracted exactly the sort of attention it was ostensibly designed to resist. According to the *Haynt* columnist, a few desperate young boys in Chmielnik decided to disguise themselves in women's clothing in order to sneak into the performance. But when they arrived at the movie theater where the play was being performed, they were stopped by young Gerer Hasidim, guarding the door to make sure that only women entered.[2] The column reported that after the young cross-dressers were exposed and stopped from entering, the Hasidic guards entered the theater and seated themselves in the first row to watch

97

the play, their eyes gleaming with "holy sparks." According to the report, these guards sighed with wonder at the sublime pleasures unfolding before them.

The sensationalist Yiddish press, which delighted in ridiculing Bais Yaakov, is clearly no unimpeachable witness to contemporary Orthodox social realities. But we know that the plays were an important part of Bais Yaakov culture. Among the dozens of pictures of interwar Bais Yaakov that survive in archives and family collections are a significant number that show students dressed in costumes for plays and other performances; one 1935 photo from the town of Różan even notes the title of the play, *Kantonisten* (Cantonists), presumably telling the story of the forced conscription of Jewish boys into the czarist army during the first half of the nineteenth century.[3]

One of the earliest mentions of Bais Yaakov theater I have found is on a 1926 poster advertising a "historical performance" in the town of Siedlice, with the same postscript mentioned by the *Haynt* reporter in 1930: "Ayngang nor far froyen" (Entrance only for women).[4]

In the years that followed, the news stories on local Bais Yaakov schools also often referenced their plays and other public programs.[5] Memoirs by Bais Yaakov girls and survivors' testimonies also occasionally include mention of these plays.[6] And as further partial corroboration of this particular story, we happen also to be in possession of a script of a Bais Yaakov biblical drama called *Judith* by the founder of the movement, Sarah Schenirer (1883–1935); the script provides a number of scenes that may have enraptured a Hasidic adolescent—as the biblical story relates the effect Judith had on all who laid eyes on her.[7] In one early scene, Holofernes rhapsodizes over Judith's beauty for many lines. Because this is a Bais Yaakov play, in which sexuality could only be presented within normative boundaries, in the fourth act, he also proposes marriage to his Israelite temptress, moving from praising her beauty to calling her an *eshes ḥayil*, a "woman of valor," as if he were not an Assyrian general determined to sleep with her (as the biblical story has it) but a traditional Jewish man looking for the sort of hardworking and capable woman praised in Proverbs 31. Judith acts as if she is considering the marriage proposal, but in the next scene, she triumphantly appears at the gates of Jerusalem bearing the general's severed, bloody head, having performed the gruesome beheading offstage.

Chmielnik was not the only town that got more than it bargained for when Bais Yaakov students began to stage biblical and historical melodrama. A 1934 story in the rival Warsaw daily *Hayntige nayes* described a similar incident that scandalized the town of Błonie, where a group of Hasidic youth disguised themselves as women in their eagerness to see a production of *The Binding of Isaac*.[8] The group was expelled and the show went on, but somehow a few boys managed to evade the guards and barricade themselves in the upstairs balcony of the rented movie theater. Finally, the old rabbi was called in to shame the boys into giving themselves up. The report wryly noted that the play featured a cast of girls, most of whom were playing male characters; this meant that the boys in the audience had cross-dressed in order to watch cross-dressed girls on stage. Once one expands the notion of the theatrical performance to include these nonscripted elements,

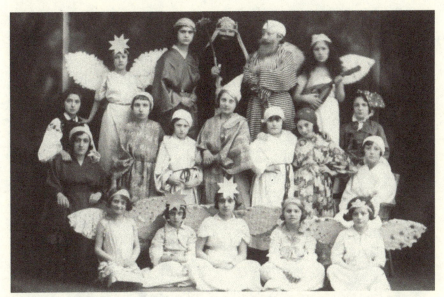

Figure 5.1. Bais Yaakov girls in Buczacz in a play called *Joseph and His Brothers*, ca. 1934. Esther Wagner (née Willig) can be seen in the second row, fifth from the right. Photo courtesy of Esther Wagner. United States Holocaust Memorial Museum Archives. Photograph number 49593.

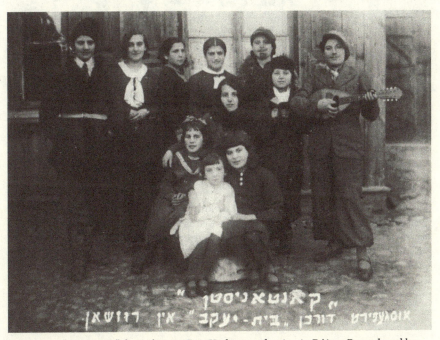

Figure 5.2. "Cantonists" from the 1935 Bais Yaakov production in Różan. Reproduced by permission of the Naftali Cohn Family Archive.

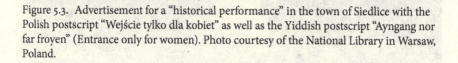

Figure 5.3. Advertisement for a "historical performance" in the town of Siedlice with the Polish postscript "Wejście tylko dla kobiet" as well as the Yiddish postscript "Ayngang nor far froyen" (Entrance only for women). Photo courtesy of the National Library in Warsaw, Poland.

it becomes clear that a double drama was being played out, beyond the curiously mirrored transvestism. On stage, the bound Isaac was saved from Abraham's knife by a deus ex machina from above; but within the larger spectacle unfolding in the theater, the play titled *The Binding of Isaac* was rescued by a different messenger from God, who saved the day for the Bais Yaakov pupils—the town rabbi, who shamed the boys into descending from the balcony so that the show could go on.

From the evidence of these stories and others covered by the Yiddish press, the innovative cultural practices of Bais Yaakov, especially its amateur theater, reverberated beyond the circles of Orthodox girls. During the 1930s, Tseirey Agudas Yisroel (the youth movement for boys and young men of the Agudath Israel, the political party of world Orthodox Jewry—often abbreviated as the Agudah) began to put on similar productions.[9] In doing so, they were tracing a curious cultural circle, since Bais Yaakov theater itself was partly borrowed from the traditionally male-only Purimshpil (Purim play) in terms of repertoire, performance practices, and the relationship with groups of young students; no doubt the thriving culture of performance in Polish schools also played a role. In this new turn of the cultural screw, however, young Orthodox men emulated the relative professionalism of Bais Yaakov theater, similarly using these productions for fundraising and marketing purposes; they thus established themselves not only as simple continuers of a long Jewish tradition but also as part of a more general modern landscape of amateur theater and cultural spectacle within interwar Jewish and non-Jewish Polish culture. In this sense, Orthodox young men, so important in the prehistory of modern Jewish theater, acted as followers here, borrowing from Polish culture, from secular Jewish youth movements, and from their female counterparts. Where the Purimshpil in its eastern European formation had traditionally been performed in domestic settings, the courtyards of synagogues, and—beginning in the nineteenth century—yeshivas, now Agudah youth followed the lead of their female counterparts in Bais Yaakov in renting movie theaters and public halls, building sets, writing scripts, and publicizing upcoming performances among the general public.[10] A telling sign that amateur theater for Orthodox young men was not a simple continuation or modernization of traditional practices was that productions in the interwar period were not limited to Purim or the month in which it fell but staged also during Hanukkah, the prime season for public programs among Poland's youth movements during this era. The time of Hanukkah corresponded, of course, to the season in which Polish schools were celebrating Christmas with such public spectacles as the *jasełka*, the Nativity play. In fact, some of the photos of Bais Yaakov plays, with their biblical costumes and angels' wings, bear a startling resemblance to photos taken of Nativity plays in Polish schools of the era.[11]

The press reports in such papers as *Haynt* and *Hayntige nayes* suggest another surprising reversal of our expectations. Bais Yaakov amateur theater spread not only from girls to boys but also from the small towns to Warsaw, the center of both Orthodox Jewish life and Polish cultural life more generally. And just as for the small-town Bais Yaakov play, Orthodox amateur theater by young men also sometimes produced scandalous effects that reverberated beyond the stage and were

reported in the popular press. The most famous and complicated of the scandals transpired in the adult-education club Khinukh (Education), which was founded in 1930 by the Warsaw chapter of the Tseirey Agudas Yisroel: the club was shut down by local Agudah authorities over a theater-related dispute in 1934. Khinukh provided classes and lectures in Jewish subjects that went beyond the normal yeshiva curriculum, including Jewish philosophy, the geography of the Land of Israel, and the Hebrew language. It began as a self-education club for boys and young men but soon opened its programs to young women, although in separate groups. The club was also the Warsaw center of the budding Orthodox literary scene, hosting such writers as Heshl Klepfish and Shmuel Nadler, the young Hasidic writer who was known as the "court poet" of the Agudah.[12] Nadler contributed regularly to Bais Yaakov publications and in fact had composed the winning Bnos hymn for a 1929 contest (Bnos was the youth movement for girls associated with Bais Yaakov), but he was also a rare Orthodox writer read and admired outside Orthodox circles.[13] Despite Khinukh's liberalism and propensity for pushing boundaries, the Agudah leadership in Warsaw initially looked the other way at its activities. They finally intervened only in December 1933, when word got out that Khinukh was planning a large-scale Hanukkah production, along lines that may have seemed too radical to the Agudah leaders. A report in *Haynt* titled "A Great Uprising in the 'Fortress' of the Agudah" followed the belated attempts of the Agudah leadership to control the production after it was well underway. The report described the Agudah's ruling that the club was only permitted to put on a Hanukkah pageant if the theatrical part of the evening program was limited to a traditional biblical drama; the Agudah recommended that old sawhorse *Joseph and His Brothers*.[14] The play could be performed only for single-sex audiences, and the cast itself would have to be either male or female, not mixed. In essence, this was a restatement of earlier rules that the Agudah had set down in relation to theatrical performances by girls.

It is hard to believe that Khinukh would have presented a play with a mixed cast, since the members were generally careful to preserve Agudah decorum in relation to public meetings. Nevertheless, the activists took this opportunity to resist their elders. According to the report, the leader of Khinukh argued that they could not possibly produce the play the Agudah was suggesting with a cast composed of members of only one sex. After all, "women wouldn't be able to throw Joseph into a pit and no man would be able to play the role of Potiphar's wife."[15] The leader's faux-naïve response laid bare an awkward tension at the heart of Orthodox cultural approaches to gender and theater: as with theatrical cross-dressing more generally, the play could either maintain traditional sexual segregation and transgress another taboo by having cast members cross-dress and thus depict homosexual seduction (or rape) in a kind of disguise or depict only "proper" gender performances and heterosexual scenes but have a mixed-gender cast.[16] Clever as this argument might have been, the Agudah recognized the temerity that it barely concealed and doubled down on its efforts to control the production. After failing to secure promises from Khinukh leaders that sexual segregation would be maintained, the Agudah shut down the production hours before the curtain was slated to rise.

But apparently the show was not entirely over. The evening after the aborted performance, Shmuel Nadler appeared at the club, where he was given an earful by the furious teenagers. A week later, Nadler spoke at the Warsaw Jewish Literary Union before an audience that included both the usual literati and many of the Orthodox and Hasidic youth who were among his greatest fans. To the surprise of the audience, Nadler appeared bareheaded and clean-shaven. Laying aside his prepared lecture, he gave a speech excoriating the Orthodox establishment for "hypocrisy, cultural mediocrity, a lack of imagination, and meddling in the activities of its youth, from whom it could have learned so many virtues."[17] With that, he renounced Orthodoxy and the Agudah and embraced the Communist party. Eddy Portnoy summarizes the press reports of what happened after that:

> Amid the ruckus, a strange thing occurred. A young Hasid who looked remarkably like Nadler mounted the stage and awkwardly approached the poet, screaming in his face, "*Akher!* For me you are dead," referencing the Talmudic figure, Elisha ben Abuya, who is said to have gone into *pardes*, paradise, and became an atheist. The young man began sobbing hysterically, tore his jacket, and collapsed to the floor, silencing the audience. The hysteric turned out to be Nadler's brother, with whom he had studied in the Lublin Yeshiva, and who was now a rabbi in a Galician shtetl. Nadler's transformation, in the mind of the brother, was a transgression so colossal that Nadler the poet had to be considered dead. Nadler the rabbi had, right then, begun the process of mourning.[18]

For all the distinctions between the small-town Bais Yaakov plays and the big-city drama in which Nadler renounced his affiliations with the Agudah, I would argue that it is possible to read these as moments within a larger and more complicated narrative of the emergence of modern amateur theater in the backwaters and centers of interwar Orthodoxy and in the story of interwar Polish Orthodoxy *as* theater. While amateur theater might seem to be a marginal phenomenon within the Orthodoxy of the period—as compared, for instance, to the political organizations or educational institutions that were emerging—it brings into focus a number of otherwise neglected dimensions of Orthodox life generally or of Bais Yaakov in particular. The play was an extracurricular aspect of school culture, separate from the classroom that played a more obvious and normative part in the overt mission of the system. The play both echoed and diverged from the classroom as a site of cultural transmission and reproduction. As a supplement to classroom instruction, it did cultural work that could not otherwise be accomplished; memoirs report that girls in small towns from even very secular families clamored to be allowed to go to Bais Yaakov schools because they were drawn to their plays.[19]

But theater also served as the most potent expression of the dynamic dimension of Bais Yaakov, the ways it moved beyond the official notion of a static set of traditions to be transmitted without loss from one generation of women to another to reimagine and enact a host of new roles that an Orthodox girl might fill, beyond the roles of daughter, wife, and mother. On the stage or set, Bais Yaakov students were also fundraisers, scene builders, and actors. As actors, they played the role of

Judith—biblical heroine and luscious seducer, decapitator of enemies before her return to her people—and the more modest role of Joseph, adored by his father, envied by his brothers, lusted after by his master's wife. It would be incorrect to read these cultural expressions purely as acts of liberation. The arena of amateur theater, like theater more generally, spelled both liberation and necessity, with girls following scripts written by the founder of their movement or one of her surrogates, adhering to the various ritual "commandments" of theater ("The show must go on"), the requirements that accompanied participation in a complicated group project, and the bodily disciplines involved in stagecraft.[20] As such, the small-town play captured some of the character of Bais Yaakov as a revolution in the name of tradition, in which novelty and tradition, freedom and necessity, worked to establish new ways of being Orthodox and female in a changing world.

Beyond the ways these insights about performance shed light on the small-town Bais Yaakov plays are the disruptive effects among its audiences, invited and paying or not. The apparent ease with which Bais Yaakov theater beyond the stage moved between piety and transgression has to take into account the viewpoints of its detractors, who tended to see innovation itself as providing an opening for all manner of sin.[21] Piety and transgression are curiously interwoven in these stories: the cross-dressing boys who created spectacles in Chmielnik and Błonie were attracted to the Bais Yaakov play as much by the modesty of its presentation as by the novelty of amateur theater and the thrill of breaking the rules. Bais Yaakov drama played itself out within this cultural dialectic of modesty and desire, publicity and interiority, but it was by following rather than breaching the rules of sexual segregation that the spectacle of the Bais Yaakov play had its more potent effects. The Bais Yaakov play publicly conformed to the dictates of modesty, announcing its modesty on advertising placards; in this public display of female privacy, the male gaze was both beckoned and forbidden. This particular combination of invitation and exclusion reversed the usual hierarchies of traditional Jewish life: here, men, rather than women, were excluded from the center of action. Female modesty worked in the Bais Yaakov play and its public marketing to reinvest the female sphere with a power that otherwise eluded its grip, boldly directing male attention to the pleasures it might hold and generating forces of attraction and influence beyond its intentionally circumscribed sphere.

Obedience and transgression, modesty and eroticism were also combined in other aspects of Bais Yaakov theater. Along with *Judith*, which seems to have been unique to the Bais Yaakov repertoire, Bais Yaakov also restaged such biblical dramas from the Purimshpil repertoire as *The Binding of Isaac* and *The Selling of Joseph* (or *Joseph and His Brothers*). These biblical plays may have been particularly popular in their all-male original contexts at least in part because they had so many male characters, avoiding the awkwardness that staging the Esther story would produce. But when Bais Yaakov borrowed this traditional repertoire, the result was in some ways the opposite: the more traditional the Bais Yaakov play, the more opportunities it provided for young girls to cross-dress. The photos of girls with beards that have survived from this era suggest the intellectual aspirations

of Bais Yaakov within an environment in which Torah study was coded as male. These images also caricature the fear that in teaching girls Torah, Bais Yaakov was producing unnatural hybrids—girls who could compete with their brothers (or even fathers) in religious knowledge.[22] In the Bais Yaakov play, this caricature and bogeyman appeared in full view, parading onstage under the protective aura of the Bible and of the masquerade that is theater.

That Bais Yaakov girls were trying on new roles previously unavailable to women was sometimes, at least indirectly, acknowledged, as in admiring statements about how the girls in the Kraków teachers' seminary accumulated such great stores of Jewish knowledge "that they would put their fathers and brothers to shame."[23] This notion rose to the surface of Bais Yaakov discourse when it came to discussing Sarah Schenirer's role as an activist, visionary, and school administrator, a role that was sometimes lent religious support through a quasi-midrashic citation of *Ethics of the Fathers*: "In a place where there is no man, try to be a man" (*Avot* 2:6). While the Mishnaic sense of this verse is that one should attempt to act morally even when others are not, in Bais Yaakov, this verse was mobilized for rather different purposes, to legitimate Schenirer's activism through reference to the failure of Orthodox men to address the crisis of Orthodox girls' defections. As Baila Bakst puts it in a memoir of her time in the Kraków seminary, Schenirer showed that "in a place where men do not want to or cannot arise, a woman will arise and demonstrate what a pure soul can accomplish, and she will take the place of the powerful and determined 'man.'"[24]

Following the model and script of Schenirer, Bais Yaakov girls pushed gender boundaries in learning Torah as diligently and passionately as their brothers were expected to do. They also performed new gender roles on stage, putting on amateur theater in a culture that had previously permitted such pleasures only to boys and young men and going even further by professionalizing it and extending its reach by renting halls, advertising on placards, using published scripts, and spending weeks on sets and rehearsals. They also performed scripts that afforded girls opportunities to try on different roles, male and female, within the broad sweep of biblical melodrama and the more immediate landscape of Polish Jewish history.

That Bais Yaakov as a whole was a kind of experimental theater, staging new roles for girls within a protective veil of traditionalism, may not be too far-fetched a claim. Schenirer, after all, was not only the celebrated founder of the school system but also its primary playwright, writing at least five scripts for publication and staging plays for the Bais Yaakov movement.[25] One former student recalled performing in a play Schenirer authored in which trees competed for their wood to be put to worthwhile uses; the "winner" was the student who declared her hope to be a bench in a Bais Yaakov school, where Jewish children learn Torah for years on end.[26] Students at the Kraków seminary also put on satirical revues, poking gentle fun at their teachers and the eccentricities of the Bais Yaakov movement; these revues were part of seminary culture especially in the summer months, when instruction moved to vacation towns in the Tatra Mountains.[27] Schenirer's interest in theater, as her recently discovered Polish diary attests, derived at least as much

from the bohemian theater culture of Kraków as from the traditional Purimshpil. The diary speaks volumes of her immersion in the cultural life of the city, describing, for instance, her 1909 attendance at what Joanna Lisek calls the "exceptionally 'non-kosher' play *Gody życia* [The Nuptials of life]" by the decadent expressionist playwright Stanisław Przybyszewski; in her diary, Schenirer writes that it was "quite a good play," though also admits to some distaste for the style.[28] As Lisek writes, Schenirer mentions two other Polish plays she attended in 1910 and 1912—the first a Romantic drama by Adam Mickiewicz that she describes as staged by the Kraków-born painter and playwright Stanisław Wyspiański and the second a translation of a French comedy by André Rivoire and Yves Mirande. She also attended lectures by "radical activists of the Polish feminist movement," participating in "the informal popular education developing in Poland at that time."[29]

The gestures of theater may also have informed Bais Yaakov pedagogy. When the leadership of the Agudah's educational arm first visited Schenirer's fledgling teachers' seminary in Kraków in 1924, they reported that the students spent their time copying Schenirer's "primitive lesson plans" by hand; one such plan, according to Judith Rosenbaum (later Grunfeld), who was recruited by Agudah leaders to professionalize the school, was composed of dialogue for the teacher and student to read out loud. In her memoir of Bais Yaakov in the early years, Rosenbaum transcribed and translated this dialogue:

> TEACHER—Wus bist du? (What are you?)
> PUPIL—Yach bin a Yidish kind. (I am a Jewish child.)
> TEACHER—Mit wus bist du a Yidish kind? (What makes you a Jewish child?)
> PUPIL—Yach bin a Yidish kind, weil ich hob die heilige Toira wus hot gegeben
> der heiliger Bescheffer die Himlen un die Erd. (I am a Jewish child, because
> I have the holy Torah, given by the Holy Creator.)[30]

It is clear from Rosenbaum's and other descriptions of the early years of Schenirer's seminary that the Central European Orthodox leaders and the educated young women they sent eastward to help with the fledgling movement considered Schenirer's hand-copied textbooks pedagogically outmoded. But perhaps they were misreading the genre: Schenirer's script here was not a textbook but rather an Orthodox Jewish variation on *Katechizm polskiego dziecka* (Catechism of a Polish child), written by Władysław Bełza (1847–1913) in 1900 and recited by Polish schoolchildren from that period through the interwar years and beyond. The first lines of the catechism already make the resemblance clear:

> —Kto ty jesteś? (Who are you?)
> —Polak mały. (A little Pole.)
> —Jaki znak twój? (What's your symbol?)
> —Orzeł biały. (The white eagle.)
> —Gdzie ty mieszkasz? (Where do you live?)
> —Między swemi. (Among my own.)
> —W jakim kraju? (In what nation?)
> —W polskiej ziemi. (In the Polish land.)[31]

As with other features of Bais Yaakov, Schenirer's Orthodox "catechism" (Bełza's title renders visible the conflation of Catholicism and Polish nationalism) closely mimicked Polish culture for the very purposes of stressing Jewish distinctiveness and religious difference. Along with its rewriting of Polish national schoolroom culture, Schenirer's script harnessed the pleasures and power of theater to revive Orthodoxy on the stage that was also a classroom.[32] The most valued role in Bais Yaakov culture was the "learned" and passionate girl, who both mimicked and rivaled her brothers and father in her zeal for Torah and its study, but the play allowed for other sorts of identifications and other ways of approaching Torah, providing roles for heroes, schoolhouse benches, and even besotted Assyrian generals.

Bais Yaakov in interwar Poland was instituted to stem the tide of Jewish girls' defection from Orthodoxy and to bring girls back to the Orthodox fold and to their roles as wives and mothers. The successes it garnered in its limited span before the destruction of the community were reinforced and repeated on an even grander scale after the Holocaust in the new centers of Orthodox life. The much-vaunted role of Bais Yaakov girls turned wives and mothers in the reproduction of Orthodox culture can hardly be denied. But it was accompanied, as these stories attest, by other wilder (and queerer) examples of cultural reproduction, whereby the collective practices of Orthodox girls were spread through cultural imitation to Orthodox boys not despite but rather through and because of the strict boundaries between the genders.[33] The pleasures of the Bais Yaakov play, despite and because it followed the rules of sexual segregation, once it was transposed to the male sphere and the big city, finally broke open a host of tensions within the project of reviving Orthodoxy. In the winter of 1933–1934, the rickety assemblage that was Orthodox theater collapsed in a grand spectacle, in which "the court poet of the Agudah" took on the new role of public critic and defector. Whether this marked the breakdown of the theater of Orthodoxy or only another kind of theater on a larger stage remains an open question.

In reversing the usual dominance within Orthodox power structures of men over women, Bais Yaakov theater also reversed the usual direction of cultural influence from the centers of Polish life to its peripheries. Bais Yaakov theater, the journalistic record shows, was particularly important in the small towns, where theater constituted a major part of school activities outside the classroom curriculum, increasing the appeal of Bais Yaakov within environments that otherwise lacked opportunities for Jewish performance and creativity. The paper trail of the Yiddish press clearly shows that the effects of Bais Yaakov theater radiated out from these small towns, first to boys and men in these towns and then to boys and men in the big city of Warsaw. Girls created the model for male amateur Orthodox theater in Agudah circles not only because of their commitments to performance (a devotion to performance that characterizes the school system until the present day) but also because the "modesty" of their efforts inspired first curiosity and then imitation. What was happening in the city was clearly of interest to those in "the provinces," and Schenirer's exposure to Kraków theater was certainly

influential in Bais Yaakov culture. But it was also true that what happened in the provinces was also of interest to those reading about the wild goings-on in small-town Bais Yaakov plays in the Yiddish Warsaw dailies, to the male counterparts of the Bais Yaakov girls trying to create an attractive Orthodox culture in the Polish big cities, and to the complicated Hasidic poet who put on his fascinating play in the Warsaw Jewish Literary Union.

Theories of performance have been powerfully mobilized in recent decades to parse the process of Jewish acculturation, assimilation, secularization, and modernization.[34] But theories of performativity are at least as usefully applied to those who resisted assimilation. Orthodox Jews were *also* obligated to shed old roles and acquire new ones, which is to say that under the new conditions of interwar Poland, for an individual to *remain* Orthodox, that individual (particularly if she were a young girl) would also have to *become* Orthodox. The theater culture of interwar Kraków should be read not only as a potential threat to Orthodox adherence but also as a source of inspiration, just as the amateur theater of girls in small towns could send waves that washed up even among male circles in the big city. But theater was a double-edged practice. As Judith Butler suggested long ago, to perform a role is to open oneself up to the possibility of performing it differently.[35] It is in this way that amateur Orthodox theater manifested its power both to secure the attachment of Bais Yaakov girls to Judaism and to encourage at least one figure in the Agudah to break the bonds that tied him to this same tradition.

Acknowledgments

I would like to thank the two anonymous readers for their helpful comments and Joanna Faisman and Charna Perman, my research assistants, for their able help with this essay.

Notes

1. "Provincial Mirror," *Haynt*, January 16, 1930, 4.

2. Gerer (or Gur) Hasidism—named after its town of origin, Góra Kalwaria—was the largest Hasidic group in interwar Poland and the one most closely affiliated with Bais Yaakov, under the broader umbrella of the Agudath Israel, the political party of Orthodoxy in which Gur played an important part. On Gur, the Gerer Rebbe, Bais Yaakov, and Agudah, see Gershon Bacon, *The Politics of Tradition: Agudat Yisrael in Poland, 1916–1939* (Jerusalem: Magnes, 1996), 168n. See both Ela Bauer's and Daniel Kupfert Heller's chapters in this volume for the ways in which movie theaters became a part of the Jewish public sphere in the interwar years.

3. We possess several photographs of Bais Yaakov plays, including one in the United States Holocaust Memorial Museum Archives from the small town of Buczacz (now in Ukraine) with this label: "Bais Yaakov girls in Buczacz in a play called *Joseph and His Brothers*. Esther Wagner (née Willig) can be seen in the second row, fifth from the right. In the afternoons (she was tutored in the mornings, because her parents did not want to expose her to the culture of public or Catholic schools), she first attended the Tarbut School and later Bais Yaakov, which her father helped establish." United States Holocaust Memorial Museum

Archives, photograph no. 49593, circa 1934, courtesy of Esther Wagner. The middle figures in the top row seem to be Joseph, Jacob, and Pharoah (or perhaps Potiphar), with others presumably playing Joseph's brothers and the stars that represent them in Joseph's dream. Other archives hold photos of Bais Yaakov plays in Kolbuszowa and Lachowice (small towns in southern Poland), Sadegora (now Sadhora, in Ukraine), Słonim (a larger town now in Belarus), and Mukachevo (Hung. Munkács, a small city now in western Ukraine). Różan (in northeastern Poland) was the town where Dvora Epelgrad (later Cohn) led a Bais Yaakov, and the dated and labeled photo of the production of *Kantonisten* (Cantonists) is in the Naftali Cohn Family Archive.

4. A flyer for a Bais Yaakov theatrical event to be held on March 3, 1926, in the City Club of Siedlice. This flyer has been digitized and reproduced by the National Library of Poland: https://academica.edu.pl/reading/readSingle?cid=103174469&uid=102420939.

5. Aside from numerous memoirs by graduates of Bais Yaakov that mention plays, the USC Shoah Foundation's Visual History Archive holds about sixty interviews with survivors who attended Bais Yaakov schools, generally in small-town supplementary schools, where classes met after public school let out. The interviewers, who seem to be following a prepared script, ask these women what they had learned in Bais Yaakov. The answers are curiously vague: "We learned to *daven*" or "We learned to read *ivre* [Modern Hebrew]." Several of them volunteer more vivid and detailed memories, specifically mentioning the school play. See Regina Guttman, Visual History Archive, USC Shoah Foundation, interview 51175, segment 26, 2000; and Bella Nadler, Visual History Archive, USC Shoah Foundation, interview 16785, segment 6, 1996.

6. News reports about Bais Yaakov performances, aside from the ones mentioned elsewhere, include "A Tu Bishvat Celebration in the Bais Yaakov of Shedlets (Siedlice)," *Unzer veg shedlets*, February 1, 1929, 4; and "A Children's Play in Bais Yaakov of Vlotslovkher (Włocławek)," *Vlotslovkher shtime*, June 29, 1934, 3.

7. Sarah Schenirer wrote a play called *Judith* for Bais Yaakov performance. It survives in Hebrew translation in Sarah Schenirer, *Em BiYisra'el: Kitve Sarah Shnirer: Toldot ḥayehah, ma'amarim, sipurim, maḥazot*, ed. Yeḥezkel Rotenberg (Tel Aviv: Hotsa'at Netsaḥ, 1955), 3:32–65. Although the book of Judith is not part of the Jewish biblical canon, it is known through rabbinic retellings and associated, moreover, with the festival of Hanukkah. Schenirer herself describes being moved and excited by Rabbi Moses Flesch's recounting of the story in praise of Jewish women on the Sabbath of Hanukkah 1914 (which fell on December 19 that year) and names this moment as the seed of the idea of Bais Yaakov as a movement that could rally Jewish women toward defending their tradition as heroically as Judith had. For a description of these events, see Schenirer, *Gezamelte shriften* (Brooklyn, N.Y.: Beth Jacob Teachers Seminary of America, 1955), 8–9. For an English translation, see Naomi Seidman, *Sarah Schenirer and Bais Yaakov: A Revolution in the Name of Tradition* (London: Liverpool University Press, 2019), 244–245.

8. "A Hasidic Revolt in Błonie," *Hayntige nayes*, March 11, 1934, 2. This play, unlike the other two I discuss, seems to have been performed not on the Sabbath eve of Hanukkah but on or around Purim, which fell on March 1 that year.

9. This chapter uses that abbreviation, except for the youth organization's name (Tseirey Agudas Yisroel). This emulation was evident in other spheres as well. Shaul Stampfer has described the ways that Orthodox yeshivas began publishing journals in the wake of the success of the *Bais Yaakov Journal*, which first appeared in 1923; Stampfer supposes that yeshiva students may have had their interest in such journalism awakened by seeing their sisters' copies of the journal. See Shaul Stampfer, *Families, Rabbis, and Education: Traditional Jewish Society in Eastern Europe* (Oxford: Littman Library of Jewish Civilization, 2010), 269.

It is also clearly the case that young Agudah-affiliated men not only read the *Bais Yaakov Journal* but also participated in its production and published their own writings in its pages, including in belletristic genres (for instance, lyric poetry) that had previously been out of bounds for Orthodox textual production.

10. Building on and revising classic studies of the Purimshpil by Ignacy Schiper (*Geshikhte fun der yidisher teater-kunst un drame: Fun di eltste tsaytn bis 1750*, 3 vols. [Warsaw: Farlag Kultur-Lige, 1927–1928]), Jacob Shatzky (*Arkhiv far der geshikhte fun yidishn teater un drame*, vol. 1 [Vilna: Yidisher visnshaftlekher institut, Teater muzey fun Ester-Rokhl Kaminski, 1930]), and others, a recent comparative, Bakhtinian analysis of the Purimshpil is Ahuva Belkin, *Hapurim shpil: Iyunim bate'atron hayehudi ha'amami* (Jerusalem: Bialik Institute, 2002). As with earlier scholars, Belkin tends to trace a genealogy from traditional folk performance to modern secular theater, but her work is useful for describing the connection of performance with yeshiva students, a clear precedence for the Bais Yaakov plays discussed here. It is part of this research to point out that modernization was not entirely a secular phenomenon, as evidenced by Orthodox amateur theater in the interwar period. On the performance details of the Purimshpil, see also Barbara Kirshenblatt-Gimblett, "'Contraband': Performance, Text and Analysis of a 'Purim Shpil,'" *Drama Review* 24, no. 3 (September 1980): 5–16.

11. I want to thank Urszula Madej-Krupitski for pointing out the connection with Polish Nativity plays, which were particularly associated both with the city of Kraków and with Polish school culture. The photo of the Buczacz play includes girls adorned with angel wings, a typical costume for the "extras" in these Polish plays. Polish Nativity plays, along with the related Nativity puppet theater, also often included stock Jewish characters. On this theater, particularly of the puppet variety, see L. R. Lewitter, "The Polish 'Szopka,'" *Slavonic and East European Review* 29, no. 72 (December 1950): 77–85. On Jewish characters within these plays, see Olga Goldberg-Mulkiewicz, "The Image of the Jew in the Polish Nativity Folk Theater," *Jerusalem Studies in Jewish Folklore* 17 (1995): 89–105.

12. On Khinukh and the episode in December of 1933, see the anonymous report "A Great Uprising in the 'Fortress' of the Agudah" [in Yiddish], *Haynt*, December 28, 1933, 6. On Shmuel Nadler and his most admired work, *Besht-Simfonye*, see Beatrice Lang Caplan, "Shmuel Nadler's *Besht-Simfonye*: At the Limits of Orthodox Literature," in *Arguing the Modern Jewish Canon: Essays on Literature and Culture*, ed. Justin Cammy et al. (Cambridge, Mass.: Harvard University Press, 2009), 599–616. On Nadler's break with the Agudah, see also Eddy Portnoy, "Politics and Poesy," *Tablet Magazine*, March 18, 2010, https://www.tabletmag.com/sections/belief/articles/politics-and-poesy.

13. The *Bais Yaakov Journal* announced a competition for the Bnos anthem in issue 45 (1929), and Nadler's anthem was published in the next issue. Shmuel Nadler, "Hymn to Bnos Agudas Yisroel" [in Yiddish], *Beys Yakov: Ortodoksisher zhurnal* 46 (1929): 6.

14. "Great Uprising in the 'Fortress,'" 6.

15. "Great Uprising in the 'Fortress,'" 6.

16. The tension within these modern attitudes has much deeper roots, expressing itself, for instance, in the ways that the clear biblical prohibition against a woman putting on men's apparel or a man wearing women's clothing (Deut. 22:5) is often acknowledged by rabbinic decisors even as they carve out a space for the practice of cross-dressing on Purim, perhaps because this custom was too prevalent to forbid outright. See, for instance, Rabbi Moses Isserles's ruling in *Oraḥ Ḥayim* 696:8 that despite the biblical prohibition, the custom is to be lenient in the case of cross-dressing on Purim. The Chofetz Chaim (Yisrael Meir Ha-Kohen Kagan, 1838–1933), an important decisor for Bais Yaakov and the Agudah, nevertheless insisted that no leniency was warranted and ruled that cross-dressing customs,

however widely practiced, should be abolished even on Purim. See Rabbi Yisrael Meir Ha-Kohen Kagan, *Mishnah Berurah*, 696:30.

17. "Great Uprising in the 'Fortress,'" 6.

18. Portnoy, "Politics and Poesy."

19. Yaffa Gora writes about the Hanukkah play she staged in Bychawa: "The whole town was astir. It was the highlight of the year, and it was because of such plays that we succeeded in attracting to the Bais Yaakov school even pupils from the most distant families, since their girls felt that we were a source of joy and longed to be part of our group." After seeing her daughter act in a Bais Yaakov play, one mother said, "I was angry at you, since our family is irreligious and our daughter wanted to go to your school only because of our neighbor. But today I felt that you gave meaning and substance to her Jewish education." See Y. Gora, "The Early Days of the Bais Yaakov Movement," in *Em BiYisra'el: Sefer zikaron lesarah shenirer* [A mother in Israel: Memorial book for Sarah Schenirer], ed. Aryeh Bauminger (Bene Berak: Netzaḥ Press, 1983), 171.

20. I borrow this insight from Andrea Most, who suggests that such combinations of discipline and freedom, communalism and individualism, shape-shifting and group loyalty, help explain the attractions of theater for American Jews. See Andrea Most, *Theatrical Liberalism: Jews and Popular Entertainment in America* (New York: New York University Press, 2013), esp. 84–87.

21. One report on a conference of Bais Yaakov schools related that the administrators complained that youth affiliated with the Agudah were throwing rocks at local Bais Yaakov schools where plays were being rehearsed or performed. See "A Conference of Bais Yaakov Girls' Schools," *Haynt*, February 18, 1930, 12.

22. These aspirations and the concerns they evoked are discussed in my book *Sarah Schenirer and Bais Yaakov*, 65–66 and elsewhere.

23. Joseph Friedenson, "The Bais Yaakov Girls' Schools in Poland," in *Haḥinukh vehatarbut ha'ivrit be'eropah ben shete milḥamot ha'olam*, ed. Zevi Scharfstein (New York: Hotsa'at Ogen al yede hahistadrut ha'ivrit ba'Amerika, 1957), 73.

24. See Baila Bakst, "In a Place Where There Are No Men . . . ," in Bauminger, *Em BiYisra'el*, 95. According to Yaffa Gora, Schenirer herself cited this verse about her endeavors in public lectures; for this, see Gora, "Early Days of the Bais Yaakov Movement," 168. A report of Schenirer citing this verse also appears in Paul Benisch, *Carry Me in Your Heart: The Life and Legacy of Sarah Schenirer, Founder and Visionary of the Bais Yaakov Movement* (Jerusalem: Feldheim, 2003), 27. This verse was cited more jokingly in a Bais Yaakov high school yearbook described by Leslie Ginsparg Klein: "A photo showed a student dressed as a Hasidic man, complete with a fake beard and the fur hat and garb commonly worn by Hasidim. She appeared surrounded by her laughing classmates. The caption beneath the picture read, '*Bemakom she'en anashim, hishtadel liḥiot ish*' [In a place where there are no men, try to be a man]. Students took a famous rabbinic dictum, which instructed a person to take a leadership role where no leaders exist, and applied it very literally, humorously acknowledging their single-sex education environment and traditional gender roles and expectations." Leslie Ginsparg Klein, "No Candy Stores, No Maxi-Skirts, No Makeup: Socializing Orthodox Jewish Girls through Schooling," *Journal of the History of Childhood and Youth* 9, no. 1 (2016): 151.

25. Schenirer's plays include *Hannah and Her Seven Sons*, *The Jug of Oil*, *Esther and Ahasueros*, *Judith*, and *The Power of Shabbat*.

26. Danielle S. Leibowitz and Devora Gliksman, *Rebbetzin Vichna Kaplan: The Founder of the Bais Yaakov Movement in America* (Jerusalem: Feldheim, 2016), 73. Note that the Yiddish writer Chaim Grade inverted this wish with his poem "Mayn shraybtish vil zayn a boym" (My desk wants to become a tree).

27. See the description of Vichna Kaplan (née Eisen) participating in such antics in Leibowitz and Gliksman, 75.

28. Joanna Lisek, "'I Feel So Crazy, like Flying the Coop': The Lesser-Known Sarah Schenirer; Side Reflections on Naomi Seidman's Book," *Shofar: An Interdisciplinary Journal of Jewish Studies* 38, no. 1 (2020): 276–277. The diary is forthcoming in Sarah Schenirer, "Żydzi. Polska. Autobiografia: Sara Szenirer," in *"Żydówką być to rzecz niemała"—pisma autobiograficzne Sary Szenirer*, ed. Dariusz Dekiert and Joanna Lisek, trans. Dariusz Dekiert (Warsaw: Wydawnictwo Naukowe PWN, forthcoming). For more on Przybyszewski's influence on Jewish culture in Poland, see Małgorzata Stolarska-Fronia's chapter in this volume.

29. Lisek, "'I Feel So Crazy,'" 278–279.

30. Judith Grunfeld-Rosenbaum, "Sara Schenierer," in *Jewish Leaders, 1750–1940*, ed. Leo Jung, 2nd ed. (Jerusalem: Boys Town Jerusalem, 1964), 415–416.

31. Władysław Bełza, *Katechizm polskiego dziecka* (Lviv, 1901), 3–4. A facsimile version is available at https://pl.wikisource.org/wiki/Katechizm_polskiego_dziecka_(zbi%C3%B3r)_(1901).

32. Another newspaper story, this one more clearly fictional than the others cited in this chapter, makes clear how well understood this tactic of Bais Yaakov was, precisely in the arena of public performance. The story, published on February 22, 1933, in the Yiddish daily *Hayntige nayes*, reported, "The Agudah Is Making Its Own Films: It Aims to Turn Bnos-Yaakov Girls into Movie Stars." As the story described this remarkable decision, the Agudah reacted to the fascination of Bais Yaakov girls with international movie stars like Greta Garbo and Marlene Dietrich and Polish stars like Hanka Ordonówna by deciding to film a Bais Yaakov movie. Sarah Schenirer was the screenwriter, and the plot was about the legend of the daughter of the ShaCh (Rabbi Shabtai Cohen), who survived the Chmielnicki massacres of 1648–1649 as a girl and lived as a secret Jew in the king's court and beloved companion to his daughter. While the story is probably satirical, the basic formula it lays out, in which the Agudath Israel often responded to Bais Yaakov girls' infatuation with secular culture by producing "kosher" variations on this culture rather than forbidding it outright, is an entirely accurate reading of this phenomenon. See "The Agudah Is Making Its Own Films: It Aims to Turn Bnos-Yaakov Girls into Movie Stars," *Hayntige nayes*, February 22, 1933, 3.

33. For a discussion of the spread of cultural practices such as school journalism from the female to the male sphere, see Stampfer, *Families, Rabbis, and Education*, 269.

34. For example, see Warren Hoffman, *The Passing Game: Queering Jewish American Culture* (Syracuse, N.Y.: Syracuse University Press, 2009).

35. Judith Butler, *Gender Trouble* (New York: Routledge, 1990), 128–149.

CHAPTER 6

A Spectacle of Differences

BRACHA ZEFIRA'S TOUR OF POLAND IN 1929

Magdalena Kozłowska

"An Evening of Exotic Songs," ran the title of an article in October 1929 in the Warsaw daily *Robotnik* announcing the concert of a Jewish-Yemenite singer from Mandatory Palestine, Bracha Zefira (1911–1988).[1] A similar announcement in the Lublin Yiddish daily *Lubliner togblat* was accompanied by a photo showing the eighteen-year-old Zefira wearing a stylized version of traditional Yemeni dress and jewelry, reproduced in figure 6.1.[2] Sitting barefoot, with bare arms and a huge smile, staring into the camera, she evoked myths about women of the "Orient" as sexually charged and uninhibited. The fact that she was different from her audiences was a key feature stressed in the advertising for her concerts. Not only were her clothes different, but her body was as well; even in the newsprint it was obvious that her complexion was far darker than that of her target audiences in Poland.

Zefira's 1929 tour of Poland served as a point of contact between Polish Jewry and "Oriental" Jewish culture. The singer visited not only the major cities of the time, such as Warsaw, Kraków, Łódź, Lublin, and Białystok, but also smaller, peripheral places such as Grodno, Włodzimierz, Tomaszów Mazowiecki, Chełm, and Brześć. What were the contexts and the consequences of these encounters? What did they say about the Jewish culture consumed in the Polish urban context? This chapter explores these questions. I argue that the concerts contributed to both breaching and sustaining ethnic (and even racial) boundaries between Polish Jews and Jews from Islamic countries, with the Middle East to be imagined as a backward periphery to modern Poland's cultural center.

Drawing on articles about Zefira's Polish tour of 1929 in both the general Polish and Polish-Jewish press, I analyze the discourse of place and the function of the "Exotic Other" in interwar Poland (which had no shortage of "internal" Exotic Others[3]) and the role of cultural appropriation at that time. Through the medium of contemporary descriptions of Zefira's performances in Polish cities and their reception by Jewish and non-Jewish audiences in Poland, I examine various images

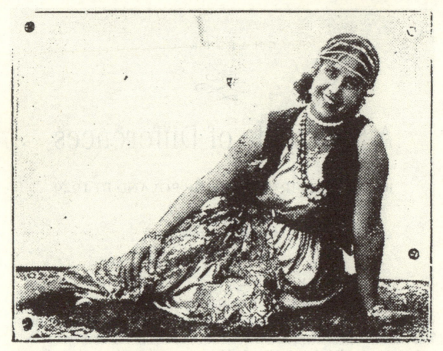

Figure 6.1. Bracha Zefira's picture accompanying the announcement of her show in Lublin. "Brakha Tsfira," *Lubliner togblat*, November 29, 1929, 7.

of Palestine's so-called Oriental Jews in late 1920s Poland that illustrate the ambivalent readings of their Otherness.

Fascination and ambivalence toward non-Ashkenazic Jews were neither typical of nor unique to Polish Jews. Similar, even stronger phenomena were also in evidence in Western Europe. In the nineteenth century, depictions of the Eastern world became widespread. This particular form of representation justified a sense of cultural supremacy of the West. It also created a false distinction between the so-called traditional Orient and the modern West, an intellectual trend known as "Orientalism," which also represented and implicated the Jews. As Ivan Kalmar and Derek Penslar have demonstrated, Jews tended to react to fin de siècle anti-Jewish Orientalism in one of three ways: by dismissing it, by glorifying the Orient and themselves as its offspring, or by framing nonacculturated Jews as "Oriental."[4] The latter two strategies were endorsed by German Jewry in particular. Studies show that as early as the late eighteenth century, the modernizing German Jewish elite looked to medieval Iberia as an iconic trope of acculturation, integration, and high culture. They constructed a Romantic image of medieval Sephardic Jewry, exaggerating its acceptance by Iberian Muslims and placing a high value on the cultural capital of the Sephardim. At the same time, they were extremely critical of traditional Ashkenazim, bemoaning and condemning their cultural deficiencies.[5] The widespread West European Jewish discourse on the Orient and their desire

to be a part of the emancipated and modern world undoubtedly influenced the way Polish Jewish elites in the interwar years perceived Jews of "Oriental" descent.

At the same time, this aspirational framing of the West versus East issue was helpful to Polish Jews in their construction of the meaning of the terms *us* and *Other*. In their desire to be part of the enlightened European world, the Polish Jewish intelligentsia started to use terms that were sometimes directed at them by others. This phenomenon can be described as "nesting Orientalisms." Coined by Milica Bakić-Hayden, this concept refers to a "gradation of Orients," meaning a pattern by which the original dichotomy that defines Orientalism is reproduced. Thus, Asia and Africa—and by extension Asian and African Jews—are perceived by Westerners (and people aspiring to be seen as and to become part of "Western cultures") to be a more extreme category of "Others" than Eastern Europeans.[6]

Jewish intellectuals in interwar Poland were well aware of and thoroughly immersed in the widespread Western rhetoric and clichés surrounding the Orient and Oriental Jews (for art music engaging such topoi, see the beginning of chapter 7). The same can be said for the organizer of Zefira's concerts in Poland: the composer Nahum Nardi (1901–1977), a graduate of the Vienna Academy of Music, an impresario (the press claimed he was also the manager of Isadora Duncan), and later her husband.[7] The publicity material stressed the fact that Zefira would be singing in several "Oriental" languages (e.g., Turkish, Hebrew, and Ladino) and that she would be wearing "Oriental garb."[8]

Bracha Zefira: The Birth of a Figurehead in the Music World of Mandatory Palestine

Bracha Zefira was born in 1911 in the Jerusalem Quarter of Nahalat Zvi, the daughter of the Yemeni-born Jews Yosef and Na'ama Zefira.[9] Her mother died in childbirth and her father from a disease when she was only three. Zefira was adopted by a Yemenite family living nearby. Shortly thereafter, she moved to another foster family in the Bukharan Quarter, with whom she stayed for three years, before being moved to a family in Yemin Moshe, where most of the residents were of Greek Jewish origin. At a very young age, she was exposed to various Jewish cultural traditions: Yemenite, Bukharan, and Sephardic.[10]

Around 1924, Zefira moved to Me'ir Shefeyah, near Zikhron Ya'akov. Me'ir Shefeyah was an orphanage founded in 1923 as a children's village, a rural community of children who lived together and learned agricultural skills. Moshe Calwary (1876–1944) directed the village, and his wife, Hadassah, worked as a local teacher. It was she who noticed Zefira's musical talent. Hadassah Calwary encouraged the girl to perform on Friday nights for her fellow students and teachers. The school board became aware of her talent and decided that she should receive a musical education. Zefira returned to Jerusalem and studied at the Kedma music conservatory, directed by Professor Sidney Siel. Soon thereafter, to pursue an acting career, she decided to move to Tel Aviv, where she worked at the Palestine Theater and in its acting studio under the supervision of Menahem Gnessin. When that

group closed, she began acting with the Hakumkum (Teapot) group, with which she stayed until it dissolved in 1929. With the support and recommendation of the Habima Theater's director, Alexander Diki (Rus. Alekseĭ Dikiĭ), and Meir Dizengoff, the mayor of Tel Aviv, she moved to Berlin to continue her studies at Max Reinhardt's studio.[11]

One point that should be noted is that all Zefira's sponsors and promoters, from the teachers at Me'ir Shefeyah onward, were Ashkenazi Jews;[12] Nahum Nardi (born Nakhum Narodetskiĭ), perhaps the most influential figure in her career, whom she met in 1929 and later married, was from Russia. In describing their first encounter, she said she begged him to sit at the piano, play the songs she would sing to him, and try to improvise an accompaniment. Thus was born a duo comprising a Yemenite female singer and an Ashkenazi male accompanist. Before long, they started giving concerts in Germany and performing songs from different traditions that Zefira knew from her childhood (Yemenite, Bukharan, Persian, and Palestinian), arranged by Nardi, who lent the songs more European-style harmonies in a commercially driven attempt to satisfy their audiences.[13] An impresario organized a tour to Poland for them that caused a stir among the Polish Jewish public.

Zefira's Body as a Medium of Difference

Zefira's tour of Poland was a great success. But it seems that it was not only the music that attracted people to come and hear her. One might even say that they came *in spite of* the music. As Gila Flam notes, contemporary reviewers paid less attention to Zefira's musical skills than to her anatomical attributes, and the same was probably also true of her audiences.[14] The tour organizers were aware of this and advertised the shows with provocative descriptions of the singer, such as "the fiery Yemenite";[15] "the marvelous Palestinian singer, full of temperament and exotic charm";[16] "a typical Jewish beauty";[17] and "a young Yemenite girl with fiery eyes, a swarthy face, and a marvelously sweet smile revealing shiny, white teeth."[18]

As Carla L. Petterson suggests, "As we observe bodies (our own or others'), we need to acknowledge that we are never just looking at individual bodies; we connect these to other bodies by comparison, placing them in groups—especially those of gender, family, race, and nation—and endowing them with a group identity."[19] Zefira's body was automatically employed as a synecdoche for the collectivity of the Yemenite Jews, who were understood as dissimilar to the Ashkenazic Jews. Reviewers contrasted the Yemenites with their own Ashkenazic readers, describing the former as very primitive and lacking in culture. They did not conceal their amazement that Zefira was not, to their minds, a stereotypical Yemenite woman: "After all, the Yemenites still dwell among superstitions and habits that imitate Muslim life. The women still wear curtains over their faces, and they do not show themselves in public, not to mention performing on stage—such a thought would not even cross their minds. . . . And suddenly a Yemenite dares to show herself on stage with her face unveiled!"[20] The notes advertising her performances usually stressed the notion of the backwardness of the Yemenites: "The Yemenites are a

primitive people, they have no major or famous writers or composers, though they do produce interesting folk songs."[21] Just as they themselves were sometimes portrayed by the Western and general Polish press as backward and primitive in view of their birthplace and their traditionalism, Jewish journalists in interwar Poland depicted their Middle Eastern brethren as a special type of Jew. This stance was also typical of East European Zionist-leaning Jewish intellectuals who adopted the discourse of speaking up for the disenfranchised or lamenting what they saw as a waning authenticity in their own culture. It is worth noting that the same rhetoric was also used at the time by Jews living in Mandatory Palestine to describe Yemenite Jews. For example, when in 1928 the Queen Esther contest, a kind of beauty pageant hearkening back to the scroll of Esther recited on the holiday of Purim, was won by Tsipora Tsabari, an impoverished Yemenite woman, journalists described her as "a dark and peppery Yemenite whom Agadati the magician helped down from her donkey."[22] This is an example of a paradoxical dichotomy whereby Middle Eastern Jews were imagined, on the one hand, as backward and primitive but, on the other hand, as keepers of tradition, cultural purity, and authenticity. This is exactly the sort of dichotomy that was constructed by elites, who were often engaged in nationalist movements and projects, around the imagined folk and its culture, which they presented as the primordial and primeval nation. A similar brand of attraction versus repulsion had been present among intellectuals since the nineteenth century in Russia (toward the peasants)[23] and was strongly in evidence in the United States in respect to African and Native Americans in the same period.[24]

Articles published after Zefira's performances focused on her appearance. Her body was deeply fetishized.[25] The Yiddish singer, folklore collector, writer, and photographer Menakhem Kipnis (1878–1942), writing for the most popular Yiddish daily *Haynt*, commented that Zefira was "a young child, a black Palestinian with black Eastern eyes and beautiful teeth."[26] Other reporters stressed her "primitiveness." *Literarishe bleter* called her a "primitive beauty," admitting that they had not expected the show to be so accomplished.[27]

Exposure to "primitiveness" was typical of the times, especially in milieus that aspired to be perceived as modern and progressive. The notion of primitivism as an artistic movement had its roots in the late nineteenth century, with artists like Paul Gauguin leaving the presumptive center of the world for Tahiti and developing a new way of painting. It continued into the twentieth century, with leading exponents including Pablo Picasso, who was influenced by African artwork, and the itinerant Paris-based ballet company Ballets Russes, which introduced European and American audiences to motifs drawn from Russian folklore.[28] In the 1920s, one of the most famous "primitive" artists, popular also among Polish Jewish audiences, was the French performer Josephine Baker.[29] As Nancy Menno notes in her analysis of Baker's performances in Berlin, the stage became a liminal space providing a meeting place between the modern and the primitive.[30] It served as a mirror in which audiences could reassure themselves of their own progressiveness. What the European audience was looking for was the primitive incarnate.[31] This

was also the case with Zefira's performances. The eager audience was engaged in a kind of voyeurism as they celebrated the spectacle of Zefira's difference. This mirroring of "us" and "Other" explains why the concerts of Zefira, a relatively unknown singer in Poland at the time, were so popular. Like Baker, she served as a link to a primitive world that was mediated through her body.[32]

Zefira, Nardi, and their manager deliberately constructed an image of her that conformed to contemporary Polish-Jewish middle-class anxieties and fantasies about themselves that they projected onto the Middle East. She performed barefoot with long, flowing hair, and the advertisements highlighted her "showy, theatrical Oriental costumes,"[33] addressing the audiences' subliminal sexual desires.[34] Zefira was introduced to the audience in a similar way to Mata Hari (1876–1917) before her. Just as the Dutch-born Mata Hari (née Margaretha Geertruida "Margreet" MacLeod) had served as a mediator between wild Java and modern Europe, so Zefira was a link between the Middle Eastern and Ashkenazic worlds. In both cases, their liminal bodies and dress embodied—and hence legitimized—their audiences' fantasies of the Orient.[35]

An important element of Zefira's image was her age. She was indeed young when she performed in Poland, though not much younger than other contemporary Polish-Jewish or Polish singers or actresses. Almost every published report or review of her highlighted that she was only eighteen. The focus on her being just over the border of a minor helped infantilize her, which allowed her to be treated paternalistically rather than as a full, mature partner.

The investment in Zefira's exoticism dovetailed with the contemporary Polish entertainment industry's fascination with Oriental themes. "Exotic numbers"— especially with Hawaiian motifs—were frequent features of revue programs.[36] There were two films that came out a few years after Zefira's Polish tour: *Głos pustyni* (Sound of the desert) and *Czarna perła* (Black pearl), directed and produced by Michał Waszyński in 1932 and 1934, respectively. In both, "exotic" women's bodies play key roles. In *Głos pustyni*, it is the Arab protagonist Jamilla (played by Nora Ney), and in *Czarna perła*, it is the Tahitian Moana (played by Anna Chevalier; stage name Reri).[37] Thus Zefira's image was also a reverberation of the fascination with Oriental women's bodies in non-Jewish Poland.[38]

Zefira as the Embodiment of the "True Jew"

Another key element of Zefira's paradoxical image in the Polish-Jewish press was her glorification as an offspring of the Orient. She embodied the desire among certain Polish Jewish intellectuals to return to the cradle of Judaism in order to be "true" Jews. Her romanticized body reminded audiences of their imagined homeland—Eretz Israel. This was a place beyond time and space that existed in their minds like an image from the Bible.[39] This message was present not only in journals programmatically connected with the Zionist project but also in periodicals like *Literarishe bleter* (probably the most influential Yiddish literary and cultural weekly of its time promoting the Yiddish language movement).[40]

As Gil Eyal states, the Yemenites served the Zionists of the time as a model for imitation, which was crucial for the latter in building their identity. The Yemenites' image served as a bridge for the Diaspora Jews between their contemporary and their "true" selves, abandoned in the course of history and acculturation. Eyal sees the Yemenites as a mirror in which Jewish immigrants from eastern Europe could see themselves and through which they could believe they, too, had a right to settle in the Middle East. This notion was especially present among visual artists, who usually hired Yemenites to sit as models for biblical figures. Eliezer Ben-Yehuda, the linguist known as a "reviver of the Hebrew language," was also said to be fascinated by them, claiming that the study of their customs could help establish how Jews behaved in Mishnaic times.[41]

The trope of Zefira's "authentic" Jewishness as reflected in her Palestinian roots is discernible in the reviews published in Poland after her shows. We read, for instance, the following in a piece on one of her performances: "It smelled of the Palestinian night; the great moon glowed green, the camels rose from the desert sands and set off.... The sweet tone of the flute rang out from a distance, the sequins of a young Bedouin began to jingle. Through the pale rays, the night carried a sad song and the sound of bare feet dancing the hora."[42]

Zefira's performances were designed to bring her audiences closer to the "essence" of the new-old Jewish identity. The Jewish daily in Grodno (now in Belarus), the *Grodner moment (ekspres)*, claimed, "In a word, Bracha Zefira is not an average singer with a more or less pleasing voice—she is ... an original product, born in Eretz Israel."[43] The very same note was also published in a newspaper in Brześć (Yid. Brisk; now Brest, Belarus), where Zefira performed on November 27, 1929.[44] Menakhem Kipnis even suggested that other performers who came to Poland from Palestine but who were of Ashkenazic origin were fake, while Zefira had "orientalism in her blood and a soul full of melancholy."[45] *Literarishe bleter* wrote, "She seemed so distant and alien, but when she started to sing she became so familiar. Her singing and soul are sunny and biblical.... One feels as if it were past generations singing."[46]

Yemenites—and, more generally, Jews from Islamic countries—served the Ashkenazic Jews as "living testimony." This extended to their musical traditions. A prime example of the search for "authentic" musical origins is Abraham Zvi Idelsohn's *Thesaurus of Hebrew-Oriental Melodies*, which he pursued in order to find a "pure" Jewish music untainted by Germanization. Equipped with the latest in recording devices, Idelsohn spent the early twentieth century roaming the Mediterranean basin in search of melodies forgotten by the Ashkenazic Jews.[47] Zefira must have been aware of these trends, as she herself collected folk songs. Idelsohn's project was also noted by Polish musicologists, who reviewed his works in the very first issue of *Polski Rocznik Muzykologiczny* (Polish musicological yearbook), the professional journal issued by the Society of the Lovers of Early Modern Music (Stowarzyszenie Miłośników Dawnej Muzyki). Though criticized for being ideologically biased, his work was judged to be pioneering and worthy of recognition.[48]

The "Authenticity" of Zefira's Music

All in all, it seems that far less attention was paid to Zefira's music than to her body. Reviewers did not focus on what she sang, preferring to describe her looks, her age, and what she symbolized. However, both she and Nardi were aware that the music they offered had to be made palatable to the East European listener. As Lewis Erenberg notes, "[The] content of popular music is determined by those who own the means of production, but it is also crucial to note that audiences are not passive. They reinterpret music at the point of reception to suit their own purposes."[49] This was also the case with the Zefira-Nardi duo.

By and large, the Oriental melodies, tunes, and languages were a novelty for both Christian Polish and Polish-Jewish audiences. Although arranged and "westernized" by Nardi, they still differed from conventional repertoires. Most reviews made little attempt to understand the music. Instead, as mentioned previously, they enthused about the whole package and primarily about Zefira's persona and costumes. We might note that most of the reviewers were men, though even Thea Weinberg (a female reviewer for the *Ewa* journal) called Zefira's music "naïve" and focused little on the music and rather on other aspects of the show.[50]

Musicologists who have studied Zefira stress her role as a "mediator" between Eastern and Western music traditions. The artist herself later drew attention to her pioneering role in introducing European Jews to the music of the Middle East.[51] It could not have been a painless process, since this type of music was treated more as a curiosity or merely an element of a show worth seeing for its links with "true Jewish culture" than as bona fide musical artistry. However, even Polish-Jewish critics admitted that she could serve as a bridge between the two cultures.[52]

The link was less obvious to Christian Polish audiences. A renowned Polish musicologist of the time, Professor Zdzisław Jachimecki of the Jagiellonian University in Kraków, commented on her performance as follows: "The singing of this little songstress with typical Semitic facial features is a natural creation, far from all the qualities of vocal art. Frankly speaking, Bracha Zefira flounces like a street urchin, which, in combination with her guttural way of pronouncing some sounds, does not always produce a positive impression."[53] Jachimecki's comment brings up the question of how folk tradition was imagined. Categories such as urban versus rural, authentic versus fake, folk versus popular, and highbrow versus middlebrow versus lowbrow were at the heart of critics' (but also audiences') responses to Jewish "folk" music or "authenticity" in music. Jachimecki himself was very involved in studying the music of the highland peasants of the Tatra Mountains (the Górale) and encouraging musicians like Karol Szymanowski to process his findings artistically.[54] It appears that to him, the music of the Górale folk was "authentic" and worthy—a rightful part of the Polish folk past—whereas that of Zefira was not.

Yet his taste was not so conservative when it came to jazz or other popular forms of entertainment. He wrote, "Cinema, reverie, barroom dancing—with its ubiquitous 'jazz'—became a magnet attracting the talents and personalities of this

minor musical genre but also, to a large extent, people of far greater artistic capabilities than the degree of aptitude it required."[55] The difference in his attitude may have been a function of the popularity of certain genres. For him, Zefira's shows in Poland were an unexpected novelty. He did not associate them with "authentic" Jewish culture and was neither fascinated nor moved by them. He seemed to have no interest in this aspect of the music. Zefira's performances only interested him from an ethnographic angle.[56]

Not all reviewers reacted so harshly, however, to Zefira's music. Jewish critics referenced her naïveté and childish sound in their articles, but they also claimed that these components were positive aspects of the performances.[57] They compared her to a rough diamond, which would truly shine in the near future.[58] They chose to judge her performance as an example of an unfamiliar genre, which she had mastered.[59] Some even claimed to be disappointed by the fact that Zefira and Nardi had decided to adapt the melodies to suit European preferences. These voices seem to echo the debates about the treatment of "folk" music that were widespread in this period throughout eastern Europe (they were centered in Hungary on Kodály and Bartok and in Poland on Szymanowski, Jachimecki, and Chybiński). Arrangements of "primitive" music were seen as an important way of disseminating it but were viewed by some critics as depriving the music of its "authenticity."

Among Polish Jews, Middle Eastern music played a role similar to that of jazz in the United States at that time. White American artists—some of whom were of Jewish origin—such as Benny Goodman and Artie Shaw were drawn to jazz for its "authenticity" and also romanticized the Black community as spontaneous and unrepressed.[60] So just like jazz, for some artists and reviewers of the time in Poland, Zefira offered a kind of expression that was perceived as emotionally authentic, in which the listener might find his or her true self.[61] These critiques followed the arguments of interwar musicologists like the aforementioned Idelsohn, who claimed that heat and warmth were the qualities characteristic of the Jewish music of the Mediterranean.[62] On the other hand, despite claiming that they were enchanted by her music, some Jewish reviewers suggested that she could have added songs people knew—that is, songs in Yiddish—to her repertoire.[63]

Zefira's Tour of America as a Point of Comparison

Seven years after her Polish tour, Zefira performed in America. The coverage suggests that these performances were constructed much as those in Poland had been. Advertisements emphasized and exoticized her body, if in a slightly less provocative manner. A sensual picture (seen in figure 6.2) of the singer with eyes closed and lips slightly parted accompanied images and articles announcing her performances from Altoona, Pennsylvania, to Akron, Ohio. As the daily the *Cincinnati Enquirer* announced, "The charm and beauty which Bracha Zfirah has in her art, is largely the result of a mystic desert influence. Bracha Zfirah might be called 'a child of the desert.'"[64]

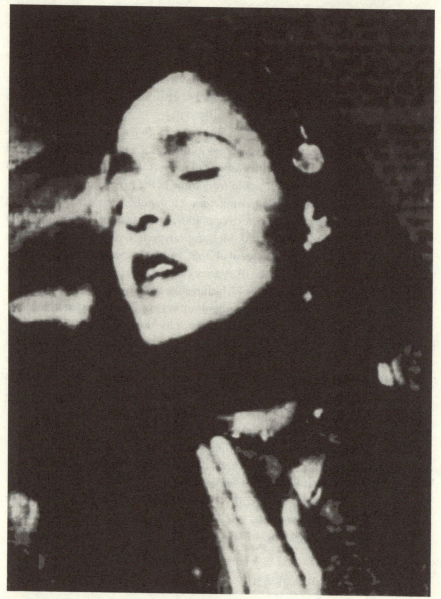

Figure 6.2. Picture of Bracha Zefira used to advertise her shows in the United States. "Interprets Art of Zion," *Cincinnati Enquirer*, February 21, 1937, 5.

Like the Polish reviewers, the Americans found Oriental music hard to grasp (even though it was again westernized for the performances). A *New York Times* reviewer wrote, "Miss Zfirah's art was so steeped in Yemenite and Palestine tradition that it was too far remote from Western standards of entertainment to be properly judged from the Occidental standpoint. Her voice to American ears sounded nasal, strident, and monotonous. But it was the typical Oriental voice,

though obviously not a highly trained one from our point of view."[65] He concluded, "Moreover, she made a series of delightful pictures in her several costumes which also were stylized in a most successful manner."[66] So for American audiences, too, Zefira was a curiosity or an incarnation of Oriental dreams.

Yet American reporters also highlighted other aspects of her stage shows that spoke to other American mythologies. They saw her biography as an example of great talent overcoming adversity. They stressed her redemption from backwardness and poverty thanks to the people (men) she met.[67] As such, their view of her was, in fact, distinctly American, playing into American myths of upward mobility.[68]

In America, the venues in which she performed were also different: they were mostly community buildings, temples, or small theaters, while in Poland (especially in smaller places, like Grodno), she had performed on major stages, and her arrival would have been an important affair for the whole town.

Conclusion

Bracha Zefira's performances in Poland in 1929 marked the beginning of her great career and created a unique opportunity to connect East European Jews with the Jews of the Middle East. Her tours were a living example of the diversity and vitality of Polish Jewish urban culture before World War II. Performances were held in various Polish cities, exposing both the Jewish and non-Jewish middle classes to the existence of Oriental Jewry through a direct encounter with a talented artistic representative. Zefira took note of her effect on Polish Jewry. "It was in the conservatory auditorium in Warsaw. That evening, after one or two songs, there was a thunder of applause. I did not know what I had brought to these people, who came backstage in admiration," she writes in her memoir.[69] Based on the press coverage, we can say that the main attraction for the crowd was her Otherness and that she represented the peripheries of the Jewish culture as it was imagined then in Poland. The shows were designed not to confront prejudices but to build upon and sustain them.

What is more, the press coverage suggests that attitudes toward Zefira were ambivalent. Her body was fetishized and sexualized; she was depicted as an embodiment of the "primitive." On the other hand, she represented the idea of the authentic Jew, a link between Biblical times and the present. Zefira and her manager were aware of these attitudes and consciously played up her image as an "Oriental goddess." This marketing and packaging ensured the success of her tours in interwar Poland.

Acknowledgments

This research was funded by the National Science Center, Poland, under grant no. 2021/43/D/HS3/00437. The author would like to thank Dani Issler for the inspiration and Smadar Lavie for the encouragement to conduct the study and for her valuable feedback.

Notes

1. "Wieczór pieśni egzotycznych," *Robotnik*, October 6, 1929, 6.
2. "Brakha Tsfira," *Lubliner togblat*, November 29, 1929, 7.
3. The mainstream hegemonic culture of the country was Polish, despite its ethnic, religious, and linguistic diversity; for instance, an Orthodox Jew could serve as an Exotic Other. Therefore, one can read Polish-Jewish culture using postcolonial tools. See Eugenia Prokop-Janiec, "Paradygmat postkolonialny w badaniach kulturowych relacji polsko-żydowskich," in *Pogranicze polsko-żydowskie: Topografie i teksty* (Kraków: Wydawnictwo Uniwersytetu Jagiellońskiego, 2013), 269–286; and Karolina Szymaniak, "Speaking Back: On Some Aspects of the Reception of Polish Literature in Yiddish Literary Criticism," in *Jewish Writing in Poland*, vol. 28 of *Polin: Studies in Polish Jewry*, ed. Monika Adamczyk-Garbowska et al. (Oxford: Littman Library of Jewish Civilization, 2015), 153–172.
4. Ivan D. Kalmar and Derek J. Penslar, eds., *Orientalism and the Jews* (Hanover, N.H.: University Press of New England; Waltham, Mass.: Brandeis University Press, 2005), xviii.
5. See Steven Ascheim, *Brothers and Strangers: The East European Jew in German and German-Jewish Consciousness, 1800–1923* (Madison: University of Wisconsin Press, 1982); John M. Efron, *German Jewry and the Allure of the Sephardic* (Princeton, N.J.: Princeton University Press, 2015); and Carsten Schapkow, *Role Model and Counter Model: The Golden Age of Iberian Jewry and German Jewish Culture during the Era of Emancipation* (Lanham, Md.: Lexington Books, 2016).
6. Milica Bakić-Hayden, "Nesting Orientalisms: The Case of Former Yugoslavia," *Slavic Review* 54 (1995): 917–931. See Aziza Khazoom, "The Great Chain of Orientalism: Jewish Identity, Stigma Management, and Ethnic Exclusion in Israel," *American Sociological Review* 68 (2003): 481–510.
7. "Pieśni smutku i radości naszych braci w Palestynie. Rozmowa współpracownika 'Naszego Przeglądu' z Brachą Zfira," *Nasz Przegląd*, October 4, 1929, 7.
8. The shows were advertised in both the Jewish press and Polish periodicals, even the right-wing *ABC*.
9. The newspapers of the time claimed that Zefira was born in Egypt.
10. Bracha Zefira, *Kolot rabim* (Tel Aviv: Masada, 1978), 13–14.
11. *The Shalvi/Hyman Encyclopedia of Jewish Women*, s.v. "Brachah Zefira," by Nathan Shahar, accessed August 4, 2020, https://jwa.org/encyclopedia/article/zefira-brachah; Gila Flam, "Beracha Zefira—a Case Study of Acculturation in Israeli Song," *Asian Music* 17, no. 2 (1986): 108–125.
12. She even highlights this fact herself in her memoir, saying that her teachers were of European descent (from Germany, Poland, and Russia). See Zefira, *Kolot rabim*, 14.
13. Flam, "Beracha Zefira," 109.
14. Flam, 110.
15. "Nur eyn kontsert," *Lubliner togblat*, December 3, 1929, 3.
16. "Dziś ostatni występ Brachy Zfiry," *Nowy Dziennik*, October 24, 1929, 11.
17. "Bracha Zfira w Gongu," *Nowy Dziennik*, October 11, 1929, 12.
18. Thea Weinberg, "Pieśniarka jemenicka Bracha Zfira w Warszawie," *Ewa*, October 13, 1929, 4.
19. Carla L. Petterson, "Eccentric Bodies," in *Recovering the Black Female Body*, ed. Michael Bennett and Vanessa Dickerson (New Brunswick, N.J.: Rutgers University Press, 2001), ix.
20. Weinberg, "Pieśniarka jemenicka Bracha Zfira w Warszawie," 4.
21. "Mit a bazukh bay der timener zingerin Brakha Tsfira," *Haynt*, October 7, 1929, 9.
22. Nina Spiegel, *Embodying Hebrew Culture: Aesthetics, Athletics, and Dance in the Jewish Community of Mandate Palestine* (Detroit: Wayne State University Press, 2013), 32.

23. Alexander Etkind, "Orientalism Reversed: Russian Literature in the Times of Empires," *Modern Intellectual History* 4, no. 3 (2007): 626–628.

24. Leah Dilworth, *Imagining Indians in the Southwest: Persistent Visions of a Primitive Past* (Washington, D.C.: Smithsonian Institution Press, 1996).

25. For more on the concept of fetishization, see Homi Bhabha, "The Other Question . . . Difference, Discrimination and the Discourses of Colonialism," *Screen* 24, no. 6 (1984): 18–36.

26. Menakhem Kipnis, "Brakha Tsfira," *Haynt*, October 9, 1929, 6.

27. "Fun vokh tsu vokh," *Literarishe bleter*, October 17, 1929, 18.

28. Patricia Leighten, "The White Peril and L'art *nègre*: Picasso, Primitivism, and Anticolonialism," *Art Bulletin* 72 (1990): 609–630; Hanna Järvinen, "'The Russian Barnum': Russian Opinions on Diaghilev's Ballets Russes, 1909–1914," *Dance Research* 26 (2008): 18–41.

29. If we are to judge from the frequent presentations of her films to Yiddish-speaking audiences in the Lodzer Jewish quarter. See, for example, "Haynt groyse yom-tev far kino-libhober!," *Nayer folksblat*, February 24, 1928, 15; and "Juzefina Baker, shvartse venus," *Nayer folksblat*, January 18, 1929, 12.

30. Nancy Menno, "Primitivism, Femininity and Modern Urban Space: Josephine Baker in Berlin," in *Women in the Metropolis: Gender and Modernity in Weimar Culture*, ed. Katharina von Ankum (Berkeley: University of California Press, 1997), 146.

31. Menno, 149.

32. Menno, 156.

33. "Czwartkowy wieczór pieśni egzotycznych Bracha Zfira," *Ilustrowana Republika*, October 8, 1929, 9; "Eyropes greste sensatsye," *Tomashever tsaytung*, October 29, 1929, 1.

34. The tradition of the East staging the East for the Western gaze continues to this day. See Susan Slyomovics, "Cross-Cultural Dress and Tourist Performance in Egypt," *Performing Arts Journal* 11, no. 3 (1989): 139–148.

35. Matthew I. Cohen, *Performing Otherness: Java and Bali on International Stages, 1905–1952* (New York: Palgrave Macmillan, 2010), 34.

36. Agata Łuksza, "Kobiecość i nowoczesność w polskiej rewii międzywojennej," *Didaskalia* 124 (2014): 18.

37. Anna Chevalier was of Tahitian/French ancestry and had starred in the Hollywood production *Tabu* (dir. F. W. Murnau [Los Angeles: Murnau-Flaherty Productions, 1931]), which was the inspiration for *Black Pearl*. See Sean Brawley and Chris Dixon, *Hollywood's South Seas and the Pacific War: Searching for Dorothy Lamour* (New York: Palgrave Macmillan, 2012), 20.

38. See Adam Uryniak, "Smak orientu i inne przyjemności. Rola filmów przygodowych i morskich w propagandzie II RP," *Kwartalnik filmowy* 95 (2016): 71–83; Natasza Korczarowska-Różycka, "Nie ma Polski bez Sahary! Kolonialne filmy Michała Waszyńskiego," *Kwartalnik filmowy* 92 (2015): 22–42; and Olivia M. Bosomtwe, "Czarna perła. Kino popularne między kolonializmem a nowoczesnością," *Kultura popularna* 1, no. 47 (2016): 146–158. Later, in 1937, Waszyński also directed *Der dibek* (*The Dybbuk*), in which the dance of death performed by a woman is also highly erotic—"the image of the virgin bride dancing with death," in Ira Konigsberg's interpretation. See Ira Konigsburg, "'The Only "I" in the World': Religion, Psychoanalysis, and 'The Dybbuk,'" *Cinema Journal* 36, no. 4 (1997): 22–42.

39. For a recent exploration of the Israeli desert as a symbolic landscape with ambivalent meanings, see Yael Zerubavel, *Desert in the Promised Land* (Stanford, Calif.: Stanford University Press, 2018).

40. Aleksandra Geller, "'Di Ufgabn Fun Yidishizm': Debates on Modern Yiddish Culture in Interwar Poland," *Colloquia Humanistica* 2 (2013): 59–78.

41. Gil Eyal, *The Disenchantment of the Orient: Expertise in Arab Affairs and Israeli State* (Stanford, Calif.: Stanford University Press, 2006), 55. See Yaron Peleg, *Orientalism and the Hebrew Imagination* (Ithaca, N.Y.: Cornell University Press, 2005).

42. Weinberg, "Pieśniarka jemenicka Bracha Zfira w Warszawie," 4.

43. "Brakha Tsfira shabes tsunakht in shtot teater," *Grodner moment (ekspres)*, November 15, 1929, 16.

44. "Brakha Tsfira," *Brisker vokhenblat*, November 22, 1929, 4.

45. Kipnis, "Brakha Tsfira," 6.

46. "Fun vokh tsu vokh," 18.

47. Philip V. Bohlman, *Jewish Music and Modernity* (Oxford: Oxford University Press, 2008), 44–47.

48. Julian Pulikowski, "Idelsohn A. Z. 'Hebräisch-orientalischer Melodienschatz' Bd. 1–4, Lipsk—Jerusalem 1912–1923, 'Jewish Music in Its Historical Development' Nowy Jork 1929: Reviews," *Polski Rocznik Muzykologiczny* 1 (1935): 173–182.

49. Lewis A. Erenberg, *Swingin' the Dream: Big Band Jazz and the Rebirth of American Culture* (Chicago: University of Chicago Press, 1999), xiii.

50. Weinberg, "Pieśniarka jemenicka Bracha Zfira w Warszawie," 4.

51. Motti Regev and Edwin Seroussi, *Popular Music and National Culture in Israel* (Berkeley: University of California Press, 2004), 196; Jehoash Hirshenberg, "The Vision of the East versus the Heritage of the West: Ideological Pressures in the 'Yishuv' Period and Their Offshoots in Israeli Art Music during the Recent Two Decades," *Min-Ad: Israel Studies in Musicology Online* 4 (2005): 95.

52. Kipnis, "Brakha Tsfira," 6.

53. "Żydowska 'śpiewaczka ludowa' z Arabji," *Kurjer Poznański*, November 18, 1929, 8.

54. He was not the only musicologist fascinated with Górale music; so, too, was Adolf Chybiński. See Alistair Wightman, *Karol Szymanowski: His Life and Work* (New York: Routledge, 2007), 240.

55. Zdzisław Jachimecki, "Siła przyciągania jazzu rewii i filmu," in *Polska, jej dzieje i kultura od czasów najdawniejszych do chwili obecnej. T. 3, Od roku 1796–1930*, ed. Aleksander Brückner (Warsaw: Trzaska, Evert i Michalski, 1932), 937. It is worth noting that right-wing critics viewed jazz as a genre that represented an impurity in Polish culture, since many Polish jazz musicians had Jewish roots. See, for example, "Plaga jazzu i tanga," *ABC*, July 29, 1933, 6.

56. "Żydowska 'śpiewaczka ludowa' z Arabji," 8.

57. "Elkhanan Tsaytlin vegn Brakha Tsfira," *Grodner moment (ekspres)*, November 12, 1929, 8.

58. "Wieczór pieśniarki jemenickiej Brachy Zfiry," *Nowy Dziennik*, October 17, 1929, 7.

59. "Brakha Tsfira in 'Plutos,'" *Byalistoker lebn*, November 13, 1929, 3.

60. Michael Alexander argues that American Jews who came from Europe remained uncomfortable with their newly acquired, improved social status and were fascinated by jazz music because they wanted to mark themselves as different from White Americans. See Michael Alexander, *Jazz Age Jews* (Princeton, N.J.: Princeton University Press, 2001).

61. Erenberg, *Swingin' the Dream*, 10.

62. Bohlman, *Jewish Music*, 38.

63. Yankev Nisenboym, "Es zingt a yudish kind...," *Lubliner togblat*, December 5, 1929, 3.

64. "Interprets Art of Zion," *Cincinnati Enquirer*, February 21, 1937, 5.

65. "Other Music," *New York Times*, December 21, 1936, 10.

66. "Other Music," 10.

67. "Interpretive Vocalist," *Altoona Tribune*, November 11, 1937, 9.

68. Lawrence R. Samuel, *The American Dream: A Cultural History* (New York: Syracuse University Press, 2012).

69. Zefira, *Kolot rabim*, 17.

CHAPTER 7

Music of "the Foreign Nations" or "Native Culture"

CONCERT PROGRAMMING IN INTERWAR LWÓW AS A DISCOURSE ABOUT JEWISH MUSICAL IDENTITIES

Sylwia Jakubczyk-Ślęczka

The Jewish Music Society (Żydowskie Towarzystwo Muzyczne; JMS) in Lwów (Yid. Lemberik; Ger. Lemberg) was established on November 16, 1919.[1] A few weeks later, audiences were wowed with a performance of Mateusz Bensman's *Palestine Symphony*. The concert was reviewed favorably in the local Polish-language Zionist daily *Chwila* by its music critic, Alfred Plohn, who at the time also started his term as the chairman of the JMS. Plohn especially praised the movement titled *Credo di Palestina*, about which he wrote, "[It] includes Arabic religious melodies and the march is based almost entirely on oriental motifs. This march, presenting the joyful procession of Jews to the newly recovered homeland, is among the most beautiful passages of the whole composition."[2] The emphasis on such self-identification through Orientalizing motives was not unusual and is explored in Magdalena Kozłowska's chapter in this book.[3] Notably, though, the JMS was *not* involved with the organization of this event, as the concert took place in the Lwów Philharmonic Hall, and instead of the orchestra of the JMS, the Municipal Theater's orchestra performed under the baton of the composer.[4]

While Plohn's review draws our attention to the "national" qualities of Bensman's music—an angle appropriate for such an unapologetically Zionist composition being reviewed in a largely Zionist newspaper—the lack of engagement with the performance of the *Palestine* Symphony on the part of the JMS, the overall schedule of the JMS's activities, and Plohn's own approaches to music all hint at a far more nuanced and diverse landscape of Jewish engagement with music in Lwów. As I will demonstrate, the JMS and its successor, the JALS (Jewish Artistic and Literary Society; Żydowskie Towarzystwo Artystyczno-Literackie), did not represent a single ideological or aesthetic platform; rather, these societies served

as an umbrella for the musical activities of the various groups of Lwów Jews, from the advocates of acculturation ("assimilationists") to folkists and Zionists.

The concert programming of the JMS reveals that there was a great deal of tension as to the ideological and aesthetic profile of the society and its role in the larger Jewish community among these factions of the Jewish intelligentsia. At various points during the two decades between 1919 and 1939, we witness how particular groups of voices prevailed and used the concerts as forums for the presentation of their vision of musical Jewishness. A closer scrutiny of cultural policies pursued by the JMS during the years 1919–1925 reveals that its leadership had little interest in supporting "Jewish national music" of the folkist or Zionist flavors. Instead, it preferred performances of mostly Austro-German canonic art music, highlighting the continued ties with Vienna as the cultural center of the region. During the years 1926–1935, as the JALS took over the role of organizing musical activities for Lwów's Jews, the programming became much more heterogeneous, with concerts dedicated to various Jewish repertories (folkloristic, religious, and others) alternating with programs featuring canonic art music or evenings of lighter fare performed by a jazz band, a mandolin orchestra, or barbershop quartet. During the last years before the war, 1936–1939, in response to the growing hostility toward the Jews in Lwów and beyond, the concert programming increasingly affirmed a Jewish national identity as it served to shore up the morale of a community under siege.

These subtle tensions in repertory choices and discourses surrounding the activities of Lwów's Jewish music lovers provide a lens into the aesthetic and ideological map of the city's Jewish communities. The following are some of the key questions I address: What were the cultural policies of the JMS and the JALS during the period under consideration? What does the programming tell us about the leadership's reluctance (or eagerness) to promote Jewish music, understood as works of Jewish composers referencing Jewish topics or Jewish folk tunes? What can we learn from the tensions regarding programming choices about the diverse ways in which segments of Lwów's Jewish intelligentsia understood their Jewish identity? In what way did Lwów serve as a regional center of musical culture, and how did musicians and musical institutions of Lwów conceive of their relationship with the two capital cities of Vienna and Warsaw? To answer these questions, I will primarily draw on the information about Lwów's concert life from *Chwila* (Moment), which covered the full spectrum of the political, economic, and cultural lives of Jews in Lwów. While it regularly reported on the activities of Jewish settlers in Palestine, it was closely attuned to the needs of local Jews, and it also touted Jewish contributions to the vigor of the young Polish state. I will carefully analyze the concert repertories of the two societies as reported in the Polish-language Zionist *Chwila*, treating them as sources of information about the self-identification that prevailed in the societies during distinct periods. In examining the shifts in the programming of concerts sponsored by the JMS and the JALS, it is necessary to recall the historical events and specific local policies of the interwar years in which the musical life of Lwów Jews developed.[5] Thus, I will discuss and interpret these findings in a broader cultural, social, and political context.

Elevating the Austro-German Musical Canon (1919–1925)

Dubbed "the most musical of Polish cities" by the well-known musicologist Adolf Chybiński, interwar Lwów boasted an exceptionally rich music scene, supported by dozens of music schools, including a renowned conservatory, music societies and other institutions, numerous concert venues, and a splendid opera house.[6] Its musicians excelled in genres ranging from popular to modernist art music. From the very beginning of the interwar period, Lwów's musical circles, weary of the potential of being tagged as a cultural periphery, tried to underscore the city's importance in relation to (and independent of) the capital city of Warsaw and other musical centers of Poland. They also sought to demonstrate regional leadership by organizing, for example, in 1922, a "society of societies," the Association of Jewish Music and Choral Societies in Galicia (Związek Żydowskich Towarzystw Muzycznych i Śpiewaczych w Galicji). In that year, the association included representatives of music societies from Lwów, Kraków, Przemyśl, and Stanisławów (and perhaps additional cities). Lwów clearly asserted itself as the musical center of Galicia, with its delegates predominating and Plohn serving as the chairman. The second gathering of the association took place in 1924 in Przemyśl, but Kraków was no longer represented. Perhaps this absence can be taken to reflect the rivalry between the two major cities of Galicia for regional leadership in the area of music, which can be also noted in other contexts. There are no further mentions of this association, and the initiative collapsed in 1924.

The JMS was established immediately after the Polish-Ukrainian Battle of Lwów (November 1918 to May 1919). During the society's earliest years, its musical policy reflected the strategies of the Jewish political leadership in Galicia. The principal figure representing the interests of Galician Jews during this fraught period was Leon Reich, a respected Lwów lawyer, a Zionist leader, a contributor to *Chwila*, and one of the most influential Jewish politicians in interwar Poland. His main objective was to improve the day-to-day situation of the Jews—a goal that the Zionist leaders described as Gegenwartsarbeit (work for the present). To achieve this, he postulated the need for cooperation with the Polish government.[7] The musical activities of the JMS both supported and benefited from this policy. While the members of the JMS—mostly Jewish amateurs and professional musicians—gained the opportunity to perform and hear the music they loved, the programming of the canonic "high art" repertory served to dispel the stereotypical image of Jews as uncivilized outsiders to European culture.[8] This aligned with the broader agenda articulated in the previous century by integrationists who pursued inclusion and full citizenship for Jews while accepting the need to modernize Jewish religious practice. To meet these goals, the leaders of the JMS turned to the Austro-German repertory of art music that was native to the Germanized Jewish middle class of Lwów, mostly eschewing the rich French, Italian, and Russian traditions.[9] In highlighting this repertory, the JMS continued to affirm Lwów's connection to Vienna as Galicia's cultural center. There was also a nod toward the new government's aspirations to establish a Polish identity in symphonic music

and develop musical connections with Warsaw as the center of Polish culture: a sprinkling of nationally themed compositions by Polish composers, such as Władysław Żeleński's characteristic overture *W Tatrach* (In the Tatra Mountains) and several performances of Mieczysław Karłowicz's symphonic poem *Stanisław i Anna Oświecimowie* (Stanisław and Anna Oświecim), the title reflecting the names of the star-crossed sibling lovers from a legend first recorded in the early nineteenth century.

Right after the JMS's inaugural concert, dedicated in its entirety to compositions of Mozart, an article about the society by Henryk Trejwart was published in *Chwila*. Trejwart was the pen name of Henryk Ignacy Hescheles, a regular contributor to and ultimately the chief editor of the journal. A member of a Lwów intelligentsia family that fully embraced acculturation, Hescheles was a Jewish activist and a Polish patriot who served in the Polish Legions during the First World War.[10] During the interwar period, he continued to contribute his efforts on behalf of several civic organizations, including serving several terms on the municipal council of Lwów. Hescheles's article offers a glimpse of the expectations some members of the Lwów Jewish intelligentsia had for the society at its conception:

> It is unfortunate that the love Jews had for the culture of the people among whom they lived distanced them from their native culture. Their role in building the edifice of European civilization has never been appreciated sufficiently. The fruits of their work were regarded as the heritage of the foreign nations [the gentiles among whom they lived]; Jewish workers never have seen a glimmer of gratitude or appreciation. This is why the organization of Jews' cultural work, both in the field of Jewish art as well as general civilizing efforts, is the duty of all Jewish people. Only in this way will the Jewish people be able to highlight their own contributions to the achievement of progress, only in this way will they demonstrate the vital agency of the Jewish element in the spiritual life of humankind. In this spirit, the establishment of the JMS in Lwów should be met with the highest appreciation.[11]

According to Hescheles, the role of the JMS was to showcase specifically Jewish art and Jewish musical contributions to European culture while continuing to participate in "general civilizing efforts." But the actual programming of the JMS concerts during the first years of its existence demonstrates that the orchestra focused on performing Western art music, mostly of the Austro-German provenance, with only a sprinkling of works by Jewish composers from the Austro-German tradition: Mendelssohn, Mahler, Goldmark, and Korngold.[12] Absent from this repertory are compositions that, like Bensman's *Palestine* Symphony, employ specifically Jewish topics. Table 7-1 shows the programs of concerts performed by the JMS symphonic orchestra led by Natan Hermelin (1878–1941). A lawyer by profession, Hermelin was a skilled violinist who throughout his life performed in chamber and symphonic ensembles.

TABLE 7-1

CONCERTS OF ART MUSIC PERFORMED BY THE JMS SYMPHONIC
ORCHESTRA LED BY N. HERMELIN (1919–1930)

Time and place	Concert's title and its repertory	Source of information
1/12/1920 NA	**Inaugural Concert Dedicated to the Works of W. A. Mozart** Violin Sonata in C major, K. 6 Piano Sonata in A major Fantasie in D minor String Quartet in D minor Arias and songs	*Chwila* 1/11/1920, 6
2/9/1920 NA	**Inaugural Concert Dedicated to the Works of W. A. Mozart** Violin Sonata in C major Piano Sonata in B-flat major Fantasie in D minor String Quartet in D minor "Pieśń Wieczorna" for men's chorus Aria from *The Marriage of Figaro* The song "Das Veilchen"	*Chwila* 2/2/1920, 7 2/4/1920, 6 2/12/1920, 4–5
5/30/1920 Lwów Philharmonic	**The First Symphonic Concert** Symphony in G minor, W. A. Mozart Serenade op. 2, M. Karłowicz Harpsichord Concerto in D minor, J. S. Bach	*Chwila* 5/23/1920, 6 6/1/1920, 4
10/24/1920 Galician Music Society	**The Second Symphonic Concert** *The Hebrides* Overture, F. Mendelssohn 2nd Symphony, J. Brahms Symphony in B minor, F. Schubert	*Chwila* 10/27/1920, 3
12/17/1920 Galician Music Society	**Concert Dedicated to the Works of L. van Beethoven** Overtures *Egmont* and *Leonora III*, 5th Symphony	*Chwila* 12/15/1920, 6
3/6/1921 NA	**The Fourth Symphonic Concert** *Sakuntala* Overture, K. Goldmark *W Tatrach*, W. Żeleński Violin Concerto in G minor, M. Bruch	*Chwila* 3/2/1921, 6 3/11/1921, 4

(CONTINUED)

TABLE 7-1 (CONTINUED)

Time and place	Concert's title and its repertory	Source of information
6/12/1921	**The Sixth Symphonic Concert**	*Chwila*
JMS	Symphony no. 3, *Scottish*, F. Mendelssohn	6/4/1921, 5
	Symphony no. 2, J. Brahms	
12/18/1921	**The Second Symphonic Concert**	*Chwila*
NA	Symphony no. 1, J. Brahms	12/23/1921, 4
	Overture to *Oberon*, C. M. von Weber	
	Death and Transfiguration, R. Strauss	
NA	**Concert Dedicated to the Works of J. Strauss II**	*Chwila* 1/19/1922, 4
	Overture to *The Gypsy Baron* and *Die Fledermaus* waltzes	
	Tales from the Vienna Woods op. 325	
	Wine, Women and Song op. 333	
	The Blue Danube op. 341	
	Spring's Voices op. 410	
4/30/1922	**The Third Symphonic Concert**	*Chwila*
Lwów Philharmonic	Overture to *Oberon*, C. M. von Weber	4/21/1922, 4
	Symphony no. 9, *From the New World*, A. Dvořák	5/5/1922, 5
	Scheherazade, N. Rimsky-Korsakov	
6/5/1922	**The Fourth Symphonic Concert**	*Chwila*
Polish Society for Music (PSM)	Symphony no. 1, J. Brahms	6/4/1922, 5
	The Hebrides Overture, F. Mendelssohn	6/9/1922, 5
	"Forest Murmurs" from *Siegfried*, R. Wagner	
1/14/1923	**Concert Dedicated to the Works of R. Wagner**	*Chwila*
2/4/1923	Excerpts from *Parsifal* and *Twilight of the Gods*	1/6/1923, 6
PSM	Overture to *Rienzi*	1/10/1923, 5
	Prelude to *Tristan and Isolde*	
4/15/1923	**The Second Symphonic Concert**	*Chwila*
NA	*Romeo and Juliet*, P. Tchaikovsky	4/13/1923, 3
	Stanisław i Anna Oświecimowie, M. Karłowicz	4/19/1923, 4
	Symphony in G minor, W. A. Mozart	

(continues)

MUSIC OF "THE FOREIGN NATIONS" OR "NATIVE CULTURE" 133

Time and place	Concert's title and its repertory	Source of information
7/1/1923 NA	**Symphonic Concert** Fantasy Overture *Romeo and Juliet*, P. Tchaikovsky *Stanisław i Anna Oświecimowie*, M. Karłowicz Excerpts from R. Wagner's works	*Chwila* 6/30/1923, 4 7/1/1923, 6
3/9/1924 3/30/1924 Yad Charutzim	**Symphonic Concert** *Leonora III* Overture, L. van Beethoven *Sakuntala* Overture, K. Goldmark Symphony no. 4, G. Mahler	*Chwila* 3/24/1924, 4 3/28/1924, 4
12/21/1924 12/26/1924 PSM	**Symphonic Concert** Symphony no. 3, J. Brahms *Stanisław i Anna Oświecimowie*, M. Karłowicz Vorspiel to *Parsifal*, R. Wagner	*Chwila* 12/15/1924, 8 12/25/1924, 7
5/30/1926 PSM	**Symphonic Concert (JALS)** Overture to the opera *Alceste*, C. W. Gluck Symphony no. 4, G. Mahler "Dance-Song of Pierrot" from the opera *The Dead City*, E. W. Korngold Excerpts from the opera *Der Rosenkavalier*, R. Strauss	*Chwila* 5/21/1926, 9 5/28/1926, 11
5/15/1927 PSM	**Concert Dedicated to the Works of L. van Beethoven (JALS)** *King Stephen* Overture Symphony no. 7 Piano Concerto in C minor	*Chwila* 5/16/1927, 10 5/18/1927, 6

In contrast, during the same period, the choir of the JMS overtly engaged with Jewish repertory. They presented music composed throughout the nineteenth century for use in progressive synagogues, such as the works of Salomon Sulzer and Louis Lewandowski, and choral arrangements of Yiddish folk songs. The latter repertory was advocated by composers who were dubbed by their contemporaries as the Jewish National School in Music and were closely associated with the St. Petersburg Society for Jewish Folk Music and its offshoots.[13] Thus, in programming this repertory, the JMS connected to artists associated with St. Petersburg, later Berlin, which served as centers of the activities of the Society for Jewish Folk Music. The compositions programmed by the JMS choir were closely tied to folklore research conducted by the Society for Jewish Folk Music, as their composers understood musical Jewishness to manifest mainly in folk tunes. The JMS choir led by Izrael Fajwiszys (1887–1943) included arrangements of Jewish folk songs and synagogue compositions in nearly all its concerts, as shown in table 7-2.

The actions of the leadership of the JMS clearly demonstrate its preference for the kind of concerts performed by the orchestra over those of the choir. As a result, the choir remained under the auspices of the JMS for only two years, while the orchestra continued to perform for eight. The efforts of the orchestra's conductor Natan Hermelin were consistently appreciated and praised by Plohn in the local Zionist press, while he admonished Fajwiszys—who soon was to be known as one of the best choral conductors in Poland—to pay more attention to classical repertory. In this vein, encouraged by Fajwiszys's inclusion of excerpts from Handel's and Mendelssohn's oratorios in the JMS's choral concert, Plohn expressed his hope that "a further successful development of the choir will allow the conductor to prepare the performance of a larger composition," which obviously meant the desire for a presentation of a full oratorio.[14]

Fajwiszys, who was brought by the leadership of the JMS to Lwów on the promise of his engagement with Yiddish-language folkloristic choral repertory and who introduced himself to his new audience by accompanying a concert of Abraham Znajda's Jewish folk song arrangements, was unable to thrive under these constraints.[15] As the musicologist Isaschar Fater explains, there was little opportunity for Fajwiszys to shape the repertory: "The choir which he conducted was forced to follow a course laid by others.... The overall atmosphere in Lwów did not reflect his mental attitude and certainly not his dynamic character."[16] This stifling environment was the reason for Fajwiszys's leaving Lwów after only eighteen months of working for the JMS (from November 1920 to April 1922). Immediately after his departure, Plohn admonished the next choir conductor that "future evenings [choral concerts] should be dedicated in their entirety to the œuvre of one composer, a certain epoch or present the history of the development of one music form."[17] This statement draws attention to the repertory preferences of the society's leadership: it indicates a rejection of Fajwiszys's heterogeneous programming style and desire for more homogeneous concerts—focused on one composer, one period of music, or a historical presentation of a musical genre—characteristic of the art-music performances of the time. Moreover, the endorsement of such homogenous concerts and the preference for large choral works (oratorios) imply a shift toward the choral repertory of art music.

Thus, rather than featuring music that would underscore an ethno-national Jewish identity that was separate from that of other Europeans, the JMS's concert programming emphasized the participation of Jewish musicians and audiences in mainstream musical heritage. At the same time, the programming of compositions of Mendelssohn, Mahler, Goldmark, and Korngold—composers who were Jewish or perceived as Jewish—drew attention to the contributions of Jewish masters to this heritage. While this strategy was consistent with the agenda embraced by the proponents of acculturation, it did not align with the views of other segments of the Jewish population of Lwów. Some members of Lwów's Jewish public expected the JMS to foster a closer connection to the community's cultural and religious life. But their requests for musical support for the events they organized met with refusals from the JMS's leadership. As early as 1920, the JMS announced that

TABLE 7-2

CONCERTS PERFORMED BY THE JMS CHOIR (1919–1925)

Time and place	Concert's title and its repertory	Source of information
NA	**The First Choral Concert of JMS**	*Chwila*
	"Evening Song," C. Gounod	3/25/1921, 4
	"Ave Verum," W. A. Mozart	
	"Rozpacz" and "Kosiarz," J. Gall	
	"Piękna Mylada," R. Schumann	
	Excerpts from oratorios by G. F. Handel and F. Mendelssohn	
	"Kol Nidre," M. Bruch	
	Jewish folk songs	
	"Liulinku," L. Low	
12/27/1921	**Hanukkah Concert**	*Chwila*
1/1/1922	Synagogue compositions by S. Sulzer, L. Lewandowski, J. Halévy, N. Blumenthal, and A. Dunajewski	12/25/1921, 4
Tempel Synagogue		12/29/1921, 5
	Finale from Sonata in G minor by A. Guilmant	12/31/1921, 5
	Organ works by L. Boëllmann and J. Rheinberger	
2/5/1922	**The First Congress of the Delegates of Jewish Music and Choral Societies from Galicia**	*Chwila*
R. Melzer Orphanage		2/9/1922, 5
	"Hallelujah," L. Lewandowski	CDIAU[1].
	Jewish folk songs performed by the JMS choir conducted by I. Fajwiszys	701, op. 3, sprava 457,
	"On Jewish Folk Song," paper by I. Fajwiszys	p. 103
4/9/1922	**Concert of the JMS Choir**	*Chwila*
Lwów Philharmonic	Synagogue, folk, and Palestinian songs, including Psalm by Blumenthal for mixed choir	4/5/1922, 4
		4/13/1922, 4
	"A Dudele," L. Low	
	"Kaddish," arranged by I. Fajwiszys	
11/26/1922	**The First Concert of the JMS Choir**	*Chwila*
JMS	Cello Concerto, G. Goltermann	11/26/1922, 5
	Songs (including "Jägerchor") by F. Schubert	12/1/1922, 5
	Ballade by L. Low	
1/21/1923	**The Second Concert of the JMS Choir**	*Chwila*
JMS	German songs	1/21/1923, 5
		1/27/1923, 6

1. The Central State Historical Archive of Ukraine in Lviv.

"because the preparation of their own concerts will completely absorb JMS's forces, [the leadership] decided not to accept invitations for participation in concerts and events sponsored by other associations. . . . Eventually the society agreed to make its mandolin orchestra available for them, since it performs suitable repertory."[18] The society showed a similar lack of interest when it was invited to participate in a jubilee concert of Chune Wolfsthal (1851–1924), a composer of Jewish operettas consisting mostly of klezmer tunes. Although, in the end, the orchestra took part in the concert, it was the only performance of the JMS symphonic orchestra from which its conductor, Hermelin, was absent.[19]

The narrow scope of concert programming and continuing refusals to interact with a broader range of religious and cultural activities of the Lwów Jewish public began the JMS's process of disintegration. The choir ceased to exist already in 1922, soon after Fajwiszys's departure. In 1924, the mandolinists decided to leave the JMS and establish a new Jewish music society, referenced in *Chwila* as Yuval.[20] At the same time, the symphony orchestra concerts attracted smaller and smaller audiences. In January 1924, Bernard Meyer complained in the press, "The Sunday symphonic concert of the JMS—the first of this season—attracted few listeners to the hall of the Polish Society for Music, even though neither the program nor its performance justified the reticence of audience. . . . The fault must be sought in the indifference of the audience who . . . left such a highly cultured Society high and dry, with a huge deficit."[21] The last concert of the JMS symphonic orchestra took place in December of 1924. Soon after, the society was dissolved. In its place, a musical section was created within the new Jewish Artistic and Literary Society (JALS). The JMS symphonic orchestra under the baton of Hermelin performed under the auspices of the new organization only twice and after that all but disappeared from the musical life of Lwów.

Connecting with the Broader Community (1926–1935)

The conflict that led to the dissolution of the JMS coincided with a crisis in Polish political life that had a far-reaching impact on the Jewish community. In 1926, because of the May Coup, the real power in Poland shifted into the hands of Marshal Józef Piłsudski. At the same time, within the Jewish leadership in Galicia, there was a growing conflict between Reich and Zionist leader Izaak Grünbaum, who was now less trusting of the Polish government's guarantees of Jewish rights.[22] The situation was further complicated by the central government's failure to fulfill promises to the club of Jewish delegates in the Polish Sejm, chaired by Reich.[23] This led to Reich's resigning his position in the Sejm and a decline in his authority. These political shifts might have contributed to the unwinding of the concerted effort to project an aura of acculturation through the programming of art music at the JMS that took place during the early 1920s. The heterogeneity of the JALS's concert programming during the first decade may be also understood as a reflection of the overall openness of the cultural milieu during the Sanacja era. At the JALS, the years 1930 to 1935 brought many new musical initiatives that often went contrary to

the cultural policy of the JMS. These were also the last five years when Poland's Jews were able to thrive in an atmosphere of relative political stability and acceptance.

By 1930, as the work of the musical section of the JALS picked up momentum, its activities were driven by the choir. In fact, the symphonic orchestra, reactivated that year under the direction of Juliusz Weinberger—a pianist, violinist, and conductor, who was among the founders of the JMS—performed only with the vocal ensemble, never independently. The programs shown in table 7-3 demonstrate that the JALS's choir and symphonic orchestra consistently promoted a Jewish repertory of folk song arrangements, religious choral compositions, Yiddish-language operettas, and art music inspired by Jewish topics. Many performances were devoted in their entirety to such music. While the canonic repertory of German and Austrian symphonic music was still programmed with some regularity, arrangements of Jewish folk songs also made appearances in these concerts.

TABLE 7-3

AN OVERVIEW OF CONCERTS OF THE JALS CHOIR AND SYMPHONY ORCHESTRA (1930–1935)

Time and place	Concert's title and its repertory	Source of information
NA	**Ceremony in Memory of Y. L. Peretz (with the Participation of the JALS Men's Choir)**	*Chwila* 4/20/1930, 12
	Becci, *Requiem*	
5/25/1930 Ukrainian Theater	**The Concert of the JALS Choir and Symphony Orchestra**	*Chwila* 5/11/1930, 14
	W. A. Mozart, K. M. Weber, I. J. Paderewski, [J.?] Strauss	5/15/1930, 12
	Jewish folk songs	5/21/1930, 12
6/9/1930 Ukrainian Theater	**The Concert of the JALS Choir and Symphony Orchestra**	*Chwila* 6/6/1930, 13
	Symphony in G minor, W. A. Mozart	6/12/1930, 15–16
	Overture to *Oberon*, K. M. Weber	
	Compositions by I. J. Paderewski and S. Rachmaninov	
	Overture to *Die Fledermaus*, J. Strauss	
	Jewish folk songs arranged by I. Heilman	
10/10/1930 JALS	**Ceremony in Memory of Prof. Simon Dubnow (with the Participation of the JALS Mixed Choir)**	*Chwila* 10/11/1930, 13
	NA	

(CONTINUED)

TABLE 7-3 *(CONTINUED)*

Time and place	Concert's title and its repertory	Source of information
NA Institute of Technology	**The Concert of the JALS Choir and Symphony Orchestra** Jewish and Hebrew songs (including "Duo Hemerl," "Mikhtav," "Halayla Ba," "Boi-na Yaldati," "Beryoskele," and "Shloyf Mayn Kind") Synagogue music (including "Ohavti" by A. Dunajewski and "Halleluiah" by L. Lewandowski) Works by F. Mendelssohn	*Chwila* 4/11/1931, 7
11/17/1931 JALS	**Ceremony in Memory of H. D. Nomberg (with the Participation of the JALS Mixed Choir)** NA	*Chwila* 11/18/1931, 14
12/8/1931 Koloseum Theater	**Jubilee Celebration of Jewish National Fund (with the Participation of the JALS Choir and Orchestra)** NA	*Dos fraye vort* 12/11/1931, 1
1/20/1932 Lwów Radio	**Concert of Jewish and Hebrew Songs Performed by JALS Choir** NA	*Chwila* 1/21/1932, 13
3/19/1932 Jewish Women's Circle	**Concert of Jewish Songs** NA	*Chwila* 3/20/1932, 16
6/4/1932 Yad Charutzim	**Charity Concert of the JALS Symphony Orchestra and Mixed Choir for Patients in the Jewish Hospital** *The Hebrides* Overture, F. Mendelssohn Symphony in D major, J. Haydn "Halleluiah," G. F. Haendel Aria "Caro mio ben" from *Simon Boccanegra*, G. Verdi "Death and the Maiden," F. Schubert Jewish and Hebrew Songs (including *S'u Sh'arim*), S. Naumbourg	*Chwila* 6/4/1932, 13 6/10/1932, 9

Time and place	Concert's title and its repertory	Source of information
6/11/1932 Lwów Radio	**Concert of Jewish and Hebrew Songs Performed by JALS Choir** NA	*Chwila* 6/16/1932, 12
4/2/1933 Jewish Community Center	**Ceremony on the Occasion of the 30th Anniversary of the Work of Prof. Majer Bałaban (with the Participation of the JALS Mixed Choir)** NA	*Chwila*: 4/3/1933, 15
6/10/1933 Yad Charutzim	**Jewish Music Concert of the JALS Symphony Orchestra and Mixed Choir** Synagogue, folk, and Hebrew songs Excerpts from the oratorio *Messiah*, G. F. Handel	*Chwila* 6/11/1933, 16 6/16/1933, 2

It seems that during this period, the integrationist faction lost the battle against Jewish folk songs. Even Radio Lwów broadcasted arrangements of Jewish and Hebrew tunes performed by the choir led by Izaak Heilman.

At the same time, new ensembles appeared during the JALS's concerts and social gatherings. As early as 1927 and 1928, the JALS organized a few dance events with the participation of the jazz band Atlantic from Lwów's Café de la Paix.[24] In 1929, the mandolin orchestra returned to the musical stage of Lwów.[25] Popular music was also programmed by the newly established chamber orchestra that continued to perform in Lwów until 1939. In addition to its regular programming, the JALS chamber orchestra provided the sort of outreach to the broader Jewish community that the leadership of the JMS had snubbed in the previous decade. The orchestra served multiple constituencies that required concerts for special occasions—celebrations of religious holidays, such as Hanukkah and Purim, and commemorative, charitable, or political events, to name some. Table 7-4 lists those concerts of the chamber orchestra for which specific program information is available. More broadly, members of musical circles associated with the JALS often teamed up with the performers of traditional Jewish music—for example, cantor Jakub Kusewicki and singers Maks Lew and Jacek Kronland.[26] The society also promoted historical knowledge by hosting a series of lectures on Jewish musical heritage, including Chaim Knopping's four-part musical readings in 1930 and Weinloes's lecture on "Badchens, Broder Singers."[27]

TABLE 7-4

AN OVERVIEW OF CONCERTS OF THE JALS CHAMBER ORCHESTRA (1930–1939)

Time and place	Concert's title and its repertory	Source of information
[2/2/1930?] Koloseum Theater	**Concert of the JALS Chamber Orchestra** *Caucasian Sketches* Suite, M. Ippolitov-Ivanov *Indian Suite* op. 90, B. Lüling *In a Persian Market*, A. Ketèlbey	*Chwila* 2/7/1930, 14
5/5/1931 JALS	**Concert of the JALS Chamber Orchestra** Compositions by F. Schubert, B. Kéler, A. Ketèlbey, etc.	*Chwila* 5/4/1931, 15
NA JALS	**Concert of Folk Songs by the JALS Choir and Chamber Orchestra** NA	*Chwila* 1/18/1932, 16
1/30/1932 Nowości Theater	**Concert of Jewish Folk Songs** Jewish songs and dances arranged by I. Heilman	*Chwila* 1/30/1932, 13
NA Nowości Theater	**Concert Showcasing Pupils of the Jewish Orphanage** NA	*Chwila* 2/10/1932, 12
3/19/1932 Jewish Academic House	**Artistic Performance and Dance Event for Ḥibat Tsiyon** NA	*Chwila* 3/18/1932, 13
4/12/1932 JALS	**Concert of the JALS Choir and Chamber Orchestra** *S'u Sh'arim*, S. Naumbourg *Bas Yerushalayim*, Ch. Wolfsthal	*Chwila* 4/14/1932, 13
5/15/1932 Marysieńka Cinema	**Palestinian Feast with the JALS Choir and Chamber Orchestra** Jewish and Hebrew songs Works for choir and orchestra	*Chwila* 5/9/1932, 16
5/21/1933 Koloseum Theater	**Palestinian Feast with the JALS Choir and Chamber Orchestra** Jewish, Hebrew, Hasidic, and other songs	*Chwila* 5/21/1933, 16
12/17/1933 Jewish Sports Club Makkabi	**Hanukkah Feast** Jewish, Hebrew, Hasidic, and Palestinian songs	*Chwila* 12/17/1933, 16

Time and place	Concert's title and its repertory	Source of information
3/3/1935 Yad Charutzim	**JALS Chamber Concert** Aria from the opera *La bohème*, G. Puccini *Córdoba*, I. Albeniz *Caprice espagnol*, M. Moszkowski *Spanish Dance (Serenade espagnole*?), C. Chaminade Overture to *Bas Yerushalayim*, Ch. Wolfsthal "On Sabbath Eve," fantasie on Jewish folk songs, D. Dauber	Chwila 2/28/1935, 10 3/5/1935, 7
6/10/1935 Yad Charutzim	**JALS Chamber Concert** Italian songs	Chwila 6/7/1935, 10
12/12/1936 The Regional Artisan Organization	**Hanukhah Concert Organized by the Regional Artisan Organization (with the Participation of O. Barbasch's Jazz Band and the JALS Chamber Orchestra)** Jewish music Dance event	Chwila 12/8/1936, 10 12/12/1936, 14
1/2/1937 The Regional Artisan Organization	**Jewish Music Concert Organized by the Regional Artisan Organization** Compositions by Ch. Wolfsthal Fantasies on Jewish folk songs	Chwila 1/2/1937, 13 1/14/1937, 10
1/31/1937 Koloseum Theater	**The Evening of Jewish Songs for the Ezrah Organization** NA	Chwila 1/24/1937, 13
12/4/1937 The Regional Artisan Organization	**Hanukkah Concert Organized by the Regional Artisan Organization** Concert Dance event	Chwila 12/1/1937, 10
12/17/1938 [The hall of the Professional Association of Painters, Varnishers, and Dyers?]	**Hanukkah Concert Organized by the Regional Artisan Organization (with the Participation of A. Awin's Jazz Band and the JALS Chamber Orchestra)** Concert Dance event	Chwila 12/14/1938, 10
12/23/1938 Nowości Theater	**Concert Dedicated to Abraham Goldfaden's Works** NA	Chwila 12/22/1938, 10
4/9/1939 Nowości Theater	**Ceremony for the 50th Anniversary of Jewish Theater in Lwów** Songs by A. Goldfaden Compositions by Ch. Wolfsthal Goldfaden's melodies arranged for an orchestra	Chwila 4/5/1939, 9

The new cultural policy of the JALS was successful. Judging from press reviews, the JALS's concerts attracted Jewish audiences in droves. The diverse programs appeared to have been aimed at different segments of Lwów's Jewish population and served a variety of needs, from entertainment to commemoration. Overall, there was a new openness to unmistakably Jewish repertoires as well as to popular jazz and dance genres that swept through Europe at the time. Under the auspices of the JALS, the establishment of the barbershop quartet Ami Shir led by Heilman, which was probably modeled on such popular barbershop quartets in interwar Poland as Chór Dana or Chór Eryana, likewise might have been the result of this pronounced interest in popular repertory.

We have some indications that the ensembles that thrived under the aegis of the JALS maintained high artistic standards. For example, in 1932, the JALS choir's concerts were twice broadcasted by the Lwów radio station—the Lwów [Radio] Wave (Lwowska Fala), famous throughout the country and beloved by its listeners. These performances were led by Heilman, whose extant compositions for the synagogue and arrangements of folk songs also attest to his compositional proficiency and sincere engagement with the music.[28] On the eve of the first radio concert of the JALS choir, Alfred Plohn praised the ensemble and its conductor in *Chwila*: "As a talented musician and a conductor who is full of enthusiasm and energy, Mr. Heilman was able to create a disciplined and well-coordinated ensemble, which with apparent passion devotes itself to the noble art of collective singing, cultivating, above all, the native Jewish and Hebrew song. Well-chosen voices sound fresh and beautiful, and the purity of intonation, rhythmic certainty, and skill in bringing out dynamic effects are virtues that bring pride to both the entire ensemble and its excellent conductor."[29]

His success at the JALS notwithstanding, in 1933, Heilman left and devoted his attention to his own Jewish music society under the name Yuval (Pol. Juwal).[30] It is not clear whether this was caused by tensions with the leadership of the music section of the JALS or if there were other reasons, but Heilman turned back to an idea he first started to implement around the time he began to work for the JALS. Yuval was registered by the Heilman brothers at the Lwów Province Office on April 1, 1931.[31] At the time, Heilman abandoned the idea of developing this organization and instead decided to work under the auspices of the JALS. Members of the JALS choir followed Heilman to Yuval; the barbershop quartet he established at the JALS also moved to its new home. Soon after, he established a brass orchestra that morphed into a chamber orchestra.[32] The new society flourished between 1933 and 1935; at the same time, the JALS's musical endeavors lost momentum. One can observe the shift by tracing the JALS's and Yuval's concert activities: after the twelve concerts of the JALS choir and orchestra documented in *Chwila* between 1930 and 1933, the journal recorded seventeen musical events showcasing Yuval's ensembles between 1933 and 1935.

It appears that Heilman's decision to leave the JALS was caused by the society's choice to return to the earlier cultural policy that prioritized the canonic Western

repertory and privileged professional musicians. The year 1933 witnessed the reappearance of the symphony orchestra, now led by Marceli Horowitz, and signaled a change in the society's cultural policy work, away from the folkloristic and synagogue choral repertories that Heilman held so dear. As had happened earlier with Fajwiszys, the faction supporting canonic Western music made programming Jewish-themed concerts all but impossible. The concert repertory, reproduced in table 7-5, attests to this shift.

TABLE 7-5

CONCERTS OF THE JALS SYMPHONY ORCHESTRA LED BY M. HOROWITZ (1933–1936)

Time and place	Concert's title and its repertory	Source of information
4/23/1933	**Symphonic Concert**	*Chwila*
PSM	*Alceste*, C. W. Gluck	4/23/1933, 17
	The Hebrides Overture, F. Mendelssohn Symphony no. 3, *Coriolan* Overture, and aria "Ah, Perfido," L. van Beethoven	4/28/1933, 10
4/22/1934	**Symphonic Concert**	*Chwila*
PSM	Overture to *Iphigenia in Aulis*, C. W. Gluck	2/18/1934, 17
	Symphony no. 1, J. Brahms	4/19/1934, 14
	Piano Concerto in E-flat major, W. A. Mozart	4/25/1934, 12
	Night on Bald Mountain, M. Mussorgsky	
4/11/1935	**JALS Symphonic Concert**	*Chwila*
PSM	Symphony no. 4, F. Schubert	3/27/1935, 10
	Piano Concerto in A major, F. Liszt	4/4/1935, 10
		4/13/1935, 11
	Suite *Pulcinella*, I. Strawinsky	
	Overture in G minor, A. Brückner	
10/29/1936	**JALS Symphony Concert**	*Chwila*
PSM	*Egmont* Overture, L. van Beethoven	10/24/1936, 13
	Symphony no. 3, J. Brahms	10/28/1936, 9
	Suite *Bergamasque*, C. Debussy	11/5/1936, 8
	Piano Concerto in C minor, W. A. Mozart	10/26/1936, 4 (evening edition)
		10/31/1936, 12 (evening edition)

Elevating Musical Jewishness (1936–1939)

After Piłsudski's death in 1935, relations between Jews and non-Jews in Poland rapidly deteriorated. Jews were increasingly excluded from Poland's public life and faced with daily acts of antisemitism. To the west in Hitler's Germany, with the enactment of the Nuremberg Laws in the fall of the same year, antisemitism and racial discrimination were written into the law of the land. Polish Jews watched these developments at home and abroad with a mixture of horror and disbelief as their hopes for achieving full social equality were fading rapidly with the rise of the influence of the right-wing National Democrats (Endecja), whose nationalist ideology made no place for Jews in the Second Republic. These circumstances provide a crucial context for the interpretation of the JALS's musical activities during the years between 1935 and 1939. Already in 1936, a heated debate about how Jewish musicians should interact with their Christian Polish colleagues took place in the circles associated with the JALS. The chairman of the society publicly expressed regret about the lack of opportunities for artistic production, which was caused by barring Jews from access to Polish cultural institutions.[33]

The JALS's concert repertory from 1936 to 1939 (see selected events from this period in table 7-6) demonstrates that during this time, unmistakably national Jewish art music was increasingly performed along the canonic art music repertory. More broadly, concerts were often programmed around a specific theme, such as program music, the oeuvre of one composer, or popular music. The society continued outreach initiatives; a special People's Concert series, designed as a way of bringing inexpensive concerts of accessible art music to the youth and "the masses," was established in 1936.[34] Moreover, while musicians associated with the JALS organized concerts for the society, they also supported the cultural life of the broader Jewish community by participating in events coordinated by other groups: jazz bands led by A. Awin, Ozajasz Barbasch, and Marek Buchsbaum took part in dance soirees, and the choir accompanied by the chamber orchestra played for religious festivals.

The most consequential changes can be observed in the repertory, which increasingly foregrounded music explicitly coded as "Jewish." In the late 1930s, as antisemitic rhetoric in Poland and abroad intensified and anxiety about the future of the Jews took root, the JALS concerts appear to have fostered a stronger sense of musical Jewishness than ever before. Moreover, the programming allowed for a variety of musical expressions of Jewishness. As in the previous years, under Fajwiszys and Heilman, concerts presented choral arrangements of Yiddish and Hebrew folk songs, synagogue music, and excerpts from Wolfsthal's operettas. But programs also featured folklore-inspired instrumental compositions associated with the St. Petersburg Society for Jewish Folk Music and its offshoots, such as the virtuoso piano works by Juliusz Wolfsohn, large art compositions such as Ernest Bloch's *Baal Shem: Three Pictures of Hasidic Life*, for violin and orchestra or violin and piano—invoking the eighteenth-century founder of the Hasidic movement, Rabbi Israel ben Eliezer (1700–1760), known as Baal Shem Tov (master

MUSIC OF "THE FOREIGN NATIONS" OR "NATIVE CULTURE" 145

or holder of a good name; viz., a fine reputation)—and Karol Rathaus's *Uriel Acosta* (discussed later), both of which probed Jewish spiritual history. There was also a concert of art music from Palestine that celebrated the toil and successes of the pioneers and an evening hosted by the opera studio of the society featuring short works performed in Yiddish with the accompaniment of incidental music (music setting the mood for or accompanying stage action). To prepare for this event, the studio offered Yiddish instruction for the performers. Even some of the canonic repertory featured Jewish themes, such as the 1937 performance of excerpts from Pietro Mascagni's *Cavalleria rusticana* in Hebrew, or the inclusion of Jewish-themed works, such as Handel's *Judah Maccabee* or Schubert's *Mirjams Siegesgesang* (*Miriam's Song of Triumph*) in the 1939 concerts.

TABLE 7-6

SELECTED MUSICAL EVENTS WITH THE PARTICIPATION OF JALS MUSICIANS (1936–1939)

Time and place	Concert's title and its repertory	Source of information
2/9/1936	**Concert of Jewish Songs**	*Chwila*
Koloseum Theater	Synagogue, folk, and Hebrew songs and recitations	1/29/1936, 10
		2/13/1936, 10
11/21/1936	**JALS People's Concert**	*Chwila*
Yad Charutzim	Solo and chamber pieces by L. van Beethoven, W. A. Mozart, I. Albeniz, J. Strauss, E. Bloch, M. Karłowicz, F. Schubert, H. Günsberg, and St. Niewiadomski	11/21/1936, 13
1/2/1937	**Jewish Music Concert**	*Chwila*
Regional Artisan Organization	Compositions of Ch. Wolfsthal	1/2/1937, 13
	Fantasies on Jewish folk songs	1/14/1937, 10
	Dance event	
NA	**Hebrew Concert**	*Chwila*
Koloseum Theater	*Conquerors of Swamp*, N. Benari (music by Sh. Postolski)	2/14/1937, 13
	Amal, A. Shlonsky	
	Massada, L. Landau	
	"[The Song of] the Vineyard from *Isaiah*" (Isa. 5:1–7)	
	Selected arias from the opera *Cavalleria rusticana* in Hebrew	

(CONTINUED)

TABLE 7-6 *(CONTINUED)*

Time and place	Concert's title and its repertory	Source of information
3/13/1937 Yad Charutzim	**JALS 3rd People's Concert** Compositions by Jewish composers (including music by J. Achron)	*Chwila* 3/10/1937, 10 3/12/1937, 9
4/23/1938 JALS	**Jewish Music Concert** *Sonatina* and *Wariacje pastoralne* in A minor for violin, cello, and clarinet, H. Guensberg Suite *Baal Shem*, E. Bloch *Jewish Rhapsody*, "Aff dem Pripetschek brennt a Faierl," from *Paraphrasen über alt-jüdische Volksweisen*, J. Wolfsohn Folk songs arranged by H. Guensberg, [E.?] Kahan, L. Loew, and Ch. Wolfsthal	*Chwila* 4/22/1938, 10 4/29/1938, 6
12/23/1938 Nowości Theater	**Concert Dedicated to the Works by A. Goldfaden** Lecture "Why We Perform *Shulamis*?" by Z. Turkow Songs and melodies by A. Goldfaden	*Chwila* 12/22/1938, 10
3/4/1939 JALS	**Vocal Concert** Arias from the oratorios *Messiah* and *Judah Maccabee*, G. F. Handel Songs by F. Schubert and J. Brahms	*Chwila* 3/3/1939, 10 3/7/1939, 8
4/1/1939– 4/2/1939 4/9/1939– 4/11/1939 4/23/1939 JALS	**Performance of the JALS Drama Section** Direction: H. Luft Music and musical direction: H. Günsberg "Der shotn," H. Ch. Andersen *Dos leybn—an ayznban*, E. Kästner *Di klyatshe*, M. Moykher-Sforim	*Chwila* 3/31/1939, 10 4/8/1939, 13 4/23/1939, 13
5/9/1939 PSM	**Annual Symphonic Concert of the JALS** Overture to *Schauspieldirektor*, W. A. Mozart Symphony no. 3. *Scottish*, F. Mendelssohn *Miriam's Song of Triumph*, F. Schubert *Uriel Acosta*, K. Rathaus	*Chwila* 4/18/1939, 9 5/3/1939, 10 5/6/1939, 13 5/9/1939, 8 5/11/1939, 9

These concerts demonstrate a discernible shift toward programming art music centered on the articulation, or even proclamation, of a distinct Jewish national identity. Beyond the nods to synagogue repertories, Yiddish theater, and the cozy *folkstimlekhkayt* (folksy nature) of the choral works that were included in concerts of the previous periods, the programs of the late 1930s were carefully designed to highlight art music by Jewish composers.[35] This was accomplished not just by including works that invoked Jewishness through folkloristic musical language (as in the works of Joseph Achron, a key member of the St. Petersburg Society for Jewish Folk Music, and Juliusz Wolfsohn, who cofounded the Society for the Promotion of Jewish Music in Vienna) but also by devising programs that reflected on the present, looked with hope into the future, and regarded the past as a source of strength. Three events—the Hebrew concert of 1937, the 1939 performances of the JALS drama section, and the last symphonic concert that took place in May of 1939—offer a glimpse of these strategies.

The repertory chosen for the Hebrew concert that took place in February of 1937 focused on the achievement of the Jewish pioneers in Mandatory Palestine. Avram Shlonsky's well-known poem *Amal* (Toil) reimagined religious language to extol the labors of Zionists who were building roads, and Nahum Benari's *Conquerors of Swamp* likely referenced the work on draining the swamps near the Ein Harod kibbutz, where both Shlonsky and Benari lived. The two writers, together with Shalom Postolski, the composer of the music for that concert, were among the founders of Ein Harod. Beginning in 1926, Postolski focused on composing songs based on the texts of Hebrew poets. The evening concluded with a selection of arias from Mascagni's *Cavalleria rusticana* performed in Hebrew. The themes of the works presented during that concert focused on the hard work and success of the Zionist pioneers, on their labor in the fields and vineyards of Palestine to put food (and drink) on the table or to build roads and drain swamps to create prosperity in their new homeland, all the while writing poems and songs by night. Through these works, they emphasize strength and hope, typical tropes of the Zionist imagination. Likewise, they deployed Hebrew, a sacred language, as a language for the everyday, used for descriptions of hard physical work. With the presentation of arias from *Cavalleria rusticana*, members of the audience could hear Hebrew as the language for high art and for opera and imagine a future opera house in Palestine, where such works could be performed in their full splendor in Hebrew. Thus, the repertory of this concert musically framed Palestine as a place of success and hope for the future. It also reimagined the exotic periphery as a center of Jewishness and musical high culture.

The performance by the JALS drama section, which was repeated several times between January and May 1939, took on a very different tone. The actors presented "Fantastic Tales," three dramatized stories in Yiddish, with incidental music by Henryk Günsberg—a physician and virtuoso pianist who professionally taught piano during the 1930s and regularly composed for theater. Erich Kästner's *Dos leybn—an ayznban* (Life—a train) was probably a translation of his poem *Das Eisenbahngleichnis* (Railway parable) published in the collection *Gesang zwischen*

den Stühlen in 1932. The poem depicts methaporically the experience of life, comparing it to a train full of diverse human types traveling at the same time to an unknown, unreachable destination. It begins with the deeply humanistic and meaningful, especially at this time and context, phrase "We're all in the same train and travel across the time." Kästner was also the author of the immensely popular book for children, *Emil and the Detectives* (1929), which was published in Yiddish translation in 1935.[36] After 1933, the writings of the deeply pacifist and anti-Nazi Kästner were banned in Germany, so staging his work was a way of honoring the author. The two other books—Hans Christian Andersen's 1847 fairy tale "The Shadow" ("Der shotn") and Mendele Moykher-Sforim's allegorical and satirical novel *Di klyatshe* (*The Nag*) of 1873—would have resonated with children and adults alike. The protagonist of "The Shadow," one of Andersen's darkest tales, is a deeply moral and idealistic writer who is being replaced by his materialist and power-hungry shadow. In the end, the fading writer is executed on the orders of the now powerful shadow. In *Di klyatshe*, the horse (a prince transformed by a spell) represents the downtrodden Jewish people, and the absurdity of the negotiations the enlightened student Isroel conducts on behalf of the mare demonstrates the failure of the integrationist project. In both tales, we witness the collapse of Enlightenment idealism and of the moral order built upon it, a finale that, no doubt, would have resonated with Jewish audiences at the end of the 1930s as a bitter reflection of their current circumstances.

The last symphonic concert sponsored by the JALS took place on May 5, 1939. With the annexation of Austria and occupation of Czechoslovakia completed, at the end of April, Hitler moved to denounce the German-Polish Non-Aggression Pact of 1934. Poland was next on his list of conquests. Considering the impending doom, the music of this concert was staged to serve as a source of dignity, strength, and hope.

The performance was led by Wilhelm Altman, a native of Stryj in Galicia, who worked for many years in Germany. As a consequence of the purges of Jewish musicians led by Goebbels and legislated through the Law for the Re-establishment of the Civil Service, Altman left the Third Reich and in 1938 settled in Lwów. The program featured compositions by two other artists whose works were rejected by the Nazi regime: the music of Mendelssohn, like that of other Jewish composers, was not permitted to be performed in concert, and neither was that of the Galician-born Karol Rathaus (from Tarnopol), whose promising Berlin career was interrupted by the establishment of the Third Reich, causing him to leave Germany and ultimately to settle in the United States.

Two works from this concert stand out in terms of their themes and affect: Schubert's *Mirjams Siegesgesang* and Rathaus's *Uriel Acosta*. The former, a twenty-minute cantata for voice, chorus, and piano (several orchestrations were available, including one by Schubert's friend Franz Lachner) to a text by Franz Grillparzer, celebrates the Lord's and Israelites' victory over their enemies. The fact that Schubert contributed compositions for Salomon Sulzer's Viennese synagogue would not have escaped the audience. The latter was a suite of incidental

music Rathaus composed for the Hebrew version of Karl Gutzkow's *Uriel Acosta* adapted as a play by Moshe Lifshits (also exiled from Germany after 1933) and performed in 1930 in Berlin by the famous Habima Theater. The play spins a fictional love story around the life of the seventeenth-century Portuguese philosopher and skeptic, who was born Christian but converted to Judaism. Rathaus took the historical time frame of Acosta as a template for musical styles, and the resulting music accompanies the story through a neo-Baroque idiom, including a majestic, Handelian overture. The last dance, however, unmistakably invokes Jewish topoi by referencing Hasidic tunes.

The concert was a resounding success, and the last composition was a particular favorite of the audience. As Alfred Plohn wrote in the review of this concert, "The performance of the program ... was flawless. Not only did it attract a large audience but also left them pleased. The best proof [of their delight] was that the last part of the suite *Uriel Acosta* by Karol Rathaus, which is based on Jewish melodies, had to be repeated."[37] In this, one of the last concerts hosted by the society, the Jews of Lwów musically defied the Nazis by featuring the music and musicians exiled from the Third Reich and found strength in a musically narrated Jewish past and dignity in the musical excellence of a perfectly crafted art music on Jewish motifs.

Taken together, the last group of the JALS's Jewish-themed programs presented a whole range of aesthetic contexts in which artists deployed musical Jewishness, from *folkstimlekhkayt* to modernism, linguistically traversing among German, Yiddish, Polish, and Hebrew. The interest in Jewish art music was new, but so was the historicist streak in the compositions presented, from Schubert's *Mirjams Siegesgesang* to Handel's *Judah Maccabee* to *Uriel Acosta* and to *Baal Shem*. The historical themes helped articulate a historical narrative of a victorious and thriving Jewish nation. As other countries had done over the course of the previous century, interwar Polish Jews learned to imagine a Jewish national history through art music, and the audiences of Lwów were now ready to hear it.

By examining the programs of Lwów's Jewish music societies of the interwar period, we can glimpse the internal discussions among diverse groups of urban Jews and their responses to major external events. The concert programs of the JMS and the JALS are illuminating, revealing a pathway from a musical scene that affirmed acculturation to one that endorsed a separate, historical, national Jewish identity. As in the case of Isroel, the protagonist of Mendele Moykher-Sforim's *Di klyatshe*, this path led from an idealistic willingness to negotiate an identity that would be acceptable to the gentile neighbors to one that—in light of the failure of that possibility—put Jewishness first.

Notes

1. The statute of the JMS was registered in the Lwów Voivodeship Office on October 16, 1920. State Archive of Lviv Oblast (DALO), fond 1, opys 52, sprava 2867, 183.

2. Alfred Plohn, "Mateusz Bensman i jego 'Palestyna,'" *Chwila*, December 9, 1919, 4.

3. For a theoretical framing of this subject in music, see Philip V. Bohlman, "East and West," in *Jewish Music and Modernity* (Oxford: Oxford University Press, 2008), 53–70.

4. Plohn, "Mateusz Bensman," 3–4.

5. On *Chwila*, see *The YIVO Encyclopedia of Jews in Eastern Europe Online*, s.v. "Chwila," by Eugenia Prokop-Janiec, accessed August 4, 2022, https://yivoencyclopedia.org/article.aspx/Chwila.

6. Adolf Chybiński, "Koncert kompozytorski Karola Szymanowskiego," *Gazeta wieczorna*, March 19, 1920, 3–4.

7. Magdalena Wróbel, "Syjonista ze Lwowa: Leon Reich (1879–1929)—polityk pogranicza," *Wieki stare i nowe: Tom specjalny: Ludzie i elity pogranicza*, 2012, 86–100.

8. Based on information in sources and comparisons with other similar societies in Poland, one can assume that the orchestra consisted mostly of Jewish professional musicians, complemented by skilled amateurs, but it was also common for gentile musicians to be invited to fill in. I discuss the sources in detail in Sylwia Jakubczyk-Ślęczka, "Życie muzyczne społeczności żydowskiej na terenach dawnej Galicji w okresie międzywojennym" (PhD diss., Jagiellonian University, 2017), 28–39, appendix A, and "Kronika działalności żydowskich organizacji muzycznych we Lwowie," 2–8.

9. Much ink has been spilled in recent years regarding the emergence of the Austro-German tradition as the core of spiritually conceived high art and the locus of middle-class identity. See, for example, David Gramit, *Cultivating Music: The Aspirations, Interests, and Limits of German Musical Culture, 1770–1848* (Berkeley: University of California Press, 2002).

10. His brother, Jan Marian Hescheles, became known as Marian Hemar, the author of thousands of lyrics for beloved popular songs. His first cousin was Stanisław Lem, a brilliant writer of science fiction books, translated into over forty languages.

11. H. Trejwart, "Wieczór inauguracyjny Żydowskiego Towarzystwa Muzycznego we Lwowie," *Chwila*, February 12, 1920, 5.

12. The Jewish circles in Poland seemed unperturbed by Mendelssohn's conversion, but they invariably referred to him without "Bartholdy," the name adopted at the time the family was baptized. Mahler converted to Catholicism in 1897.

13. Leonid Sabaneev, "The Jewish National School in Music," *Musical Quarterly* 14, no. 3 (July 1929): 448–468; Aron Marko Rothmüller, *The Music of the Jews: An Historical Appreciation* (Cranbury, N.J.: Perpetua, 1975), 179–248.

14. Alfred Plohn, "Pierwszy koncert chóralny Żydowskiego Towarzystwa Muzycznego," *Chwila*, March 25, 1921, 4.

15. Abraham Znajda, "Z sali koncertowej," *Chwila*, November 18, 1920, 4.

16. Isaschar Fater, *Yidishe muzik in Poyln tsvishn beyde velt milkhomes* (Tel Aviv: Veltfederatsye fun poylishe yidn, 1970), 184.

17. Alfred Plohn, "Wieczór muzyczny sekcyi chóralnej Żydowskiego Towarzystwa Muzycznego," *Chwila*, December 1, 1922, 5.

18. *Chwila*, November 18, 1920, 5.

19. Alfred Plohn, "Z sali koncertowej. Koncert kompozytorski Ch. Wolfsthala," *Chwila*, December 20, 1923, 5.

20. *Chwila*, June 17, 1925, 6; *Chwila*, October 31, 1925, 15. These are the only mentions of this society, and there is no indication that it was in any way related to the "Yuval" established in 1931 by the Heilman brothers.

21. Bernard Meyer, "Koncert Symfoniczny Żydowskiego Towarzystwa Muzycznego," *Chwila*, December 25, 1924, 7.

22. Jolanta Żyndul, *Państwo w państwie: Autonomia narodowo-kulturalna w Europie Środkowowschodniej w XX wieku w XX wieku* (Warsaw: DiG, 2000).

23. See Antony Polonsky, *Dzieje Żydów w Polsce i Rosji*, trans. Mateusz Wilk (Warsaw: Wydawnictwo Naukowe PWN, 2014), 305–362.

24. *Chwila*, November 28, 1927, 8; *Chwila*, January 8, 1928, 9; *Chwila*, January 23, 1928, 13.

25. *Chwila*, December 28, 1929, 10; *Chwila*, March 4, 1934, 16.

26. *Chwila*, December 1, 1929, 15; *Chwila*, December 28, 1929, 10; *Chwila*, February 22, 1930, 12; *Chwila*, February 6, 1932, 14; ap., "Z estrady. Maks Lew," *Chwila*, November 23, 1933, 10.

27. *Chwila*, January 26, 1930, 15; *Chwila*, April 13, 1933, 4.

28. Yitzchak Heilman, *Liturgical Compositions for Cantor and Choir*, ed. Felix Shpits (Haifa: F. Shpits, 2009); Yitzchak Heilman, Joel Engel, and J. Shertok, *Unzer Lid* (Bruxelles: Imprimerie "S.W.S.," 1949).

29. Alfred Plohn, "Żydowskie Towarzystwo Artystyczno-Literackie," *Chwila*, June 10, 1932, 9.

30. The name references Yuval, the son of Lamech and Adah, a descendant of Cain, considered the ancestor of all musicians (Gen. 4:20–21). It was also used elsewhere to mark Jewish music-making endeavors. For example, Joel Engel, the composer and founder of the St. Petersburg Society for Jewish Folk Music, established the Juwal publishing house in 1923 in Berlin. Jascha Nemtsov, Eliott Kahn, and Verena Bopp, "The History of the Jewish Music Publishing Houses Jibneh and Juwal," *Musica Judaica* 18 (5766/2005–2006): 1–42.

31. DALO, fond 1, opys 52, sprava 2878, 268. See also Alfred Plohn, "Muzyka we Lwowie a Żydzi," *Muzykalia XIII / Judaica 4* (May 2012): 1–24, http://demusica.edu.pl/wp-content/uploads/2019/07/plohn_muzykalia_13_judaica_4.pdf.

32. See Sylwia Jakubczyk-Ślęczka, "Jewish Music Organizations in Interwar Galicia," *Jews and Music-Making in the Polish Lands*, vol. 32 of *Polin: Studies in Polish Jewry*, ed. François Guesnet, Benjamin Matis, and Antony Polonsky (London: Littman Library of Jewish Civilization, 2020), 363.

33. Natan Landau, "Koncert Żydowskiego Towarzystwa Artystyczno-Literackiego a szerzenie kultury żydowskiej," *Chwila*, November 5, 1936, 9.

34. "Dziś koncert popularny ŻTAL," *Chwila*, November 21, 1936, 13. Similar efforts in Vienna in the form of Volksconcerte series are discussed in Margaret Notley, "*Volksconcerte* in Vienna and Late Nineteenth-Century Ideology of the Symphony," *Journal of the American Musicological Society* 50 (1997): 421–453.

35. Compare the discussion of similar issues in James Loeffler, "'A Special Kind of Antisemitism': On Russian Nationalism and Jewish Music," *Yuval Online: Studies of the Jewish Music Research Center* 9 (2015): 1–16, https://jewish-music.huji.ac.il/volume-year/2015-volume-9; and Esther Schmidt, "Nationalism and the Creation of Jewish Music: The Politicization of Music and Language in the German-Jewish Press Prior to the Second World War," *Musica Judaica* 15 (2000): 1–32.

36. Erich Kästner, *Emil un di detektivn*, trans. Mojsze Tajchman (Warsaw: Kinder fraynd, 1935).

37. Alfred Plohn, "Z sali koncertowej. Koncert symfoniczny Żydowskiego Towarzystwa Artystyczno-Literackiego," *Chwila*, May 11, 1939, 9.

CHAPTER 8

From *Lodzermensz* to *Szmonces* and Back

ON THE MULTIDIRECTIONAL FLOW OF CULTURE

Marcos Silber

The banker's daughter is a good catch. His competitor wants to marry her:

BANKER: "No, Sir, I can't give [my] daughter to a man who has so many debts."
COMPETITOR: "But think about how ancient my ancestors are."
BANKER: "Whatever. I no longer trade in old goods."[1]

This joke, printed in 1910 in *Łodzianka*, an annual satirical publication devoted to Łódź (Yid. Lodzh) and its inhabitants, reflects a clash between two ethoi. One ethos stressed the importance of illustrious lineage. The other only valued money while mocking the significance of pedigree. Whereas in the competitor's world, an illustrious ancestry could acquire tangible and concrete coins and notes, for the banker, pedigree was an outmoded, worthless fossil. How is this joke related to the clash of values and norms in contemporaneous Łódź? How can it shed light on lesser-known aspects in the process of the creation of modern Polish-Jewish culture? How does it reflect the relations between centers and peripheries?

This chapter addresses these questions by reframing an assumed Polish-Jewish duality as a multidimensional social process. Using the concept of a Lodzermensz (Yid. Lodzhermensh; Ger. Lodzermensch)—an ethnically blended, stereotypical inhabitant of Łódź—that traveled between satirical contexts and venues of Łódź and Warsaw, I posit the existence of a multidirectional flow of cultural assets between Jews and non-Jews, between Polish and Yiddish, and between the periphery, in this case Łódź, and the center, Warsaw.[2]

ŁÓDŹ AT THE FIN DE SIÈCLE

Łódź, a city without an ancestral past, was situated in a country whose hegemonic culture venerated pedigree. The city's landscape was connected neither to stories of glorious deeds of men with aristocratic surnames nor to folktales of loyal peasants. On the contrary, having experienced rapid industrial development in the nineteenth century, Łódź became the center of the workaday textile industry in Poland. The ironically titled fin de siècle novel *The Promised Land* by the Nobel laureate Władysław Stanisław Reymont (1867–1925) scorned the city and its capitalistic character. It was Reymont who popularized the term Lodzermensz as a negative depiction of the industrialist bourgeois, a morally degraded individual who abandons his world of values, his roots, and devotes himself to the "god of money and success."[3] This new type was in direct contrast to the values of the *szlachta* (noble class) tradition, which venerated agrarianism and denigrated the market economy.

Despite this negative stereotype, for much of the nineteenth century, Łódź continued to be the destination of many who were seeking a better future and new horizons. This was a city where industrious "nobodies" could become magnates. Yet in fact, poverty was the destiny of hundreds of thousands in Łódź who had been drawn to its teeming factories. There was no other place like it in Poland, where great fortune and intense misery were in such proximity to each other.

Within a relatively short period of time, this boomtown became the second-largest city in Polish lands under czarist rule, growing from 32,500 inhabitants in the 1860s to 314,000 residents, according to the 1897 census.[4] This dynamic increase in population, combined with the fast and chaotic process of urbanization, created a brick forest of overcrowded tenements and factories and older, small, wooden houses in deplorable condition, with islands of spectacular palaces surrounded by spacious gardens. Łódź was a city of both opulent wealth and despair.

Economic modernity suddenly transformed Łódź into Kominogród (a chimney city)—as the poet Julian Tuwim (b. 1894 in Łódź), the outstanding Jewish son of Łódź and one of the greatest Polish poets of his generation, calls his hometown—because of the preponderance of thin smoky towers that airbrushed the skyline in gray. It was in Łódź, in December 1898, that the first electric tram in Russian-controlled Poland became operational, followed by the opening of the first cinema a few months later (on cinema as a new form of leisure activity, see Ela Bauer's chapter in this volume). Both were symbols of the readiness of its inhabitants to adopt the novelties of a new era.[5]

As new habits appeared, so too did new trends that repudiated them. In political life, socialism grew from the left, as it did throughout industrializing eastern Europe.[6] On the other side of the political perspective, conservatives considered Łódź "the evil city," where red anger met boredom, creating social disruption and even anarchy. In Zygmunt Bartkiewicz's eponymous book *Złe miasto* (Bad [or evil] city), published in 1911, the city was a space shaken by social explosions and fratricidal struggle that endangered the integrity of the national soul and body.[7] Bartkiewicz and Reymont represented those modern Poles who

idealized the "good old days" at the very same time when others embraced new inventions, ideas, and opportunities.

Łódź was a multiethnic city. Out of the 314,000 residents in Łódź in 1897, some 48 percent (150,720) were Roman Catholic, 32 percent (98,700) were Jewish, 18 percent (56,500) were Protestant, and 2 percent (6,000) were listed as Russian Orthodox. Polish was declared the mother tongue of about 46 percent (145,600) of the population, with an additional 21 percent (67,300) that declared German, 29 percent (92,400) Yiddish, and some 3 percent (8,700) Russian and other languages. The city's Jewish population was particularly diverse. In addition to most Jews who declared Yiddish as their mother tongue, 4.1 percent of the Jewish population (4,084) cited Polish, 1.2 percent (1,228) cited Russian, and 1.1 percent (1,034) cited German. Further, many Jews employed what Itamar Even-Zohar calls a "multilingual system," speaking different languages under different circumstances.[8] Likewise, while the core of non-Jewish groups in the city shared a mother tongue of either Polish or German, people on the social "frontier" (where people of different ethnic, religious, and linguistic backgrounds converged and intermixed) were more linguistically fluid.[9] On the eve of the First World War, the population of Łódź approached half a million people, and its multiethnic, multireligious, multilingual, and multicultural character was becoming more and more vigorous.

On the whole, the different ethnic and social groups in the city seemed to be living side by side, evidenced by the emergence of ethnic residential segregation. Yet despite the clear evidence of residential ethnic niches, the ethnic mixture on many streets and in tenements was tangible.[10] Yards were shared by adults and children of different religious affiliations and mother tongues. With vivid images, Julian Tuwim describes the yard of his early childhood and his friends' ways of talking: "His speech was very strange: *Naprawek* (!) [repair, in a distorted Polish], new *ancug* ([German for] clothes), *dźwik* (door [in a distorted Polish]), *badecymer* ([German for] bathroom).... Other children in our yard used some German-Polish dialect: oh, *wata* ([mispronounced German for wait] *warte*), my dad will show you, you don't have to beat Gustav! Do you want a *leberwurst* [German for liver sausage]?"[11]

The results of such interethnic religious-linguistic relations manifested as both cosmopolitanism—understood as the rejection of exclusive attachments to a defined particularistic culture—and nationalism. Cosmopolitanism and nationalism became competing categories that shaped the imagination of the changing urban society and its boundaries. By the turn of the century, and especially during the decade preceding the Great War, the cracks in traditional society were easier to see. The cosmopolitan/nationalist and also conservative/liberal divides shaped demands for social reorganization.[12]

Lodzermensz

It was in this environment that the archetype of the Lodzermensz emerged: individuals who were hard to identify as essentialized Jews, Poles, or Germans; rather, they blurred the boundaries of language and ethnicity. In most cases, they had no

FROM *LODZERMENSZ* TO *SZMONCES* AND BACK 155

political principles beyond their own personal benefit and bon viveur. For Reymont and other conservative writers, the Lodzermensz were negative characters with no clear-cut ethno-national identity. They despoiled the Polish language by mixing in foreign expressions. For them, the Lodzermensz was dangerously unaware of national concerns and lacked true patriotism.

The following from a caricature entitled "Lodzermensz Examine Nationality" (see figure 8.1), published in 1909 in Warsaw's *Śmiech* (Laughter), a humorous and satirical illustrated weekly, reflects the negative stereotype:

> LODZERMENSZ 1. "[In German] That is not true! [In broken Polish] You not a Pole and you have to pay taxes for the German schools!"
> ŁODZIANIN. "[In Polish] I'm a Pole and I have no intention to pay to support Germanization efforts."
> LODZERMENSZ 2. "[In Polish] That is not true! A Pole does not have such a big belly! [In a mixture of broken Polish and German] In this country only our brother would have a big belly!"[13]

The caricature presents three characters: one standing, respectfully dressed, the Łodzianin (Lodzian), clearly a resident of the city, and the others, sitting, dressed as

Figure 8.1. Satirical caricature reflecting the negative status of Lodzermenszn. "Lodzermenszn Examine Nationality," *Śmiech*, January 28, 1909. Image courtesy of Polona, a digital library administered by the National Library of Poland.

elves—echoing the image of mythical creatures from German folklore—presented as Lodzermenszen. The cartoonist sought to emphasize their sinister, ambiguous identity. Ostensibly, they are all German, sporting stereotypical markers, such as the use of German vocabularies and their big beer bellies. However, all of them are also displaying Polish markers, such as the use of Polish words and expressions, and the standing city resident is wearing a "Polish" mustache. The Łodzianin claims to be a Pole and is unwilling to pay for German schools in a city with parallel private schooling in different languages (Polish, Russian, German, and Yiddish) that fostered the national identity of each group. But the Lodzermensz unmasks him, trying to bring him back from the in-between status of a person in "national limbo" to an ostensibly clear-cut ethno-national identity. Yet the elves themselves do not inhabit this seamless ethno-national identity.

The prototypical Lodzermensz was also imagined as superficial and selfish, a nouveau riche social climber by many of those proud of their cultural capital. This is reflected in the following couplet published in Warsaw's *Mucha* (Housefly), another satirical weekly:

"Flower Day" in Łódź

Saleswoman: "Sir, buy a flower!"

Lodzermensz 1: "I'm not stupid, go away."

Woman: "Give me a penny for a flower."

Lodzermensz 2: "Lady, stuff it."

Woman: "Maybe you'd like a few flowers?"

Lodzermensz 3: "I do not donate to beggars."

Woman: "A small flower for charity goals . . ."

Lodzermensz 4: "You're ugly! I will take a flower from another."

Woman: "Buy a flower for four cents."

Lodzermensz 5: "Go, damn you!"

We can conclude from these pictures
That "Lodzers" are boors;
They have weaving mills, finishing [machines],
But they lack culture.[14]

But many locals in Łódź reversed this negative stereotype, creating a more complex character. For them, the willingness to shift national affiliations in order to overcome difficulties, as in the previous case of the Łodzianin who wants to avoid unnecessary payments, became a positive characteristic. This is the subject of a cartoon published in *Śmiech*, a Lodzian namesake to the Warsaw journal, and drawn by the painter and miniaturist Artur Szyk (b. 1894 in Łódź), who later became internationally known for his illustrated series for *The Statute of Kalisz*, *Washington and His Times*, and the *Haggadah*. In the illustration, we see two characters, Jojna and Simcha. Both are bearded, with sidelocks, and are wearing kapotes and *kashkets* (a felt cap often used by Polish religious Jews). Their conversation is implicit in the use of hand gestures attributed stereotypically to the Jews. They are worried about the rising antisemitism of the Endecja (the right-wing National

Democracy party) around the elections to the fourth Duma in 1912 that resulted in a Polish anti-Jewish boycott:

"Listen, Jojne, you do not fear the boycott?"
"I will tell you something, Symcha. At first, I was afraid, but now I am not afraid."
"Why is that? Because if they do not want to buy from Jews, I will make [my shop] an *echt* [Ger. genuine] German shop, and everything will be fine."[15]

The prototypical figure, Jojne, appeals to the empathy of the reader. The changes brought about by the new era perplex him, but he responds with ingenuity. He believes that by crossing ethno-national boundaries (by presenting himself as a German), he can overcome antisemitism. However, the reader understands that his plan is unrealistically naïf. Despite his use of the German language, he is undoubtedly a Jew. In this regard, the despised nationless Lodzermensz is transformed in Łódź's *Śmiech* into a gullible trusting soul who gains the reader's sympathy.

Yet the Lodzermensz could be also reimagined as shrewd and quick-witted, as seen in a discussion about the dowry between a young city slicker and his future father-in-law:

THE CITY SLICKER: "So you are giving 60,000 for your daughter?"
FATHER: "Yes—cash."
THE CITY SLICKER: "Would you like to do business and earn 20,000?"
FATHER: "Woe is me! Oj wej! [Yid. in Polish spelling] Why not? I like such businesses very much."
THE CITY SLICKER: "Give me 40,000 without the daughter."[16]

Gender also informed the image of the Lodzermensz. On the one hand, women of Łódź were depicted as victims of these unscrupulous materialistic Lodzermenszn. For example, in one depiction, after a marital quarrel, the wife says to her husband, "Actually, I don't know why you married me. . . ." The husband responds, "Don't talk nonsense. If I could have gotten your money without you, I wouldn't have married you at all."[17] But on the other hand, Lodzian women were also portrayed as irremediably licentious:

THE WOMAN (TO HER HUSBAND COMING LATE IN THE NIGHT): "Is that you, my love?"
THE HUSBAND: "No. It's me."[18]

At the same time, Lodzian women could also be depicted as incisive, biting, and aware of their unquestionable natural equal rights, even if those were not yet legislated politically. A conversation between a woman and her husband illustrates the emergence of feminist consciousness:

"Darling, could you give me an acceptable dinner at least once in your life?"
"You don't know what a learned feminist writes, do you?"
"How should I know?"
"Well, she writes that every husband should have the dinner he deserves."[19]

The Lodzermensz was the local prototype of the metropolitan experience. Her and his everyday lives were impacted by new trends, which included the rise of consumerist culture. The Lodzermensz was ambitious and always seeking joie de vivre. Such is the case of the Lodzermensz father who advises his son in pre–World War I Łódź to always aspire for more, with glimmering illusions of pursuing immediate, large-scale profit: "My son, if you know what you want, and you want what you can, and you can do all that you want, and you know that you can do what you do want, then you are finished."[20]

At the same time, the Lodzermensz can lose all his money in the vicissitudes of Łódź's unbridled market and yet remain adorably clumsy, humorous, and likable.[21] The following example comes from a Łódź calendar containing jokes and cartoons, published in 1910 on the eve of the opening of the impressive, luxurious seven-story Hotel Savoy, which remained the tallest building in Łódź for decades:

> In the Hotel
>
> "How much for a room?"
> "On the ground floor ten rubles per day. Further up, it is cheaper. Each floor up, the price drops one ruble."
> "In this case, for me, your hotel is too low."[22]

A "creative class," to use Richard Florida's conceptualization, that thrived on innovation constructed the Lodzermensz—and similar types—throughout the first two decades of the century in western capitals.[23] The Lodzermensz discourse was the result of two processes responding to two contradictory logics. The first was the logic of creating internal ethno-national borders. It condemned the dissolution of ethno-national identities and marked the Lodzermensz negatively as the embodiment of the denationalized individualist, without a stable identity. The second, as its discursive reaction, re-created the Lodzermensz to mock the overemphasized seriousness of the national discourse but also to parody the elusive sociocultural practices of the parvenu who was not even born into the system but chose it of her or his own free will.[24] On the one hand, the re-created Lodzermensz contested the old-fashioned conservative bon ton, potentially challenging the fragile, old order. On the other hand, it was also a humorous reflection of the perplexity caused by the new, modern order.

The Creative Class of Łódź on the Eve of the Second Polish Republic

The innovative technological revolution that took place intensively in Łódź from the late nineteenth century until the First World War fueled an entrepreneurial culture among the creative class—talented poets, writers, painters, actors, entertainers, cultural figures, cultural entrepreneurs, and other creative professionals.[25]

The dynamic sociocultural atmosphere in the first two decades of the twentieth century in Łódź, which encouraged relative cultural openness and a disregard and disrespect for social mores perceived as old-fashioned, enabled the creative class of

Łódź to offer new cultural practices. The literary cabaret was one of the most important new forms, and its genre attracted several artists working in different fields of art.

The aforementioned Artur Szyk, a talented illustrator, collaborated with those engaged in words. Among them was Konrad Tom (Konrad Runowiecki; b. 1887 in Warsaw), a screenwriter and a renowned artist of the interwar literary cabaret, who shuttled between Łódź and Warsaw, where he joined the famous cabaret Momus. In Łódź, he was the literary editor of Śmiech from October 26, 1912, until the outbreak of World War I. Szyk contributed many of the caricatures and illustrations, while Tom wrote for and edited the weekly, sometimes under the significant pseudonym Oncle Thom, which became his pseudonym for the rest of his life.[26] Andrzej Włast (Gustaw Baumritter; b. 1885 in Łódź) also contributed poetry to the weekly. He later went on to become the lyricist for hundreds of beloved interwar-era Polish songs.

While writing for Śmiech, Tom, Włast, Tuwim, and their other collaborators continued to develop the motif of the Lodzermensz. They performed it at the first literary cabaret in Łódź, Reduta Śmiechu (Laughter redoubt), a name that reverberates with the name of the weekly. Tom explained in the daily Nowa Gazeta Łódzka (New Łódź gazette) that after the numerical increase of the creative class in Łódź—in his words, "the literary-artistic colony"—the weekly's creators of texts and pictures developed into the literary cabaret, combining images and words with a new element: voice.[27] Reduta Śmiechu first performed on January 24, 1914, in the restaurant of the aforementioned Hotel Savoy. Szyk painted the decorations, cartoons, and posters that advertised the cabaret's activity. Tom wrote many of the texts and boasted that "the most outstanding men and women representatives of the local bohemia of literature and art" participated in the performance.[28]

Later, in the middle of February 1914, the same people founded Bi-Ba-Bo, the iconic Łódź cabaret, in the same Hotel Savoy.[29] The program included many sketches addressing Łódź and Lodzermenszn, characters well known to the readers of Śmiech. Ludwik Lawiński (Latajner; b. 1887) joined the program. He began his performances in his native Lwów, toured Austria, and arrived in Łódź in 1913, attracted by the opportunities the city offered.[30] Józef "Pikuś" Urstein (1884–1923) made his first performing steps on the little stage of Bi-Ba-Bo, creating the telephone monologues of a modernized Jew who kept his ethnic markers that would later lead him to fame. During the First World War, Urstein moved to Vienna and worked in Franz Grünbaum's (Kriebaum) cabaret; upon his return to Warsaw in 1917, he brought the practices he had learned there.[31] The multidirectionality between Łódź and Vienna in the field of popular culture was not exceptional during the Great War. For instance, the Yiddish popular song "Itsik, kum mit nakh Lodzh," which expressed the irony of those going to Łódź in search of the "promised land," was transformed in Vienna in 1915 into the satirical song "Rosa, wir fahren nach Lodz," reflecting now the miseries of the Austrian soldiers going to the front near Łódź.[32] This multidirectionality reflects not only the connection between a geographical periphery and the center but also the adoption and adaptation of Yiddish popular culture into Viennese popular culture.

Reviewers constantly compared Momus and Bi-Ba-Bo, emphasizing changes that took place during the cultural transfer between the center and the periphery. For instance, Tom stated in *Nowa Gazeta Łódzka* that the difference between the two was that Bi-Ba-Bo was less elitist and more satirical than Momus, reflecting the stereotype of the less polished Lodzermensz, who demanded more popular entertainment.[33] The writer, poet, and translator Leo Belmont (Leopold Blumental; 1865–1941), a devoted Esperantist and supporter of Polish-Jewish coexistence who was nonetheless baptized in 1913, prized Bi-Ba-Bo's use of a variety of genres familiar to audiences in Germany and Paris, thus emphasizing Łódź's Europeanness: "It is nice to see this sort of theater that stands at the European level. That's Bi-Ba-Bo!"[34] Bi-Ba-Bo adopted, adapted, and combined the practices of Warsaw's Momus with the fin de siècle Parisian chanson and the social satire of Munich, transferring new cultural practices to Łódź. Using upside-down logic, however, Belmont marked Łódź as peripheral when expressing surprise at its "European" character.

The most outstanding talent among the members of *Śmiech* and Bi-Ba-Bo was Julian Tuwim, who was also a close friend of Szyk and Włast. It was Tuwim who pushed them to reactivate Bi-Ba-Bo at the end of 1915 (after a hiatus caused by the start of the war), writing new sketches ridiculing the Lodzermensz, his cunning and mistrust, and the miserliness of the tenements' owners.[35]

In Bi-Ba-Bo, the young artists celebrated the inventive consumerism of mass culture. Their stagings reflected the effects and experience of living in Łódź, a new urban center, and the figure of the Lodzermensz was their metonym. They transformed the negative image of a nationless Lodzermensz into a likable modern petit bourgeois who consumed media (i.e., the satirical press) and institutions (i.e., variety shows, new luxurious hotels, cinema) with aspirations for upward mobility. The Bi-Ba-Bo artists did so by adopting models from France, Germany, and Austria. They adapted these models for the Łódź milieu through sophisticated monologues, sad or mischievous songs, and malicious sketches, and by mocking language standards.

These artists continued creating cabaret and satire in Łódź until the city experienced a downturn in its economic fortunes following the Great War and Polish independence that cut it off from the Russian market. These developments put an end to the thriving, innovative heyday of the Łódź creative class, which suffered from the financial downturn and stagnation.[36] In the new socioeconomic reality, Łódź lacked the economic and social resources for supporting its creative class. Many of its artists left for greener pastures. Tuwim, Włast, Tom, and others sought a better future in Warsaw, and in the process, they transferred their artistic experience and specific stage types from the Łódź literary cabaret to Warsaw, creating the Qui Pro Quo, the Polish cabaret par excellence.

From *Lodzermensz* to *Szmonces*

In Warsaw, the Lodzermensz type was absorbed into the *szmonces* genre. *Szmonces* (Yid. *shmontses*) was a humorous entertainment form that gained popularity in

literary cabaret and variety shows in interwar Poland. It presented "Jewish" characters in songs, satires, and sketches that portrayed the absurdity of the new times and the upheavals of modern life.[37] I do not claim that Lodzermensz is the only type that shaped *szmonces*, as there were many more antecedents that contributed to the Jewish types represented in this form, including the deeply rooted theatrical convention of the comical Jew.[38] But as many of its creators—Tuwim, Tom, Urstein, Włast, and Kazimierz Krukowski (Lopek), who was Tuwim's cousin—migrated from Łódź to Warsaw, they took with them assets that had first been created in the periphery, translating the local parody of the Lodzermensz into a general phenomenon.

The adaptation of the motif of the Lodzermensz into the *szmonces* genre is evident when looking, even superficially, at one of the "classic" Tuwim *szmonces* monologues, first published in *Estrada* in 1918. This conversation reproduces the previously mentioned 1910 satirical dialogue involving a Lodzermensz at the Hotel Savoy in Łódź.

Handelman and Kantorowicz are talking about going to Warsaw:

HANDELMAN: "Where are you going to stay?"
KANTOROWICZ: "In the 'Central,' a superb hotel."
HANDELMAN: "Expensive?"
KANTOROWICZ: "First floor, 20 marks; second, 15. Third, 10."
HANDELMAN: "How many floors does it have?"
KANTOROWICZ: "Three."
HANDELMAN: "For me, this hotel is too low."[39]

But transfer does not mean reproduction; rather, it speaks to a reinterpretation of motifs. In the process of transfer, the monologue changed its meaning, even turning into its opposite. Konrad Tom's hit, performed by Kazimierz Krukowski (Lopek) in Qui Pro Quo, reflects such a transformation. In Qui Pro Quo, he sang his famous motto: "If you don't have what you like, then you like what you have."[40] It suggests the opposite of the advice offered by the Lodzermensz father, which was discussed previously. In the process of movement from one place to another, from periphery to center in the context of new socioeconomic conditions, the transferred motif completely changed its meaning. The prewar Lodzermensz's promise of upward mobility to his young son became a chimera in interwar Warsaw. On the stage of Qui Pro Quo, Lopek's character who performed the song, instead of being the young son, was a grown-up man observing the consumer feast while maneuvering a life of ongoing crisis and stagnation. The modern consumerist practices, which were celebrated in prewar Łódź while also manifesting social anxieties, were translated by *szmonces* into a universal experience with a disorganized logic but an identifiable cause. In the process of the transfer, we see particularities that are always contingent and dependent on context.

The *szmonces* characters often resembled that of the Lodzermensz: greedy but sympathetic; vociferous, extroverted, and open; and absurd but refreshingly frank in their processing of "strange" new fashions.[41] The *szmonces* dialogues of Maks

and Moryc (Urstein and Tom, respectively) in Qui Pro Quo reproduced some of their satirical dialogues from Łódź, but in Warsaw, these acts highlighted the hardships of upward mobility in the new Poland.[42] The character of Lopek, played by Kazimierz Krukowski, likewise transformed the former Lodzermensz into the new everyman, who was confused by life in the uncertain, rapidly changing world of the modern metropolis.[43] Dora Kalinówna (Klingbeil; b. 1900 in Łódź), the only female actress among the many male stars, performed *szmonces* at Qui Pro Quo.[44] Her performances of female characters bore the hallmarks of Lodzian women: extremely snobbish and frivolous.[45]

Transformed in Warsaw, the Lodzermensz became the epitome of an all-embracing social experience representing the relations of the individual to the new modern world. However, the concept of Lodzermensz now performed within the *szmonces* genre did not lose its Otherness. Simultaneously, the performance negotiated it as representing *universal* troubles and misfortunes of the individual in an incomprehensible modern existence. The performance provided the necessary empathetic link between the character-performer and the spectator.

As the scholar of Polish literature Knut Andreas Grimstad observes, the language of *szmonces* represented everyday urban life.[46] The *szmonces* dialect, based on the "Jewish" way of speaking and accent or ethnolect, also relied on stereotypical characters derived from the popular stereotype of "the Jew," and the actors employed ethnic markers in their performance. Although the language of the interwar literary cabaret was Polish, the performance itself challenged the language, translating the corrupted local language of the Lodzermensz into a generalized, urban phenomenon.

As in the earlier type of the Lodzermensz, the characters we find in *szmonces* were characterized by "bad pronunciation," explicitly modulated Polish in foreign accents (Czech, Hungarian, German, and Russian), with foreign words and expressions (German, French, and Yiddish). In the cabarets of Warsaw, the authors and performers virtuosically used multilingual quotes and phraseology from many European languages. In doing so, they created a new sociolinguistic register that matched the reflexivity of its creators and actors.

As in the earlier Lodzermensz dialogues, the texts of *szmonces* frequently contained slang and words invented by the writers, a game at which Tuwim excelled even before his arrival in Warsaw.[47] Rather than a merely artistic or commercial decision, this constituted a subversive political move, offering an alternative to the purist vision of language and society. Contemporary critics drew attention to the way in which cabaret created a particular language, with its own syntax, intentional stylistic errors, word formations, and lexical neologisms. "Every term [represented] a concept," the celebrated literary critic, playwright, and translator Tadeusz Boy-Żeleński (1874–1941) wrote in 1924.[48] Writing and staging "Jewish" characters as visible members of society who embodied the problematics of the era, the creators of the cabaret experimented with a "new language" and thus undermined essentialist boundaries through foreign accents and challenged static concepts of language and nationality.

The process of including the Lodzermensz in the *szmonces* genre reflects an aspirational sense of metropolitan-style culture in both center and periphery, including the singular dynamics of Łódź as an advancing center that imported cultural assets, elaborated upon them, made them local, and then exported them again. In other words, not only did Łódź, as a periphery, "import" certain assets from the hegemonic centers (Paris, Munich, and Warsaw), but it also "exported" certain re-elaborated assets. In the process, the Warsaw center showcased the peripheral local characteristics and—as a metropole—translated them into the "universal." The transfer between the periphery and the center allows us to see that the claim to the "universal" made in the center carries with it traces of the transferred "particular."

Kleynkunst Teater: Literary Cabaret in Yiddish

By the end of the Great War, Lodzian Jewish painters and sculptors met Yiddish poets and writers (after some of them returned from Russia, Ukraine, and Germany), and toward the end of 1918, they created the avant-garde artistic group Yung-yidish, which Małgorzata Stolarska-Fronia explores in chapter 4 of this volume. The group published an eponymous journal in Yiddish, featuring a mixture of visual art and words—"poems and words in drawings"[49]—reflecting the idea that no barriers should come between artistic genres. As in Bi-Ba-Bo before that, the combination of literature and visual arts was enhanced through the addition of *voice* to written words and images in the first Yiddish *kleynkunst teater* performance in Łódź, which took place toward the end of 1919.[50] It was a onetime performance by Moyshe Broderzon, his wife (Sheyne-Miryam), Yitskhok (Wincenty) Brauner, and other people close to Yung-yidish. As in other performances in this genre in contemporary Łódź and Warsaw, it included dance, declamation, and popular music.[51]

I posit that the emergence of the sophisticated Yiddish *kleynkunst teater* was also a reflection of the contemporary Polish-language literary cabaret. Yung-yidish artists and the artists who created Bi-Ba-Bo and later Qui Pro Quo kept contacts dating back to their formative years. Some of the Yung-yidish artists studied with Szyk at the school of Kacenbogen (Katsenbogen), including Yitskhok Brauner and Henokh (Henryk) Barczyński. They continued to stay in touch beyond their school years.[52] Yung-yidish artists, among them Ida and Yitskhok Brauner, created illustrations for the Łódź journal *Tańczący ogień* (Dancing fire; whose only issue appeared in late 1919), which published poems by Antoni Słonimski and Julian Tuwim.[53] This suggests additional interactions behind the scenes. Moreover, the idea of "poems and words in drawings" transcended not only the Yiddish-Hebrew divide but also the Jewish-Polish one. *Tańczący ogień* attempted to organize an artistic evening of "Word, Voice and Tone" ("Słowa, Głosu i Tonu"), with the participation of Yung-yidish artists.[54]

After other short-lived incursions in the genre, Moyshe Broderzon founded in Warsaw the first Yiddish *kleynkunst teater*, Azazel, in 1926.[55] Shortly after, in 1927, Broderzon established and directed the very popular *kleynkunst* Ararat in Łódź,

analyzed in extenso in Zehavit Stern's chapter. Broderzon modeled it (at least partially) on the earlier Bi-Ba-Bo cabaret, on the contemporary Polish-language literary cabaret in Warsaw that also performed in Łódź (its performances were covered by the local Yiddish press), and on the Russian Siniaia Ptitsa, among others.[56] Along the lines of Qui Pro Quo, Broderzon introduced, for example, political sketches in Yiddish into Ararat performances.

However, Broderzon's practice of cultural translation, emphasizing the traffic within and between cultures and languages and between the center of Warsaw and the periphery of Łódź, did not mean simple reproduction. While the Polish-language Lodzermensz dialogues and *szmonces* sketches performed in cabaret embodied the social hardships experienced by the modernizing urban society of Łódź and, more broadly, Poland, Ararat emphasized the difficulties of Jewish existence in contemporary Poland. Ararat shifted the focus to the particular worries and tribulations of the local Jew, presented as a concrete human rather than a concept that signified a generalized experience of modernity. In the Yiddish *kleynkunst teater*, the Lodzer protagonist returned from serving the universal back to the local and particular. The return to the particular was also an understandable reaction to the failed promise of universalism that was implicit in the aesthetics of the Warsaw literary cabaret.

Broderzon and his creation of a Yiddish literary cabaret in Łódź conclude a multidirectional spiral flow of culture from Lodzermensz to *szmonces*, from Polish to Yiddish, from the periphery to the center, and from the center back, transformed, to the periphery, this time celebrating the particularity. This chain, however, reinitiated a new cycle in the process of mutual cultural and multidirectional transference that undoubtedly existed in interwar Poland in other fields of mass culture like cinema or radio and seemingly in other practices of leisure. This merits further exploration in future studies.

Conclusion

A creative class that produced new popular and mass urban culture came into being in Łódź during the early twentieth century, when socioeconomic conditions favored its rise. A group of Łódź artists who operated on the sociocultural "frontier" transferred elements between cultures into ostensibly clear-cut "Polish" or "Jewish" ones. This creative class performed a complex process of cultural transference between languages, ethno-national discourses, and class stereotypes, encapsulated in the stereotype of the Lodzermensz. During World War I, they transferred this set of concepts to Warsaw. There the Lodzermensz merged into the *szmonces* genre and gained a "universal" meaning; traces of the Lodzermensz were appropriated for the use of the hegemonic metropolitan center. Later, it returned to Łódź within the Yiddish-language *kleynkunst teater*, where the "particular" was reinscribed back into the periphery.

This multidirectional flow of culture that transferred artistic genres, cultures, and languages undercuts the assumption that the metropole was *the* creative center,

which radiated to the periphery. Indeed, we can now see Łódź as a focus of cultural exchange. The so-called peripheral city was an original site of culture, which stimulated a transnational network of popular culture that took interwar Warsaw by storm and then returned home.

Notes

1. "Już nie handluje," in *Łodzianka: Kalendarz humorystyczny na rok 1910* (Łódź: Rubinek, 1909), 28.
2. For a useful introduction to the complexities of cultural transmission, see Anthony Grafton, "Introduction: Notes from Underground on Cultural Transmission," in *The Transmission of Culture in Early Modern Europe*, ed. Anthony Grafton and Ann Blair (Philadelphia: University of Pennsylvania Press, 1990), 1–7.
3. L. Skawińska and Z. Skibiński, "Rozmowy w 'Tyglu': Lodzermensch—historia i mit," *Tygiel Kultury*, nos. 3–4 (1998): 33; M. Wika, "Nazwy Łódź, łódzki, po łódzku jako element wartościujący w powieści Władysława Reymonta Ziemia obiecana," in *Inny Reymont*, ed. Władysława Książek-Bryłowa (Lublin: Wydawnictwo Uniwersytetu Marii Curie-Skłodowskiej, 2002). For an English translation of the renowned novel, see Władysław Stanisław Reymont, *The Promised Land*, trans. Michael Henry Dziewicki, 2 vols. (New York: Alfred A. Knopf, 1927).
4. Julian Janczak, "Struktura narodowościowa Łodzi w latach 1820–1939," in *Dzieje Żydów w Łodzi 1820–1944, Wybrane problemy*, ed. Wiesław Puś and Stanisław Liszewski (Łódź: Wydawnictwo Uniwersytetu Łódzkiego, 1991), 42–44, here 48; Julian Janczak, "The National Structure of the Population in Łódź in the Years 1820–1939," in *Jews in Lodz, 1820–1939*, vol. 6 of *Polin: Studies in Polish Jewry*, ed. Antony Polonsky (Oxford: Basil Blackwell for the Institute for Polish-Jewish Studies, 1991), 20–26, here 25.
5. Hanna Krajewska, *Życie filmowe Łodzi w latach 1896–1939* (Warsaw: PWN, 1992); Piotr Kulesza, Anna Michalska, and Michał Koliński, *Łódzkie kina od Bałtyku do Tatr* (Łódź: Księży Młyn, 2015), 11; Wojciech Źródlak, Jan Raczyński, and Tomasz Igielski, eds., *Łódzkie tramwaje 1898–1998* (Łódź: Księży Młyn, 1998).
6. The literature on the topic is vast. See, for instance, Norman Naimark, *Terrorists and Social Democrats: The Russian Revolutionary Movement under Alexander III* (Cambridge, Mass.: Harvard University Press, 1983). On the involvement of Jews in socialism in Russia, see, among others, Jonathan Frankel, *Prophecy and Politics: Socialism, Nationalism and the Russian Jews, 1862–1917* (Cambridge: Cambridge University Press, 1984); and Erich Haberer, *Jews and Revolution in Nineteenth-Century Russia* (Cambridge: Cambridge University Press, 1995).
7. Zygmunt Bartkiewicz, *Złe miasto* (Warsaw: Nakładem Jana Czempińskiego, 1911).
8. Israel Bartal, "Midu-leshoniyut mesoratit leḥad-leshoniyut le'umit," *Shvut* 15 (1992): 183–194; Itamar Even-Zohar, "Aspects of the Hebrew-Yiddish Polysystem: A Case of a Multilingual Polysystem," *Poetics Today* 11 (1990): 121–130. The bilingualism so widespread in Jewish life was present in some measure also in non-Jewish society. See Krystyna Radziszewska and Krzysztof Woźniak, eds., *Pod jednym dachem: Niemcy oraz ich polscy i żydowscy sąsiedzi w Łodzi w XIX i XX wieku / Unter einem Dach: Die Deutschen und ihre polnischen und jüdischen Nachbarn in Lodz im 19. und 20. Jahrhundert* (Łódź: Wydawnictwo Literatura, 2000), 127, 138.
9. Janczak, "Struktura narodowościowa Łodzi," 49. Almost 6 percent of all Protestants (i.e., more than three thousand people) claimed Polish as their mother tongue; 8 percent of all Catholics (thirteen thousand) claimed German. Janczak, "Population in Łódź," 22.

See also Marek Budziarek, "Konfessionelle Koexistenz in Lodz im 19. und 20. Jahrhundert," in *Polen, Deutsche und Juden in Lodz 1820–1939: Eine schwierige Nachbarschaft*, ed. Jürgen Hensel (Osnabrück: Fibre, 1999), 269–282, esp. 270–272.

10. Wiesław Puś, *Żydzi w Łodzi w latach zaborów, 1793–1914* (Łódź: Wydawnictwo Uniwersytetu Łódzkiego, 2001), 47, 49; Jerzy Tomaszewski, "Jews in Łódź in 1931 according to Statistics," in Polonsky, *Jews in Lodz*, 6:177–179.

11. Elżbieta Umińska-Tyton, "'Łódzka mowa' oczami Juliana Tuwima (na podstawie 'Kwiatów polskich')," in *Julian Tuwim: Biografia, twórczość, recepcja*, ed. Krystyna Ratajska and Tomasz Cieślak (Łódź: Wydawnictwo Uniwersytetu Łódzkiego, 2012), 165–166.

12. The literature on the topic is voluminous. See more recently Agata Zysiak, "The Desire for Fullness: The Fantasmatic Logic of Modernization Discourses at the Turn of the 19th and 20th Century in Łódź," *Praktyka teoretyczna* 13 (2014): 41–69; and Agata Zysiak et al., *From Cotton and Smoke: Łódź—Industrial City and Discourses of Asynchronous Modernity, 1897–1994* (Kraków: Jagiellonian University Press, 2019), 88–97.

13. *Śmiech*, January 28, 1909, 1.

14. *Mucha*, June 23, 1911, 10. Ellipsis in original.

15. *Śmiech*, November 30, 1912, 9.

16. "Złoty młodzieniec," in *Łodzianka*, 16.

17. "Co to znacze," in *Łodzianka*, 48. Ellipsis in original.

18. "Pociemku [sic!]," *Śmiech*, January 17, 1914, 3.

19. "Z feminizmu," *Śmiech*, February 7, 1914, 3.

20. "Ojcowska rada," in *Łodzianka*, 30.

21. Frank M. Schuster, "Stadt der vielen Kulturen—Stadt der 'Lodzermenschen': Komplexe lokale Identitäten bei den Bewohnern der Industriestadt Lodz 1820–1939/1945," in *Intercultural Europe: Arenas of Difference, Communication and Mediation*, ed. Barbara Lewandowska and Tomaszczyk Hanna Pułaczewska (Stuttgart: Ibidem Verlag, 2014), 33–60; Frank M. Schuster, "Die verborgene Stadt: Die Wiederentdeckung der polyethnischen Vergangenheit der Stadt Łódź," *Convivium: Germanistisches Jahrbuch Polen*, no. 2 (2008): 143–170.

22. *Łodzianka*, 32.

23. Richard Florida, *Cities and the Creative Class* (New York: Routledge, 2005).

24. See Hannah Arendt, "From the Dreyfus Affair to France Today," *Jewish Social Studies* 4 (1942): 195–240; and Hannah Arendt, "The Jew as Pariah: A Hidden Tradition," *Jewish Social Studies* 6 (1944): 99–122.

25. Although his essentialist arguments are problematic, Rafał Matera applied Florida's theory to explain Łódź's economic development. See Rafał Matera, "Rola Żydów w rozwoju Łodzi (do 1914 roku) w świetle teorii klasy kreatywnej," in *Rola Żydów w rozwoju gospodarczym ziemi łódzkiej, Wybrane zagadnienia*, ed. Janusz Skodlarski et al. (Łódź: Wydawnictwo Uniwersytetu Łódzkiego, 2014), 31–76.

26. The novel *Uncle Tom's Cabin* was known in Poland already in 1853, with the first full translation in 1856 and three others by 1901. It was also often performed on the theater stage. See Pat M. Ryan, "Some Polish Perspectives on African American History and Culture," *Polish Review* 37 (1992): 137n13, 158. When adopting the pen name Oncle Thom, Konrad Runowiecki was undoubtedly aware of the novel, but its connotations in Poland, especially for a Polish Jew who endeavored to bridge the Polish and Jewish cultures, cannot be presumed to be the same as those in the United States when it was first written or how it was received in the early decades of the twentieth century.

27. Oncle Thom (Konrad Tom), "Kolonia literacko-artystyczna w Łodzi" and "Bi-Ba-Bo," *Nowa Gazeta Łódzka*, no. 49 (March 2, 1914): 3.

28. Oncle Thom (Konrad Tom), "Bi-Ba-Bo," *Nowa Gazeta Łódzka*, no. 49 (March 2, 1914): 3; Janusz Dunin, *W Bi-Ba-Bo i gdzie indziej: O humorze i satyrze z miasta Łodzi od*

Rozbickiego do Tuwima (Łódź: Wydawnictwo Łódzkie, 1966), 53–90; Joseph Ansell, *Arthur Szyk: Artist, Jew, Pole* (Oxford: Littman Library of Jewish Civilization, 2004), 18–19; Aneta Stawiszyńska, *Łódź w latach i wojny światowej* (Oświęcim: Wydawnictwo Napoleon V, 2016), 169–170.

29. Dunin, *W Bi-Ba-Bo*.

30. E. Bar, "Życie prywatne bandytów rewiowych," *Ilustrowana Republika*, June 25, 1932, 7.

31. In Łódź, he began using the nickname "Pipman." On his Bi-Ba-Bo contributions, see, for instance, "Pipman mów," *Śmiech*, March 21, 1914, 5; "Bi-Ba-Bowe fotografie," *Śmiech*, May 4, 1914, 9; and biographical sketches in "Zgon Józefa Ursteina," *Polska zbrojna*, October 9, 1923, 5. He was born in Warsaw in 1884 and worked from 1913 to ca. 1915 or 1916 in Łódź. During World War I, he worked in a literary cabaret in Vienna. In 1917, he began working in Warsaw's Miraż. He moved to Qui Pro Quo after its establishment.

32. Artur Marcel Wera, *Rosa, wir fahr'n nach Lodzh: Marsch-couplet* (Vienna: Kreun, 1915); Alexander Kossert, "'Promised Land'? Urban Myth and the Shaping of Modernity in Industrial Cities: Manchester and Lodz," in *Imagining the City*, vol. 2, *The Politics of the Urban Space*, ed. Christian Emden, Catherine Keen, and David R. Midgley (Frankfurt: Peter Lang, 2006), 180; Winson Chu, *The German Minority in Interwar Poland* (Cambridge: Cambridge University Press, 2012), 117.

33. Thom, "Bi-Ba-Bo"; Anna Kuligowska-Korzeniewska, "Roch Pekiński w 'Różowym Słoniu'—estradowe wystąpienia Juliana Tuwima w Łodzi podczas Wielkiej Wojny," in Ratajska and Cieślak, *Julian Tuwim*, 209–210.

34. Leo Belmont, "Bi-Ba-Bo," *Życie łódzkie: Jednodniówka*, 1914, 18.

35. Stawiszyńska, *Łódź w latach*, 144–145.

36. On the Great War economic cataclysm and the immediate post–World War I crisis, see, inter alia, Stawiszyńska, 244–386, 466–496.

37. Knut Andreas Grimstad, "Shmontses," in *Enzyklopädie jüdischer Geschichte und Kultur*, ed. Dan Diner (Stuttgart: Verlag Metzler, 2014), 5:468–472.

38. Michael C. Steinlauf, "Józio Grojseszyk: A Jewish City Slicker on the Warsaw Popular Stage," in *Jewish Theatre: A Global View*, ed. Edna Nahshon (Leiden: Brill, 2009), 70–71.

39. Anna Krasowska, *Szmonces przedwojenny żydowski humor kabaretowy wybór tekstów* (Warsaw: Wydawnictwo Uniwersytetu Kardynała Stefana Wyszyńskiego, 2015), 92.

40. Beth Holmgren, "Cabaret Nation: The Jewish Foundations of Kabaret Literacki, 1920–1939," in *Poland and Hungary: Jewish Realities Compared*, vol. 31 of *Polin: Studies in Polish Jewry*, ed. François Guesnet, Howard Lupovitch, and Antony Polonsky (London: Littman Library of Jewish Civilization, 2018), 287.

41. Dorota Fox, *Kabarety i rewie międzywojennej Warszawy* (Katowice: Wydawnictwo Uniwersytetu Śląskiego, 2007), 168, 170–174; Ryszard Marek Groński, *Jak w przedwojennym kabarecie* (Warsaw: Wydawnictwa Artystyczne i Filmowe, 1987), 44–46; Holmgren, "Cabaret Nation."

42. Holmgren, "Cabaret Nation," 21.

43. Knut Andreas Grimstad, "Transcending the East-West? The Jewish Part in Polish Cabaret in the Interwar-Period," *Jahrbuch des Simon-Dubnow-Instituts* 7 (2008): 161–188; Dorota Fox, "Teatralny rodowód Lopka na marginesie szmoncesu," in *Żydzi w lustrze dramatu, teatru i krytyki teatralnej*, ed. Eleonora Udalska and Anna Tytkowska (Katowice: Wydawnictwo Uniwersytetu Śląskiego, 2004), 185–202; Holmgren, "Cabaret Nation."

44. According to Kalinówna, she was born in Łódź in 1905, where she studied at the local Hebrew gymnasium while dreaming about becoming an actress in Palestine. "Rozmowa z Dorą Kalinówną," *Ewa*, June 23, 1929, 2.

45. Grimstad, "Shmontses," 5:470; Holmgren, "Cabaret Nation," 285–286.

46. Grimstad, "Transcending the East-West?," 176.

47. Originally neutral, later on, especially during the 1930s, *szmonces* ethnolect acquired pejorative connotations as *żydłaczenie* ("talking like a Jew").

48. Tadeusz Boy-Żeleński, *Pisma* (Warsaw: Państwowy Instytut Wydawniczy, 1958), 21:494, quoted in Fox, *Kabarety i rewie*, 196. On Boy-Żeleński, see Bożena Shallcross's chapter in this volume.

49. *Yung-yidish*, no. 1 (February–March 1919): 2.

50. "A Bagrisung," *Yung-yidish*, nos. 4–6 (December 1919); Jerzy Malinowski, *Grupa "Jung Idysz" i żydowskie środowisko "Nowej Sztuki" w Polsce: 1918–1923* (Warsaw: Polska Akademia Nauk. Instytut Sztuki, 1987), 38.

51. "A Bagrisung"; Malinowski, *Grupa "Jung Idysz"*; Marek Bartelik, "Modele Wolności: Kobiety w Składzie Łódzkiej Grupy Jung Idysz w Latach 1919–1921," in *Polak, Żyd, artysta: Tożsamość a awangarda*, ed. Jarosław Suchan and Karolina Szymaniak (Łódź: Muzeum Sztuki w Łodzi, 2010), 61.

52. Malinowski, *Grupa "Jung Idysz,"* 15; Jerzy Malinowski, "Żydowskie środowisko artystyczne w Łodzi," in *Polacy-Niemcy-Żydzi w Łodzi w XIX I XX w. Sąsiedzi dalecy i bliscy*, ed. Paweł Samuś (Łódź: Uniwersytet Łódzki, 1997), 299; Tamara Sztyma-Knasiecka, *Syn swojego Ludu: Twórczość H. Glicensteina 1870–1942* (Warsaw: Neriton, 2008), 125.

53. Julian Tuwim's poem "Pijaństwo," *Tańczący ogień: Dla sztuki i wszystkiego, co z nią związane*, 1920, 6; Antoni Słonimski, "Zwycięscy," *Tańczący ogień: Dla sztuki i wszystkiego, co z nią związane*, 1920, 25; "Sonet," *Tańczący ogień: Dla sztuki i wszystkiego, co z nią związane*, 1920, 29. See also Bartelik, "Modele wolności," 60.

54. *Tańczący ogień: Dla sztuki i wszystkiego, co z nią związane*, 1920, 34; Malinowski, *Grupa "Jung Idysz,"* 40, 145.

55. M. V., "Khronik fun yiddishn teater," *Yidish teater* 1 (1927): 99; Aviv Livnat, "Far unzere kinstler (For Our Artists): Tea Arciszewska and the Jewish Artists," in *Art in Jewish Society*, ed. Jerzy Malinowski et al. (Warsaw: Polish Institute of World Art Studies, 2016), 28.

56. Chone Szmeruk, "Mojżesz Broderzon a teatr w języku jidysz w Łodzi (przyczynki do monografii)," in *Łódzkie sceny żydowskie: Studia i materiały*, ed. Małgorzata Leyko (Łódź: Wydawnictwo Uniwersytetu Łódzkiego, 2000), 64; Zehavit Stern, "From Jester to Gesture: East-European Jewish Culture and the Re-imagination of Folk Performance" (PhD diss., University of California, Berkeley, 2011), 76–77, 80–82.

PART III

Maps and Spaces

CHAPTER 9

The Layered Meanings of an Unbuilt Monument

KRAKÓW JEWS COMMEMORATE THE POLISH KING CASIMIR THE GREAT

Alicja Maślak-Maciejewska

In the last quarter of the nineteenth century, an idea was raised among Cracovian Jewry to erect a full-figure statue of Casimir the Great, a Polish fourteenth-century king from the Piast dynasty, remembered as a great monarch and the builder of Poland. Casimir the Great became a symbol of the great Polish past, which is reflected in a popular saying about his reign: "When he ascended, Poland was made of wood, when he left us, it was from stone."

The several-meters-tall statue was supposed to be built in Wolnica Square, the old market square of Kazimierz, near the former town hall (up until the early nineteenth century, Kazimierz was a separate town; later, it became a district of Kraków). The project was executed exclusively by Jews who constituted and later sat on the Monument Erecting Committee and who collected money among themselves for this purpose. For more than two decades, the committee discussed and developed the idea, but despite numerous efforts, the statue never came into being in its envisioned shape. The monument of Casimir the Great was never built. Soon the project fell into complete oblivion; it has been absent not only from the collective memory of Kraków's citizens but also from the scholarly literature on the history of the city and its Jewish community.

This chapter was born from the conviction that the project, although only envisioned and never accomplished, nevertheless has great potential to become a powerful analytical tool in research on Galician Jewry in the last decades of the nineteenth century, particularly on the processes of acculturation, the efforts of Jewish cultural production, and the intellectual and social life of Jewish intelligentsia. Investigated through various contexts, it might offer us insights into an

intellectual universe and set of values of the people who formulated the initiative and worked on it.

A Short History of the Project[1]

The idea of building a statue of Casimir the Great in Kazimierz was most probably raised for the first time in the early 1880s.[2] Since the very beginning, the majority of its proponents were Jews who had ties with the local progressive synagogue, known as the Tempel. Two subsequent leaders of the Monument Erecting Committee, Jonathan Warschauer and Jan Albert Propper, were simultaneously two of the most prominent activists of the progressive milieu. The very group of "progressive Jews" crystallized in the 1840s, establishing the Progressive Association. Although it was internally diversified, one can discern several characteristics: its members were relatively well educated, many of them belonged to the professional intelligentsia, their socioeconomic status was often high, and they were usually acculturated, yet they had strong bonds with Judaism and Jewish tradition. In the Tempel, an emphasis was put on decorum and on the elegance of the religious service. While several innovations in the service were introduced—such as a Polish or German sermon, a mixed choir, and various regulations to disallow latecomers to attend services—it avoided far-reaching reforms.[3] Since the 1860s, the progressive milieu made efforts, which were partially successful, to strengthen its influences and to represent the whole Jewish community.[4]

While pro-Polish attitudes in the nineteenth century were not limited to progressive circles (and not all members of those circles held them), the Tempel became one of the centers of Polish patriotic activities among Kraków Jewry. It organized festive ceremonies on the anniversaries of important events in Polish history, such as national uprisings.

One of the most active groups engaged in the project of building the king's statue gathered in the Reading Room of the Jewish Mercantile Youth (Pol. *Czytelnia Starozakonnej Młodzieży Handlowej*), an organization closely associated with the Tempel. The Reading Room was a secular organization established in 1882 in order to provide youth employed in trade and commerce with an opportunity to spend their free time productively and wisely.[5] In the years to follow, the Reading Room organized public lectures on various topics; sponsored music, theater, and literary events or short trips; offered access to new journals; and opened a lending library. The Reading Room became one of the centers of pro-Polish activities among Kraków Jewry, as it regularly organized literary and musical evenings devoted to Polish writers like the national poet Adam Mickiewicz and to important events in Polish history.

The idea of building the statue of Casimir the Great crystallized in the second half of 1883. A series of meetings was organized at that time to discuss both the form of the future monument and the manner in which the work would be conducted.[6] As one of the contemporaries summarized, the building of the statue became at that time "la question du jour."[7] As a result, in 1884, the first Monument

Erecting Committee was constituted, composed mainly of the members of the Reading Room of the Jewish Mercantile Youth. Soon it received a permit from the Government of Galicia (Pol. *Namiestnictwo*) to conduct a public money collection. Subsequently, it sent out an appeal to Jewish communal organizations, reminding them about the importance of Casimir the Great for the Jews and asking for support for this initiative. The committee decided to collect money exclusively among Jews, hoping that it would become a symbolic sign of gratitude presented to the king and to the Polish nation.[8] Jonathan Warschauer opposed this exclusion and argued that "[Israelites] should avoid any separatism, and erection of the monument is a common task of those living in Polish lands, regardless of their faith."[9] At the time when Warschauer voiced his opinion, the activities of the Monument Erecting Committee were already perceived by some as too slow or sluggish. Soon the committee reorganized.

Since the 1880s, the committee consulted with several artists about the idea of erecting the monument; twice the negotiations became advanced and, as press reports suggest, the project was close to realization. In 1888, the head of the Monument Erecting Committee, Jan Albert Propper, discussed the project with Stanisław Lewandowski,[10] a young and successful sculptor who had twice recently won the first prize in a prestigious competition announced by the Association of Fine Arts (Pol. *Towarzystwo Zachęty Sztuk Pięknych*).[11] The monument they envisioned was supposed to feature a life-size bronze figure of the king seated on a pedestal carved in stone. Although Lewandowski offered to make the statue just for the cost of materials, the funds collected by the committee did not suffice.[12] Three years later, work on the monument was undertaken by the Zawiejski brothers, Jan (architect) and Mieczysław (sculptor).[13] The brothers had Jewish roots, though their grandparents were baptized in the mid–nineteenth century and their father, Leon, changed the family name from Feintuch to Zawiejski. The family actively cultivated Polish patriotic traditions, supporting, for example, the Polish insurgents during the January Uprising. Jan Zawiejski is best known for his project of the monumental Municipal Theater in Kraków (today, the Słowacki Theater).[14]

The monument the Zawiejski brothers designed was supposed to be eight meters high (a four-meter figure of the king and a four-meter pedestal), enclosed by a decorative fence with four candelabra.[15] Although we do not know exactly why this project, already advanced, was abandoned again around 1894, we can assume that it related to the departure of Mieczysław Zawiejski, who left Kraków around that time.

In the 1880s and 1890s, the project of building the king's monument had its ups and downs. The initiative would be relinquished on many occasions and then revived after a period of a few months or sometimes years. Meanwhile, the Monument Erecting Committee was reorganized several times. While in the 1880s it was composed exclusively of men, at the end of the nineteenth century, women assumed leadership. The "women's committee" was formed in 1896 with Aniela Korngut, a writer and journalist, and Adela Propper at the helm.[16] All in all, the Monument Erecting Committee (with its members changing several times) was active for almost three decades but failed to raise the monument in the planned form.

The Role and Position of Casimir the Great

Why in the late nineteenth century did Jews want to commemorate Casimir the Great, the fourteenth-century Polish king? There are several answers to this question. The first is embedded in a historical narrative about the role he played in improving the position of Jews in Poland; this narrative had become increasingly mythologized over time. His reign was described as a moment of strengthening the visibility and power of formerly unprivileged groups within the society, and the king himself was presented as a benefactor of the Jews who allowed them to settle and flourish in his country. This narrative was conveyed to Jewish society by both oral tradition (the legend about Esther, the king's wife/mistress, thanks to whom he was more sensitive toward Jews) and contemporary historical narrations.[17] In 1862, when it became known that the king's sarcophagus on the Wawel Hill required renovation, the Warsaw-based *Gazeta Polska* suggested that the groups that "profited most" from the king's politics should donate money for this purpose.[18] Soon the Warsaw Polish-Jewish weekly *Jutrzenka* responded to this plea by publishing a lengthy article on its front page, explaining to its Jewish readers that this request applied to them. By writing "only the well-being of all groups within society, and their cooperation could provide serenity to the whole society," the editors symbolically bridged the times of Casimir the Great with the contemporary.[19] The article was followed by a list of Jews who had already donated money for this sake. We find among them a number of prominent figures, such as Daniel Neufeld and Matthias Rosen.[20]

For Kraków Jewry, the king, as the founder of the town bearing his name, had additional meaning. Kazimierz, a district of Kraków by the nineteenth century, had for centuries been a place where Jewish life flourished. Moreover, in the 1880s, when the idea to build the king's memorial was raised for the first time, the memory of the events of 1869 was still fresh. In that year, during the restoration of the king's sarcophagus in Wawel Cathedral, his ashes were "miraculously" found in situ (common knowledge was that the sarcophagus was in fact only a cenotaph). Contemporaries agreed that "finding" the king's ashes was an event of great symbolic importance in the times when Poland "had no king and no independence." The event triggered patriotic enthusiasm that engaged Poles from Galicia and other partitioned Polish lands who came to Kraków to celebrate the king's memory and to attend his second burial. At that time, Kraków and Wawel Hill (formerly the monarch's residence) gained a particularly strong patriotic meaning for Poles as the cradle of Polish civilization and as a center and symbol of Polishness. It became the site of numerous festive historical commemorations, including the jubilee of Polish writer Józef Ignacy Kraszewski in 1879, the two hundredth anniversary of the Relief of Vienna in 1883, the transfer of Mickiewicz's ashes to Kraków in 1890, and the five hundredth anniversary of the Battle of Grunwald in 1910. The development of this jubilee culture had great importance for fostering Polish identity and for the process of nation building during the time when Poland lacked political independence.[21] In the nineteenth century, Kraków was on the periphery

of the Habsburg Empire and played a lesser political role than did Lwów, the capital of the province of Galicia. Nevertheless, Kraków maintained its central role as a Polish spiritual capital (Pol. *stolica duchowa*).

In 1869, on the day of Casimir the Great's second burial, a festive ceremony including a procession and mass in the Wawel Cathedral gathered crowds. Jews also participated in this patriotic fervor and organized a solemn service in the Tempel. During the service, the preacher, Szymon Dankowicz (1834–1910), delivered a Polish sermon in which he called Kraków a "true Polish Jerusalem" and referred multiple times to a common Polish-Jewish history and Polish-Jewish brotherhood. Both nations, he intoned, were "bound together by a common fortune and misfortune, by sorrow and the times of peace."[22] Since Christians were invited to the service and indeed participated in it in significant numbers, the event became an occasion of Polish-Jewish rapprochement. The accounts of the service in the Tempel with the accompanying sermon were published in the local Polish press. One newspaper even described the service in the synagogue as being more spiritual and more moving than the Catholic one, and the sermon itself was soon published in a separate brochure that made it better known to the wider public.[23] One can assume that in 1882, when the initiative to build Casimir's monument emerged among Kraków Jewry, a memory about the 1869 manifestations was, if not fresh, at least present. Therefore, this initiative could have symbolically referred to this instance of successful, mutual rapprochement. One of the Kraków correspondents of the Polish-Jewish biweekly *Ojczyzna* reflected on the symbolic geography of Wawel, Casimir the Great's burial place. He wrote, "The same God who created a rainbow as a sign that the Flood will be no more, made Wawel to stand until these days between the Jewish quarter, Kazimierz, and the actual city to be a sign that the discord between Judah and Lechia has to stop. . . . In the Wawel Cathedral the king of Jews, Casimir the Great, is facing our quarter [Kazimierz] as if he wanted to remind us about the benefaction we received."[24]

Honoring the memory of Casimir the Great might also be situated in another context—namely, the problem of the "Jewish identity" of progressive Jews. While being Polish patriots, they never questioned their Jewish identity, which was not limited to religion but also encompassed tradition, customs, and common historical experience. Progressive Jews often stressed the importance of the local, Polish historical context. The long history of Jews in Poland became an important facet of their identity. They perceived themselves as "Polish Jews," meaning not only Jews speaking (or aspiring to speak) Polish or living in Poland but above all as being shaped by specific *Polish* historical developments. Casimir the Great was surely a key figure in this historical narrative.

Commemoration Culture and Adam Mickiewicz's Memorial

The project of building the statue of Casimir the Great was like other initiatives of building statues of "great men," a custom well established in European culture and art since antiquity. The closest example in terms of geography, time, and symbolism

was the memorial statue of Adam Mickiewicz, designed by Teodor Rygier, which was unveiled on the Kraków market square in 1898.[25] The idea to raise the Mickiewicz monument was voiced for the first time in the late 1860s, but it was revived only a decade later, during the Kraszewski jubilee organized in Kraków in 1879, when significant steps were taken to accomplish the project. A fundraiser was organized, and the competition for the project was announced. The most vivid discussions pertinent to the Mickiewicz monument occurred in the 1880s: the place where the monument could be placed was discussed and three competitions for its design were held in 1882, 1885, and 1888. The projects submitted to the 1882 competition were exhibited in the central covered market, the Sukiennice, and then made available to the public, which instigated public debate on the shape of the future monument.[26] During the last two decades of the nineteenth century, the Kraków daily press frequently reported about the developments pertinent to Mickiewicz's statue. We can conclude that Cracovians were generally familiar with this venture.

Jews engaged in this endeavor as well, both through individual donations and by organizing fundraising initiatives. For example, in 1883, Jewish teachers from a school in Kazimierz organized a "musical-literary evening" with a rich repertoire, during which they collected money for Mickiewicz's statue.[27] The initiative of raising the monument was nevertheless led and organized exclusively by Christians, and no Jew was invited to join the committee. Despite some financial contributions of Jews, their input was not pronounced and most probably not visible to the general public. As a result, they remained symbolically invisible among the creators and builders of the monument. This exclusion might have been meaningful or even bitter for the Polish-Jewish intelligentsia due to the importance that Mickiewicz played in their identities. In the last quarter of the nineteenth century, his figure and his oeuvre were constantly present in the intellectual life of those circles. Mickiewicz was commemorated in the Tempel, his biography and oeuvre were discussed, and his poetry was regularly recited during patriotic evenings organized by the Reading Room of the Jewish Mercantile Youth. The "Mickiewicz evenings" had a rich repertoire composed of speeches about the poet's oeuvre, and recitation and interpretation of his poems interlarded with musical pieces. The evening organized in November 1889 began with introductory remarks about Mickiewicz's work, crowned by an appeal to the "young Jewish intelligentsia to pick up the ideas mooted by the bard." The lecture was followed by, among others, a collective declamation of Mickiewicz's *Dziady, Part III* and the recitation of his poem *Reduta Ordona*.[28] In 1890, Jews participated in the transfer ceremony of Mickiewicz's ashes to the Wawel Cathedral; they marched in the procession, offered a wreath with the inscription "For the immortal author of Jankiel's concert" (portrayed in *Pan Tadeusz*; 1834), and also hosted delegates of non-Kraków Jewish associations who wanted to participate in the ceremony.[29]

The statue of Casimir the Great was supposed to be built by Jews: they initiated the project, sat on the Monument Erecting Committee, and collected and donated money. Building this statue would have allowed Jews to be included in the projects of Polish commemoration culture. The similarities between the two

initiatives, the building of Mickiewicz's statue with that of Casimir the Great's, are striking; both envisioned full figures on a pedestal and were initiated at the same time, in the last two decades of the nineteenth century. The locations in which both monuments were supposed to be situated also had similar symbolic meanings: the Kraków market square and the former market square of Kazimierz, respectively. Moreover, Mickiewicz and Casimir the Great were figures with similar importance to Poland's historical culture that played an increasingly visible role in shaping the consciousness of the modern Polish nation. Both were perceived as great Poles who fundamentally shaped the history and culture of Poland, and their memories had the power of fortifying the spirit of the nation. Additionally, both Casimir the Great and Adam Mickiewicz were perceived as philosemitic or, at least, tolerant of Jews; as a consequence, their personae occupied a special place in the Polish-Jewish patriotic narrative. The affinities between both projects were visible to contemporaries who regularly compared them. For example, a correspondent of *Ojczyzna* wrote with irony that the sluggish activities of the committee in building Casimir the Great's statue might set a bad example for the builders of Mickiewicz's monument.[30]

Progressive Jews hoped that commemorating a figure important to the Polish nation as a whole would lead to a sort of synergy between Jews and Christians. If the project had been successful at the turn of the nineteenth and twentieth centuries, Kraków would have had two monuments of prominent individuals important to "Jewish-Christian" Polish history, and Jews would have participated on equal terms in this commemoration process and building common *lieux de mémoire*.[31] The importance of Casimir the Great could not have been questioned in the nineteenth century, and no less importantly, no one could question the right of the Jews to commemorate "their benefactor."

Two Jewish Monuments:
Casimir the Great and Maurycy Gottlieb

The desire to commemorate Casimir the Great illustrates a high degree of its builders' acculturation, manifested through the very choice of "the object" of commemoration, the modus operandi that mimicked that of non-Jewish society (building a full-figure statue was alien to Jewish tradition[32]), and their following Polish cultural codes. What was the motivation of those who stood behind this initiative? What message was the finished project supposed to convey? Loyalty of Jews to their Christian counterparts? Proof of the possibility of coexistence? Proof of successful assimilation? Insight into those questions might be offered by juxtaposing the project of building the king's memorial with another initiative discussed at that time, the building of a tombstone monument for Maurycy Gottlieb (1856–1879), Jan Matejko's student, the acclaimed Drohobycz-born Jewish painter who died prematurely at the age of twenty-three. Gottlieb's memorial was executed by the same group of people who planned to build the memorial of Casimir the Great.

Soon after Gottlieb's death, the progressive milieu organized a religious service in his memory in the Tempel. During this ceremony, Józef Oettinger, one of the

most active members of this intellectual-religious environment, delivered a eulogy for the deceased artist.[33] Soon, Jews who identified as progressives began to collect money for a future monument.[34] In the years to follow, the Reading Room of the Jewish Mercantile Youth sought to raise the money for the monument. Initially, its members fundraised within their own circles. In 1885, they established a building committee and acquired a permit from the government to seek donations from the public.[35] As they declared, their aim was to "erect for Gottlieb at least a humble monument."[36] In November 1886, the committee, led by Jakub Bałaban, initiated a public fundraising campaign.[37] Funds were collected using the intermediary of several newspapers and through other initiatives, such as the sale of Salomon Spitzer's brochure on Moses Montefiore, but they were still insufficient.[38] The monument was finally completed a few years later. The unveiling ceremony was accompanied by a festive religious service in the Tempel devoted to the memory of the deceased artist, during which Gottlieb was celebrated as a young, exceptionally gifted artist widely acclaimed for his talent, who remained faithful to his own tradition and culture.[39]

Similarities between both projects went beyond the fact that they engaged the same social group. Both were initiated by Jews and were financed from the funds collected within Jewish society. Both faced similar difficulties: a lack of money and insufficiently broad social engagement and support. They were undertaken in the same time frame and in the same city. It is not surprising, therefore, that both monuments were juxtaposed in their day by their initiators and other contemporaries. The Reading Room of the Jewish Mercantile Youth, in its report from 1884–1885, mentioned the two monuments one by one as the initiatives that engaged its members.[40] Also, Kraków correspondents of *Ojczyzna* mentioned both projects jointly. For example, in 1886, after the president of the Reading Room changed, one of the correspondents expressed his hope that under new leadership, "the institution will successfully develop and will finally undertake the 'dormant' projects that it had commenced, the statue of Casimir the Great and the tombstone for Gottlieb."[41] Similar juxtaposition appeared in this journal in 1889. The correspondent complained that the Monument Erecting Committee had not managed to erect the king's memorial and, a few lines later, mentioned the slow progress of fundraising for the Gottlieb memorial. Interestingly, Mickiewicz's memorial was also mentioned in the same correspondence.[42] In 1889, with the tenth anniversary of Gottlieb's death approaching, the fundraising efforts intensified.[43] The Monument Erecting Committee published the list of donors and announced the sum of money collected. Moreover, for the sake of the monument, an amateur theatrical event was organized. Nevertheless, those attempts turned out to be insufficient and did not lead to the timely completion of the project. At the end of 1890, an *Ojczyzna* correspondent bitterly addressed the Cracovian Jewish intelligentsia and blamed it for negligence. He also singled out two projects that had been neglected: the monuments for Casimir the Great and for Gottlieb.[44] We might extrapolate from this that erecting both monuments was, in his opinion, a moral obligation of the same social group—namely, the Polish-Jewish intelligentsia associated with the Kraków Tempel and the Reading Room of the Jewish Mercantile Youth.

Yet why would the same group of people strive simultaneously to commemorate a medieval Polish king and a contemporary Jewish painter? Could it be that both monuments conveyed a similar message and symbolic meaning?

In the last decade of the nineteenth century, a narrative began to develop that presented Gottlieb as a "Hebrew artist" and "Jewish painter" whose art was an embodiment of Jewishness. After Gottlieb's tomb was finally unveiled in 1892, Zionists criticized the way in which he was commemorated and remembered. From the Zionist-oriented point of view, Gottlieb was above all a Jewish artist and should be honored as such. They denounced the Polish inscription engraved on his tomb as improper, a misappropriation of his national origins and their meaning.[45] For the progressive group that built the monument, Gottlieb was certainly a Jewish artist, but his Jewishness was always juxtaposed to his Polishness. Gottlieb's late nineteenth-century biographer Jonasz Weisenberg presented him as an artist whose life "demonstrated the need of cooperation between Poles and Jews, linked together by a communality of fate, joy, and misfortune."[46] The same motive was stressed during the unveiling ceremony by Wilhelm Feldman, a writer and literary critic, for whom Gottlieb was an artist uniquely positioned "to bridge the gap between Judaism and Christianity, between Polishness and Jewishness."[47] Feldman's words were emblematic of a kind of credo of the group that executed the project. The motif of a Polish-Jewish common faith and common fortune was a recurring theme in those circles. The song "Boże coś Judę" ("God Save Judah") served as one of the most telling examples of this symbolic symbiosis. It was modeled after the Catholic Polish patriotic song "Boże coś Polskę" ("God Save Poland"), which before 1918 held a position similar to a national anthem. Since the 1880s, "Boże coś Judę" was often sung in the Tempel. In "Boże coś Judę," Poland and Judah are depicted as "two martyrs" (dwie męczennice) who similarly suffered throughout the centuries and whose fate was entangled by their common history, a twinning of the victim symbology of the Polish Romantic tradition.

The statue of Casimir the Great might also have had a similar symbolic meaning for those who envisioned it. The context of Gottlieb's monument suggests that Casimir the Great was commemorated not merely as a monarch having a positive attitude toward Jews but above all as a personal embodiment of the Polish-Jewish symbiosis aspired to and internalized by Kraków's Jewish intelligentsia. Commemorating him aimed to strengthen this narrative of a Polish-Jewish common fate and projected the hope of future cooperation and rapprochement, a narrative that was embodied by Gottlieb's art.

Interconfessional Initiatives

Philanthropic initiatives financed by progressive Jews and devoted to needy Christians and Jews alike provide another context in which to understand the motivation for building the king's statue. This context has a more distant character, since it has no direct connection with the project of raising the king's monument. The common denominator between communal charity and supporting the statue of

Casimir the Great is the similar symbolic mechanism that provided the impetus for both activities.

In the last quarter of the nineteenth century, progressive Jews both established and participated in several philanthropic initiatives that operated "regardless of one's faith" (Pol. bez różnicy wyznania). Although we know examples of other similar initiatives from Lwów or Warsaw, one should keep in mind that in general, in the nineteenth century, both in the Kingdom of Poland and in Galicia, charities were in the overwhelming majority confessional, meaning that they were devoted either to Christians or to Jews, not to both groups.[48]

The interconfessional initiatives established by Kraków's progressive Jews included funding academic scholarships, buying a supply of coal for the winter, lending money to needy artisans, and providing needy children with daily hot meals, among other activities. The founders of these social philanthropic initiatives wanted not only to manifest their pro-Polish attitude but also to contribute to the improvement of future Christian-Jewish relations. For example, the founders of the free kitchen for boys and girls of both faiths who learned in the schools of Kazimierz—which gave out up to several hundreds of hot meals a day—expressed their hope that by eating meals together, both Christian and Jewish Polish children would forge friendships, which would create better mutual understanding between them in their future, adult lives.[49]

By supporting both needy Christians and Jews, progressive Jews positioned themselves on the same grounds as Christian philanthropists active in Kraków. While joining the ranks of patrons and benefactors, they symbolically ceased to be "the others." The dividing line moved; instead of dividing Jews from Christians, it now divided the poor and needy of both confessions from those engaged in helping those unprivileged groups. Both the monument building and philanthropic initiatives actively created new social circumstances and urban space in which confessional divisions were to a certain extent surmounted or put aside (though not intentionally abandoned or concealed, since the initiators acted as Jews and did not promote a collective self-liquidating "assimilation").

It is impossible to determine whether the previously described actions were part of a conscious strategy for progressive Jews to enter Polish society or rather an expression of the already acquired feelings of belonging to this society regardless of one's faith. This "active" or "systematic integrationism" not only involved the attitudes of individual Jews and their entry into non-Jewish social spheres but also created a new, imaginary Christian-Jewish basis of harmonious cooperation: the commemoration of the common past and providing for the common future.

A Dubious Failure

It is hard to determine the most important cause of the project's failure. It seems, however, that the causes might have been more coincidental than ideological. Among the obstacles the builders faced were the deaths of the leaders of the progressive circles, such as Jonathan Warschauer, one of the originators of the project

engaged in this initiative, who died in 1888; haphazard occurrences, such as the departure of the artist Mieczysław Zawiejski (who worked on the statue) from Kraków; and the lack of a time-sensitive goal for the project's completion. No particular anniversary was supposed to be remembered by this monument. There was therefore no particular "deadline" that could motivate the builders. Perhaps the most important factor was financial. Less money was collected than was necessary to complete the project.

On the one hand, the inability of the committee to raise a sufficient sum of money could be interpreted as proof of a lack of broad social support for the initiative, perhaps as a sign of the weakening of integrationist forms of Polish patriotism due to the growing influence of Zionism.[50] On the other hand, one must remember that most of the efforts to raise monuments at that time faced similar financial challenges. This was the case not only with the aforementioned Mickiewicz and Gottlieb monuments but also with others, such as the Kościuszko monument in Lwów.[51] Since they were funded by the population at large, their creation was usually prolonged, and it took years until they were completed. As Patrice Dabrowski remarks regarding the struggles around building the Mickiewicz memorial, "Early enthusiasm soon waned, as did donations."[52] This often proved true about other memorials. It is worth remembering that even the Mickiewicz monument, which engaged far more public attention and became almost a national cause, might never have been built due to the financial difficulties, prolonged discussions, and controversies surrounding it. Dabrowski concludes, "In fact, the monument might never have been unveiled had it not been for members of the Cracow city council, who in 1897 pressed for the completion of the monument in time for the one hundredth anniversary of Mickiewicz's birth the following year."[53]

The available sources do not provide a conclusive answer as to which factor contributed most to the fact that Casimir the Great's monument was never built as it had been planned. The project might have been simply too grandiose. The initiators might have overestimated the possible interest in the project, as well as its financial challenges. The monument was far more expensive than the contemporaneous initiative of building Gottlieb's memorial, which faced financial challenges as well. Its scale might rather be compared to the monuments of Mickiewicz or Kościuszko, which were built by disproportionally larger groups of people, not by just a small part of the Jewish society. At the beginning of the twentieth century, it became clear to the Monument Erecting Committee that the full-figure statue of the king might never be erected. In 1907, it was decided that the money collected during all those years would be used to fund a humbler and significantly cheaper monument in the form of a bas-relief plaque. The task was commissioned to a young Jewish sculptor, Henryk Hochman (1879–1943), who finished it around 1909–1910. The plaque, entitled *The Admission of Jews to Poland by Casimir the Great* (*Przyjęcie Żydów do Polski przez Kazimierza Wielkiego*), depicted a group of Jews approaching the allegory of Polonia wearing Casimir the Great's crown (figure 9.1). The inscription accompanying the relief read, "In Memory of Casimir the Great—Jews-Poles" (Pol. *Pamięci Kazimierza Wielkiego Żydzi Polacy*).

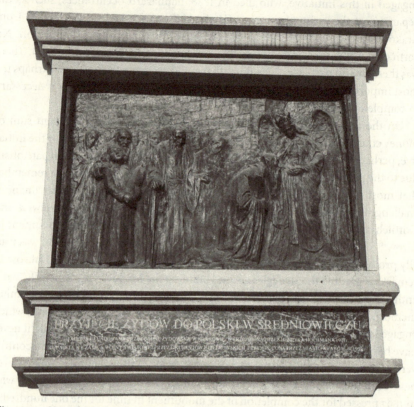

Figure 9.1. Henryk Hochman, *Admission of Jews to Poland in the Middle Ages / The Admission of Jews to Poland by Casimir the Great*, 1902. Commemorative present-day plaque with modified title situated outside the Seweryn Udziela Museum of Ethnography in Kraków. Photo by Alicja Maślak-Maciejewska.

The iconographic motif of *The Admission of Jews to Poland by Casimir the Great* was well known in the Polish historical paintings of the last quarter of the nineteenth century by Wojciech Gerson (1874) and Jan Matejko (1889). According to the original project of the monument of Casimir the Great by Stanisław Lewandowski, the pedestal was supposed to be decorated with four bas-reliefs: the Jerusalem Temple, the destruction of the Temple, the dispersion of Jews, and their admission to Poland. Thanks to this juxtaposition, *The Admission of Jews to Poland by Casimir the Great* was presented as a major and culminating event in the history of Jews, a symbol of Poland as the Jews' welcome resting place after long years of exile. It is therefore not surprising that this scene—as a culminating one—was chosen as the the subject of the plaque that stood for the full monument. The plaque by Hochman was mounted on the northern wall of the former Kazimierz market square, then home to a Jewish school (today the Ethnographic Museum) and unveiled on November 15, 1911.[54] The Polish press described it enthusiastically as "impressive," praising its artistic values.[55]

While the full-figure statue of the king was never erected, the creation of the plaque prompts us to consider whether the underlying project was actually fulfilled, even if in a decidedly more humble and partial form. The decision to commission the plaque, and hence to pursue the project, reveals the builders' perseverance, especially since the very idea of raising a memorial to the king might have been controversial at that time.[56] Later, in the interwar period, the iconography of the plaque and the message it conveyed was sharply criticized. Symptomatic is the opinion of the Zionist *Nowy Dziennik*, which censured the posture of a kneeling Jew as suggesting his inferiority and called the plaque "simply embarrassing."[57] It seems probable that due to the growing influence of Zionism, similar controversies existed already in the first decade of the twentieth century, when the plaque was first unveiled.[58]

Unbuilt yet Missed

Why is the story of the unbuilt monument of Casimir the Great worth recalling? It shows the complexity of the position occupied by the Polish-Jewish intelligentsia. The group tried to define the status of Jews in contemporary Polish society as equal partners in national belonging, having the same goals and, to some extent, a common heritage and a common history as Polish Jews. The intelligentsia wished to celebrate this common past, along with providing for the well-being of the whole society. They wanted to cooperate, live, and work together with their Christian counterparts. While their undertakings clearly manifest a high degree of acculturation, acculturation was not the goal per se but an already acquired attribute. Members of those circles clearly wanted to retain their Jewish identity, which was not limited to religious beliefs. The story of Casimir the Great was a perfect choice to serve their agenda. Not only was he symbolically important for Polish society at that time, but he was also widely remembered for his positive attitude toward Jews. His monument, which presented the Christian-Jewish coexistence as eternal, provided it with historical legitimization.

The nineteenth-century project of erecting the king's monument could be placed also within the contemporary twenty-first-century debates about the place of Jewish Poles, Jews, and Jewishness in the Polish national narrative and in the public sphere. In the past two decades, the initiative to build a statue of Casimir the Great in the Kazimierz district has resurfaced several times. As recently as 2017, the project of erecting a Casimir the Great statue was proposed for funding from the Kraków "participatory budget."[59] The contemporary supporters of the project raised several arguments for its inclusion in the municipal budget. They referred to the "greatness" of the king, who was described as "one of the most famous in Europe," and his impact on the economic and territorial growth of Poland, which almost tripled in size during his reign.[60] Supporters argued that in light of Casimir's strong bonds with Kraków, the lack of a statue commemorating him was "surprising," "hard to explain," and "embarrassing."[61] A group that applied in 2017 for the money to build the monument argued that the existence of statues of Casimir the Great erected in

small cities like Bochnia, Niepołomice, and Skawina made the need to erect such a statue in Kraków even more pressing.[62]

The contemporary proponents of erecting the king's statue have entirely different motivations than their nineteenth-century counterparts. For the prewar Jews, the king represented beneficence toward Jews and a royal symbol of Polish-Jewish historical coexistence. In the contemporary discussions, the Jewish subject is almost entirely absent; the king is presented above all as a great monarch who contributed to the development of Poland. The Kazimierz district as the locus of the monument also held different meanings for both groups. In the contemporary moment, the location was chosen not because of its Jewish character but merely to mark the district's name with its eponymous founder. The nineteenth-century Jewish initiative to erect a memorial to Casimir the Great has been completely forgotten and is unknown to the contemporary activists wishing to build the king's monument. They neither refer to it nor perceive their strivings as a continuation or resurgence of the old ideas. Despite the bas-relief plaque that hangs today in Wolnica Square and is therefore "lying in plain sight"—to paraphrase a comment from this volume's introduction—the history of the Jewish project of erecting the king's statue is deeply hidden from the view of contemporaries.

This contemporary initiative reveals how the nineteenth-century Jewish unbuilt monument is relevant today because it is both lacking and missed. So much of twentieth-century Polish Jewish history has become a history of absence, but that absence has powerful symbolic meaning.

Acknowledgments

I am grateful to Mikol Bailey for language assistance.

Notes

1. I have presented the details of the history of the project and the activities undertaken by the Monument Erecting Committee in Alicja Maślak-Maciejewska, "Pamięci Kazimierza Wielkiego Żydzi-Polacy—o zapomnianym projekcie budowy pomnika królewskiego na krakowskim Kazimierzu," *Modus: Prace z historii sztuki* 16 (2016): 61–74. The description here is limited to the most important developments concerning the project.

2. The idea might have been inspired by Alfred Nossig, a sculptor and writer active in Lwów. See Józef Grabiec, "Wilhelm Feldman jako Publicysta," in Jan Niecisław Baudouin de Courtenay, *Pamięci Wilhelma Feldmana* (Kraków: Drukarnia Narodowa, 1922), 67.

3. For more about this milieu and its religious views, see Alicja Maślak-Maciejewska, *Modlili się w Templu: Krakowscy Żydzi postępowi w XIX wieku: Studium społeczno-religijne* (Kraków: Wydawnictwo Uniwersytetu Jagiellońskiego, 2018).

4. Hanna Kozińska-Witt, *Die Krakauer Jüdische Reformgemeinde 1864–1874* (Frankfurt: Peter Lang, 1999), 113–133.

5. *Ojczyzna* 3, no. 23 (December 1, 1883): 95.

6. *Nowa Reforma* 3, no. 292 (December 23, 1883): 3; *Nowa Reforma* 3, no. 293 (December 25, 1883): 3; "Pomnik Kazimierza Wielkiego w Krakowie," *Nowa Reforma* 4, no. 29 (February 5, 1884): 3; K-cz., "Kraków, dnia 10 stycznia 1884," *Ojczyzna* 4, no. 3 (February 1, 1884): 11.

7. S. T., "Kraków, 3. stycznia 1885 [sic!]," *Ojczyzna* 4, no. 2 (January 15, 1884): 7.

8. S. T., "W sprawie pomnika Kazimierza Wielkiego," *Ojczyzna* 4, no. 8 (April 18, 1884): 30–31; *Nowa Reforma* 4, no. 236 (October 12, 1884): 4. For more about how the money was collected, see Maślak-Maciejewska, "Pamięci," 63–64.

9. m.-t., "Kraków dnia 25. marca 1885," *Ojczyzna* 5, no. 7 (April 3, 1885): 26–27.

10. "Pomnik Kazimierza Wielkiego," *Ojczyzna* 8, no. 16 (August 15, 1888): 125–126.

11. On Lewandowski, see Hanna Kubaszewska, "Lewandowski, Stanisław Roman," in *Słownik artystów polskich i obcych w Polsce działających: Malarze, rzeźbiarze, graficy*, ed. Jolanta Maurin-Białostocka (Wrocław: Zakład Narodowy im. Ossolińskich, 1993), 5:74.

12. *Ojczyzna* 8, no. 12 (June 15, 1888): 93; *Nowa Reforma* 8, no. 122/123 (May 31, 1888): 4; *Nowa Reforma* 8, no. 139 (June 20, 1888): 2.

13. *Kurjer Polski* 3, no. 287 (October 21, 1891): 3.

14. Jacek Purchla, "The Polonization of Jews: Some Examples from Kraków," in *Jews in Kraków*, vol. 23 of *Polin: Studies in Polish Jewry*, ed. Michał Galas and Antony Polonsky (Oxford: Littman Library of Jewish Civilization, 2011), 199–212. See too Jacek Purchla, *Jan Zawiejski, Architekt przełomu XIX i XX wieku* (Warsaw: Państwowe Wydawnictwo Naukowe, 1986).

15. *Kurjer Polski* 3, no. 287 (October 21, 1891): 3; *Ojczyzna* 11, no. 21 (October 1, 1891): 167.

16. For more on the activities of the "women's committee," see Maślak-Maciejewska, "Pamięci," 67–69.

17. The legendary history of the romantic relationship between King Casimir and the Jewess Esther was first described by Jan Długosz, a fifteenth-century Polish historian and chronicler. In centuries to follow, the legend developed in both Polish and Jewish oral tradition. See Chone Shmeruk, *The Esterke Story in Yiddish and Polish Literature: A Case Study in the Mutual Relations of Two Cultural Traditions* (Jerusalem: Zalman Shazar Center, 1985).

18. *Gazeta Polska*, no. 242 (October 22, 1862): 2.

19. "Pomnik Kazimierza Wielkiego," *Jutrzenka: Tygodnik dla Izraelitów polskich* 2, no. 44 (October 31, 1862): 361. Interestingly, this initiative of *Jutrzenka* was noticed by the Kraków daily *Czas*. See *Czas*, no. 276 (November 31, 1862): 3. Later, the same newspaper reported when the money sent by Warsaw Jews arrived. See "[Ofiary izraelitów warszawskich złożone]," *Czas*, no. 13 (January 17, 1863): 3.

20. "Pomnik Kazimierza Wielkiego," *Jutrzenka: Tygodnik dla Izraelitów polskich* 2, no. 44 (October 31, 1862): 361.

21. The subject of "jubilee culture" and the role of the Polish patriotic commemoration in the process of nation building have been well studied. See Józef Buszko, *Uroczystości kazimierzowskie na Wawelu w roku 1869* (Kraków: Ministerstwo Kultury i Sztuki, 1970); and Patrice M. Dabrowski, *Commemorations and the Shaping of Modern Poland* (Bloomington: Indiana University Press, 2004). On another facet of "jubilee culture"—namely, pro-Habsburg imperial celebrations organized at that time in the empire, including Galicia—see Daniel L. Unowsky, *The Pomp and Politics of Patriotism: Imperial Celebrations in Habsburg Austria, 1848–1916* (West Lafayette, Ind.: Purdue University Press, 2000).

22. Szymon Dankowicz, *Kazanie miane w czasie żałobnego nabożeństwa za wiekopomnej pamięci Króla Kazimierza Wielkiego w dniu powtórnego pochowania zwłok Jego na Wawelu dnia 8 lipca 1869 roku w Synagodze Izraelitów przyjaciół postępu na Podbrzeziu w Krakowie* (Kraków: Czcionkami Karola Budweisera, 1869), 10, 16.

23. *Kraj*, no. 107 (July 11, 1869): 1; Dankowicz, *Kazanie*.

24. See Ka, "Listy z Krakowa I," *Ojczyzna* 2, no. 12 (June 15, 1882): 49.

25. See Piotr Szubert, "Pomnik Adama Mickiewicza w Krakowie—idea i realizacje," in *Dzieła czy kicze*, ed. Elżbieta Grabska-Wallis and Tadeusz Stefan Jaroszewski (Warsaw: Państwowe Wydawnictwo Naukowe, 1981), 159–242; and Waldemar Okoń, "O krakowskim pomniku Adama Mickiewicza raz jeszcze," *Quart* 1 (1999): 19–30.

26. About the commemoration of Mickiewicz, including the process of building the monument, see Dabrowski, *Commemorations*, 133–156.

27. *Nowa Reforma*, no. 39 (February 18, 1883): 2. Among the organizers and the performers were Józef Fischer (cantor in the Tempel), Salomon Spitzer, and Majer Schlesinger (the latter two were teachers of Mosaic religion and members of the Progressive Association).

28. *Ojczyzna* 10, no. 1 (January 1, 1890): 7.

29. "Z obchodu złożenia zwłok Adama Mickiewicza na Wawelu," *Ojczyzna* 10, no. 14 (July 15, 1890): 109–110.

30. Homo (Wilhelm Feldman?), "Kraków, 7. kwietnia," *Ojczyzna* 9, no. 8 (April 15, 1889): 62. Identification of "Homo" as Wilhelm Feldman was done by Jolanta Kruszniewska, whom I thank for this information.

31. Pierre Nora, ed., *Les lieux de mémoire*, 3 vols. (Paris: Gallimard, 1984–1986).

32. Although the projects of such full-figure statues were designed by Jewish artists since the late nineteenth century, many of them remained only projects and were never built to full size. See Tamara Sztyma, "Unrealised Projects: Plans for Jewish Monuments before 1939," in *Art in Jewish Society*, ed. Jerzy Malinowski et al. (Warsaw: Polish Institute of World Art Studies, 2016), 73–84.

33. *Czas*, no. 172 (July 29, 1879): 2.

34. Presumably, Józef Oettinger's eulogy was printed in pamphlet form and sold to collect money for the monument. I was not able to find this brochure, but it is mentioned in the literature on the subject. See Ezra Mendelsohn, *Painting a People: Maurycy Gottlieb and Jewish Art* (Hanover, N.H.: University Press of New England; Waltham, Mass.: Brandeis University Press, 2002), 167. Mendelsohn based his claim on an article by B. (first name unknown) Spira published in *Izraelita*, in which Spira complains that although the process of collecting money started soon after Gottlieb's death, it was very slow. See B. Spira, "Z Krakowa," *Izraelita* 27, no. 30 (July 17/29, 1892): 256.

35. It is not clear what the relationship was between this committee and the one established soon after Gottlieb's death.

36. *Sprawozdanie z czynności Wydziału Stowarzyszenia Czytelni Starozakonnej Młodzieży Handlowej w Krakowie za czas od d. 1 października 1884 r. do d. 1 października 1885 r.* (Kraków: Józef Fischer Publishing House, 1885), 6.

37. *Ojczyzna* 9, no. 8 (April 15, 1889): 64.

38. Homo, "Kraków, 7. kwietnia," 62. Spitzer was engaged in this initiative as the secretary of the Monument Erecting Committee and as one of the money collectors. See Salomon Spitzer and M. Rosengarten, *Ojczyzna* 9, no. 21 (November 1, 1889): 170.

39. Spira, "Z Krakowa," 256.

40. *Sprawozdanie z czynności*, 7.

41. m.-t., "Kraków w maju 1886," *Ojczyzna* 6, no. 17 (June 1, 1886): 43–44.

42. *Ojczyzna* 9, no. 8 (April 15, 1889): 64.

43. *Ojczyzna* 9, no. 11 (June 1, 1889): 89; "[Na nagrobek dla b.p. Maurycego Gottlieba]," *Ojczyzna* 9, no. 13 (July 1, 1889): 105; "[Z Krakowa donoszą nam]," *Ojczyzna* 9, no. 17 (September 1, 1889): 138.

44. Judaeus, "Kraków, 20. grudnia 1890," *Ojczyzna* 11, no. 1 (January 1, 1891): 3–4.

45. Mendelsohn, *Painting a People*, 172.

46. Jonasz Weisenberg, *Maurycy Gottlieb (1856–1879): Szkic biograficzny* (Złoczów: Zukerkandel, 1888), cited by Mendelsohn, *Painting a People*, 167.

47. Mendelsohn, *Painting a People*, 170.

48. Hanna Kozińska-Witt, "Miłosierdzie gminy? Samorządowe subsydia dla krakowskich instytucji żydowskich w latach autonomii galicyjskiej, 1866–1914," in *Z dziejów i kultury*

Żydów w Galicji, ed. Michał Galas and Wacław Wierzbieniec (Rzeszów: Wydawnictwo Uniwersytetu Rzeszowskiego, 2018), 15–16.

49. For more on the activities of this kitchen, see Maślak-Maciejewska, *Modlili się*, 193–196; about the nonconfessional associations, see Maślak-Maciejewska, 228–231.

50. For more on Zionism's development in Galicia, see Joshua Shanes, *Diaspora Nationalism and Jewish Identity in Habsburg Galicia* (Cambridge: Cambridge University Press, 2012).

51. Markian Prokopovych, *Habsburg Lemberg: Architecture, Public Space, and Politics in the Galician Capital, 1772–1914* (West Lafayette, Ind.: Purdue University Press, 2009), 173.

52. Dabrowski, *Commemorations*, 136.

53. Dabrowski, 142.

54. It took two years to obtain permission from the city council to mount it. The unveiling ceremony was presumably quiet and modest. In the daily press, we find no invitations for the ceremony; the plaque was only described in the press after its unveiling. See *Czas*, no. 530 (November 20, 1911): 2; "Odsłonięcie tablicy pamiątkowej króla Kazimierza Wielkiego na starym ratuszu w Krakowie," *Nowa Reforma*, no. 532 (November 21, 1911): 2; and *Ilustrowany Kurier Codzienny* 2, no. 264 (November 18, 1911): 5. The note in *Ilustrowany Kurier Codzienny* explicitly states that the city council agreed for the plaque to be unveiled only under the condition that the ceremony would be humble, without publicity and speeches (Pol. "*bez rozgłosu i przemów*").

55. "Odsłonięcie tablicy pamiątkowej," 2.

56. Historian Majer Bałaban vaguely mentions that opinions about the plaque differed among Cracovian Jewry. See Majer Bałaban, *Przewodnik po żydowskich zabytkach Krakowa: Z 13 rycinami w tekście, z 24 rotograwjurami na oddzielnych tablicach, z 2 planami* (Kraków: Solidarność B'nei B'rith, 1935), 107.

57. L., "Kraków złożył hołd pamięci wielkiego króla," *Nowy Dziennik* 16, no. 167 (June 20, 1933): 12.

58. Bałaban, *Przewodnik po żydowskich*, 107.

59. A participatory budget is a system that allocates part of municipal money to fund initiatives proposed by the inhabitants of the city (in this case, Kraków), according to the result of democratic voting.

60. "Projekt ogólnomiejski nr 50: Pomnik Króla Kazimierza Wielkiego," Budżet obywatelski, accessed August 4, 2022, https://budzet.krakow.pl/projekty/1827-pomnik_krola_kazimierza__wielkiego.html.

61. "Kazimierz Wielki będzie miał pomnik w Krakowie?," *Dziennik Polski*, March 4, 2009, https://dziennikpolski24.pl/kazimierz-wielki-bedzie-mial-pomnik-w-krakowie/ar/2559734.

62. "Projekt ogólnomiejski nr 50."

CHAPTER 10

Mapping Modern Jewish Kraków

WOMEN—CULTURAL PRODUCTION—SPACE

Eugenia Prokop-Janiec

Recalling his experience growing up in interwar Kraków, the Polish Jewish writer and literary critic Henryk Vogler (1911–2005) notes that "even the most convinced Zionists primarily used the Polish language, and for the Jewish intelligentsia it was their native tongue.... Only among the poorest masses was Yiddish the only language used. Hebrew, on the other hand, was not current at all."[1] Women were reportedly the most Polonized group among the Jews in Kraków, which stemmed from their attending Polish schools, common even among Orthodox families. Preeminent physicist Leopold Infeld (1898–1968) recalls that his mother "spoke good Polish. She had finished seven grades, which made her educated for those times."[2] Infeld's father, on the other hand, "knew Jewish and German well, but made mistakes in Polish. He attended only the fourth grade at school."[3] Linguistic Polonization spread even in Orthodox circles. In the early 1930s, according to Zalmen Reizen, "in some cities, for example in Kraków and partly in Warsaw, Hasidic daughters were ultra-Polonized."[4] Sarah Schenirer (1883–1935), the founder of the Bais Yaakov movement, consumed Polish literature and culture, as explored by Naomi Seidman in this volume; her memoir in Polish displays literary tastes characteristic of the fin de siècle in Kraków.

How did this gendered process find expression in Kraków, and what was the link between the linguistic Polonization of Jewish women and their role in Cracovian cultural production?[5] In this chapter, I focus on the various forms of Jewish women's cultural activity that was practiced by learning and using Polish. I will explore only one segment of the dynamic multilingual (Hebrew, Yiddish, and Polish) polysystem of modern Jewish culture, which connected three language systems.[6] This polysystem was an open entity that connected with Polish culture through the Polish system, thus becoming a sphere of Polish-Jewish interaction. From the perspective of individuals participating in a multilingual Jewish culture, it constituted a repertoire of language with institutional and ideological options. It

was possible to participate in only one or in all the systems, and the Polish system made it accessible to Christian Poles as well. During the interwar period, the Polish component of the polysystem grew and strengthened significantly in Kraków and beyond. In Kraków and in Galicia, the disparity of the elements in the multilingual polysystem was particularly striking. Historians of Hebrew literature and the press emphasize that Kraków "made a very modest, if not negligible, contribution to the development of the Hebrew press" at that time.[7] Nor was it a thriving center of Yiddish literature.[8] In the interwar years, 52 percent of the Jewish press in Kraków was published in Polish, while 36 percent was in Yiddish and only a few titles were in Hebrew.[9]

I will examine the historical dynamics of change through three specific temporal moments, 1899, 1919, and 1939. The years 1919 and 1939, marking the beginning and end of the Second Republic, need little justification. The year 1899 was when the first effects of education reform implemented in the Austrian-occupied part of Poland became evident.[10] The creation of the first secondary schools for girls, which allowed them to take final exams (the *matura*) and enroll in universities, enabled them to become active in various professional fields, including cultural institutions.[11] Educational institutions were places where students acquired cultural capital, which they later used as a tool in various fields of cultural production, such as literature, art, science, or politics. It is the growing number of people who have received education (at various levels of schooling) that Pierre Bourdieu regards as one of the main factors of change in cultural production, since it increases the number of producers and consumers of culture alike.[12] Contemporary cultural studies also emphasize the importance of the educational system for members of minority groups, who use it to develop new cultural capital that enables them to attain a new status outside their own group.[13] In her recent study, Rachel Manekin argues that the process of education of Jewish girls in state institutions outside Jewish society was the main factor of their socialization with Poles and engagement with Polish language and culture in Galicia.[14]

To shed light on the changing cultural patterns among Jewish women and their cultural activism in Kraków during the four decades of modernization from 1899 to 1939, I will use maps as an analytical tool that—as Franco Moretti puts it—"[brings] to light relations that would otherwise remain hidden."[15] My three maps of Kraków indicate the main institutions of modern culture in which Jewish women were present in 1899, 1919, and 1939. They serve as spatial inventories of such institutions, revealing their locations within the quarters, zones, and ethnic enclaves of the city as well as visualizing the processes of acculturation and cultural production in Polish closely connected with women's emancipation. I derive my methodological inspiration from Pierre Bourdieu's theory in which subjects and institutions are the key elements of the field of cultural production, which, in turn, is situated in a broader social and national space. I am interested both in institutions that enabled women to acquire cultural capital and in those in which women could put that capital to use. Adopting the position suggested by Bourdieu, I will not limit myself to high-culture sites and will understand the cultural field

as a varied and hierarchic area that contains both popular, standard, commercial production and an avant-garde, innovative, distinct one.[16] I will therefore include multifarious forms of cultural activity related to education, libraries, the press, literature, theater, cultural associations, literary circles, and artistic salons.

The history of women in Kraków, and specifically the history of Jewish women in Kraków, has not been analyzed in a systematic manner.[17] Despite a wave of publications devoted to the Jews of Kraków in the past two decades, the state of research on women's history has not changed substantially.[18] All of them continue to focus primarily on the achievements of men while marginalizing or completely overlooking those of women.[19]

In building my maps, I relied on earlier studies devoted to the history of Kraków, the history of education, the press, literature, and cultural life in the city, as well as the data from archives, reports published by institutions, and biographical documents, memoirs, and autobiographies.

Kraków and Its Jews

The status of Kraków in the late nineteenth and early twentieth centuries was paradoxical, as noted by Jacek Purchla. On the one hand, it was "a relatively small and poor city," which was economically weak and had been reduced to the role of one among many peripheral centers of the Habsburg Monarchy; on the other hand, Kraków was considered to be a spiritual capital, a symbol of the unity and grand historical past of the Polish people.[20] In the 1860s, thanks to liberal reforms in Austria Galicia, it acquired its autonomy, which created new momentum for the city's status. The new political climate favored Kraków's transformation into a modern center of Polish life, and the number of its inhabitants grew from 40,000 in the mid-nineteenth century to 159,000 in 1914.[21] After Poland regained its independence in 1918, Kraków still could hardly rival the capital and metropolitan status of Warsaw and the opportunities it offered. However, Kraków managed to negotiate an attachment to its heritage with modernizing ambition and fast-paced development. In the interwar period, the city became an important administrative, scientific, cultural, and economic hub of Małopolska (Lesser Poland) and was assigned the role of the center of the southwestern part of the country.[22] This was accompanied by demographic growth; the city's population reached 259,000 on the eve of the Second World War.

Among the city's residents, Jews were the second-largest group, after ethnic Poles. Their number was thirteen thousand in 1857, more than thirty-two thousand in 1910, and about sixty-four thousand on the eve of World War II, when Kraków was the sixth-largest Jewish community in the Second Polish Republic.[23] From the beginning of the nineteenth century, Jews lived throughout the city; however, Kraków was also divided into ethnic symbolic spatial domains, and Kazimierz, which had been a separate Jewish city in centuries past, remained symbolically distinct from the main city center. For centuries, this boundary was determined by the course of the Vistula River. From the 1870s onward, after the old riverbed was

filled and replaced by Dietla Street and Planty Dietlowskie (also known as Planty Żydowskie), these streets marked the boundary of the Jewish quarter. This symbolic marker persisted until 1939, preserving the memory of the division between Kazimierz and Kraków.[24]

The second half of the nineteenth century and the interwar period were times of modernizing changes in the lives of Kraków Jews, which manifested in their increased social, cultural, scientific, and political activity in the city. In the process of modernization, the Jewish communities in East Central Europe embraced local, non-Jewish languages. Command of the Polish language alone became a form of cultural and symbolic capital.[25] While we have no reliable data on the degree of linguistic Polonization of the Jews in Kraków between the end of the nineteenth century and 1939, there is, however, general agreement that during the four decades under analysis, it was extremely high compared with that in other urban centers in Poland.[26] According to statistical data from 1880, 65 percent of the inhabitants of Kraków were Roman Catholics, and 33 percent were Jews, but as many as 95 percent of the city's inhabitants used the Polish language in their daily lives. Irena Homola believes that such a high figure for Polish-language users resulted from the fact that the census did not include the category of Jewish nationality.[27] On the other hand, in the general census of 1931, only 20 percent of the Kraków Jews declared Polish as their native tongue, although this time one may reasonably suppose that the figure was understated because the census questionnaire did not ask about nationality. Before the census, various political groups in Kraków, especially the Zionists, campaigned for declaring Hebrew as the mother tongue; notably, the popular Zionist leader Ozjasz Thon, rabbi of the Tempel Synagogue, advocated for the declaration of Hebrew as the Jews' mother tongue.[28] The struggle for espousing Yiddish and Hebrew as national languages took place within acculturated intelligentsia circles; for example, *Trybuna Akademicka*, a Zionist periodical addressed to Jewish university youth, sharply criticized students of the Jagiellonian University when in 1928 only 263 out of 1,963 students declared Hebrew or Yiddish as their mother tongues.[29]

Data on school attendance confirms the trend of Polonization and its gendered manifestations. In the school year 1869/1870, 288 boys and 346 girls attended schools in the Kazimierz district. In 1870/1871, the number rose to 331 boys and 522 girls, while in the following school year, 286 boys and 551 girls were registered.[30] Thus, girls were the majority among those elementary students. Later, young women made up an equally significant proportion of students at Kraków's secondary schools and at the Jagiellonian University.[31]

Map One: Year 1899

The 1890s was a period of intensive change in the cultural life of Kraków, which was connected to the development of the Young Poland (Młoda Polska) literary movement.[32] Combining neoromantic and modernist trends, Young Poland was one of

Figure 10.1. Main institutions of modern culture in Kraków involving Jewish women, 1899. Wincenty Juliusz Wdowiszewski, *Najnowszy plan miasta Krakowa* (Kraków: Nakładem księgarni J. M. Himmelblaua, ca. 1898–1906). Image courtesy of Polona, a digital library administered by the National Library of Poland; annotated by the author. Legend: 1. Casimir the Great School (1 Wolnica Square); 2. Reading Room "Ruth" (14 Brzozowa Street); 3. elementary school for girls (7 Bernardyńska Street); 4. St. Scholastica School for Girls (34 Św. Marek Street); 5. Private Gymnasium for Girls (11 Św. Jan Street); 6. Św. Anna Gymnasium (9 Na Groblach Square); 7. A. Baraniecki Higher Courses for Women (32 Karmelicka Street); 8. Jagiellonian University (24 Gołębia Street); 9. office of the periodical *Krytyka* (26 Sławkowska Street); 10. Juliusz Słowacki Reading Room for Women (7 Szpitalna Street); and 11. office of the newspaper *Nowa Reforma* (10 Jagiellońska Street).

many currents of Young Europe developing across the continent. The general shift in the city's cultural atmosphere reverberated in Jewish life as well.

In 1899, the most important places of cultural production accessible to women were educational institutions, particularly elementary schools. Separate classes for girls were already created in the first modern school for Jewish children, the so-called Casimir the Great School (Szkoła Kazimierzowska), located in the town hall in Kazimierz. The school was initially financed from the funds of the Jewish religious community and state subsidies and later became a public school. After 1867, Polish became the language of instruction. While lessons for boys took place in the town hall building at 1 Wolnica Square, lessons for girls were initially taught in rented private rooms in Kazimierz, whose addresses are no longer known. In 1876, a separate school for girls was formed out of the girls' classes from the Casimir the Great School.[33]

Jewish girls also attended other public elementary schools for girls located outside of Kazimierz. Judaism classes were taught at many other schools of this type, among them the St. Scholastica School for Girls, the first public school for girls in Kraków, established in 1871 and located at 34 Św. Marek Street. Jewish girls certainly attended the public school at 7 Bernardyńska Street; in the school year 1900/1901, they made up 50 percent of all its students, so one may assume that they also studied there in 1899.[34]

Education at a higher level was offered by private Polish schools for girls. The year 1896 saw the establishment of the Private Gymnasium for Girls, which operated initially at 11 Św. Jan Street. Founded by a group of activists of the women's emancipation movement, the gymnasium also admitted Jewish girls, who, according to historians' estimates, made up about 30 percent of its students.[35] The gymnasium for girls was not authorized to administer the *matura* examinations, so its alumnae had to obtain their certificates as external students from St. Anna Gymnasium for boys, located at 9 Na Groblach Square.[36] The available data suggest that most Polish and Jewish women who enrolled in the Jagiellonian University after 1897 obtained their *matura* in this way.[37]

Without the *matura* certificate, girls could study at teacher-training colleges that had been operating since 1871[38] and at A. Baraniecki Higher Courses for Women (the so-called Baraneum, launched in 1868, and since 1895 located at 32 Karmelicka Street)[39] or attend university lectures as auditors. In 1899, one such teacher-training college for women operated at 6 Podwale Street.[40] The same year, the Baraneum was reorganized under a new charter and offered two-year studies in three fields: literary, artistic, and scientific.[41]

Training to become an elementary school teacher was a relatively frequent choice among Jewish women,[42] as it was one of the career avenues most accessible for educated women in Galicia.[43] Teaching offered a chance for employment and for personal independence. Moreover, it was a profession considered appropriate for women.[44] In Galicia, women were accepted as teachers of Judaism as well.[45] The available lists of elementary school teachers in Kraków demonstrate that Jewish women worked mostly in schools for girls located in Kazimierz and its environs. In

1899, Regina Pniowerówna (1863–?), who penned several short stories and dramas for children, worked at the elementary school for girls located in the town hall at 1 Wolnica Square.[46] She published her works in the Polish-Jewish and Polish press (and her collections of works for children continued to be published during the 1920s and 1930s).[47] That same year, Cecylia Rosenberg (1860–?) taught in the Klementyna Tańska-Hoffmanowa Public Elementary School for Girls at 30 Dajwór Street (likely an earlier locale for the school later situated at 32 Miodowa Street). She became rather well known from her activity in various educational initiatives undertaken by assimilationist circles.[48]

In 1899, women were also active in two other types of cultural institutions: the press and cultural associations representing diverse ideological positions. On the initiative of a Zionist-oriented group of women, the reading room for Jewish women "Ruth" was established sometime around 1898 at 14 Brzozowa Street. Among its founders were Antonina Silberfeld, Salomea Bester, and Franciszka Glassheit. Their objective in establishing "Ruth" was nationally inspired education and self-education, with the goals of spreading the knowledge of Jewish history and culture and of the Hebrew language. Lectures were conducted in Polish, and the organization's journal, the eponymously named *Ruth*, also appeared in Polish,[49] illustrating that this double linguistic loyalty was typical of nationalist Jewish circles in Galicia, where Zionist involvement went hand in hand with linguistic Polonization.[50] In 1895, another reading room for women—the Czytelnia dla Kobiet im. Juliusza Słowackiego (the Juliusz Słowacki Reading Room for Women)—opened at 7 Szpitalna Street. Among its founders were Jewish women from assimilationist circles, including Malwina Garfeinowa-Garska (1870–1932), who had moved to Kraków from Congress Poland. Run by Maria Siedlecka and Kazimiera Bujwidowa, central figures in Polish feminism, its establishment is considered to be one of the turning points in the history of modern, emancipated women's Kraków.[51]

Jewish women also collaborated with the influential monthly *Krytyka*, with offices at 26 Sławkowska Street. Declaring its profile as "progressive," its editorial line sympathized with socialism and advocated Jewish civic rights and integration of the Jews into Polish society.[52] Moreover, *Krytyka* belonged to those periodicals that supported the modernist artistic movement, and its editor in chief at the time was an eminent assimilatory activist, the modernist writer and literary critic Wilhelm Feldman (1868–1919).[53] In 1899, *Krytyka* published works by numerous women active in socialist and feminist circles, including articles on literature, art, and social issues penned by Malwina Garfeinowa-Garska. The sister of Stanisław Posner, a socialist party activist, and a wife of the philosopher Stanisław Garfein-Garski,[54] Garfeinowa participated in the city's political, artistic, and intellectual life and was renowned as a prose writer and translator.[55]

Other prominent Polonized Jewish women writers and translators were active in Kraków at that time. Most prominent among them were Maria Feldmanowa (1874–1953) and Aniela Korngutówna (ca. 1868–1942). Born in the small town Brzostek, Maria Kleinman married Wilhelm Feldman in 1898, and they collaborated on

editing *Krytyka*, on whose editorial board she served (1901–1914). She translated the writings of John Ruskin, Oscar Wilde, Henrik Ibsen, Knut Hamsun, Rudyard Kipling, Jacob Wasserman, and Israel Zangwill. The now forgotten feminist writer Aniela Korngutówna, who published her works under the pen name Aniela Kallas, was one of the most active female authors in Galicia's assimilationist circles.[56] Her literary activity focused on genres characteristic of Jewish women writers of that period: novels, short stories, and dramas.[57] Kallas was among the first generation of Jewish women educated at Polish schools in Galicia. After completing a girls' boarding school, she was a nondegree student at the Jagiellonian University, where she probably attended the lectures by the historian of Polish literature Stanisław Tarnowski and the historian of German literature Wilhelm Creizenach.[58] She then worked as a teacher and published in Polish and Polish-Jewish periodicals, including the integrationist Lwów weeklies *Ojczyzna* (Homeland) and *Jedność* (Unity) and the satirical Polish periodical *Diabeł* (Devil).[59]

In her texts on Jewish themes, Kallas usually assumed the role of a writer rooted in a Galician context and referred to local problems and realities, remaining within the regional horizon. Her earliest stories introduced the link between the women's issue and Jewish emancipation and offered the perspective of one of the best-informed and self-conscious Jewish feminists. The structure of many of her stories—for example, her 1912 *Córki marnotrawne* (Prodigal daughters)—was based on the parallels and antitheses of the fates of brothers and sisters who were offered different, gendered educations, which, in turn, delimited the range of life choices and scope of personal freedom.

In sum, in 1899, Jewish women's places of cultural production were mostly Polish educational and press institutions situated in the city center, with its adjacent area, and in the Jewish enclave of Kazimierz, as well as some Jewish institutions operating in the frontier zone between the Jewish and the Polish parts of the city.

Map Two: Year 1919

During the following two decades, the network of places in which Jewish women could develop cultural production expanded, with theater being one of the most dynamic new avenues of expression. Teatr Ludowy, on the outskirts of the city at Żółkiewskiego Street, began to stage plays written by Aniela Kallas. Her first play shown at this theater in 1902 was an adaptation of Eliza Orzeszkowa's famous novel *Meir Ezofowicz* (1878), one of the most important Polish works advocating Jewish modernization. Jewish women appeared among the actresses at the Juliusz Słowacki Municipal Theater. Julia Romowicz (Julia Monderer; 1889–[1942?]) debuted on this stage in 1909 and then pursued her acting career by playing roles in adaptations of Stanisław Wyspiański's and Adam Mickiewicz's works.[60] Later on, she was also involved in performances promoting avant-garde literature.[61]

The Jewish press in the Polish language representing various ideological profiles continued to grow in Galicia in the first decades of the twentieth century. In 1905, the integrationist weekly *Tygodnik* started to be published in Kraków (9 Św. Anna

Figure 10.2. Main institutions of modern culture in Kraków involving Jewish women, 1919. Józef Jezierski, *Plan miasta Krakowa* (Kraków: Józef Jezierski, ca. 1910). Image courtesy of Polona, a digital library administered by the National Library of Poland; annotated by the author. Legend: 1. office of the newspaper *Nowy Dziennik* (13 Stradom Street); 2. Hebrew Secondary School (8/9 Podbrzezie); 3. Queen Jadwiga Gymnasium for Girls (13 Wolska Street); 4. trade school (2 Kapucyńska Street); 5. A. Baraniecki Higher Courses for Women (32 Karmelicka Street); 6. Jagiellonian University (24 Gołębia Street); 7. Social Reading Room (39 Rynek Główny); 8. Academy of Fine Arts (13 Matejko Square); 9. office of the periodical *Tygodnik* (9 Św. Anna Street); 10. office of the newspaper *Nowa Reforma* (10 Jagiellońska Street); 11. office of the periodical *Przodownica* (7 Szpitalna Street); and 12. Juliusz Słowacki Municipal Theater (1 Plac Św. Ducha).

Street). Among its editors was Adolf Gross, an assimilatory activist and leader of the Jewish Democratic Party, and among its collaborators was Aniela Kallas, who published her short stories and sketches there.[62] In weekly columns in 1913, Kallas debated with Kazimiera Bujwidowa over the emancipation of Jewish women. This exchange was triggered by Kallas's novel *Córki marnotrawne*, which depicted Galician women's intricate roads "out of the ghetto."[63] In the same year, 1913, the Zionist monthly *He'atid/Przyszłość* (Future) was launched, featuring Helena Hecker, among other female authors, in its columns.[64] In this period, Jewish women writers also published short stories and sketches in Polish periodicals, such as the feminist weekly *Przodownica* (at 7 Szpitalna Street)[65] and the democratically oriented daily *Nowa Reforma* (at 10 Jagiellońska Street).[66]

In the columns of *Tygodnik*, Jewish women advertised their private lessons, while Jewish kindergartens published job offers addressed to them. In its "Chronicle" section, the weekly announced courses for adults organized by Jewish institutions and listed their teachers, such as Celestyna Rosenberg.[67]

These publications signaled women's presence in all types of educational institutions that increased significantly in the first decades of the twentieth century. Historians estimate that before 1917, Jewish women composed 20 percent of the female teachers employed in secondary private schools for girls in Galicia.[68] In Kraków, they also established new Jewish educational institutions, such as "Ognisko Pracy," a vocational school for girls founded in 1916.

The change was particularly visible at the Jagiellonian University, where as many as 709 out of 944 alumnae of the Kraków gymnasia in 1890–1914 enrolled.[69] Mariusz Kulczykowski estimates that Jewish women made up over 30 percent of all women students there,[70] while Urszula Perkowska concludes that "in percentage terms, there were more Jewish women than Jewish men among university students in Kraków."[71] In the years 1907–1917, Jewish women dominated among female students pursuing doctoral degrees. During that period, fifty-two women earned doctorates; most of these titles were awarded in German studies.[72] Jadwiga Suchmiel argues that not only were many of the first women who earned their doctoral degrees at the university Jewish, but also "in some years, Jewish women were the only ones who obtained doctorates."[73]

These data suggest that educational accomplishments and their formal confirmations were regarded as a significant component of building cultural capital and its public manifestation. The popularity of university education may have been related to the prestige accorded higher education by the intelligentsia in Galicia during its period of autonomy.[74] At the same time, acculturating Jewish middle-class families highly valued formal education.

Several women who were awarded doctoral degrees by the Jagiellonian University became important activists in cultural production. In 1910, the Jagiellonian University awarded a doctoral degree to Franciszka Schiffmann, in 1911 to Sara Hollander, and in 1919 to Henryka Fromowicz-Stillerowa (1895–1942), a historian of art, who would become one of the most prolific and well-known Jewish women writers in Kraków before 1939.[75] In 1919, a doctorate in the history of art was

awarded to Stefania Lesser (1889–1961), known publicly after her marriage in 1912 as Stefania Zahorska, an eminent modern art and film critic, journalist, and novelist.[76] In her autobiographical novel *Korzenie* (Roots; 1937), Zahorska portrays the generation of Jewish women born in Kraków who studied at university during the first decades of the twentieth century. Depicting a wider social and cultural background, she presents in her novel various attitudes toward women's emancipation and education within the Jewish community before 1914. Far from naive enthusiasm, supporters of women's higher education portrayed by Zahorska praised education as women's best capital and a means of independence.

In addition to the Jagiellonian University, women were admitted to the Baraniecki courses (at 32 Karmelicka Street), which expanded their fields of study. Janina Kras estimates that 693 Jewish women attended the courses between 1901 and 1924.[77] Jewish women also participated in the courses offered by private art schools, opportunities that opened the door to the plastic arts for women because the Academy of Fine Arts in Kraków was closed to them until 1919.[78] Private art schools—such as the Free School of Drawing and Painting, established in 1918 and operated initially at 8 Szlak Street and later at 21 Wolska Street—were also popular among Jewish students, including women.[79]

Women, including university students, were also active in Jewish cultural associations such as the Czytelnia Towarzyska (the Social Reading Room). Launched in 1912, it operated in a tenement building at 39 Rynek Główny until 1939. Its members were recruited from the acculturated Jewish intelligentsia and middle-class circles, mostly lawyers, doctors, teachers, merchants, and entrepreneurs. The Social Reading Room offered access to a multilingual library—a marker of acculturation—as well as participation in language courses and public lectures. It provided a wide arena for activities by women.[80]

In the independent Polish state, new Jewish institutions emerged in Kraków, two of which would prove especially important for women: the Hebrew Secondary School with instruction in Polish (at 8/10 Podbrzezie Street) and the previously mentioned Polish-Jewish daily *Nowy Dziennik* (at 13 Stradom Street).[81] The Hebrew Gymnasium was a coeducational school; by the end of the 1920s, women made up approximately one-third of the teaching staff. Initially publishing little material written by women, by the mid-1920s, Franciszka Sonnenscheinówna and Gizela Landau found voice in *Nowy Dziennik*, while Runa Reitmanowa and Eliza Silbersteinowa belonged to the editorial board.[82]

As can be seen, the map of the centers of cultural production by Jewish women changed in 1919 with the emergence of new Polish-Jewish institutions situated mainly on the outskirts of Kazimierz, near Planty Dietlowskie, which was regarded as a symbolic border between the Polish and the Jewish parts of the city. Nevertheless, the new Polish-Jewish centers were frequently connected with Jewish institutions operating in Kazimierz. *Nowy Dziennik* (located at the time at 13 Stradom Street) was printed by Deutscher's printing house at 10 Boże Ciało Street in 1919. This new spatial model contrasts with the location of many institutions founded by assimilationists—such as the Social Reading Room, which operated in

a tenement at 39 Rynek Główny, and *Tygodnik*, whose editorial office was located at 9 Św. Anna Street.[83]

Map Three: Year 1939

In the Second Polish Republic, the development and expansion of the network of institutions in which Jewish women engaged in cultural production continued. This process was particularly visible in the field of education, mirroring the general increase in numbers of students enrolled in various institutions.[84]

Several accounts testify to the fact that Jewish girls attended Polish public schools situated in various parts of the city during this period.[85] Jewish memoirists recall the Maria Konopnicka Primary School on Św. Sebastian Street and the Teofil Lenartowicz School at 13 Pędzichów Street. A unique document—a school chronicle written by the pupils of the Klementyna Tańska-Hoffmanowa Public Elementary School for Girls at 32 Miodowa Street—has also survived.[86] Jewish girls could be found among the student body at art-oriented schools, such as the School for Decorative Arts and Art Industry at 3 Mickiewicz Avenue.[87]

The Hebrew Secondary School at 5 Brzozowa Street played an important role in the careers of Jewish female students and teachers. The gymnasium also offered positions for student teachers of Polish, German, or Latin, mainly to female students enrolled at the Philosophical Faculty of the Jagiellonian University. For example, in 1929, 22 boys and 23 girls obtained their *matura* certificates there.[88] In the school year 1931/1932, as many as 402 boys and 283 girls attended grades one through seven.[89] In the same year, the teaching staff was composed of six women—Anna Brossowa, Rachel Goldwasserowa, Sara Grossbard-Perlmutterowa, Nella Rostowa, Hudes Steinbergowa, and Etla Hornówna—and twenty-one men.[90] Some of the women, such as Anna Brossowa, held doctoral degrees.[91] Brossowa worked for many years as a qualified teacher of history at the Hebrew Secondary School, where she ran a history club for students.[92] Its meetings were devoted to the history of Europe, Poland, and Kraków as well as to the history of Jews in Europe, Poland, and Kraków.[93] Students not only discussed the historical topics but also visited museums and collected documents such as photos or postcards.

Female Jewish teachers continued to work in various types of public and private schools in the city. From 1933, the Private Jewish Coeducational Middle School for Trade, the so-called Trade Gymnasium, operated at 10 Stradom Street.[94] In 1936, the expanding vocational school "Ognisko Pracy" moved into its own new building at 7 Skawińska Boczna Street. A year later, in 1937, Bronisława Infeld (1902–1943) established an innovative cooperative secular gymnasium for Jewish girls "Nasza Szkoła," at 1 Starowiślna Street.

A teaching career was only one of the possibilities accessible for educated women in interwar Kraków. Women who graduated from the Jagiellonian University worked as journalists, translators, and writers. In the 1920s, after women had been allowed to obtain habilitation degrees and teach at universities, Jewish women obtained appointments at the Jagiellonian University.[95] One of them was

Figure 10.3. Main institutions of modern culture in Kraków involving Jewish women, 1939. Jerzy Rys Borkowski, *Wycinek "Śródmieście" stoł. król. miasta Krakowa* ([Kraków?]: [Nauka i Sztuka?], [1939?]). Image courtesy of Polona, a digital library administered by the National Library of Poland; annotated by the author. Legend: 1. office of the newspaper *Nowy Dziennik* (7 Orzeszkowa Street); 2. Hebrew Gymnasium (5 Brzozowa Street); 3. vocational school "Ognisko Pracy" (7 Skawińska Boczna Street); 4. Klementyna Tańska-Hoffmanowa Public Elementary School for Girls (32 Miodowa Street); 5. Private Jewish Coeducational Middle School for Trade (10 Stradom Street); 6. gymnasium for Jewish girls "Nasza Szkoła" (1 Starowiślna Street); 7. office of the newspaper *Ilustrowany Kurier Codzienny* (1 Wielopole Street); 8. Jagiellonian University (24 Gołębia Street); 9. Academy of Fine Arts (13 Matejko Square); 10. Anna Brossowa's translator office (10 Grodzka Street); 11. Social Reading Room (39 Rynek Główny); 12. Róża Heller's salon (5 Lubicz Street); 13. School for Decorative Arts and Art Industry (3 Mickiewicz Avenue); 14. office of the periodical *Życie Świadome* (7 Dunajewski Street); 15. office of the Polish Radio Station (6 Pędzichów Boczna Street); 16. editorial office of *Okienko na Świat* (24 Lubicz Street); 17. Juliusz Słowacki Municipal Theater (1 Plac Św. Ducha); 18. and Bagatela Theater (6 Karmelicka Street).

the eminent art historian Zofia Ameisenowa (1897–1967), who continued her career as a professor in the postwar period.[96] Six Jewish women were among university lecturers in the years 1919–1939.[97]

Many university-educated women were simultaneously involved in different types of cultural activity as teachers, journalists, scholars, translators, and writers. This group included, among others, Anna Brossowa (1890–1942), Wanda Kragen (1893–1982), Henryka Fromowicz-Stillerowa (1895–1942), Felicja Stendigowa (1895–1945), Gizela Reicher-Thonowa (1904–?), and Stella Landy (1905–1943). Fromowicz-Stillerowa published studies on the history of art and literary criticism, as well as articles on social issues. Brossowa, a history teacher, was also a translator and authored studies on the history of Italy, France, and Poland and on pedagogy and psychology.[98] Reicher-Thonowa, who published pioneering comparative studies on literature, worked as a teacher.[99] Kragen wrote poetry; novels; pieces of reportage; translations of German, English, and French literature; and critical studies. Landy made her literary debut in the late 1920s, then translated English and German literature.[100] Stendigowa published articles on the history and situation of women in the world—problems of marriage, family, and childrearing—that appeared both in the Polish-Jewish press (*Nowy Dziennik*) and in Polish journals (*Ilustrowany Kurier Codzienny*, *As*) in Kraków, Lwów, and Warsaw (*Chwila*, *Ewa*).[101]

The connection between the university and the circles of Polish-Jewish intelligentsia in Kraków was very important for women. Even if they did not graduate, some female journalists and writers still attended open lectures, seminars, and cultural events organized under the umbrella of the Jagiellonian University. In many autobiographical accounts, the university serves as a center of both public and private space. Mala Mandelbaum, a university graduate and teacher at Polish and Jewish schools, recalls, "What I remember best is the university period. Wawel... the university... I always sat there and wrote my doctoral dissertation, there were lectures... during breaks we walked in Planty. I remember the school in Wolska street.... I remember!"[102] However, in the late 1930s, the number of Jewish women who studied at the Jagiellonian University considerably decreased. Mariusz Kulczykowski estimates that they formed 14–21 percent of women students at that time.[103]

In about the mid-1920s, a group of women authors formed around the newspaper *Nowy Dziennik*. It began to issue supplements, *Głos Kobiety Żydowskiej* (The voice of the Jewish woman) and *Dzienniczek dla dzieci i młodzieży* (Daily for children and youth) in 1928.[104] This group grew to include Henryka Fromowicz-Stillerowa, Wanda Kragen, Felicja Stendigowa, Anna Brossowa, Marta Hirschprung, and Maria Hochberg (1913–1996). In 1937, Fromowicz-Stillerowa and Hirschprung launched *Okienko na Świat* (Window on the world) for children, with its editorial office at 24 Lubicz Street and then at 52 Słowackiego Avenue. Women also wrote for Polish journals published in Kraków, from popular dailies and weeklies, such as *Ilustrowany Kurier Codzienny* and the related publications *Kuryer Literacko-Naukowy* and *As* (1 Wielopole Street), to

liberal monthlies, like the organ of the Society of Planned Motherhood and the League for the Reform of Morals *Życie Świadome* (7 Dunajewski Street).[105] They also took opportunities offered by the new media and delivered lectures at the Polish Radio.[106]

Journals are institutions of the cultural field that serve to manifest the symbolic capital and position of their team of authors. As Bourdieu theorizes, the so-called original group of authors enjoys a strong position, whereas those who are later co-opted have a weaker standing.[107] In the Polish-Jewish *Nowy Dziennik*, the position of women was certainly weaker than the men; *Okienko na Świat*, on the other hand, was their own creation.

Some Polish-Jewish cultural institutions launched before 1919, such as the Social Reading Room, continued to operate and grew in the 1920s and 1930s, organizing lectures, literary meetings, and performances. Women were not only members of the reading room's board and management staff but also among the lecturers. The report for the activities in the 1931–1932 year included Regina Fischlerówna's lecture "On Marriage and Morality."[108] Women continued to be active in other Jewish reading rooms in the 1920s and 1930—for example, Czytelnia Ludowa "Jedność" (People's Reading Room "Unity"), which later transformed into Czytelnia Ludowa I. L. Pereca (the I. L. Peretz People's Reading Room), which had a substantial collection of books in Polish.[109]

Another forum for the creation and expression of cultural opinions in interwar Kraków were literary salons. Held by women from Christian and Jewish backgrounds, they functioned as an intermediate zone between the private and public domains and offered a kind of common space for various artistic and intellectual circles.[110] The salon of the translator Róża Heller ([1909?]–[1938?]) at 5 Lubicz Street was regarded as one of the most influential.[111] The only daughter of the wealthy owners of Hotel Europejski and a student of the Jagiellonian University, Heller was an ardent admirer of the popular Polish writers Tadeusz Boy-Żeleński and Zygmunt Nowakowski. She tried her hand as a translator and signed her translations under the pen name Helena Hellerówna.[112] We also have accounts of meetings organized by sisters Felicja Stendigowa and Bronisława Infeld, who brought together Jewish artists and intellectuals.[113]

Last, Jewish women participated in self-education associations as well as educational and artistic events organized by them—for example, in public lectures and various forms of theater performances. Unfortunately, only fragmentary data pertaining to this form of cultural activity have been preserved. For example, "Ruth," the reading room for nationalist Jewish women, continued to operate in the 1930s at 17 Zielona Street and organized a series of public lectures. Some women—for example, the painter Hanka Landau-Eiger (1904–1999)—collaborated with the cabaret Bury Melonik (1935–1936), launched by Bruno Hoffman and Adam Polewka, which operated in the Social Reading Room at 39 Rynek Główny.[114] Jewish actresses, such as Zofia Jasińska-Filipowska (née Gottlieb; 1908–2003), also played in professional theaters (e.g., Bagatela Theater and the Juliusz Słowacki Municipal Theater).[115]

Conclusion

This preliminary analysis has allowed me to draft approximate maps of Jewish women's cultural production in Kraków. My findings are based on cultural activities Jewish women carried out in Polish; in the future, they will need to be interpreted alongside similar maps of cultural production in other languages used by Kraków Jews. These limitations notwithstanding, the maps allow for some general conclusions about the place of Jewish women's cultural activities in Kraków's urban space. Moreover, the maps could be read from numerous perspectives, since they highlight various social and cultural phenomena and processes.

The data available today show how multifaceted were their cultural activities, as they strove to accumulate cultural capital and took advantage of the various institutional opportunities. Thus, we could interpret the maps both as a network of institutions with which active individuals became involved and as a spectrum of possibilities that these institutions offered to such individuals. We can also trace some of the locations and relocations of individuals in the cultural field and their personal strategies for functioning in it.

The cultural production of women in Polish occurred in different areas: education, journalism, literature, and theater. Its basis was formed by the educational system, where cultural capital was produced and reproduced. Women could put this acquired capital to use in other institutions of the cultural field. The expanded net of cultural institutions of cultural activity was closely connected with the progress of educational opportunities for women and their emancipation. Moreover, educational institutions, schools and university, functioned as important Polish-Jewish contact zones. The location of these institutions in the city space helps map both the local centers of cultural activity and centers of socialization and acculturation.

Women involved in the cultural activities in Kraków between 1899 and 1939 represented at least three generations born in the years 1860–1920.[116] For some, their emancipation, modernization, and activism in the cultural field often resulted in their gradual estrangement from home or even an open conflict with their traditional families. Many, however, were supported in their professional ambitions and cultural aspirations by their nearest and dearest: their parents, siblings, and husbands. They formed a group of creative, ambitious women active in Polish-Jewish institutions, as well as in Polish ones, while their ideological positions ranged from assimilatory to Zionist. As a result, many of them participated in the process of "integration into the majority community without any loss of ethnic or national integrity" characteristic for Jews in Kraków in the interwar years.[117]

The Kraków of modern culturally active women was a multiethnic, Polish and Jewish space, in which sites of women's cultural production functioned as nodes of a network connecting activities of various groups. "Women's places" on this general map shared space, but the points of interconnectivity changed over time.

Since the last decades of the nineteenth century, Jewish women played a significant role in the process of the Jewish spatial move beyond Kazimierz, which was closely connected with the phenomena of Jewish emancipation and

modernization.[118] The maps visualize this process and enable us to grasp the emerging field of Jewish cultural institutions in the Polish language and their location in the city space.

The shift in Jewish women's cultural production was not only spatial but also had a gender dimension. Initially connected with Polish institutions, with time, the activities of women also utilized Jewish institutions that used the Polish language. These were mostly educational institutions, cultural associations, and periodicals established by men. The network of separate Polish-Jewish women's institutions was relatively small. It comprised self-educational and educational institutions (such as reading rooms and schools), as well as special supplements and periodicals addressed to women and children. Thus, it can be said that these modern forms of activity were also focused on domains traditionally regarded as belonging to women—namely, social work and childcare.

Since Jewish women's cultural production in the Polish language became a part of Polish educational, press, and literary institutions, it was intertwined with the spatial arrangement of Polish culture at the time. Therefore, the maps of women's cultural production also give us insight into the dialectic of separateness and connectedness of the Polish and Jewish parts of Kraków, revealing both ethnic boundaries and instances in which those boundaries were crossed; in those cases, ties were created between the two communities despite such boundaries.

Notes

1. Henryk Vogler, *Wyznanie mojżeszowe: Wspomnienia z utraconego czasu* (Warsaw: Państwowy Instytut Wydawniczy, 1994), 20.

2. Leopold Infeld, *Kordian, fizyka i ja: Wspomnienia* (Warsaw: Państwowy Instytut Wydawniczy, 1967), 125.

3. Infeld, 127.

4. Zalmen Reyzen, "Ortodoksishe yidishizm," *Vilner tog*, no. 269 (April 10, 1931), quoted in Joanna Lisek, "'Dos loszn fun jidiszkajt'—ortodoksyjny jidyszyzm na łamach «Bejs Jakow» w kontekście religijnego feminizmu żydowskiego w Polsce," in *Studia z dziejów trójjęzycznej prasy żydowskiej na ziemiach polskich (XIX–XX w.)*, ed. Joanna Nalewajko-Kulikov, Grzegorz P. Bąbiak, and Agnieszka J. Cieślikowa (Warsaw: Wydawnictwo Neriton, 2012), 347.

5. For a sophisticated analysis of gender, language, and education among American Haredi Jews, see Ayala Fader, *Mitzvah Girls: Bringing Up the Next Generation of Hasidic Jews in Brooklyn* (Princeton, N.J.: Princeton University Press, 2009).

6. Chone Shmeruk, "Hebrew—Yiddish—Polish: A Trilingual Jewish Culture," in *The Jews of Poland between Two World Wars*, ed. Yisrael Gutman et al. (Hanover, N.H.: University Press of New England, 1989).

7. Magda Sara Szwabowicz, "Twórcy i ośrodki literatury hebrajskiej w Polsce międzywojennej," *Studia Judaica* 1 (2015): 146.

8. Regarding Yiddish literature in Galicia, see Adam Stepnowski, "Debora Vogel w galicyjskim Jidyszlandzie. Czasopismo 'Cusztajer,'" *Schulz/Forum* 16 (2020): 177–179.

9. Czesław Brzoza, "Pierwsze lata 'Nowego Dziennika,' organu syjonistów krakowskich," *Rocznik Historii Prasy Polskiej* 1, nos. 1–2 (1998): 25.

10. Renata Dutkowa, *Żeńskie gimnazja Krakowa w procesie emancypacji kobiet (1896–1918)* (Kraków: Księgarnia Akademicka, 1995); Aleksandra Bilewicz, "Prywatne średnie,

ogólnokształcące szkolnictwo żeńskie w Galicji w latach 1867-1914," *Acta Universitatis Wratislaviensis: Prace Pedagogiczne* 116 (1997): 3-128; Katarzyna Dormus, "Krakowskie gimnazja żeńskie przełomu XIX i XX wieku," *Studia Paedagogica Ignatiana* 19, no. 2 (2016): 87-103.

11. Eliyana R. Adler, *In Her Hands: The Education of Jewish Girls in Tsarist Russia* (Detroit: Wayne State University Press, 2011).

12. Pierre Bourdieu, *The Rules of Art: Genesis and Structure of the Literary Field*, trans. Susan Emanuel (Stanford, Calif.: Stanford University Press, 1996).

13. B. A. Levinson and D. C. Holland, "The Cultural Production of the Educated Person: An Introduction," in *The Cultural Production of the Educated Person: Critical Ethnographies of Schooling and Local Practice*, ed. B. A. Levinson, D. E. Faley, and D. C. Holland (Albany: State University of New York Press, 1996), 7-8.

14. Rachel Manekin, *The Rebellion of the Daughters: Jewish Women Runaways in Habsburg Galicia* (Princeton, N.J.: Princeton University Press, 2020), 237.

15. Franco Moretti, *Atlas of the European Novel 1800-1900* (London: Verso, 1998), 3.

16. Bourdieu, *Rules of Art*.

17. Fundacja Przestrzeń Kobiet (Women's Space Foundation) has recently published several volumes on women's activities and mapping them onto Kraków. See Ewa Furgał, ed., *Krakowski szlak kobiet: Przewodniczki po Krakowie emancypantek*, 5 vols. (Kraków: Fundacja Przestrzeń Kobiet, 2009-2013). See too Agata Dutkowska and Wojciech Szymański, eds., *Kraków kobiet: Przewodnik turystyczny* (Kraków: korporacja ha!art, 2011); and Ewa Mańkowska-Grin and Katarzyna Janusik, eds., *Żydowscy obywatele Krakowa: Kobiety* (Kraków: Wydawnictw EMG, 2021).

18. Important new studies include Sean Martin, *Jewish Life in Cracow, 1918-1939* (London: Vallentine Mitchell, 2004); A. Kutylak-Hapanowicz and M. Fryźlewicz, eds., *Krakowianie: Wybitni Żydzi krakowscy XIV-XX w.* (Kraków: Muzeum Historyczne Miasta Krakowa, 2006); Łukasz Sroka, *Żydzi w Krakowie: Studium o elicie miasta 1850-1918* (Kraków: Wydawnictwo Naukowe Akademii Pedagogicznej im. Komisji Edukacji Narodowej, 2008); Wiesław Kozub-Ciembroniewicz, ed., *Uczeni żydowskiego pochodzenia we współczesnych dziejach Uniwersytetu Jagiellońskiego* (Kraków: Wydawnictwo Uniwersytetu Jagiellońskiego, 2014); *Jews in Kraków*, vol. 23 of *Polin: Studies in Polish Jewry*, ed. Michał Galas and Antony Polonsky (Oxford: Littman Library of Jewish Civilization, 2011); and Alicja Maślak-Maciejewska, *Modlili się w Templu: Krakowscy Żydzi postępowi w XIX wieku: Studium społeczno-religijne* (Kraków: Wydawnictwo Uniwersytetu Jagiellońskiego, 2018).

19. For more on the difficulties of studying the history of women in Kraków in the nineteenth century, see Maślak-Maciejewska, *Modlili się*, 271.

20. The processes leading to Kraków's provincialization began already in the seventeenth century when its political status declined compared to Warsaw's. See Jacek Purchla, *Kraków: Prowincja czy metropolia?* (Kraków: Towarzystwo Autorów i Wydawców Prac Naukowych "Universitas," 1996), 13.

21. Purchla, 84.

22. Purchla, 16.

23. Kazimierz Karolczak, "Ludność żydowska w Krakowie na przełomie XIX i XX wieku," in *Żydzi w Małopolsce: Studia z dziejów osadnictwa i życia społecznego*, ed. Feliks Kiryk (Przemyśl: Południowo-Wschodni Instytut Naukowy w Przemyślu, 1991), 251.

24. See Alicja Maślak-Maciejewska's contribution to this volume.

25. For more on linguistic capital, see Bourdieu, *Rules of Art*, 280-281.

26. Henryk Halkowski, "Świat przed katastrofą?," in *Świat przed katastrofą: Żydzi krakowscy w dwudziestoleciu międzywojennym*, ed. Jan M. Małecki (Kraków: Międzynarodowe Centrum Kultury, 2007).

27. Irena Homola, *"Kwiat społeczeństwa . . .": Struktura społeczna i zarys położenia inteligencji krakowskiej w latach 1866-1914* (Kraków: Wydawnictwo Literackie, 1984), 9-10.

28. See Ozjasz Thon, "Znamiona narodowości," *Nowy Dziennik*, no. 324 (1931): 3; and "Językiem ojczystym Żydów jest język hebrajski!," *Nowy Dziennik*, no. 330 (1931): 11. Regarding the multilingualism of Cracovian Jews, see Martin, *Jewish Life in Cracow*, 49-53.

29. Hael, "Język ojczysty," *Trybuna Akademicka*, no. 10 (1928): 6-7.

30. Andrzej Żbikowski, *Żydzi krakowscy i ich gmina w latach 1869-1919* (Warsaw: Wydawnictwo DiG, 1994), 244.

31. Urszula Perkowska, *Studentki Uniwersytetu Jagiellońskiego w latach 1894-1939: W stulecie immatrykulacji pierwszych studentek* (Kraków: Wydawnictwo i Drukarnia "Secesja," 1994); Jadwiga Suchmiel, *Udział kobiet w nauce do 1939 roku w Uniwersytecie Jagiellońskim* (Częstochowa: Wydawnictwo Wyższej Szkoły Pedagogicznej w Częstochowie, 1994).

32. About the institutional changes in the city's literary life, see Jacek Olczyk, *Życie literackie w Krakowie w latach 1893-2013* (Kraków: korporacja ha!art, 2016).

33. Krystyna Samsonowska, "Elementarne szkolnictwo żydowskie w Krakowie w latach 1867-1918. Rywalizacja środowisk żydowskich o model wychowania i wykształcenia młodego pokolenia," *Rocznik Komisji Nauk Pedagogicznych* 53 (2000): 34.

34. Martin, *Jewish Life in Cracow*, 30.

35. Dormus, "Krakowskie gimnazja żeńskie przełomu," 98.

36. See the course of women students' school education in Jadwiga Suchmiel, *Kariery zawodowe lekarek ze stopniem doktora wykształconych w Uniwersytecie Jagiellońskim podlegających pod Krakowską Izbę Lekarską do 1939 roku: W stulecie immatrykulacji studentek medycyny* (Częstochowa: Wydawnictwo Wyższej Szkoły Pedagogicznej w Częstochowie, 1998).

37. Suchmiel.

38. Bogusława Czajecka, *"Z domu w szeroki świat": Droga kobiet do niezależności w zaborze austriackim w latach 1890-1914* (Kraków: TAiWPN Universitas, 1990), 91.

39. Janina Kras, *Wyższe kursy dla kobiet im. A. Baranieckiego 1868-1924* (Kraków: Wydawnictwo Literackie, 1972), 79.

40. Józef Czech, ed., *Józefa Czecha Kalendarz Krakowski na rok 1899* (Kraków: W księgarni J. Czecha, 1899), 191.

41. Czajecka, *"Z domu w szeroki świat,"* 138.

42. Jadwiga Suchmiel, *Żydówki ze stopniem doktora wszech nauk lekarskich oraz doktora filozofii w Uniwersytecie Jagiellońskim do czasów Drugiej Rzeczypospolitej* (Częstochowa: Wydawnictwo Wyższej Szkoły Pedagogicznej w Częstochowie, 1997), 6.

43. For a comparison in interwar New York, see Ruth Jacknow Markowitz, *My Daughter, the Teacher: Jewish Teachers in the New York City Schools* (New Brunswick, N.J.: Rutgers University Press, 1993).

44. Grażyna Kubica, *Siostry Malinowskiego, czyli kobiety nowoczesne na początku XX wieku* (Kraków: Wydawnictwo Literackie, 2006), 130; Czajecka, *"Z domu w szeroki świat,"* 166.

45. See Mirosław Łapot, "Nauczycielki religii mojżeszowej w szkołach publicznych w Galicji w latach 1867-1939," *Prace Naukowe Akademii im. Jana Długosza w Częstochowie. Seria: Pedagogika* 20 (2011): 407-418.

46. *Józefa Czecha Kalendarz Krakowski na rok 1899*, 193. Anna Horowitz and Ludwika Rottersman worked at this school as well.

47. About Pniowerówna's activities, see Zuzanna Kołodziejska-Smagała and Maria Antosik-Piela, eds., *Literatura polsko-żydowska 1861-1918: Antologia* (Kraków: Wydawnictwo Uniwersytetu Jagiellońskiego, 2017), 297. In 1908, Pniowerówna worked in the St. Salomea School at 15 Krupnicza Street. See "Spis alfabetyczny urzędów, instytucji publicznych i

prywatnych, szkół, zakładów, stowarzyszeń i zawodów w Krakowie," in *Stefana Mikulskiego Wielka Księga Adresowa Stołecznego Królewskiego Miasta Krakowa i Królewskiego Wolnego Miasta Podgórza*, vol. 4 (Kraków: Nakładem Stefana i Maryi Mikulskich, 1908), 20.

48. Kołodziejska-Smagała and Antosik-Piela, *Literatura polsko-żydowska 1861–1918*, 194. Rosenberg still worked there in 1908 (*Stefana Mikulskiego Wielka Księga Adresowa*, 20) and in 1913 (Julian Dobrzański, ed., *II Sprawozdanie C. K. Rady Szkolnej Okręgowej Miejskiej w Krakowie za rok szkolny 1912/1913* [Kraków: Nakładem Gminy Stołecznego Królewskiego Miasta Krakowa, 1913], 43).

49. Magdalena Kopeć, "Czytelnia dla kobiet narodowo-żydowskich 'Ruth,'" in *Krakowski szlak kobiet: Przewodniczki po Krakowie emancypantek*, ed. Ewa Furgał (Kraków: Fundacja Przestrzeń Kobiet, 2013), 5:60–61. In her diary, Sarah Schenirer gives an account of one of such meetings organized by "Ruth" in the 1910s and portrays women who participated in it. See Joanna Lisek, *Kol isze—głos kobiet w poezji jidysz (od XVI w. do 1939 r.)* (Sejny: Pogranicze, 2018), 250. On Schenirer, see Naomi Seidman's chapter in this volume.

50. Regarding the role of the Polish language in Galician Zionist activity and their rituals, see Joshua Shanes, *Diaspora Nationalism and Jewish Identity in Habsburg Galicia* (Cambridge: Cambridge University Press, 2012), 65–69.

51. Gabriela Matuszek, "Kobiety a proces modernizacji: Rekonesans galicyjskiej herstorii," in *Kraków i Galicja wobec przemian cywilizacyjnych 1866–1914: Studia i szkice*, ed. Krzysztof Fiołek and Marian Stala (Kraków: TAiWPN Universitas, 2011), 49–51.

52. Joanna Stryjczyk, "*Krytyka*—czasopismo jako sposób działania," in *Modernistyczne źródła dwudziestowieczności*, ed. Mieczysław Dąbrowski and Andrzej Z. Makowiecki (Warsaw: Wydział Polonistyki Uniwersytetu Warszawskiego, 2003), 373–386; Tomasz Gąsowski, *Między gettem a światem: Dylematy ideowe Żydów galicyjskich na przełomie XIX i XX wieku* (Kraków: Księgarnia Akademicka, 1996), 113.

53. Ezra Mendelsohn, "Jewish Assimilation in L'viv: The Case of Wilhelm Feldman," in *Nationbuilding and the Politics of Nationalism: Essays on Austrian Galicia*, ed. Andrei S. Markovits and Frank E. Sysyn (Cambridge, Mass.: Harvard University Press, 1982), 94–110.

54. See Jerzy Kojkoł, *Myśl filozoficzna Stanisława Garfein-Garskiego* (Toruń: Wydawnictwo Adam Marszałek, 2001).

55. Under the pen name Maria Zabojecka, she published several novels and translations of the works of Georg Brandes, Knut Hamsun, Gerhardt Hauptman, and Romain Rolland, continuing to write in the subsequent decades. In the 1920s, Malwina Garfeinowa-Garska edited the feminist literary anthology *Z kobiecej niedoli* (Warsaw: Nakładem Spółdzielni Księgarskiej "Książka," 1927).

56. Eugenia Prokop-Janiec, "Women's Assimilation Narratives in Galicia: The Works of Aniela Kallas," *Studia Judaica* 18 (2010): 284–297; Eugenia Prokop-Janiec, "A Woman Assimilationist and the Great War: A Case of Aniela Kallas," *Medaon: Magazin für jüdisches Leben in Forschung und Bildung* 10 (2016): 18.

57. Regarding the genres of English-Jewish women's writing, see Michael Galchinsky, *The Origin of the Modern Jewish Woman Writer: Romance and Reform in Victorian England* (Detroit: Wayne State University Press, 1996), 32–38.

58. Jadwiga Czachowska and Alicja Szałagan, ed., *Współcześni polscy pisarze i badacze literatury* (Warsaw: Wydawnictwa Szkolne i Pedagogiczne, 1996), 4:22.

59. Aniela Kallas, "Dobrani," in *Ilustrowany Kalendarz Diabelski na Rok 1896* (Kraków: Nakładem księgarni Władysława Poturalskiego, 1896); "Stanisławowa," in *Ilustrowany Kalendarz Diabelski na Rok 1897* (Kraków: Nakładem księgarni Władysława Poturalskiego, 1897).

60. "Romowicz, Julia," in *Słownik biograficzny teatru polskiego 1765–1965*, ed. Zbigniew Raszewski (Warsaw: Państwowe Wydawnictwo Naukowe, 1973), 601; Diana Poskuta-Włodek,

"Duchy przeszłości: Ciocia Julcia," in *Sławomir Mrożek: Rzeźnia: Teatr im. J. Słowackiego w Krakowie* (Kraków: Centrum Druku, D. A., 1999), 14-18.

61. Iwona Boruszkowska, "Akuszerki awangardy: Kobiety a początki nowej sztuki," *Pamiętnik Literacki* 3 (2019): 11.

62. Aniela Kallas, "Sierota," *Tygodnik*, no. 29 (1906): 2-3; Aniela Kallas, "Sierota," *Tygodnik*, no. 30 (1906): 2-3; "Przeznaczenie," *Tygodnik*, no. 28 (1909): 2-3.

63. Aniela Kallas, "Córki marnotrawne. List otwarty w odpowiedzi prof. Bujwidowej na artykuł pod powyższym tytułem," *Tygodnik*, no. 44 (1913): 2; Aniela Kallas, "Córki marnotrawne. List otwarty w odpowiedzi prof. Bujwidowej na artykuł pod powyższym tytułem," *Tygodnik*, no. 45 (1913): 2.

64. Sabina Kwiecień, "Kartka z dziejów żydowskiej prasy dla dzieci i młodzieży w okresie autonomii galicyjskiej," *Annales Universitatis Paedagogicae Cracoviensis: Studia ad Bibliothecarum Scientiam Pertinentia* 13 (2015): 147.

65. Aniela Kallas, "Basia Kowalanka," *Przodownica*, no. 10 (1902): 4-7; "Sprawiedliwość Boża," *Dodatek do Przodownicy*, no. 11 (1903): 5-8.

66. Regarding the role of *Nowa Reforma* at the turn of the nineteenth and twentieth centuries in the promotion of Jewish emancipation, see Czesław Brzoza, *Polityczna prasa Krakowa 1918-1939* (Kraków: Nakładem Uniwersytetu Jagiellońskiego, 1990), 66-69. Kallas published numerous short stories and sketches using different pen names (inter alia Juliusz Piasecki) in *Nowa Reforma*. See Juliusz Piasecki, "Na kresach: Prezes," *Nowa Reforma*, no. 47 (1903): 1-2; Juliusz Piasecki, "Na kresach: Pyton," *Nowa Reforma*, no. 48 (1903): 1; Aniela Kallas, "Na Rusi: Szkice i obrazki: Drużba," *Nowa Reforma*, no. 197 (1906): 1; and Aniela Kallas, "Mój debiut dziennikarski," *Nowa Reforma*, no. 198 (1909): 1; Aniela Kallas, "Mój debiut dziennikarski," *Nowa Reforma*, no. 203 (1909): 1.

67. "Kronika," *Tygodnik*, no. 14 (1913): 3. The names of teachers of particular public schools are listed by Julian Dobrzański in *II Sprawozdanie C. K. Rady Szkolnej*.

68. Bilewicz, *Prywatne średnie*, 100.

69. Dutkowa, *Żeńskie gimnazja Krakowa*, 116.

70. Mariusz Kulczykowski, *Żydzi studenci Uniwersytetu Jagiellońskiego w Drugiej Rzeczypospolitej (1918-1939)* (Kraków: Polska Akademia Umiejętności, 2004), 43-102.

71. Perkowska, *Studentki Uniwersytetu Jagiellońskiego*, 98.

72. See Suchmiel, *Żydówki ze stopniem*, 26.

73. Suchmiel, 6.

74. Homola, *"Kwiat społeczeństwa..."*

75. Kulczykowski, *Żydzi studenci Uniwersytetu Jagiellońskiego*, 359. On Fromowicz, see also Vogler, *Wyznanie mojżeszowe*, 59.

76. Marta Struzik, "I przychodź do mnie często: Osobista sygnatura Stefanii Zahorskiej," in *Krakowski szlak kobiet: Przewodniczki po Krakowie emancypantek*, ed. Ewa Furgał (Kraków: Fundacja Przestrzeń Kobiet, 2011), 3:92.

77. Kras, *Wyższe kursy dla kobiet*, 79.

78. In that year, Jewish women first appeared among academy students. Natasza Styrna, *Zrzeszenie Żydowskich Artystów Malarzy i Rzeźbiarzy w Krakowie (1931-1939)* (Warsaw: Wydawnictwo Neriton, 2009).

79. For biographical notes on Jewish women painters, see Styrna, *Zrzeszenie Żydowskich Artystów Malarzy*, 266, 274, 293.

80. Archival documents list the members of the Social Reading Room, their occupations, and their addresses. Among the most active participants were Natalia Landauowa, Michalina Langroderowa, Róża Schiffowa, Hela Sternbachówna, Klara Oberlenderowa, Zofia Lachsowa, Ludwika Horowitzówna, Pola Taubenschlagowa, Helena Grunhutowa, Eugenia Heumannowa, Berta Lieblingowa, Anna Wintersteinowa, Regina Blankówna, Róża Striżowerówna,

and Berta Baumgartenowa. Archiwum Narodowe w Krakowie, Kraków, StGK 239, file "Czytelnia Towarzyska w Krakowie."

81. Zygmunt Hoffman, "Prywatne Żydowskie Koedukacyjne Gimnazjum w Krakowie (1918-1939)," *Biuletyn Żydowskiego Instytutu Historycznego*, nos. 3-4 (1988): 101-110; Krystyna Samsonowska, "Gimnazjum Hebrajskie na mapie szkolnictwa żydowskiego w Krakowie," in *To była hebrajska szkoła w Krakowie: Gimnazjum Hebrajskie 1918-1939*, ed. Maciej Władysław Belda (Kraków: Muzeum Historyczne Miasta Krakowa, 2011).

82. Zygfryd Moses, "*Nowy Dziennik*—nieco historii i statystyki," *Nowy Dziennik*, no. 190 (1928): 21. For a comparison between Polish Jewish women journalists and Polish Christian women journalists in the same period, see Z. Sokół, "Czasopisma, dodatki kobiece i dla kobiet wydawane przez koncern IKC (w latach 1918-1939)," in *Ilustrowany Kurier Codzienny (1910-1939): Księga pamiątkowa w stulecie powstania dziennika i wydawnictwa*, ed. Grażyna Wrona, Piotr Borowiec, and Krzysztof Woźniakowski (Kraków: "Śląsk" Wydawnictwo Naukowe, 2010), 338-339.

83. See Eugenia Prokop-Janiec, "Żydowski Kraków literacki między wojnami" (Unpublished article), 25-26. One of the initiatives of the Social Reading Room was the Collegium of Scholarly Lectures (Kolegium wykładów naukowych). The activity of the collegium is remembered by many Polish writers of the interwar period as well—among others, Jalu Kurek, *Mój Kraków* (Kraków: Wydawnictwo Literackie, 1978), 141.

84. Historical research demonstrates that a substantial group among the working inhabitants of the city was students of secondary schools and universities, constituting 20 percent of the population of Kraków in 1938.

85. See the accounts by Lea Shinar and Miriam Akavia in Anis Pordes, *Ich miasto: Wspomnienia Izraelczyków przedwojennych mieszkańców Krakowa* (Warsaw: Prószyński i Spółka, 2004), 38, 41. The available memoirs suggest that the lists of schools compiled by Zofia Wordliczek and Sean Martin could be much longer. See Martin, *Jewish Life in Cracow*; and Zofia Wordliczek, "Żydowskie szkolnictwo podstawowe, średnie i zawodowe w okresie II Rzeczypospolitej Polskiej ze szczególnym uwzględnieniem Krakowa," *Krzysztofory* 19 (1992): 120-134.

86. Jarosław Borowiec, ed., *Kronika Szkolna uczennic żydowskich z lat 1933-1939: Miejskiej Szkoły Powszechnej nr 15 im. Klementyny Tańskiej-Hoffmanowej przy ul. Miodowej w Krakowie* (Kraków: Wydawnictwo Austeria, 2006). See also Irena Bronner, *Cyklady nad Wisłą i Jordanem* (Kraków: Wydawnictwo Literackie, 1991).

87. Anna Boguszewska, "Kształcenie w zakresie grafiki w szkolnictwie artystycznym Krakowa, Lwowa i Wilna w latach międzywojennych," *Biuletyn Historii Wychowania* 29 (2013): 85-99.

88. *Sprawozdanie Kierownictwa Żydowskiego Gimnazjum Koedukacyjnego Typu Humanistycznego Towarzystwa Żydowskiej Szkoły Ludowej i Średniej w Krakowie za rok szkolny 1928/1929* (Kraków: Nakładem Kierownictwa Żydowskiego Gimnazjum *Koedukacyjnego* w Krakowie, 1929), 28.

89. *Sprawozdanie Kierownictwa Żydowskiego Gimnazjum Koedukacyjnego Typu Humanistycznego Towarzystwa Żydowskiej Szkoły Ludowej i Średniej w Krakowie za rok szkolny 1931/1932* (Kraków: Nakładem Kierownictwa Żydowskiego Gimnazjum *Koedukacyjnego* w Krakowie, 1932), 28.

90. *Sprawozdanie Kierownictwa Żydowskiego Gimnazjum Koedukacyjnego za rok szkolny 1931/1932*, 33.

91. On Anna Brossowa (née Chaya Kluger), see Manekin, *Rebellion of the Daughters*, 135-164. See too Maria Stinia, "Między patriotyzmem a syjonizmem—wychowanie w gimnazjum żydowskim w Krakowie (1918-1939)," in *Procesy socjalizacji w Drugiej Rzeczypospolitej 1914-1939*, ed. Anna Landau-Czajka and Katarzyna Sierakowska (Warsaw: Instytut Historii

PAN, 2013), 38; Maria Stinia, "Rola nauczycielek w prywatnym koedukacyjnym gimnazjum Żydowskiego Towarzystwa Szkoły Ludowej i Średniej w Krakowie w latach 1918-1939," in *Edukacja*, ed. G. Pańko, M. Skotnicka-Palka, and B. Techmańska (Wrocław: GS Media, 2013); and Emilia Leibel, *Wspomnienia Żydówki krakowskiej*, ed. Maria Kłańska (Kraków: Polska Akademia Umiejętności, 2010), 56, 97.

92. See Belda, *To była hebrajska szkoła w Krakowie*, 82, 89, 90, 96.

93. The lists of topics discussed by students were published in *Sprawozdanie Kierownictwa Żydowskiego Gimnazjum Koedukacyjnego za rok 1928/1929*, 25.

94. See an account by Mala Mandelbaum at the Trade Gymnasium in Pordes, *Ich miasto*, 210, 212.

95. See Jadwiga Suchmiel, "Emancypacja kobiet w uniwersytetach w Krakowie i we Lwowie do roku 1939," *Prace Naukowe Akademii im. Jana Długosza w Częstochowie. Seria: Pedagogika* 13 (2004): 115–123.

96. See Suchmiel, *Udział kobiet*, 187–188.

97. Urszula Perkowska, "Kariery naukowe kobiet a Uniwersytet Jagielloński w latach 1904–1939," in *Kobiety i kultura: Kobiety wśród twórców kultury intelektualnej i artystycznej w dobie rozbiorów i w niepodległym państwie polskim*, ed. A. Żarnowska and A. Szwarc (Warsaw: Wydawnictwo DiG, 1996), 145.

98. Brossowa's monograph *Józef Mazzini szermierz niepodległości Włoch i przyjaciel Polski* (Lwów: Filomata, 1939) was edited in 1939. She published articles for the general public in the Polish-Jewish *Nowy Dziennik* and Polish *Kuryer Literacko-Naukowy*, and her scholarly studies appeared in Polish and Polish-Jewish journals, such as *Filomata*, *Przegląd Pedagogiczny*, *Ruch Pedagogiczny*, *Życie Szkolne*, and *Przegląd Społeczny*.

99. Piotr Oczko, "Gizela Reicher-Thonowa, zapomniana matka polskiej komparatystyki literackiej," *Pamiętnik Literacki* 1 (2010): 187–200.

100. Stella Landy, "Czasem mi tak żal," *Hejnał*, no. 1 (1928): 17; "Zegar," *Głos Prawdy. Organ Radykalizmu Polskiego. Tygodnik*, no. 269 (1928): 698.

101. Some of her works were also published collectively in Felicja Stendigowa, *Usta lakierowane* (Kraków: Księgarnia Powszechna, 1938). I discuss Stendigowa's writings in Eugenia Prokop-Janiec, "Siostra Infelda: Krakowska rodzina żydowska i nowoczesność," in *Dyskursy pogranicza, wektory literatury*, ed. J. Pasterska and Z. Ożóg (Rzeszów: Wydawnictwo Uniwersytetu Rzeszowskiego, 2019), 173–186.

102. Pordes, *Ich miasto*, 213.

103. Kulczykowski, *Żydzi studenci Uniwersytetu Jagiellońskiego*, 50–51. He argues that the decrease of Jewish students at the Faculty of Philosophy—where, inter alia, future teachers were taught—mirrored the difficult and insecure position of graduates and their lack of future prospects.

104. About women journalists cooperating with *Nowy Dziennik*, see Moses, "*Nowy Dziennik*." *Dzienniczek dla dzieci i młodzieży* was published in the years 1928–1936 and then continued as *Dzienniczek* in the years 1937–1939. See Sabina Kwiecień, "Dziewięć lat *Dzienniczka dla dzieci i młodzieży*—dodatku do *Nowego Dziennika*," *Annales Universitatis Paedagogicae Cracoviensis: Studia ad Bibliothecarum Scientiam Pertinentia* 12 (2014): 38–55.

105. Such was the case of Felicja Stendigowa. Felicja Stendigowa, "Eugenika i regulacja urodzeń w służbie lepszego jutra," *Życie Świadome: Kwartalnik poświęcony zagadnieniom reformy seksualnej i obyczajowej*, no. 1 (1936): 33–37; "Dwutorowa amoralność—czy jednotorowa moralność?," *Życie Świadome: Kwartalnik poświęcony zagadnieniom reformy seksualnej i obyczajowej*, no. 4 (1937): 32–35.

106. Both Anna Brossowa and Felicja Stendigowa were active as lecturers at the Polish Radio. In 1928, Brossowa delivered the radio lecture "Kościuszko jako szermierz oświaty"

("Co usłyszymy dziś przez radio," *Hasło Łódzkie*, April 4, 1928), while Stendigowa mostly discussed "women's" topics. Jakub Stendig, *Płaszów: Ostatnia stacja krakowskiego Żydostwa* (Kraków: Muzeum Historyczne Miasta Krakowa, 2020), 45–46.

107. Bourdieu, *Rules of Art*, 418.

108. Archiwum Narodowe w Krakowie, Kraków, StGK 239, file "Czytelnia Towarzyska w Krakowie."

109. Among the most active members of the association were Pola Targownik, Pola Kleinberger, Cecylia Lincer, and Stefania Kaufler. Archiwum Narodowe w Krakowie, Kraków, StGK 239, file "Czytelnia Ludowa 'Jedność' w Krakowie."

110. For more on the evolving functions of the salon and its current forms, see Grzegorz Jankowicz et al., eds., *Literatura polska po 1989 roku w świetle teorii Pierre'a Bourdieu: Raport z badań* (Kraków: korporacja ha!art, 2014), 80–81. See too Bourdieu, *Rules of Art*, 82–83, for more on the role of salons as a link between different social fields.

111. Vogler, *Wyznanie mojżeszowe*, 60–62; Dawid Lazer, "Frezje, mimoza i róże," in *Frezje, mimoza i róże: Szkice polskie z lat 1933–1974* (Tel Aviv: Aviva Devir, 1994), 13–18; Anna Gabryś, *Salony krakowskie* (Kraków: Wydawnictwo Literackie, 2006), 125.

112. Helena Hellerówna printed her translations mostly in the periodical *As* published in Kraków in the 1930s. On Boy-Żeleński, see Bożena Shallcross's contribution to this volume.

113. Pordes, *Ich miasto*, 284; Leopold Infeld, *Szkice z przeszłości: Wspomnienia* (Warsaw: Państwowy Instytut Wydawniczy, 1964), 40.

114. See Styrna, *Zrzeszenie Żydowskich Artystów Malarzy*, 266. Bury Melonik was run by Adam Polewka and Bruno Hoffman.

115. Mańkowska-Grin and Janusik, *Żydowscy obywatele Krakowa*, 180.

116. Among the Jewish teachers were also some women born in 1850.

117. Martin, *Jewish Life in Cracow*, 243.

118. See Majer Bałaban, *Dzieje Żydów w Krakowie i na Kazimierzu (1304–1868)* (Kraków: Nakładem Izraelickiej Gminy Wyznaniowej w Krakowie, 1912), 1:23–24; Karolczak, "Ludność żydowska w Krakowie," 252–253; and Jan M. Małecki, "Żydzi krakowscy w XIX wieku: Wyjście z getta," in *Wspólnoty lokalne i środowiskowe w miastach i miasteczkach ziem polskich pod zaborami i po odzyskaniu niepodległości*, ed. Maria Bogucka (Toruń: Wydawnictwo Uniwersytetu Mikołaja Kopernika, 1998).

CHAPTER 11

Movie Theaters and the Development of Jewish Public Space in Interwar Poland

Ela Bauer

In the 1920s and 1930s, the halls in big cities and small towns in which Jewish cinema viewers watched silver screen film icons like Gloria Swanson, Greta Garbo, Rudolph Valentino, Harold Lloyd, and Charlie Chaplin transformed occasionally into suitable spaces for mass Jewish public assemblies. In these gatherings, the Jewish audience participated in public gatherings and cultural programs, meeting leaders and public figures of different Jewish political parties. In 1933, for example, the Jewish public who was Zionist in orientation could meet Nahum Sokolow (1859–1936), who at the eighteenth Zionist Congress was renominated to serve as the president of the World Zionist Organization, in different movie theaters in Lwów and Łódź, among other locations.[1] In August of that year, before the opening of the congress, David Ben-Gurion (1886–1973) also made a lengthy visit in Poland.[2] Like Sokolow, Ben-Gurion crossed the Polish state and attended as many public meetings as he could in *shtetlakh* (Yid. market towns) and in big cities.[3] Several of the meetings that Ben-Gurion had with the supporters of his party, Mapai (Hebrew acronym for Mifleget Po'ale Erets Yisra'el, the Labor Zionist Party), took place in movie theaters.[4] So, too, was the case of Vladimir (Ze'ev) Jabotinsky (1880–1940), the leader of the right-wing Zionist Revisionist Party, which grew in popularity in Poland in the interwar years.[5] During his many visits in Poland, Jabotinsky crossed the country and participated in many political rallies that were often in local movie theaters.[6]

The encounters of Ben-Gurion, Jabotinsky, Sokolow, and other Jewish political figures with the Jewish public in Poland have already attracted appropriate scholarly attention.[7] Less attention, however, has been given to the venues, the physical spaces in which these meetings were hosted: the halls of movie theaters in big cities, small towns, and many *shtetlakh* in the periphery of the Second Polish Republic. By

1930, there were 750 movie theaters throughout Poland, and many of the owners of these theaters were Jews.[8]

From its first days, the cinema was a very popular form of leisure and entertainment among Jews and non-Jews, particularly among the middle and lower classes.[9] Already in 1920s Poland, many Jews turned into an enthusiastic cinema audience. Indeed, the second half of the 1930s (1935–1939) became rightly known as the "golden age" of Yiddish cinema.[10] Nevertheless, throughout the 1930s, many Jewish public figures and intellectuals argued that cinema was a low-class popular art unequal to other forms of culture, such as literature or theater, which they respected as highbrow.[11] Why, then, did Jewish political figures appear to consider the spaces of movie halls as an appropriate new Jewish public space?

The term *Jewish space* has, until recently, been discussed almost exclusively within the boundaries of traditional and religious environments. Of late, however, scholarly references to Jewish space have included secular sites and locations, demarcating new forms of Jewish space, such as Jewish urban neighborhoods in North American, Middle Eastern, and North African cities. The German-Jewish schools in Moravia in the nineteenth and twentieth centuries have also been considered Jewish spaces, likewise the coffeehouses of Warsaw, Vienna, Berlin, and New York City.[12] Some neutral, secular spaces would become "Jewish" spaces because of the activities and events that took place within them.[13] For instance, summer camps such as Camp Boiberik and Camp Hemshekh that supporters of the Jewish Labor Bund (Yid. Der Algemayner Yidisher Arbeter Bund in Lite Poylin un Rusland; the General Union of Jewish Workers in Lithuania, Poland, and Russia) operated in the United States became Jewish spaces, even if their locations were not necessarily originally designated as Jewish.[14] Based on this more capacious view of Jewish space, I will present how movie theaters that operated throughout Poland in the interwar period can be considered Jewish space. Several times a week—in big cities, small towns, and *shtetlakh*—movie halls hosted assorted events, such as political rallies, public assemblies, and cultural programs that were aimed at the Jewish public. Within the walls of the movie halls, films directed toward a public mass audience and politics, also oriented toward a new population of enfranchised citizens through rallies and public meetings, came together. The movie house was thus a space for public political culture while being a venue for leisure and entertainment.

Even though movie theaters were not exclusively Jewish cultural institutions, their contribution to the development of a mass Jewish political life in interwar Poland was significant. Jewish society needed public places that did not have a fixed political or ideological identification, such as synagogues or halls associated with different political and ideological organizations. Movie theaters were ostensible neutral spaces, and their halls could host different Jewish political and ideological gatherings.

In small towns as well as in many *shtetlakh*, there were few public halls; most public buildings were used for religious purposes (e.g., as churches and

synagogues). And those public spaces that did exist were associated with different political and ideological organizations. Hence, movie halls were almost the only spaces that were neutral. In big cities, on the other hand, there were more halls that could host different Jewish political gatherings and could be considered neutral spaces. And yet movie theaters, spaces with which the general public was familiar, were the preferred places for holding a variety of political rallies. The fact that many of the theaters were owned by Jews also made them ideal venues for different Jewish public and political gatherings.

Nevertheless, several Jewish political leaders did not feel comfortable with the fact that they were expected to participate in rallies and other public gatherings in halls that were also the sites where films were screened. They considered the venues for showing films "vulgar," as were the films themselves, produced purely for commercial reasons.[15] During the time Sokolow was in Poland in 1933, he shared his experiences from the visit with the Zionist activist and member of the Jewish Agency Board Berl Locker (1887–1972). In addition to reporting to Locker on his political achievements and failures, Sokolow also shared his impressions of Polish Jewry.[16] He believed several local communities were in decline due not only to the fragile new state's economic crises but also to the rise of what he called the "democratic mob," the crowd that participated in the democratic process and was involved in assorted mass political activities.[17] In his attempt to clarify who the democratic mob was, Sokolow referred to the "kino [Pol. cinema] audience."[18] He believed that the Jewish "kino" viewers were the victims of the chaotic economic and political situation; he disparaged their "vulgar" behavior, including a lack of civil manners and problematic dress but conceded that they were engaged with democratic politics.[19] To Sokolow, the average Jewish cinema fans were people who had narrow cultural and intellectual worldviews. He linked the rise of Jewish mass politics to the development of mass culture. This correlation was not limited only to the center or to big cities but could be found also in small towns and in the periphery of eastern Galicia.[20]

Sokolow was not the only Zionist leader who criticized the "kino" audiences, the crowds that he and other Zionist leaders encountered during political rallies held in various movie theaters throughout Poland. Other Zionists perceived cinema, noisy jazz bands, politicians who delivered speeches on radio broadcasts, and public advertisements as negative consequences of the popularization and vulgarization processes that both Jewish and non-Jewish society experienced already by the end of the 1920s.[21] Many Zionist pioneer circle leaders in Poland had contempt for mass culture and considered films inappropriate entertainment for their young charges.[22] This contempt was shared by the hegemonic Zionist circles in Palestine.[23]

Nevertheless, despite this attitude, Jewish leaders, politicians, and activists met their supporters and others in the halls of movie theaters. When Zerubavel Ḥaviv (1884–1987), the envoy of the KKL (Keren Kayemeth L'Yisrael; Jewish National Fund) from Palestine, was in Poland in 1937, most of his meetings with various Jewish communities took place in provincial movie theaters.[24] In that same year, Abba Ahimeir (1897–1962), journalist, political activist of the radical sector of the

Revisionist Zionists, and founder of Brit Habirionim (the Union of Zionist Rebels) in Palestine, resided with his family in Warsaw. During this stay, he participated in numerous political rallies in different parts of Poland, as can be seen from the announcement reproduced in figure 11.1 about the meeting between Ahimeir and the supporters of the Zionist Revisionist Party and the members of the youth movement Betar, which was held in the Apollo movie theater in Baranowicze (now Baranavichy in Belarus).

Likewise, in the summer of 1938, in order to give the Jewish public an opportunity to hear "a true report" about the events in Palestine, the Po'ale Tsiyon Semol (Left Poale Tsiyon Party) organized a series of meeting with Israel (Marom) Marminski (1891–1956) in movie theaters.[25]

The halls of different movie theaters all around Poland not only hosted Zionist activists from Palestine. Local Jewish leaders and activists met the Jewish public in various halls of movie theaters in different parts of the country. In October 1931, Yitshak Grünbaum (1879–1970), a representative of the General Zionist party and deputy to the Sejm, attended a rally that was held in the Corso movie theater in Radom (see figure 11.2). Grünbaum attended many other rallies that were held in movie theaters across Poland.[26] So did the leader of the Left Poale Tsiyon Party, Ya'akov (Vitkin) Zerubavel (1886–1967), who in one of many encounters that took place at the Adria movie theater in Lublin lectured on "Palestine, Birobidzhan and the Jewish problem."[27] In addition to rallies with assorted leaders, various Zionist district conferences took place in movie theaters, such as in the Apollo, Casino, and Eden, all around Poland. The conference of the Zionist sector of western Galicia was held in a movie theater in Kraków in September 1934, and the local conference of the Revisionist Zionists was held in the Miraż movie theater in Radom in 1933, and its reception took place in the Karasa movie theater.[28]

Even Mizrahi, the Zionist religious movement, held meetings at the Fama movie theater in Warsaw. The participation of rabbis and other Mizrahi leaders at gatherings that took place in movie theaters could be seen as peculiar because, in all probability, these speakers had never watched a film. They were fully aware of the fact that watching films, even if it was not done on Friday evenings, Saturdays, or Jewish holidays—when it could be done—challenged the boundaries of traditional society. We do know that there were several occasions in which rabbinical authorities tried to distance the Jewish public from movie theaters.[29] As Gershon Bacon has shown, the fact that religious parties turned to the secular movie hall to disseminate their political program illustrates that the supposed divide between "religion" and popular culture is more complicated; even the leadership of Agudath Israel was willing to deploy modern "secular" tactics to spread its ideological antimodern program.[30]

The Zionist movement was not the only ideological movement in Poland that made use of movie theaters to showcase its activities. In addition to the screening of films at subsidized prices on Saturday mornings, the Bund—the socialist, diaspora-oriented political and ideological rival of the Zionists—also organized political gatherings and rallies with leaders and other political activists in movie

Figure 11.1. Poster advertising a speech by Abba Ahimeir in Baranowicze. Reproduced by permission of the Jabotinsky Institute Archive. Poster collection, PS-695.

Figure 11.2. Poster announcing a rally with Yitshak Grünbaum in Radom, 1931. Reproduced by permission of the Central Zionist Archives, Jerusalem. Poster KRU/1406 1931.

theaters.[31] This was the case, for example, in Lublin's Palace movie theater in 1934, when the general secretary of the Bund, Emanuel Nowogrodzki (1891–1967), gave the lecture "Where Is the Way Out?" on a Saturday afternoon. In 1933, in another movie theater in Lublin, Karasa, the leading activist of the Bund and editor of the Yiddish daily *Folkstsaytung*, Henryk Ehrlich (1882–1942), also gave a lecture.[32]

The different examples presented here demonstrate how movie theaters turned into central components of the Jewish public sphere. These halls were not just places that were engaged with popular culture (films) but public spaces open to the masses. In the process, they also became political public spaces as the "Jew on the street" became more politically engaged.[33] Yitshak Grünbaum recalls that the democratization of Jewish political life in interwar Poland brought with it a concomitant increase in vulgarity, noise, and shouting.[34] Occasionally, the intensification of Jewish political life turned violent.[35] To the Jewish common people who came to movie theaters to watch films, it did not seem odd that they met politicians and activists in these halls. They did not think that this routine or their cultural choices needed to be justified.[36] Those whom Sokolow saw as the "democratic mob" did not see anything wrong with the fact that their representatives and leaders met them at movie theaters. It appears mainstream Zionist activists, like Sokolow, felt more discomfort with the movie theater as the appropriate arena for presenting ideology and political agenda than Bundist leaders and activists.

As an ideological movement that took upon itself the task of representing the Jewish working class, holding different kinds of events (political and cultural) aligned with Bundist ideology and strengthened its credibility and reliability. In addition to screening films at subsidized prices, the Kultur-Lige (Yid. Culture League) and the Bund organized other cultural and intellectual activities at movie theaters in various towns. Some of the events were not necessarily engaged with "low" popular culture, such as the commemoration of the fourteenth *yortsayt* of the renowned and beloved Yiddish writer Yitskhok Leibush Peretz (1852–1915) organized by the Kultur-Lige and held in the Miraż movie theater in Biała Podlaska in 1929 (found in figure 11.3). A similar event was held a year later at the Splendor movie theater in Łódź in April 1930, showcasing Peretz's literary works.[37]

However, there were several occasions in which the attempt to hold high-culture events in movie theaters was not always successful. In Gołowka, a "literary trial" of the literary works of Sholem Asch (1880–1957) was held at the Karasa movie theater in July 1934. The subsequent report in the local Yiddish newspaper informed readers that the Jewish public did not show great interest in this event and suggested that perhaps it would be better if future public programs dealt with current events.[38] Handling discussions about literary texts of well-known authors in the format of a trial was typical of the interwar Jewish youth movements.[39] The failure of the Asch event may have been due to the fact that the format, which worked in intimate settings, was not suited to the big gatherings held in movie theater halls. It could be, however, that Asch, who did not share Peretz's iconic

Figure 11.3. Announcement of the commemoration ceremony marking the 14th anniversary of the death of Y. L. Peretz in Biała-Podlaska. Reproduced by permission of the YIVO Archive. RG 28/p/394.

status, would not draw a crowd no matter the venue. So, too, Asch's play, *Der got fun nekome* (*God of Vengeance*), was considered too provocative and problematic for the average Jewish audience.[40]

Other Jewish organizations also chose to place their official events in movie theaters.[41] This was the case in the summer of 1927, when a concert in honor of the thirtieth anniversary of the *Haynt* newspaper took place in the local movie theater in Otwock.[42] Otwock, located fourteen miles from Warsaw, was a popular resort spot for Warsaw Jewry from the end of the nineteenth century until 1939. *Haynt*'s leadership doubtless decided to set the summer event in a pastoral setting as a way of disconnecting *Haynt* from Warsaw to stake its claim as Polish Jewry's national newspaper. Various activities of the local TOZ (Pol. *Towarzystwo Ochrony Zdrowia Ludności Żydowskiej*; the Society for Safeguarding the Health of the Jewish Population) branches were also held in movie theaters in Otwock and in Tomaszów Mazowiecki.[43]

No matter whether Jewish political parties and ideological movements criticized the popular nature of films—which others in Poland celebrated as the "tenth muse"—most Jewish parties and ideological organizations were involved and sponsored cultural events in movie theaters.[44] The Bund screened films on Saturday mornings at subsidized prices through the Kultur-Lige in Poland.[45] Several Zionist youth movements from varying sectors of the Zionist movement showed documentary and even propaganda films as part of their activities.[46] This can be seen in the flyer that announced the screening of the film *Vladimir Jabotinsky: Let the Jews Enter Palestine* in Łódź, probably in 1934, at the Roxy movie theater (see figure 11.4). Jewish political parties and ideological movements were no different from contemporaneous political actors in Europe who were aware that in the era of mass politics, films could make a vital contribution to propaganda and political organizing.[47]

There were quite a few occasions in which the arena of the movie theater turned into violent arenas of political conflict when being used by Jews.[48] More than a few times, Jewish political meetings in movie theaters were interrupted halfway because of contentious ideological arguments. In the 1930s, several Zionist envoys from Palestine reported that members of Betar, the youth movement of the right-wing Zionist Revisionist party, sabotaged many of the assemblies that took place in local movie theaters. *Der moment* published a report in 1930 about the involvement of the local police in breaking up—no doubt adding to the unrest—a disputatious Zionist gathering in a movie theater.[49] At the same time, movie theaters could be neutral "Polish" public spheres where Jews and non-Jews were able to leave political and social conflicts outside during a film screening.[50] When films were screened in movie theater halls, these places became spaces in which Poles, Jews, and other national minorities, such as Ukrainians, gathered together several times a week to be entertained. The love of cinema and the desire to watch films enticed the audiences to leave political and national confrontations outside the doors of

Figure 11.4. Poster announcing the screening of the film *Vladimir Jabotinsky: Let the Jews Enter Palestine* at the Roxy movie theater, Łódź, June 30, 1934. Reproduced by permission of the Jabotinsky Institute Archive. PS-113.

these halls, creating spaces of multinational cooperation. For several hours a week, national conflicts and civil political disputes were put on hold.[51]

Movie theaters marked an innovation in the idea of the new, modern secular Jewish public sphere. They were considered by many Jewish political organizations, such as the Bund and the Left Poale Tsiyon Party, to be spaces without any ideological, political, or religious affiliations. This was in marked contrast to the synagogue buildings that had been used for public meetings in earlier eras and could not be considered neutral spaces. In the second half of the nineteenth century, after the failure of the Polish rebellion of 1863, the Russian authorities only allowed Polish Christians and Jews to build public buildings for religious uses, a practice that continued into the early twentieth century.[52] In the large cities in Congress Poland, church and synagogue buildings were also used for nonreligious purposes and hosted public meetings, lectures, and other secular events. During the formative years of the Zionist movement in the Russian Empire, most, if not all, of its public meetings were held in synagogues.[53] The synagogue as a site of Jewish public space began to be displaced in European cities outside Congress Poland already at the end of the nineteenth century, while in Congress Poland and in the Russian Empire, this change only occurred after 1905.[54]

The entry of movie theaters into Jewish life returned the synagogues to their original sacred purpose and created a solid dichotomy between the secular and the holy in the Jewish public sphere. The secular nature of the events held in movie theaters was "performed" publicly, as some of them were held on Saturday morning.[55] Scheduling events on Saturday morning was not necessarily a provocation. It allowed Jewish workers who did not work on Saturday to participate. Nevertheless, scheduling a secular, public Jewish event on a Saturday morning clearly marked a break with the practice of traditional synagogue attendance. Memorial events that in previous years were held in synagogues were held in movie theaters in the interwar period. These Yizkor events were dedicated to political leaders such as Theodor Herzl as well as to cultural figures like Y. L. Peretz and Yossele Rosenblatt (1882–1933), the famous *chazzan* (cantor).[56]

The almost universal devotion of the Jewish community, regardless of its political or religious orientation, to Józef Piłsudski (1867–1935), the legendary Polish military hero and minister of military affairs until his death, encouraged the local Jewish community in Kraków to hold the one-year commemoration event of his passing in the Adria movie theater on Starowiślna Street in 1936.[57]

Commercial movie theaters in small peripheral cities functioned as public spaces for Jewish political rallies, public assemblies, and cultural events in the 1920s and 1930s, which diminished the cultural and ideological divide between Jewish communities in big cities and those in the periphery. If in the second half of the nineteenth century, trains and railroads were the innovations that narrowed the geographical and ideological gap in both Christian and Jewish Polish society, in interwar Poland, the attendance of Jewish viewers in movie theaters in the *shtetlakh* and the periphery created a similar effect.[58] Local residents in market towns were able to watch the same films that screened in Warsaw and other European cities,

allowing Jewish cinema viewers, often the majority of the audience, to feel closer to other cinema viewers—both Jewish and non-Jewish—in different parts of Poland as well as outside the Second Polish Republic.[59] Film watching created a transregional public culture for Polish Jewry and offered the possibility of removing political, religious, cultural, and social barriers.[60] Even if many of the shtetl dwellers rarely left their hometowns, the meetings with the different envoys from Palestine and other leaders opened up the world to Jews in the periphery. The political leaders who met them in the movie theaters counted on their support in the same way they counted on the support of those in the big cities. Likewise, film could transport Jews who lived outside of Poland's major cities beyond their provincial context.[61] Sitting together with other citizens to screen a film or attending a political rally held in a movie theater made those present feel they were part of a much wider community.

A challenge remains, however, in uncovering in full detail the activities of the moviegoing public in small towns in the interwar period. *Yizker bikher* (Yid. memorial books) written after World War II by Holocaust survivors who wanted to preserve the lost lives of their Jewish communities make almost no mention of watching films or attending movie theaters. The sections of these books dedicated to cultural life and leisure provide detailed descriptions of performances by various Jewish theater groups, the activities of local amateur drama groups, lectures that were given in Jewish libraries, and the activities of assorted Jewish choirs. Information on movie theaters or other public halls in which movies were screened, the frequency with which Jews used to watch movies, whether Jews watched films on the Sabbath, and what types of movies were favorites of Jewish viewers is mostly mentioned only in passing, usually in anecdotal form. Many *yizker bikher* do not contain this kind of information at all. Since these books present Jewish life before World War II through the prism of the Holocaust, many of the contributors were moved to commemorate Jewish life before the war in an idealistic manner.[62] While *yizker bikher* provide us with diverse information about social and educational institutions, political parties, and sports clubs in the *shtetlakh* on the periphery, they are relatively silent on the new, popular art of film.

Despite the evidentiary challenges, the newspaper reports, memoirs, and advertisements in the interwar Polish press in Polish, Yiddish, and Hebrew support my claim that movie theaters became important neutral Jewish public spaces. Hosting public meetings, political rallies, commemorative events, literary evenings, and film screenings, commercial movie theaters played a central role in creating a rich and vital Jewish public life in Warsaw and beyond.

Notes

1. See, among others, the announcements of the public meeting in Lwów in *Dos fraye vort*, October 20, 1933. See also the announcement of the public meeting in Łódź in *Haynt*, November 26, 1933.

2. On the visit of Ben-Gurion in 1933 and the public meetings he held in different places, see Tom Segev, *Medinah behol mehir* (Jerusalem: Keter, 2018), 224–230.

3. See the report of Ben-Gurion in David Ben-Gurion, *Zikhronot* (Tel Aviv: Am Oved, 1972), 2:176.

4. "Akhtung khaverim fun di rayze," *Dos fraye vort*, May 12, 1933.

5. In 1929, during the elections to the sixteenth Zionist Congress, the Revisionist Party gained 7,107 votes in Poland. In the elections to the seventeenth Zionist Congress in 1931, the Revisionist Party already gained 29,985 votes in Poland. See Joseph Schechtman, *Ze'ev Jabotinsky* (Tel Aviv: Karni, 1959), 2:192. For more on Revisionism and the Zionist movement, see Daniel Kupfert Heller, *Jabotinsky's Children: Polish Jews and the Rise of Right-Wing Zionism* (Princeton, N.J.: Princeton University Press, 2017). See also Daniel Kupfert Heller's chapter in this volume.

6. See the announcement of a public meeting with Jabotinsky at the cinema in *Haynt*, February 17, 1927. On the public meeting of Jabotinsky at a movie theater in Vilna, see "Dos yidish leben in Vilna," *Unzer ekspres*, March 29, 1933.

7. Ezra Mendelsohn, "Jewish Politics in Interwar Poland: An Overview," in *The Jews of Poland between Two World Wars*, ed. Yisrael Gutman et al. (Hanover, N.H.: University Press of New England; Waltham, Mass.: Brandeis University Press, 1989), 9–10.

8. Jacob Leshtshinsky, *Yidn in film industriye* (Vilna: YIVO, 1932).

9. David Desser, "The Cinematic Melting Pot: Ethnicity, Jews, and Psychoanalysis," in *Unspeakable Images: Ethnicity and the American Cinema*, ed. Lester D. Friedman (Urbana: University of Illinois Press, 1999), 380–381.

10. See Eric A. Goldman, *Visions, Images, and Dreams: Yiddish Film, Past and Present*, rev. ed. (Teaneck, N.J.: Holmes & Meier, 2011); and J. Hoberman, *Bridge of Light: Yiddish Film between Two Worlds*, rev. ed. (Hanover, N.H.: Dartmouth College in association with the National Center for Jewish Film, 2010).

11. Maks, "Fun shraybtish biz tsum ekran," *Film velt*, November 3, 1928; W. Y. Tenenbaum, "Etlikhe verter vegen der film industriye," *Film velt*, January 1, 1929.

12. Julia Brauch, Anna Lipphardt, and Alexandra Nocke, "Exploring Jewish Space: An Approach," in *Jewish Topographies: Visions of Space, Traditions of Place*, ed. Julia Brauch, Anna Lipphardt, and Alexandra Nocke (Burlington, Vt.: Ashgate, 2008), 1–2; Marsha Rozenblit, "Creating Jewish Space: German-Jewish Schools in Moravia," *Austrian History Yearbook* 44 (2013): 108–147.

13. Brauch, Lipphardt, and Nocke, "Exploring Jewish Space," 5; Cecile E. Kuznitz, "On the Jewish Street: Yiddish Culture and the Urban Landscape in Interwar Vilna," in *Yiddish Language and Culture: Then and Now*, ed. Leonard Jay Greenspoon (Omaha: Creighton University Press, 1998), 65–92.

14. Sandra Fox, "'Laboratories of Yiddishkayt': Postwar American Jewish Summer Camps and the Transformation of Yiddishism," *American Jewish History* 103, no. 3 (2019): 279–301. The term *Jewish space* has also been used to understand the shift that occurred in places that were vital to Jewish life before World War II but were characterized by "Jewish emptiness" after the war. Eszter B. Gantner and Jay (Koby) Oppenheim, "Jewish Space Reloaded: An Introduction," *Anthropological Journal of European Cultures* 23, no. 2 (2014): 1–10. See, too, Barbara E. Mann, *Space and Place in Jewish Studies* (New Brunswick, N.J.: Rutgers University Press, 2012).

15. This kind of attitude can be found, among others, in "Fun kina zu kina," *Haynt*, June 22, 1930; W. Y. Tenenbaum, "Film retsentsiyes," *Film velt*, January 1, 1929; Maks, "Fun shraybtish biz tsum ekran"; and A. Kinoman, "Fun ekran," *Haynt*, April 14, 1929.

16. Nahum Sokolow, "Masa leFoloniyah bishenat (1934)," in Gezel Kressel, *Hatsofeh levet Yisra'el* (Jerusalem: Sifriyah tsiyonit, 1961), 307.

17. Sokolow, 251. On the involvement of crowds in political life and the development of mass politics, see Alice Widner, ed., *Gustave Le Bon, the Man and His Works* (Indianapolis: Liberty Press, 1979); and William Kornhauser, *The Politics of Mass Society* (New York: Routledge, 2018).

18. Sokolow, "Masa leFoloniyah," 251.

19. Sokolow, 251.

20. Sokolow, 240–244.

21. M. Bernholz, "Kol-bo: Sikot im hakori'im," *Hatsefirah*, February 16, 1927.

22. Shelomo Even-Shoshan, Ḥayim Dan, and Yeshayahu Stavi, eds., *Zikhronot hakhsharot goshi hakhsharah mesaprim* (Kibuts Loḥamei Hageta'ot: Ghetto Fighters' House, 1983), 126, 143, 291.

23. On the negative attitude toward cinema in Palestine in the period of the British Mandate and the early years of the State of Israel, see Oz Almog, *Hatsabar dyokan* (Tel Aviv: Am Oved, 1997), 329; and Anat Helman, "Zerikhat kolno'a bayeshuv bemedinat Yisrael beshnotah harishonot," in *Kolno'a vezikaron: Yaḥasim mesukanim?*, ed. Ḥayim Bereshit, Shelomo Zand, and Moshe Zimmerman (Jerusalem: Mercaz Zalman Shazar, 2004), 77–82.

24. On the gathering in Rovno, see Zerubavel Ḥaviv, *Tsir Shalo'aḥ: Me'erets Yisra'el leFolin besheliḥot KKL, 1937* (Tel Aviv: Hamakhon leḥeker toldot keren kayemet liYisra'el, 2002.), 102–103.

25. Marminski was a political activist who, among other roles, was the treasurer of the Histadrut in Palestine. For details on this rally, see "Der emes fun erets yisroyel," *In kamf*, August 28, 1938. The reference in the article's headline about Marminski's lecture is to the famous article by Ahad Ha'am (Asher Zvi Ginsberg), "Truth from the Land of Israel," *Hamelits*, June 18/30, 1891.

26. See the announcement of a public meeting with Grünbaum in *Haynt*, January 7, 1926; a rally with Grünbaum in the Karasa theater in Lublin in *Lubliner togblat*, January 24, 1933; and another rally with him in the movie theater in Lwów in "Yitskhok Grünbaum in Lemberg," *Dos fraye vort*, September 8, 1934. See too an announcement about a meeting and discussion with Yehoshua Gottlieb and Josef Haftma in movie theaters in *Haynt*, September 19, 1928.

27. "Zerubavel in Lublin," *Lubliner togblat*, July 20, 1934.

28. *Dos fraye vort*, September 14, 1934; "Di Tsiyonistish ravizionistish krayz konforents in Radom," *Radomer-kieltser lebn*, February 24, 1933.

29. Natan Gross, *Toldot hakolno'a: Hayehudi beFolin* (Jerusalem: Magnes, 1990), 23.

30. Gershon Bacon, *The Politics of Tradition: Agudat Yisrael in Poland, 1916–1939* (Jerusalem: Magnes, 1996). See too Naomi Seidman's chapter in this volume.

31. See, for example, the Bund's poster that announced a rally at the hall of the Flora movie theater; the slogan of the event was "Po'ale Tsiyon and the Reds against the Bund." The poster, which announced a political meeting in a movie theater, was printed in *Unzer lodzher veker* (March 10, 1933) and published in Barbara Łetocha, Zofia Głowicka, and Izabella Jabłońska, *Żydowska Łódź na afiszach wydanych w II Rzeczypospolitej, Dokumenty ze zbiorów Biblioteki Narodowej* (Warsaw: Biblioteka Narodowa, 2011).

32. On Ehrlich, see Daniel Blatman, "Erlich, Henryk," in *The YIVO Encyclopedia of Jews in Eastern Europe*, ed. Gershon D. Hundert (New Haven, Conn.: Yale University Press, 2008), 1:477–478.

33. Yitsḥak Grünbaum, *Milḥamot yehude Polaniyah* (Jerusalem: Tel Aviv Ḥaverim, 1951), 464–466.

34. Grünbaum, 464–466.

35. There were many reports on confrontations between supporters of the left and right Zionist parties in the Jewish press in the 1930s. See, among others, the report in M. G.

[Moshe Glickson], "Al haperek," *Ha'arets*, May 4, 1933, about a "bomb" made from sand and bricks that was thrown in a political meeting in a theater in Warsaw while Ben-Gurion spoke. Another article from *Czas* (June 18, 1933), published in Vilna, reported an attempt by supporters of the Revisionist Party to attack Ben-Gurion during his visit to the city.

36. On the popularity that films gained among broad Jewish social classes, see Avraham Levite, *Sefer zikaron kehilat Brzozów* (Tel Aviv: Yotsei Brzozow vehasevivah, 1984), 12, 25; and "Shtimen fun unzere lerer," *Kin ta rad*, December 24, 1926.

37. "Announcement," *Unzer lodzher veker*, April 11, 1930.

38. "Der Oryaile fun Literarish Mishpet," *Gluboker lebn*, July 13, 1934.

39. See, for example, "Homer lekinosi hahoref shel madrikhim Histadrut Hehaluts-hatsa'ir," November 1934, Ghetto Fighters' House Archive, Mador rishom merkazi (Holdings Registry) 24386, 19.

40. Matthew Hoffman, *From Rebel to Rabbi: Reclaiming Jesus and the Making of Modern Jewish Culture* (Stanford, Calif.: Stanford University Press, 2007).

41. See, for example, the announcement on the thirtieth jubilee of the Jewish Philanthropy Society for supporting the poor in the kino: "Palas," *Haynt*, January 25, 1929.

42. *Haynt*, August 2, 1927. On *Haynt*, see Joanna Nalewajko-Kulikov, "'Hajnt' (1908–1939)," in *Studia z dziejów trójjęzycznej prasy żydowskiej na ziemiach polskich (XIX–XX w.)*, ed. Joanna Nalewajko-Kulikov, Grzegorz P. Bąbiak, and Agnieszka J. Cieślikowa (Warsaw: Wydawnictwo Neriton, 2012), 61–77; and Joanna Nalewajko-Kulikov, "*Di Haynt*—Mishpokhe Study of a Group Picture," in *Warsaw: The Jewish Metropolis; Essays in Honor of the 75th Birthday of Professor Antony Polonsky*, ed. Glenn Dynner and François Guesnet (Leiden: Brill, 2015), 252–270.

43. On the activity of the local branch of TOZ and its Jewish women's organization in Tomaszów Mazowiecki, see the announcement in *Tomashover vort*, October 16, 1936. On TOZ events in Otwock, see *Der moment*, March 14, 1930.

44. In Poland, the use of the term *tenth muse* to stress the connections between cinema and art first appeared in Karol Irzykowski, *X Muza: Zagadnienia estetyczne kina* (Kraków: Krakowska Spółka Wydawnicza, 1924). The term *tenth muse* to describe the art of films appeared in Jewish periodicals already in the 1920s. See, among others, Maks, "Fun shraybtish biz tsum ekran."

45. Jacob Shalom Herz, *Geshikhte fun bund*, vol. 4 (New York: Unzer Tsayt, 1972), 195. For information on film screenings organized by Kultur-Lige in Łódź, see, among others, *Lodzher veker*, April 11, 1930; and *Lodzher veker*, December 29, 1933. More about the Kultur-Lige in interwar Poland can be found in Hillel Kazovsky, "Kultur-Lige," in Hundert, *YIVO Encyclopedia of Jews*, 1:953–956.

46. Meir Finklestein, Shelomo Tsemach, and Mordechai Halamish, eds., *Sefer Plonsk vehasevivah: Yad vezekher lekehilot sheneharevu* (Tel Aviv: Irgun yotse Plonsk biYisra'el, 1963), 207–208; "Report on counsels' seminar in Falenica," in *Hehaluts-hatsa'ir*, March 1939, 14.

47. On the use of films for propaganda in the USSR and Germany in the Nazi era, see Mira Leham and Antonin J. Leham, *The Most Important Art: Soviet and Eastern European Film after 1945* (Berkeley: University of California Press, 1977), 7–45; Hilmar Hoffmann, *The Triumph of Propaganda: Film and National Socialism 1933–1945* (Providence: Berghahan, 1996); and David Welch, *The Third Reich: Politics and Propaganda* (London: Routledge, 1993).

48. On the influence of violence on Jewish political life in interwar Poland, see Kamil Kijek, "Violence as Political Experience among Jewish Youth in Interwar Poland," in *From Europe's East to the Middle East: Israel's Russian and Polish Lineages*, ed. Kenneth B. Moss, Benjamin Nathans, and Tavo Tsurumi (Philadelphia: University of Pennsylvania Press, 2022), 243–270.

49. "Der farsharftekh vol kamf in Lemberg," *Der moment*, November 2, 1930.

50. This fragile, neutral social atmosphere was like the interethnic/interfaith cooperative environment of the Polish film industry, which allowed a measure of Christian and Jewish Polish collaboration despite the hostility Jews experienced in the interwar years and their exclusion from various public educational and political arenas. See Marcos Silber, "Narrowing the Borderland's 'Third Space': Yiddish Cinema in Poland in the Late 1930s," *Jahrbuch des Simon-Dubnow-Instituts* 7 (2008): 229–255.

51. See Ela Bauer, "The Jews and the Silver Screen: Poland at the End of the 1920s," *Journal of Modern Jewish Studies* 16 (2017): 80–99.

52. Meir Ya'akov Fried, *Yamim veshanim* (Tel Aviv: Dvir, 1938), 1:255.

53. Ehud Luz, *Makbilim nifgashim* (Tel Aviv: Am Oved, 1985), 147–154; David Biale, "A Journey between Worlds: East European Jewish Culture from the Partitions of Poland to the Holocaust," in *Cultures of the Jews: A New History*, ed. David Biale (New York: Schocken, 2002), 821.

54. Gideon Reuveni and Nils Roemer, *Longing, Belonging and the Making of Jewish Consumer Culture* (Leiden: Brill, 2010), 11.

55. See the report on a gathering in "Sabat Akademya," *Gluboker lebn*, February 21, 1936. Reports of different cultural gatherings in Łódź can be found in *Unzer lodzher veker* (April 25, 1930, March 10, 1933, 29 December 1933).

56. On Yossele Rosenblatt, see Jeffrey Shandler, "Marketing Cantors in the Early 20th Century: The Case of Yossele Rosenblatt," in *Chosen Capital: The Jewish Encounter with American Capitalism*, ed. Rebecca Kobrin (New Brunswick, N.J.: Rutgers University Press, 2012), 255–271.

57. A placard from the collection of placards and posters, published in *Dzieje Krakowskich Żydów na przestrzeni wieków, materiały z zasobów Archiwum Narodowego w Krakowie*, ed. Alicja Maślak-Maciejewska et al. (Kraków: Jagiellonian University Press, 2018), 94.

58. On the contribution of trains and railways to the secularization of eastern European Jewish society, see Biale, "Journey between Worlds," 112–117; and Israel Bartal, "Harakevet magiyah l'ayra," in *Zeman yehudi ḥadash*, ed. Yirmiyahu Yovel and David Shaham (Jerusalem: Keter, 2007), 1:287–290.

59. Jean Claude Carriere, *Sefat hasimanim shel hakolno'a* (Tel Aviv: Am Oved, 1996), 7.

60. Maks, "Fun shraybtish biz tsum ekran"; Osif Dimov, "A bagegenish mit der film heldin Liliyen Gish," *Film velt*, November 1928.

61. Zerubavel Gilad to Mazkirut Hakibuts Hame'uḥad, March 23, 1938, Ghetto Fighters' House Archive, Kibuts Loḥamei Hageta'ot, Mador rishom merkazi (Holdings Registry) 24411.

62. See Jonathan Boyarin and Jack Kugelmass, eds., *From a Ruined Garden: The Memorial Books of Polish Jewry*, rev. and expanded ed. (Bloomington: Indiana University Press, 1998); Samuel Kassow, "Community and Identity in the Interwar Shtetl," in Gutman et al., *Jews of Poland*, 198–220; and Natalia Aleksiun, "Gender and Nostalgia: Images of Women in Early Yizker Bikher," *Jewish Culture and History* 5, no. 1 (Summer 2002): 69–90.

CHAPTER 12

The Politics of Jewish Youth Movement Culture in Interwar Poland's Eastern Borderlands

Daniel Kupfert Heller

Between the two world wars, Poland was home to a vibrant, dynamic, and turbulent Jewish political life that played a particularly important role in the life of Jewish youth. The unprecedented opportunities for political activity provided to Jews in the new Polish state, coupled with the persistent discrimination they faced, inspired them to create numerous political parties to speak on their behalf. Interwar Poland's Jewish political activists poured their efforts into mobilizing young Jews living in both cities and market towns through a variety of Jewish youth movements that vied for the support of locals as young as ten and as old as twenty-two. Whether Orthodox or secular, socialist or Zionist, or everything in between, political activists created elaborate cultural rituals for their youth movements to attract support for their political programs. The very cultural activities promoted by the youth movements—from marching in unison, hiking in nearby forests, or singing in public squares or around bonfires—aimed to be emotionally immersive experiences that would set the political allegiances of young people for the rest of their lives.

To capture this dynamic world, historians often rely on newspapers and political periodicals produced in the cities of Warsaw, Kraków, Lwów, and Wilno.[1] While these sources amply document the cauldron of ideologies promoted by Jewish political leaders in urban centers, they often marginalize, or ignore altogether, the ways in which Jewish political culture was experienced and practiced in hundreds of market towns across Poland, where nearly 40 percent of the country's Jewish population resided. Building on the work of recent scholars who have set out to explore the social history of Polish Jewish politics, this essay calls into question the assumption that the political attitudes and behaviors of Jews in interwar Poland's provincial towns merely echoed the ideological proclamations and political

decisions of urban Jewish political leaders.[2] It does so by investigating the complex relationship between the urban architects of "official" youth movement culture and the Jewish youth in Poland's market towns whom they tried to instruct how to think and act politically.

The essay examines two of the largest Zionist youth movements in interwar Poland, each with roughly thirty thousand members in the early 1930s: the Labor Zionist youth movement Hashomer hatsa'ir (Heb. The young guard; it was known at the time for its antireligious, revolutionary Marxist program) and the Revisionist Zionist youth movement Betar (known for its vehement opposition to socialism, veneration of militarism, and leadership cult for the right-wing Zionist activist Vladimir Jabotinsky). Given that the members of these two political movements viewed one another as sworn enemies, it is unsurprising that historians tend to focus on their differences.[3] A comparative approach, however, yields fascinating insights into the common struggles faced by the political leaders of these youth movements to implement their cultural programs in Poland's "periphery."

The essay sets its focus on the 1930s, when both youth movements launched major recruitment initiatives in the market towns of Poland's eastern borderlands, a region that lay along the Polish-Soviet border. Special attention is paid to Jewish communities in Wołyń and Polesie. Although Jews composed only 10 percent of these provinces' inhabitants, they often made up the majority of residents in their cities and the dozens of market towns that dotted their landscape. Although no two communities were alike, Jewish market towns, known in Yiddish as *shtetlakh* (sing. shtetl), shared several common characteristics. Jews made up 50 percent or more of these towns' inhabitants and were more likely than their urban counterparts to use Yiddish as their daily vernacular. The centers of life were the towns' bustling marketplaces, where Jews would sell their wares to peasants from nearby villages. Traditional Jewish religious institutions—from synagogues and prayerhouses to centers of religious learning, such as the *kheyder* for young children and the *beys-medresh* for more advanced study for men—played a large role in determining the public life and communal norms of the towns. As we shall see, these dynamics, coupled with the geopolitical conditions of the region, had an impact on the development of Jewish youth movement culture in the region.

In order to reconstruct this unique culture, this essay draws upon instruction guidelines by urban leaders regarding their followers' activities in provincial towns, correspondence between Jewish youth in the market towns of Wołyń and Polesie and their youth movements' urban leaders, and memorial books (Yid. *yizker bikher*) written by former Jewish residents of these towns. It also draws upon the treasure trove of autobiographies written by Polish Jewish youth that were collected by the YIVO Institute for Jewish Research in the 1930s. These sources reveal how Jewish observers of the period noted significant differences between the political culture of Jewish youth movements in the region's market towns and that of Jewish youth movements in cities. These differences included the role of communal religious norms in shaping the youth movements' political rituals, the function of youth movements' cultural activities within the broader context of the region's

cultural life, the impact of youth movement culture on gender relations, and the influence of relations with Polish government officials on the cultural activities of Jewish youth movements.

Between "Center" and Periphery: Networks of Cultural Transmission

Based in Warsaw, the national leadership of Hashomer hatsa'ir and Betar had good reason to pour their efforts into mobilizing young Jews living in provincial towns across Poland's eastern borderlands. By the early 1930s, they realized that the number of their followers in the region was growing at a rate that far outpaced the growth of their movements in central Poland and western Galicia.[4] By 1932, Betar leaders listed Wołyń as the region with the greatest number of Betar members and described it as the "fortress of the Revisionist movement."[5]

That same year, Hashomer hatsa'ir's leaders in Warsaw decided to launch an "intensification" campaign in Poland's eastern borderlands. Reeling from a bitter ideological split over the movement's attitudes toward communism, as well as the emigration of many of its leaders to Mandatory Palestine, they enthused that their increased activity in the region could double their membership and help them gain as many as fifty thousand new supporters.[6]

The vast distance between Warsaw and the eastern borderlands made recruiting young Jews in the region no easy task. Nonetheless, Hashomer hatsa'ir's and Betar's leaders in Warsaw could count on the ever-expanding networks between eastern Poland's villages, towns, and cities and the rest of the country to facilitate the growth of their youth movements. Each provincial town was already part of a regional economic network that included larger towns and small cities within their vicinity. Jewish youth from small towns in search of education and work frequently arrived in the region's larger towns or small cities, such as Równe, Łuck, or Kowel in the province of Wołyń or Brześć Litewski and Pińsk in the province of Polesie. There, they encountered a more robust youth movement culture.[7] Both Hashomer hatsa'ir and Betar established regional hubs in these locations and sent trusted emissaries of their movements to implement the cultural directives of their superiors in Warsaw. During winter or summer school breaks, Betar and Hashomer hatsa'ir leaders could expect some of the young students involved in their movements' regional hubs to return home and establish youth movement outposts in their hometowns. Students were far more likely to gain exposure to Zionist youth movement culture if they were enrolled in a Zionist and Hebraist Tarbut school, which counted over 150 branches and were especially popular in the eastern borderlands. Seen as leading cultural activists in the towns where they were posted by the school network's leadership in Warsaw, some Tarbut school teachers helped organize Zionist youth movements among their students.[8] In addition, urban political activists relied upon Poland's slowly expanding postal network to circulate information about their youth movements. Young Jews in market towns eager to establish a local chapter of a national movement could write to its regional or

national leadership to obtain instructional material.[9] In turn, leaders in the youth movements' headquarters in Warsaw set about publishing a flurry of newspapers, journals, educational bulletins, and circulars for their branches in Poland's east.

Religion and the Rituals of Recruitment

When leaders of Hashomer hatsa'ir and Betar discussed how to promote their youth movements' culture in the eastern borderlands, they took pains to emphasize that small-town life in the "periphery" demanded a unique approach to cultural activity. Like other Zionist leaders, the Warsaw-based activists of Betar and Hashomer hatsa'ir understood that in order to "capture" shtetl Jews in Poland's eastern borderlands, they had to reckon with the dynamics of Jewish religious life in each town, from its rabbinical authorities to its local customs. Doing so was no simple task: from their inception at the end of the nineteenth century, modern Jewish political movements in eastern Europe had an uneasy relationship with traditional Judaism and rabbinic authority. Although support for Zionism among traditional rabbinic leaders had increased over time, many rabbis in Poland continued to insist that Zionism rejected God's will to keep Jews in exile until the era of messianic redemption and viewed the Zionist movement's cultural activity as a secularizing influence on their followers. Towns with a large presence of Hasidim or a strong and vibrant yeshiva, or both, could be especially hostile to the secular cultural activities they associated with Zionism and other modern political movements.[10]

As they prepared their campaigns to strengthen their movements in the eastern borderlands, Betar's and Hashomer hatsa'ir's leaders acknowledged that they would have to pay close attention to the religious dynamics of the region's small towns. They not only recognized that Jewish public life in provincial towns was regulated by the tempo of the Jewish ritual calendar far more than life was in cities; they also understood that their own behavior would, by sheer dint of a town's size, be under increased surveillance and scrutiny. They were entering towns that were, in the words of historian Samuel Kassow, "face-to-face communities," where it was possible to know nearly everyone by name.[11] The social and geographic intimacy of shtetl life meant that going unnoticed was rarely an option.

Zionist activists who set their sights on Poland's eastern borderlands not only wrote to one another about strategies to avoid the wrath of local religious authorities.[12] They also discussed strategies to co-opt local rabbis to help promote their political goals. These activists were far from alone in viewing religion as a potentially powerful recruitment tool. Despite their critiques of traditional Judaism, Zionist leaders, particularly in eastern Europe, had for decades poured their efforts into reinterpreting Jewish religious traditions as blueprints and justifications for political action.[13] They viewed local synagogues as arenas where they could convince ordinary Jews that durable connections existed between traditional Judaism and their political goals. Charged with setting up new Betar branches in Polesie's towns, an activist from Warsaw reported that the best place to begin his work was within a town's *beysmedresh*.[14] In many provincial towns, the *beysmedresh* was the

center of Torah learning and religious life in the community and was oftentimes adjacent to or integrated into the town's main synagogue. While some young men in the community spent their days in the *beysmedresh* studying, other men, of a variety of ages, learned on an ad hoc basis, coming and going as they pleased. Betar activists reasonably assumed that their presence there would bring them into close contact with the community's rabbinic authorities and other prominent communal leaders. Religious learning could also confer upon local youth movement leaders a degree of trust and status within the community. A leader of Betar from the vibrant market town of Luboml, located on the northwestern edge of the province of Wołyń, attributed the decision of his youth movement's leadership to appoint him as a leader to his reputation as a serious student in local Hasidic study houses.[15]

As members of a movement that celebrated socialism and promoted secularism, Hashomer hatsa'ir's local leaders were far less likely to gain the support of rabbinic authorities. Nonetheless, many local activists from the movement strove to obtain a public letter of approval (Heb. *haskama*) from their town's rabbis. These letters, certifying their youth movement's culture as religiously and politically "kosher," were often seen as a necessary criterion for their work. Hashomer hatsa'ir's leaders believed that these rabbinic imprimaturs of approval could simultaneously attract youth to their movement and fend off any suspicions of Jewish parents or local Polish government officials that the movement posed a danger to the status quo. The stacks of such letters, currently housed in the youth movement's archives, serve as important counterpoints to the movement's periodical literature produced in Warsaw, which frequently expressed a hostile attitude toward traditional Judaism.[16]

They also serve as important reminders of the ways in which local youth movements in the eastern provinces weighed their ideological goals against pragmatic recruitment considerations. In Wołyń, a former resident of the town of Młynów, situated on the banks of the Ikwa River, recounted how the local Hashomer hatsa'ir founder only managed to gain members once he made an alliance with religious youth clubs affiliated with the town's main synagogue.[17] Writing in 1939, a young autobiographer from the small town of Osowa Wyszka presented an even more extreme case of ideological adjustment. He recounted how his sister founded a local branch of Hashomer hatsa'ir. It was a far cry from the revolutionary utopia envisioned by the movement's activists in Warsaw. "The town's organization," he explained, "had an entirely different character than that of the general organization. . . . It was forbidden to enter the clubhouse without a head covering, and the boorish members of the organization believed that Hashomer was a religious organization. They couldn't fathom that it would be possible for a Jewish organization not to be religious."[18] Instead of discussing the fundamentals of class conflict and proletarian revolution, they debated how to rebuild the Holy Temple in Jerusalem as speedily as possible.

Elsewhere, youth movement leaders performed recruitment rituals that demonstrated that their cultural activities complemented local religious norms. Zionists had long drawn on Jewish religious holidays to reinforce their visions for building the future Jewish state. One popular way youth movements blended their politics

with their provincial town's religious life was by staging traditional memorial services in honor of Theodor Herzl and other well-known deceased Zionist leaders.[19] In Warkowicze, a town in Wołyń whose religious life was dominated by two Hasidic dynasties, several young men in the late 1920s sought to use such an event to recruit members to their fledgling Betar branch. They decided that the best way to gain popularity was to go to the *beysmedresh* and appropriate the town's Hasidic custom of using candles to spell the name of a deceased rabbi. Instead of naming a Hasidic leader, however, they used the candles to commemorate the death of Joseph Trumpeldor, the movement's secular Zionist hero who was killed in 1920 while defending a Jewish settlement in Mandatory Palestine. "The activity," one Betar member later recalled, "was a total success; those who prayed in the *beysmedresh* looked favourably upon these youth, who also [like other Hasidic Jews] had the desire to commemorate their 'rebbe' in this way."[20]

Although recruitment rituals in synagogues were largely, if not exclusively, the preserve of men, female members of youth movements engaged in other recruitment rituals that followed the rhythms of local religious life. During the Jewish holiday of Hanukkah, for example, Zionist youth movements in towns across Poland would stage theatrical events and parties designed to draw in new recruits and raise money for their movements. The springtime holiday of Lag Ba'Omer was considered an annual highlight for Zionist youth movements and an important opportunity to draw new members into their ranks. The religious holiday, in its original iteration, marked a break from a forty-nine-day period of mourning between the Jewish holidays of Passover and Shavuot. Traditional Jews marked the day by lighting bonfires, listening to music, and singing. Zionist activists retained the practice of lighting bonfires and singing but repurposed the holiday as a commemoration of the initial victory of the Bar Kochba revolt against the Romans in ancient Palestine (132–136 CE).[21] In numerous memoirs, former members of Hashomer hatsa'ir and Betar from the eastern borderlands recalled taking advantage of their towns' proximity to the region's dense forests during Lag Ba'Omer. Members of Zionist youth movements would celebrate the day by gathering in the center of their town. Dressed in the youth movement's uniforms and led by an orchestra, they would march in formation into the nearby forests, where they would spend the day hiking and singing Zionist songs. At dusk, they would return to their towns, light bonfires, and dance the *horah*.[22]

Although local Zionist youth movement activists in Poland's eastern borderlands invested time and effort into crafting public activities that corresponded to the religious norms of their market towns, they did not always acquiesce to the expectations of traditional community leaders. Some Zionist youth movement leaders took their followers on hikes during the Sabbath, when such activities were viewed as a desecration of the day.[23] By holding their main meetings on Saturday afternoons, youth movements took young Jews away from their families' homes or places of communal prayer. Even as they insisted upon their deep connection to Jewish tradition, the secularizing influence of local youth movement branches on the social norms of their town's public life was unmistakable.

Youth Movements as Cultural Portals

Although Zionist leaders fantasized about recruiting tens of thousands of Jewish youth in Poland's eastern borderlands, they also feared that the task of successfully indoctrinating their new followers would prove immensely difficult. The poems, novels, and treatises written by East European advocates of the Jewish Enlightenment (Haskalah) furnished the youth movement leaders with tales of allegedly futile struggles to transform Jews living in provincial towns. Jewish inhabitants of these towns were often depicted as stubborn and ignorant traditionalists who were to be lampooned, pitied, and ultimately rescued.[24] Drawing upon this extensive repertoire of literary images, Hashomer hatsa'ir's and Betar's leaders envisioned their cultural work as a quest to modernize Jews who would otherwise have languished in the "backwardness" of the region.[25] These assessments were not just the preserve of political activists born and raised in major urban centers. Several of Hashomer hatsa'ir's and Betar's leading figures in Warsaw were themselves from the eastern borderlands.[26]

Describing their work in the borderlands as a civilizing mission, Hashomer hatsa'ir's and Betar's activists sought to convince their recruits that their youth movement would not only provide them with a Zionist education but also fill a cultural vacuum in their lives. Although most Jewish children in 1930s Poland attended, at one point or another, a Polish public school, secondary education was rare. Youth movement members who may have longed to enroll in private Jewish high schools rarely had the financial resources to do so. Even if their town possessed a Polish state gymnasium, they often faced antisemitic officials determined to restrict the entry of Jews into their school.[27] Young Polish Jewish autobiographers from the eastern borderlands frequently described youth movements as vital educational institutions that offered its members an intellectual and cultural portal not only to Mandatory Palestine but to the wider world.[28]

Youth movement leaders in both Betar and Hashomer hatsa'ir insisted that their lesson plans were at the cutting edge of modern education and often cited German and American pedagogical experts as proof.[29] These curriculum plans often strayed beyond the realm of Zionist politics. In their first curriculum circular of 1930, for example, Hashomer hatsa'ir's leaders provided an extensive bibliography of German and Polish books on topics related to the psychological development of youth. Among the authors included in these lists were Sigmund Freud, Eduard Spranger, and Hans Blüher. A special section of the curriculum, designed to teach Hashomer hatsa'ir members how to learn independently, included such Polish-language titles as "What to Read and How to Read" and "How to Educate Oneself."[30] Two years later, the movement's leaders issued a special catalog of suggested reading. The guide instructed members of local branches to read Honoré de Balzac, Thomas Mann, Stefan Zweig, Bernard Shaw, and Luigi Pirandello.[31]

Betar's leaders, in the meantime, instructed the youth movement's members to hang a checklist on their clubhouse wall with the names of the group's members and the books they were expected to read. One such checklist consisted of *Don*

Quixote, David Copperfield, and a book of legends about India.[32] Both Hashomer hatsa'ir's and Betar's leaders encouraged their followers to collectively study a book and then invite the town's Jewish population to a "literary trial" of the book's author, characters, and themes. Immensely popular forms of entertainment in market towns, literary trials were conceived as theatrical performances that could display the intellectual and cultural sophistication of their followers.[33] To further convince the town's inhabitants to view their clubs as a destination for wide-ranging learning, youth movement activists in Warsaw urged the provincial branches to establish libraries filled with books in Hebrew, Yiddish, and Polish. The YIVO autobiographies and memorial books from towns in the eastern borderlands are replete with descriptions of youth movement libraries as vital cultural hubs for young Jews.[34]

When it came to Zionist education within the movements' ranks, youth movement activists in Warsaw crafted detailed curriculum guidelines. One of the most popular cultural activities within Zionist youth movement clubs were *siḥot*, the Hebrew term used by young Zionists to describe group discussions. Nervous that local youth movement leaders in provincial towns might stray from the ideological convictions of their superiors, the urban leadership of Hashomer hatsa'ir and Betar created scripts for their local leaders to follow during these discussions.[35] While the ideological content of these talks differed according to each movement, they generally covered the following topics: ancient, medieval, and modern Jewish history; the history of Zionism; contemporary Zionist movements; and the geography and demography of Mandatory Palestine. The *siḥot* scripts often encouraged youth movement leaders to "transport" their young followers to the Land of Israel. A conversation guide for Hashomer hatsa'ir leaders in Tel Aviv, for example, instructed them to take their young recruits on a virtual tour of the city. Using photographs from the city, they would imagine what it might be like to descend from a ship at the Jaffa Port, travel through the city's neighborhoods, and admire its cultural institutions.[36] Youth movement leaders in Warsaw expected similar photographs, along with maps of the Land of Israel and portraits of Zionist leaders, to adorn the walls of youth movement clubhouses across Poland.[37]

The curriculum guidelines also sought to invest educational significance into the leisure activities associated with youth movement culture. Jewish youth living in provincial towns viewed youth movements not only as educational centers but also as hubs of sporting, musical, and theatrical activity. Members of Jewish youth movements who submitted autobiographies to the YIVO contest often boasted of their group's soccer clubs, dramatic societies, musical groups, or hiking trips to the surrounding countryside.[38] Many youth movement members looked forward to annual weeklong summer and winter camps in nearby fields and forests. While discussion of these activities occupies comparatively little space in the political periodicals of Betar and Hashomer hatsa'ir, former members of these movements describe these activities as vital components of their experiences with Jewish youth movement culture.[39] What little was written on the topic by the youth movements' leaders sought to convince Polish Jewish youth that every activity in

which they engaged was invested with ideological significance. Hikes over mountains and through forests, for example, could be used as occasions to reenact the lives and struggles of biblical heroes appropriated by the Zionist movement as ancient national leaders.[40] So too could their theatrical performances and concerts, coupled with the absence of a thriving theatrical and musical scene in town, draw large audiences.[41] Sporting and scouting activities were described as necessary steps for meek Diaspora Jewish youth to physically transform into the Zionist movements' ideal Jew—strong, resilient, and courageous.[42]

Gender Trouble in the Borderlands

As much as Jewish youth movements added to the vibrant public cultural life of their communities, young Jews also valued their local clubs as spaces for secluded social activity, a respite from the prying eyes of elders who tried to enforce traditional social norms. This relative seclusion offered unprecedented opportunities for male and female teenagers to interact. Traditional gender roles in market towns were relatively rigid. Although women played an important role in the family economy, men held positions of communal power, whether in synagogues or Jewish community councils (Heb. *kehilot*). Sexual relations of any degree were strictly forbidden until marriage. Youth movements accelerated the decline of several of these social norms. For Meir Brill, the founder of Hashomer hatsa'ir in Włodzimierz Wołyński, a large town on the western border of Wołyń, the fact that he gathered young men and women together in his house was nothing short of revolutionary.[43] In communities where anonymity was next to impossible, many of the cultural activities in Jewish youth movements—whether singing in their local clubs or hiking in nearby fields and forests—offered the possibility of social interaction beyond the view of their parents. The participation of local Jewish youth in *hakhsharot*—the youth movements' elite training programs in farms, stone quarries, or lumberyards—was particularly worrisome to parents. Often considered the final training grounds before immigrating to Mandatory Palestine, the *hakhsharot* offered young men and women the opportunity to live together under the same roof (for one such mixed group, see figure 12.1).[44] Although most youth movements emphasized that their experiments in communal living were chaste, parents feared that this rule was honored in the breach.[45]

Jewish youth movements also provided possibilities for young Jewish women to assume positions of leadership. Several women in the eastern borderlands who belonged to both Betar and Hashomer hatsa'ir founded local branches of their youth movement and served as regional emissaries.[46] The possibility of empowerment, however meager, may have been one of the reasons that youth movements proved immensely popular among Jewish girls and young women. By 1933, Betar activists reported to their "head command" that Jewish women made up more than 40 percent of their youth movement.[47] In 1933, Hashomer hatsa'ir's leaders in Warsaw observed that in nearly every local branch of the movement in the eastern borderlands, young women outnumbered young men—in some cases, dramatically so.[48]

Figure 12.1. Betar members at a *hakhsharah* agricultural training farm near Łuck, Wołyń province, 1933. Reproduced by permission of the Jabotinsky Institute Archive. PH-5188.

Yet the presence of young women in these movements did not entail equality with their male counterparts. Doubts about the value of Jewish women's political activism were not solely harbored by traditional Jews. Despite the numerous fault lines dividing Polish Jewry—from region and class to religious practice and political affiliation—suspicions about women's political activism were remarkably widespread.[49] Zionist organizations were no different. Throughout the 1930s, Hashomer hatsa'ir's and Betar's leaders spilled much ink in their periodical literature over the "women's question," fretting over whether coeducation and women's equal participation in their movements' activities would result in the loss of their feminine qualities. While Hashomer hatsa'ir's leaders debated the extent to which young women could take on intensive agricultural labor, Betar's leaders argued over the extent to which they should provide military training to young women.[50] In one typical article on the topic, a Betar activist warned, "I would not be exaggerating if I said that . . . all women in the Zionist youth movements are sick with a deep and dangerous psychological illness . . . our young women would very much want, if it was in their power, to turn into men. . . . There is no charm, beauty or advantage to such a type."[51] Writing in April 1933, a young woman from the small town of Kostopol, with some four thousand Jews, urged Betar's leaders to move past their fantasies about the supposed threat posed by women and focus instead on the real challenges they faced. "The problem," she explained, "is that men in *Betar* despise women. . . . We are not counted in *Betar*'s leadership, none of us get the opportunity to develop our organizational abilities and use our intelligence. . . . Are we really incapable of doing anything more than cooking, washing and sewing? Is it really true that nature has degraded us?"[52]

Despite these debates, neither youth movement offered definitive guidelines on coeducational activity or the scope of young women's participation in their movements' activities. Ultimately, the leaders of both Hashomer hatsa'ir and Betar decided that it was best not to intervene in how each provincial branch decided to address the "women's question." The reticence of the youth movements' leadership in Warsaw was perhaps borne of the recognition that a more progressive and inclusive approach to women's full participation and leadership might invoke communal scorn in certain provincial towns. The leadership of both youth movements essentially left their local branches to their own devices, allowing them to determine the level of coeducation that would be suitable for their local contexts.

The Limits of the Civilizing Mission

Hashomer hatsa'ir's and Betar's leadership in Warsaw hoped that the regional network of their activists, along with the flurry of periodicals, pamphlets, and curriculum guidelines they published, would help them transform the young Jews in eastern Poland who had joined their ranks. If historians were to solely rely on their instruction guidelines, they might be tempted to view these urban activists as powerful political players whose influence extended far beyond Warsaw. A fundamentally different picture of youth movement culture in the "periphery" emerges from letters between the youth movements' emissaries and their Warsaw superiors, as well as from the YIVO autobiographies written by provincial Jewish youth. These documents not only shed light on the limits of the urban activists' mission but also further illuminate the extent to which the unique dynamics of each town could influence the ideological, economic, social, and cultural development of youth movements.

No matter how many cultural prescriptions they issued to their followers in the eastern borderlands, the Warsaw leaders of Hashomer hatsa'ir and Betar had little control over whether or not their followers actually read them. Writing to their provincial emissaries in Wołyń in 1932, Hashomer hatsa'ir's leadership in Warsaw lamented, "Over the past month, we've published nine circulars within various bulletins ... in addition to numerous letters and notices, but one cannot feel the impact of any one of them."[53] A year later, they lamented that over seventy branches of their youth movement in Poland's eastern region had all but ignored their cultural directives.[54] The fact that the movement's leadership chose, until the late 1930s, to publish their directives in Hebrew, which few Jewish youth spoke fluently, undoubtedly made matters worse.[55] Betar's leaders were far more willing to relax their commitment to "Hebraization" and use Yiddish and Polish in order to reach their target audience. Yet they also feared that their carefully crafted cultural scripts for how to think and behave, spanning from discussion guidelines and songs to choreography for public ceremonies, were being ignored. One of Betar's first journals, *Avodatenu* (Heb. Our work), which provided specific instructions for the operation of Betar branches from 1931 onward, was replete with angry letters from the editor scolding the youth movement's branches in the eastern

borderlands for failing to subscribe to their educational publications.[56] Even if the publications reached their intended audience, it was no guarantee of success. One young autobiographer in Wołyń described how his sister used to stuff the journals sent by Hashomer hatsa'ir's Warsaw office into a drawer in their home in order to prevent her followers from discovering the movement's socialism and antagonism toward traditional Jewish authorities, beliefs, and practices.[57]

Letters from provincial branches of Hashomer hatsa'ir and Betar to their youth movements' headquarters in Warsaw provide a fascinating window into the gap between the cultural prescriptions of Warsaw's Zionist activists and the activities of their followers. Take, for example, a series of letters by a young Hashomer hatsa'ir activist from Prużana, a town with four thousand Jews on the banks of the Muchawiec River in Polesie (see figure 12.2). Writing to his youth movement's leaders in Warsaw, he noted that it was impossible to use their cultural guidelines to educate Prużana's Jewish youth. To start with, he wrote, the content of the discussion scripts for *siḥot* was "entirely inappropriate" for his town. Young Jews cared little for socialist-Zionist squabbles over ideological minutia. The only way he could conduct *siḥot* was to choose topics to "get them talking" and to "ignite their imagination." After listing the topics he had chosen—none of which related to socialism or Zionism—he described yet another reason why the Warsaw leadership was tone-deaf to the lived experience of Prużana's Jewish youth. In contrast to Warsaw's directives for multiple meetings each week, he noted that they only gathered on the Sabbath, a day that provided traditional Jews with a religiously mandated respite from work.[58] Given the dire economic situation in Poland, they likely could not afford to leave their work in order to meet regularly from Sunday to Thursday.

Figure 12.2. Members of Betar in Łuck, Wołyń province, 1938. Reproduced by permission of the Jabotinsky Institute Archive. PH-5497.

Some 150 miles southeast, youth movement activists from the town of Dąbrowica in Polesie, with a population of some three thousand Jews, wrote the Warsaw leadership of Hashomer hatsa'ir with an entirely different complaint regarding their cultural directives. After reading their youth movement's articles designed for *siḥot*, they concluded that their leaders in Warsaw were using "radical revolutionary prose to push radical youth towards fascist deeds." The letter then declared that all the leaders of the local movement would abandon their posts unless the leaders in Warsaw reversed course.[59] Hashomer hatsa'ir's leaders in Warsaw, many of whom had written numerous articles denouncing Fascism, were stunned to receive this letter. They swiftly sent a copy to their youth movement's regional hub in Równe, a small city with over twenty-five thousand Jews that served as the district capital of Wołyń (see figure 12.3). The "hub" consisted of three emissaries in their early twenties plucked from the youth movement's cadre of elite activists. Hashomer hatsa'ir's activists in Warsaw presumed that the ideological misunderstanding was a product of distance: the town was not only 320 miles from Poland's capital but also at least 100 miles away from the youth movement's emissaries in Równe. Scolding them for not keeping abreast of the situation in Dąbrowica, the Warsaw leadership urged the emissaries to immediately travel to the town to "clarify matters."[60] The three emissaries quickly responded that they not only were well aware of the situation in Dąbrowica but had already sent numerous letters to the youth movement's headquarters in Warsaw notifying them of what had taken place. They railed against the Warsaw leaders for ignoring their pleas for help.[61] Left to their own devices and without any financial support from their youth movement's leaders in Warsaw, the emissaries declared that they could not conduct any meaningful cultural activity. One emissary described being on the edge of starvation, and another spoke of the shame they felt when they could not pay their rent for their "regional office."[62] Strapped for cash, their plans to write and send out cultural guidelines to the regional branches had come to a standstill.[63] Letters between Betar's leadership in Warsaw and their emissaries in eastern Poland point to similar scenarios.[64] In the absence of sustained contact between the movement's central leadership and its branches in eastern Poland, local youth movement activists frequently determined their own cultural course.

The Polish Government, Antisemitism, and Youth Movement Culture in the Borderlands

Local dynamics between Jews and Polish officials in the eastern borderlands could have had a profound impact on youth movement politics and culture, sometimes in ways that challenged the directives of the youth movement's leadership in Warsaw. Fearful of the nationalist aspirations of eastern Poland's Ukrainian majority and determined to fortify the region as a buffer zone between Poland and the Soviet Union, the Polish government invested a great deal of effort into observing and controlling the political activity of residents in the region's small towns. Its proximity to the Soviet Union made already extant fears of young Jews being communist

Figure 12.3. Members of Hashomer hatsa'ir in Równe, Wołyń province, 1926. Photo courtesy of Ora Ninio. United States Holocaust Memorial Museum Photo Archives. Photograph number 78329.

sympathizers all the more acute, which, in turn, made socialist Jewish groups like Hashomer hatsa'ir all the more suspect in the eyes of Polish officials.

Writing to their youth movement's headquarters in Warsaw, Hashomer hatsa'ir activists noted that the smaller size of the towns, in comparison to Poland's large cities, made it more difficult to go unnoticed by local officials. Fearing that local Polish officials would serve him conscription papers for the Polish Army, one activist notified Warsaw's leadership that he had to abandon his work for the youth movement. Explaining his decision, he noted that "Równe is not Warsaw"; there was no crowd into which he could disappear.[65] Other emissaries of the movement spoke of the eagerness of local Polish policemen to find any excuse to shut down the youth movement's cultural activities, arrest its leaders, or even expel them from town. In November 1935, a young woman who had joined the Równe emissary team reported that a Polish police officer arrested her after overhearing her giving a speech at a local youth movement club. The fact that the speech was in Yiddish, and likely unintelligible to the officer, did not stop him from accusing her of trying to incite a "social democratic revolution." She was released but on the condition that she would leave town. The fact, she quipped, that she was now "famous" among local Polish officials made her cultural work for the youth movement all the more difficult to perform.[66]

While the anxiety of Polish officials about communism in the eastern borderlands made the work of Hashomer hatsa'ir's activists more difficult in the region, in some instances, it facilitated the work of Betar's activists. As members of a movement that had declared war on the Jewish Left, local Betar leaders presented their youth movement to Polish government officials as an antidote to the threat

of Jewish communism. In small towns throughout eastern Poland, Betar members staged public cultural events, including laying wreaths at local memorials for Polish soldiers, in which they condemned communism, pledged loyalty to the Polish state, and expressed their readiness to defend the country's borders. When the time came to submit requests to local Polish officials to stage these events, Betar officials invited them to participate. As a result of these contacts, many local Polish officials in the region permitted Betar members to join paramilitary training programs run by the local government.[67]

Ultimately, however, Betar's cultural ceremonies proclaiming Polish-Jewish brotherhood belied a far more complicated reality. As the 1930s drew to a close and antisemitic attacks increased in Poland, some Betar leaders, like leaders of other youth movements, insisted on organizing armed squads to engage in self-defense. They were out of sync with the official policy of their leaders in Warsaw. In 1936, Vladimir Jabotinsky began to court the support of Polish government officials in Warsaw to support his "evacuation plan," which called for 1.5 million Jews to emigrate from eastern Europe to Mandatory Palestine over the course of ten years.[68] Given the vested interests of right-wing Zionists in maintaining a good relationship with Polish officials, it was their policy to keep criticism of the Polish government far from public view. Well aware that the Polish government forbade the formation of vigilante groups to combat anti-Jewish violence, journalists writing in the movement's press in Warsaw and Kraków were also careful to avoid describing local cases of their young Jewish followers defying government regulations.

Decades later, former Betar members writing in memoirs and memorial anthologies for their hometowns expressed none of these reservations. Ya'akov Hetman, a Betar leader from the town of Luboml, recalled how his branch's public ceremonies proclaiming Polish-Jewish brotherhood, as well as his close relations with local Polish officials, did little to deter him from organizing an armed response to antisemitic riots.[69] When rioters began to attack elderly Jews on Sabbath evenings, Hetman recalled that "it was obvious that we had to 'pay back' the attackers."[70] Creating strong Jews who could engage in self-defense was, after all, at the core of the cultural transformation that the youth movement sought to implement. When two Polish rioters were stabbed by Hetman's men and sent to the hospital in critical condition, police officials placed the blame for the violent clashes squarely on Betar. The youth movement's members were no longer permitted to march in Polish patriotic parades or participate in government-sponsored military training programs, as they had done in the past.

Conclusion

In many respects, Jewish youth movement branches in Poland's provincial towns shared many of the same features as those in the country's major cities. Whether in Warsaw or Warkowicze, youth movement clubs provided an arena for young Jews to gather and engage with some of the most pressing political questions of their day. Dreaming and debating about a better future and gathering in the

streets to promote their cause, young people could feel a sense of empowerment that eluded them in their daily lives. Soccer matches, hikes in the forest, dramatic presentations, mandolin bands—these and other leisure activities provided comfort and respite, however brief, from the social, economic, and political turbulence that characterized Jewish life in interwar Poland. The leaders of youth movements, no matter their location, staged public events with their followers with the aim to mobilize the support of onlookers for their cause. Whether in provincial towns or cities, youth movements were also characterized by a large turnover rate. Much like their parents—perhaps even more so—many young Jews were politically promiscuous. Their affiliations frequently changed based on their ever-changing assessments of their immediate social, cultural, political, and economic needs.[71]

Despite these similarities, Jewish observers of the period also noted critical differences between the politics and culture of youth movements in provincial towns and those in cities. If in Warsaw, modern Jewish political institutions could be found throughout Jewish neighborhoods, in provincial towns, their number paled in comparison to the number of prayerhouses and religious organizations lining its streets. If in cities, the sheer volume of competing synagogues and prayerhouses meant that youth movements were not beholden to any one of them, in provincial towns, local religious leaders and long-standing religious communal norms were viewed as forces with which to be reckoned. Youth movement activists in provincial towns felt that they were under greater scrutiny and surveillance, whether at the hands of rabbis or Polish government officials. In the absence of the theaters, sports arenas, and libraries that lined the streets of cities like Warsaw, Kraków, and Lwów, the cultural institutions and activities of youth movements in provincial towns outmatched their counterparts in cities in their importance and impact. Young Jews in provincial towns viewed their youth movements as portals to the cultural and political ferment of cities in Poland and beyond.

Even as youth movements left a deep imprint on the politics and culture of Poland's provincial towns, they also were the source of frustration and anger on the part of their urban leaders. Ezra Mendelsohn's observation that Polish Jewish politics oscillated between euphoria and despair certainly holds true when reading Betar's and Hashomer hatsa'ir's triumphant ideological texts in tandem with letters from the very same authors lamenting the indifference of their provincial followers to their youth movement's program.[72] Despite the growing opportunities to harness developments in technology and transportation, the vast distances between Poland's capital and provincial towns in the eastern borderlands impeded the efforts of urban political activists to mobilize Polish Jewish youth. The case studies of this chapter point to how various local contingencies—whether relations with Polish officials or religious leaders, the presence or absence of Zionist schools, or the nature of gender relations—could prove equally, if not more, influential than Warsaw's Jewish leadership in determining the development of local youth movements. These local contingencies demand further historical research. As historians continue to map the politics of Jewish provincial life, a fuller portrait of modern Jewish politics in interwar Poland, at once panoramic and intimate in scope, will emerge.

Notes

1. See, for example, Celia Heller, *On the Edge of Destruction: Jews of Poland between the Two World Wars* (New York: Columbia University Press, 1977); Ezra Mendelsohn, *Zionism in Poland: The Formative Years, 1915-1926* (New Haven, Conn.: Yale University Press, 1982); and Emanuel Melzer, *No Way Out: The Politics of Polish Jewry, 1935-1939* (Cincinnati: Hebrew Union College Press, 1997).

2. See Michael Steinlauf, "Jewish Politics and Youth Culture in Interwar Poland: Preliminary Evidence from the YIVO Autobiographies," in *The Emergence of Modern Jewish Politics: Bundism and Zionism in Eastern Europe*, ed. Zvi Gitelman (Pittsburgh: University of Pittsburgh Press, 2003), 91-104; and Kenneth Moss, "Negotiating Jewish Nationalism in Interwar Warsaw," in *Warsaw: The Jewish Metropolis; Essays in Honor of the 75th Birthday of Professor Antony Polonsky*, ed. Glenn Dynner and François Guesnet (Leiden: Brill, 2015), 390-436.

3. Eli Tzur, *Lifne bo ha'afelah: Hashomer hatsa'ir beFolin uveGalitsiyah, 1930-1940* (Kiryat Sde Boker: Makhon Ben Guriyon, 2006); Daniel Kupfert Heller, *Jabotinsky's Children: Polish Jews and the Rise of Right-Wing Zionism* (Princeton, N.J.: Princeton University Press, 2017).

4. She'elonim snif Polanyah, 1930, Jabotinsky Institute (hereafter cited as JI), Tel Aviv, Israel, box 1, folder 10.

5. "Hamifkadot hagliliyot," *Ḥoveret betar: Avodatenu*, December 1932, 14.

6. "Circular Number One," head command of Hashomer Hatsa'ir to regional branches, November 5, 1932, p. 3, Hashomer hatsa'ir Archives (hereafter cited as HH), 2-1.22(3)/1436. See also Tzur, *Lifne bo ha'afelah*, 66-79, 218-260.

7. Meir Brill, "Ken Betar," in *Sefer Vladimerets: Gal-ed lezekher irenu*, ed. Aharon Meyerowitz (Tel Aviv: Ofer, 1962), 222; Y. Z., "Hashomer hatsa'ir," in *Yizkor: Kehilot Luninyets/ Kozharodok*, ed. Yosef Ze'evi et al. (Tel Aviv: Aḥdut, 1952), 31; Tsvi Hadari (Pomerantz), "Hashomer hatsa'ir ve'irgune no'ar aḥerim be'Ustila," in *Kehilat Ustilah bevinyanah uveḥurbanah*, ed. Aryeh Avinadav (Tel Aviv: Irgun yotse Ustilah biYisra'el uvatefutsot, 1961), 85.

8. Moshe Zingerman, "Irgune hano'ar hatsioni," in *Sefer yizkor likehilat Sarni*, ed. Yosef Kariv (Jerusalem: Yad Vashem, 1961), 203; Efraim Shnaider, "Hashomer hatsa'ir beSarny," in Kariv, *Sefer yizkor likehilat Sarni*, 205; G. Beigel, "Tsionizm un kultur in Berezne," in *Mayn shtetele Berezne*, ed. G. Beigel (Tel Aviv: Berezener landslayt komitet in Yisroyel, 1954), 59. On Poland's Tarbut schools, see Kamil Kijek, "Was It Possible to Avoid Hebrew Assimilation? Hebraism, Polonization and Tarbut Schools in the Last Decade of Interwar Poland," *Jewish Social Studies* 21, no. 2 (2016): 105-141.

9. Z., "Hashomer hatsa'ir," 31; Brill, "Ken Betar," 222.

10. Samuel Kassow, "Community and Identity in the Interwar Shtetl," in *The Jews of Poland between Two World Wars*, ed. Yisrael Gutman et al. (Hanover, N.H.: New England University Press, 1989), 128.

11. Kassow, 125.

12. Sunały to Avraham Axelrod, January 31, 1932, JI/P-14/3; Hashomer hatsa'ir's Wołyń department to Warsaw leadership, October 22, 1935, HH2-1.22(3)/1454.

13. See, for example, Anita Shapira, "Religious Motifs of the Labor Movement," in *Zionism and Religion*, ed. Shmuel Almog, Jehuda Reinharz, and Anita Shapira (Jerusalem: Zalman Shazar Center, 1994), 250-272.

14. "Masa'ot betefutsot hagolah," *Hamedinah*, November 26, 1935. *Hamedinah* was a bilingual journal that published in both Yiddish and Hebrew.

15. Ya'akov Hetman, "Betar beLuboml," in *Sefer yizkor lekehilat Luboml*, ed. Berl Cohen and Ya'akov Hetman (Tel Aviv: Mofet, 1974), 219.

16. Tzur, *Lifne bo ha'afelah*, 41.

17. Moshe Cohen, *Hashomer hatsa'ir beVolin* (Givat Haviva: Merkaz ti'ud veḥeker, 1991), 32.
18. "Sufferer 1001," YIVO Institute for Jewish Research, RG4, folder 3511. Reprinted in Avraham Novershtern, ed., *Alilot ne'urim: Otobiyografyot shel bene no'ar yehudim meFolin ben shete milḥamot ha'olam* (Tel Aviv: Institute for the History of Polish Jewry, 2011), 496.
19. Meir Shatz, "Ludmir: Tenu'otehah, mosadotehah ve'anshehah," in *Pinkas Ludmir: Sefer-zikaron likehilat Ludmir* (Tel Aviv: Irgun yotse Ludmir biYisra'el, 1962), 205.
20. "Ken betar varkovich," JI/P-153/3/9.
21. Yael Zerubavel, *Recovered Roots: Collective Memory and the Making of Israeli National Tradition* (Chicago: University of Chicago Press, 1995), 96–103.
22. Dov Kirshner, "Tsionistishe bavegung in Pruzshene," in *Pinkes fun finf fartilikte kehiles: Pruzshene, Bereze, Maltsh, Sherhshev, Selts*, ed. Mordkhe Bernshteyn and David Porer (Buenos Aires: Landslayt fareyn fun Pruzshene in Argentine, 1958), 224; Yosef Bobman, "Tsionistishe fareynungen in Pruzshene," in Bernshteyn and Porer, *Pinkes fun finf fartilikte kehiles*, 242; Zerubavel, *Recovered Roots*, 31; Shnaider, "Hashomer hatsa'ir beSarny," 204.
23. Kassow, "Community and Identity," 15.
24. For an excellent overview of literary images of the shtetl, see Dan Miron, "The Literary Image of the Shtetl," *Jewish Social Studies* 1, no. 3 (Spring 1995): 1–43.
25. Moshe Goldberg, "Dos Beytarisher folk redt," *Hamedinah*, January 6, 1935; Wołyń department to Hashomer hatsa'ir headquarters, December 27, 1934, HH2-1.22(3)/1454; Wołyń department to Hashomer hatsa'ir headquarters, July 9, 1935, HH2-1.22(3)/1454; Tzur, *Lifne bo ha'afelah*, 61–63.
26. For example, both Ya'akov Hazan, one of the founders of Hashomer hatsa'ir, and Menachem Begin, who would become Betar's head commander in 1938 and Israel's first right-wing Zionist prime minister in 1977, were born and raised in Polesie's capital, Brześć nad Bugiem.
27. See, for example, Ostrów-Mazowiecka Hashomer hatsa'ir to Hashomer hatsa'ir headquarters, October 12, 1935, HH2-1.28(3)/1460. On Jewish enrollment in private and state secondary schools, see Raphael Mahler, "Jews in Public Service and the Liberal Professions in Poland," *Jewish Social Studies* 6, no. 4 (1944): 346–347.
28. Kijek, "Was It Possible?," 182–218.
29. See, for example, Israel Epsztajn, *Hora'ot lehakhsharah hatarbutit bakenim* (Warsaw: Futura, 1935), 6–15.
30. "Tokhnit le'asefot hamenahalim beshikhvat ha-tsofit," Hashomer hatsa'ir, bulletin 1, HH2-1 3. (7)/1434.
31. "Katalog lesifrut yafah," Hahanhagah harashit, October 11, 1933, HH2-1 8. (2)/1439.
32. "Lezn," *Avodatenu*, 1932, JI/PR-251.
33. Epsztajn, *Hora'ot lehakhsharah hatarbutit bakenim*, 42, 47.
34. Moshe Kligsberg, "Di yidishe yugnt-bavegung in poyln tsvishn beyde velt milkhomes," in *Shtudies vegn yidn in Poyln 1919–1939*, ed. Joshua Fishman (New York: YIVO Institute for Jewish Research, 1974), 164–172.
35. See, for example, "Mitoḥ siḥah," *Hashomer hatsa'ir*, nos. 23–24 (1930): 11; "Basiḥah," *Hashomer hatsa'ir*, February 15, 1932, 7; *Avodatenu*, 1932, 1–3, JI/PR-251; and *Biyuletin brit trumpeldor, mifkedet galil baranowicze*, December 22, 1934, JI/B33-3/2.
36. "Tezisim lesiḥot beshikhvah alef," *Hashomer hatsa'ir*, January 1, 1933, 20.
37. Moshe Goldberg, *Der beytarisher ken: Instruktsyes un onvayzungen* (Warsaw: Styldruk, 1934), 10–12.
38. Kijek, "Was It Possible?," 328–343.
39. Kirshner, "Tsionistishe bavegung in Pruzshene," 225; Bobman, "Tsionistishe fareynungen in Pruzshene," 295; Zerubavel, *Recovered Roots*, 31; Zingerman, "Irgune hano'ar

hatsioni," 203; Avraham Piterman, "Tsionistishe bavegungen in Mezritsh," in *Mezritsh: Zamlbukh in heylikn ondenk fun di umgekumene Yidn in unzer geboyrn-shtot in Poyln*, ed. José Horn (Buenos Aires: Mezritsher landslayt-farayn in Argentine, 1952), 307–314.

40. See, for example, Zelig Lerner, *Mahanot kayits/zumer lagern* (Warsaw: Grafja, 1932).

41. See, for example, Epsztajn, *Hora'ot lehakhsharah hatarbutit bakenim*, 24–25; and Rahel L., "Lishe'elat hamuzikah haproletarit," *Hashomer hatsa'ir*, nos. 5–6, March 1932.

42. "Keitsad lehathil be'avodat hasport behistadrut no'ar," *Madrikh betar* 1 (September 1932): 36–37; Isaac Remba, "Havah nishekah," *Madrikh betar* 2 (November 1932): 26–27.

43. Brill, "Ken Betar," 222.

44. See Israel Oppenheim, "Hahakhsharah hakibutsit shel betar beFolin bishnot ha-30 (1930–1936)," *Divre hakongres ha'olami lemada'e hayahadut* 2 (1973): 295–305; and Levi Deror and Yisrael Rosenzweig, eds., *Sefer Hashomer hatsa'ir* (Merhaviyah: Sifriyat Po'alim, 1956), 1:209–211.

45. Rona Yona, "Ninyeh kulanu halutzim: Halutsiyut vele'umiyut amamit bitnu'at hehaluts beFolin ben milhamot ha'olam." PhD diss., Tel Aviv University, 2013, 72–110.

46. Shlomo Sheinboim, "Tehilat hape'ilut hatsionit," in *Ayaratenu Stepan*, ed. Yitzhak Ganuz (Tel Aviv: Irgun yotse Stepan vehasevivah beYisra'el, 1977), 111–112; the letters of an emissary for Hashomer hatsa'ir in Wołyń with the first name Margalit, HH/2-1.22(3)/1454.

47. Ajzik Remba, ed., *Shnatayim: Din ve-heshbon shel netsivut Betar beFolanyah* (Warsaw: Futura, 1934), 3.

48. Duhot kenim lefi gelilot, 1935–1936, HH2-1.27(3)/1459.

49. *The Shalvi/Hyman Encyclopedia of Jewish Women*, s.v. "Poland: Interwar," by Gershon Bacon, accessed March 3, 2019, https://jwa.org/encyclopedia/article/poland-interwar; Paula Hyman, "East European Jewish Women in an Age of Transition, 1880–1930," in *Jewish Women in Historical Perspective*, ed. Judith Baskin, 2nd ed. (Detroit: Wayne State University Press, 1998), 216–221; Jolanta Mickute, "Modern, Jewish and Female: The Politics of Culture, Ethnicity and Sexuality in Interwar Poland, 1918–1939" (PhD diss., Indiana University, 2011).

50. See, for example, "Misaviv leshe'elat hinukh habahurah," *Hashomer hatsa'ir*, nos. 23–24 (1930): 2–3; "Lehinukh habahurah bagil hahitbagrut," *Hashomer hatsa'ir*, 2–3 (March 1937): 3–4; "Habahurah betenuatenu," *Hashomer hatsa'ir*, nos. 2–3 (March 1937): 4–5; Y. Krelman, "Betaryah (ma'amar sheni)," *Madrikh betar*, December 1933, 47; and Josef Blatt, "Ha'isha beVetar," *Madrikh Betar*, May 1933, 48.

51. Krelman, "Betaryah," 7.

52. Batya Kremer, "Di bahura oyf hakhsharah," *Hamedinah*, March 30, 1935.

53. "Circular Number One," Hashomer Hatsa'ir headquarters to regional branches, November 5, 1932, HH/1436, 3.

54. Hashomer hatsa'ir headquarters to all leaders, October 17, 1933, HH2-1 8.(2)/1439.

55. Tzur, *Lifne bo ha'afelah*, 83.

56. See, for example, "Yedi'ot," *Avodatenu*, November 1932, 5; "Aktuele zaytl," *Avodatenu: Hora'ot La'avodah*, n.d., 2; "Vegn der rosh betar aktsye," *Avodatenu*, January 1932, 14; and "Vegn instruktorn kurs," *Avodatenu*, February 1932, 6.

57. "Sufferer 1001," in Novershtern, *Alilot ne'urim* 496.

58. Prużana Hashomer hatsa'ir to Hashomer hatsa'ir headquarters, December 12, 1935, HH2-1.22(3)/1463.

59. Dąbrowica Hashomer hatsa'ir to Hashomer hatsa'ir headquarters, August 2, 1935, HH2-1.22(3)/1454.

60. Hashomer hatsa'ir headquarters to Równe Hashomer hatsa'ir, October 1, 1935, HH2-1.22(3)/1454.

61. Równe Hashomer hatsa'ir to Hashomer hatsa'ir headquarters, October 8, 1935, HH2-1.22(3)/1454.

62. See the series of letters written by Równe Hashomer hatsa'ir to the movement's headquarters: January 25, 1935; July 9, 1935; September 26, 1935; and October 8, 1935, HH2-1.22(3)/1454.

63. Równe Hashomer hatsa'ir to Hashomer hatsa'ir headquarters, December 31, 1935, HH2-1.22(3)/1454.

64. Yosef Khrust to Avraham Axelrod, March 29, 1932, JI/P14-3; Aharon Propes to Avraham Axelrod, September 19, 1931, JI/P14-3.

65. Równe Hashomer hatsa'ir to Hashomer hatsa'ir headquarters, September 8, 1935, HH2-1.22(3)/1454.

66. Równe Hashomer hatsa'ir to Hashomer hatsa'ir headquarters, November 27, 1935, HH2-1.22(3)/1454.

67. Heller, *Jabotinsky's Children*, 133–166.

68. On these negotiations, see Laurence Weinbaum, *A Marriage of Convenience: The New Zionist Organization and the Polish Government, 1936–1939* (Boulder: East European Monographs, 1993).

69. Ya'akov Hetman, "Betar beLuboml," JI/P-153/3/9, 2.

70. Hetman, "Betar beLuboml," 218–221.

71. Kijek, "Was It Possible?," 375–390.

72. Ezra Mendelsohn, "Jewish Politics in Interwar Poland: An Overview," in Gutman et al., *Jews of Poland*, 10.

Acknowledgments

This book started with a chance encounter at the 2016 meeting of the American Musicological Society in Vancouver, British Columbia, when our mutual colleague Rebecca Cypess introduced us with a casual comment: "You both care about Poland." In a lengthy and fruitful conversation over skimpy hotel bar drinks, we brainstormed about how we could shift the focus of Polish-Jewish studies to cultural production beyond the *shtetlakh* and klezmer music (or as we preferred to think of it, "Let's take that fiddler off the roof already") and how we could decenter the preoccupation with the Polish capital to bring a better understanding of Jewish modernity in other Polish urban centers. We quipped that our concept was #NotWarsaw. We quickly agreed to collaborate on a workshop and reached out to four scholars, Irena Grudzińska-Gross, Jessie Labov, Karen Underhill, and Geneviève Zubrzycki, who in 2013 had founded the Polish Jewish Studies Initiative (PJSI), an international, interdisciplinary forum for scholars involved in research and teaching at the intersection of Polish and Jewish studies.

With Natalia Aleksiun, we organized the Fifth Annual Polish Jewish Studies Workshop "Centering the Periphery: Polish Jewish Cultural Production beyond the Capital" at Rutgers University, New Brunswick, in March of 2018 (https://www.europe.rutgers.edu/polish-jewish-workshop). We are deeply grateful to the sponsors whose generous funding allowed an international group of scholars to gather for two days to present and discuss topics that became the foundation of this volume: Irene Kronhill Pletka, chairperson of the Kronhill-Pletka Foundation; Shana Penn, executive director of the Taube Philanthropies; Andrzej Rojek, board chairman of the Jan Karski Educational Foundation; Director Dariusz Stola and the POLIN Museum's Global Education Outreach Program; Patti Kenner, president of Campus Coach Lines; Agnieszka Rudzińska of the Adam Mickiewicz Institute; and Marek Skulimowski, president of the Kosciuszko Foundation. Various units at Rutgers University sponsored the workshop. At the School of Arts and Sciences, we were supported by Executive Vice Dean James Masschaele; the Departments of History, Jewish Studies, and German, Russian, and East European Languages

and Literatures; the Center for European Studies; and the Allen and Joan Bildner Center for the Study of Jewish Life. At Indiana University, we received funding for the workshop and the book from the Robert A. and Sandra S. Borns Jewish Studies Program "Friends" Fund, with the support of Directors Mark Roseman and Judah Cohen; the Mellon Endowment grant from the Robert F. Byrnes Russian and East European Institute through Director Sarah Phillips and Associate Director Mark Trotter; and Ambassador Lee Feinstein, founding dean of Hamilton Lugar School of Global and International Studies. We also appreciate the assistance from Dean Michael Shmidman at the Graduate School of Jewish Studies, Touro College.

A highlight of the workshop was the exhilarating concert "Soundscapes of Modernity: Jews and Music in Polish Cities," held at the Kirkpatrick Chapel at Rutgers, which presented music of Polish Jews that is little known to American audiences—choral pieces from nineteenth-century progressive ("Reform") congregations, compositions associated with Jewish music societies, and avant-garde works by Jewish composers. It was performed by professional musicians and students at the Mason Gross School of the Arts.

Organizational support for the workshop and the concert was indefatigably provided by Susanna Treesh, administrative director of the Center for European Studies at Rutgers, who patiently and attentively took care of the multiple parts in producing both events.

We are likewise indebted to all who assisted us with the production of the book and the accompanying website (https://polishjewishmusic.iu.edu): Miguel Arango Calle for securing images and copyrights, Nazareth "Naz" Pantaloni for guiding us through the complexities of copyright law, Katie Chapman for developing the website to showcase musical performances from the concert that accompanied the 2018 workshop, Kirby Haugland and Anne Lake for their contribution as bibliographers, Kate Mertes for her work on the index, and Hannah McGinnis for expertly copyediting the manuscript. We are thrilled with the beautiful cover designed by adam b bohannon. We are thankful to Elisabeth Maselli, then the acquisitions editor at Rutgers University Press, for her initial support and encouragement as we worked with our authors to conceptualize the volume. But our greatest editorial appreciation is to the amazing Christopher Rios-Sueverkruebbe, assistant acquisitions editor in religious studies and Jewish studies at Rutgers University Press, who grasped this project in hand firmly in the spring of 2022 and made the complicated process of producing a book painless. It was an absolute pleasure to work with someone so attentive and professional.

Last, we want to acknowledge our scholarly and artistic collaborators. Natalia Aleksiun was an outstanding partner as we co-organized the 2018 workshop and worked tirelessly through the early stages of the book. Rebecca Cypess made the concert possible by connecting us to the talented musicians of the Mason Gross School of the Arts at Rutgers University: Paul Conrad, Jordan Enzinger, Yenhsuan Lee, Erin Schwab, Jihyang Seo, and Enriqueta Somarriba. We are especially grateful to Patrick Gardner, distinguished professor of music and director of choral activities at the Mason Gross School of the Arts, whose talents are legion and who is

deeply committed to presenting his students with the highest professional artistic experiences while modeling diversity, civics, and humanism. The musicians' exquisite artistry would have made any performance memorable, but "Soundscapes" had an added poignancy. Many of the works had never been heard before because the artists themselves were murdered during World War II and the postwar Jewish community in Poland had more pressing issues than reviving the music of their modernist forebears. As one audience member commented, "We know what we lost in the 'old country,' but we are always hoping against hope to find any trace of the magnificent culture that existed among the Jews of Poland. You gave us a powerful and rich portrait of the differing styles that were popular during that entire interwar period."

The cover of this book was inspired by Leon Chejfec's image for the published score of "Rebeka," a sentimental tango from the revue *Yo-Yo*, which premiered in the Morskie Oko (Sea Eye) theater in Warsaw in 1932. For interwar audiences, the actor/singer Dora Kalinówna's rendition of the yearning for modern love by a traditional Jewish young woman epitomized the encounters between Jewish tradition and modernity of the period. The catchy song became an instant hit performed by many other artists. A photograph of Kalinówna onstage as Rebekah and an interwar performance of the song can be found here: https://stare-kino.pl/premiera-w-morskim-oku-yo-yo/. Honoring the artistry of Chejfec and Kalinówna—as well as that of the composer, Zygmunt Białostocki, and of Andrzej Włast, the lyricist and publisher of the song, and the founder of the Morskie Oko theater—our book's cover symbolically captures the breadth of imagination of interwar Jewish artists.

We are deeply gratified that we could bring the creativity of Jews in Polish lands to a broader audience in this volume and in its accompanying website.

Appendix

Soundscapes of Modernity Program

RUTGERS
Mason Gross School
of the Arts

SOUNDSCAPES OF MODERNITY:
JEWS & MUSIC IN POLISH CITIES

Rutgers Kirkpatrick Choir
Patrick Gardner, Director
Paul Conrad, Accompanist

Jordan Enzinger, Cello
Yenhsuan Lee, Viola
Erin Schwab, Soprano
Jihyang Seo, Violin
Enriqueta Somarriba, Piano

Part of the Fifth Annual Polish Jewish Studies Workshop
Natalia Aleksiun, Halina Goldberg, & Nancy Sinkoff,
Organizers

Monday, March 5, 2018 | 7:30 p.m.

Kirkpatrick Chapel
Rutgers, The State University of New Jersey

Program

"Boże zmiłuj się nad nami" (Psalm 67, Composed by Jakob Leopold Weiss
"God be merciful unto us") (1825–1889)
 From *Ozar schire jeschurun* Polish translation by Franciszek Karpiński
 (1873 and 1881)

 Rutgers Kirkpatrick Choir
 Paul Conrad, Accompanist

"Lecho dodi" Abraham Ber Birnbaum
 From *Hallel w'simrah* (1897) (1865-1922)
 Text by Salomon Alkabetz (ca. 1505-1584)

 Rutgers Kirkpatrick Choir
 Joshua Gonzalez, Solo
 Paul Conrad, Accompanist

Intermezzo, Op. 2 (1900) Paula Szalit
 (1886-1920)

 Enriqueta Somarriba, Piano

Mazurek" (1930) Henryk Cylkow
 (1866-1945)

 Enriqueta Somarriba, Piano

Mazurek" (1930s) Paweł Anhalt
 (1910-?)

 Enriqueta Somarriba, Piano

ive Pieces for Violin and Piano (1931) Aleksander Tansman
 (1897–1986)

 Jihyang Seo, Violin
 Enriqueta Somarriba, Piano

INTERMISSION

"Szkoda twoich łez, dziewczyno" Artur Gold
("It's No Use Crying, Girl") (1929) (1897–1943)
 Text by Andrzej Włast (1895-1943?)

 Erin Schwab, Soprano
 Enriqueta Somarriba, Piano
 Jihyang Seo, Violin

"Rochel's keiver" (ca. 1920) Zavel Zilberts
 (1881-1949)
 Text by K.A. Spiro

 Erin Schwab, Soprano
 Enriqueta Somarriba, Piano
 Jordan Enzinger, Cello

String Trio, Op. 10 (1928) Józef Koffler
 (1896-1944)

 Jihyang Seo, Violin
 Yenhsuan Lee, Viola
 Jordan Enzinger, Cello

"Farshpreyt zikh, vekhter," khor fun di Felix Mendelssohn-Bartholdy
vekhter fun di druidn, num. 4 der kantate (1809-1847)
Walpurgis nakht ("Verteilt euch, wack're Männer" Text by J.W. Goethe
from *Die erste Walpurgisnacht*) Yiddish translation by
 Moshe Broderzon (1890-1956)

 Rutgers Kirkpatrick Choir
 Paul Conrad, Accompanist

Setting of the folk song "Her nor, sheyn meydele" Izrael Fajwiszys
 (1887-1943)

 Rutgers Kirkpatrick Choir
 Paul Conrad, Accompanist

About the Program

In 1638 King Władysław IV, the ruler of the Polish-Lithuanian Commonwealth, was entertained during a banquet given in his honor in Lwów by an orchestra consisting of Jewish musicians—"musicorum Synagoga symphoniaci de tribu Juda"—dressed in Turkish attire. The chronicler commented that the king, who was overall favorably disposed toward the Jews, reacted with delight, and enjoyed himself well into the night while listening to the music and dancing.

Buried in Polish archives, such stories repeatedly remind us that regardless of legal restrictions and fierce competition between Jewish and gentile musicians, there were many opportunities for interaction between them. Court orchestras of Polish aristocrats were known to hire Jewish musicians when they were short of performers. Likewise, Jewish and gentile village bands borrowed each other's musicians for weddings and other festivities.

Opportunities for interaction and collaboration became even more frequent after the advent of the Haskalah (the Jewish Enlightenment). As early as the first decades of the 19th century, Jewish benefactors and audiences began supporting art music and Jewish musicians, who performed alongside gentiles on concert and operatic stages in Polish cities. This sort of musical engagement aligned well with several goals stated by the *maskilim* (advocates of the Haskalah) in Polish lands. Aesthetics were a central feature of their broader project of modernization, which they understood, in part, as "civilizing" the Jewish masses in order to regenerate Jewish culture. They were particularly interested in music's ability to foster cultural integration and encourage positive moral impulses. The same circles of patrons also supported the cultivation of new musical practices within the liturgy of the so-called "progressive" synagogues, Jewish houses of worship that sought to reform Jewish religious practice, albeit in a less radical manner than that of American Reform synagogues. The Jewish choral tradition thus established found new outlets at the start of the 20th century, with the rise of Jewish choral societies, many of them associated with Folkist, Socialist, and Zionist groups. All along, the broader Jewish audiences demonstrated a growing appetite for popular musical entertainment. At first, in the later 19th century, such music was associated with garden orchestras and operetta;

and later, during the interwar period, with cabaret and the movies.

The goal of today's concert is to present the breadth of music created in Polish cities during the 19th and early 20th centuries by Jewish composers whose careers were rooted in these diverse musical worlds. The program is framed by choral music: we open with compositions written expressly for progressive synagogues in Polish cities and close with musical arrangements prepared specifically for the use of Jewish choral societies. In between these bookends, we will hear various highbrow and popular styles of solo and chamber music that were cultivated by Jewish performers and composers and enjoyed by Jewish and gentile audiences.

With the establishment of two progressive congregations in Warsaw during the first quarter of the 19th century came changes to music heard during services. Following models established by Salomon Sulzer in Vienna, these congregations hired talented cantors who were charged with replacing the older tradition of a *hazzan* (prayer leader) accompanied by *meshorerim* (vocal accompanists) with a modern choir, alternating with and complementing the *hazzan*. In fact, Leon Sternberger—a student of Sulzer, who served in Warsaw during the 1840s—later became the cantor of the New York congregation Ansche Chesed in 1849 and is credited with having ushered in a new era in American synagogue music.

When **Jakob Leopold Weiss** (1825–1889) arrived in Warsaw in 1860, he was not only expected to perform the duties of chief cantor but was also given the authority to find and train the finest singers for the synagogue choir. Weiss, who later served a Wilno congregation, also composed choral music for his synagogues. "Boże zmiłuj się nad nami" is a setting of Psalm 67, "God be merciful unto us," in the Polish translation by the celebrated poet Franciszek Karpiński (1741–1825). Cantor Weiss, like his counterparts in Reform synagogues abroad, adopted a choral style that emulated Protestant choral traditions.

Similar choral writing is found in **Abraham Ber Birnbaum's** setting of the beloved poem "Lecho dodi" by the mystic Salomon Alkabetz (ca. 1505–1584), sung during the weekly ritual of the *kabbalat Shabbat*, "the welcoming of the Sabbath" (today's performance uses the traditional Ashkenazi pronunciation of the Hebrew). Abraham Ber Birnbaum (1865–1922)—not to be confused with Eduard

Birnbaum, the famous cantor of Königsberg, who amassed the collection now at Hebrew Union College in Cincinnati—trained in Łódź, and, starting in 1893, became the chief cantor of the progressive congregation in Częstochowa, a position he held for 20 years. During his tenure, he spearheaded countless initiatives, including the establishment of a cantorial school at Częstochowa's stately New Synagogue and the founding of two choral societies—the Jewish "Hazomir" and the nondenominational "Lira."

By the end of the 19th century, the amateur choral movement took root, with organizations such as "Lira," "Hazomir" and "Szir" sprouting in small towns and big cities. In Łódź, "Hazomir" and the affiliated symphonic orchestra performed an ambitious repertory of oratorios by Handel, Haydn, and Mendelssohn-Bartholdy, and other monumental works, including Beethoven's Ninth Symphony and Mozart's Requiem. Among "Hazomir's" conductors were Józef Rumszyński (yes, the legendary Rumshinsky, who in 1904 settled in New York and became a celebrated composer for Yiddish theater) and **Zavel Zilberts** (1881–1949), who after emigrating, established several prominent choral groups in New York, and whose "Rochel's keiver" (Rachel's Tomb) is also presented today.

The setting of the well-known folk song "Her nor, sheyn meydele" is by **Izrael Fajwiszys** (1887–1943), whose illustrious conducting career took him from Brody to both Kraków and Lwów, where he conducted synagogue and amateur choirs. He settled in 1922 in Łódź, directing both the "Hazomir" and "Szir" choirs and teaching choruses in Jewish high schools. Even in the last years before he per-ished in the Nazi camp in Poniatowa, Fajwiszys conducted the children's choir "Dror" in the Warsaw Ghetto. Fajwiszys's arrangement of "Her nor, sheyn mey-dele" and the Yiddish rendition of the chorus from *Die erste Walpurgisnacht* by **Felix Mendelssohn-Bartholdy** (1809–1847) come from a rare copy of a two-vol-ume collection published in Wilno on the eve of World War II. Billed as the repertory of a chorus led by Jakub Gersztajn (who perished in the Wilno Ghetto in 1943), and assembled by him, the collection demonstrates trends typical of Wilno's artistic circles: the interest in Jewish folk culture and the penchant for performing mainstream musical compositions in Yiddish translation (there, one could even hear Verdi's and Puccini's operas in Yiddish).

The extraordinary participation in the international concert arena of Polish Jewish virtuosos—the likes of Edward Wolff, Karol Tausig, Ignacy Friedman, Maurycy Rosenthal, Wanda Landowska, Felicja Blumental, Artur Rubinstein, and Mieczysław Horszowski, to mention just some of the pianists flourishing between the early 19th and late 20th centuries—is represented here by music of **Paula Szalit** (1886–1920), a brilliant pianist from Drohobycz, who died in Lwów before reaching the age of 35. Szalit was only 14 years old when she composed the *Intermezzo*—a little gem of extraordinary beauty.

At the turn of the 20th century, new aesthetic and artistic tendencies gained a foothold in major cultural centers of the Western world, and Polish Jewish artists—writers, poets, painters, sculptors, architects, and composers—enthusiastically engaged with modernism in the local and international arenas, side-by-side their gentile counterparts. These modernist movements were characterized by diverse and complex ways of imagining the encounters between the past and the future, tradition and innovation, form and contents.

The mazurkas by **Henryk Cylkow** (1866–1945) and **Paweł Anhalt** (1910–?), Jewish musicians active in Kraków during the interwar period, show remarkable affinity with the new stylistic trends initiated by Karol Szymanowski, the doyen of the Polish musical scene during this period, who imbued the traditional genre of the mazurka with new expressive harmonic contents. Indeed, what catches our attention is the expanded harmonic language of these pieces, which firmly places them in the new modernist milieu.

For **Aleksander Tansman** (1897–1986), a composer who grew up in Łódź, Paris became home (with the exception of war years, when he sought refuge in Los Angeles). Thus, Tansman's musical language became aligned with the aesthetics of neoclassicism favored by the Parisian musical circles. His *Five Pieces for Violin and Piano* are characterized by adventurous melodic and harmonic idiom but are cast in forms and genres hailing back to the Baroque instrumental partita. In listening to the piece, one cannot help but be swayed by the exquisite lyricism and daring virtuosity of Tansman's music.

In contrast to Tansman, **Józef Koffler** (1896–1944) looked to Vienna for inspira-

tion. Born in Stryj, Koffler was associated for most of his life with Lwów musical institutions. During his studies in Vienna, he became acquainted with the dodecaphonic (12-tone) technique, characteristic of compositions by Arnold Schoenberg, Alban Berg, and Anton Webern. Upon his return to Lwów, Koffler became the first Polish composer to embrace this technique consistently. His works, exemplified in today's concert by the string trio, tend toward the more lyrical idiom of Berg (as opposed to the more abstract works of Webern). Listening to the expressive power and compositional craft of Koffler's avant-gardist work, one realizes what an extraordinary loss for Polish music was his brutal death at the hands of the Nazis and the destruction of nearly half of his compositions.

No concert that intends to demonstrate the range of music contributed by Polish Jews would be complete without a sampling of Polish popular music from the interwar period. These contributions—by Jewish lyricists, composers, bandleaders, instrumentalists, and singers—were staggering. Even the founder of Syrena Record, the phonograph record company that was responsible for the distribution of many of these songs, was Jewish. It is difficult to find a tango, a foxtrot, a cabaret song, or a film score from that period that did not have a Jewish contributor in some role. Young working-class Jews from large cities were among the most enthusiastic consumers of this music, so much so that some of the songs were performed and recorded in Yiddish, or even Hebrew, for export to Palestine. **Andrzej Włast** (1895–1943?), the lyricist of the tango "Szkoda twoich łez, dziewczyno" (It's No Use Crying, Girl), who was born in Łódź as Gustaw Baumritter, is credited with over 2,000 texts, fruits of his collaborations with theaters, cabarets, and composers. **Artur Gold** (1897–1943), a composer of many hits of the era, was also the leader of a popular jazz band. Both Włast and Gold were murdered by the Nazis.

We tend to imagine musical activities in Poland as taking place in segregated Jewish and gentile realms. With this concert, we hope to dispel these notions. Beyond the tragic loss of individual musicians during the Holocaust, the destruction of Polish Jewry resulted in the erasure of the historical memory about the role of Jewish music and musicians in the musical history of Poland. Our hope is to give these artists back their musical voice.

<div align="right">Notes by Halina Goldberg</div>

Rutgers Kirkpatrick Choir
Patrick Gardner, Director
Paul Conrad, Accompanist

Soprano
Alexis Bethea-Awokoya
Gabriella Camiolo
Hannah Carr*
Gabriella Florio
Deirdre Hansalik
Megan Lako
Genesis Marte
Lynn Messina
Maya Mitterhoff
Hannah Orr
Nicolette Policastro
Alison Rydwin
Alessia Santoro
Felicia Zangari

Tenor
Alex Ashman
Nathan Bishop
Jonathan Blanco
Kyle Casem
Nicolás de la Cruz
Joseph Dodrv
Stephen Dodrv
Vincent Giampino
Joshua Gonzalez
Peter Gillett
Joshua LeRose
Brian McCann
Nicholas Nicassio*
Paul Salierno
Matthew Zabiegala*

*Denotes teaching assistant

Alto
Brooke Barkdull
Amanda Batista
Kelly Brecker
Shreya Choudhury
Rebekah Daly
Jennifer Dinan
Arielle Fuhrman
Linda Garcia
Glynnis Gourhan
Rachel Horner
Lyndsey Larsen
Kathleen Lonski
Reid Masters*
Shobhana Sridhar
Riti Suresh

Bass
Jason Allen
Jonathon Dawson
Larrej Drayton
Joseph Ferguson
Kyle Gelatka
Jeffrey Greiner
Joseph Haverlock
Steven Haverlock
Taylor Hine
Omar Marcial
Lucas Marin
Carl Muhler
Nicolas Noa
Michael Tatoris
Sean Ullmer

About the Artists

Paul Conrad holds a bachelor of music in piano performance from the Mason Gross School of the Arts, where he studied with Paul Hoffmann. He collaborates with the Berkshire Choral Festival and NJ Region Choirs. Conrad is an avid ballet pianist, playing regularly for the Mason Gross Dance Department and at the Cecchetti International Summer School in Michigan. He serves as organist at Middlebush Reformed Church in Franklin, New Jersey, and as accompanist for the Highland Park Community Chorus. He rejoins his "brothers (and sisters)-in-song" at Rutgers as accompanist for both the Rutgers University Glee Club and Rutgers Kirkpatrick Choir. He is pursuing his master's degree in collaborative piano at Mason Gross.

With a versatile background in solo, chamber, and orchestral music, **Jordan Enzinger** is a freelance performing and teaching cellist in the New Jersey, New York City, and Philadelphia areas. He regularly performs with ensembles such as the Orchestra of St. Luke's, American Symphony, and Princeton Symphony, in venues including Carnegie Hall, Lincoln Center, and the Kimmel Center. As a pedagogue, Enzinger serves as collegiate cello faculty at Seton Hall University; guest lectures for collegiate music classes at Rutgers; serves as cello faculty at the Mason Gross Extension Division and the Princeton String Academy; and serves as chamber music faculty at the Rutgers Young Artist Program and the American String Teachers Association Chamber Music Institute. He is a registered cello instructor for the Suzuki Association of the Americas and maintains his private cello studio in New Brunswick, New Jersey. He holds a D.M.A. in cello from the Mason Gross School of the Arts.

Patrick Gardner's performances have been acclaimed by audiences, critics, and composers, including Tarik O'Regan, William Bolcom, John Harbison, Lou Harrison, Lukas Foss, and Jennifer Higdon. The performance last year of major works by Lou Harrison, which he curated and conducted at Trinity Church Wall Street, was named in *The New York Times* list of "Best Classical Performances of 2017." Director of the Riverside Choral Society of New York City, Gardner is also director of choral activities at Rutgers University, conducting the Rutgers Kirkpatrick Choir and the Rutgers Glee Club and supervising doctoral students in

choral conducting. He has conducted more than 100 major choral orchestral masterworks, from the Bach B-minor Mass at Carnegie Hall to the Missa Solemnis and the Verdi and Brahms Requiems at Lincoln Center. He has presented master classes for advanced choral conducting students and professional conductors in Taiwan, Italy, and the Netherlands. Gardner has served as a member of the grants panel of the National Endowment for the Arts and has recorded for the Naxos, Albany, Ethereal, and Folkways labels.

Yenhsuan Lee is a second-year M.M. student in viola at the Mason Gross School of the Arts, studying under Daniel Panner and Yura Lee. A graduate of Cleveland Institute of Music, Lee has attended the American Conservatory summer music festival in Fontainebleau, France, and has participated in master classes and lessons under Benjamin Zander, James Buswell, Jean Sulem, Peter Salaff, Yehudi Wyner, and Pierre-Henri Xuereb, among many others.

Erin Schwab is a second-year M.M. candidate in voice at the Mason Gross School of the Arts, in the studio of Judith Nicosia. She holds a B.M. from Rutgers, along with an award for Outstanding Achievement in Music (2014). Further studies include the Chautauqua Institution Voice Program (2015) and the Castleton Artists' Training Seminar (2012–2014). Operatic roles include Susanna *(Le Nozze di Figaro)*, Die Erste Dame *(Die Zauberflöte)*, Venus *(Venus and Adonis)*, Soeur Constance *(Les Dialogues des Carmélites)*, La Princesse *(L'enfant et les sortilèges)*, Alexandra *(Regina)*, Ginevra *(Ariodante)*, Nanetta *(Falstaff)*, Lucia *(The Rape of Lucretia)*, Noémie *(Cendrillon)*, and Lucy Lockit *(The Beggar's Opera)*. Upcoming engagements include the role of Nanetta *(Falstaff)* at the Crested Butte Music Festival. Schwab is also an accomplished chorister and concert soloist.

Jihyang Seo is a D.M.A. candidate in violin performance at the Mason Gross School of the Arts. She has studied with Soovin Kim, Philip Setzer, and Jennifer Frautschi at the State University of New York at Stony Brook, and she is a student of Carmit Zori. She has served as concertmaster and principal second violin of the Rutgers Symphony Orchestra.

Spanish pianist **Enriqueta Somarriba** has been praised by the New York Concert Review for her "aplomb" and her "natural, individual interpretation." Her

repertoire ranges from the Baroque to the 21st century, with focus on contemporary, Spanish, and Latin American music. She has appeared at New York's Carnegie Hall, Cervantes Institute, Liederkranz Concert Hall, and internationally renowned venues in Italy, Belgium, France, and Spain. She has recorded for RNE (Spanish National Radio), 98.7 WFMT Chicago, 89.1 WWFM radio, and MSR Classics. Somarriba studied with Solomon Mikowsky at Manhattan School of Music, and she is a D.M.A. candidate at Rutgers University, where she serves as lecturer.

Rutgers Kirkpatrick Choir, with approximately 60 members, is the most advanced choir at the Mason Gross School of the Arts. Its mission: to educate professional musicians through performance. The Rutgers Kirkpatrick Choir performs a significant repertory of major choral orchestral masterworks, Baroque music accompanied by period instruments, and important works of the 20th and 21st centuries. The Rutgers Kirkpatrick Choir was approached by the Milken Archive of American Jewish Music to record several CDs of important 20th-century works, including Miriam Gideon's Sacred Service, which was released as part of the Milken Archive of American Jewish Music's comprehensive multiyear recording series on Naxos American Classics series. They also have a Naxos release of Samuel Adler's Five Sephardic Songs.

About the Symposium

Soundscapes of Modernity: Jews and Music in Polish Cities is offered in conjunction with the Fifth Annual Polish Jewish Studies Workshop, taking place at the Rutgers University Inn and Conference Center, March 5–6. The workshop focuses on Jewish cultural production, but also on cultural collaborations and tensions between Christians and Jews in the years of Poland's partitions and independence (1772–1939) in urban centers other than Warsaw—especially Wilno, Lwów, Kraków, and Łódź. The symposium is organized by Natalia Aleksiun (Touro College), Halina Goldberg (Indiana University), and Nancy Sinkoff (Rutgers University). The workshop's website is:
www.sas.rutgers.edu/cms/ces/polish-jewish-workshop

Selected Bibliography

Given the shifting and inconsistent state borders during the period considered in this book, we have dispensed with the name of the country for the published primary sources. We retained the Yiddish name Vilna for primary sources published in Yiddish. For secondary sources, the names of the publisher's city and country reflect current state borders, e.g., Lviv, Ukraine and Vilnius, Lithuania.

Primary Sources

Archives and Databases
Abraham Liessin Papers. YIVO Archives, RG 201. New York.
Archiwum Narodowe w Krakowie. Kraków.
Ben-Yehuda Project. Edited by Assaf Bartov and Shani Ebenstein Siglov. Hebrew Literature Digitization Society. Israel. https://benyehuda.org/.
Central State Historical Archive of Ukraine. Lviv, Ukraine.
Central Zionist Archives. Jerusalem.
Collection of the Emanuel Ringelblum Jewish Historical Institute. Warsaw, Poland.
Ghetto Fighters' House Archive. Kibuts Loḥamei Hageta'ot, Israel.
Hashomer hatsa'ir Archives. Israel.
Historical Jewish Press Project. Directed by Yaron Tsur and Yaron Deutscher. The National Library of Israel in partnership with Tel Aviv University. http://www.jpress.org.il/.
Naftali Cohn Family Archive. Montreal, Canada.
Poland Collection. YIVO Archives, RG 28. New York.
Polona. Administered by the National Library of Poland. https://polona.pl.
Poster Collection. Jabotinsky Institute. Tel Aviv, Israel.
State Archive of Lviv Oblast. Lviv, Ukraine.
United States Holocaust Memorial Museum Archives. Washington, D.C.
Visual History Archive. USC Shoah Foundation. Los Angeles, Calif.

Printed Materials

Periodicals

ABC
Albatros
Altoona Tribune
Architektura i Budownictwo
Avodatenu
Beys Yakov: Ortodoksisher zhurnal
Biyuletin brit trumpeldor, mifkedet galil baranowicze
Brisker vokhenblat
Byalistoker lebn
Chwila
Czas
Der moment
Di tsukunft
Dos fraye vort
Enquirer
Ewa
Film velt
Filomata
Gazeta Polska
Gazeta wieczorna
Głos Prawdy
Gluboker lebn
Grodner moment (ekspres)
Ha'arets
Hamedinah
Hamelits
Hashomer hatsa'ir
Hasło Łódzkie
Hatsefirah
Haynt
Hayntige nayes
Heḥaluts-hatsa'ir
Hejnał
Ḥoveret betar: Avodatenu
Ilustrowana Republika
Ilustrowany Kurier Codzienny
In kamf
Izraelita
Jüdisch-liberale Zeitung
Jutrzenka: Tygodnik dla Izraelitów polskich
Kin ta rad
Kraj
Kurjer Polski
Kurjer Poznański
Landkentenish: Tsaytshrift far fragn fun landkentenish un turistik, geshikhte fun yidishe yishuvim, folklor un etnografiye
Lippincott's Monthly Magazine
Literarishe bleter
Lubliner togblat
Madrikh betar
Maḥmadim
Mucha
Musical Quarterly
Nasz Kurjer
Nasz Przegląd
Nayer folksblat
New York Times
Nowa Gazeta Łódzka
Nowa Reforma
Nowe Życie
Nowy Dziennik
Ojczyzna
Opinia
Pologne Litteraire
Polska zbrojna
Przegląd Pedagogiczny
Przegląd Społeczny
Przodownica
Radomer-kieltser lebn
Ringen
Robotnik
Ruch Pedagogiczny
Śmiech
Tańczący ogień: Dla sztuki i wszystkiego, co z nią związane
Tomashever tsaytung
Tomashover vort
Trybuna Akademicka
Tygodnik
Unzer ekspres
Unzer lodzher veker
Unzer veg
Vilner tog
Vlotslovkher shtime
Yidish teater
Yung-Vilne
Yung-yidish
Życie
Życie Świadome: Kwartalnik poświęcony zagadnieniom reformy seksualnej i obyczajowej
Życie Szkolne

Other Publications

Agnon, Samuel. *Das Buch von den polnischen Juden*. Edited by Samuel Agnon and Aharon Eliasberg. Berlin: Jüdischer Verlag, 1916.

———. *Die Erzählung vom Toraschreiber*. Translated by Max Strauß. Berlin: Verlag Marx, 1923.

Aleichem, Sholem. *Shomers mishpet*. Berdichev: Sheftl, 1888.

Bartkiewicz, Zygmunt. *Złe miasto*. Warsaw: Nakładem Jana Czempińskiego, 1911.

Bauminger, Aryeh, ed. *Em BiYisra'el: Sefer zikaron lesarah shenirer*. Bene Berak: Netzaḥ Press, 1983.

Benjamin, Walter. *Selected Writings*. Vol. 2, *1927–1934*, edited by Michael Jennings, Howard Eiland, and Gary Smith. Cambridge, Mass.: Harvard University Press, 2001.

Bleter 1940: Zamlbukh far literatur un kunst. Kaunas: Union of Yiddish Writers and Artists in Lithuania, 1940.

Boy-Żeleński, Tadeusz. *Pisma*. Vol. 21. Warsaw: Państwowy Instytut Wydawniczy, 1958.

Broderzon, Moyshe. *Forshtelungen*. Łódź: Nayer Folksblat, 1936/1937.

———. *Shvarts-shabes*. Łódź: Farlag Yung-yidish, 1921.

———. *Sikhes khulin*. Moscow: Nashe Iskusstvo, Shamir, 1917.

———. *Tkhiyes hameysim*. Łódź: Farlag Yung-yidish, 1917.

Brossowa, Anna. *Józef Mazzini szermierz niepodległości Włoch i przyjaciel Polski*. Lwów: Filomata, 1939.

Brückner, Aleksander, ed. *Polska, jej dzieje i kultura od czasów najdawniejszych do chwili obecnej. T. 3, Od roku 1796–1930*. Warsaw: Trzaska, Evert i Michalski, 1932.

Courtenay, Jan Niecisław Baudouin de. *Pamięci Wilhelma Feldmana*. Kraków: Drukarnia Narodowa, 1922.

Czech, Józef, ed. *Józefa Czecha Kalendarz Krakowski na rok 1899*. Kraków: W księgarni J. Czecha, 1899.

Dankowicz, Szymon. *Kazanie miane w czasie żałobnego nabożeństwa za wiekopomnej pamięci Króla Kazimierza Wielkiego w dniu powtórnego pochowania zwłok Jego na Wawelu dnia 8 lipca 1869 roku w Synagodze Izraelitów przyjaciół postępu na Podbrzeziu w Krakowie*. Kraków: Czcionkami Karola Budweisera, 1869.

Dobrzański, Julian, ed. *II Sprawozdanie C. K. Rady Szkolnej Okręgowej Miejskiej w Krakowie za rok szkolny 1912/1913*. Kraków: Nakładem Gminy Stołecznego Królewskiego Miasta Krakowa, 1913.

Epsztajn, Israel. *Hora'ot lehakhsharah hatarbutit bakenim*. Warsaw: Futura, 1935.

Eynhorn, Dovid. *Gezamlte lider 1904–1924*. Berlin: Farlag yidishe arbeter-bukhhandlung, 1924.

Fried, Meir Ya'akov. *Yamim veshanim*. Vol. 1. Tel Aviv: Dvir, 1938.

Friedman, Filip. *Dzieje Żydów w Łodzi, od początków osadnictwa Żydów do r. 1863 stosunki ludnościowe, życie gospodarcze, stosunki społeczne*. Łódź: Nakładem Łódzkiego Oddziału Żydowskiego Towarzystwa Krajoznawczego w Polsce, 1935.

Garfeinowa-Garska, Malwina. *Z kobiecej niedoli*. Warsaw: Nakładem Spółdzielni Księgarskiej "Książka," 1927.

Goldberg, Moshe. *Der beytarisher ken: Instruktsyes un onvayzungen*. Warsaw: Styldruk, 1934.

Grodzenski, A. Y., ed. *Vilner almanakh*. Vilna: Ovnt kurier, 1939.

Ilustrowany Kalendarz Diabelski na Rok 1896. Kraków: Nakładem księgarni Władysława Poturalskiego, 1896.

Ilustrowany Kalendarz Diabelski na Rok 1897. Kraków: Nakładem księgarni Władysława Poturalskiego, 1897.

Irzykowski, Karol. *X Muza: Zagadnienia estetyczne kina*. Kraków: Krakowska Spółka Wydawnicza, 1924.

Kästner, Erich. *Emil un di detektivn*. Translated by Mojsze Tajchman. Warsaw: Kinder fraynd, 1935.
Lerner, Zelig. *Maḥanot kayits / Zumer lagern*. Warsaw: Grafja, 1932.
Levin, Moyshe. *Friling in kelershtub: Noveln un humoreskes*. Vilna: B. Kletskin, 1937.
Łodzianka: Kalendarz humorystyczny na rok 1910. Łódź: Rubinek, 1909.
Lorentz, Zygmunt. *Narodziny Łodzi nowoczesnej*. Łódź: Nakładem Prezydjum Rady Miejskiej, 1926.
Marinetti, Filippo Tommaso, Emilio Settimelli, and Bruno Corra. "The Synthetic Futurist Theatre: A Manifesto" (Milan, 1915). Translated by Suzanne Cowan. *Drama Review* 15, no. 1 (Autumn 1970): 142–146.
Murnau, F. W., dir. *Tabu*. Los Angeles: Murnau-Flasherty Productions, 1931.
Peretz, Yitzkhok Leyb. *Gleichnisse*. Translated by Alexander Eliasberg. Lithographs by Jakob Steinhardt. Berlin: Verlag für Jüdische Kunst und Kultur Fritz Gurlitt, 1920.
——. *Musikalische Novellen: Mit fünf Original-Lithographie von Jakob Steinhardt*. Translated by Alexander Eliasberg. Berlin: Verlag für Jüdische Kunst und Kultur Fritz Gurlitt, 1920.
Plohn, Alfred. "Muzyka we Lwowie a Żydzi (1936)." *Muzykalia XIII / Judaica* 4 (May 2012): 1–24. http://demusica.edu.pl/wp-content/uploads/2019/07/plohn_muzykalia_13_judaica_4.pdf.
Przybyszewski, Stanisław. *Moi współcześni: Wśród obcych*. Warsaw: Instytut Wydawniczy Biblioteka Polska, 1926.
Pulikowski, Julian. "Idelsohn A. Z. 'Hebräisch-orientalischer Melodienschatz' Bd. 1–4, Lipsk—Jerusalem 1912–1923, 'Jewish Music in Its Historical Development' Nowy Jork 1929: Reviews." *Polski Rocznik Muzykologiczny* 1 (1935): 173–182.
Remba, Ajzik, ed. *Shnatayim: Din ve-ḥeshbon shel netsivut Betar beFolanyah*. Warsaw: Futura, 1934.
Schenirer, Sarah. *Em BiYisra'el: Kitve Sarah Shnirer: Toldot ḥayehah, ma'amarim, sipurim, maḥazot*. Edited by Yeḥezkel Rotenberg. 4 vols. Tel Aviv: Hotsa'at Netsaḥ, 1955–1960.
——. *Gezamelte shriften*. Brooklyn, N.Y.: Beth Jacob Teachers Seminary of America, 1955.
——. *"Żydówką być to rzecz niemała"—pisma autobiograficzne Sary Szenirer*. Edited by Dariusz Dekiert and Joanna Lisek. Translated by Dariusz Dekiert. Warsaw: Wydawnictwo Naukowe PWN, forthcoming.
Schiper, Ignacy. *Geshikhte fun der yidisher teater-kunst un drame: Fun di eltste tsaytn bis 1750*. 3 vols. Warsaw: Farlag Kultur-Lige, 1927–1928.
Shatzky, Jacob, ed. *Arkhiv far der geshikhte fun yidishn teater un drame*. Vol. 1. Vilna: Yidisher visnshaftlekher institut, Teater muzey fun Ester-Rokhl Kaminski, 1930.
Sprawozdanie Kierownictwa Żydowskiego Gimnazjum Koedukacyjnego Typu Humanistycznego Towarzystwa Żydowskiej Szkoły Ludowej i Średniej w Krakowie za rok szkolny 1928/1929. Kraków: Nakładem Kierownictwa Żydowskiego Gimnazjum Koedukacyjnego w Krakowie, 1929.
Sprawozdanie Kierownictwa Żydowskiego Gimnazjum Koedukacyjnego Typu Humanistycznego Towarzystwa Żydowskiej Szkoły Ludowej i Średniej w Krakowie za rok szkolny 1931/1932. Kraków: Nakładem Kierownictwa Żydowskiego Gimnazjum Koedukacyjnego w Krakowie, 1932.
Sprawozdanie z czynności Wydziału Stowarzyszenia Czytelni Starozakonnej Młodzieży Handlowej w Krakowie za czas od d. 1 października 1884 r. do d. 1 października 1885 r. Kraków: Józef Fischer Publishing House, 1885.
Stefana Mikulskiego Wielka Księga Adresowa Stołecznego Królewskiego Miasta Krakowa i Królewskiego Wolnego Miasta Podgórza. 10 vols. Kraków: Nakładem Stefana i Maryi Mikulskich, [1906?]–1925.
Stendigowa, Felicja. *Usta lakierowane*. Kraków: Ksiegarnia Powszechna, 1938.

Szyk, Zalmen. *Toyznt yor Vilne*. Vilna: Gezelshaft far landshaftkayt in Poyln-Vilner opteyl, 1939.

Trunk, Yekhiel Yeshaya. *Poyln: Zikhroynes un bilder*. 7 vols. New York: Farlag "Unzer tsayt," 1944–1953.

Vogler, Elkhonen. *A bletl in vint*. Vilna: Yung-Vilne, 1935.

———. *Friling afn trakt: Lider un poemen*. Paris: Farband fun di Vilner in Frankraykh, 1954.

———. *Tsvey beriozes baym trakt*. Vilna: Yidisher literatn-fareyn un PEN-klub in Vilne, 1939.

Wera, Artur Marcel. *Rosa, wir fahr'n nach Lodzh: Marsch-couplet*. Vienna: Kreun, 1915.

Wiesenberg, Jonasz. *Maurycy Gottlieb (1856–1879): Szkic biograficzny*. Złoczów: Zukerkandel, 1888.

Secondary Sources

Adamczyk-Garbowska, Monika, Eugenia Prokop-Janiec, Antony Polonsky, and Sławomir Jacek Żurek, eds. *Jewish Writing in Poland*. Vol. 28 of *Polin: Studies in Polish Jewry*. Oxford: Littman Library of Jewish Civilization, 2015.

Adler, Eliyana R. *In Her Hands: The Education of Jewish Girls in Tsarist Russia*. Detroit: Wayne State University Press, 2011.

Aleksiun, Natalia. *Conscious History: Polish Jewish Historians before the Holocaust*. Oxford: Littman Library of Jewish Civilization in association with Liverpool University Press, 2021.

———. "Gender and Nostalgia: Images of Women in Early *Yizker Bikher*." *Jewish Culture and History* 5, no. 1 (Summer 2002): 69–90.

Alexander, Michael. *Jazz Age Jews*. Princeton, N.J.: Princeton University Press, 2001.

Almog, Oz. *Hatsabar dyokan*. Tel Aviv: Am Oved, 1997.

Almog, Shmuel, Jehuda Reinharz, and Anita Shapira, eds. *Zionism and Religion*. Jerusalem: Zalman Shazar Center, 1994.

Ankum, Katharina von, ed. *Women in the Metropolis: Gender and Modernity in Weimar Culture*. Berkeley: University of California Press, 1997.

Ansell, Joseph. *Arthur Szyk: Artist, Jew, Pole*. Oxford: Littman Library of Jewish Civilization, 2004.

Aptroot, Marion, Efrat Gal-Ed, Roland Gruschka, and Simon Neuberg, eds. *Leket: Yidishe shtudyes haynt / Jiddistik heute / Yiddish Studies Today*. Düsseldorf: Düsseldorf University Press, 2012.

Arendt, Hannah. "From the Dreyfus Affair to France Today." *Jewish Social Studies* 4 (1942): 195–240.

———. "The Jew as Pariah: A Hidden Tradition." *Jewish Social Studies* 6 (1944): 99–122.

Ascheim, Steven. *Brothers and Strangers: The East European Jew in German and German-Jewish Consciousness, 1800–1923*. Madison: University of Wisconsin Press, 1982.

Avinadav, Aryeh, ed. *Kehilat Ustilah bevinyanah uveḥurbanah*. Tel Aviv: Irgun yotse Ustilah biYisra'el uvatefutsot, 1961.

Bacon, Gershon. *The Politics of Tradition: Agudat Yisrael in Poland, 1916–1939*. Jerusalem: Magnes, 1996.

Bakić-Hayden, Milica. "Nesting Orientalisms: The Case of Former Yugoslavia." *Slavic Review* 54 (1995): 917–931.

Bałaban, Majer. *Dzieje Żydów w Krakowie i na Kazimierzu (1304–1868)*. Vol. 1. Kraków: Nakładem Izraelickiej Gminy Wyznaniowej w Krakowie, 1912.

———. *Przewodnik po żydowskich zabytkach Krakowa: Z 13 rycinami w tekście, z 24 rotograwjurami na oddzielnych tablicach, z 2 planami*. Kraków: Solidarność B'nei B'rith, 1935.

Baranowicz, Jan, Marian Brandys, Jan Brzechwa, Bohdan Czeszko, Stanisław B. Dobrowolski, Helena Duninówna, Adam Grzymała-Siedlecki et al., eds. *Kredą na tablicy: Wspomnienia z lat szkolnych*. Warsaw: Czytelnik, 1958.

Baron, Salo W. "Eulogy: Philip Friedman." *Proceedings of the American Academy of Jewish Research* 29 (1960): 1–7.
Bartal, Israel. "Midu-leshoniyut mesoratit leḥad-leshoniyut le'umit." *Shvut* 15 (1992): 183–194.
Bartal, Israel, and Antony Polonsky, eds. *Focusing on Galicia: Jews, Poles, and Ukrainians, 1772–1918*. Vol. 12 of *Polin: Studies in Polish Jewry*. London: Littman Library of Jewish Civilization, 1999.
Bartelik, Marek. *Early Polish Modern Art: Unity in Multiplicity*. Manchester: Manchester University Press, 2005.
Baskin, Judith, ed. *Jewish Women in Historical Perspective*. 2nd ed. Detroit: Wayne State University Press, 1998.
Bauer, Ela. "The Jews and the Silver Screen: Poland at the End of the 1920s." *Journal of Modern Jewish Studies* 16 (2017): 80–99.
Beigel, G., ed. *Mayn shtetele Berezne*. Tel Aviv: Berezener landslayt komitet in Yisroyel, 1954.
Belda, Maciej Władysław, ed. *To była hebrajska szkoła w Krakowie: Gimnazjum Hebrajskie 1918–1939*. Kraków: Muzeum Historyczne Miasta Krakowa, 2011.
Belis, Shloyme. "Bay di onheybn fun Yung-Vilne." *Di goldene keyt* 101 (1980): 11–65.
———. "Vegn fir molers fun Yung-Vilne." *Di goldene keyt* 109 (1982): 36–41.
Belkin, Ahuva. *Hapurim shpil: Iyunim bate'atron hayehudi ha'amami*. Jerusalem: Bialik Institute, 2002.
Ben-Gurion, David. *Zikhronot*. Vol. 2. Tel Aviv: Am Oved, 1972.
Benisch, Pearl. *Carry Me in Your Heart: The Life and Legacy of Sarah Schenirer, Founder and Visionary of the Bais Yaakov Movement*. Jerusalem: Feldheim, 2003.
Bennett, Michael, and Vanessa Dickerson, eds. *Recovering the Black Female Body*. New Brunswick, N.J.: Rutgers University Press, 2001.
Benson, Timothy O., and Eva Forgács, eds. *Between Worlds: A Sourcebook of Central European Avant-Gardes, 1910–1930*. Cambridge, Mass.: MIT Press, 2002.
Bereshit, Ḥayim, Shelomo Sand, and Moshe Zimmerman, eds. *Kolno'a vezikaron: Yaḥasim mesukanim?* Jerusalem: Mercaz Zalman Shazar, 2004.
Berg, Hubert van der, and Walter Fähnders, eds. *Metzler Lexikon: Avantgarde*. Stuttgart: J. B. Metzler, 2009.
Berlevi, Henryk. "Der zig-zag fun der yidisher kunst." *Almanakh: Aroysgegebn durkhn fareyn fun yidishe shrayber un zhurnalistn in Frankraykh* 1 (1955): 97–108.
Bernshteyn, Mordkhe, and David Porer, eds. *Pinkes fun finf fartilikte kehiles: Pruzshene, Bereze, Maltsh, Sherhshev, Selts*. Buenos Aires: Landslayt fareyn fun Pruzshene in Argentine, 1958.
Bhabha, Homi. "The Other Question . . . Difference, Discrimination and the Discourses of Colonialism." *Screen* 24, no. 6 (1984): 18–36.
Biale, David, ed. *Cultures of the Jews: A New History*. New York: Schocken, 2002.
Bilewicz, Aleksandra. "Prywatne średnie, ogólnokształcące szkolnictwo żeńskie w Galicji w latach 1867–1914." *Acta Universitatis Wratislaviensis: Prace Pedagogiczne* 116 (1997): 3–128.
Bogucka, Maria, ed. *Wspólnoty lokalne i środowiskowe w miastach i miasteczkach ziem polskich pod zaborami i po odzyskaniu niepodległości*. Toruń: Wydawnictwo Uniwersytetu Mikołaja Kopernika, 1998.
Boguszewska, Anna. "Kształcenie w zakresie grafiki w szkolnictwie artystycznym Krakowa, Lwowa i Wilna w latach międzywojennych." *Biuletyn Historii Wychowania* 29 (2013): 85–99.
Bohlman, Philip V. *Jewish Music and Modernity*. Oxford: Oxford University Press, 2008.
Borowiec, Jarosław, ed. *Kronika Szkolna uczennic żydowskich z lat 1933–1939: Miejskiej Szkoły Powszechnej nr 15 im. Klementyny Tańskiej-Hoffmanowej przy ul. Miodowej w Krakowie*. Kraków: Wydawnictwo Austeria, 2006.

Boruszkowska, Iwona. "Akuszerki awangardy: Kobiety a początki nowej sztuki." *Pamiętnik Literacki* 3 (2019): 5–14.
Bosomtwe, Olivia M. "Czarna perła. Kino popularne między kolonializmem a nowoczesnością." *Kultura popularna* 1, no. 47 (2016): 146–158.
Bourdieu, Pierre. *The Rules of Art: Genesis and Structure of the Literary Field*. Translated by Susan Emanuel. Stanford, Calif.: Stanford University Press, 1996.
Boyarin, Jonathan, and Jack Kugelmass, eds. *From a Ruined Garden: The Memorial Books of Polish Jewry*. Rev. and expanded ed. Bloomington: Indiana University Press, 1998.
Brauch, Julia, Anna Lipphardt, and Alexandra Nocke, eds. *Jewish Topographies: Visions of Space, Traditions of Place*. Burlington, Vt.: Ashgate, 2008.
Brawley, Sean, and Chris Dixon. *Hollywood's South Seas and the Pacific War: Searching for Dorothy Lamour*. New York: Palgrave Macmillan, 2012.
Broderzon, Sheyne-Miryam. *Mayn laydns-veg mit Moyshe Broderzon*. Buenos Ayres: Tsentral-farband fun poylishe yidn in Argentine, 1960.
Bronner, Irena. *Cyklady nad Wisłą i Jordanem*. Kraków: Wydawnictwo Literackie, 1991.
Bru, Sasha, Jan Baetens, and Benedikt Hjartson, eds. *Europa! Europa? The Avant-Garde, Modernism and the Fate of Continent*. Berlin: De Gruyter, 2009.
Brzoza, Czesław. "Pierwsze lata 'Nowego Dziennika,' organu syjonistów krakowskich." *Rocznik Historii Prasy Polskiej* 1, nos. 1–2 (1998): 23–47.
———. *Polityczna prasa Krakowa 1918–1939*. Kraków: Nakładem Uniwersytetu Jagiellońskiego, 1990.
Budorowycz, Bohdan. "Poland and the Ukrainian Problem, 1921–1939." *Canadian Slavonic Papers* 25, no. 4 (1983): 473–500.
Buszko, Józef. *Uroczystości kazimierzowskie na Wawelu w roku 1869*. Kraków: Ministerstwo Kultury i Sztuki, 1970.
Butler, Judith. *Gender Trouble*. New York: Routledge, 1990.
Cammy, Justin. "The Prose of Everyday Life: Moyshe Levin's Vilna Peoplescapes." *Colloquia* 48 (2021): 239–258.
Cammy, Justin, Dana Horn, Alyssa Quint, and Rachel Rubinstein, eds. *Arguing the Modern Jewish Canon: Essays on Literature and Culture*. Cambridge, Mass.: Harvard University Press, 2009.
Carriere, Jean Claude. *Sefat hasimanim shel hakolno'a*. Tel Aviv: Am Oved, 1996.
Chu, Winson. *The German Minority in Interwar Poland*. Cambridge: Cambridge University Press, 2012.
Cohen, Berl, and Ya'akov Hetman, eds. *Sefer yizkor lekehilat Luboml*. Tel Aviv: Mofet, 1974.
Cohen, Matthew I. *Performing Otherness: Java and Bali on International Stages, 1905–1952*. New York: Palgrave Macmillan, 2010.
Cohen, Moshe. *Hashomer hatsa'ir beVolin*. Givat Haviva: Merkaz ti'ud veḥeker, 1991.
Czachowska, Jadwiga, and Alicja Szałagan, eds. *Współcześni polscy pisarze i badacze literatury*. Vol. 4. Warsaw: Wydawnictwa Szkolne i Pedagogiczne, 1996.
Czajecka, Bogusława. *"Z domu w szeroki świat": Droga kobiet do niezależności w zaborze austriackim w latach 1890–1914*. Kraków: TAiWPN Universitas, 1990.
Czyż, Anna Sylwia, and Katarzyna Chrudzimska-Uhera, eds. *Materiały LXV Ogólnopolskiej Sesji Naukowej Stowarzyszenia Historyków Sztuki, Warszawa, 24–25 listopada 2016*. Warsaw: Zarząd Główny SHS, Oddział Warszawski SHS, 2017.
Dąbrowski, Mieczysław, and Andrzej Z. Makowiecki, eds. *Modernistyczne źródła dwudziestowieczności*. Warsaw: Wydział Polonistyki Uniwersytetu Warszawskiego, 2003.
Dabrowski, Patrice M. *Commemorations and the Shaping of Modern Poland*. Bloomington: Indiana University Press, 2004.

Datner, Helena. *Ta i tamta strona żydowska inteligencja Warszawy drugiej połowy XIX wieku*. Warsaw: Żydowski Instytut Historyczny, 2007.

Dawidowicz, Lucy S. *From That Place and Time*. New York: W. W. Norton, 1989.

Deleuze, Gilles, and Félix Guattari. *Kafka: Toward a Minor Literature*. Translated by Marie Maclean. Minneapolis: University of Minnesota Press, 1986.

Deror, Levi, and Yisrael Rosenzweig, eds. *Sefer Hashomer hatsa'ir*. 3 vols. Merḥaviyah: Sifriyat Po'alim, 1956–1964.

Digital Yiddish Theatre Project (website). Nick Underwood, project manager. University of Wisconsin, Milwaukee. Accessed February 11, 2023. https://web.uwm.edu/yiddish-stage/.

Dilworth, Leah. *Imagining Indians in the Southwest: Persistent Visions of a Primitive Past*. Washington, D.C.: Smithsonian Institution Press, 1996.

Diner, Dan, ed. *Enzyklopädie jüdischer Geschichte und Kultur*. 7 vols. Stuttgart: Verlag Metzler, 2011–2017.

Dmitrieva, Marina, ed. *Zwischen Stadt und Steppe: Künstlerische Texte der ukranischen Moderne aus den 1910er bis 1930er Jahren*. Berlin: Lukas Verlag, 2012.

Dohrn, Verena, and Gertrud Pickhan, eds. *Osteuropäisch-jüdische Migranten in Berlin 1918–1939*. Göttingen: Wallstein Verlag, 2010.

Dormus, Katarzyna. "Krakowskie gimnazja żeńskie przełomu XIX i XX wieku." *Studia Paedagogica Ignatiana* 19, no. 2 (2016): 87–103.

Dunin, Janusz. *W Bi-Ba-Bo i gdzie indziej: O humorze i satyrze z miasta Łodzi od Rozbickiego do Tuwima*. Łódź: Wydawnictwo Łódzkie, 1966.

Dutkowa, Renata. *Żeńskie gimnazja Krakowa w procesie emancypacji kobiet (1896–1918)*. Kraków: Księgarnia Akademicka, 1995.

Dutkowska, Agata, and Wojciech Szymański, eds. *Kraków kobiet: Przewodnik turystyczny*. Kraków: korporacja ha!art, 2011.

Dynner, Glenn. *Yankel's Tavern: Jews, Liquor, and Life in the Kingdom of Poland*. Oxford: Oxford University Press, 2014.

Dynner, Glenn, François Guesnet, and Scott Ury, eds. *Warsaw: The Jewish Metropolis; Essays in Honor of the 75th Birthday of Professor Antony Polonsky*. Leiden: Brill, 2015.

Dziennik Polski. "Kazimierz Wielki będzie miał pomnik w Krakowie?" March 4, 2009. https://dziennikpolski24.pl/kazimierz-wielki-bedzie-mial-pomnik-w-krakowie/ar/2559734.

Dzigan, Shimen. *Der koyekh fun yidishn humor*. Tel Aviv: Gezelshaftlikher komitet, 1974.

Earle, William D. *The Harvard Five in New Canaan: Midcentury Modern Houses by Marcel Breuer, Landis Gores, John Johansen, Philip Johnson, Eliot Noyes, and Others*. New York: W. W. Norton, 2006.

Efron, John M. *German Jewry and the Allure of the Sephardic*. Princeton, N.J.: Princeton University Press, 2015.

Emden, Christian, Catherine Keen, and David R. Midgley, eds. *Imagining the City*. Vol. 2, *The Politics of the Urban Space*. Frankfurt: Peter Lang, 2006.

Encyclopedia of Jewish History and Culture Online. Edited by Dan Diner. Brill Online. Accessed February 2, 2023. https://referenceworks.brillonline.com/browse/encyclopedia-of-jewish-history-and-culture.

Engel, David. "Citizenship in the Conceptual World of Polish Zionists." *Journal of Israeli History* 27, no. 2 (2008): 191–199.

Erenberg, Lewis A. *Swingin' the Dream: Big Band Jazz and the Rebirth of American Culture*. Chicago: University of Chicago Press, 1999.

Etkind, Alexander. "Orientalism Reversed: Russian Literature in the Times of Empires." *Modern Intellectual History* 4, no. 3 (2007): 617–628.

Even-Shoshan, Shelomo, Ḥayim Dan, and Yeshayahu Stavi, eds. *Zikhronot hakhsharot goshi hakhsharah mesaprim*. Kibuts Loḥamei Hageta'ot: Ghetto Fighters' House, 1983.

Even-Zohar, Itamar. "Aspects of the Hebrew-Yiddish Polysystem: A Case of a Multilingual Polysystem." *Poetics Today* 11 (1990): 121–130.

Eyal, Gil. *The Disenchantment of the Orient: Expertise in Arab Affairs and Israeli State.* Stanford, Calif.: Stanford University Press, 2006.

Fader, Ayala. *Mitzvah Girls: Bringing Up the Next Generation of Hasidic Jews in Brooklyn.* Princeton, N.J.: Princeton University Press, 2009.

Fater, Isaschar. *Yidishe muzik in Poyln tsvishn beyde velt milkhomes.* Tel Aviv: Veltfederatsye fun poylishe yidn, 1970.

Finklestein, Meir, Shelomo Tsemach, and Mordechai Ḥalamish, eds. *Sefer Plonsk vehasevivah: Yad vezekher lekehilot sheneḥarevu.* Tel Aviv: Irgun yotse Plonsk biYisra'el, 1963.

Fiołek, Krzysztof, and Marian Stala, eds. *Kraków i Galicja wobec przemian cywilizacyjnych 1866–1914: Studia i szkice.* Kraków: TAiWPN Universitas, 2011.

Fishman, Joshua, ed. *Shtudies vegn yidn in Poyln 1919–1939.* New York: YIVO Institute for Jewish Research, 1974.

Flam, Gila. "Beracha Zefira—a Case Study of Acculturation in Israeli Song." *Asian Music* 17, no. 2 (1986): 108–125.

Florida, Richard. *Cities and the Creative Class.* New York: Routledge, 2005.

Fox, Dorota. *Kabarety i rewie międzywojennej Warszawy.* Katowice: Wydawnictwo Uniwersytetu Śląskiego, 2007.

Fox, Sandra. "'Laboratories of Yiddishkayt': Postwar American Jewish Summer Camps and the Transformation of Yiddishism." *American Jewish History* 103, no. 3 (2019): 279–301.

Frakes, Jerold C. *Jerusalem of Lithuania: A Reader in Yiddish Culture History.* Columbus: Ohio State University Press, 2011.

Frankel, Jonathan. *Prophecy and Politics: Socialism, Nationalism and the Russian Jews, 1862–1917.* Cambridge: Cambridge University Press, 1984.

Friedenson, Joseph. "The Bais Yaakov Girls' Schools in Poland." In *Haḥinukh vehatarbut ha'ivrit be'eropah ben shete milḥamot ha'olam,* edited by Zevi Scharfstein, 61–82. New York: Hotsa'at Ogen al yede hahistadrut ha'ivrit ba'Amerika, 1957.

Friedman, Lester D., ed. *Unspeakable Images: Ethnicity and the American Cinema.* Urbana: University of Illinois Press, 1999.

Furgał, Ewa, ed. *Krakowski szlak kobiet: Przewodniczki po Krakowie emancypantek.* 5 vols. Kraków: Fundacja Przestrzeń Kobiet, 2009–2013.

Gabryś, Anna. *Salony krakowskie.* Kraków: Wydawnictwo Literackie, 2006.

Galas, Michał, and Antony Polonsky, eds. *Jews in Kraków.* Vol. 23 of *Polin: Studies in Polish Jewry.* Oxford: Littman Library of Jewish Civilization, 2011.

Galas, Michał, and Wacław Wierzbieniec, eds. *Z dziejów i kultury Żydów w Galicji.* Rzeszów: Wydawnictwo Uniwersytetu Rzeszowskiego, 2018.

Galchinsky, Michael. *The Origin of the Modern Jewish Woman Writer: Romance and Reform in Victorian England.* Detroit: Wayne State University Press, 1996.

Gantner, Eszter B., and Jay (Koby) Oppenheim. "Jewish Space Reloaded: An Introduction." *Anthropological Journal of European Cultures* 23, no. 2 (2014): 1–10.

Ganuz, Yitzhak, ed. *Ayaratenu Stepan.* Tel Aviv: Irgun yotse Stepan vehasevivah biYisra'el, 1977.

Gąsowski, Tomasz. *Między gettem a światem: Dylematy ideowe Żydów galicyjskich na przełomie XIX i XX wieku.* Kraków: Księgarnia Akademicka, 1996.

Gelber, Mark H., and Sami Sjöberg, eds. *Jewish Aspects in the Avant-Garde: Between Rebellion and Revelation.* Berlin: De Gruyter, 2017.

Geller, Aleksandra. "'Di Ufgabn Fun Yidishizm': Debates on Modern Yiddish Culture in Interwar Poland." *Colloquia Humanistica* 2 (2013): 59–78.

Gitelman, Zvi, ed. *The Emergence of Modern Jewish Politics: Bundism and Zionism in Eastern Europe.* Pittsburgh: University of Pittsburgh Press, 2003.

Glad, John, and Daniel Weissbort, eds. *Russian Poetry: The Modern Period*. Iowa City: University of Iowa Press, 1978.

Głuchowska, Lidia. "Artyści polscy w orbicie 'Der Sturm': Historia i historyzacje." *Quart* 29 (2013): 3–30.

Goldberg-Mulkiewicz, Olga. "The Image of the Jew in the Polish Nativity Folk Theater." *Jerusalem Studies in Jewish Folklore* 17 (1995): 89–105.

Goldman, Eric A. *Visions, Images, and Dreams: Yiddish Film, Past and Present*. Rev. and expanded ed. Teaneck, N.J.: Holmes & Meier, 2011.

Grabska-Wallis, Elżbieta, and Tadeusz Stefan Jaroszewski, eds. *Dzieła czy kicze*. Warsaw: Państwowe Wydawnictwo Naukowe, 1981.

Grafton, Anthony, and Ann Blair, eds. *The Transmission of Culture in Early Modern Europe*. Philadelphia: University of Pennsylvania Press, 1990.

Gramit, David. *Cultivating Music: The Aspirations, Interests, and Limits of German Musical Culture, 1770–1848*. Berkeley: University of California Press, 2002.

Greenspoon, Leonard Jay. *Yiddish Language and Culture: Then and Now*. Omaha: Creighton University Press, 1998.

Grimstad, Knut Andreas. "Transcending the East-West? The Jewish Part in Polish Cabaret in the Interwar-Period." *Jahrbuch des Simon-Dubnow-Instituts* 7 (2008): 161–188.

Groński, Ryszard Marek. *Jak w przedwojennym kabarecie*. Warsaw: Wydawnictwa Artystyczne i Filmowe, 1987.

Gross, Natan. *Toldot hakolno'a: Hayehudi beFolin*. Jerusalem: Magnes, 1990.

Grünbaum, Yitshak. *Milḥamot yehude Polaniyah*. Jerusalem: Tel Aviv Ḥaverim, 1951.

Guesnet, François, Howard Lupovitch, and Antony Polonsky, eds. *Poland and Hungary: Jewish Realities Compared*. Vol. 31 of *Polin: Studies in Polish Jewry*. London: Littman Library of Jewish Civilization, 2018.

Guesnet, François, Benjamin Matis, and Antony Polonsky, eds. *Jews and Music-Making in the Polish Lands*. Vol. 32 of *Polin: Studies in Polish Jewry*. London: Littman Library of Jewish Civilization, 2020.

Gutman, Yisrael, Ezra Mendelsohn, Jehuda Reinharz, and Chone Shmeruk, eds. *The Jews of Poland between Two World Wars*. Hanover, N.H.: University Press of New England; Waltham, Mass.: Brandeis University Press, 1989.

Haberer, Erich. *Jews and Revolution in Nineteenth-Century Russia*. Cambridge: Cambridge University Press, 1995.

Ḥaviv, Zerubavel. *Tsir Shalo'aḥ: Me'erets Yisra'el leFolin besheliḥot KKL, 1937*. Tel Aviv: Hamakhon leḥeker toldot keren kayemet liYisra'el, 2002.

Heilman, Yitzchak. *Liturgical Compositions for Cantor and Choir*. Edited by Felix Shpits. Haifa: F. Shpits, 2009.

Heilman, Yitzchak, Joel Engel, and J. Shertok. *Unzer Lid*. Bruxelles: Imprimerie "S.W.S.," 1949.

Heller, Celia S. *On the Edge of Destruction: Jews of Poland between the Two World Wars*. New York: Columbia University Press, 1977.

Heller, Daniel Kupfert. *Jabotinsky's Children: Polish Jews and the Rise of Right-Wing Zionism*. Princeton, N.J.: Princeton University Press, 2017.

Hensel, Jürgen, ed. *Polen, Deutsche und Juden in Lodz 1820–1939: Eine schwierige Nachbarschaft*. Osnabrück: Fibre, 1999.

Herz, Jacob Shalom. *Geshikhte fun bund*. Vol. 4. New York: Unzer Tsayt, 1972.

Hirshenberg, Jehoash. "The Vision of the East versus the Heritage of the West: Ideological Pressures in the 'Yishuv' Period and Their Offshoots in Israeli Art Music during the Recent Two Decades." *Min-Ad: Israel Studies in Musicology Online* 4 (2005): 93–115.

SELECTED BIBLIOGRAPHY

Hitchcock, Henry-Russell, and Philip Johnson. *The International Style: Architecture since 1922.* New York: W. W. Norton, 1932.

Hoberman, J. *The Bridge of Light: Yiddish Film between Two Worlds.* Updated and expanded ed. Hanover, N.H.: Dartmouth College in association with the National Center for Jewish Film, 2010.

Hoffman, Eva. *Shtetl: The Life and Death of a Small Town and the World of Polish Jews.* Boston: Houghton Mifflin, 1997.

Hoffman, Matthew. *From Rebel to Rabbi: Reclaiming Jesus and the Making of Modern Jewish Culture.* Stanford, Calif.: Stanford University Press, 2007.

Hoffman, Warren. *The Passing Game: Queering Jewish American Culture.* Syracuse, N.Y.: Syracuse University Press, 2009.

Hoffman, Zygmunt. "Prywatne Żydowskie Koedukacyjne Gimnazjum w Krakowie (1918–1939)." *Biuletyn Żydowskiego Instytutu Historycznego,* nos. 3–4 (1988): 101–110.

Hoffmann, Hilmar. *The Triumph of Propaganda: Film and National Socialism 1933–1945.* Providence: Berghahn, 1996.

Holmgren, Beth. "Acting Out: *Qui Pro Quo* in the Context of Interwar Warsaw." *East European Politics and Societies and Cultures* 27, no. 2 (2013): 205–223.

Homola, Irena. "*Kwiat społeczeństwa . . .*": *Struktura społeczna i zarys położenia inteligencji krakowskiej w latach 1866–1914.* Kraków: Wydawnictwo Literackie, 1984.

Horn, José, ed. *Mezritsh: Zamlbukh in heylikn ondenk fun di umgekumene Yidn in unzer geboyrn-shtot in Poyln.* Buenos Aires: Mezritsher landslayt-farayn in Argentine, 1952.

Horowitz, Brian, and Haim Gottschalk, eds. *Yiddish Modernism: Studies in Twentieth-Century Eastern European Jewish Culture.* Bloomington, Ind.: Slavica, 2014.

Howe, Irving, Ruth Wisse, and Chone Shmeruk, eds. *The Penguin Book of Modern Yiddish Verse.* New York: Penguin, 1987.

Hundert, Gershon, ed. *Essential Papers on Hasidim: Origins to Present.* New York: New York University Press, 1991.

Infeld, Leopold. *Kordian, fizyka i ja: Wspomnienia.* Warsaw: Państwowy Instytut Wydawniczy, 1967.

———. *Szkice z przeszłości: Wspomnienia.* Warsaw: Państwowy Instytut Wydawniczy, 1964.

Jagodzińska, Agnieszka. *Pomiędzy: Akulturacja Żydów Warszawy drugiej połowy XIX wieku.* Wrocław: Wydawnictwo Uniwersytetu Wrocławskiego, 2008.

Jakubczyk-Ślęczka, Sylwia. "Życie muzyczne społeczności żydowskiej na terenach dawnej Galicji w okresie międzywojennym." PhD diss., Jagiellonian University, 2017.

Janion, Maria. *Bohater, spisek, śmierć: Wykłady żydowskie.* Warsaw: Wydawnictwo W. A. B., 2009.

Jankowicz, Grzegorz, Piotr Marecki, Alicja Palęcka, Jan Sowa, and Tomasz Warczok, eds. *Literatura polska po 1989 roku w świetle teorii Pierre'a Bourdieu: Raport z badań.* Kraków: korporacja ha!art, 2014.

Järvinen, Hanna. "'The Russian Barnum': Russian Opinions on Diaghilev's Ballets Russes, 1909–1914." *Dance Research* 26 (2008): 18–41.

Jung, Leo, ed. *Jewish Leaders, 1750–1940.* 2nd ed. Jerusalem: Boys Town Jerusalem, 1964.

Kaes, Anton, Martin Jay, and Edward Dimendberg, eds. *The Weimar Source Book.* Berkeley: University of California Press, 1994.

Kalmar, Ivan D., and Derek J. Penslar, eds. *Orientalism and the Jews.* Hanover, N.H.: University Press of New England, 2005.

Kariv, Yosef, ed. *Sefer yizkor likehilat Sarni.* Jerusalem: Yad Vashem, 1961.

Kelly, Catriona, and Steven Lovell, eds. *Russian Literature, Modernism and the Visual Arts.* Cambridge: Cambridge University Press, 2000.

Khazoom, Aziza. "The Great Chain of Orientalism: Jewish Identity, Stigma Management, and Ethnic Exclusion in Israel." *American Sociological Review* 68 (2003): 481–510.

Kijek, Kamil. "Was It Possible to Avoid Hebrew Assimilation? Hebraism, Polonization and Tarbut Schools in the Last Decade of Interwar Poland." *Jewish Social Studies* 21, no. 2 (2016): 105–141.

Kilcher, Andreas, and Gabriella Safran, eds. *Writing Jewish Culture: Paradoxes in Ethnography*. Bloomington: Indiana University Press, 2016.

Kirshenblatt-Gimblett, Barbara. "'Contraband': Performance, Text and Analysis of a 'Purim Shpil.'" *Drama Review* 24, no. 3 (September 1980): 5–16.

Kiryk, Feliks, ed. *Żydzi w Małopolsce: Studia z dziejów osadnictwa i życia społecznego*. Przemyśl: Południowo-Wschodni Instytut Naukowy w Przemyślu, 1991.

Klein, Leslie Ginsparg. "No Candy Stores, No Maxi-Skirts, No Makeup: Socializing Orthodox Jewish Girls through Schooling." *Journal of the History of Childhood and Youth* 9, no. 1 (2016): 140–158.

Kobrin, Rebecca, ed. *Chosen Capital: The Jewish Encounter with American Capitalism*. New Brunswick, N.J.: Rutgers University Press, 2012.

Kohlrausch, Martin. *Brokers of Modernity: East Central Europe and the Rise of Modernist Architects, 1910–1950*. Leuven: Leuven University Press, 2019.

Kojkoł, Jerzy. *Myśl filozoficzna Stanisława Garfein-Garskiego*. Toruń: Wydawnictwo Adam Marszałek, 2001.

Kołodziejska-Smagała, Zuzanna, and Maria Antosik-Piela, eds. *Literatura polsko-żydowska 1861–1918: Antologia*. Kraków: Wydawnictwo Uniwersytetu Jagiellońskiego, 2017.

Konigsburg, Ira. "'The Only "I" in the World': Religion, Psychoanalysis, and 'The Dybbuk.'" *Cinema Journal* 36, no. 4 (1997): 22–42.

Korczarowska-Różycka, Natasza. "Nie ma Polski bez Sahary! Kolonialne filmy Michała Waszyńskiego." *Kwartalnik filmowy* 92 (2015): 22–42.

Kordjak, Joanna, ed. *Szklane domy: Wizje i praktyki modernizacji społecznych po roku 1918*. Warsaw: Zachęta, 2018.

Kornhauser, William. *The Politics of Mass Society*. New York: Routledge, 2018.

Kozińska-Witt, Hanna. *Die Krakauer Jüdische Reformgemeinde 1864–1874*. Frankfurt: Peter Lang, 1999.

Kozub-Ciembroniewicz, Wiesław, ed. *Uczeni żydowskiego pochodzenia we współczesnych dziejach Uniwersytetu Jagiellońskiego*. Kraków: Wydawnictwo Uniwersytetu Jagiellońskiego, 2014.

Krajewska, Hanna. *Życie filmowe Łodzi w latach 1896–1939*. Warsaw: PWN, 1992.

Kras, Janina. *Wyższe kursy dla kobiet im. A. Baranieckiego 1868–1924*. Kraków: Wydawnictwo Literackie, 1972.

Krasowska, Anna. *Szmonces przedwojenny żydowski humor kabaretowy wybór tekstów*. Warsaw: Wydawnictwo Uniwersytetu Kardynała Stefana Wyszyńskiego, 2015.

Kressel, Gezel. *Hatsofeh levet Yisra'el*. Jerusalem: Sifriyah tsiyonit, 1961.

Krzywicka, Irena. *Wyznania gorszycielki*. Warsaw: Czytelnik, 1992.

Książek-Bryłowa, Władysława, ed. *Inny Reymont*. Lublin: Wydawnictwo Uniwersytetu Marii Curie-Skłodowskiej, 2002.

Kubica, Grażyna. *Siostry Malinowskiego, czyli kobiety nowoczesne na początku XX wieku*. Kraków: Wydawnictwo Literackie, 2006.

Kulczykowski, Mariusz. *Żydzi studenci Uniwersytetu Jagiellońskiego w Drugiej Rzeczypospolitej (1918–1939)*. Kraków: Polska Akademia Umiejętności, 2004.

Kulesza, Piotr, Anna Michalska, and Michał Koliński. *Łódzkie kina od Bałtyku do Tatr*. Łódź: Księży Młyn, 2015.

Kurek, Jalu. *Mój Kraków*. Kraków: Wydawnictwo Literackie, 1978.

Kutylak-Hapanowicz, A., and M. Fryźlewicz, eds. *Krakowianie: Wybitni Żydzi krakowscy XIV–XX w.* Kraków: Muzeum Historyczne Miasta Krakowa, 2006.

Kwiecień, Sabina. "Dziewięć lat *Dzienniczka dla dzieci i młodzieży*—dodatku do *Nowego Dziennika*." *Annales Universitatis Paedagogicae Cracoviensis: Studia ad Bibliothecarum Scientiam Pertinentia* 12 (2014): 38–55.

———. "Kartka z dziejów żydowskiej prasy dla dzieci i młodzieży w okresie autonomii galicyjskiej." *Annales Universitatis Paedagogicae Cracoviensis: Studia ad Bibliothecarum Scientiam Pertinentia* 13 (2015): 137–156.

Landau-Czajka, Anna, and Katarzyna Sierakowska, eds. *Procesy socjalizacji w Drugiej Rzeczypospolitej 1914–1939.* Warsaw: Instytut Historii PAN, 2013.

Łapot, Mirosław. "Nauczycielki religii mojżeszowej w szkołach publicznych w Galicji w latach 1867–1939." *Prace Naukowe Akademii im. Jana Długosza w Częstochowie. Seria: Pedagogika* 20 (2011): 407–418.

Lawton, Anna, ed. *Russian Futurism through Its Manifestoes, 1912–1928.* Ithaca, N.Y.: Cornell University Press, 1988.

Lazer, Dawid. *Frezje, mimoza i róże: Szkice polskie z lat 1933–1974.* Tel Aviv: Aviva Devir, 1994.

Leham, Mira, and Antonin J. Leham. *The Most Important Art: Soviet and Eastern European Film after 1945.* Berkeley: University of California Press, 1977.

Leibel, Emilia. *Wspomnienia Żydówki krakowskiej.* Edited by Maria Kłańska. Kraków: Polska Akademia Umiejętności, 2010.

Leibowitz, Danielle S., and Devora Gliksman. *Rebbetzin Vichna Kaplan: The Founder of the Bais Yaakov Movement in America.* Jerusalem: Feldheim, 2016.

Leighten, Patricia. "The White Peril and L'art *nègre*: Picasso, Primitivism, and Anticolonialism." *Art Bulletin* 72 (1990): 609–630.

Leshtshinsky, Jacob. *Yidn in film industriye.* Vilna: YIVO, 1932.

Łetocha, Barbara, Zofia Głowicka, and Izabella Jabłońska. *Żydowska Łódź na afiszach wydanych w II Rzeczypospolitej, Dokumenty ze zbiorów Biblioteki Narodowej.* Warsaw: Biblioteka Narodowa, 2011.

Levin, Moyshe. "Tsalel the Glazier after the Pogrom: A Tale of the November Days in Vilna, 1936." Translated by Justin Cammy. *Colloquia* 48 (2021): 267–275.

Levinson, Avraham. *Kitve Avraham Levinson.* Vol. 1. Tel Aviv: Davar, 1956.

Levinson, B. A., D. E. Faley, and D. C. Holland, eds. *The Cultural Production of the Educated Person: Critical Ethnographies of Schooling and Local Practice.* Albany: State University of New York Press, 1996.

Levite, Avraham. *Sefer zikaron kehilat Brzozów.* Tel Aviv: Yotse Brzozow vehasevivah, 1984.

Lewandowska, Barbara, and Tomaszczyk Hanna Pułaczewska, eds. *Intercultural Europe: Arenas of Difference, Communication and Mediation.* Stuttgart: Ibidem Verlag, 2014.

Lewitter, L. R. "The Polish 'Szopka.'" *Slavonic and East European Review* 29, no. 72 (December 1950): 77–85.

Leyko, Małgorzata, ed. *Łódzkie sceny żydowskie: Studia i materiały.* Łódź: Wydawnictwo Uniwersytetu Łódzkiego, 2000.

Lisek, Joanna. "'I Feel So Crazy, like Flying the Coop': The Lesser-Known Sarah Schenirer; Side Reflections on Naomi Seidman's Book." *Shofar: An Interdisciplinary Journal of Jewish Studies* 38, no. 1 (2020): 272–290.

———. *Kol isze—głos kobiet w poezji jidysz (od XVI w. do 1939 r.).* Sejny: Pogranicze, 2018.

Loeffler, James. "'A Special Kind of Antisemitism': On Russian Nationalism and Jewish Music." *Yuval Online: Studies of the Jewish Music Research Center* 9 (2015): 1–16. https://jewish-music.huji.ac.il/volume-year/2015-volume-9.

Łuksza, Agata. "Kobiecość i nowoczesność w polskiej rewii międzywojennej." *Didaskalia* 124 (2014): 10–18.

Luz, Ehud. *Makbilim nifgashim*. Tel Aviv: Am Oved, 1985.
Mahler, Raphael. "Jews in Public Service and the Liberal Professions in Poland." *Jewish Social Studies* 6, no. 4 (1944): 346–347.
Małecki, Jan M., ed. *Świat przed katastrofą: Żydzi krakowscy w dwudziestoleciu międzywojennym*. Kraków: Międzynarodowe Centrum Kultury, 2007.
Malinowski, Jerzy. *Grupa "Jung Idysz" i żydowskie środowisko "Nowej Sztuki" w Polsce: 1918–1923*. Warsaw: Polska Akademia Nauk. Instytut Sztuki, 1987.
———. *Painting and Sculpture by Polish Jews in the 19th and 20th Centuries (to 1939)*. Translated by Krzysztof Z. Cieszkowski. Warsaw: Polish Institute of World Art Studies, 2017.
Malinowski, Jerzy, Renata Piątkowska, Małgorzata Stolarska-Fronia, and Tamara Sztyma-Knasiecka, eds. *Art in Jewish Society*. Warsaw: Polish Institute of World Art Studies, 2016.
Mally, Lynn. *Revolutionary Acts: Amateur Theater and the Soviet State, 1917–1938*. Ithaca, N.Y.: Cornell: Cornell University Press, 2000.
Manekin, Rachel. *The Rebellion of the Daughters: Jewish Women Runaways in Habsburg Galicia*. Princeton, N.J.: Princeton University Press, 2020.
Mańkowska-Grin, Ewa, and Katarzyna Janusik. *Żydowscy obywatele Krakowa: Kobiety*. Kraków: Wydawnictwo EMG, 2021.
Mann, Barbara E. *Space and Place in Jewish Studies*. New Brunswick, N.J.: Rutgers University Press, 2012.
Markov, Vladimir. *Russian Futurism: A History*. Washington, D.C.: New Academia, 2006.
Markovits, Andrei S., and Frank E. Sysyn, eds. *Nationbuilding and the Politics of Nationalism: Essays on Austrian Galicia*. Cambridge, Mass.: Harvard University Press, 1982.
Markowitz, Ruth Jacknow. *My Daughter, the Teacher: Jewish Teachers in the New York City Schools*. New Brunswick, N.J.: Rutgers University Press, 1993.
Marmer, Jake, and John Schott. "Interview with Joshua Horowitz on the Orchestration of *Bas-Sheve*." Digital Yiddish Theatre Project. February 13, 2020. https://web.uwm.edu/yiddish-stage/interview-with-joshua-horowitz-on-the-orchestration-of-bas-sheve.
Martin, Sean. *Jewish Life in Cracow, 1918–1939*. London: Vallentine Mitchell, 2004.
Maślak-Maciejewska, Alicja. *Modlili się w Templu: Krakowscy Żydzi postępowi w XIX wieku: Studium społeczno-religijne*. Kraków: Wydawnictwo Uniwersytetu Jagiellońskiego, 2018.
———. "Pamięci Kazimierza Wielkiego Żydzi-Polacy—o zapomnianym projekcie budowy pomnika królewskiego na krakowskim Kazimierzu." *Modus: Prace z historii sztuki* 16 (2016): 61–74.
Maślak-Maciejewska, Alicja, Anna Jakimyszyn-Gadocha, Barbara Zbroja, Edyta Gawron, and Magdalena Marosz, eds. *Dzieje Krakowskich Żydów na przestrzeni wieków, materiały z zasobów Archiwum Narodowego w Krakowie*. Kraków: Jagiellonian University Press, 2018.
Matuszek, Gabriela. *"Der geniale Pole?" Stanisław Przybyszewski in Deutschland (1892–1992)*. Translated by Dietrich Scholze. Hamburg: Verlag Literatur & Wissenschaft, 2015.
Maurin-Białostocka, Jolanta, ed. *Słownik artystów polskich i obcych w Polsce działających: Malarze, rzeźbiarze, graficy*. Vol 5. Wrocław: Zakład Narodowy im. Ossolińskich, 1993.
Melzer, Emanuel. *No Way Out: The Politics of Polish Jewry, 1935–1939*. Cincinnati: Hebrew Union College Press, 1997.
Mendelsohn, Ezra. *On Modern Jewish Politics*. Oxford: Oxford University Press, 1993.
———. *Painting a People: Maurycy Gottlieb and Jewish Art*. Hanover, N.H.: University Press of New England; Waltham, Mass.: Brandeis University Press, 2002.
———. *Zionism in Poland: The Formative Years, 1915–1926*. New Haven, Conn.: Yale University Press, 1982.
Mertins, Detlef. "The Enticing and Threatening Face of Prehistory: Walter Benjamin and the Utopia of Glass." *Assemblage* 29, no. 1 (April 1996): 6–23.
Meyerowitz, Aharon, ed. *Sefer Vladimerets: Gal-ed lezekher irenu*. Tel Aviv: Ofer, 1962.

SELECTED BIBLIOGRAPHY

Mickiewicz, Adam. *Dzieła*. Vol. 10. Edited by Julian Maślanka. Translated by Leon Płoszewski. Warsaw: Czytelnik, 1998.

———. *Dzieła*. Vol. 11. Edited by Julian Maślanka. Translated by Leon Płoszewski. Warsaw: Czytelnik, 1998.

Mickute, Jolanta. "Modern, Jewish and Female: The Politics of Culture, Ethnicity and Sexuality in Interwar Poland, 1918–1939." PhD diss., Indiana University, 2011.

Miron, Dan. "The Literary Image of the Shtetl." *Jewish Social Studies* 1, no. 3 (Spring 1995): 1–43.

Moretti, Franco. *Atlas of the European Novel 1800–1900*. London: Verso, 1998.

Moss, Kenneth B. *An Unchosen People: Jewish Political Reckoning in Interwar Poland*. Cambridge, Mass.: Harvard University Press, 2021.

Moss, Kenneth B., Benjamin Nathans, and Tavo Tsurumi, eds. *From Europe's East to the Middle East: Israel's Russian and Polish Lineages*. Philadelphia: University of Pennsylvania Press, 2022.

Most, Andrea. *Theatrical Liberalism: Jews and Popular Entertainment in America*. New York: New York University Press, 2013.

Nahshon, Edna, ed. *Jewish Theatre: A Global View*. Leiden: Brill, 2009.

———. *Yiddish Proletarian Theatre: The Art and Politics of the Artef, 1925–1940*. Westport, Conn.: Greenwood, 1998.

Naimark, Norman. *Terrorists and Social Democrats: The Russian Revolutionary Movement under Alexander III*. Cambridge, Mass.: Harvard University Press, 1983.

Nalewajko-Kulikov, Joanna. *Mówić we własnym imieniu: Prasa jidyszowa a tworzenie żydowskiej tożsamości narodowej (do 1918 roku)*. Warsaw: Neriton, 2016.

Nalewajko-Kulikov, Joanna, Grzegorz P. Bąbiak, and Agnieszka J. Cieślikowa, eds. *Studia z dziejów trójjęzycznej prasy żydowskiej na ziemiach polskich (XIX-XX w.)*. Warsaw: Wydawnictwo Neriton, 2012.

Nasiłowska, Anna. "Życie Świadome i nieświadome." *Teksty Drugie* 2011, no. 4 (2011): 120–125.

Nemtsov, Jascha, Eliott Kahn, and Verena Bopp. "The History of the Jewish Music Publishing Houses Jibneh and Juwal." *Musica Judaica* 18 (5766/2005–2006): 1–42.

Nora, Pierre, ed. *Les lieux de mémoire*. 3 vols. Paris: Gallimard, 1984–1986.

Notley, Margaret. "*Volksconcerte* in Vienna and Late Nineteenth-Century Ideology of the Symphony." *Journal of the American Musicological Society* 50 (1997): 421–453.

Novershtern, Avraham, ed. *Alilot ne'urim: Otobiyografyot shel bene no'ar yehudim meFolin ben shete milḥamot ha'olam*. Tel Aviv: Institute for the History of Polish Jewry, 2011.

Oczko, Piotr. "Gizela Reicher-Thonowa, zapomniana matka polskiej komparatystyki literackiej." *Pamiętnik Literacki* 1 (2010): 187–200.

Okoń, Waldemar. "O krakowskim pomniku Adama Mickiewicza raz jeszcze." *Quart* 1 (1999): 19–30.

Olczyk, Jacek. *Życie literackie w Krakowie w latach 1893–2013*. Kraków: korporacja ha!art, 2016.

Oppenheim, Israel. "Hahakhsharah hakibutsit shel betar beFolin bishnot ha-30 (1930–1936)." *Divre hakongres ha'olami lemada'e hayahadut* 2 (1973): 295–305.

Pańko, G., M. Skotnicka-Palka, and B. Techmańska, eds. *Edukacja*. Wrocław: GS Media, 2013.

Pasterska, J., and Z. Ożóg, eds. *Dyskursy pogranicza, wektory literatury*. Rzeszów: Wydawnictwo Uniwersytetu Rzeszowskiego, 2019.

Peleg, Yaron. *Orientalism and the Hebrew Imagination*. Ithaca, N.Y.: Cornell University Press, 2005.

Perkowska, Urszula. *Studentki Uniwersytetu Jagiellońskiego w latach 1894–1939: W stuleciu immatrykulacji pierwszych studentek*. Kraków: Wydawnictwo i Drukarnia "Secesja," 1994.

Petrovsky-Shtern, Yohanan. *The Golden Age Shtetl: A New History of Jewish Life in Eastern Europe*. Princeton, N.J.: Princeton University Press, 2014.

Pinel, Carol, Julio Guillen, and Dominique Reniers. "Transparency and Truth: Towards a Cult of Confession." *Recherches en psychanalyse* 11 (2011): 29–37.

Pinkas Ludmir: Sefer-zikaron likehilat Ludmir. Tel Aviv: Irgun yotse Ludmir biYisra'el, 1962.

Polonsky, Antony. *Dzieje Żydów w Polsce i Rosji*. Translated by Mateusz Wilk. Warsaw: Wydawnictwo Naukowe PWN, 2014.

———, ed. *Focusing on Jews in the Polish Borderlands*. Vol. 14 of *Polin: Studies in Polish Jewry*. London: Littman Library of Jewish Civilization, 2001.

———, ed. *Jews in Lodz, 1820–1939*. Vol. 6 of *Polin: Studies in Polish Jewry*. Oxford: Basil Blackwell for the Institute for Polish-Jewish Studies, 1991.

———, ed. *Poles and Jews: Renewing the Dialogue*. Vol. 1 of *Polin: Studies in Polish Jewry*. Oxford: Basil Blackwell for the Institute for Polish-Jewish Studies, 1986.

Pordes, Anis. *Ich miasto: Wspomnienia Izraelczyków przedwojennych mieszkańców Krakowa*. Warsaw: Prószyński i Spółka, 2004.

Porter-Szűcs, Brian. *Poland in the Modern World: Beyond Martyrdom*. West Sussex: Wiley Blackwell, 2014.

Portnoy, Eddy. "Politics and Poesy." *Tablet Magazine*, March 18, 2010. https://www.tabletmag.com/sections/belief/articles/politics-and-poesy.

"Projekt ogólnomiejski nr 50: Pomnik Króla Kazimierza Wielkiego." Budżet obywatelski. Accessed August 4, 2022. https://budzet.krakow.pl/projekty/1827-pomnik_krola_kazimierza__wielkiego.html.

Prokop-Janiec, Eugenia. *Pogranicze polsko-żydowskie: Topografie i teksty*. Kraków: Wydawnictwo Uniwersytetu Jagiellońskiego, 2013.

———. "A Woman Assimilationist and the Great War: A Case of Aniela Kallas." *Medaon: Magazin für jüdisches Leben in Forschung und Bildung* 10 (2016): 1–11.

———. "Women's Assimilation Narratives in Galicia: The Works of Aniela Kallas." *Studia Judaica* 18 (2010): 284–297.

———. "Żydowski Kraków literacki między wojnami." Unpublished article.

Prokopovych, Markian. *Habsburg Lemberg: Architecture, Public Space, and Politics in the Galician Capital, 1772–1914*. West Lafayette, Ind.: Purdue University Press, 2009.

Pulaver, Moyshe. *Ararat un lodzher tipen*. Tel Aviv: Y. L. Peretz, 1972.

Purchla, Jacek. *Jan Zawiejski, Architekt przełomu XIX i XX wieku*. Warsaw: Państwowe Wydawnictwo Naukowe, 1986.

———. *Kraków: Prowincja czy metropolia?* Kraków: Towarzystwo Autorów i Wydawców Prac Naukowych "Universitas," 1996.

Puś, Wiesław, and Stanisław Liszewski, eds. *Dzieje Żydów w Łodzi 1820–1944, Wybrane problemy*. Łódź: Wydawnictwo Uniwersytetu Łódzkiego, 1991.

———. *Żydzi w Łodzi w latach zaborów, 1793–1914*. Łódź: Wydawnictwo Uniwersytetu Łódzkiego, 2001.

Rabinbach, Anson. "Between Enlightenment and Apocalypse: Benjamin, Bloch and Modern German Jewish Messianism." *New German Critique* 34 (Winter 1985): 78–124.

Radziszewska, Krystyna, and Krzysztof Woźniak, eds. *Pod jednym dachem: Niemcy oraz ich polscy i żydowscy sąsiedzi w Łodzi w XIX i XX wieku / Unter einem Dach: Die Deutschen und ihre polnischen und jüdischen Nachbarn in Lodz im 19. und 20. Jahrhundert*. Łódź: Wydawnictwo Literatura, 2000.

Ran, Leyzer. "Der umbakanter Yung-Vilner dertseyler Henekh Soloveytshik." *Di goldene keyt* 101 (1980): 96–101.

Raszewski, Zbigniew, ed. *Słownik biograficzny teatru polskiego 1765–1965*. Warsaw: Państwowe Wydawnictwo Naukowe, 1973.

SELECTED BIBLIOGRAPHY

Ratajska, Krystyna, and Tomasz Cieślak, eds. *Julian Tuwim: Biografia, twórczość, recepcja.* Łódź: Wydawnictwo Uniwersytetu Łódzkiego, 2012.

Ravitsh, Melekh. *Mayn leksikon.* Vols. 1–3. Montreal: Komitet, 1945–1958.

———. *Mayn leksikon.* Vol. 4 in 2. Tel Aviv: Farlag Y. L. Perets, 1980–1982.

Regev, Motti, and Edwin Seroussi. *Popular Music and National Culture in Israel.* Berkeley: University of California Press, 2004.

Reuveni, Gideon, and Nils Roemer. *Longing, Belonging and the Making of Jewish Consumer Culture.* Leiden: Brill, 2010.

Reymont, Władysław Stanisław. *The Promised Land.* Translated by Michael Henry Dziewicki. 2 vols. New York: Alfred A. Knopf, 1927.

Rothmüller, Aron Marko. *The Music of the Jews: An Historical Appreciation.* Cranbury, N.J.: Perpetua, 1975.

Rothschild, Joseph. *East Central Europe between the Two World Wars.* Seattle: University of Washington Press, 1974.

Rotman, Diego. *Habamah kevayit ara'i: Hate'atron shel dzigan veshumakher (1927–1980).* Jerusalem: Magnes, 2017.

Rozenblit, Marsha. "Creating Jewish Space: German-Jewish Schools in Moravia." *Austrian History Yearbook* 44 (2013): 108–147.

Rozier, Gilles. *Mojżesz Broderson: Od Jung Idysz do Araratu.* Łódź: Hamal, 1999.

———. *Moyshe Broderzon: Un écrivain yiddish d'avant-garde.* Saint-Denis: Presses universitaires de Vincennes, 1999.

Ryan, Pat M. "Some Polish Perspectives on African American History and Culture." *Polish Review* 37 (1992): 135–166.

Samsonowska, Krystyna. "Elementarne szkolnictwo żydowskie w Krakowie w latach 1867– 1918. Rywalizacja środowisk żydowskich o model wychowania i wykształcenia młodego pokolenia." *Rocznik Komisji Nauk Pedagogicznych* 53 (2000): 19–40.

Samuel, Lawrence R. *The American Dream: A Cultural History.* New York: Syracuse University Press, 2012.

Samuś, Paweł, ed. *Polacy-Niemcy-Żydzi w Łodzi w XIX I XX w. Sąsiedzi dalecy i bliscy.* Łódź: Uniwersytet Łódzki, 1997.

Sass, Anne-Christin. *Berliner Luftmenschen: Osteuropäisch-jüdische Migranten in der Weimarer Republik.* Göttingen: Wallstein Verlag, 2012.

Schapkow, Carsten. *Role Model and Counter Model: The Golden Age of Iberian Jewry and German Jewish Culture during the Era of Emancipation.* Lanham, Md.: Lexington Books, 2016.

Scharfstein, Zevi, ed. *Haḥinukh vehatarbut ha'ivrit be'eropah ben shete milḥamot ha'olam.* New York: Hotsa'at Ogen al yede hahistadrut ha'ivrit ba'Amerika, 1957.

Schechtman, Joseph. *Ze'ev Jabotinsky.* Vol. 2. Tel Aviv: Karni, 1959.

Schmidt, Esther. "Nationalism and the Creation of Jewish Music: The Politicization of Music and Language in the German-Jewish Press Prior to the Second World War." *Musica Judaica* 15 (2000): 1–32.

Schuster, Frank M. "Die verborgene Stadt: Die Wiederentdeckung der polyethnischen Vergangenheit der Stadt Łódź." *Convivium: Germanistisches Jahrbuch Polen,* nos. 2 (2008): 143–170.

Segev, Tom. *Medinah beḥol meḥir.* Jerusalem: Keter, 2018.

Seidman, Naomi. *Sarah Schenirer and Bais Yaakov: A Revolution in the Name of Tradition.* London: Liverpool University Press, 2019.

The Shalvi/Hyman Encyclopedia of Jewish Women. Jewish Women's Archive. Accessed August 4, 2020. https://jwa.org/encyclopedia/.

Shandler, Jeffrey. *Shtetl: A Vernacular Intellectual History.* New Brunswick, N.J.: Rutgers University Press, 2014.

Shanes, Joshua. *Diaspora Nationalism and Jewish Identity in Habsburg Galicia*. Cambridge: Cambridge University Press, 2012.

Shayntukh, Yekhiel, ed. *Sefer hahumoreskot vehaparodi'ot hasifrutiyot beyidish: Mivḥar ketavim humoristiyim al yehude mizraḥ eropah vetarbutam beFolin ben shete milḥamot ha'olam*. Jerusalem: Magnes, 1990.

Shmeruk, Chone. *The Esterke Story in Yiddish and Polish Literature: A Case Study in the Mutual Relations of Two Cultural Traditions*. Jerusalem: Zalman Shazar Center, 1985.

Shulman, Eliyohu. *Yung-Vilne 1929–1939*. New York: Getseltn, 1946.

Silber, Marcos. "Cinematic Motifs as a Seismograph: Kazimierz, the Vistula and Yiddish Filmmakers in Interwar Poland." *Gal-Ed: On the History and Culture of Polish Jewry* 23 (2013): 37–57.

———. "Narrowing the Borderland's 'Third Space': Yiddish Cinema in Poland in the Late 1930s." *Jahrbuch des Simon-Dubnow-Instituts* 7 (2008): 229–255.

Singer, Icchok Baszewis. *Felietony, eseje, wywiady*. Warsaw: Sagittarius, 1993.

Skawińska, L., and Z. Skibiński. "Rozmowy w 'Tyglu': Lodzermensch—historia i mit." *Tygiel Kultury*, nos. 3–4 (1998): 33.

Skodlarski, Janusz, Rafał Matera, Andrzej Pieczewski, and Kamil Kowalski, eds. *Rola Żydów w rozwoju gospodarczym ziemi łódzkiej, Wybrane zagadnienia*. Łódź: Wydawnictwo Uniwersytetu Łódzkiego, 2014.

Sławomir Mrożek: Rzeźnia: Teatr im. J. Słowackiego w Krakowie. Kraków: Centrum Druku, D. A., 1999.

Slyomovics, Susan. "Cross-Cultural Dress and Tourist Performance in Egypt." *Performing Arts Journal* 11, no. 3 (1989): 139–148.

Spiegel, Nina. *Embodying Hebrew Culture: Aesthetics, Athletics, and Dance in the Jewish Community of Mandate Palestine*. Detroit: Wayne State University Press, 2013.

Środa, Magdalena. *Kobiety i władza*. Warsaw: Wydawnictwo W. A. B., 2009.

Sroka, Łukasz. *Żydzi w Krakowie: Studium o elicie miasta 1850–1918*. Kraków: Wydawnictwo Naukowe Akademii Pedagogicznej im. Komisji Edukacji Narodowej, 2008.

Stahl, Neta. *Other and Brother: Jesus in the 20th-Century Jewish Literary Landscape*. Oxford: Oxford University Press, 2012.

Stampfer, Shaul. *Families, Rabbis, and Education: Traditional Jewish Society in Eastern Europe*. Oxford: Littman Library of Jewish Civilization, 2010.

Stawiszyńska, Aneta. *Łódź w latach i wojny światowej*. Oświęcim: Wydawnictwo Napoleon V, 2016.

Steinlauf, Michael. "Fear of Purim: Y. L. Peretz and the Canonization of Yiddish Theater." *Jewish Social Studies*, n.s., 1, no. 3 (Spring 1995): 45–65.

Stendig, Jakub. *Płaszów: Ostatnia stacja krakowskiego Żydostwa*. Kraków: Muzeum Krakowa, 2020.

Stepnowski, Adam. "Debora Vogel w galicyjskim Jidyszlandzie. Czasopismo 'Cusztajer.'" *Schulz/Forum* 16 (2020): 176–190.

Stern, Zehavit. "From Jester to Gesture: East-European Jewish Culture and the Re-imagination of Folk Performance." PhD diss., University of California, Berkeley, 2011.

Stoner, Jill. *Toward a Minor Architecture*. Cambridge, Mass.: MIT Press, 2012.

Styrna, Natasza. *Zrzeszenie Żydowskich Artystów Malarzy i Rzeźbiarzy w Krakowie (1931–1939)*. Warsaw: Wydawnictwo Neriton, 2009.

Suchan, Jarosław, and Karolina Szymaniak, eds. *Polak, Żyd, artysta: Tożsamość a awangarda*. Łódź: Muzeum Sztuki w Łodzi, 2010.

Suchmiel, Jadwiga. "Emancypacja kobiet w uniwersytetach w Krakowie i we Lwowie do roku 1939." *Prace Naukowe Akademii im. Jana Długosza w Częstochowie. Seria: Pedagogika* 13 (2004): 115–123.

———. *Kariery zawodowe lekarek ze stopniem doktora wykształconych w Uniwersytecie Jagiellońskim podlegających pod Krakowską Izbę Lekarską do 1939 roku: W stulecie immatrykulacji studentek medycyny.* Częstochowa: Wydawnictwo Wyższej Szkoły Pedagogicznej w Częstochowie, 1998.

———. *Udział kobiet w nauce do 1939 roku w Uniwersytecie Jagiellońskim.* Częstochowa: Wydawnictwo Wyższej Szkoły Pedagogicznej w Częstochowie, 1994.

———. *Żydówki ze stopniem doktora wszech nauk lekarskich oraz doktora filozofii w Uniwersytecie Jagiellońskim do czasów Drugiej Rzeczypospolitej.* Częstochowa: Wydawnictwo Wyższej Szkoły Pedagogicznej w Częstochowie, 1997.

Sztyma-Knasiecka, Tamara. *Syn swojego Ludu: Twórczość H. Glicensteina 1870–1942.* Warsaw: Neriton, 2008.

Szwabowicz, Magda Sara. "Twórcy i ośrodki literatury hebrajskiej w Polsce międzywojennej." *Studia Judaica* 1 (2015): 139–170.

Szymaniak, Karolina, ed. *Warszawska awangarda jidysz: Antologia tekstów.* Gdańsk: Słowo/obraz terytoria, 2005.

Szymańska, Olga. "Lachert, the Law Courts on Leszno and Saska Kępa." Jewish Historical Institute. Accessed November 2019. https://www.jhi.pl/en/articles/lachert-the-law-courts-on-leszno-and-saska-kepa,331.

Tuszyńska, Agata. *Krzywicka: Długie życie gorszycielki.* Kraków: Wydawnictwo Literackie, 2009.

Tzur, Eli. *Lifne bo ha'afelah: Hashomer hatsa'ir beFolin uveGalitsiyah, 1930–1940.* Kiryat Sde Boker: Makhon Ben Guriyon, 2006.

Uchowicz, Katarzyna, and Aleksandra Kędziorek. "Sieciotwórcza rola maszyny do pisania: Z Katarzyną Uchowicz, badaczką architektury modernizmu, rozmawia Aleksandra Kędziorek." *Autoportret: Pismo o dobrej przestrzeni* 3, no. 62 (2018): 104–123. https://autoportret.pl/artykuly/sieciotworcza-rola-maszyny-do-pisania/.

Udalska, Eleanora, and Anna Tytkowska, eds. *Żydzi w lustrze dramatu, teatru i krytyki teatralnej.* Katowice: Wydawnictwo Uniwersytetu Śląskiego, 2004.

Unowsky, Daniel L. *The Pomp and Politics of Patriotism: Imperial Celebrations in Habsburg Austria, 1848–1916.* West Lafayette, Ind.: Purdue University Press, 2000.

Ury, Scott. *Barricades and Banners: The Revolution of 1905 and the Transformation of Warsaw Jewry.* Stanford, Calif.: Stanford University Press, 2012.

Uryniak, Adam. "Smak orientu i inne przyjemności. Rola filmów przygodowych i morskich w propagandzie II RP." *Kwartalnik filmowy* 95 (2016): 71–83.

Veidlinger, Jeffrey, ed. *Going to the People: Jews and the Ethnographic Impulse.* Bloomington: Indiana University Press, 2016.

Vogler, Elkhonen. "Di mishpokhe Yung-Vilne." *Di goldene keyt* 23 (1955): 174–181.

———. "Moyshe Kulbak: Der dikhter fun royer erd." *Di goldene keyt* 43 (1962): 103–105.

Vogler, Henryk. *Wyznanie mojżeszowe: Wspomnienia z utraconego czasu.* Warsaw: Państwowy Instytut Wydawniczy, 1994.

Walden, Joshua. "Leaving Kazimierz: Comedy and Realism in the Yiddish Film Musical *Yidl Mitn Fidl.*" *Journal of Music, Sound, and the Moving Image* 3, no. 2 (Autumn 2009): 159–193.

Weinbaum, Laurence. *A Marriage of Convenience: The New Zionist Organization and the Polish Government, 1936–1939.* Boulder: East European Monographs, 1993.

Welch, David. *The Third Reich: Politics and Propaganda.* London: Routledge, 1993.

Wenderski, Michał. *Cultural Mobility in the Interwar Avantgarde Art Network: Poland, Belgium and the Netherlands.* New York: Routledge, 2019.

Widner, Alice, ed. *Gustave Le Bon, the Man and His Works.* Indianapolis: Liberty Press, 1979.

Wightman, Alistair. *Karol Szymanowski: His Life and Work.* New York: Routledge, 2007.

Wodziński, Marcin. *Hasidism and Politics: The Kingdom of Poland, 1815–1864*. Oxford: Littman Library of Jewish Civilization, 2013.

———. *Historical Atlas of Hasidism*. Cartography by Waldemar Spallek. Princeton, N.J.: Princeton University Press, 2018.

Wordliczek, Zofia. "Żydowskie szkolnictwo podstawowe, średnie i zawodowe w okresie II Rzeczypospolitej Polskiej ze szczególnym uwzględnieniem Krakowa." *Krzysztofory* 19 (1992): 124–134.

Wróbel, Magdalena. "Syjonista ze Lwowa: Leon Reich (1879–1929)—polityk pogranicza." *Wieki stare i nowe: Tom specjalny*, 2012, 86–100.

Wrona, Grażyna, Piotr Borowiec, and Krzysztof Woźniakowski, eds. *Ilustrowany Kurier Codzienny (1910–1939): Księga pamiątkowa w stulecie powstania dziennika i wydawnictwa*. Kraków; "Śląsk" Wydawnictwo Naukowe, 2010.

The YIVO Encyclopedia of Jews in Eastern Europe. 2 vols. Edited by Gershon D. Hundert. New Haven, Conn.: Yale University Press, 2008.

The YIVO Encyclopedia of Jews in Eastern Europe Online. Edited by Gershon D. Hundert. YIVO Institute for Jewish Research. https://yivoencyclopedia.org/.

Yovel, Yirmiyahu, and David Shaham, eds. *Zeman yehudi ḥadash*. Vol. 1. Jerusalem: Keter, 2007.

Żarnowska, A., and A. Szwarc, eds. *Kobiety i kultura: Kobiety wśród twórców kultury intelektualnej i artystycznej w dobie rozbiorów i w niepodległym państwie polskim*. Warsaw: Wydawnictwo DiG, 1996.

Zawiszewska, Agata. *Życie Świadome: O nowoczesnej prozie intelektualnej Ireny Krzywickiej*. Szczecin: Wydawnictwo Naukowe Uniwersytetu Szczecińskiego, 2010.

Żbikowski, Andrzej. *Żydzi krakowscy i ich gmina w latach 1869–1919*. Warsaw: Wydawnictwo DiG, 1994.

Ze'evi, Yosef, Nahum Hinitz, Asher Plotnik, and Haim Rubinraut, eds. *Yizkor: Kehilot Luninyets/Kozharodok*. Tel Aviv: Aḥdut, 1952.

Zefira, Bracha. *Kolot rabim*. Tel Aviv: Masada, 1978.

Zerubavel, Yael. *Desert in the Promised Land*. Stanford, Calif.: Stanford University Press, 2018.

———. *Recovered Roots: Collective Memory and the Making of Israeli National Tradition*. Chicago: University of Chicago Press, 1995.

Zieliński, Jarosław. *Atlas dawnej architektury ulic i placów Warszawy*. Vol. 10, *Mackiewicza-Mazowiecka*. Warsaw: Wydawnictwo Towarzystwa Opieki nad Zabytkami, 2004.

Zimmerman, Joshua. *Poles, Jews, and the Politics of Nationality: The Bund and the Polish Socialist Party in Late Tsarist Russia, 1892–1914*. Madison: University of Wisconsin Press, 2004.

Źródlak, Wojciech, Jan Raczyński, and Tomasz Igielski, eds. *Łódzkie tramwaje 1898–1998*. Łódź: Księży Młyn, 1998.

Żyndul, Jolanta. *Państwo w państwie: Autonomia narodowa w Europie Środkowowschodniej w XX wieku*. Warsaw: DiG, 2000.

Zysiak, Agata. "The Desire for Fullness: The Fantasmatic Logic of Modernization Discourses at the Turn of the 19th and 20th Century in Łódź." *Praktyka teoretyczna* 13 (2014): 41–69.

Zysiak, Agata, Kamil Śmiechowski, Kamil Piskała, Wiktor Marzec, Kaja Kaźmierska, and Jacek Burski. *From Cotton and Smoke: Łódź—Industrial City and Discourses of Asynchronous Modernity, 1897–1994*. Kraków: Jagiellonian University Press, 2019.

Notes on Contributors

NATALIA ALEKSIUN is the Harry Rich Professor of Holocaust Studies at the University of Florida, Gainesville. She is the author of *Dokad dalej? Ruch syjonistyczny w Polsce, 1944–1950* (Where to? The Zionist movement in Poland, 1944–1950; 2002) and editor of several volumes, including *Polin: Studies in Polish Jewry*, vol. 29, *Writing Jewish History in Eastern Europe* (2017; with Brian Horowitz and Antony Polonsky) and *European Holocaust Studies*, vol. 3, *Places, Spaces, and Voids in the Holocaust* (2021; with Hana Kubátová). Her most recent book is *Conscious History: Polish Jewish Historians before the Holocaust* (2021).

ELA BAUER is an associate professor in the Department of Film and Media and the Department of History at the Kibbutzim College in Tel Aviv. She is the author of *Between Poles and Jews: The Development of Nahum Sokolow's Political Thought* (in Hebrew; 2005). Her most recent publications include "Commemoration and Jewish National Identity: Lviv in the Last Decades of the Nineteenth Century" in *Journal of Jewish Identities* 14, no. 1 (2021); and "'Polishing' the Jewish Masses: Personal Hygiene, Public Health, and Jews in *Fin de Siècle* Warsaw" in *Jewish History* 35, nos. 1–2 (2021).

JUSTIN CAMMY is a professor and the chair of Jewish Studies and World Literatures at Smith College. He is the co-editor of *Arguing the Modern Jewish Canon: Essays on Literature and Culture* (2009) and translator from Yiddish of Hinde Bergner's *On Long Winter Nights: Memoirs of a Jewish Family in a Galician Township, 1870–1900* (2005) and Sholem Aleichem's *The Judgment of Shomer* (2009). His critical edition and translation of Abraham Sutzkever's *From the Vilna Ghetto to Nuremberg* was a finalist for the 2021 National Jewish Book Award.

HALINA GOLDBERG is a professor and the chair of Musicology at Indiana University-Bloomington and an affiliate of the Borns Jewish Studies Program, Polish Studies Center, and Byrnes Russian and East European Institute. She is the author of

Music in Chopin's Warsaw (2008; Polish translation, 2016) and editor of *The Age of Chopin: Interdisciplinary Inquiries* (2004), *Chopin and His World* (2017; with Jonathan Bellman), and a special issue of the *Musical Quarterly* "Jewish Spirituality, Modernity, and Historicism in the Long Nineteenth Century: New Musical Perspectives" (101, no. 4; 2019), to which she contributed the article "'On the Wings of Aesthetic Beauty Towards the Radiant Spheres of the Infinite': Music and Jewish Reformers in Nineteenth-Century Warsaw." She directs the digital project Jewish Life in Interwar Łódź. See https://jewish-lodz.iu.edu/.

DANIEL KUPFERT HELLER is the Kronhill Senior Lecturer in East European Jewish History at Monash University. He is the author of *Jabotinsky's Children: Polish Jews and the Rise of Right-Wing Zionism* (2017). His article "The Gendered Politics of Public Health: Jewish Nurses and the American Joint Distribution Committee in Interwar Poland" appeared in *Jewish History* 31, nos. 3–4 (2018).

SYLWIA JAKUBCZYK-ŚLĘCZKA is a lecturer in the Musicology Institute of the Jagiellonian University. Her recent publications include "Za kulisami sceny koncertowej—polityka kulturalna Żydowskiego Towarzystwa Muzycznego w Krakowie" (Behind the scenes of the concert stage—the cultural policy of the Jewish Music Society in Kraków) in *Żydzi krakowscy: Nowe kierunki badań* (2021, ed. Alicja Maślak-Maciejewska) and "Jewish Music Organizations in Interwar Galicia" in *Polin* 32 (2020).

MAGDALENA KOZŁOWSKA is an assistant professor of history at the University of Warsaw. She is the author of *Świetlana przyszłość? Żydowski Związek Młodzieżowy Cukunft wobec wyzwań międzywojennej Polski* (A bright future? The Jewish youth association Tsukunft faces the challenges of interwar Poland; 2016), the editor and translator from Yiddish of S. L. Shneiderman, *Wojna w Hiszpanii: Reportaż z głębi kraju* (The Spanish civil war: Report from the hinterlands; 2021), and the editor of *The World beyond the West: Perspectives from Eastern Europe* (2022; with Mariusz Kałczewiak).

ALICJA MAŚLAK-MACIEJEWSKA is an assistant professor in the Institute of Jewish Studies at the Jagiellonian University and head of the Center for the Study on the History and Culture of Kraków Jews. She is the author of *Rabin Szymon Dankowicz (1834–1910)—życie i działalność* (Rabbi Szymon Dankowicz [1834–1910]—Life and history; 2013) and *Modlili się w Templu: Krakowscy Żydzi postępowi w XIX wieku: Studium społeczno-religijne* (Those who prayed in the Tempel: Kraków progressive Jews in the 19th century; A socio-religious study; 2018).

EUGENIA PROKOP-JANIEC is a professor in the Department of Literary Anthropology and Cultural Studies of the Faculty of Polish Studies at the Jagiellonian University. She is the author of *Międzywojenna literatura polsko-żydowska jako zjawisko kulturowe i artystyczne* (1992), issued in English as *Polish-Jewish Literature*

in the Interwar Years (2003), and *Pogranicze polsko-żydowskie: Topografie i teksty* (Polish-Jewish borderlands: Topographies and texts; 2013). She has also edited *Teatr żydowski w Krakowie* (Jewish theater in Kraków; with Jan Michalik; 1995) and the anthology *Międzywojenna poezja polsko-żydowska* (Interwar Polish-Jewish poetry; 1996).

BOŻENA SHALLCROSS is a professor of Polish literature in the Department of Slavic Languages and Literatures at the University of Chicago. She is the author of *The Holocaust Object in Polish and Polish-Jewish Culture* (2011) and *Through the Poet's Eye: The Travels of Zagajewski, Herbert, and Brodsky* (2008), among other monographs. She recently published "War and Violence: How to Rescue a Wartime Artifact" in *The Cambridge Handbook of Material Culture Studies* (2022).

NAOMI SEIDMAN is the Chancellor Jackman Professor of the Arts in the Department for the Study of Religion and the Centre for Diaspora and Transnational Studies at the University of Toronto. Her books include *Faithful Renderings: Jewish–Christian Difference and the Politics of Translation* (2006), *The Marriage Plot; or, How Jews Fell in Love with Love, and with Literature* (2016), and *Sarah Schenirer and Bais Yaakov: A Revolution in the Name of Tradition* (2019).

MARCOS SILBER is a senior lecturer in the Department of Jewish History, University of Haifa. He is the author of *Le'umiyut shonah: Ezraḥut shaveh! Hama'amats lehasagat otonomiyah leyehude Polin bemilḥemet ha'olam harishonah* (Different nationality, equal citizenship! The efforts to achieve autonomy for Polish Jewry during the First World War; in Hebrew; 2014) and, with Szymon Rudnicki, *Stosunki polsko-izraelskie (1945–1967): Wybór dokumentów* (Polish-Israeli diplomatic relations [1945–1967]: A selection of documents; Polish and Hebrew editions; 2009).

NANCY SINKOFF is a professor of Jewish studies and history and the academic director of the Allen and Joan Bildner Center for the Study of Jewish Life at Rutgers University. She is the author of *Out of the Shtetl: Making Jews Modern in the Polish Borderlands* (2004; 2nd edition, 2020) and *From Left to Right: Lucy S. Dawidowicz, the New York Intellectuals, and the Politics of Jewish History* (2020; paperback 2022); winner of a 2020 National Jewish Book Award; and editor of *Sara Levy's World: Gender, Judaism, and the Bach Tradition in Enlightenment Berlin* (2018; with Rebecca Cypess), recognized as an outstanding book from the Jewish Studies and Music Study Group of the American Musicological Society.

ZEHAVIT STERN teaches in the Department of Theatre Studies at the Hebrew University and at the Tisch School of Film and Television at Tel Aviv University. Her most recent publications include "The Art of Cultural Translation: Performing Jewish Traditions in Modern Times" in *Journal of Modern Jewish Studies* 16, no. 3 (2017); "On Dubbing the Dead: The Dybbuk 1937–2017" in *Drama Review* 63, no. 2

(2019); and "The Archive, the Repertoire, and Jewish Theatre: Zygmunt Turkow Performs a National Dramatic Heritage" in *Skenè: Journal of Theatre and Drama Studies* 6, no. 2 (2020).

MAŁGORZATA STOLARSKA-FRONIA is a researcher at the University of Potsdam. She is the author of *Udział Żydów wrocławskich w kulturalnym i artystycznym życiu miasta od emancypacji do 1933 roku* (The participation of Breslau Jews in the artistic and cultural life of the city from emancipation until 1933; 2008), editor of *Polish Avant-Garde in Berlin* (2019), and coeditor of *Art in Jewish Society* (2016; with Jerzy Malinowski, Renata Piątkowska, and Tamara Sztyma-Knasiecka) and *From Ausgleich to the Holocaust: Ukrainian and Jewish Artists of Lemberg/Lwow/Lviv* (2019; with Sergey R. Kravtsov and Ilia Rodov).

Index

Page numbers in *italics* indicate illustrations and tables.

Abramovich, Sholem Yankev (Mendele Moykher Sforim), 25, 34n24
Academy of Fine Arts, Kraków, 9, *196*, 198
acculturation. *See* assimilation/acculturation
Achron, Joseph, *146*, 147
Acosta, Uriel, 145, *146*, 148, 149
Adler, Yankl, 29, 77, 79, *80*, 82, 84–85, 88, 89, 90n4, 91n24, 92n50
Admission of Jews to Poland by Casimir the Great, The (Przyjęcie Żydów do Polski przez Kazimierza Wielkiego; Henryk Hochman, bas-relief plaque), 181–183, *182*, 184, 187n54
Adria movie theaters: Kraków, 222; Lublin, 215
Africa and Africans, 115, 117, 213
African Americans, 117, 121, 166n26
Agnon, Shmuel Yosef (Samuel), 88
Agudath Israel (Agudah; Agude Yisroyel; Tseirey Agudas Yisroel), 101–102, 108n1, 109–110n9, 110n13, 111n21, 112n32, 215
Ahimeir, Abba, 214–215, *216*
Albéniz, Isaac, *141*, 145
Aleksiun, Natalia, 6, 254, 287
Alexander, Michael, 126n60
Alexander II (czar), assassination of, 6
Alkabetz, Salomon, 255
Altman, Wilhelm, 148
Amal (Toil; Shlonsky), *145*, 147
Ameisenowa, Zofia, 201
Ami Shir, 142
Andersen, Hans Christian, *146*, 148
Anhalt, Paweł, 255, 260
anniversary/jubilee culture in Poland, 136, 138, 174–176, 181, 185n21, 226n41

An-sky (Shloyme Zanvl Rappoport), 29
antisemitism/anti-Judaism: concert programming in interwar Lwów confirming Jewish national identity in face of, 128, 144–149, *145–146*; education and, 234; of Endecja (National Democracy) party, 18, 68, 73n48, 144, 156–157; of Krasiński, 92n42; Orientalism and, 114; Russia, restrictions on Jewish public buildings in, 222; *szmonces* genre, acquired negative connotations of, 168n47; in Wilno and elsewhere in interwar years, 18, 45, 54n25; youth movements and Polish government, 240–242
apocalyptic and messianic themes, 8, 77, 83–88, *86*, *87*, 92nn40–41, 92n51
Apollo movie theater, Baranowicze (now Baranavichy, Belarus), 215, *216*
Ararat *Kleynkunst* Theater (Łódź), 3, 7, 15–32; aesthetic vision of Broderzon and, 21–25, 28; anthem of, 20, 33n15; as "art cabaret," 15, 17, 27; as "artistic revue theater" or "artistic revolutionary theater," 15, 17; cabaret craze of early 20th century and, 17, 18–19, *19*, 163–164; emblem of, 22, 24; ensemble actors of, 21, 32, 33n7; first program, 28, *30–31*; folksy (*folkstimlekher*) theatricality of, 28–29, 32; funding and attendance issues, 21, 27; *Garbage* (*Opfal*), 28; *kunst/shund* binary and, 7, 17, 25–26, 28; *Literarishe bleter* review of, 15–17, *16*; local Yiddish dialect, use of, 27; lost history of, 3; marginal positionality of, 15–17; name of, 15, 20; populist modernism of, 7, 18–20; "Shverd, Di" (The sword; Peretz),

291

Ararat Kleynkunst Theater (Łódź) *(cont.)* 32; sources, scarcity of, 17–18; success of, 29–32; as synthetic theater, 27–28, 35n42, 35n49; Vakhtangov, influence of, 35n47; Warsaw, move to, 32. *See also* Broderzon, Moyshe
Architects and architecture. *See* Glass House; Goldberg, Maksymilian
Architektura i Budownictwo (Architecture and construction; journal), 61, *63*, 71n11
Aronson, Boris, 81
Artef theater, New York, 20
As (journal), 201, 211n112
Asch, Sholem, 218–220
Ashkenazi Jewry: romantic image of "Oriental" Jews, 114, 117–119; self-critiques and self-doubt of, 114, 117–118; Yemenite Jews physically contrasted with, 116; Zefira working with, 116
assimilation/acculturation: Casimir the Great monument (unbuilt), Kraków and, 171, 177, 183; concert programming in interwar Lwów and, 128, 130, 134, 136, 149; defined, 6; institutional spaces for women's cultural production in Kraków and, 194, 195, 203; multilingualism and, 198; "Oriental," framing of nonacculturated Jews as, 114; origins of ideology of, 6; performativity theory and, 108
Association of Architects of the Polish Republic (Stowarzyszenie Architektów Rzeczypospolitej Polskiej), 61
Association of Fine Arts (Towarzystwo Zachęty Sztuk Pięknych), 173
Association of Jewish Music and Choral Societies in Galicia (Związek Żydowskich Towarzystw Muzycznych i Śpiewaczych w Galicji), 129
Association of Jewish Writers and Journalists, 53n9
Astoria Café, Łódź, 33n13
At Night at the Old Market (Peretz), 85
avant-garde, European, 19, 21, 70, 71n11, 73n46, 77
avant-garde, Jewish, 21, 75–76, 78–79, 81–85, 88–89. *See also* Yung-yidish group and Jewish expressionism
Avodatenu (Our work; Betar journal), 238
Awin, A., *141*, 144
Azazel *Kleynkunst* Theater (Warsaw), 33n6, 163–164

Baal Shem (Bloch), 144–145, *146*, 149
Baal Shem Tov (Israel ben Eliezer), 144–145
Bach, Johann Sebastian, *131*
Bacon, Gershon, 215
Bagatela Theater, Kraków, *200*, 202

Bais Yaakov Journal, 109–110n9, 110n13
Bais Yaakov movement, 97, 106–107, 188. *See also* Schenirer, Sarah, and Bais Yaakov theater performances
Baker, Josephine, 117–118
Bakić-Hayden, Milica, 115
Bałaban, Jakub, 178
Bałaban, Majer, *139*, 187n56
Ballets Russes, 117
Balzac, Honoré de, 234
Banda (The band; cabaret, Warsaw), 19
Baraneum (A. Baraniecki Higher Courses for Women), Kraków, *192*, 193, *196*, 198
Baranowicze (now Baranavichy, Belarus), Apollo movie theater, 215, *216*
Barbasch, Ozajasz, *141*, 144
Barczyński, Henryk (Henokh), 89, 163
Bar Kochba revolt, 233
Bartelik, Marek, 15
Bartkiewicz, Zygmunt, 153
Bartok, Béla, 121
Bauer, Ela, 10, 108, 153, 212, 287
Baumgartenowa, Berta, 209n80
Baumritter, Gustaw (Andrzej Włast), 159, 160, 161, 256, 261
Becci's *Requiem*, 137
Beethoven, Ludwig van, *131*, *133*, *143*, 145
Begin, Menachem, 245n26
Belis, Shloyme, 48
Belkin, Ahuva, 110n10
Belmont, Leo (Leopold Blumental), 160
Bełza, Władysław, 106
Benari, Nahum, *145*, 147
Ben-Gurion, David, 212, 224n2, 226n35
Benjamin, Walter, 57–58, 69, 78
Bensman, Mateusz, 127, 130
Ben-Yehuda, Eliezer, 119
Berg, Alban, 261
Berlewi, Henryk (Henokh), 81, 82, 83, 84, 89, 90n4, 90n18, 91–92n35
Berlin: Josephine Baker in, 116–117; Der blaue Vogel (Rus. Siniaia Ptitsa; cabaret) in, 19, *19*, 29, 33n12, 164; coffeehouses of, 213; Habima Theater, 35n47, 116, 149; Die Pathetiker in, 83, 92n40; Yung-yidish group and expressionist milieu of, 78, 79, 88, 89
Bester, Salomea, 194
Betar, 10, 229; *Avodatenu* (Our work; journal), 238; Menachem Begin and, 245n26; as cultural portal, 234–235; gap between cultural prescriptions and actual activities, 238–239, 240; movie theaters as Jewish public spaces and, 215, 220; Polish government and, 241–242; recruitment efforts of 1930s, 230; religious dynamics, awareness of, 231–232, 233; women members and male-female interaction, 236, *237*, 238, 239

INDEX

beysmedresh, 229, 231–232, 233
Biała Podlaska, movie theater in, 218
Bi-Ba-Bo (cabaret; St. Petersburg), 33n11
Bi-Ba-Bo (literary cabaret; Łódź), 19, 33n11, 159–160, 163, 164, 167n31
Bienenstock, Maks, 84, 90n5
Binding of Isaac, The (Bais Yaakov play), 98–101, 104
Birnbaum, Abraham Ber, 255, 258–259
Blankówna, Regina, 208n80
blaue Vogel, Der (The blue bird, Rus. Siniaia Ptitsa; cabaret, Berlin), 19, *19*, 29, 33n12, 164
bletl in vint, A (A page in the wind; Vogler), 42–46, *43*
Bloch, Ernst, 77, 78, 144, *145*, *146*
Blok group, 73n46
Błonie, Bais Yaakov in, 98–101, 104; "A Hasidic Revolt in Błonie," 109n8, 112n33
Blüher, Hans, 234
Blum, Henryk, 71n11
Blumental, Felicja, 260
Blumental, Leopold (Leo Belmont), 160
Blumenthal, N., *135*
Bnos (youth movement for Bais Yaakov girls), 102
Boëllmann, L., *135*
Bourdieu, Pierre, 189, 202
Boy-Żeleński, Tadeusz, 66–67, 73n37, 162, 202
Boże coś Judę (God Save Judah) anthem, 179
Brahms, J., *131*, *132*, *133*, *143*, *146*
Brandes, Georg, 207n55
Brauner, Ida, 163
Brauner (Broyner), Yitskhok (Wincenty), 29, 83, 84, 85, *86*, *87*, 90n4, 91n24, 163
Brecht, Bertolt, 18, 35n47
Brill, Meir, 236
Brit Habirionim (Union of Zionist Rebels), 215
Broderzon, Moyshe: aesthetic vision of, 21–25, 28, 77, 83; apocalypticism and messianism in work of, 84; appearance/images of, 21, *22*, 79, *80*; Der blaue Vogel (Rus. Siniaia Ptitsa) and, 19; as cultural activist in Łódź, 20–21, 22, 75–76; *Dovid un Bas-Sheve* (opera), 20, 34n17; Hasidim, followers known as, 21; *kleynkunst teater* performances of, 163–164 (*see also* Ararat Kleynkunst Theater [Łódź]); on *kunst/shund* binary, 25–26; as Lodzermensz, 75–76, 88–89; Młoda Polska and, 84; Moscow period (WWI and Russian Revolution), 21, 27, 34n22, 90nn4–5; multidirectional flow of culture between Warsaw/Łódź and, 163–164; religious Jewish vocabulary, use of, 35n45; *Shvarts-shabes*

(Black Sabbath), 79–81, *80*, 84; *Sikhes khulin*, 85; on Vogler, 54n27; "The way of our theater" ("Der veg fun unzer teater"), 22, 27, 28–29; WWII and postwar life of, 17–18; Yiddish translation of *Walpurgis nakht*, 256
Broderzon, Sheyne-Miryam, 18, 163
Brossowa, Anna, 199, *200*, 201, 210n98, 210–211n106
Broyner (Brauner), Wincenty (Yitskhok), 29, 83, 84, 85, *86*, *87*, 90n4, 91n24, 163
Bruch, M., *131*, *135*
Brückner, A., *143*
Brzechwa, Jan, 5
Brześć (also Brześć Litewski; Yid. Brisk; now Brest, Belarus), 8, 113, 119; youth movement culture in, 230
Buber, Martin, 78, 90n8
Buchsbaum, Marek, 144
Budko, Josef, 89
Bujwidowa, Kazimiera, 194, 197
Bund (Yid. Der algemayner yidisher arbeter bund in lite poyln un rusland), 66, 72n28, 213, 215–218, 220, 222, 225n31
BUNT group, Poznań, 77, 79
Bury Melonik (cabaret), Kraków, 202, 211n114
Butler, Judith, 108
Bychawa, Bais Yaakov in, 111n19

cabarets: Ararat *Kleynkunst* Theater (Łódź) as "art cabaret," 15, 17, 27; Der blaue Vogel (Rus. Siniaia Ptitsa, Berlin), 19, *19*, 29, 33n12, 164; early 20th century craze for, 17, 18–19; *kleynkunst teater* as reflection of literary cabarets, 163–164; in Kraków, 19, 202, 211n114; literary cabarets, 19, 159–164; in Łódź, 19, 159–160, 163, 164; in St. Petersburg, 19, 33n11; in Warsaw, 19, 159–164. *See also specific cabarets by name*
Cabaret Voltaire (Zurich), 19
Calwary, Moshe and Hadassah, 115
Cammy, Justin, 7, 37, 287
Casimir the Great monument (unbuilt), Kraków, 9, 171–184; anniversary/jubilee culture in Poland and, 174–175, 181, 185n21; artists, consultations with, 173; assimilation/acculturation and, 171, 177, 183; bas-reliefs intended for pedestal of, 182; commemoration culture in Poland and, 175–177; contemporary initiatives for, 183–184; Esther legend, 174, 185n17; as exclusively Jewish endeavor, 171, 173, 176; funding issues, 173, 181, 187n59; Gottlieb tombstone monument campaign compared, 177–179, 181; government permit for, 173; Hochman's bas-relief plaque

Casimir the Great monument *(cont.)*
The Admission of Jews to Poland erected instead of, 181–183, *182*, 184, 187n54; interconfessional philanthropic initiatives and, 179–180; Kazimierz district, intended for, 171, 174, 184; Mickiewicz memorial statue and, 176–177, 178, 181; Monument Erecting Committee, 171, 172–173, 178, 181; origins of idea for, 172–173; progressive Jews and Jewish organizations involved in, 172, 175, 177, 178; reasons for failure to build, 180–183; reasons for Jewish desire to commemorate, 174–175; restoration of Casimir's sarcophagus, Wawel Cathedral, 174–175; significance of, 171–172, 183–184; women's involvement in, 173
Casimir the Great School (Szkoła Kazimierzowska), Kazimierz, Kraków, *192*, 193
Cavalleria rusticana (Mascagni), *145*, 147
"Centering the Periphery" conference, Rutgers University (2018), 6
Central Yiddish School Organization (CYSHO; Yid. Di tsentrale yidishe shul-organizatsye), 10
Chagall, Marc (Marek Szagał), 81–82, 89
Chaĭkov, Iosif, 21, 80–81, 91n21
Chaminade, Cécile, *141*
Chaplin, Charlie, 212
charitable initiatives, interconfessional, Kraków, 179–180
Chmielnicki massacres, 112n32
Chmielnik, Bais Yaakov in, 97, 98, 104
Chofetz Chaim (Yisrael Meir Ha-Kohen Kagan), 110–111n16
choral tradition, Jewish, and choral music, 6, 129, 133, 134, *135*, 137, 143, 144, 147, 254–261
Chór Dana, 142
Chór Eryana, 142
Chwila (Moment; daily), 127, 128, 129, 130, 136, 142, 201
Chybiński, Adolf, 121, 126n54, 129
CIAM (International Congresses of Modern Architecture), 60, 61, 71n9
Cincinnati Enquirer, 121
cinema. *See* movies; movie theaters as Jewish public spaces
Circle for Jewish National Aesthetic, 21
coffeehouses, 213
Cohen, Shabtai (ShaCh), daughter of, 112n32
Cohn, Dvora Epelgrad, 109n3
Commedia dell'arte, 27, 34n24, 35n48
commemoration culture, 175–177. *See also* Casimir the Great monument (unbuilt), Kraków
communism, 103, 230, 240–242
concert programming in interwar Lwów, 8–9, 127–149; acculturation and, 128, 130,

135, 136, 149; Austro-German canonical art music, focus on (1919–1925), 128, 129–136, *131–133*, *135*; barbershop quartet, 132; community events and activities, 134–136, 139; growing antisemitism and confirmation of Jewish national identity (1936–1939), 128, 144–149, *145–146*; heterogeneous programming, move to (1926–1935), 128, 136–143, *137–139*, *140–141*; JALS chamber orchestra, 139, *140–141*; JALS choir, 137, *137–139*, *140*, 142; JALS drama section, *146*, 147–148; JALS symphony orchestra, 137, *137–139*, *143*, *146*, 147, 148; Jewish Artistic and Literary Society (JALS), 127–128, 136–149, *137–139*, *140–141*, *143*, *145–146*; Jewish Music Society (JMS), 127–137, *131–133*, *135*, 139, 149; JMS choir, 133–134, *135*, 136; JMS symphonic orchestra, 130, *131–133*, 134, 136; lecture series, 139, *146*; mandolin orchestra, 136, 139; musical culture and institutions of Lwów, 129; musicians, 150n8; People's Concert series, 144, *145*, *146*; Polish musical identity and Polish composers, 129–130; Yuval (music society), 136, 142, 151n30
"Confiteor" (Przybyszewski), 78
Congress Poland, 1, 194, 222
Conquerors of Swamp (Benari), *145*, 147
Conrad, Paul, 254, 255, 256, 262, 263
Córki marnotrawne (Prodigal daughters; Kallas), 195, 197
Corso movie theater, Radom, 215, *217*
Council for Motherhood Awareness, 67
Creizenach, Wilhelm, 195
cubism, 76, 90n8
cubo-futurists, 24, 26, 76
culture, Polish Jewish. *See* Polish Jewish culture beyond Warsaw
Cylkow, Henryk, 255, 260
CYSHO (Central Yiddish School Organization; Yid. Di tsentrale yidishe shul-organizatsye), 10
Czarna perła (Black pearl; film), 118
Czytelnia. *See* reading rooms, Kraków

Dąbrowica in Polesie, youth movements in, 240
Dabrowski, Patrice, 181
Dada movement, 19, 90n8
Dancing Devil, The (Yitskhok Brauner), 84, 85, *86*, 92n45
Dankowicz, Szymon, 175
Dauber, D., *141*
David Copperfield (Dickens), 234–235
Dawidowicz, Lucy S. (Lucy Schildkret), 10
Debussy, Claude, *143*
Deleuze, Gilles, 73n50

de Stijl movement, 61
Deutscher's printing house, Kraków, 198
Diabeł (Devil; periodical), 195
Dibek, Der (*The Dybbuk*; film), 125n38
Dietrich, Marlene, 112n32
Diki, Alexander (Rus. Alekseĭ Dikiĭ), 116
Długosz, Jan, 185n17
doctorates, Jewish women earning, 197–198, 199
doikayt (hereness or at-homeness), 3, 11, 37, 50
Dom Prasy (The Press House), Warsaw, 61
Don Quixote (Cervantes), 234–235; "Jewish Don Quixote," 34n24
Dovid un Bas-Sheve (opera, Broderzon), 20, 34n17
Dubnow, Simon, *137*
Dunajewski, A., *135*, *138*
Duncan, Isadora, 115
Düsseldorf, Die Junge Rheinland in, 79
Dvořák, Antonín, *132*
Dybbuk, The (An-sky; play), 29, 35n47. See also *Dibek, Der* (*The Dybbuk*; film)
Dziady, Part III (Mickiewicz), 176
Dzienniczek dla dzieci i młodzieży (Daily for children and youth), 201, 210n104
Dzigan, Shimen, 18, 21, 27, 32, 33n7, 33n15

Earle, William D., 68–69
East versus West: expressionism and, 76, 77, 78, 81; multidirectional flow between, 5, 8; nesting Orientalisms, 115; Orientalism, concept of, 114–115; "Oriental" (Middle Eastern) Jewry, image of, 8, 113–115, 118, 119, 120, 122–123; Ostjuden (Eastern European Jewry), image of, 88, 89; Zefira's music as mediator between, 120
education: doctorates, Jewish women earning, 197–198, 199; institutional spaces for women's cultural production in Kraków and, *192*, 193–194, *196*, 197–198, 199, *200*, 203, 209nn84–85, 210n103; Jewish education for girls, 8, 105, 106–107, 188, 193, 197, 199 (*see also* Schenirer, Sarah, and Bais Yaakov theater performances); journals, schools publishing, 109–110n9; Moravia, German-Jewish schools in, 213; Polish school Nativity plays and Bais Yaakov theater performances, 110n11; Polonization of, in Galicia, 6, 155–156, 188–189; regional towns and cities, students moving to, 230; student population of Kraków, 209n84; teachers and university professors, women training and working as, 193–194, 195, 197, 199–201, 210n103, 211n116; youth movements and, 234–236; Yung-yidish group, foreign studies of, 90n4

ego-futurists, 24
Ehrlich, Henryk, 218
Ein Harod, 147
Elisha ben Abuya, 103
Emil and the Detectives (Kästner), 148
Endecja (National Democracy) party, 18, 68, 73n48, 144, 156–157
Engel, Joel, 151n30
Enzinger, Jordan, 254, 256, 263
Epelgrad (later Cohn), Dvora, 109n3
Erenberg, Lewis, 120
Esther (biblical queen), 104, 111n25, 117
Esther (wife/mistress of Casimir the Great), 174, 185n17
Estrada (journal), 161
Ethics of the Fathers, 105
Even-Zohar, Itamar, 154
Ewa (journal), 120, 201
exoticism: Orientalism, 114–115; "Oriental" (Middle Eastern) Jewry, image of, 8, 113–120, 122–123; primitivism and the primitive, 35n42, 82, 116–118, 121. See also Zefira, Bracha
expressionism: impressionism versus, 81; of Vogler, 51. See also Yung-yidish group and Jewish expressionism
Eyal, Gil, 119
Eynhorn, Dovid, 40, 42
Ezrah Organization, *141*

Fajwiszys, Izrael, 133, 134, *135*, 143, 144, 256, 259
Fama movie theater, Warsaw, 215
Feldman, Wilhelm, 179, 186n30, 194
Feldmanowa, Maria Kleinman, 194–195
feminists and feminism, 8, 64, 67, 106, 157–158, 194–195, 197, 198, 207n55
film. *See* movies; movie theaters as Jewish public spaces
Finkin, Jordan, 53n13
Fischer, József, 186n27
Fischlerówna, Regina, 202
Flam, Gila, 116
Flesch, Moses, 109n7
Flora movie theater, Łódź, 225n31
Florida, Richard, 158, 166n25
Folkstsaytung (Yiddish daily), 218
folk style: Ararat theater, folksy (*folkstimlekher*) theatricality of, 28–29; concert programming in interwar Lwów and, 128, 133, 134, *135*, *137*, *141*, 143, 144, *145*, *146*, 147, 149; Górale folk music, 120, 126n54; primitivism and the primitive, 116; of Sutzkever's cover art, 42, *43*, *47*, *48*; in Vogler's work, 42, *43*, 44, *48*, 49, 51; Yung-yidish and Jewish expressionism, 82, 88; Zefira, songs performed by, 117, 119, 120, 121

Formism; Formists, 68, 73n46
Free School of Drawing and Painting, Kraków, 198
Freud, Sigmund, 234
Friedman, Filip, 2–3, 6, 11–12n7, 10–11
Friedman, Ignacy, 260
Friling afn trakt (Springtime on the country highway; Vogler), 52, 55n41
Fromowicz-Stillerowa, Henryka, 197, 201, 208n75
Fuchs, Henokh, 81
functionalism, in architecture, 7, 60, 61, 62
futurists and futurism, 22, 23, 24, 26, 35n42, 76, 77, 90n8, 91n24

Gądzikiewicz, Stanisław, 71n7
Galicia: education, Polonization of, 6, 155–156, 188–189; emancipation of Jews in, 6; Habsburg grant of cultural hegemony to (1867), 1; Kraków becoming part of, 2; musical culture in, 129. *See also specific towns*
Gall, J., *134*
Garbo, Greta, 112n32, 212
garden city movement, 59, 67, 70
Gardner, Patrick, 254, 262, 263–264
Garewicz, Jan, 67
Garfeinowa-Garska, Malwina (Maria Zabojecka), 194, 207n55
Gauguin, Paul, 117
Gazeta Polska, 174
Gegenwartsarbeit (work for the present), 129
Gelbard, Jerzy, 71n11
gender and women's history, 5; Casimir the Great monument (unbuilt), Kraków and, 173; feminists and feminism, 8, 64, 67, 106, 157–158, 194–195, 197, 198, 207n55; Glass House and owner Irena Krzywicka, 7–8, 64–70; Lodzermensz/*szmonces*, women as, 157, 162; Polonization of Jewish women, 188–189; small communities, gender roles in, 236; youth movements, women members and male-female interaction in, 10, 232, 233, 236–238, *237, 239*; Yung-Vilne and, 54n18. *See also* institutional spaces for women's cultural production in Kraków; Schenirer, Sarah, and Bais Yaakov theater performances
Gerer (Gur) Hasidim, 2, 97, 108n2
German, ethnic, in Poland, 2
German-Polish Non-Aggression Pact (1934), renunciation of, 148
Gerson, Wojciech, 182
Gersztajn, Jakub, 259
Gesang zwischen den Stühlen (Kästner), 147–148

Glassheit, Franciszka, 194
Glass House, Podkowa Leśna, 7–8, 56–70; excentricity of, 56, 68, 69–70; features and appearance of, 62–64, *63, 64*, 72n25; flat roof of, 68, 73n46; functional architectural style of, 7, 60, 61; garden city movement and founding of Podkowa Leśna, 59, 70; geometric modernism of, 62; Goldberg and Rutkowski, firm of, 7–8, 56, 60–64; impact on neighborhood, 68–69, 70; Irena Krzywicka (owner), lifestyle of, 7–8, 64–70; local library in, 73n44; Malewicz's paintings, influence of, 62, 72n24; minor architecture, theorization of, 73n44; in modern architectural history, 59–60; modern architecture, employment of glass in, 57–58; New Canaan (CT) glass house, 57; postwar survival of, 72n25, 73–74n51; privacy in, 63–64, 72n27; *pudełka* (boxes) of 1960s and, 71–72n20; transparency, as modernist concept, 56–57, 64. *See also* Krzywicka, Irena
Głos Kobiety Żydowskiej (The voice of the Jewish woman), 201
Głos pustyni (Sound of the desert; film), 118
Gluck, C. W., *133, 143*
Gnessin, Menahem, 115
Gody życia (The Nuptials of life; Przybyszewski, play), 106
Goebbels, Joseph, 148
Goethe, Johann Wolfgang, 34n29, 75, 256
Gold, Artur, 256, 261
Goldberg, Halina, 1, 3–4, 6, 254, 261, 287–288
Goldberg, Maksymilian: background and education, 60–61; construction of Glass House by, 7–8, 56, 60–64, *63, 64*, 67, 69, 70; Krzywicka, relationship with, 61–62, 71n17, 71n19; National Museum, Warsaw, design competition for, 71n12; in Warsaw Ghetto, 72n21. *See also* Glass House
Goldberg, Stanisław, 66
Goldfaden, Abraham, 3, 25, 26, 28–29, 36n36, *141, 146*
Goldmark, K., 130, *131, 133, 134*
Goldszmit, Henryk (Janusz Korczak), 4, 5
Goldwasserowa, Rachel, 199
Goll, Yvan, 90n18
Gołowka, Karasa movie theater in, 218
Goltermann, G., *135*
Gonzalez, Joshua, 255
Goodman, Benny, 121
Gora, Yaffa, 111n19, 111n24
Góra Kalwaria (Yid. Ger) and Hasidim, 2, 108n2
Górale folk music, 120, 126n54
Gordin, Jacob, 34n24

INDEX

got fun nekome, Der (*God of Vengeance*; Asch), 220
Gottlieb, Maurycy, tombstone monument for, 177–179, 181, 186n34
Gounod, Charles, *135*
Grade, Chaim, 111n26
Grimstad, Knut Andreas, 33n10, 162
Grinberg, Uri Tsvi, 24, 84
Grodner moment (ekspres) (daily), 119
Grodno, Zefira's performance in, 8, 113, 119, 123
Gropius, Walter, 60
Gross, Adolf, 197
Grossbard-Perlmutterowa, Sara, 199
Grünbaum, Franz (Kriebaum), 159
Grünbaum, Yitshak (Izaak), 136, 215, *217*, 218, 225n26
Grunfeld, Judith Rosenbaum, 106
Grunhutowa, Helena, 208n80
Grunwald, five hundredth anniversary of Battle of (1910), 174
Guattari, Félix, 73n50
Guilmant, A., *135*
Günsberg (Guensberg), Henryk, *145*, *146*, 147
Gutzkow, Karl, 149

Habima Theater, Berlin, 35n47, 116, 149
Haggadah (Artur Szyk), 156
Haggadot, 93n52
Hakhsharot (Heb., youth movements' training programs), 236, *237*
Halévy, Jacques-François-Fromental, *135*
Hamsun, Knut, 195, 207n55
Handel, George Frideric, 134, *135*, *139*, *145*, *146*, 149
Hanukkah, 97, 101, 102, 109nn7–8, 111n19, *135*, *139*, *140*, *141*, 233
Hasenclever, Walter, 66, 72n32
Hashomer hatsa'ir, 10, 229; as cultural portal, 234–235; gap between cultural prescriptions and actual activities, 238, 239, 240; Hazan and, 245n26; Polish government and, 241; recruitment efforts of 1930s, 230; religious dynamics, awareness of, 231, 232, 233; women members and male-female interaction, 236, *237*, 238
Hasidim: amateur theatricals and, 97–98, 103, 111n24; Bloch's *Baal Shem*, 144–145; Broderzon's followers known as, 21; Buber on, 78; Gerer (Gur) Hasidim, 2, 97, 108n2; *hitlahavut* (Heb. ecstatic prayer) of, 76; *nefilat hatsadik* (the descent of the zaddik), 93n55; pseudo-Hasidic dance, Ararat's performance of, 29; Rathaus's *Uriel Acosta* invoking tunes of, 149; regional centers for, 2; youth movements and, 231, 232, 233; Zionism and, 231

Haskalah (Jewish Enlightenment), 28, 55n40, 80, 148, 234, 257
haskama (Heb. public letters of approval), 232
Hauptman, Gerhardt, 207n55
Ḥaviv, Zerubavel, 214
Haydn, Joseph, *138*
Haynt (daily), 97, 98, 101, 102, 117, 220
Hayntige nayes (daily), 98, 101, 112n32
Hazan, Ya'akov, 245n26
He'atid/Przyszłość (Future; Zionist monthly), 197
Hebrew language and literature: in Kraków, 188, 189, 191, 194; youth movements and, 238
Hebrew Secondary School (also Hebrew Gymnasium), Kraków, *196*, 198, 199, *200*
Hecht, Józef, 83
Hecker, Helena, 197
hefkerdik, 25
Heilman, Izaak, *137*, *139*, *140*, 142–143, 144
Heller, Daniel Kupfert, 10, 228, 288
Heller, Róża (Helena Hellerówna), 202, 211n112
Help Through Work (organization), 38
Hemar, Marian (Jan Marian Hescheles), 5, 150n10
Hermelin, Natan, 130, *131*, 134, 136
Herzl, Theodor, 222, 233
Hescheles, Henryk Ignacy (Henryk Trejwart), 130
Hescheles, Jan Marian (Marian Hemar), 5, 150n10
Hetman, Ya'akov, 242
Heumannowa, Eugenia, 208n80
Ḥibat Tsiyon, *140*
Hirschprung, Marta, 201
Hitchcock, Henry-Russell, 60
hitlahavut (Heb. ecstatic prayer), 76
Hitler, Adolf, 144, 148
Hochberg, Maria, 201
Hoffman, Bruno, 202, 211n114
Hollander, Sara, 197
Holocaust, reclaiming histories lost to, 3–4, 10–11, 223
Homola, Irena, 191
horizontal art history, Piotr Piotrowski's concept of, 76
Hornówna, Etla, 199
Horowitz, Marceli, *143*
Horowitzówna, Ludwika, 208n80
Horszowski, Mieczysław, 260
Hotel Europejski, Kraków, 202
Howard, Ebenezer, 59

Ibsen, Henrik, 195
Idelsohn, Abraham Zvi, 119

I. L. Peretz People's Reading Room (Czytelnia Ludowa I. L. Pereca; formerly People's Reading Room "Unity" [Czytelnia Ludowa "Jedność"]), Kraków, 200, 202, 211n109
Ilustrowany Kurier Codzienny (journal), 201
impressionism versus expressionism, 81
Infeld, Bronisława, 199, 202
Infeld, Leopold, 188
institutional spaces for women's cultural production in Kraków, 9, 188–204; in 1899, 191–195, *192*; in 1919, 195–199, *196*; in 1939, 199–202, *200*; cultural and self-educational associations, 194, *195*, *196*, 198, *200*, 202; doctorates, Jewish women earning, 197–198, 199; educational institutions, *192*, 193–194, *196*, 197–198, 199, *200*, 203, 209nn84–85, 210n103; familial support for, 188, 197, 203; fine art education and painting, 198; first secondary schools for girls, 189; Kazimierz neighborhood and, *192*, 193, 195, 198, 203–204; literary salons, *200*, 202; literature and journalism, 194–199, 201–202, 203; maps as analytical tools for, 189–190, 203; multilingual polysystem of Jewish culture, 188–189; Polonization of Jewish women and attendance at Polish schools, 188–189, 191; radio broadcasting, *200*, 202, 210–211n106; status and significance of Kraków and its Jews, 190–191; teachers and university professors, women training and working as, 193–194, 195, 197, 199–201, 210n103, 211n116; theater, 195, *196*, *200*, 202, 203. *See also* reading rooms, Kraków; *specific institutions by name*
interethnic and interreligious hybridity: "Boże coś Judę" ("God Save Judah") anthem, 179; Casimir the Great monument (unbuilt), Kraków and, 175, 177; of Kahan, 42; in Łódź, 77, 154; of Mickiewicz, 83–84; philanthropic initiatives, interconfessional, 179–180; in Polish film industry, 227n50; of Vogler, 47; of Yung-yidish and Jewish expressionism, 88
International Congresses of Modern Architecture (CIAM), 60, 61, 71n9
international style, in architecture, 60
Ippolitov-Ivanov, Mikhail, *140*
Israel. *See* Mandatory Palestine
Israel ben Eliezer (Baal Shem Tov), 144–145
Isserles, Moses, 110n16
Iwaszkiewicz, Anna Lilpop, 71n7
Iwaszkiewicz, Jarosław, 71n7

Jabotinsky, Vladimir (Ze'ev), 212, 220, *221*, 224nn5–6, 229, 242
Jachimecki, Zdzisław, 120–121
Jagiellonian University, Kraków, 9, 120, 191, *192*, 193, 195, *196*, 197–198, 199–201, *200*, 201, 202, 210n103
Jakubczyk-Ślęczka, Sylwia, 8–9, 127, 288
JALS. *See* Jewish Artistic and Literary Society
January Uprising (1863–1864), 173, 222
jasełka (Polish Nativity plays) and Bais Yaakov theater, 101, 110n11
Jasińska-Filipowska, Zofia Gottlieb, 202
jazz music, 6, 18, 120–121, 126n55, 126n60, 128, 139, *141*, 142, 144, 214
Jedność (Unity; journal), 195
Jewish Agency Board, 214
Jewish Artistic and Literary Society (JALS; Żydowskie Towarzystwo Artystyczno-Literackie), Lwów, 127–128, *133*, 136–149, *137–139*, *140–141*, *143*, *145–146*. *See also* concert programming in interwar Lwów
Jewish choral tradition, 254–261
Jewish Democratic Party, 197
Jewish Enlightenment (Haskalah), 28, 55n40, 69, 80, 148, 234, 257
Jewish Historical Institute, 72n21
Jewish Labor Bund. *See* Bund
Jewish Literary Union, 47, 103, 108
Jewish Music Society (Żydowskie Towarzystwo Muzyczne; JMS), Lwów, 127–137, *131–133*, *135*, 139, 149. *See also* concert programming in interwar Lwów
Jewish National Fund (Keren Kayemeth L'Yisrael; KKK), *138*, 214
Jewish National School in Music, 133
Jewish Philanthropy Society, 226n41
Jewish Polish culture. *See* Polish Jewish culture beyond Warsaw
Jewish Renaissance, Martin Buber's idea of, 78, 82, 90n8
Jewish Society for Knowing the Land (Yid. Yidisher gezelshaft far landkentenish; Pol. Żydowskie Towarzystwo Krajoznawcze), journal of, 2, 11n7
Jewish space, concept of, 213, 224n14
JMS. *See* Jewish Music Society
Johnson, Philip, 57, 60
Joseph and His Brothers (*The Selling of Joseph*; Bais Yaakov play), 99, 102, 104, 108–109n3
jubilee/anniversary culture in Poland, 136, 138, 174–176, 181, 185n21, 226n41
Judah Maccabee (Handel), 145, *146*, 149
Judith (Schenirer; Bais Yaakov play), 97, 98, 104, 109n7
Juliusz Słowacki Municipal Theater, Kraków, 173, 195, *196*, *200*, 202
Juliusz Słowacki Reading Room for Women (Czytelnia dla Kobiet im. Juliusza Słowackiego), Kraków, *192*, 194

INDEX

Junge Rheinland, Die, Düsseldorf, 79
Jutrzenka (weekly), 174, 185n19

Kagan, Yisrael Meir Ha-Kohen (Chofetz Chaim), 110–111n16
Kahan, E., 146
Kahan, Shimshn, 41–42, 54n17
Kalinówna (Klingbeil), Dora, 162, 251
Kallas, Aniela (Aniela Korngutówna or Korngut), 174, 194, 195, 197, 208n66
Kalmar, Ivan, 114
Kamerniĭ theater (Moscow), 27
Kantonisten (Cantonists; Bais Yaakov play), 98, 99, 109n3
Kaplan (née Eisen), Vichna, 112n27
Karasa movie theaters: Gołowka, 218; Lublin, 218, 225n26; Radom, 215
Karłowicz, Mieczysław, 130, 131, 132, 133, 145
Karpiński, Franciszek, 255
Kassow, Samuel, 231
Kästner, Erich, 146, 147–148
Katechizm polskiego dziecka (Catechism of a Polish child; Bełza), 106
Kaufler, Stefania, 211n109
Kazimierz (Yid. Kuzmir): as distinctive Jewish district/neighborhood of Kraków, later incorporated into, 2, 171, 174, 175, 190–191; institutional spaces for women's cultural production and, 192, 193, 195, 198, 203–204; plan to erect monument to Casimir the Great in former market square of, 171, 174, 184
kehilot (Heb. Jewish community councils), 236
Kéler, B., 140
Keren Kayemeth L'Yisrael (KKK; Jewish National Fund), 138, 214
Ketèlbey, A., 140
Khad-gadye puppet theater (Łódź), 20
Khalyastre (The gang; expressionist periodical), 24, 35n33
Khalyastre, Di (The gang; art group), 24, 81, 84, 91n24
kheyder, 77, 229
Khinukh (Education; club) theatricals, 102–103
Kiev: Jewish avant-garde milieu in, 78; Kultur-Lige in, 77, 81, 82, 93n57
Kipling, Rudyard, 195
Kipnis, Menakhem, 117, 119
KKL (Keren Kayemeth L'Yisrael; Jewish National Fund), 138, 214
Klein, Herman and Regina, villa of, 62
Klein, Leslie Ginsparg, 111n24
Kleinberger, Pola, 211n109
Klementyna Tańska-Hoffmanowa Public Elementary School for Girls, Kraków, 194, 199, 200

Klepfish, Heshl, 102
kleynkunst teater, 3, 7, 15–32, 163–164. See also Ararat Kleynkunst Theater (Łódź)
klezmer music, 29, 136
Klingbeil (Kalinówna), Dora, 162
klyatshe, Di (The Nag; Moykher-Sforim), 146, 148
Knopping, Chaim, 139
Kodály, Zoltán, 121
Koffler, Józef, 256, 260–261
Kołakowski, Leszek, 69
Kon, Henekh, 20, 29, 33n11
Konigsberg, Ira, 125n38
Korczak, Janusz (Henryk Goldszmit), 4, 5
Korngold, E. W., 130, 133, 134
Korngold, Lucjan, 71n11
Korngutówna, Aniela (Aniela Korngut; Aniela Kallas), 174, 194, 195, 197, 208n66
Korzenie (Roots; Zahorska), 198
Kościuszko monument, Lwów, 181
Kostopol, youth movements in, 237
Kowel, youth movement culture in, 230
Kozłowska, Magdalena, 8, 113, 127, 288
Kragen, Wanda, 201
Kraków (Yid. Kroke): Bais Yaakov in, 105, 106; cabarets in, 19, 202, 211n114; changing political status of, 1, 2, 174–175, 190–191, 205n20; Jews of, 190–191; Mickiewicz memorial statue, market square, 176–177, 178; Adam Mickiewicz's ashes transferred to, 174, 176; movie theaters in, 215, 222; music societies in, 129; student population of, 209n84; theater culture of, 105–106, 195. See also Casimir the Great monument (unbuilt), Kraków; institutional spaces for women's cultural production in Kraków; Kazimierz; reading rooms, Kraków; specific buildings and locations
Krasiński, Zygmunt, 92n42
Kraszewski, Józef Ignacy, 174, 176
Kriebaum's (Franz Grünbaum's) cabaret, Vienna, 159
Krivoe zerkalo (Broken/false mirror; cabaret, St. Petersburg), 19
Król Maciuś Pierwszy (King Matt the First; Korczak), 4
Kronland, Jacek, 139
Krukowski, Kazimierz (Lopek), 161, 162
Krytyka (journal), 192, 194–195
Krzywicka, Irena, 7–8, 56, 64–70; background and education, 64–66; Goldberg, relationship with, 61–62, 71n17, 71n19; image of, 65; marriage and lovers, 66–67, 72n33; modest means and expectations of, 61, 71n18; political views, cultural involvement, and women's rights, 66–70; transparency, living out modernist concept of,

Krzywicka, Irena *(cont.)*
 56–57, 64, 67, 69–70; *Wyznania gorszy-cielki* (Confessions of a scandalist), 69.
 See also Glass House
Krzywicki, Andrzej, 67
Krzywicki, Jerzy, 66–67, 73n37
Krzywicki, Ludwik, 66
Krzywicki, Piotr, 66
Kubiak, Anna (Chana), 72n21
Kulbak, Moyshe, 25, 40–41, 42, 44, 45, 46, 53n13
Kulczykowski, Mariusz, 197, 201, 210n103
Kultur-Lige (Yid. Culture League), 77, 81, 82, 93n57, 218, 219, 220, 226n45
kunst (art) / *shund* (Yid. trashy culture) binary, 7, 17, 25–26, 28
Kuryer Literacko-Naukowy (weekly), 201
Kusewicki, Jakub, 139

Lachert, Bohdan, 62, 72n21
Lachsowa, Zofia, 208n80
Lag Ba'Omer, 233
lamedvovnikim, 51
Landau, L., 145
Landau-Eiger, Hanka, 202
Landauowa, Natalia, 208n80
landkentenish (knowing the land), Vogler's poetics of, 37, 44–45
Landkentenish: Tsaytshrift far fragn fun landkentenish un turistik, geshikhte fun yidishe yishuvim, folklor un etnografiye (Knowing the land: Journal for questions of knowing the land and tourism, the history of Jewish settlements, folklore, and ethnography; journal), 2, 11n7
Landowska, Wanda, 260
Landy, Stella, 201
Langroderowa, Michalina, 208n80
Lawiński (Latajner), Ludwik, 159
Le Corbusier, 60
Lee, Yenhsüan, 254, 256, 264
Left Poale Tsiyon Party (Po'ale Tsiyon Semol), 215, 222
Leib, Manni, 38
Lem, Stanisław, 5
Leśmian, Bolesław, 5
Lesser, Stefania, later Zahorska, 198
Levin, Moyshe, 54n22, 54n25
Levinson, Avraham, 15
Lew, Maks, 139
Lewandowski, Louis, 133, *135*, *138*
Lewandowski, Stanisław, 173, 182, 185n11
leybn, Dos—an ayznban (Life—a train; Kästner), *146*, 147–148
Leyvik, H., 23
Lichtensztajn, Yitskhok (Isaac Lichtenstein), 75

Lieblingowa, Berta, 208n80
Liessin, A., 46–47
Lifshits, Moshe, 149
Lilpop, Stanisław, 59, 70, 71n7
Lincer, Cecylia, 211n109
Lindsey, Benjamin Barr, 66, 72n34
Linetski, Yitskhok Yoyel, 25
Lissitzky, El, 21, 85, 89
Liszt, F., *143*
"Lite" (Eynhorn), 40
Literarishe bleter (Literary pages; art journal), 15–17, *16*, 26, 75, 117, 118, 119
literary cabarets, 19, 33n10, 159–164
literary salons in Kraków, *200*, 202
Lithuania, Republic of, rule over Wilno (1940), 51–52
Litvak Jewish identity and Vogler's poetry, 7, 37, 40, 44–46, 49, 53n1, 53n9
"Litvishe tsigayner" (Lithuanian Gypsies; Kahan), 42
Lloyd, Harold, 212
Locker, Berl, 214
Łódź (Yid. Lodzh): artistic culture and "creative class" of, 15–17, 77–81, 89, 158–160; Astoria Café, 33n13; Bartkiewicz's *Złe miasto* about, 153; Bi-Ba-Bo (literary cabaret), 19, 33n11, 159–160, 163, 164; Broderzon as cultural activist in, 20–21, 22, 75–76; cultural exchange, as focus of, 165; Friedman's monograph on, 6; Hotel Savoy, 158, 159, 161; as industrial/commercial hub, 19, 40, 77, 153; Jewish population of, 90n13, 154; Khad-gadye puppet theater, 20; *kleynkunst teater* in, 163–164; as Kominogród (chimney city), 153; literary cabarets in, 19, 33n10, 159–160, 163, 164; lost Jewish history of, 3–4; movie theaters in, 153, 212, 218, 220, 225n31; multiethnicity of, 77, 154; overall population of, 153, 154; Piotrkowska Street, 19, 33n13; Reymont's *The Promised Land* about, 153; as *tabula rasa*, 83. See also Ararat *Kleynkunst* Theater (Łódź); multidirectional flow of culture between Warsaw and Łódź; Yung-yidish group and Jewish expressionism
Łódź Artist Society (*Artistn-farayn*), 27
Lodzermensz (Yid. Lodzhermensh; Ger. Lodzermensch): Broderzon as, 75–76, 88–89; concept of, 152, 153, 154–158, *155*, 164; gendered interpretation of, 157; in literary cabarets, 159, 160; multidirectional flow of culture between Warsaw/Łódź and, 154–158, *155*, 164; *szmonces* genre, included in, 160–163, 164
Łodzianka (annual), 152
Loew (Low), L., *135*, *146*
Lopek (Kazimierz Krukowski), 161, 162

INDEX

Lublin, movie theaters in, 215, 218; Zefira in, 113, *114*
Lubliner togblat (daily), 113
Luboml, youth movements in, 232, 242
Łuck, youth movement culture in, 230, *237*, *239*
Luft, H., *146*
Lüling, B., *140*
Luxemburg, Rosa (Róża), 72n29
Lwów (Yid. Lemberik; Ger. Lemberg; Ukr. Lviv): Kościuszko monument, 181; movie theaters in, 212; musical culture and institutions of, 129; shifting political boundaries of Poland and significance of, 1. *See also* concert programming in interwar Lwów
Lwów, Polish-Ukrainian Battle of (1918–1919), 129
Lwów [Radio] Wave (Lwowska Fala), 142
Lyady and Hasidim, 2

maggid (itinerant preachers), 29
Mahler, Gustav, 130, *133*, 134, 150n12
Makhmadim, 79
Malewicz, Kazimierz, 62, 72n24
Małopolska (Lesser Poland), 190
Małżeństwo koleżeńskie (*The Companionate Marriage*; Lindsey), 66
Mandatory Palestine: concert programming in Lwów from, 145, 147; Hashomer hatsa'ir leaders emigrating to, 230; Jabotinsky's evacuation plan for Polish Jews to, 242; "Oriental" (Middle Eastern) Jewry, image of, 8, 113–120, 122–123; popular culture, contempt for, 214, 225n23; *siḥot* (group discussions) of youth movements on, 235; speakers from, in Poland, 212–215, *216*, *217*, 220, 223; Yemenite Jews, Orientalization of, 117; youth movements providing cultural portal to, 234; Zefira's background and early career in, 8, 113, 115–116
Mandelbaum, Mala, 201
Manekin, Rachel, 189
Manievich, Abraham, 76
Mann, Thomas, 234
Mapai, 212
maps, as analytical tools, 189–190, 203. *See also* institutional spaces for women's cultural production in Kraków
Maria Konopnicka Primary School, Kraków, 199, *200*
Mark, Arn, 48
market towns. *See* shtetlakh
Markish, Perets, 24, 25, 35n33, 80–81, 84
Marminski, Israel (Marom), 215, 225n25
Marx, Karl, 57, 66, 70

Marxism, 66, 77, 229
Mascagni, Pietro, 145, 147
Maślak-Maciejewska, Alicja, 9, 171, 288
Mata Hari (Margaretha Geertruida "Margreet" MacLeod), 118
Matejko, Jan, 177, 182
Matera, Rafał, 166n25
matura certificates, 193, 199
Mayakovsky, Vladimir, 22, 34n25, 34n29, 77
May Coup (1926), 18, 136
Meidner, Ludwig, 78, 88, 92n40, 93n54
Meir Ezofowicz (Orzeszkowa), 195
Mendelsohn, Ezra, 186n34, 243
Mendelssohn Bartholdy, Felix, 130, *131–132*, *134*, *135*, *138*, *143*, *146*, 148, 150n12, 256, 259
Menno, Nancy, 117
messianic and apocalyptic themes, 8, 77, 83–88, *86*, *87*, 92nn40–41, 92n51
Metzler Lexikon: Avantgarde, 76
Meyer, Bernard, 136
Meyerhold, Vsevolod, 27
Mickiewicz, Adam: ashes transferred to Wawel Cathedral, Kraków, 174, 176; *Dziady, Part III*, 176; Irena Krzywicka and, 66; literary evenings dedicated to, 172, 176; memorial statue of, Kraków market square, 176–177, *178*, 181; *Pan Tadeusz*, 176; philosemitism of, 84, 92n42, 177; *Reduta Ordona*, 176; Sarah Schenirer and, 106; theater adaptations of works of, 195; Warsaw street named for, 58; Yung-yidish movement and, 83–84, 92nn41–42
Mies van der Rohe, Ludwig, 60
Mikhton, Bentsye, 42
Mirande, Yves, 106
Miraż movie theater, Biała Podlaska, 218
Miraż movie theater, Radom, 215
Mirjams Siegesgesang (*Miriam's Song of Triumph*; Schubert), 145, *146*, 148, 149
Miron, Dan, 25, 245n24
Mizrahi (Zionist religious movement), 215
Młoda Polska (Young Poland) movement, 77, 84, 191–193
Młynów, youth movements in, 232
modernism/modernity: in architecture, 7, 60, 62, 73n46 (*see also* Glass House); artistic modernity, Polish circumstances fostering, 6; Chagall as first modern artist, 81–82; concert programming in interwar Lwów and, 129, 149; Eastern Europe, emergence in, 8; folk modernism of Vogler, 51; Jewish education for girls as modernist project, 8; Polish Jewish artists' engagement with, 260; populist modernism of Ararat *Kleynkunst* Theater (Łódź), 7, 18–21; Russian modernism/avant-garde, 17, 21–24, 29, 33n9, 34n22; transparency, as

modernism/modernity *(cont.)*
 modernist concept, 56–57, 64; of Vogler's poetry, 7; Yiddish modernist writers' interest in expanding Yiddish borders, 52; Young Poland and, 191–193; Yung-Vilne and, 7, 37; Yung-yidish and, 77, 81

moment, Der (journal), 220

Momus (literary cabaret, Warsaw), 159–160

Monderer, Julia (Julia Romowicz), 195

Montefiore, Moses, 178

Moravia, German-Jewish schools in, 213

Moretti, Franco, 189

Morskie Oko (Sea eye; cabaret, Warsaw), 19, 251

Moscow: Broderzon in, 21, 27, 34n22, 90nn4–5; Kamernii theater, 27

Moscow Art Theater, 27

Moscow Circle of Yiddish Writers and Artists, 21

Most, Andrea, 111n20

Moszkowski, Maurycy, *141*

movies: Bais Yaakov story about potential movie, 112n32; interethnic/interfaith cooperative environment of Polish film industry, 227n50; "kino" audience and popular nature of medium, concerns about, 212, 214, 218, 220; popularity of cinema in Poland, 212, 213, 214, 220–222; religious/rabbinical authorities' views on, 215; as *tenth muse*, in Poland, 220, 226n44

movie theaters as Jewish public spaces, 10, 212–223; Bund and, 213, 215–218, 220, 222; concept of Jewish space, 213, 224n14; cultural, literary, and philanthropic events, 218–220, 226n41; documentary and propaganda films, organizations sponsoring, 220, *221*; Kultur-Lige and, 218, *219*, 220; mass Jewish public assemblies, movie theaters as spaces for, 212–214; as neutral spaces bridging cultural and ideological gaps, 220–223, 227n50; number of movie theaters in Poland, 213; political disputes and violent confrontations, 220, 225–226n35; religious/rabbinical authorities and, 215; synagogues compared, 222; Yiddish cinema, 213; youth movements and, 220; Zionist speakers and events, 212, 214–218, *216*, *217*, 220. *See also specific towns and theaters*

Moykher-Sforim, Mendele, *146*, 148, 149

Mozart, Wolfgang Amadeus, 130', *131*, 132, 135, 137, *143*, *145*, 146

Mucha (Housefly; weekly), 156

multiculturalism. *See* interethnic and interreligious hybridity

multidirectional flow of culture between Warsaw and Łódź, 9, 152–165; Broderzon and, 163–164; "creative class" in Łódź, 158–160; *kleynkunst teater*, 163–164; life and culture in fin de siècle Łódź, 153–154; literary cabarets, 159–163; Lodzermensz, concept of, 154–158, *155*, 164 (*see also* Lodzermensz); magazines and journals, *155*, 155–157, 159, 160, 161, 163; *szmonces* genre, 160–163, 164, 168n47; Yung-yidish group and, 163

Munch, Edvard, 77

Municipal Theater (now Juliusz Słowacki Municipal Theater), Kraków, 173, 195, *196*, 200, 202

music. *See* concert programming in interwar Lwów; "Soundscapes of Modernity" concert; Zefira, Bracha

Mussorgsky, Modest, *143*

Nadler, Shmuel, 102, 103, 110nn12–13

Nardi, Nahum (Nakhum Narodetskiĭ), 115, 116, 118, 120, 121

Nasza Szkoła, Kraków, 199, *200*

Nasz Przegląd (daily), 81–82

National Democrats (Endecja), 18, 68, 73n48, 144, 156–157

Naumbourg, Samuel, *138*, *140*

Nayman, Yekhezkl Moyshe, 88

Neufeld, Daniel, 174

New Canaan (CT) glass house, 57–58, 68–69

New York Times, 122–123

Ney, Nora, 118

Niewiadomski, Stanisław, *145*

Nomberg, H. D., *138*

Nossig, Alfred, 184n2

November Uprising (1830–1831), 92n41

Nowa Gazeta Łódzka (New Łódź gazette), 159, 160

Nowakowski, Zygmunt, 202

Nowa Reforma (journal), 197, 208n66

Nowogrodzki, Emanuel, 218

Nowy Dziennik (daily), 183, *196*, 198, *200*, 201, 202

Nuremberg Laws, 144

Oberlenderowa, Klara, 208n80

Oettinger, Józef, 177–178, 186n34

Ognisko Pracy (vocational school for girls), Kraków, 197, 199, *200*

Ojczyzna (Homeland; biweekly), 175, 177, 178, 195

Okienko na Świat (Window on the world; children's periodical), *200*, 201, 202

Oncle Thom (Konrad Tom/Konrad Runowiecki), 159, 160, 161, 162, 166n26

Ordonówna, Hanka, 112n32

"Oriental" (Middle Eastern) Jewry, image of, 8, 113–120, 122–123

INDEX

Orientalism, 114–115, 119, 127
Oriental music, 119, 120–121, 122–123, 127
Orthodox Judaism: Agudath Israel as political party of, 108n2; Bais Yaakov, as Orthodox school movement, 8, 97, 98, 101, 103–104, 106–107; exotic othering of, 124n3; linguistic Polonization of, 188; literature and, 102, 103, 109–110n9; Shmuel Nadler's renunciation of, 103; school journals, 109n9; theatrical productions and, 97, 101–103, 107–108, 110n10; women and, 104, 108, 188
Orzeszkowa, Eliza, 195
Osowa Wyszka, youth movements in, 232
Ostjuden (Eastern European Jewry), image of, 78, 88
Otwock, movie theaters in, 220

Paderewski, Ignacy Jan, *137*
Palace movie theater, Lublin, 218
Palestine. *See* Mandatory Palestine
Palestine Symphony (Bensman), 127, 130
Pan Tadeusz (Mickiewicz), 176
Passover, 38, 93n52, 233
Pathetiker, Die (Berlin), 78, 83, 92n40
PEN Club, 47
Penslar, Derek, 114
People's Reading Room "Unity" (Czytelnia Ludowa "Jedność"; later Czytelnia Ludowa I. L. Pereca [I. L. Peretz People's Reading Room]), Kraków, 202
Peretz, Yitzkhok Leyb, 23, 29, 32, 36n53, 85, 88, *137*, 202, 218, *219*, 222
performativity theory, 108
Perkowska, Urszula, 197
Perln oyfn bruk (Pearls on the cobblestones; Yung-yidish), 83
Perskie Oko (Persian eye; cabaret, Warsaw), 19
Petterson, Carla L., 116
philanthropic initiatives, interconfessional, 179–180
philosemitism: of Casimir the Great, 174, 177; of Mickiewicz, 84, 92n42, 177
Picasso, Pablo, 117
Piłsudski, Józef, 2, 18, 136, 144, 222
Pińsk, youth movement culture in, 230
Piotrowski, Piotr, 76, 92n35
Pipman. *See* Urstein, Józef "Pikuś"
Pirandello, Luigi, 234
Plohn, Alfred, 127, 129, 134, 142, 149
Pniowerówna, Regina, 194, 206–207n47
Po'ale Tsiyon Semol (Left Poale Tsiyon Party), 215, 222
Podkowa Leśna, Glass House in. *See* Glass House
pogroms, 76

303

Polesie, youth movements in, 229, 231, 240, 245n26
Polewka, Adam, 202, 211n114
Polish Jewish culture beyond Warsaw, 1–11; center/periphery pairings, 5; cultural production, focus on, 4–6; gender and women's history, 5; geographical and temporal framework, 4, 5–6; Holocaust and lost history of, reclaiming, 3–4, 10–11; majority/minority cultures, relationships between, 6; modern artistic expressions of, 7–8 (*see also* Ararat *Kleynkunst* Theater [Łódź]; Glass House; Vogler, Elkhonen; Yung-yidish group and Jewish expressionism); performers and audiences, interplay between, 8–9 (*see also* concert programming in interwar Lwów; multidirectional flow of culture; Schenirer, Sarah, and Bais Yaakov theater performances; Zefira, Bracha); postcolonial approach to, 124n3; regionalism, Friedman on, 2–3; shifting political boundaries of Poland affecting, 1, 2, 6; spatial components of, 9–10 (*see also* Casimir the Great monument [unbuilt], Kraków; institutional spaces for women's cultural production in Kraków; movie theaters as Jewish public spaces; youth movements)
Polish Jewish Studies Workshop, Rutgers University, 6
Polish language, Jewish use of, 5, 155, 188, 189, 191, 195–197
Polish-Lithuanian Commonwealth (Rzeczpospolita Obojga Narodów), 1
Polski Rocznik Muzykologiczny (Polish musicological yearbook), 119
Portnoj, Felicja Barbanel Goldberg, 66, 72n29
Portnoj, Jekutiel, 66
Portnoy, Eddy, 103
"Postne Lite" (Modest Lithuania; Vogler), 51–52, 55n40
Postolski, Shalom, *145*, 147
Poznań, BUNT group in, 77, 79
primitivism and the primitive, 82, 116–118, 121
Private Gymnasium for Girls, Kraków, *192*, 193
Progressive Association, 172, 186n27
progressive Jews, 133, 172, 175, 177, 180, 194, 250, 257, 258
Prokop-Janiec, Eugenia, 9, 188, 288–289
Proletkult theater (Soviet), 20
Promised Land, The (Reymont), 153
Propper, Adela, 173
Propper, Jan Albert, 172, 173
Prużana, youth movements in, 239

Przedwiośnie (*The Coming Spring*; Żeromski), 58
Przemyśl, music societies in, 129
Przodownica (feminist weekly), *196*, 197
Przybyszewski, Stanisław, 77–78, 84, 106
Przyjęcie Żydów do Polski przez Kazimierza Wielkiego (*Admission of Jews to Poland by Casimir the Great*; Henryk Hochman, bas-relief plaque), 181–183, *182*, 184, 187n54
Puccini, Giacomo, *141*
Pulaver, Moyshe, 18
Purchla, Jacek, 190
Purim and Purimshpil (Purim play), 34n24, 35n47, 101, 104, 106, 109n8, 110n10, 110–111n16, 117, 139
Puterman, Julian (Julian Sadłowski), 71n11

Queen Esther contest, 117
Qui Pro Quo (cabaret, Warsaw), 19, 160–164, 167n31

Rabinovich, Solomon Naumovich (Sholem Aleichem), 25, 34n24, 35n37
Rachmaninov, Sergei, *137*
radio broadcasting, 139, 142, *200*, 202, 210–211n106, 214
Radio Lwów (Wave), 139
Radom, movie theaters in, 215, *217*
Rapoport, Y., 54n28
Rappoport, Shloyme Zanvl (An-sky), 29
Rathaus, Karol, 145, *146*, 148–149
Ravitsh, Melekh, 24–25
Raysn (Kulbak), 40–41, 44, 46
reading rooms, Kraków: Czytelnia dla Kobiet im. Juliusza Słowackiego (Juliusz Słowacki Reading Room for Women), *192*, 194; Czytelnia Ludowa "Jedność" (People's Reading Room "Unity"; later Czytelnia Ludowa I. L. Pereca [I. L. Peretz People's Reading Room]), *200*, 202, 211n109; Czytelnia Towarzyska (Social Reading Room), *196*, 198–199, *200*, 202, 208–209n80; Reading Room of Jewish Mercantile Youth (Czytelnia Starozakonnej Młodzieży Handlowej), 172, 173, 176, 178; "Ruth" reading room for Jewish women, *192*, 194, 202, 207n49
Reduta Ordona (Mickiewicz), 176
Reduta Śmiechu (literary cabaret, Łódź), 159
Reform Synagogue, Kraków. *See* Tempel (progressive or reform synagogue), Kraków
Regional Artisan Organization, *141*
regional Polish Jewish culture. *See* Polish Jewish culture beyond Warsaw
Reich, Leon, 129, 136
Reicher-Thonowa, Gizela, 201

Reinhardt, Max, 116
Reizen, Zalmen, 188
religion: Broderzon's use of religious Jewish vocabulary, 35n45; Mizrahi (Zionist religious movement), 215; movie theaters, religious/rabbinical authorities and, 215; youth movements, religious dynamics of, 231–233; Zionism, religious Jews and, 231. *See also* Hasidim; interethnic and interreligious hybridity; messianic and apocalyptic themes; Orthodox Judaism; synagogues
Reri (Anna Chevalier), 118, 125n37
Revisionist Zionists, 212, 215, 220, 224n5, 226n35. *See also* Betar
Reymont, Władysław Stanisław, 153, 155
Rheinberger, J., *135*
Rimsky-Korsakov, Nikolai, *132*
Rise and Fall of the City of Mahagonny, The (*Aufstieg und Fall der Stadt Mahagonny*; Brecht/Weil), 18
Rivoir, André, 106
Robotnik (daily), 113
Rolland, Romain, 207n55
Roma people, 42
Romowicz, Julia (Julia Monderer), 195
Rosen, Matthias, 174
Rosenbaum (later Grunfeld), Judith, 106
Rosenberg, Cecylia, 194
Rosenberg, Celestyna, 197
Rosenblatt, Yossele, 222
Rosenthal, Maurycy, 260
Rosenzweig, Franz, 77, 78
Rostowa, Nella, 199
Rotman, Diego, 33n7
Równe, youth movement culture in, 230, 240, *241*
Roxy movie theater, Łódź, 220, *221*
Różan, Bais Yaakov in, 98
Rozhanski, Elkhonen. *See* Vogler, Elkhonen
Rubinstein, Artur, 260
Runowiecki, Konrad (Konrad Tom; Oncle Thom), 159, 160, 161, 162, 166n26
Ruskin, John, 195
Russia: attitudes toward peasants in, 117; Broderzon in, 21, 27, 34n22, 90n4; modernism/avant-garde in, 17, 21; pogrom refugees from, 76; Proletkult theater, 20; restrictions on Jewish public buildings in, 222; Siniai͡a Ptit͡sa (Berlin cabaret) founded by Russians, 19, *164*; Vogler in, 52. *See also specific cities*
Russian Poland, industrialization of, 6
Rutgers Kirkpatrick Choir, 254, 255, 256, 262, 265
Rutgers University Polish Jewish Studies Workshop, 6

INDEX

Ruth (journal), 194
"Ruth" reading room for Jewish women, Kraków, *192*, 194, 202, 207n49
Rutkowski, Hipolit, 56, 60–64, *63*, *64*. See also Glass House
Ryback, Yisakhar Ber, 21, 76, 81, 89
Rygier, Teodor, 176
rynek (market square), 2

Sabbatean doctrine, 93n55
Sabbath observance/nonobservance, 39, 46, 89, *141*, 215–218, 220, 223, 233, 239, 242
Sadłowski, Julian (Julian Puterman), 71n11
Sambatyon, 17, 33n6
Schenirer, Sarah, and Bais Yaakov theater performances, 8, 97–108; Agudath Israel and, 101–102, 108n1, 109–110n9, 111n21; *Avot* 2:6 and, 105, 111n24; *Bais Yaakov Journal*, 109–110n9, 110n13; *The Binding of Isaac*, 98–101, 104; Bnos (associated youth movement), 102; cross-dressing by girls, 98–101, *99*, 104–105, 110–111n16, 111n24; female-only audiences and boys' efforts to attend, 97–101, *100*, 104; importance of theater to Bais Yaakov culture, 98, 103–107, 111n19; *Joseph and His Brothers/The Selling of Joseph*, *99*, 102, 104, 108–109n3; *Judith*, 97, 98, 104, 109n7; *Kantonisten*, 98, *99*, 109n3; Khinukh's efforts to present play with mixed-gender cast, 101–102; Kraków theater culture, Schenirer influenced by, 105–106, 107–108; movie, rumor about, 112n32; Orthodox amateur young men's theater and, 101–102, 107, 108, 110n10; pedagogy of Bais Yaakov and, 106–107, 188; Polish Nativity plays and, 110n11; reproduction of Orthodox culture and Bais Yaakov girls, 107; "Ruth" reading room, Kraków, Schenirer on meetings at, 207n49; scripts written by Schenirer, 98, 105, 111n25; small towns to cities, direction of cultural influence from, 107–108; Torah learning for girls, Bais Yaakov providing, 8, 105
Schiffmann, Franciszka, 197
Schiffowa, Róża, 208n80
Schildkret, Lucy (Lucy S. Dawidowicz), 10
Schlechter, Emanuel, 4
Schlesinger, Majer, 186n27
Schoenberg, Arnold, 261
Scholem, Gershom, 78, 93n55
School for Decorative Arts and Art Industry, Kraków, 199, *200*
schools and schooling. See education; specific schools
Schubert, Franz, *131*, *135*, *138*, *140*, *143*, 145, *145*, *146*, 148, 149

Schumann, Robert, *135*
Schwab, Erin, 254, 256
Seidman, Naomi, 8, 97, 289
Seo, Jihyang, 254, 255, 256, 264
Sephardic Jewry, 114, 115
Seydenbeutel, Edward, 71n11
Sforim, Mendele Moykher (Sholem Yankev Abramovich), 25, 34n24
Shabbat HaGadol, 93n52
ShaCh (Shabtai Cohen), daughter of, 112n32
Shallcross, Bożena, 7–8, 56, 289
Shavuot, 233
Shaw, Artie, 121
Shaw, George Bernard, 234
Shaykevitch, Nokhem Meyer (Shomer), 25
Shlonsky, Avram, *145*, 147
Sholem Aleichem (Solomon Naumovich Rabinovich), 25, 34n24, 35n37
Shomer (Nokhem Meyer Shaykevitch), 25
"shotn, Der" (The Shadow; Andersen), *146*, 148
Shprotsungen (Fresh growths; journal), 39
shtetlakh (Yid. market towns), 2, 10, 82, 85, 212–213, 222, 223, 228–230, 233, 235, 236, 249
"shtot, Di" (The city; Kulbak), 40
Shulman, Eliyohu, 46
Shumacher, Yisroel, 32, 33n7, 33n15
shund (Yid. trashy culture), 7, 17, 25–26, 28–29
Shvarts-shabes (Black Sabbath; Broderzon), 79–81, *80*, 84
Shveln (Threshold; Markish), 80–81
Siedlecka, Maria, 194
Siedlice, Bais Yaakov in, 98, *100*
Siel, Sidney, 115
Sigalin, Grzegorz, 71n11
sihot (group discussions), 235, 239, 240
Sikhes khulin (Broderzon), 85
Silber, Marcos, 9, 33nn10–11, 152, 289
Silberfeld, Antonina, 195
Singer, Isaac Bashevis, 82
Siniaia Ptifsa (Der blaue Vogel, Russian cabaret in Berlin), 19, *19*, 29, 33n12, 164
Sinkoff, Nancy, 1, 6, 254, 289
Skamander (poetic group), 71n7
Słonimski, Antoni, 163
Śmiech (Laughter; Łodz weekly), 156–157, 159, 160
Śmiech (Laughter; Warsaw weekly), *155*, 155–156
socialism, 6, 66, 80, 153, 165n6, 194, 228, 229, 232, 239, 241, 257. See also Bund
Social Reading Room (Czytelnia Towarzyska), Kraków, *196*, 198–199, *200*, 202, 208–209n80
Society for Jewish Folk Music, 133

Society for the Promotion of Jewish Music, Vienna, 147
Society of Planned Motherhood and the League for the Reform of Morals, 202
Society of the Lovers of Early-Modern Music (Stowarzyszenie Miłośników Dawnej Muzyki), 119
Sokolow, Nahum, 212, 214, 218
Soloveytshik, Henekh, 39, 41
Somarriba, Enriqueta, 254, 255, 256, 264–265
"Soundscapes of Modernity" concert, Rutgers University (2018), 6, 253–265
Soviet Union. *See* Russia
Spitzer, Salomon, 178, 186n27, 186n38
Splendor movie theater, Łódź, 218
Spranger, Eduard, 234
Środa, Magdalena, 67
Stanislavski, Konstantin, 27
Stanisław i Anna Oświecimowie (Karłowicz), 130
Stanisławów, music societies in, 129
Statute of Kalisz, The (Artur Szyk), 156
Stawisko (house of Stanisław Lilpop), 71n7
Steinbergowa, Hudes, 199
Steinhardt, Jakob, 78, 88, 89, 92n40, 93n54
Steinlauf, Michael, 25
Stendigowa, Felicja, 201, 202, 210n101, 210–211nn105–106
Sterling, Seweryn, 4
Stern, Zehavit, 7, 15, 289–290
Sternbachówna, Hela, 208n80
Sternberger, Leon, 258
Stolarska-Fronia, Małgorzata, 8, 75, 163, 290
Stoner, Jill, 73n50
Stowarzyszenie Architektów Rzeczypospolitej Polskiej (Association of Architects of the Polish Republic), 61
Stowarzyszenie Miłośników Dawnej Muzyki (Society of the Lovers of Early-Modern Music), 119
St. Petersburg, cabarets in, 19, 33n11
St. Petersburg Society for Jewish Folk Music, 133, 144, 147, 151n30
Strakun, Leopold, 82
Strashun library, Wilno, 39
Strauss, Johann, II, 132, *137*, 145
Strauss, Richard, 132, 133
Strawinsky, I., *143*
Striżowerówna, Róża, 208n80
St. Salomea School, Kraków, 206–207n47
St. Scholastica School for Girls, Kraków, *192*, 193
Suchmiel, Jadwiga, 197
Sullivan, Louis H., 60
Sulzer, Salomon, 133, *135*, 148, 258
summer camps, 213
Sutzkever, Avrom, 51

Sutzkever, Rokhl, 42, *43*, 47, *48*, 54n18
Swanson, Gloria, 212
synagogues: Jewish choral tradition and, 257–258; as Jewish public spaces, 222; Tempel (progressive or reform synagogue), Kraków, 172, 175, 176, 177, 178, 179, 191; youth movements and, 231, 232
synthetic theater, 27–28, 35n42, 35n49
Syrena Record, 261
Szagal, Marek (Marc Chagall), 81–82, 89
Szalit, Paula, 255, 260
Szczuka, Mieczysław, 68, 73n46
Szkoła Kazimierzowska (Casimir the Great School), Kazimierz, Kraków, *192*, 193
szlachta (noble class) tradition, 152, 153
szmonces (Yid. *shmontses*) genre, 160–163, 164, 168n47
Szternfeld, Ary, 4
Szwarc, Marek, 29, 79, 90n4, 91n24
Szyk, Artur, 21, 22, 156, 159, 160, 163
Szyk, Zalmen, 55
Szymanowski, Karol, 120, 121

Tairov, Aleksandr, 27
Tańczący ogień (Dancing fire; journal), 163
Tansman, Aleksander, 4, 255, 260
Tarbut schools, 230
Targownik, Pola, 211n109
Tarnopol (Ukr. Ternopil), shifting political significance of, 1
Tarnowski, Stanisław, 195
Taubenschlagowa, Pola, 208n80
Tausig, Karol, 260
Tchaikovsky, Pyotr Ilyich, 132, *133*
teachers, women training and working as, 193–194, 195, 197, 199–201, 210n103, 211n116
Teatr Ludowy, Kraków, 195
Tekiye gedola (The great shofar blast; Yitskhok Brauner), 84, 85, *87*, 92n45
Tempel (progressive or reform synagogue), Kraków, 172, 175, 176, 177, 178, 179, 191
tenth muse, movies as, in Poland, 220, 226n44
Teofil Lenartowicz School, Kraków, 199, *200*
theater: as institutional space for women's cultural production in Kraków, 195, *196*, *200*, 202, 203; Orthodox Jewish theatrical productions, 97, 101–103, 107–108, 110n10; youth movements and, 236. *See also* Ararat *Kleynkunst* Theater (Łódź); movie theaters as Jewish public spaces; Schenirer, Sarah, and Bais Yaakov theater performances; *specific theaters*
Thesaurus of Hebrew-Oriental Melodies (Idelsohn), 119
Thon, Ozjasz, 191

Threepenny Opera (*Die Dreigroschenoper*; Brecht/Weil), 18
Tkhiyes hameysim (Resurrection; Yung-yidish), 83
Tom, Konrad (Konrad Runowiecki; Oncle Thom), 159, 160, 161, 162, 166n26
Tomaszów Mazowiecki, movie theaters in, 220
To-Morrow: A Peaceful Path to Real Freedom (Howard), 59
Towarzystwo Ochrony Zdrowia Ludności Żydowskiej (TOZ; Society for Safeguarding the Health of the Jewish Population), 220
Towarzystwo Zachęty Sztuk Pięknych (Association of Fine Arts), 173
Trade Gymnasium (Private Jewish Coeducational Middle School for Trade), Kraków, 199
transparency: as architectural feature, 57–58, 69; Krzywicka living out modernist concept of, 56–57, 64, 67, 69–70; as modernist concept, 56–57, 64; psychoanalysis and, 70n1
Traveler Disguised, A (Miron), 25
Trejwart, Henryk (Henryk Ignacy Hescheles), 130
Trumpeldor, Joseph, 233
Trunk, Yekhiel Yeshava, 22
Trybuna Akademicka, 191
Tsabari, Tsipora, 117
Tseirey Agudas Yisroel. *See* Agudath Israel
tsukunft, Di (art journal), 47
Tsvey beriozes baym trakt (Two birch trees by the highway; Vogler), 47–51, *48*
Tunkeler, Der (Yoysef Tunkel), 28
Turkow, Zygmunt, 26, *146*
Tuszyńska, Agata, 69
Tuwim, Julian, 5, 153, 154, 159–163
Tygodnik (weekly), 195–197, 199

Ukrainians in Poland, 2, 220, 240
Uncle Tom's Cabin (Stowe), Polish reception of, 166n26
United States: dichotomous view of African and Native Americans in, 117; Europe, American Jews from, 126n60; *Uncle Tom's Cabin* (Stowe), Polish reception of, 166n26; Zefira's tour of, 121–123, *122*
"Unity" People's Reading Room (Czytelnia Ludowa "Jedność"; later Czytelnia Ludowa I. L. Pereca [I. L. Peretz People's Reading Room]), Kraków, *200*, 202, 211n109
university professors, women working as, 199–201
Uriel Acosta (Gutzkow), 149
Uriel Acosta (Rathaus), 145, *146*, 148–149
Urstein, Józef "Pikuś" (Pipman), 159, 161, 162, 167n31

Vakhtangov, Yevgeny, 35n47
Valdiks (Of the forest; Avrom Sutzkever), 51
Valentino, Rudolph, 212
Velfke's tavern, Wilno, 39
Verdi, Giuseppe, *138*
Vienna: coffeehouses of, 213; Franz Grünbaum's (Kriebaum's) cabaret, 159; hundredth anniversary of Relief of (1883), 174; Society for the Promotion of Jewish Music, 147
Vilna. *See* Wilno
Vilna Conservatory, 46
"Vilne" (Kulbak), 41, 53n13
Vilner tog (daily), 39
Vladimir Jabotinsky: Let the Jews Enter Palestine (film), 220, 221
Vogler, Elkhonen, 7, 37–52; *bletl in vint, A* (A page in the wind), 42–47, *43*; early life and career, 38–39; folk style, use of, 42, 43, 44, *48*, 49, 51; *Friling afn trakt* (Springtime on the country highway), 52, 55n41; influences on, 40–42; Litvak Jewish identity and, 7, 37, 40, 44–46, 49, 53n1, 53n9; localized language, use of, 44–45, 49, 55n34; pastoralism, turn to, 37, 44–46, 47, 49, 52; poetics of, 39–40; "Postne Lite" (Modest Lithuania), 51–52, 55n40; pseudonym taken on by, 38, 39, 52; self-doubt of, 46–47, 48, 49; *Tsvey beriozes baym trakt* (Two birch trees by the highway), 47–51, *48*; WWII and postwar life and career, 52; Yung-Vilne and, 37, 39, 42, 46, 47, 51–52
Vogler, Henryk, 188

Wagner, Esther Willig, 99, 108–109n3
Wagner, Richard, *132*, *133*
Warecka, Aniela, 66, 72n30
Warkowicze, youth movements in, 233, 242
Wars, Henryk, 4
Warsaw: Ararat's move to, 32; cabarets in, 19, 159–164; Dom Prasy (The Press House), 61; Fama movie theater, Mizrahi Zionist meetings in, 215; as "ferment," 73n35; glass house in, 58; Jewish avant-garde milieu in, 78; Jewish Literary Union in, 103, 108; Irena Krzywicka in, 64–66; Momus (literary cabaret), 159–160; as press and publishing center, 53n9; Qui Pro Quo (cabaret), 19, 160–164, 167n31; Saska Kępa neighborhood architecture in, 61; shifting political boundaries of Poland and significance of, 1; Ziemiańska Café, 67, 69. *See also* multidirectional flow of culture between Warsaw and Łódź
Warschauer, Jonathan, 172, 173, 180–181
Washington and His Times (Artur Szyk), 156

Wasserman, Jacob, 195
Waszyński, Michał, 118, 125n38
Wawel Cathedral, Kraków, 174–175, 179
We (Zamyatin), 58
Weber, Carl Maria von, *132*, 137
Webern, Anton, 261
Weil, Kurt, 18
Weinberg, Thea, 120
Weinberger, Juliusz, 137
Weinloes, 139
Weinreich, Max, 54n25
Weinzieher, Michał, 82
Weisenberg, Jonasz, 179
Weiss, Jakob Leopold, 255, 258
West versus East. *See* East versus West
Wiadomości Literackie (Literary news; weekly), 67, 69
Wilde, Oscar, 195
Willig, Esther (later Wagner), 108n3
Wilno (Yid. Vilna; Lith. Vilnius): Jewish Literary Union and PEN Club, 47; as Jewish regional center, 2, 40, 51–52, 55n40; Nazi destruction of Jewish Wilno, 52; Republic of Lithuania's rule over (1940), 51–52; shifting political boundaries of Poland and significance of, 1; Strashun library, 39; Velfke's tavern, 39. *See also* Vogler, Elkhonen; YIVO; Yung-Vilne
Wintersteinowa, Anna, 208n80
Wiśniowski, Teofil, 61
Władysław IV Vasa (King, Polish Lithuanian Commonwealth), 257
Włast, Andrzej (Gustaw Baumritter), 159, 160, 161, 256, 261
Włodzimierz Wołyński, youth movements in, 236
Woff, Edward, 260
Wolfram House, 62, 72n23
Wolfsohn, Juliusz, 144, *146*, 147
Wolfsthal, Chune, 136, *140*, *141*, 144, *145*, *146*
Wolnica Square, Kraków, 171, 182
Wołyń, youth movements in, 229, 230, 232, 233, 236, 239, 240
women's history. *See* gender and women's history
Wordsworth, William, 52, 55n42
World Zionist Organization, 212
W Tatrach (In the Tatra Mountains; Żeleński), 130, *131*
Wyspiański, Stanisław, 84, 92n46, 106, 195
Wyznania gorszycielki (Confessions of a scandalist; Irena Krzywicka), 69

Yemenite Jews: Orientalization of, in Mandatory Palestine, 117; Zefira's Yemenite background, 115–116; Zionism and, 118–119
Yiddish cinema, 213
Yiddish language and literature in Kraków, 188, 189, 191
YIVO (Jewish Scientific Institute): autobiographies collected by, 10, 229, 235; Friedman, regionalism article of, 2–3; Lucy Schildkret (Lucy S. Dawidowicz) at, 10; Wilno's cultural/scholarly traditions and, 53n9
yizker bikher (Yid. memorial books), 10, 223
Young Poland (Młoda Polska) literary movement, 77, 84, 191–193
youth movements, 10, 228–243; for Bais Yaakov girls, 102; commemorations and holidays, 233; as cultural portals, 234–236; gap between cultural prescriptions and actual activities, 238–240; *haskama* (public letters of approval) sought by, 232; libraries established by, 235; movie theaters, public events in, 220; Polish government and, 240–242, 243; in provincial towns versus cities, 243; recruitment initiatives of 1930s, 229, 230–231; religious dynamics of, 231–233; *siḥot* (group discussions), 235, 239, 240; sources and recent scholarship, 228–230; sports and physical activities, 235–236; women members and male-female interaction, 10, 232, 233, 236–238, *237*, 239. *See also specific organizations*
Yung-Vilne (Young Vilna), 7; catastrophism of, 46; interethnic and interreligious hybridity of poems of, 42, 47; under Lithuanian occupation (1940), 51–52; regionalism of, 41–42; Vogler and, 37, 39, 42, 46, 47, 51–52 (*see also* Vogler, Elkhonen); Wilno as Jewish cultural center and, 55n40; women in, 54n18; WWII and dispersal of, 52
Yung-yidish (art journal): Broderzon founding, 20, 22; Broderzon's manifestos in, 83, 84; first issue of, 83, 84; manifesto of, 22, 23, 34n27; mix of visual art and text in, 163; self-critique of, 26
Yung-yidish group and Jewish expressionism, 8, 75–89; Adler's title page for Broderzon's *Shvarts-shabes*, 79–81, *80*; adoption of expressionism by Yung-yidish, 81–82; aesthetic vision of Broderzon and, 24–25, 77, 83; apocalyptic and messianic themes, 8, 77, 83–88, *86*, *87*, 92nn40–41, 92n51; artistic culture of Łódź and influences on, 77–81, 89; Berlin expressionists and, 78, 79, 88, 89; Chagall as model for, 81–82; emergence and purpose of, 76, 77–78; foreign studies of, 90n4; form, subject matter, and features of, 82–83, 90n8; Jewish heritage and spirituality, embrace of, 77–79, 81,

85–88; Jewish Renaissance and, 78, 82, 90n8; *kleynkunst teater* performed by, 163; Lodzermensz identity of, 75–76, 88–89; multidirectional flow of culture between Warsaw/Łódź and, 163; *Perln oyfn bruk* (Pearls on the cobblestones), 83; *Tkhiyes hameysim* (Resurrection), 83. *See also* Broderzon, Moyshe; *and other specific members*

Yuval (music organization), 136, 142, 150n20, 151n30

Zabojecka, Maria (Malwina Garfeinowa-Garska), 194, 207n55
Zahorska, Stefania Lesser, 198
Zakopane architectural style, 68, 73n49
Zamyatin, Evgeniy, 58
Zangwill, Israel, 195
za-um (trans-reason) poetry, 26
Zawiejski, Jan and Mieczysław, 173, 181
Zdrój (magazine), 77
Zefira, Bracha, 8, 113–123; age of, 118; appearance, body, and images of, 113, *114*, 116–118, 120, *122*, *123*; Ashkenazi influences on, 116; musical skills and performances of, 116, 120–121; "Oriental" (Middle Eastern) Jewry, image of, 8, 113–120, 122–123; Poland, tour of, 8, 113–121, *114*; as true or authentic Jew, 118–119, 123; U.S., tour of, 121–123, *122*; Yemenite background and early career in Mandatory Palestine, 8, 115–116
Zefira, Yosef and Na'ama, 115
Żeleński, Władysław, 130, *131*
Żeromski, Stefan, 58
Zerubavel, Ya'akov (Vitkin), 215
Zieliński, Jarosław, 61
Zielony Balonik (The little green balloon; cabaret, Kraków), 19
Ziemiańska Café, Warsaw, 67, 69, 73n45

Zilberts, Zavel, 256, 259
Zionism: Bund's opposition to, 72n28; Casimir the Great monument (unbuilt), Kraków, impact on, 181; concert programming in interwar Lwów and, 128, 136, 147; Gottlieb, commemoration of, 179; *He'atid/Przyszłość* (Future; monthly), 197; Hochman's bas-relief plaque *The Admission of Jews to Poland*, criticism of, 183; institutional spaces for women's cultural production in Kraków and, 203; Jewish choral societies and, 257; language use and, 188, 191, 194; movie theaters as Jewish public spaces and, 212, 214–218, *216*, *217*, 220; origins of ideology of, 6; rabbinical support for, 231; regionalism versus, 3; synagogues, Zionist meetings held in, 222; Vogler's poetry defying logic of, 37; Yemenite/Oriental Jewry and, 118–119. *See also* youth movements
Zionist Congresses, 212, 224n5
Zionist Revisionist Party, 212, 215, 220, 224n5, 226n35. *See also* Betar
Złe miasto (Bad [or evil] city; Bartkiewicz), 153
Znajda, Abraham, 134
Żórawski, Juliusz, 58
Zweig, Stefan, 234
Związek Żydowskich Towarzystw Muzycznych i Śpiewaczych w Galicji (Association of Jewish Music and Choral Societies in Galicia), 129
Życie Świadome (The conscious life; monthly), 67, 202
Żydowskie Towarzystwo Artystyczno-Literackie. *See* Jewish Artistic and Literary Society
Żydowskie Towarzystwo Muzyczne. *See* Jewish Music Society